Contemporary African Cinema

AFRICAN HUMANITIES AND THE ARTS

Contemporary African Cinema

Olivier Barlet

Michigan State University Press | *East Lansing*

Translation by Melissa Thackway

The author received the precious backing of the French National Book Center to write this book.
He also received a literary grant from the Rhônes-Alpes region in France.
The author extends his heartfelt thanks to both organizations.

 The paper used in this publication meets the minimum requirements
of ANSI/NISO Z39.48-1992 (R 1997) (Permanence of Paper).

Michigan State University Press
East Lansing, Michigan 48823-5245

Printed and bound in the United States of America.

22 21 20 19 18 17 16 1 2 3 4 5 6 7 8 9 10

LIBRARY OF CONGRESS CATALOGING-IN-PUBLICATION DATA
Barlet, Olivier.
[Cinimas d'Afrique des annies 2000. English]
Contemporary African cinema / Olivier Barlet ; [translated by Melissa Thackway].
pages cm.—(African humanities and the arts)
Includes bibliographical references and index.
ISBN 978-1-61186-211-9 (pbk. : alk. paper)—ISBN 978-1-60917-497-2 (pdf)—ISBN 978-1-62895-270-4 (epub)—
ISBN 978-1-62896-270-3 (kindle) 1. Motion pictures—Africa, Sub-Saharan—History—21st century. I. Title.
PN1993.5.A35B36813 2016
791.4309967—dc23
2015033719

Book design by Charlie Sharp, Sharp Designs, Lansing, Michigan
Cover design by Shaun Allshouse, www.shaunallshouse.com
Cover image is of Soufia Issami, in *Sur la planche/On the Edge* by Leïla Kilani (Morocco, 2011).
Photo reproduced courtesy of Epicentre Films. All rights reserved.

g green press INITIATIVE

Michigan State University Press is a member of the Green Press Initiative and is committed to developing
and encouraging ecologically responsible publishing practices. For more information about the Green
Press Initiative and the use of recycled paper in book publishing, please visit www.greenpressinitiative.org.

Visit Michigan State University Press at *www.msupress.org*

Contemporary African Cinema

By

Olivier Barlet

The author would like to thank
Michael Martin and the
Black Film Center / Archive at Indiana University
for their generous financial support.

BLACK FILM CENTER/ARCHIVE

·

This book is dedicated to
video artist and performer
Ahmed Basiouny,
who died after being shot in the head
in Tahrir Square, Cairo,
on January 28, 2011.

·

.

Only
the imagination
can stop the world today
from being anything other
than a pulverized rock
or a ruined
echo.

.

AIMÉ CÉSAIRE

Contents

Preface

Why would I hold my tongue?

> —Tchicaya U Tam'si, in the film *Tchicaya, la petite feuille qui chante son pays*, directed by Léandre-Alain Baker (Congo, 2001)

Some fifteen intense years have passed since I published my first book on African film.[1] At the time, I firmly stated that this first book was just a step, so clear to me was it that my understanding of the films that have emerged from Africa's extreme complexity could never be the object of a single undertaking. Since, I have continued to talk to filmmakers and write about their films, feeling bold enough now to give this critical exercise a certain visibility. This, of course, created new challenges of its own, and necessarily launched me again into an unending inquiry. But I felt the need to pursue this route to articulate the relationship that binds me to these films, and the ways in which they help further my understanding of both myself and our turbulent world.

While it draws generously from the 1,500 or so articles, interviews, and reviews written over these years, this book does not reproduce or summarize texts that can easily be found online, notably on the *Africultures* website. On the contrary, I felt an absolute need to step back, pause, and reflect on exactly where I was and which

key ideas were essential before being able to continue on. It was impossible to start from scratch, however, and I have continued here to take my usual approach of frequently stepping aside to let the creators and professionals speak for themselves.

Even when it draws extensively on academic works, critics' writing has a logic of its own, which we shall try to clarify. It is difficult to condense daily journalism into book form. Yet this is the challenge here: not to lay claim to any one truth, but to attempt to establish some cogent ideas on the crucial issues that current developments are rendering even more complex. As with everything else, it is the process that matters more than the results, which are ever changing.

The world itself is continually shifting. While I was writing this book, the Arab revolutions fundamentally changed the situation of North African film and opened up unprecedented possibilities. Since the publication of my first book, I have indeed undertaken to discover films from this region; they are thus equally present in this book as films from sub-Saharan Africa. We still lack the necessary distance to understand the ways in which films made in the 2000s announced the changes now underway, yet, very rapidly, certain elements have emerged. This book's cover illustration, which features Soufia Issami, who plays the main character in Leïla Kilani's *Sur la planche/On the Edge* (Morocco, 2011), reflects this: both the form and content of this slam-like film are extremely contemporary, not merely as a reflection of our times—which would hardly be anything new—but in their aesthetic innovation and quirkiness, and thus shed light on our era. Looking back over her shoulder, her eyes alert and the trace of a smile playing on her lips, doesn't Soufia Issami's image, with her leather jacket and headphones, mirror the youth that led the Arab Spring?

The thematic approach usually developed by those writing about African film has its own limits. All too often, this approach neglects aesthetic aspects and circumvents criticism, taking the films' discourse at face value. Above all, it categorizes rather than raising questions, reinforcing a static image of the continent without posing the essential question of our vision of Africa and Africans. It generally thus neglects the central question of the vital deconstruction of the representations inherited from the colonial past.

Indeed, we cannot broach filmmaking in Africa today in isolation from the fraught public debates on migration, nor without recalling the tragedy of undocumented immigrants and all those who lose their lives trying to scale walls and cross seas, without giving space to African responses to the outrageous comments made in Africa itself by our highest-ranking political leaders, without situating these films

in the context of Euro-African history, the Rwandan genocide, and other tragedies that have taken place on the continent, nor without being aware of what the crisis of capitalism is doing to Africa and the rest of the planet. Without memory, without a reflection on violence, there will be no reconciliation in our world. It is a field that Africa can teach us a lot about, if we are willing to listen, without trying to guide or, worse, save it, and if we are willing to recognize its relevance and contemporaneity. I am indeed inhabited by Africa when the scandal of all the inequality and a desire for all possibilities seize me—not out of compassion, but out of a sense of responsibility; not out of indebtedness, but as a utopia. This requires embracing complexity. When Michel Leiris wrote *Phantom Africa*, it was this difficulty in understanding Africa to which he was referring. It requires being prepared to listen, and that doesn't happen unless you put your heart into it.

Based on films produced from 1996 to the present, this book is thus more a meditation than a study. It is an attempt to answer the questions facing critics today as humbly and frankly as possible. It is marked by the uncertainties of our time. It makes no claims to exhaustivity, or to belong to any particular school of thought; it defends its favorite films, readily recognizes its shortcomings, while at the same time regretting its omissions, and readily calls for a dialogue with other works. It has unquestionably benefited from the in-depth collaborative work of the *Africultures* team, to whom I wish to pay homage: I owe them so much. It is in this collective framework of friendship and constant reflection that I have worked through the ideas put to the reader here.

I must also, of course, again thank the filmmakers and all those involved in African cinema for their receptiveness and availability to me in my daily work as a film journalist.

I above all wish to thank the African journalists from the Federation of African Critics' Africiné network; their sensitivity and perspectives are an endless source of new questioning for me. I would particularly like to thank Thierno Ibrahima Dia for this daily critical exchange that I find so enriching. As "one hand cannot applaud without the other," they help to break a certain solitude, for there are precious few of us in France who take a real interest in African film.

If this book focuses on the question of criticism, it is because it is clearly an increasingly urgent one today. It is of course important to accompany and support film sectors, which, fragile as they may be, in my opinion constitute one of the key vectors of development. Indeed, to cite Célestin Monga, they "stimulate the capacities of the poor by providing them with an ethical corpus and the cultural

infrastructures they need to free themselves from their own fears" (4406).[2] But it is also in order to contribute a voice to the grand dialogue of international criticism, and to shine a light on films about Africa, whether made by Africans or set in Africa. Certain Western directors would be less sure of themselves if their anecdotes and clichés met with searing African reviews. Certain African directors too would truly benefit from the confrontation with constructive, unindulgent critical readings.

Before both the onslaught of images that convey the world's dominant models, and their spontaneous reproduction by those who take up cameras in the South without having the critical tools to enable them to consider the aesthetic stakes, critical thought is more necessary than ever. This book, which revolves in its entirety around critical questions, thus opens and closes on the issue of criticism. Criticism is essential in grasping the continuities and ruptures of contemporary creation. And in Africa's case, it is its responsibility to contribute to identifying and deconstructing the prejudices that engender discrimination. Rather than identity-based frames, which tend to essentialize an "African cinema" genre, we shall speak about the strategies that filmmakers adopt to subvert the gaze directed at Africa and Africans, and to find a place beyond the marginality in which this "monstrous" (Haffner)[3] and now "schizophrenic" (Haroun)[4] cinema is confined. This will lead us on to the possibilities that the explosion of digital technology and the emergence of popular cinema have created, and which are fundamentally changing the situation for the future of African film. It will also allow us to posit criticism as the condition of cinema as a critical art.

At a time when neoliberalism is triumphing all over the planet and causing the upheavals that we know, is the market the only possible way forward for cinema? The eternal question of audience encroaches on the necessary questioning of the function of a Seventh Art, which, from the outset, has been a popular form. We shall address this question once again, putting the spectator, not the public, at the heart of the question.

It is clear today that the metaphysics of revolutionary prophesying did not deliver a brighter future, and all those who long for a fairer society have the blues. Films are infused with the world's solemnity. Isn't this return to the present welcome? Rather than being intellectual guides who show the right path, filmmakers focus on today's evolutions. Cinema is no longer there to awaken the dormant masses, but to come to terms with the present, assessing the local to better understand the global, and documenting those sites of resistance that define themselves as neither

isolated nor hermetic, but rather as experiences that, while uncertain, are desirable for all. It does not attempt to construct new models, but rather the belief that it is possible to forge alliances among those who have the patience to rethink humanity in all its profundity. It is in addressing humankind today, in all its dimensions, that African cinema can help us come to terms with the world, and have confidence in our capacity to develop new possibilities.

This book stands in this perspective. The first chapter addresses the stakes of criticism today. The emergence of African criticism and, since 2004, its organization into an African Federation are not the fruit of hazard. A certain dismay is perceptible among both artists and spectators confronted with a cinema that no longer reflects their preoccupations. Africa's almost complete absence from major international film festivals suggests a crisis of creation. A critical point of view is needed.

Critical analysis offers perspective: it is important to grasp both the ruptures at play today and the continuities if we are to avoid critical misunderstandings. The second chapter positions film within Africa's literary and artistic history. There are filmmakers who have emerged since the mid-1990s who innovate in an attempt to break out of the confinement of identity-based politics, to escape the fixation with victimhood, and to give poetry new content. Yet they do so without denying a legacy that they deeply respect. Their provisions to better understand *the tremblings of our world,* to borrow an expression dear to Edouard Glissant, whose thought informs this work, are uncertainty, errantry, and hybridity.

To do so, they have constantly to struggle against the reductions and projections that beset all representations of Africa; this is the subject of the third chapter of the book. All relationships to African creation are marked by the "colonial fracture." It is beyond this violence and its misunderstandings that a common life is possible in a world of strangers.

But a troubled memory breeds violence. It is only by working this through that reconciliation can become possible, allowing a return to the future, the subject of the fourth chapter of this book. Today's clashes ring with the cries of the past, while the trauma of Rwanda marks a before and after. Forgiving is not forgetting, but inventing; in other words, defining the imagination of a utopia.

In cinema too, this is articulated through film style. The aesthetics dared by the filmmakers of the new generations are strategies of urgency that the fifth chapter of the book aims to outline. This paradoxically entails a return to the sources of orality in an effort to determine a form of resistance to formatting and standardization. They call upon the spiritual and the sacred, as has always been the case in African

culture when freedom is in jeopardy. And as the intimate constitutes the main strategy, bodies speak realms on the screen, guided by women's determination.

The real is more than ever at the heart of films and, as in all films from all around the world today, new aesthetic strategies are at play. Documentary sculpts fiction, opening up new paths. The sixth chapter strives to apprehend these, in the light of the transformations at play since the advent of digital technology and the emergence of a vibrant popular cinema, but one that is full of ambiguities. How is the need for images in Africa evolving today, and need it still be supported in the form of grants and cooperation programs? Does the informal sector suffice to foster diversity and democratization?

Each of these chapters poses more questions than it answers, but in the ambient complexity, and before the disarray of the decision makers and uncertainty of the creators, isn't it necessary to pose these questions again in the light of the films that filmmakers of African descent have proposed these last few years? And to thus try to return to simple ideas that are capable of guiding African film criticism?

The numbers in parentheses in the text are keyed to content published on the *Africultures* website. To access these articles, enter these numbers in the site's "quick search." There is also a list of articles keyed to these reference numbers at the end of the bibliography.

To make it easier to appreciate their diversity, I have indicated the director's African country of origin after each film title, even if the filmmaker was born elsewhere or is bicultural, followed by the year of production.

Unless otherwise stated, all quotations in the book have been translated by the translator.

The Question of Criticism

The work of art, from whichever side you approach it, is an act of confidence in the freedom of men.

—Jean-Paul Sartre, *What Is Literature?*

1.1. Disarray

You know African cinema; it tends to be serious, not light.

—Dani Kouyaté, in joint interview of the *Ouaga Saga*
production team, by Olivier Barlet (2004)

1.1.1. Crisis: A New Paradigm

I wish to ram into every word the pain of those living in the clutches of a century that messes up hopes and maintains a relationship of panic with the future.

—Sony Labou Tansi, *Antoine m'a vendu son destin*

What is the cause of Hami's death? Evil is eating away at the village community, which can only quell the scourge with the help of Calacado, the diviner, who determines everyone's place. Like the child Hami, Africa is burning from its inability to distinguish the living from the dead (9622 and 2188).[1] Africa is the subject of Flora Gomes's *Po di Sangui/Tree of Blood* (Guinea-Bissau, 1996), but its theme is the world. The crisis that forces the entire village onto the road of exile, while the loggers destroy the forest that harbors everyone's tree of life, is at the same time cultural, ecological, and economic. Duality upsets the world's unity and ruins human lives. Flora Gomes expresses this through twinhood. Twins Hami and Dou are two facets of the same son, Hamidou, for whom his mother, in a trance, calls out in a striking scene in which the clay-covered women pass a twin pitcher through the dyed red drapes—the color of both blood and power in animist tradition.

"The ancestors declared that one of you had to die, but your father and the imam refused," exclaims the mother in her trance before giving birth to the pitcher of reconciliation. What sacrifice must be made, then? Dou emigrates, while Hami stays behind. Strengthened by his overseas experience, Dou leads the village, while Calacado remains on the sidelines; the village can confront its heritage, if it lets itself be guided, like Saly, by the sun.

Something has to be sacrificed to counter the disarray. What is the way out of the crisis that threatens human unity? The lines need to move. Is letting a part of oneself go necessarily a loss? Dou is also the name of the African character in Cheick Fantamady Camara's first short film, *Konorofili* (Guinea, 2000), whose title means "anxiety." His characters seek the strength to overcome despair through relationships (2299). But the film is still pessimistic. Before a world dominated by market forces, which threaten the fundamental balance of the planet and human survival, "the artist is paralyzed," to quote Patrick Chamoiseau (8067). "Why make images? For what future?" asks Raoul Peck at the start of his documentary *Profit & Nothing But!* (Haiti, 2001), set in the small Haitian village of Port-à-Piment, "a country where figures no longer mean a thing." How to continue making films in this wilderness that Taïeb Louhichi portrays in *La Danse du vent/Belly Dance* (Tunisia, 2003)? Before the formatting of access to dreams, the film makes a vital plea for a meaningful cinema, for meaning that draws on the imagination as a source of utopia (3474). "Your dreams are your salvation," Zazia the Bedouin says, during a dance, to the filmmaker played by the Algerian director Mohamed Chouikh. Today's flood of images paradoxically goes hand in hand with a deficit of representation.

We have not finished eating dust, like this filmmaker who gradually runs out of steam chasing his dream in an arid world; but, in the ancient books and customs, a Zazia is there who cannot be reduced to a distant illusion.

To reflect the urgent issues of their communities, artists need to go forth, rooted in their sense of belonging—"stemming from their belonging, but well in advance of it," adds Patrick Chamoiseau (8067). "Henceforth," the artist is "ahead of the world." With the collapse of the nineteenth-century grand narratives, the local now more resolutely opposes the global, but we are all aware of inhabiting the same planet. That is what the concept of globality encapsulates, and it is within this new paradigm that the critical debates on the new forms of audiovisual production and distribution lie.

"There are positive and negative aspects in every culture," Flora Gomes declared during the *Po di Sangui* press conference when the film was presented in official competition at the Cannes Film Festival. A statement of the obvious? Not necessarily! His film shows that the price to pay for modernization goes beyond the age-old tradition versus modernity conflict: namely, a certain abnegation, a sacrificing of a part of oneself to accept what is of value in the Other. "The problem is not so much economic as mental," Ousmane Sembene said to Samba Gadjigo in 2004, concerned about the future of an Africa that is struggling to organize its economic exchanges. "The coming century is the most dangerous one" (3369). The main obstacle is the ruling classes, which he was planning, had death not struck him down, to focus on in the third part of his triptych after *Faat Kine* (2000) and *Moolaade* (2004): *La Confrérie des rats/The Brotherhood of Rats.*

"Authoritarian restoration here, administrative multiparty systems there, elsewhere feeble advances that, notwithstanding, remain reversible and, pretty much everywhere, high levels of social violence, or even festering situations, simmering conflicts, or open war, set to a backdrop of an economy of extraction that, true to the colonial mercantile logic, continues to encourage predation; this, with a few notable exceptions, is the overall landscape." Achille Mbembe's bleak portrait (9139) expresses the blockage experienced by the multitude of "have-nots," those who, abandoned to their own lot, have nothing left to lose. This imagery of permanent civil war fosters emigration, criminality, and illegality. Underpinned by an often criminal complicity, a minimalist state, and international indifference—not to mention what Mbembe calls the "logic of extraction and predation that characterize the political economy of resources in Africa"—it destroys the chances of inventing an alternative future.

Of course, the African continent aspires to freedom and well-being, but "this desire struggles to find a language, effective practices, and above all a translation in new institutions and a new political culture where political struggle is no longer a zero-sum game," Mbembe adds. Constructing this new imagination necessarily means reconsidering the question of this Other who traverses the whole of African history, which Chamoiseau expresses by proposing an "imagery of diversity to think the unthinkable."

When, for example, in the United States, whose cinema invades the entire planet, only 3 percent of literary publications are translations, it is urgent—yet not always easy—to discover the world, for it indeed confronts us with our ignorance of our own culture, encouraging us to develop it. At a time when our world is moving further and further away from the human, reducing the spirit to matter, desire to need, the subject to object in a greed orchestrated into an insatiable rapaciousness, there is a danger of restoring narcissism to guarantee order. It is necessary to return to the fundamentals. By calling his second film about the Pygmies *L'Eau, la forêt, la terre/Water, Forest, Earth* (2002)—the first, *Le Dernier des Babingas/The Last Babingas* (Congo, 1989), portrayed how industrial logging has radically altered their environment and ruined the forest—David-Pierre Fila uses these three elements to illustrate his fear for the future of the world (2795), already expressed in his short film *Elle revient quand maman?/When Is Mamma Coming Back?* (Congo, 2000). It is essential to return to the human, to our origins, to our destiny, to our inscription in nature and our finiteness to reflect on the crisis and to rediscover the meaning of our derisory passage on this planet. But given the runaway advances of science, technology, the economy, and profit that constitute our modern perils (crises, ecology, terrorism, war), it is crucial to remember "that you never kill a passion without substituting it with another, with a new paradigm," as Pascal Bruckner pointed out in *Le Monde* newspaper on February 28, 2009.

To orient its reflection, criticism may, then, reference a poetics of the global, far from identity-based essentialism, "not the anguish-ridden solitude of economic globalization, but individuation as a negotiation between one's self and Others, which builds a grouping of solidarities," as Chamoiseau puts it (8067). This can help it identify and encourage new imaginary forms, symbolic reorganizations, and the new demands for humanization in artworks.

1.1.2. A Terrifying Crossing

> No frontier exists that cannot be crossed.
>
> —Patrick Chamoiseau and Edouard Glissant, "Les Murs"

On August 2, 1999, two young Guineans, Yaguine Koïta and Fodé Tounkara, were found in Brussels, frozen to death in the undercarriage of a plane. They left behind a letter, addressed to "the members and heads of Europe": "It is our honorable pleasure and in confidence that we write you this letter to inform you of the objective of our voyage and our suffering, we the children and youth of Africa." They continued with this plea: "Help us, we are greatly suffering in Africa, we have problems and suffer abuses of child rights." Gahité Fofana based his film *Un matin bonne heure/ Early in the Morning* (Guinea, 2005) on this anything but innocuous incident (4460).

Sixty percent of the African population is under eighteen. Just like the European metropolises' inner-city or suburban housing projects, Africa's cities have become sites of relegation where young people suffer, as is clear from the opening voice-over of Merzak Allouache's *Harragas* (Algeria, 2009), decrying the cramped housing conditions, unemployment, and lack of prospects (9206). This loss of power over one's territory, life, and future turns these places into launch pads to an elsewhere. Leaving becomes a survival mechanism, even if Allouache's film opens on a suicide and a suicide note: "If I stay, I die. If I leave, I die"—a terrible indictment on the country of departure.

Africa's youth are trapped, and the experience is as violent as slavery in the past. Meanwhile, the elites import socially frivolous goods (SUVs, alcohol, arms). The youth are caught between leaving and resignation, as Laïla Marrakchi's short metaphor *200 dirhams* (Morocco, 2002) (2323) portrays, in which a young herder dreams of crossing the freeway. As the late documentary filmmaker Samba Félix Ndiaye said: "When I see the young taking boats, preferring suicide because they don't have the answers to their fears and their future, we have a duty to find a response, we can't be silent. Once again, Africa is being won over by a sort of fatalistic resignation!" (7956). Discussing this question as he presented his last film, *Questions à la terre natale/Questions to the Native Land* (Senegal, 2007), at the Apt Film Festival, he left the full movie theater a moment, overcome with emotion, unable to hold back his tears. I also remember Abderrahmane Sissako's tears at his Q&A on the same subject during the Cannes Film Festival's Social Visions selection. In his film *Bamako* (Mauritania, 2006), the few shots of immigrants crossing the desert—more

mobilizing than they are damning—sum up the outrageous inhumanity of how they are treated. No words are needed. As Oumou Sangare's melancholic voice resounds, the cloths that the women are dyeing redden the water, and the freshly dyed cloth fills the screen (4429).

Before the horror of watching its youth go to their likely deaths, should or can the cinema be sounding the alarm?

A far cry from Sissako's minimalist metaphors, is social cinema, which seeks to engage people's emotions and understand the mechanisms at work, the answer? The success of Philippe Lioret's *Welcome* (France, 2008) would suggest so. But pedagogical intent and heavy-handed messages conveyed through melodrama that wear their good intentions on their sleeves tend to undermine the genre. This can be said of *Et après...*, by Mohamed Ismaël (Morocco, 2002), which closes with the words "Populations do not die of hunger, they die of humiliation" (2687). The film focuses on the lure of the world of money. Even if they tragically recall the divide between deprivation and abundance, it is reductive to believe that the *harraga*, "those who burn" their ID papers or "burn" borders—in other words, clandestine migrants—are attracted only by a Western Eldorado; they know its limits only too well. "The West's lights aren't lights, they're just electricity," as Djibril Diop Mambety put it (4690). The term used to describe them—"burners"—incarnates a dream of another kind. That is what *Tanger, le rêve des brûleurs/Tangiers, the Burners' Dream* (Morocco, 2002) captures. In the film, Leïla Kilani films the geography of little streets, walls, containers, and puddles in impressionistic images and sounds. Every image vibrates with solitude, austerity, despair, and incertitude. The "burners" do anything to leave: they burn their papers, their identity. Willing to force their destinies, they have the makings of those cowboy heroes whose independence and grit we admire. Tangiers is a physical, corporal, sensual frontier vibrating with these men and women who dream of a mythical elsewhere that they can only find on the other side of this barrier (see interview with Leïla Kilani, 3043).

Yasmine Kassari's documentary *Quand les hommes pleurent/When Men Cry* (Morocco, 2000) portrays the sad outcome, voicing the words of exploited and uprooted immigrants in Spain, who no longer burn at all (0039). The tragedy of those who have managed to cross is no longer the same tragedy of those who are trying to cross, as testified by the young Africans who are turned back, and who also speak directly to the camera, relating their traumatic experiences in *Victimes de nos richesses, pays pillés très endettés/Victims of Our Riches* (Mali, 2007), by Kal Touré (8950).

As the worlds imagined by these "burners" that no borders can hold back are not rational, appealing to reality is pointless. Cinema thus turns to fiction, restoring these characters' psychological depth, which is often neglected in social films in favor of social relations and mores. Dedicated to the anonymous casualties of the Gibraltar Straits, Mostéfa Djadjam's *Frontières/Frontiers* (Morocco, 2002) surpasses the sociological to broaden understanding of these characters by following the relationship between six men and one woman, whose solidarity wanes when each individually faces the crossing (2131). One character in Hassan Legzouli's *Tenja/ Testament* (Morocco, 2004) offers an unclichéd representation of the prospective illegal migrant: Mimoun, the head of the morgue, whose name and "Morocco" T-shirt are so evocative. He too burns with the desire to leave, despite the bodies that pile up in his morgue. He has the folly that the project takes, the detachment of dreams, and the tragedy of humanity: he burns. As such, he is a guide for the main character, Nordine, who is also seeking some form of structure, without wanting to become attached (3580).

That is the crux of the question: how, today, to nurture an imagination of globalization in a world where most people cannot circulate without risking their lives. Mati Diop faithfully captures the "burners'" dreams and imagination in *Atlantiques* (Senegal, 2009) through the character Serigne. He states that Africa only offers him the dust in his pockets, but his reasons to leave lie elsewhere: in the initiatory myth of travel, in the unknown, the unspeakable. This imaginary realm, which transcends death for want of being able to live life, proves to be an illusory, tragic beacon, however, that plunges them into the sea—not the Mediterranean, but the Atlantic, the sea that hitherto swallowed the enchained slaves (9405).

Indeed, people smugglers rob migrants before turning them in or throwing them into the sea. This is common knowledge, so why show it again on the screen? Some, like Abderrahmane Sissako in *Heremakono/Waiting for Happiness* (Mauritania, 2002), set in Nouadibou, try instead to understand the perversity that the frontier has now become. Daoud Aoulad-Syad frees himself from the shackles of narrative to capture the suspended state of awaiting departure in the merciless hole that is *Tarfaya*, after which the film is named (Morocco, 2004). Eschewing a sociological approach too, Daoud Aoulad-Syad focuses less on migration itself than on the obsession it provokes in us all—a tragic expression of the thirst for freedom. Frontiers should be a passage, a link, a relation between cultures, yet they have become a terrible impermeability between nation-states. As a result, people wait, seek. These are uncertain bodies who carry their past while the future remains closed to them.

Focusing on this circular in-betweenness between people and places, *Tarfaya* is a meditation on the state of our divided world, one part of which dreams only of reaching the mirage of the Other, even though, as the kid wants to tell his father who has emigrated, "things are good here too" (468g).

How to avoid sliding into melancholy, or desperation, before this waste, this human tragedy, before the deadly madness of those who risk their lives trying to advance? How to not only appeal to the spectator's conscience, but also awaken his or her sense of hospitality, which could counter the closing of borders demanded by voters in the North? A shakeup, a challenge is needed. In *Mirages* (France, 2008), Olivier Dury accompanies illegal migrants traveling from Agadez in Niger to Djanet, Algeria, so crammed into open trucks that even their toes are enmeshed (8134). Their time is that of the long, grueling, terrible journey. We feel cramped just sitting in our seats. The lack of commentary accentuates the strain, and the dust, like the duration, imposes a kind of metaphysics of fog. Dury's lens is level with the men he films; the camera does not zoom or use effects. With him, we watch these people carve out a destiny from this ordeal, packed together in the immensity of the desert. And we plunge with them into this rite of passage. As he hones in on these buffeted, jam-packed, compact bodies—bodies that also pray, fall sick, or speak during the pauses—and by making them and only them his subject, Dury creates an essential familiarity: that which connects humans, or in other words, them and us, bodies tossed back and forth by life.

The youth in Slim Ben Cheikh's *Aéroport Hammam-Lif/Hammam-Lif Airport* (Tunisia, 2007) represent other disadvantaged bodies that speak through their gestures and the symbols in which they drape themselves. They are not trying to cross the desert, but rather find ways to slip into containers or trucks at night to take the boat to Italy. Their only horizon is exile, and they openly and with good humor recount their failed attempts and reattempts (8134). The fall of these modern Icaruses are those of sons and daughters trying to fly in the labyrinth of the world, at risk of losing their wings. They all lose a part of themselves at any rate, as they try to find their place; they are no longer from here, and not allowed to be from there. Seen from a plane, Italy is just a stone's throw away, but this insurmountable distance measures their impossible movement in a world that refuses them a place. As the closing rap berates us: "I believed, but now . . ."

"Things are good here too." Film strives to show in what ways. *Bab el web* (Algeria, 2004) portrays a city no longer to be left, but inhabited (3705). Here, Merzak Allouache portrays a new Algeria, after having depicted its tragic future in his 2001

film *L'Autre monde/The Other World* (0041). In Abdellatif Ben Ammar's *Le Chant de la Noria/Melody of the Waterwheel* (Tunisia, 2002), Zeineb embodies resistance: "Neither North, South, East, nor West!" She does not succumb to any illusions: "No resources, projects, trips, disasters; it's our destiny!" before repeating what Mouldi says: "The only thing to fear is fear!" Her determination questions the menfolk, and M'hamed: where are the men of our childhood? It is indeed a question of virility here, of the power to take the country's destiny in hand (2314 and interview 2315).

Ultimately, why stay in the hellhole that is Benares? That is the question that Barlen Pyamootoo's *Bénarès* (Mauritius, 2006) poses with utmost gentleness. Why not go and see Benares—the real one that people flock to, to earn their place in heaven? Maybe because life is in fact possible in Benares, Mauritius (4601).

1.1.3. Cinema Does Not Change the World

> What a writer aspires to the most is to act. To act, rather than testify. . . . But how can writers act when all they know how to do is recall? Solitude is the writer's lot.
>
> —Jean-Marie Gustave Le Clézio, Nobel Prize Acceptance
> Lecture, Stockholm, December 7, 2008

"Internationally, people expect our films to reflect our youth's preoccupations, and they do not," said Tunisian filmmaker Mahmoud Ben Mahmoud during his Hergla Festival master class (8073). This is also a cause for concern. African film finds itself caught between two issues: the pertinence of its discourse (and notably its role vis-à-vis the tragedy of prospective migrants) and its access to the international market—or in other words, its economy, visibility, and participation in the world's imagination. In answer to Renaud de Rochebrune's question of why African cinema is so undynamic and lacking in visibility today, Mahamat-Saleh Haroun said: "There are two reasons for this. Firstly, of course, the absence of local funding. Filmmakers are forced to seek funding wherever they can. That undermines initiative. But also, too often, filmmakers treat nonessential subjects. They content themselves with telling tales about traditional African life, without proper funding into the bargain, which stops them from confronting their works with those made elsewhere."[2]

It has to be said that recent productions have been lacking in terms of both quantity and quality (7946). Quantity is a recurrent problem and has not improved, despite the digital technology–fueled emergence and boom of extremely

low-budget, mass-produced films destined for local or diaspora audiences. As for quality, there are few films and directors who can compete internationally. The reasons usually given are lack of training and unpolished screenplays, a dearth of technicians, funding problems, and the eternal obstacle of the funders' prejudices. All that is true, but there is a risk of getting trapped in an attitude of victimization. Striking the right balance between local and global is not easy, and the risk is diluting one's discourse to suit the market. A constant negotiation occurs within each film, resulting from the cost of filmmaking and its desire to be universal, but it is completely wrong to accuse filmmakers of systematically scuppering their art and selling out to the enemy!

The problem is that there is no cinema without creativity; that is the rub. In their first feature films, many promising filmmakers flail beneath the ambitiousness of their projects, which are often driven by their acute awareness of the continent's tragedies, but bogged down in pedagogical intent. "We have done all we can, yet the world hasn't changed; so much conviction for nothing!," as Raoul Peck puts it in *Profit & Nothing But!* (Haiti, 2000). So why make films, then? "Because it's more acceptable than burning cars," answers Peck! The misunderstanding stems from what constitutes a critical art, which is necessarily political without having to be a category unto itself, as it lies in the common, public sphere. Pedagogic illusions confuse the potential of film and that of the spectator. An art that questions the political to challenge it sets out an issue rather than an objective. As Jacques Rancière suggests: "In its most general expression, critical art is a type of art that sets out to build awareness of the mechanisms of domination to turn the spectator into a conscious agent of world transformation."[3]

"Writers no longer presume that they can change the world," Le Clézio added in Stockholm. Nor do filmmakers. Film is no longer the dominant narrative mode that unites generations around common references, and the flood of moving images has marginalized the movie screen. Notwithstanding the surge of reactions sometimes stirred by news reports, filmmakers generally no longer believe in the romantic, socially just notion that images can shape history. They no longer believe art to necessarily be effective. Much was written and said about Rachid Bouchareb's *Indigènes/Days of Glory* (Algeria, 2005) (4433), its joint Best Actor award at Cannes, and its three million admissions at the box office leading to the unfreezing of the African war veterans' pensions.[4] While the film unquestionably focused media attention on the problem, and may well have spurred a political decision that was nonetheless ultimately a half-measure, this says little about art's social clout, for, as

Adorno writes, "what is attributed to its spontaneity in fact depends on the general social trend."[5] The outraged reception given to *Hors-la-loi/Outside the Law* (Algeria, 2010), whose re-creation of the Sétif massacres was attacked by a French right wing opposed to any form of repentance (9500, 9498, and 9541), indeed confirms that the social repercussions triggered by a film's reception depend on what Jauss referred to as the "horizon of expectations."[6]

Filmmakers no longer share their subjects' illusions either. "They use the camera in the same way that I do. The only difference is that they believe their suffering can still move people and change the course of their destiny," Anne-Laure Folly commented with regard to the Angolan women caught up in the thirty-year-long war filmed in *Les Oubliées/The Forgotten Women* (Togo, 1996). Yet audiences share this illusion too, as they demand clear messages and still demand the engaged cinema of the pioneers. Hence the criticism leveled at filmmakers, and in part reiterated by journalists and academics, which we shall come back to later (1.2.4). A chasm of misunderstanding is growing that is of no benefit to anyone.

The question of denunciation is hardly new, however. Walter Benjamin already raised the issue in 1934 in his writings on Brecht. Based on conviction, it is more on the order of rhetoric than artistic language. The Latin word *denuntiare* means "to intimate" or "declare," but can also be applied to something reprehensible. We "denounce" a guilty party. In his documentaries, Michael Moore articulates an unequivocal discourse that is assumed to be self-evident to the spectator. This presupposes sharing a belief, or even certitudes, and thus preaching to the converted. Here, film becomes a crusade, verging into the realm of propaganda. But, as Rancière states: "The exploited rarely require an explanation of the laws of exploitation. The dominated do not remain in subordination because they misunderstand the existing state of affairs, but because they lack confidence in the capacity to transform it." This confidence only comes with being involved in a political process of change. But worse than being superfluous, denunciation risks enshrining the very thing it hoped to change: "the work which builds understanding and dissolves appearances kills, by so doing, the strangeness of the resistant appearance that attests to the non-necessary or intolerable character of a world."[7]

Denunciation undermines interpretation, and thus basically amounts to a confiscation of the spectators' critical position, and manipulating them instead of making them an involved and knowing partner, especially as, if we are not careful, the spectacle of horror quickly becomes a source of fascination and pleasure. Moreover, a denunciatory discourse can even serve the enemy denounced, who will

not hesitate to co-opt it. That happened to the Surrealists and the neo-avant-gardists of the 1960s, and threatens all art. The documentary filmmaker Jean-Louis Comolli clearly demonstrated this in his reflections on how he filmed the French far-right National Front party: the denial engendered reinforced the adversary by enabling the party to parade all the more. It is thus the person denouncing who is in turn manipulated. The solution, according to Comolli, is "to give the enemy body and presence, so that his/her power is revealed."[8] To show the enemy for what he or she is, then. Or in other words, to film party leader Le Pen in all his glory! The Americans made the grave error of depicting Saddam Hussein diminished, unshaven, and holed up in his hideout. The entire Arab world felt humiliated. When Eric Deroo filmed the Togolese dictator Eyadema in *Eyadema, président, tirailleur, général/Eyadema: President, Tirailleur, General* (France, 1998), he showed the man and his discourse of power as they were, and thus shot a true indictment. The Togolese regime still used the film for its propaganda purposes, even announcing the time of its television broadcasts on its website! Deroo filmed Eyadema without diminishing him, as he wished to appear, in all his glory, without Eyadema realizing that the public thus saw him in all his horror.

Denunciation's efficacy nonetheless remains a deeply rooted illusion in the minds of many people, who believe you can show and tell to make people know and understand. There is quickly a tendency to exaggerate in order to assert one's point of view. That results in cinema that, as critic Serge Daney put it, "points the finger rather than pointing the gaze." This belief is based on the correlation between knowledge and power established by the workers' movement and the historical avant-garde. Today, it is a triumph of communication to have us believe that we can render visible the invisible, and thus grasp the world. But one characteristic of globalization is the invisibility of systems of oppression. Exploitation can be shown, but not its mechanisms, which are well disguised. "The real decisions are taken by people we shall never hear of," notes Edouard Glissant (2842). We evolve within this imperceptibility, and this incertitude is a source of anxiety. Artistic responses can only be aesthetic and intimate (and not aestheticizing and inward-looking), and are thus necessarily destabilizing for the spectator. To avoid the dangers of being co-opted, art has to ask itself the question of its own production, hence Brechtian distancing mechanisms and obstacles to illusion, and notably montage.

But it is also possible to react in terms of production itself. "The current responses to globalization are the local development of video products that meet

the population's demand, with all the ambiguities they may contain. Auteur films are what they have always been: alien phenomena limited to a handful of specialized festivals," Mahmoud Ben Mahmoud also commented at Hergla (8073). Is this a crisis of creation, or a crisis of the market? "Both are always connected, given that a successful film is the meeting of an auteur's vision and the state of society," insists Michel Reilhac, head of cinema at ARTE television.[9] But ultimately, it is the radical change in audience behavior that has changed today's situation: audiences prefer mainstream cinema and are turning their backs on what we know as auteur, quality, or committed cinema—the slot into which all African films fall, as does all "world cinema" (in other words, not national or Hollywood cinema). In Africa, movie theaters are closing, or multiplexes are developing that apply the same rules as in the West, and in which auteur films' access to the screens is increasingly random, uncertain, and ephemeral. They do not have the clout of heavily marketed mainstream films and can only survive in underground niches—festivals mainly—and on the university circuit in the United States. We are thus witnessing a complete collapse in their audience, which in turn results in their usual funding and distribution partners' withdrawal.

Today, could the late Adama Drabo's *Taafe Fanga/Skirt Power* (Mali, 1997) still open with the griot Sidiki Diabaté switching off the TV (on which we see a line of bare-legged chorus girls dancing in a cabaret) and sitting to play the kora to the audience gathered in the compound? He thanks them for their reception and declares that his "duty is to capture the past to feed the present and prepare the future." Since the seventeenth century, Western thought has conveyed the idea that one must know the world to change it, and African thought traditionally draws on the griotic notion that the future stems from the past. Both these paradigms are in crisis today: the world is in unpredictable chaos, and the place we occupy in the present determines the future more than identity-based references to the past.

The result is a loss of reference, an in-betweenness, a wavering, a malaise, a concern, a limbo, a torpor similar to that which overcomes Pierre-Yves Vandeweerd in *Les Dormants/The Sleepers* (Belgium, 2008), who films this moment at the start of his newborn's life and on the eve of his mother's death; it is there too in the practice, in Mauritania, of *Istikara*, in which the dead guide the living in their dreams (8057). This transitory phase—a melancholic state of disenchantment—opens us to the founding experience of doubt, and thus reconstruction, like the moving birth of Vanderweerd's film. With utmost modesty and an incredible foreknowledge of the world crisis to come, in *35 Rums* (France, 2008), Claire Denis captures this state

of suspension, of limbo, where comfort and clichés do not suffice, through the relationship between a young woman, played by Mati Diop, and her father, played by Alex Descas, who is tied to past suffering, but full of the desire to breathe and to be able to love (8307). With *White Material* (France, 2009), shot in Cameroon, and whose screenplay was cowritten by Marie Ndiaye, Claire Denis again explores this tense in-betweenness in an Africa where fences no longer provide protection. Maria's (Isabelle Huppert) fear of being uprooted is resolved in the death of the father, once she understands that her mistake was to imitate the men in their obstinate defense of a land that she identifies with her own body: to lose it is to lose one's life (9280). Trapped in her colonial mentality, she can in no way envisage the abnegation that John Maxwell Coetzee portrays in the magnificent *Disgrace*, adapted to the screen by Australian Steve Jacobs in 2009: when in the minority, clinging onto one's land equates a loss of integrity (9152).

While what is at issue in this crisis is moving on from the old, the new is not yet visible on the horizon. "Globalization is a downward leveling, that is to say, an attempt to reduce everyone to the same desires, whether for food or sports," Glissant states (2842). The entire planet loved *Dallas*. What to do? "The best way to react is not to shut oneself in the confines of one's own identity or specificities," Glissant replies, calling for a pooling of the world's imaginations. "Mondiality is thus the sentiment that my imagination and my neighbor's touch complement one another and mutually exchange, and it is in this exchange, in this mutual completeness that we can find spaces to really live our diversities, while making them concur at the same time."

1.1.4. The Paths of Reconstruction

> I would hurl words into this darkness and wait for an echo, and if an echo sounded, no matter how faintly, I would send other words to tell, to march, to fight, to create a sense of the hunger for life that gnaws in us all, to keep alive in our hearts a sense of the inexpressibly human.
>
> —Richard Wright, *Black Boy (American Hunger): A Record of Childhood and Youth*

Isn't the world crisis an opportunity for a new culture that combines listening, solidarity, mutual assistance, human scales, modesty, sincerity, and humanity in the grand momentum of giving and receiving that Glissant evokes when he talks about mondiality? Africa's contribution is essential to the "grand moral coalition

beyond states" that Achille Mbembe calls for: "a coalition of all those who believe that, without its African part, not only will world security not be guaranteed, but our world will be decidedly even poorer in both spirit and humanity" (9139).

But given the ambient disaster, and in the face of repression and loss of all revolutionary illusions, this will require alternative paths. Filmmakers can show the way. Film does not change the world, but, as Wim Wenders said, by improving images of the world, we can improve the world itself. The 2000s have seen the emergence of a major artist: Tariq Teguia. In the space of several films, he has captured the geography of ambient disarray, exploring possible connections and vanishing points. "The desire to flee is to be on the side of the living," Teguia commented during his Apt Film Festival master class (9014)—like the activists in *Inland* (Algeria, 2008), whose debates appear to go round in circles, but who do not lose faith and who are capable of laughing at themselves. They seek both a life amidst the contradictions, and a hermaphroditic Algeria capable of associating masculine and feminine, autonomy and relations (8481). And like the youth in *Rome plutôt que vous/Rome Rather Than You* (Algeria, 2007) who, through their bodies, laughter, and dancing to a Cheb Azzedine *raï song* ("Glory, glory to us the living!") proclaim that they are full of life and would like not to have to leave, that this is not an end unto itself, in a magnificent party scene that eschews despair, filmed by a camera that caresses their bodies; indeed physicality is primordial in this carnal film, for these are truly men and women here, bursting with the will to live (7458).

It is notably through cinema that Africa can propose renewed imaginations capable of bringing about this *coalition of the living*. It is thus necessary to invent new ways of telling stories and testifying, an invention that is as complicated as it is unpredictable. "Writers are never better witnesses than when witnesses in spite of themselves, against their own will," Le Clézio also said in Stockholm. "Paradoxically, what they testify to isn't what they have seen, nor even what they've invented." This reflects a wonderful humility, but is also an apt definition of the power of art, which detects the invisible to open the array of possibilities. First of all, however, we must reject reactivity in thinking today's world and, as Sophie Bessis hopes, get over "knee-jerk reactions such as Afrocentrism or Arab nationalism"—a reactiveness that implies that "as you have declared us inferior, we say that we are superior, deploying exactly the same logic" (0052). In other words what Maxime Rodinson calls *a culture of resentment*.

For Abderrahmane Sissako, another major filmmaker of the 2000s, this different approach is a program unto itself: "I don't think we've done what's necessary

to call ourselves into question. We always tend to lay the blame elsewhere. Yet responsibility always lies with "us," whatever the conflict. It's always shared" (5958). Although *Bamako* (Mauritania, 2006) unquestionably develops a radical discourse as it puts the international institutions on trial, highlighting their role in Africa's pauperization, the film is not at all aggressive. It simply points out that there will be more tears, like the moving tears of Aïssa Maïga as she beautifully sings, and that utopia—the African ram that literally rams Counselor Rappaport, the legal institutions' attorney—is all that we have left to stem their flow. And that this *utopia at all costs* would be to put these institutions back at the service of mankind, not liberal capitalism, as was their initial vocation (4429).

Beyond the acute awareness of Africa's tragedy—this solitary body that only a dog comes to sniff—fresh air is possible, if the fans are put in the right place. "Nothing worthwhile comes without utopia!" Edouard Glissant reminds us. That means claiming one's place in the universal, while at the same time criticizing Western hegemony. As did Césaire. As did Fanon. That means thinking identities in the making—in other words, identities that are not fixed, definitive, and exclusive—in accord with Glissant: "I can change by exchanging views with the Other, without losing or denaturing myself" (2842). And that means accepting that the world is unpredictable, that is to say that we will find our way walking and singing in the desert, like Ishtar and the blind old dervish in Nacer Khemir's *Bab'Aziz—The Prince That Contemplated His Soul* (Tunisia, 2005). We know the storm on which the film opens: it is our loss of bearings in a world where "even the dunes have changed place." There is no map, no mapped-out path: what matters is seeking, not finding (4381 and interview 4383).

"When you speak, it isn't so cold," Ishtar tells the grandfather, to get him to continue telling his tales. To communicate via these words that teach "to see the heart with your eyes." The sand that later covers their grandfather's corpse reminds us that the baby in the mother's womb does not know the beauty of the world, and that the same goes for death. The wisdom of this beauty of the unpredictable chases all notions of purity from our minds, of being chosen by God, of preeminence, of the right to interfere. We can only evolve through contact and exchange with the Other. "Several islands aren't enough; we need an archipelago," Lakhdar says in *Inland*, which, from topographies to electric wires, traces the connections of a flight toward life. The *coalition of the living*'s multiple forms of resistance to a homogenizing universal are archipelago-like, unpredictable and inducive.

1.2. Unease

Those who can still dream no longer sleep.
> —Mounir Fatmi, in the film *Hard Head*, directed by Mounir Fatmi (Paris, 2008)

1.2.1. An Intruder Enters the Game

Don't go shouting it about, but the negro says: screw you!
> —François Fèvre, in the film *Aimé Césaire: Un nègre fondamental*,
> directed by Laurent Chevallier and Laurent Hasse (France, 2007)

Can we fight a homogenizing universalism? It is true that the image is no longer the absolute weapon of the West. An *intruder* has come and upset the rules of the game. "The West can no longer construct the world's paradigms alone without engendering an equally powerful counter propaganda. The globalizing days of colonial, ethnocentric images or the North's dominant stereotypes of the South are over," wrote historian Pascal Blanchard and director Eric Deroo in response to 9/11 (2197). The opposition between the white hero and the systematically devalued Other still persists in productions from the North, of course, drawing on codes still solidly rooted in people's imaginations by colonial cinema, John Ford Westerns, and all the Tarzan, Rambo, and other adventure films. But the imagery of the white man out to conquer the globe, retrospectively legitimated by scientific reason, is now challenged by the decolonizing of minds that the South's responses have set in motion.

"Since Fanon," writes Achille Mbembe, "we know that it is the entire history of the world that we must revise; that we cannot sing the past at the expense of our present and future; that 'the Negro soul' is the white man's invention; that the Negro does not exist, any more than do the whites; and that we are our own founding" (6784). Yet, as Abderrahmane Sissako points out, a race is on: "Unless we react, the next twenty or fifty years are going to see a terrible acculturation. Television and the media are fueling this, not only in Africa but also in Europe" (2351).

My generation—that which came of age with the ideals and ideologies of the 1960s and 1970s—failed to prevent the progressive dictatorship of the world market in the 1980s and 1990s. Our lack of critical spirit now places us before serious modern ecological and political dangers. We are in the same situation as the cavemen, who already sensed just how fragile their future was; posing the question of the future of

humanity in reality posed the question of their own humanity. As the philosopher Marie-José Mondzain reminds us,[10] cave paintings reveal that while man continually progresses in his hominization, through these inaugural gestures, humans posited the necessary symbolization of their representation, that is to say, the construction of an active spectator who is preoccupied with his or her fragility and thus with the future of his/her humanization (3038). We must thus consider man as a being of beginnings, to borrow Hannah Arendt's expression.

African films are intruders and, precisely, happen to be bursting with life force; it is indeed their vanishing point, as we saw in the previous chapter. This is the boomerang effect of the colonial subject; in other words, it comes from inside, not outside. Challenging stereotypes is an endogenous intrusion, even if the films are generally situated in Africa. Watching them supposes accepting the foreign and lowering one's guard; it means accepting becoming a stranger oneself. We too become intruders. Unease. Especially as this reinforces solitude, rather than encouraging exchange: "Becoming foreign to myself does not reconcile me with the *intrus*," philosopher Jean-Luc Nancy reminds us, after undergoing a heart transplant.[11] Especially as one intruder may hide another; they tend to multiply. Neill Blomkamp demonstrates this masterfully in *District 9* (South Africa, 2008) with his character Wikus van der Merwe, a bureaucrat appointed to relocate the aliens who have settled in Johannesburg for the previous twenty-eight years. Yet Wikus becomes the theater of an intrusion himself. After being contaminated, he starts to turn into an alien too. In this allegory not only of apartheid but also of the relation to immigrants in South African society and the rest of the world, being contaminated by the Other means having to manage not only the Other's alterity, but one's own alterity too—a real social issue! (9189).

Yet by opposition, the intrusion of life evokes death, or at least death in life. The intruder that is the image-taker challenges our certitudes, reveals the agonies of our world, but also invites us to recognize the inseparable life-death duo. In *Bamako*, Falaï the photographer astonishingly says that even though he photographs weddings, he prefers the dead: "I'm not interested in the faces of people who speak. There is no truth. I prefer the dead; they're more true. There's nothing like death." Abderrahmane Sissako specified: "This character is the author" (4428). But the unease also concerns the intruder him/herself and his or her capacities. Another character in *Bamako* wants to film the trial, but is not authorized to, even though the official reporters do: "It's my way of saying that the state—in other words, us—is not willing to talk about this trial, even if it lets it

go ahead. It's perhaps too soon for this intruder to take his camera and film, too soon for it to be an individual who does so."

The huge success in France of Abderrahmane Sissako's *Timbuktu* (Mali/Mauritania, 2014), winner of seven Césars in 2015 (the French equivalent of the Oscars), and unfairly overlooked by the Cannes Film Festival jury despite being classed a favorite by the press, comes from the film's radically humanist approach. The film opens with a shot of a fleeing gazelle. "Don't kill it, wear it out!" shouts the head of the jihadists pursuing the animal in a jeep. That is what they do to the population too. In other words, they trample and destroy their cultural references. Masks and statues serve as targets for firing practice. They impose bans on everything, from cigarettes to games, music, and even sitting out on the doorstep. They impose black veils, socks, and gloves on the women, including the fishmongers in the market. For the women are their first targets, subjected to forced marriages, against their parents' will. Only the madwoman Zabou—played by Bamako-based Haitian dancer Kettly Noël—eludes them. A local *Linguere*,[12] proud and untouchable—the Jihadists have no sway over madness—she evokes January 12, 2010, in Haiti: "The earthquake is my body. I'm fissured all over." The earth quakes there where human life is flouted. In the city of Timbuktu, everything is earth-colored. The film is impregnated with the ochers of the desert and adobe walls. If the earth is shaken, so too is the world, so long as it can represent this drama. That is the role of cinema. The repression is shown: the beatings, the expeditious judgments, and a lapidation during which all that is visible are the heads of bodies buried in this same earth—a lapidation that, according to Abderrahmane Sissako, was at the origin of the film. But to avoid descending into pathos, Sissako injects humor into this "tragedy seen from behind," to quote Genette. The more tragic the subject, the greater the distance required. And Sissako's humor is scathing, revealing the hypocrisy of the invaders and their ridiculous contradictions. The Islamic police try to localize the singing and music, only to realize that they are religious praise songs. Coming from Libya, the jihadists only speak Arabic in a land where Tamashek and Bambara are spoken, forcing them to resort to French. This creates some delicious situations, like the filmed propaganda message that needs to be effective. As in Godard's *Ici et ailleurs/Here and Elsewhere*, every facet of the image has to be composed to make it politically meaningful. As ever, established discourse masks the realities of desire and pleasure, in the image of Abdelkrim (Abdel Jafri), the jihadist chief who behaves like a child. This earth is stirred up too by the cosmic dance of the jihadist played by Hichem Yacoubi, in his prayer-cum-choreography. It is a magnificent scene, magnificently

filmed by Sofiane El Fani (also director of photography on Abdellatif Kechiche's *La Vie d'Adèle/Blue Is the Warmest Color*), capturing details that serve as metonymies. At this point in the film, the poetry supersedes the derision. With the same force as at the end of Antonioni's *Blow-Up*, the youth play a football match orchestrated without a ball.

For the population resists every day, "singing in their heads the music they were forbidden to sing," as Sissako stated at the Cannes press conference, before breaking off a moment, overcome by emotion. It is to this resistance that he wanted to testify, and notably that of these youth who continue to play music, and this woman who dares to sing: Fatoumata Diawara's beautiful and enchanting voice rings out beneath the lashes. This recalls the poet-singer Marwan in Youssef Chahine's *Destiny*, threatened by the fundamentalists, and who cries: "I can still sing!" This resistance "is the real liberation," Sissako added, "not that of those who appropriate everything!" To those subjected to repression, *Timbuktu* gives this resistance a face. It is the faces of his daughter Tayo and his wife Satima that the Tuareg herder Kidane desperately wants to see again before dying. And it is precisely on Tayo's face that the film ends, for Sissako strives to give the repressed back a face. Tayo keeps trying to pick up a signal for her cell phone; the jihadists cannot quell the desire to communicate. Nor to play, love, or sing. Their repression is derisory; their chief, Abdelkrim, even stoops to gunning down the grasses that form a bush in the dip of the dunes, the sensual image that had already ended *Heremakono*, and an evocation of the femininity that ought to pervade society. "The humiliation cannot go on," says the herder Kidane, but his altercation with the black-skinned fisherman Amadou is not about vengeance. Which humiliation is he referring to? That suffered by the Tuareg in their confrontation with the Malian people? That of not being able to lead their nomadic lives? The confrontation scene is of great formal maturity, bearing the mark of a filmmaker who knows where to place his camera and in which light to shoot. Sissako turns the risky challenge of reacting in the heat of the moment to a contemporary situation into a demonstration of sensitivity, intelligence, and creativity. Further still, he gives all the characters back the right to their humanity. The jihadist who sympathizes while forbidding the translator from translating this sympathy is a misled man, but a man nonetheless. The jihadists' fragility is certainly derided, but is also a sign of the weaknesses that suggest they belong to the community of mankind. Without ever softening his condemnation of extremism, and with the same firmness but also the same dignity as the wise imam of the Timbuktu mosque, through cinema, Aberrahmane Sissako engages in

a dialogue with those who exert their terrible repression. His tragicomic derision is not a lack of respect, but a lucid evaluation. He engages himself—and us—in a humanist vision that is necessarily more complex than media simplifications. Beautifully titled, *Timbuktu, le chagrin des oiseaux/Timbuktu, the Grief of Birds* is both a homage to the sufferings and the dead, and a celebration of the resistance of the living. Only a truly talented filmmaker could pull off the challenge of giving this a face with such coherence and sensitivity (12233).

1.2.2. Humanity in Danger

> Being human takes will and constant effort.
>
> —Patrick Chamoiseau, "Un admirable 'Eclat de conscience,'"
> *Le Monde des livres*, October 30, 2009

It was nonetheless these individuals who took up the camera, unaccompanied, with no industry backing. And, frequently, they continue to do so in the same conditions, by any means possible, even with their cell phones, as was seen during the Arab Spring in 2011. Their concern, as we have seen, is the future of humanity, conscious as they are of the scandalous pauperization and divide that the rich everywhere are exacerbating. "From W. E. B. Du Bois to C. L. R. James, from Martin Luther King to Nelson Mandela, from Stuart Hall to Paul Gilroy, Fabien Eboussi Boulaga and all the others," writes Achille Mbembe, "leading black thought has always been couched in the form of the dream of a new humanism, of a renaissance of the world over and above race, of a universal polis in which it is everyone's recognized right to inherit the whole world. The Africa they claim—the word and the name—is a living multiplicity which, like the word 'Jew,' is linked, since its origins, to the future of the universal" (6864).

As those who approach world imagination most closely, artists play a leading role in this new humanism. "Making films or theater, painting, and making sure that art, which is the very synonym of freedom, becomes a necessity in our societies is the best way to counter all forms of extremism and obscurantism," commented Moroccan filmmaker Faouzi Bensaïdi (2911). The danger is falling into naive optimism, of films that spend their whole time banging the humanism, goodness, tolerance drum. We know how ephemeral such practices are if they are not accompanied by an evolution in imagination. The issue is no longer to dream the world, but to enter it, as Glissant suggests.[13] In other words, to drop empty

sociology and banal empathy that change nothing. A film like *Scheherazade, Tell Me a Story* (Egypt, 2009) exposes, as director Yousry Nasrallah puts it, "a dominant mentality that can be summed up as replacing everything that relates to sentiment, love, and human relations with a contract, with a commercial exchange" (9287). In *Waiting for Pasolini* (Morocco, 2007), Daoud Aoulad-Syad portrays a world full of manipulation in which imagination has lost the game. It is a harsh observation, but derision is a way of challenging powers and appearances while smiling (8198).

There is, of course, more to admire in man than to despise, as Albert Camus put it; yet, in keeping with the realities of our time, it is art's task to address man's contradictions—in other words, man's inhumanity. We will come back to the ways in which film portrays violence in chapter 4 of this book, but let us now point out a danger. In writing about *Kini & Adams* (Burkina Faso, 1997), I highlighted how Idrissa Ouedraogo attempted to explore humans in crisis to better, and almost obsessionally, assert an *idea*: that of humanity. The result is a certain theatricality and, above all, the systematic orchestration of reconciliation. *Kini & Adams* is the story of a never-ending reunion. But in extremity, in death, the two friends make up to the backdrop of the same recurring image—a sunset—whose kitschiness reflects the fetishization of the theme: their conflicts were just for show, a *comédie humaine*, repeatedly resolved as the bond between them is ever stronger. So much so that, rather than confronting humanity head-on to help prevent its dislocation, the film falls into the conservatism of lofty sentiments (0188).

1.2.3. A Nonexistent Family

> I am black, I am a man. Why does that sound like a disappointment?
>
> —Tchicaya U Tam'si, *Le Mauvais Sang*

A famous Jeff Wall photo—*After "Invisible Man" by Ralph Ellison, The Prologue*—shows a black man who lives in a forgotten corner of a New York apartment, as in the Ralph Ellison novel that it takes its inspiration from; 1,369 lightbulbs illegally rigged up to the electricity supply light up the blackness of his invisibility. Filmmakers too are increasingly condemned to light invisible lamps guerrilla-style, plunging them into existential crisis. As in many other films, the madman character in *Delwende* (Burkina Faso, 2005) wants to pass on his knowledge, but no one will listen to him. "He remains a witness without a voice. I too am the object of this lack of recognition," Pierre Yaméogo claimed (3852). Like Taïb Louhichi,

who was forced to abandon several projects, Youssef, the filmmaker in *La Danse du vent* (Tunisia, 2003), burns the screenplays he never manages to shoot. He is challenged by a character who asks: "What have you shot in your life? Not even ten usable hours!" (3364). As for the late Didier Ouenangaré, he divorced four times while struggling to finish his film, *Le Silence de la forêt/The Forest* (CAR/ Cameroon, 2003), which, in an unhappy compromise, he eventually cosigned with Bassek Ba Kobhio (2909).

Caught between the arduousness of the profession and the invisibility of the results, doubts set in. Why sacrifice one's health? What is needed is to be able to count on solidarity, teamwork, a dynamic. That is a source of anxiety too, solitude being most filmmakers' lot in life. Like the bug that gesticulates but does not give up in video artist Moussa Sarr's *Frédi la mouche* (2010, 2'), filmmakers carry their films alone. As a result, "the screenplays are often unpolished. Filmmakers need feedback on their work: this distance would allow them to expand their works," the late critic Jean-Servais Bakyono commented back in 1997. But he added: "They don't draw on their civilizations, or read enough. Filmmakers exchange little with each other on the image or technical aspects. Working together on some films would give them greater professionalism" (4361).

Filmmakers did attempt to create this exchange with the African Guild of Directors and Producers, an association set up on October 22, 1998, to group together diaspora professionals. Presided over successively by Jean-Marie Teno in 1999, Fanta Regina Nacro in 2001, Abderrahmane Sissako in 2006, and Dani Kouyaté in 2007, with Mahamat-Saleh Haroun as editor in chief of its bulletin, the Guild ran a website (set up with *Africultures'* backing), and later a blog. It took radical stances, criticizing existing practices, and developing solidarity through an exchange of services and equipment. It also organized events during the major festivals such as Cannes or FESPACO (Festival panafricain du cinéma et de la télévision de Ouagadougou). Its main objective was to stop individually addressing funders, and to facilitate distribution. Set up in 1999, it was highly vocal, before gradually unraveling, undermined by internal dissension, to the point of only sporadically appearing on the scene since March 2007. "Solidarity ends where egos begin," Haroun commented laconically in 2011 (10002).

The first defection came about in 2003. Following Fanta Regina Nacro's "censorship" of the editorial he had written for the bulletin, Jean-Marie Teno asked *Africultures* to publish it (3081). Teno took the opportunity to announce his departure from the Guild, explaining his reasons in another article (3250). Nadia El Fani followed

suit and left too. It is interesting to note that the conflict concerned the question of criticism. The Guild organized a roundtable on the question at the Namur Film Festival. "What do we care about 'African film' critics' view of our work? Especially as some critics' gaze, far more than ours, seems to be perpetually searching for a meaning and often stands out more for its need to exist, for the mediocrity of its analysis, and for its inability to put the filmmakers' discourse into perspective, when filmmakers have a discourse," commented Teno, evoking "the 'sectarization' of our cinema in which, more than ever, a hazy notion of Africanity is emerging based on the filmmaker's place of residence." I myself subsequently published a paper to contribute to this debate entitled "Criticism Isn't a Judgment" (3073), in which I insisted on the need for criticism, and notably African criticism, to escape the ambient ethnocentrism.

"Aren't we progressively slipping from the solidarity we established as the Guild's prime objective into 'solitarity'? We claim to be together, we tell everyone so, and yet among ourselves, it's each for him or herself . . . as ever," Teno added. And everyone returned to their own solitude. This deficit of "family" is not innocuous; it echoes the historical atomization that black people have been subjected to in the face of adversity, which, in addition to its integrating education, reinforces an attachment to one's family of origin. With considerable humor and originality, Dumisani Phakathi's *Don't Fuck with Me, I Have 51 Brothers and Sisters* (South Africa, 2004) illustrates this relation to the distended family: his father, an ANC activist regularly sent on missions around the country, takes a wife at each port of call and sires yet more children! (3957).

But this solitude is also that of films that the "Africa" label prevents from existing in their own right. "The hope is that African films can exist as films, and not as some kind of generality. Then, it will be possible to make connections, to build bridges that will break their solitude," critic Jean-Michel Frodon remarked at a roundtable at Cannes (3855). Indeed, the history of cinema shows the importance of groups. Would the French New Wave filmmakers, all of whom were different, have made such an impact individually? "A synergy is necessary. . . . We are trying to create a family, but there is no group," Mahamat-Saleh Haroun added in 2004 (3685).

To belong to a family is to share the same reactions, intuitions, and to see the world. Must this "family" be African? "We shouldn't stop coming back to Africa, even if our daily environments are elsewhere, even if they are urban and Western. If we forget that regeneration, we become nothing anymore, just zombies," Mama Keïta said in 1999 (2063). Since, the impression of being shut in a ghetto has worsened.

In the *La Graine et le mulet/Couscous* press release (Tunisia, 2007), Abdellatif Kechiche claimed to face "latent hostility": "I ought to be able to say that I belong to the family of French cinema, but I have the impression that I belong to one part of this family, against the other. It's as if I were always having to justify what I am. . . . I want to be an ordinary director, who people criticize, like, or otherwise, but irrespective of my origins."

Being confined to "the African genre," which reflects host societies' and world cinema's issues with difference, is a burden on African cinema, which struggles more than the rest to escape the relation to the Other. There have been evolutions as the West's gaze and its relation to immigration have evolved (0138).[14] For better, but more often for worse, Africa has historically been traversed by the culture of the Other, and African cinema often only exists thanks to outside funding. That is a fact and, in times of international coproductions everywhere, is not necessarily an evil to be eradicated at all costs. Above all, it should not be a hindrance, as Wole Soyinka's famous phrase suggests: "A tiger does not proclaim its tigritude; it pounces."

1.2.4. An Era of Suspicion

> The Gauls were Romanized, weren't they? It didn't kill them. There's no shame in that, in being alien. In being a stranger to oneself, to one's history. For those who wield two languages—the mother and colonial—necessarily screw better.
>
> —Blaise Ndjehoya, *Le Nègre Potemkine*

The "African genre" is not homogeneous, however. It is divided in two, along a demarcation line that no one can define, but which a multitude of observers evoke, and which fuels many a verbal or written invective, between a cinema considered in touch with its "natural" audience (that situated in Africa), and an elitist cinema that panders to the West. This recurrent suspicion is serious: its pressure is such that it limits the margins of creation and exacerbates the current crisis.

This accusation of dancing "cheek-to-cheek with the Devil," to cite Blaise Ndjehoya, is essentially leveled at diaspora filmmakers. They are accused of betraying their African brothers and sisters to play in the league of the elite. They have the example of a "popular" cinema born out of digital technology thrown at them, and which is extolled because it at last resolves the virtuous equation of a self-funding cinema because it is popular with audiences. Film is thus only considered in economic terms, without reflection on its content (4438).

When not bordering on insult and disingenuousness, this debate does at least question the standardization, or in other words the transmission, or even imposition, of an imagination that all intercultural relations provoke. In the historical context of French-African relations, this debate is neither fortuitous nor futile! (9541 and 9865). But it is important not to demonize; from the moment there is contact, there is an exchange, and thus both a richness and ambiguity. This particularly concerns training programs, but also applies to funding and coproductions. Marcel Mauss refers to this in *The Gift* (a word that, in Germanic languages, has the double meaning of "gift" and "poison"). While the instructor, funder, or coproducer's subjectivity must constantly be corrected, it cannot be eliminated altogether. Neutrality is illusory in this instance, or even manipulative. Rousseau wrote in *Emile; or, Concerning Education*: "No subjection is so perfect as that which retains the appearance of liberty."[15] Without this subjectivity, there would be no confrontation, and it is precisely this confrontation that is dynamic, sparking debate and forcing everyone to situate themselves.

If this suspicion is unhealthy, however, it is because it too often reveals an opposition between the "authenticity" of those who are in direct contact with African reality, and the "under the influence" distance of the rest. This distinction between those who live in the right place and those who do not brings to mind what Achille Mbembe calls "the nativist reflex, a bio-racism" between "those from here" (the indigenous population) and "those who have come from elsewhere" (the nonindigenous), remembering that "nativists forget that, in their stereotypical forms, the customs and traditions they claim as theirs were often invented, not by the locals themselves, but in reality by the missionaries and colonialists" (4290). What is unhealthy is that claims of authenticity draw on a sense of victimization and bitterness, which gives rise to policies of exclusion and hatred—the ultimate paradox for artists! It is hard to escape an understanding of identity as different to that of others, yet it is the source of so much pain, based as it is on the definition of a single identity in atavistic cultures that, in their understanding of an absoluteness of being, justified conquest and colonization.

As the true polemicist that he is, Jean-Marie Teno wrote in 2003: "Good Africans are apparently those who fraternize in the antechambers of African presidential palaces with those responsible for starving the people, while the unauthentic Africans are among all those Africans excluded from the media in Europe, who live in the suburban housing projects, poor neighborhoods of the major cities, and in certain European villages" (3081). One of the greatest African poets, Tchicaya U

Tam'si, lived in Nogent-sur-Marne, France. He used to tell the compatriots who urged him to come home: "You live in Congo; Congo lives in me" (2123). In Congo, however, albeit partly due to the ailing education system, the poet is unknown to the general public, as Léandre-Alain Baker's *Tchicaya, la petite feuille qui chante son pays* (Congo, 2001) attests (2464).

Tchicaya U Tam'si's expression is important for critics who follow postcolonial theory, and notably the concept of hybridity developed by Homi K. Bhabah: the meeting of two emerging identities that, through this dialogue, are constantly in the making. Henceforth, such critics will approach films as hybrid works in which two cultures coexist in constant negotiation.

1.2.5. The Individual versus the Group

Be whatever you want to be, but be a country for us.

—from the film *Making Of,* directed by Nouri Bouzid (Tunisia, 2006)

The "cheek-to-cheek" suspicion degenerates into "betraying the community" when filmmakers are perceived to defend Western individualism. The scenario that has historically predominated is that of the individual who escapes the influence of the group to stand up to all forms of conservatism, which get replaced by emancipated ways of behaving. This "revolt of the self" (Khémaïs Khayati) did not challenge the predominance of the people, however, given that these new practices were destined to enlighten them. It was more a case, in keeping with African tradition, of celebrating the vital life force of the individual, who initiation leaves free to define his or her modernity in accordance with the collective values. Or as Kenyan theologian John Mbiti famously put it: "we are, therefore I am."

It was not, and is still not a question of opposing the individual to the group, then. If filmmakers today question the power of individualization as a force for detraditionalization (emigration, new forms of religiosity, the pursuit of fashion and luxury), it is to better ask the question of responsibility vis-à-vis the group. Scholars like Teshome Gabriel and Nwachukwu Frank Ukadike have seen the filmmakers' positioning of themselves as griots speaking on behalf of the community—a position first championed by Ousmane Sembene, and repeated like a leitmotif right up until Jean-Marie Teno's *Lieux saints/Sacred Places* (Cameroon, 2009)—as a way of distinguishing themselves from the West's focus on the individual. But Ken Harrow disputes this, arguing that in African films, the community's problems

are still often articulated by heroes who stand for the group, drawing on narrative structures that resemble the Hollywood paradigms (9464).

What has evolved is the definition of individuation vis-à-vis its evolution in the Western world. Prior to the 1980s, the West considered autonomy as independence, in the sense of choosing one's life. Then, it became more an autonomy of competition, which destabilized society by abandoning individuals to market forces. This undermining of social ties has meant that the inequalities previously experienced as a collective destiny that needed correcting are now seen as a personal failing; the individual feels incapable of achieving, which destroys his or her self-esteem. As globalization generalizes individualism and consumerism, this sentiment is becoming more and more prevalent throughout the world—not uniformly, but in a great variety of declinations. What is becoming unequivocally generalized everywhere, however, is the growing divide between rich and poor.

This reinforces the state of uncertainty already referred to. Daoud Aoulad-Syad's *Adieu Forain/Farewell Traveling Player* (Morocco, 1998) is a bittersweet chronicle about this. The three main characters could be the three facets of a Moroccan society searching for itself. Kacem, the father and old fairground artist, cannot resolve to end his life on the road. Larbi, the son just released from prison, is too macho to have friends. Yet he ends up joining forces with Rabii, the transvestite, who dreams of an elsewhere he cannot reach. This constellation, where each constantly wonders where to go and who with, without knowing deep down who he is, illustrates today's painful question of identity, in which the individual becomes central in a society still based on the community (0793).

Many films confront us with this question, but let us take two examples here to highlight the evolution that took place from 2000 to 2010. Symbolically, they are the two films that were selected at the Cannes Film Festival before and after the long, thirteen-year absence of sub-Saharan African films in official competition. Let us consider *Kini & Adams* (Burkina Faso, 1997) again from this angle. The film portrays two country guys trying to survive, and whose sole dream is to leave for the town. Jealousy, ambition, and rivalry eventually set them at loggerheads. It is this blockage that interests Idrissa Ouedraogo, this interior blockage in everyone in a society torn between what it is becoming and what it was—the emergence of a new individual fascinated by consumer technologies, yet anxious about the vacuity and perversion of values that the logics of profit and exclusion of the weakest imply. It is this tug-of-war that Ouedraogo addresses, which will ultimately destroy a friendship and lead to the tragic end of a man who cannot stand the

impoverishment he is offered. We are far from the hero in Westerns who acts freely, unburdened by the weight of customs, and free of the state's control, totally ready to fulfill a destiny that he has the power, if he likes, to define and magnify. If Kini and Adams both in their own way seek to assert themselves individually in their social ambition, it is in the refusal of individualism that they ultimately express their quest for individuality (0188).

Mahamat-Saleh Haroun's *Un homme qui crie/A Screaming Man* (Chad, 2010) does not reference the same norms, and Adam is not torn between desire and vacuity. When his son destabilizes him by taking his pool attendant's job, their rivalry is generational. The question of values is only posed when Adam finds himself in a position to eliminate his son by letting him be forcefully conscripted into the army. Adam's choice is not determined by ethical norms; in other words, those transcendent rules that regulate good and evil in society. On the contrary, at first indecisive, he only acts once it is too late. He is like us; he is human and anything but rational or virtuous. Letting things happen and indecision suit his purposes. But that does not free him from his moral responsibility, or rather his social responsibility in a society that lives and permits all ethical transgressions. He fails in his role of protecting father. That is the role that filmmakers adopt today: they awaken consciences, rather than preach. This calling on people's responsibility, rather than on models to follow, favors the individual rather than the collective. Responsibility is that of the individual, whereas duty is the group's. But this does not necessarily mean that they are opposed: what matters to the filmmaker is the audience's ability to take its life into its own hands and to make personal choices, in solidarity with its fellows. Adam takes in Djeneba,[16] the foreign woman who bears his son's child—two people that he will now be capable of loving. He does this not in an isolating intellectuality (typical of Western films), but in an energy where, aware of death, spirituality has its place, even if it does not take the form of a normative religion. He thus is in harmony not just with his community's prime values, but also with the energy of the world (9479).

1.2.6. Exile Consciousness

> Living means leaving traces.
>
> —Walter Benjamin, *Paris—Capital of the Nineteenth Century*, 1939

"By going into exile, you lose your place in the world," said Sartre. Exile was long experienced in these terms: both a loss and a sense of guilt—loss of a loved land,

guilt for adapting to elsewhere. According to this way of thinking, and accentuated by the myth of return—the Back to Africa movement—you can only be African in Africa. The diasporic experience is consequently a negative one, and this malaise prevents people from imagining themselves as belonging to the world.

But exile is not necessarily geographic. Plenty of people feel like they are in exile in their own countries! But they are not disconnected from their roots or reality, and cannot be accused of inauthenticity! Many African writers in the 1980s felt suffocated in their often totalitarian home countries. Exile is a state—a state of wandering, whether in one's own country or abroad. It is a quest. While it is sometimes chosen, it is often incurred to escape a lack of prospects, repression, or war, as Mahamat-Saleh Haroun notes: "If we live abroad, it's quite simply because, at a given moment, destiny has decided so" (3697).

To the Negritude authors (Césaire, Senghor, Damas), exile was romantic. The autobiographical novels of the 1950s (Oyono, Dadié, Ouologuem), however, saw it as negative, or even deadly in Cheikh Hamidou Kane's *L'Aventure ambiguë* (*Ambiguous Adventure*) published in 1961. In it, Samba Diallo fails to reconcile two opposing cultures and dies, assassinated by a madman. By the 1990s, writers accepted this notion of wandering and no longer saw exile as suffering, but as discovering the world, and even taking root. Congolese Henri Lopes, for example, has his character Marie-Madeleine say in *Sur l'autre rive* (*On the Other Shore*): "I learned the world there like nowhere else before. I gained from it; I looked deep into myself and understood my country better. It was there that I learned the fecundity of solitude. To learn, to think, to create!"[17]

When Alain Gomis refers to *L'Aventure ambiguë* in *L'Afrance* (Senegal, 2001) to show that hybridization was once considered deadly, he has his main character declare: "suicide was pre-programmed!" But in his film, a kind of manifesto, despite the trauma experienced in France by this Senegalese student whose temporary visa has expired, "you don't die from encountering the Other," as Momar Désiré Kane put it (2778).[18] Glissant expresses this clearly in the film Manthia Diawara made about him, *Edouard Glissant: One World in Relation* (Mali, 2010): "We are not disarticulated because we are multiple; we remain ourselves." In the film, Glissant opposes the Western family tree, which excludes others, and the Creole garden, where multiple species mutually protect one another: the principle of the rhizome (9595). Achille Mbembe calls the transnational culture of filmmakers who constantly go to and fro between Africa and Europe "Afropolitan": "an incalculably rich gaze and sensitivity" (4290).

"I live in Conakry, but inhabit Paris," declared Gahité Fofana (2069). These "deeply African and deeply European" filmmakers, to use Balufu Bakupa-Kanyinda's expression (2068), have the huge fortune that few enjoy, considering that the scandal of today's world is the barrier between the North and South. Films are witness to the violence of the bodies washed up on the shores, such as on the Nouadhbiou coast in *Heremakono/Waiting for Happiness* by Abderrahmane Sissako (Mauritania, 2002), or those lost in the desert in Mahamat-Saleh Haroun's *Expectations* (Chad, 2008). The people of the South are denied the freedom to circulate. "West Indians tend to be more trapped in neuroses, whereas Africans are trapped in their countries," notes writer Fabienne Kanor (3689), whose film *La Noiraude/The Darky* (Martinique, 2004), codirected with her sister Véronique, broaches the topic of people of her generation's "spilling over": "this visceral malaise of knowing where 'Antillaniness' starts and ends, of knowing who we are before knowing where we come from."

For in-betweeners also experience a sense of wavering, limbo, and the afore-mentioned vertigo. They are displaced within themselves, opening the way for spectators to their own disorientation, their own loss of identity, their own sense of something missing. "At times, I step back and realize the major balancing act I perform between two realities: Dakar and Paris. It's a little schizophrenic at times, but can become interesting if it generates a work," Mati Diop has stated (7669). This dual belonging to such radically different cultures can indeed generate the mobilizing turmoil that Monique Mbeka Phoba explores in *Sorcière, la vie!/A Bewitched Life* (DRC, 2006), a film about the beliefs that a Western mind finds hard to accept, but which are also effectively cruel. The film ends on this turmoil: "Demonized in our own eyes, we are setting out on the world's paths with no guide or references" (3950).

Cinema has seen the emergence of a movement equivalent to that of the twenty or so African writers living in France, whom Djiboutian author Abdourahman A. Waberi collectively referred to in 1998 as the "children of the post-colony": born after Independence, holding two passports, and declaring themselves "international mongrels."

As Lydie Moudilen demonstrated in *Africultures* 28, this kind of generational categorization is nonetheless problematic, as it encourages critics to focus on just the content of works, and not on their aesthetics. The historicist postcolonial reference that reduces them to an origin is unwelcome to writers who systematically deconstruct questions of authenticity, identity, and a single root (1359). The same could be said of the filmmakers who grouped together in the aforementioned

Guild of African Directors and Producers, but who form no more of a school than the widely divergent writers. What does unite them is their affirmation of their hybridity, nomadic identities, and their desire to challenge African artists' invisibility in France.[19] They have moved away from the tautological assertion of being "simply a filmmaker," not "an African filmmaker," launched in the 1990s to escape being reduced to their difference: "Even if identities are transversal today, the continent and its visual representation remain our common denominator," they wrote in their manifesto for a new African cinema.[20] Indeed, while writers focus predominantly on Paris, exile, and migration, films tend essentially to be set in Africa. Which did not stop them from adding: "We don't forget that we are African filmmakers, but we are above all filmmakers." They thus claim their artistic affiliation with the contemporary world, while also specifying their African heritage as an element of their identities: a tension between the universal and the particular that characterizes all contemporary African creation.[21]

It is not criticism's role to resolve this tension, but rather to detect its modes of expression in a work's aesthetics, going beyond the categories used up until now to envisage the question of difference from the perspective of converging imaginations. Like Barbet Schroeder's *La Vallée/The Valley* (France, 1972), Mama Keïta's *Le Fleuve/The River* (Guinea, 2003) is the imagination to be reached within oneself; in other words, necessarily a result of experiences and encounters. The mixed-race French character played by Stomy Bugsy has to flee to an Africa he knows nothing about. The shock is initiatory. The fact that Mama Keïta chose the same title as Renoir's film is not fortuitous: here too, nothing is picturesque; here too, we have a web of relationships bathed in the presence of things and beings. But while the river represents a passage, a light, and a resource in Renoir's film, it is an imagination in Keïta's, and it is Africa in all its harshness that plays the initiatory role. In short, a discreet way of recalling that relationships with the continent need to go beyond fascination (2683).

Afro-modern thought—that of in-betweenness and entwinement—shows that knowing oneself supposes emerging from the maelstrom of identities to open up to the Other. As the Franco-Senegalese writer Sylvie Kande puts it, "uprooting is the very foundation of the poetic act." It opens us to an awareness of the world via encountering the Other, starting with those who are the farthest removed from us: the intruders! This defines a new relation to one's place in the world: "We have the possibility of becoming different beings today, a certain polymorphism and the gift of ubiquity; that is how a space, a territory begins to emerges," says Fabienne

Kanor (3689). This space challenges the myth of authenticity, but does not sever the ties: "The farther we go from home, the more attached to it we become!," comments Mahamat-Saleh Haroun. "This creates a conflict with those who believe that geographic proximity guarantees truth. In art history, exile has always been an affliction that brings something new. This new identity is a constant questioning and that is its strength" (3685).

But people miss the savor of their origins. The return to the native land, or to the land of one's kin, thus constitutes the narrative thread of a multitude of films. It allows the question of dual belonging to be explored in terms other than necessarily a conflict: "To me, the relationship with one's roots isn't about fracture; it's a bonus, an added value, as it were," states Hassan Legzouli (3611). In his film *Tenja/Testament* (Morocco, 2004), Nordine fulfills his father's wish to be buried in Morocco, bringing his body back in his taxi. In the process, he discovers his father's homeland through the eyes of a tourist, but also with a box of souvenirs belonging to this father whom he gradually learns to understand. "A wadi always returns to its bed": the return to one's roots is necessary, especially when the aim is not to remain (3580).[22]

Indeed, "we eat with our mouths, but our stomachs digest": whether the voyage is back to one's roots or to an elsewhere, this distance allows people to see farther, or as the Guinean writer Tierno Monenembo put it: "Diaspora owes the continent its memory, and the continent owes the diaspora its modernity."[23] The problem is that "the question of Africanity is only asked of Africans; people don't expect us to emerge from our forests!" commented Mahamat-Saleh Haroun (3685). Whereas, like the Senegalese Baye Fall's patchwork clothing, artists try to be the sum total of all they receive, people expect individual filmmakers to sum up Africa—not the real Africa, but the Africa that audiences dream of. This means that filmmakers have to free themselves from the Other's gaze and "affirm themselves as singular artists who are not the sum total of all Africans," adds Haroun, defining a vital position that challenges indigenism: "Contrary to what Ahmadou Hampâté Bâ said—'You have to know where you come from to know where you are going'—many of us feel that it's more important to know where we are and where we are going. You can know where you are from, and yet not where you're going; it's this awareness that allows aesthetic experimentation."

"We are more the sons of our time than our fathers' sons," says the proverb. That recalls one character's provocative line in Alain Gomis's *L'Afrance*: "My country is where my feet are"; in other words, beyond any notion of belonging, everyone forges their own universe and imagination. It is neither a denial nor a

betrayal. On the contrary, awareness of Africa is the diaspora filmmakers' common denominator. This is also an awareness of an absence, or a double absence. Mama Keïta expresses this as a "physical need to go back to Africa, to go there and see" (2063). But it is also the absence of those who have left and whose presence is cruelly missed by those left behind, the theme of his aptly named *L'Absence/The Absence* (Guinea, 2009). "The fact that we are not on the continent makes the vision far more painful, and the urgencies much greater," Cameroonian François Woukoache stated back in 1999 (2061). Later, following his experience in Rwanda, he left the floodlights of the international festivals and settled there to help train young filmmakers.

African filmmakers do not have superior vision when it comes to seeing Africa, but their awareness orients and sharpens their gaze. "You saw nothing in Hiroshima," the Japanese lover repeats like a leitmotif in Alain Resnais's *Hiroshima Mon Amour* (France, 1958) in answer to his French mistress's affirmations, backed by news documents and reconstructions, about the atomic bomb disaster. If Mweze Dieudonné Ngangura plays on such a famous phrase in calling his documentary *Tu n'as rien vu à Kinshasa/You Saw Nothing in Kinshasa* (DRC, 2009), it is undoubtedly not just to highlight the extent of the catastrophe in such a rich country. By taking the time to listen and give voice to the voiceless, who thereby become subjects in the full dignity of the center frame, Mweze challenges the jumped-to conclusions of those who think they know it all and do not need to listen. The difference between his film and an objective film report lies precisely in this relationship. A Congolese man speaks with other Congolese. If this shared origin matters, it is not exclusive; a foreign filmmaker could have done the same thing, even if being able to speak Lingala is a major bonus. It is not necessarily a question of knowing the terrain either; Mweze has lived in Brussels for years, and if he goes back to the DRC, it is not necessarily to the areas he describes here. More than a militant approach, what transpires in this film, then, is a shared awareness. The film indeed calls for more of a state, for real social policies, but with all those who know how to look and listen. For these inhabitants of Kinshasa, who face the cruelest poverty, organize themselves, and create and reinforce solidarities. In that, they point us back to what is urgent in our dark times: they remind us to be human again (8770).

It is not politicians, but artists who address such issues today. "This is how we can create our own worlds, which the Other can also enter," claims Fabienne Kanor. "I believe in this network, in this invisible community of spirits around the world, in a kind of kingdom. *Africultures* is an example of this: it is by building citadels of

strong spirits that a territory, an invincible parallel world will emerge" (3689). Film is the perfect tool. When Mahamat-Saleh Haroun gives his camera to his young cousin at the end of *Bye Bye Africa* (Chad, 1998) so that the child can film the family and lessen the distance of exile, he gives him the most beautiful gift in the world: he too will be able to film life with this gaze that says, "it's my business."

1.2.7. An African Cinema?

> "The African" was the invention of a West that saw itself as a totality and constructed an opposing totality. For me, saying I am African is a way of keeping the old Pan-African dream alive. Every time I say it, I breathe new life into a utopia.
>
> —Kossi Efoui, "La Polka au pays de la rumba: Entretien de Taina Tervonen avec Kossi Efoui"

In 1988, the young Togolese writer Kossi Efoui submitted the play *Le Carrefour/ The Crossroads* to a Radio France Internationale (RFI) theater competition. The characters are not described as African or black, but as bodies, as human voices in a dramaturgy of encounters that expresses an evolving identity (0939). He was criticized for writing "denatured," Western theater. African artists evolve in this tension of imposed structures, obliged to refute both the West's fictional Africa and their home camp's suspicions of betrayal. What Kossi Efoui says in the above citation is that the fact of being African does not define him as a man who reasons, but as a black man whose identity is based on customs and whose territory is Africa. For everyone—both Westerners and Africans—seems to want to defend this so-called African specificity, this difference, under constant threat, that allows Africans to claim "an African interpretation" of things, rather than considering Africans as alter egos, as "kindred others." They above all see Africans as victims of history, who must be saved from their damnation so that they can at last live the Pan-African utopia of this difference constructed as a system, even if it leads them back into authoritarian, nonegalitarian models that no one ventures to question.

In his 8-minute short film *Taxcarte* (DRC, 1996), Joseph Kumbela explores the fact of being reduced to the image of the Other with scathing humor. A boubou-clad African filmmaker, who struts like a star at an African film festival, finds himself face to face with his two French conquests, neither of whom is aware that the other exists. As he phones home to Africa, he learns that his wife has just given birth, and ends up cornered by the women in the phone booth! (2438). This self-derision is

not innocuous: it denounces those who play on their Africanity to sell clichés to audiences who demand exactly that.

Can symbolically murdering the Other help construct one's own image? In her nine-minute short film *Le Génie d'Abou/Abu's Genie* (Ivory Coast, 1997), Isabelle Boni-Claverie portrays the ritual murder of a rotund white woman by a black sculptor as a black woman vigilantly looks on. The aggressive, artistic ritual orchestrates this emancipation from the Other's (maternal) clutches, a prerequisite for creation, for language, for taking one's own life in hand (1738).[24] But how to extract the Other from the self when so deeply embedded? Does this mean eradicating the contaminated part from a pure being? Music teaches us that there is no such thing as purity in art. As in human phenomena, all music is a *blend*. It also teaches us that what we call "world music" results either from creolization at a time when this was indispensable to survive and express, or from a negotiation arising from the meeting of cultures, or is a market fabrication to meet the demand for exoticism. As in *In My Genes* by Lupita Nyong'o (Kenya, 2009), which documents the social inscription of people with albinism, "African cinema" is, in this respect, albinistic, with people unsure whether it is black or white.

Under the pretext of opposing globalization and escaping manipulation, some dabble in a metaphysics of de-Westernization in the utopian dream of severing Africa from the rest of the world, in the mad hope of living without the Other. The term "African cinema," which everyone uses indiscriminately, means nothing more than constantly coming back to this isolating and reductive schema. Its globalization does not take the extreme diversity of its cultures into account at all, any more than it does the hybridity of most of its forms, the fact that many of its directors are mixed-race; the almost complete absence of discernible national, and even less continental, film cultures; and the quasi-generalized lack of cultural policies or film industries—in other words, the only criteria that might justify such a denomination. "African cinema" is a myth that is kept alive to reinforce its relegation to its difference, in a genre unto itself with clearly defined codes ("like the Western," as Balufu Bakupa-Kanyinda comments [9073]). Férid Boughedir[25] and Teshome Gabriel[26] celebrated this difference as a force of resistance and subversion in the societies concerned. It was also posited as a source of meaning by neostructuralists, such as Lizbeth Malkmus and Roy Armes,[27] who sought to identify this difference in film texts. They were closer, however, to modernism, asserting the primacy of the auteur's subjectivity and independence vis-à-vis the political and financial powers. Scholars receptive to this approach, such as Manthia Diawara,[28] focus their

writings on analyzing this independence, and on aesthetics, to the detriment of the films' specific content.

In his critique of these theoretical approaches,[29] Stephen Zacks insists on the dangers of the Férid Boughedir or Teshome Gabriel type neo-Marxist classifications, which struggle to fit everyone into categories whose criteria of Africanity end up, according to Zacks, by strangely resembling the old colonial criteria. As for the binary distinctions made by Armes and Malkmus (voice/orality, space/time, individual/group, etc.), they tend, according to Zacks, to universalize elements that were not destined to be, and risk falling into schematic assumptions that invent a new colonial subject. The modernist approach, he claims finally, verges on an apolitical position when neocolonialism still continues to inflict ravages in both these countries and their people's minds (1369).

There is a widely developed tendency in North American universities' African studies departments, and which manifests in a number of the collections of articles spawned by the American academic "publish or perish" rule, that confuses filmic discourse with a committed discourse on film. This tendency is ideological, in the vein of Third Cinema theory and its rupture with Hollywood and auteur film to develop a radical awareness. It has been reactivated by scholars such as Teshome Gabriel since the 1980s, and struggles to surpass a political commentary that fails to account for the ruptures at play today. It comes down to telling "African cinema" what it should be, and trying to define what an African film language should be from an African perspective, to use an expression of Nwachuku Frank Ukadike's, who uses the term "African cinema" without ever defining it.[30]

This recurrent habit of reducing people to their difference bridles possibilities, and thus creativity. Attempts to adapt screenplays to this paradigm to meet the funders' and audience's expectations make it difficult to make films that truly come from the heart. Moreover, as the difference syndrome draws on a re-enchantment of tradition, it becomes impossible to consider tradition from the dynamic perspective of its accumulated and constantly questioned modernities. Henceforth, the notion of "calabash cinema," largely conveyed by African and Western critics and journalists alike, undermines any attempts to depict this. Directly attacked filmmakers such as Adama Drabo and Gaston Kaboré suffered from this. The latter, who invested a great deal of energy in heading the Pan-African Federation of Filmmakers (FEPACI), told me in 2008: "People prematurely sought to categorize and create labels for the African continent's cinematographic expressions, and that proved to be harmful in numerous ways. Can we even measure the momentum nipped in the

bud? The number of auteurs stifled? The sterile oppositions that were artificially created between filmmakers who could have mutually stimulated one another? The generations of families, clans and filmmaker statuses that were rashly created, sowing confusion, frustration, and vain acrimony within the community of African filmmakers?" (7209).

Today still, accusations are legion in the tiny microcosm of "African cinema," especially when a filmmaker ventures into accepting a position of responsibility. Perhaps this expression could be recycled too—pejoratively—to designate the intrigues and accusations of back-stabbing, not to mention the arrogant power of the funding institutions. Isolated in specialist festivals, filmmakers want to escape the ghetto, but their visibility continues to pose a problem, especially in France, which is historically the prime market and place of recognition for films produced in the Francophone zone.

The evolution of demands on the part of France's immigrant movements reflects the evolution of this misunderstanding, whose roots lie in the question of difference. The main ethos of the 1980s anti-racist movement's "Don't touch my buddy" fight against prejudice was the "right to be different" (1215).[31] The traces of this are easily found in film criticism from the time and its reductive terms such as "naive," "primitive," "contemplative," "ingenious," "candid," "inexperienced," and so forth. Paternalism was de rigueur, insisting on the West's duty to help these film forms reach the level of the West. The official funding bodies' choice to first and foremost back films that were likely to meet international film criteria reinforced this, to the detriment of the emergence and organization into an industry of all sorts of film cultures capable of winning over their own audiences.

Confronted with a vision of Africans that serves as a foil to forge one's own identity (both French and European), and before the increasing exclusion encouraged by a "Le Pen-ization" of discourse, in the 1990s the immigrant movement in France changed tactics: rather than "the right to be different," it called for "the right to indifference," or, in other words, to be considered just like anybody else, a citizen in a society that accepts itself as plural. Filmmakers followed suit, and this was when we saw the emergence of the demand to be considered "simply as filmmakers," or as individuals who make films (1369).[32]

A filmed study carried out by Manthia Diawara in 2009 reveals that by the 2000s, this mythical essentialism had fallen out of favor; filmmakers are now willing to describe themselves as "African filmmakers," while at the same time refusing the empty expression "African cinema."[33] They now espouse the idea of existing as

Africans who share similar political, economic, social, and cultural realities, and are thus bearers of their own specificity, but reject cultural marginalization. There lies the rub. There is a fierce debate in French society between the old colonial assimilationist ideology, tangible in each and every policy to regulate immigration or defend an imagined national identity, and a readiness borne by young people and whole sectors of society to celebrate the multiplicity of cultural contributions and learning to live together.

The question of spaces of visibility is a complex one in these times of transition. Escaping the margins means being visible, but this visibility is generally guaranteed by ghettoizing specialist festivals and collections alone (DVDs, etc.). It is not easy to stand out from the "family of African cinema" (9541). The debate is not dissimilar to the one about quotas. Clearly, without rules, "visible minority" representation has not improved on France's screens, beyond basic tokenism. But quotas are demeaning: one is quickly suspected of having been chosen not for one's talent, but out of obligation. Various actions to improve visibility sincerely combat marginalization, but risk paternalism or condescension and reinforcing the representation of Africa as a world apart. "The more Africa gets forgotten, the more we have to remind the world that it's there," said Mahamat-Saleh Haroun. "We are currently in a war of images, in which Africans must find their place in order to impose a different representation of Africa in the world." Yet he added: "We have to reach out to the world and refuse the slots ethnically dedicated to African cinema which end up becoming ghettos" (9501).

It is still important to develop specific spaces to improve visibility today, as a form of organized resistance. The clichés born out of colonial imagery, which ranks humans and cultures in hierarchies, continue to fuel discrimination and to marginalize migrant cultures. Resisting means speaking out when voices are inaudible, broadcasting hitherto invisible images, and re-posing questions considered unimportant or simply avoided. In France, people have a problem with what historian Pap Ndiaye calls "minority" expressions.[34] According to Ndiaye, this is due to the classical French republican approach that only recognizes an abstract citizen, to the detriment of specificities, and in reaction to the negative perception of what is considered as America's "dictatorship of minorities." But it is also the result of social sciences that have never taken minorities into account. An audiovisual landscape that excludes such "minority" expressions does not fully represent society, and perpetuates a reductive, misrepresentative, and dangerous image for its cohesion and future. And, as we are not advancing in the matter despite

all the seminars and debates that rage in the public space, film festivals specializing in African film, in their geographic sphere, and within the limits of their means, still have a role today in restoring a visibility that continues to constitute a form of resistance and solidarity. It is in this same logic that the work of the multicultural *Africultures* team lies, who constantly fight against being reduced to identities and for the recognition of African cultural works as contemporary expressions.

This position on the part of Africans claiming their place in the world motivates the rupture underway that Cheick Fantamady Camara described, talking to Manthia Diawara: "Postcolonial cinema is coming to an end, opening the way to a free cinema." By free, he means autonomous vis-à-vis the historical funding institutions, and thus free to make films that reflect Africans' realities in the world. "I think we have sold our souls," Dani Kouyaté stated. "We are nothing anymore. We try to copy what we see, instead of thinking from within to see what we can contribute to the international artistic and cinematographic discourse. Why do we have a complex? Because we haven't managed to draw things from our values to enhance film aesthetics. So people go on about calabash films! Film can't be talked about in terms of geography, but in terms of gaze, of viewpoint" (2293).

"We are good, polite pupils," says Mahamat-Saleh Haroun, who has always wanted the debate to focus more on form: "In *Bye Bye Africa*, I put everything into the form, but ended up concluding that people weren't interested in this debate. 'In vain' derives from 'vanity,' so better to abstain. . . . We will only advance if we propose new paths. This discussion about form is lacking. It's not surprising we're not getting anywhere and that only a handful advance, thanks to their universes and singularity" (3685).

"The worst blockages are those that prevent us from opening up to others and their works, from considering that, far from depriving us of something, their successes and conquests on the contrary enrich us," Gaston Kaboré added (7209). Wise words when it comes to watching films that seek a just gaze and rhythm to testify, from within, to the intimacy of the African experience and question the world. Their specificity does not reside in a so-called African essence, but in their affirmation, in their very existence, in the recognition of their hybridity that stems from the negotiation between an origin and dominant cultures, themselves ridden with tensions. Their force is their incertitude, as the intertitle at the end of Zeka Laplaine's *(Paris: xy)* (DRC, 2001) makes clear: the mathematics equation of the masculine and feminine chromosomes does not necessarily have a solution.

1.3. Critical Stakes

Looking properly is, I believe, something you learn.

—Emmanuelle Riva to Eiji Okada, in the film *Hiroshima Mon Amour*,
directed by Alain Resnais (France, 1959)

1.3.1. In the Guise of a Definition

An insolent tongue is a poor weapon.

—Wolof proverb

What authorizes me to write? "Writing is a profession. A profession that requires training, hard work, a professional conscience and a sense of responsibility," Jean-Paul Sartre wrote in *What Is Literature?* That says it all, and more. Critics speak out to be heard, but it is the reader who determines the relevance of their words. Readers know a signature, follow a style, trust the regular relationship that the media allows. It would be dangerous to take this as a form of power. "Art demands to be served, not used by critics," Jean Douchet wrote,[35] defining criticism as the *art of loving*, at the same time a passion and lucidity. Neither judges nor advocates, critics do not give a definitive viewpoint. Their word is not gospel; it is just an opinion. They are only an authority if their arguments give their readers critical tools, for the aim is not to confiscate their opinion, but, like a good film, to give them a voice. In that, critics claim the right to error and invite criticism of their critiques, which aim simply to start a conversation.

This conversation is only different from the one that spectators engage in right after a film in that it brings distance, work, and a perspective based on culture. This culture is that of taste, forged by viewing many films and reading widely. This culture identifies the continuities in a filmography, affiliations, trends, connections between films and with other artworks. This contextualization is essential, for it allows a film to exist beyond a simple isolated act. It is from this conversation, and from contextualization, that a commonality of sensibilities emerges, and a community of those ready to journey together in their way of experiencing both love and conflict. If a judgment is made, it is in the discernment that founds or recalls the values of living together, politically too, in terms of the choices made in running the public sphere. "To speak about a work is always to take the risk of

defining, at a given moment, one's own conception of freedom," writes philosopher Marie-José Mondzain, who concludes: "The task is endless."[36]

Critical reflection is thus what allows us to be autonomous, speaking subjects, yet related to the collectives to which we are connected. "It is the relation to the collective and to the real characteristics of cinema that gives film the capacity of initiating, in all of us, both a relation to, and a separation from images and stories, establishing a connection between the human world and the self as a member of this world, a connection that everyone constructs to traverse this divide," writes critic Jean-Michel Frodon.[37] Critics aim to illuminate this relationship and this separation, knowing that a work of art is never finished in the sense that it always leaves a void, something missing for the spectator to complete him/herself. "There is no boundary between true and false," as Dani Kouyaté put it. "You always have to decode it yourself. That is the meaning of fiction" (0192). Criticism does not consist of filling this void, but of seeing whether the film proposes to. The Greek etymology of the word "criticism" recalls this function, in the sense of a discernment. *Krisis* means "crisis," or a situation of convulsion, in which critical faculties start to operate. Criticism is indeed an act and not a verdict. This act of speech seeks to resolve the tension arising from the crisis that the aforementioned relation and separation provokes. Detecting and resolving the crisis is all the more important considering that certain images subject, while others liberate. A film can invite me to think freely, proposing that I be responsible for my future, or to believe in its discourse, which in general will be that of an institution (state, religion, ideology, etc.), or reinforce prejudices and regressions (4698).

The 5th Madagascar Short Film Festival in Antananarivo in April 2010 was the theater of a heated debate that addressed this question directly, following the screening in competition of the eight-minute, thirty-second short film *Tsy diso lalana* (*The True Path*) by Nantenaina Ambinintsoa Rakotoarimanana, a director whose self-professed model was Mel Gibson's *The Passion of the Christ* (USA, 2003). Rakotoarimanana's film was criticized for not respecting the historical facts: it evokes the martyrdom of a number of Christians killed by a Madagascan queen, when in reality there are thought to have only been a few. Gushingly lyrical, *The True Path* (whose title in itself suggests "a" truth) indeed deliberately constructs a myth; the film takes the form of a video clip based on a canticle, while the images evoke a retable. The viewer is invited to share a belief in reference to his or her own Christian faith. He or she is in no way invited to think critically. In this, the film becomes a propaganda tool for the Church that funded it. What is striking is

how far it is from the image of the icon meant to represent faith, whose reference to contemplation manifests the invisible, or absence, more than presence. On the contrary, *The Truth Path* is violently demonstrative and simply proposes an idol to worship (9448).[38]

While this example is very obvious, a lot of films are more subtle. The aim is not to bang the drum, but rather to question appearances, to detect and explain implicit discourses, the ultimate criteria remaining the freedom of the viewer. When documentary employs maieutics rather than haranguing, and the image is taken in the Greek (*mimesis*: to participate in presence, to manage absence) not Latin sense (*imitare*), we reach subtle understandings. We have already mentioned Leïla Kilani's *Tanger, le rêve des brûleurs/Tangiers, the Burners' Dream* (Morocco, 2002) (see 1.1.2). In it, the images manage absence in the sense that the "burners'" desire inhabits them, in that they only show what evokes that, in that they hammer no message home, no certitudes other than the awareness of the gap between the world's North and South. The film is not a report, or sociological, or entertainment, and in this respect, it is profoundly human (3053 and 3043).

When, on the contrary, directors attempt to prove their point in images, discourse saturates the gaze, an illusion of knowledge permeates the screen, and the spectator has no choice but to swallow what he or she is no longer in a position to criticize; it is an exploitative use of cinema (3038). As the French documentary filmmaker Denis Gheerbrant likes to point out, "a film is a question, and making films is to learn to formulate the question, not the answer." In short, a cinema that engages the spectator by giving him or her food for thought, rather than a cinema that belittles the spectator by spoon-feeding him or her a vision of the world. "We have to be a rampart against the rampant amnesia, the devaluation of culture, free creation, and intellectual work," critic Alain Bergala reminds us.[39] As such, critics are neither filmmakers' enemies nor accomplices, but rather, as Samuel Lelièvre suggests, their key interlocutors (9328). Critics' arguments' legitimacy lies not in their knowledge, nor the force of their verve. Critics are not experts in categorical judgments, but assert their subjectivity, in the sense that Jean Douchet writes: "Their sensibility need not confront the world, as an artist's does, and from which a work's creation results, but simply, without abdicating a thing, confront this work thanks to which they will discover the world and the artist."[40] For cinema is like love, critic Jean-Louis Bory said; "it is much more than what it is."[41]

1.3.2. Questioning Criticism

> A camel cannot see its own hump.
>
> —Mauritanian proverb

Some twenty-five thousand books, essays, articles, papers, theses, and so forth have been written on the meaning of *Hamlet*. While some consider this plethora of commentaries the necessary advancement of a reflection that is constantly renewed over time, others consider it parasitic. They prefer creative criticism; in other words, that of artists who, in their works, rewrite and enrich the work of their predecessors. George Steiner writes: "Cruelly, perhaps, it does seem to be the case that aesthetic criticism is worth having only, or principally, where it is of a mastery of answering form comparable to its object."[42] How many times have I found myself faced by filmmakers who despise criticism and claim to only want to heed the (often indulgent) reactions of spectators! That is generally the case in festivals, where filmmakers are considered the only people capable of presenting and analyzing their own work, as if an auteur's intentions summed up the work itself. Yet, as griots put it, "words are like groundnuts; they have to be shelled." Without analyses that go beyond the ephemeral and relate a work to others, artworks are not enhanced. Not to mention that, functioning more on an intuitive level, many filmmakers struggle to find the words to talk about their films.

Jacques Rivette, himself still a critic at the time, wrote of Alfred Hitchcock's *I Confess* (USA, 1953): "Only the director, by whom I mean the person who has posed himself the true questions of his art, can sense the beauty."[43] It is true that many critics' superficiality, mediocrity, patchy knowledge, and theoretical shortcomings do the profession little service at a time when journalism is struggling to distinguish itself from communications and PR. As Barthes wrote in *S/Z* (1970), "to interpret a text is not to give it meaning, but, on the contrary, to appreciate what plurality constitutes it."

But what Rivette highlights is a shortcoming of another order: the difficulty, for many, to perceive a film and each shot as a creative act that is not there to be scholastically decoded, but felt, given that it is the emotion associated with taste that founds judgment—this same emotion that bonds the viewers gathered together before the screen yet isolated in the dark. "Cinema is like the last subway," said Godard. Laughing, crying, being scared, loving or hating together founds a community of emotions and shared reactions.

That is not to confuse the intimate emotion that works of art trigger with the sentimentality of tear-jerker films or the shock of action movies. Weepy scenes always tap into a fear or echo an experience, but they remain isolating and change nothing. Slick action scenes are nothing more than entertainment unless they manage to build the tensions that allow an imaginary proximity with the Other. Characters drop like flies in such films without us feeling the tragedy of taking a life or death. I watched Amor Hakkar's *La Maison jaune/The Yellow House* (Algeria, 2007) with my stomach in knots and tears in my eyes. Yet the film is all tact, distance, minimalism, and respect for humans, for before death, there is no need for words. Hakkar replaces speech with the magic of cinema, kindling the hope of restoring the image of the lost son to trigger the return to life. The emotional magic comes from his strategies of mise-en-scène. It is in the ellipsis that drapes the stolen casket with dignity, in the joy of a marriage during which we learn the gutting news, in the cry of the woman in the distance, her back turned, for we only feel pain if we can imagine it; it is in the very human gifts of those who unhesitatingly share the devastation of a lost son (7190).

The emotion conveyed to an audience only engages and advances the spectators if it is the object of a transformation. Nouri Bouzid shot *Making Of* (Tunisia, 2006) in the hope of warning young people of the dangers of being manipulated by fundamentalists. It is not enough to analyze in order to mobilize; simple denunciation, and even the deconstruction of the logics at play, cannot alone change behaviors that draw on emotion and imagination. A symbolic distancing is needed. Bouzid interrupts the film three times, portraying his actor's terror and revolt vis-à-vis the role he has him play: that of a futureless youth who becomes a suicide bomber (4688). During one of these passages, shot like a "making of," Bouzid explains that this role is a form of catharsis. The word is stated. It is not about purging emotions, as is often claimed; it is about stripping them raw in a process of artistic distancing to transform them into autonomous thought, which is one of the stakes of cinema.[44]

This formal audacity, this very clear revealing of the critical process going on in the film itself, divided the Tunisian press. The press indeed focused on this transgression without ever tackling the heart of the film, thereby confirming that Bouzid had challenged a taboo. His tactic worked, then, keeping him a step ahead of the critics, focusing their attention on the form rather than on the content (5872). What was at stake for him was not to let them misrepresent the film at a time when the media simply parroted official discourse.

Tunisia has regularly seen filmmakers battle with the media. At the Carthage Film Festival in 2002, a conference was even held to try to defuse certain critics' escalating virulence. Three Tunisian films that had received a warm critical reception in France were violently attacked in the Tunisian press in 2000–2001: Khaled Ghorbal's *Fatma*, Moufida Tlatli's *La Saison des hommes/The Season of Men*, and Raja Amari's *Satin rouge/Red Satin*—three films that focus on Tunisian women's conditions, lives, alienation, and struggle for emancipation. As the philosopher Rachida Triki insisted, "The articles generally went like this: the West celebrates Tunisian films that convey stereotypical images of the Arab world; festivals select this kind of films; filmmakers adapt to meet this demand" (2670). The accusation was thus of selling out, of betrayal. The articles were entitled "The South in the North's Eye," "Clichéd," "Enough!," or "Same Old Song." Such judgments overlooked the films themselves, and simply attacked, deploying semantics alien to film criticism, such as "an OK film," "a so-so plot," "a film that runs out of steam," "a conviction-less character," "narrative fit for film school," and so forth. The truth was imposed. One article cited the woman filmmaker, but added, "Not at all; far from it even," while another exclaimed "Try again!" Yet critic Naceur Sardi pointed out during the 2010 seminar that "the Tunisian critics who attacked *Satin rouge* have changed their minds and now consider it one of the best films of the past decade!" (9867).

The incriminated women filmmakers were not invited to respond. This recalls the outcry in France in 1999 when director Patrice Leconte called critics "the gravediggers of French popular cinema," and which led to the publication of a "Manifesto of Angry Filmmakers" denouncing a film criticism "lacking in intelligence, competence, analysis, and enthusiasm." The manifesto demanded that "no negative film reviews be published until after the first weekend following a film's release." It was a bombshell, and the media in turn attacked this desire to control film criticism, already reduced at the time to the few daily or weekly papers willing to give proper space to detailed analysis, as opposed to short reviews made up of withering sound bites. "A tongue that slips causes more harm than a foot that trips," says the proverb. Everyone toned it down, but the damage was done. This mutual suspicion is fostered by long-standing recriminations, even though people tend to skim rather than read reviews nowadays, which are rarely heard out in full. Critics are accused of taking themselves for quick-witted Hermes—the god of orators and benevolent protector of mortals, guide to heroes and conductor of souls, the one who deciphers for others—mediating between a film and its audience. The term "intercessor" used by Serge Daney evokes a pastoral power over film lovers, the

fascination of "those who can domesticate, who can secularize the mystery and demands of creation."[45]

Based on a participative conception of culture, blogs and social networks today radically challenge this vision of a high-brow culture that needs to be conveyed to a public in need of enlightenment. Horizontal culture is preferred, a phenomenon also found in politics, and notably in the majority groupings formed by the likes of Silvio Berlusconi and Nicolas Sarkozy this past decade, developing an empathetic leadership based on a TV model of leaders' identification with the people. This has regrettably encouraged these leaders to develop xenophobic populism, but their success lies in their being perceived as different to the vertical models of the De Gaulles, Giscards, Mitterrands, and Blairs, who embodied guides who communicated democratically with the people to show them the way.

People cultivate themselves, instantly gleaning snippets of information from the web and social networks. Gone are the moguls. Learning is egalitarian, and practice has the same value as knowledge. In the United States, the renowned, aging critics are being toppled one by one from their media tribunes. The preference is for young freelancers who have their finger on the public's pulse, and who are underpaid. After all, one review is just as good as the next! Film criticism is still a profession, but not one you can make a living from, and it still only has any influence in the world of art-house film. Former critics are becoming festival art directors, or creating niches on the web where their faithful followers can continue to read them, in competition with a plethora of new critics who are trying to create a following. Their pages are interactive, and the films are discussed live with visitors to the site. But the major risk in marking one's distance in this way from an elitist, even arrogant vision of culture is a dumbing-down of critical thought. This challenge to hierarchical transmission indeed often favors spontaneity and intuition over knowledge of the past. And superficiality henceforth replaces argumentation.

Depriving oneself of the pleasure of knowledge and understanding that only intercessors of taste and educators of culture can pass on in a lasting way is problematic. It is up to these intercessors to find participative forms, as it is not so much their knowledge that is in question, as the hierarchical nature of its transmission and their posture as experts. Being an authority does not mean holding the truth, but rather answering to one's word; that is, simply giving and explaining one's vision. Sensibilities cannot be unequivocal, and there is no single interpretation. As Michelange Quay said of *Mange, ceci est mon corps/Eat, for This Is My Body* (Haiti, 2007)—a, to say the least, complex film—filmic grammar "can say one thing one

day, and something else the next" (7734). This is how filmmakers are little by little dispossessed of their films, as the critics and spectators appropriate them. Gaston Kaboré confirmed as much during his Cannes Film Festival master class in 2007: "Films have a life after the screening and their own journey" (6656).

1.4. The Necessity of Film

> It is from crack to crack, poem to poem, work of art to social struggle that the mental tectonic plates shift.
>
> —Patrick Chamoiseau, "Un admirable 'Eclat de conscience,'"
> *Le Monde des livres*, October 30, 2009

1.4.1. Against Derealization

> Each word has the taste of my saliva, the smell of my armpits.
>
> —Edouard Maunick, in *Désir d'Afrique*, by Boniface Mongo-Mboussa

A deep and complex rupture is at play. Once again, it concerns the question of the real. Once again, for the very essence of film is to be realistic from the moment that it aims to elucidate the real, and thus constantly poses the question of the relationship with reality. Granted, it manipulates rather than shows reality to represent it. "I am inventing you as you are," wrote Robert Bresson, who called for "reject[ing] everything about the real *that does not become true*. (The dreadful reality of the false)."[46] What he was seeking, in the wake of classical philosophy, was the truth of bodies—just as Godard claimed in *Le Petit Soldat/The Little Soldier* (1960) that "cinema is the truth 24 times per second." It is not that he believed in an essential truth, but, believing that the cinema is "a form that thinks," that the image could represent the real. Since Plato, we understand image as a reflection; since Foucault, as an art of thinking. If African filmmakers often cite Italian Neorealism, it is because they recognize their own quest to restore this "truth" of reality in its natural settings, nonprofessional actors, refusal of artifice, and generosity of gaze. Unlike naturalism, which only records the real, realism makes the visible tangible. Positioning cinema as a "mirror space"[47] was historically necessary to stop abstracting Africa: firstly to counter the misrepresentations of colonial imagery, then to confront the contradictions of independent Africa during its disillusionment

phase, and finally, today, to develop the awareness of the tragedy at play, with the constant desire to find morsels of hope, the pillar of our world. In general, these filmmakers prefer ordinary folk to heroes, and the quotidian to the exceptional. After initially focusing on denouncing obsolete practices and the corruption of its elites, they have increasingly come to see film as a tool of resistance to the reductive clichés that stop Africa from escaping its marginality.

Like other minority film practices, African filmmakers have had to accept the failure of militant film, of this cinema that was supposed, in Thomas Sankara's famous words, to "tell the truth 24 times per second." The emergence of today's eminent filmmakers, and the rupture they signal, re-poses the question of Africa's place in the world, rather than magnifying the force of its origins. This place has yet to be won, on an egalitarian basis. Graham Huggan has demonstrated how artists from the South are the object of a new exoticism on the contemporary art market.[48] They represent subalternity, poverty, exclusion, marginality, and again find themselves locked in a role. Critiques of the origin-based essentialism can thus not afford not to deconstruct these new hegemonic discourses.

Deleuze saw in Neorealism a distinction between the movement-image and time-image. To project a future, it is indeed the relationship to time that has become a vector for the narrative for many African directors. It is no longer about reproducing the past to forge an identity, but to know where they are at today. That has engendered the aesthetic experimentation explored in chapter 5.

Knowing where one is implies questioning one's place both in terms of territory and in terms of influences and commonalities. Hence the term *métis* ("mixed") cinema, which has now gradually been replaced by "nomadic" or "transient" cinema. It is not surprising that the Guild rejected the term *métissage* ("mixing" or "blending") in its 2001 manifesto. Qualifying these films as *métis* suggests that they embody a mix of supposedly autonomous or separate origins, whose hierarchical categorization is still rampant in the world and evokes an essentialist vision of Africa. This vision ignores the fact that this African origin is itself riddled with other cultures. Reducing them to their identity confines and fixes them in a difference that is held up as their prime characteristic. Africa is traversed by the Other because it had no choice (the slave trade, colonization, neocolonialism), but also because African cultures are willingly syncretic. This is not a *métissage*; it is an appropriation (3727).

When Abderrahmane Sissako films himself in the overflowing abundance of a Parisian supermarket buying a huge cuddly toy in *La Vie sur terre/Life on Earth* (Mauritania, 1998), what an ironic reference it is to the inanity of certain

cultural influences! His film resonates with this complex and violent North-South relationship. Citing Césaire, Sissako lambastes Westerners' way of viewing Africa as some kind of show (misery, anecdotal images, sensationalism, superficiality, seduction, etc.). Through the difficulties that the Sokolo inhabitants face to make a phone call, he conveys how hard the continent is trying to communicate. The public phone operator sums it up by saying, "Communication is a matter of luck. Sometimes it works, sometimes it doesn't." What counts is not whether it works or not, but the desire to communicate. Henceforth, what may have seemed static in this village where life goes at its own sweet pace comes to life with people's desire, and this simple wish to communicate testifies to their willingness to encounter the Other.

Sissako meets a village woman and a connection grows, but will not last; this hovering incertitude characterizes his relation to the real, and thus his film style: taking chance into account, which, in the footsteps of Godard and Cassavetes, is not a lack of action, but an opening up of possibilities. This translates into the permanent fluctuation of the screenplay that may change according to what is encountered or questioned along the way. A woman walked into the shot while Sissako was filming *La Vie sur terre*; she became a recurrent element in the narrative. The film thus reverberates with the willingness to listen that it portrays, and proposes this as an ethic of the gaze; "The eye should listen," as Godard put it. It is no longer about the ready-made solutions of hammered-home messages and messianic ideologies, but a humble, involved search for the paths of an uncertain future. This filmmaking is thus impregnated with an awareness of the continent's current issues. Capturing their reality is above all a question of perceiving the dignity of its inhabitants, not as Africans, but as people, to reintegrate them into this humanity from which history and stereotypes banished them.

"To the obsession with uniqueness," writes Achille Mbembe, "we must oppose the thematics of similarity, that is the process through which, under current conditions, Africans are coming to feel themselves similar to others, or not; the everyday practices through which they manage and recognize the world, or not, and to maintain with the world an unprecedented familiarity, at the same time inventing something that is both their own and beckons to the world in its generality."[49] Resisting the steamroller effect at work today constantly determines the idea that Africans might have of themselves and the discourses they articulate about themselves. This "colonial library"[50] constitutes an openness to, and encounter with, the Other. In the global context, this library is constantly evolving,

and film is one of its main vectors. Its permanent depreciation of Africans stems from the derealization masterfully orchestrated by mainstream, predominantly Hollywoodian cinema (see 3.4 for Hollywood's vision of Africa), of which it has become the very structure. Instantly consumable just like popcorn, it elicits instantaneous reactions in viewers, without giving them the necessary distance to make a judgment. "In contemporary mainstream American production, a film is nothing other today than an appearance opposed to the real, but an appearance posited as a value unto itself."[51] That generates a derealization not only of the world, but of film too.

Paradoxically, it is by adding this appearance of the real that Hollywood films derealize. As Jean-Louis Comolli comments, "the reality effect is achieved through derealization."[52] But this veneer of reality is the falseness that Bresson denounced in the words cited at the start of this chapter; it is artifice, which means that most reality is achieved through even more techniques and an inflation of images and sounds that perpetually seek to outdo themselves in a frenetic one-upmanship.

Such cinema does not help think ourselves in relation to the world around us. The spectator's solitude is only resolved in a solidarity of a new kind; in other words, in the connections that need to be looked for in a shared reflection regarding our place in the world. Hence the now recognized importance of documentary film. In filming Brazzaville street children in *Poussières de ville/City Dust* (Senegal, 2001), or rape victims in *Nous sommes nombreuses/We Are Many* (Senegal, 2004), Moussa Touré does not seek to elicit the spectator's compassion; the distance he adopts is just, and not meant to draw tears. He seeks instead to raise awareness, and he does so via an aesthetic that involves the way in which he frames these women and children, in which setting, with what lighting, where he places his camera, at what distance, the questions he poses, whether he leaves the freedom and time to respond, what he really shares with them, and the risks he runs (see 5.2). This proximity is essential; it is completely sincere. It is these two factors that allow the subject to be simply human, rather than African, and thus to interest the entire world as an alter ego, a similar other, and not a tear-jerking curiosity.

Real life readily permeates cinema, just as it does today's dance and theater. After having staged eight sporty teenagers in *Surface de réparation/Penalty Area* in 2007, Rachid Ouramdan, the French choreographer of Algerian descent, based his *Des témoins ordinaires/Ordinary Witnesses* on the testimonies of torture victims. In 2009, the South African choreographer Robyn Orlin based her *Babysitting Little Louis* on the experiences of eight Louvre Museum attendants, integrating them

into the creative process. Just as Abderrahmane Sissako did in *Bamako* (Mauritania, 2006), Jean-Stéphane Bron put the mighty on trial in *Cleveland versus Wall Street* (Switzerland, 2010), showing how the American banks swindled poor, mainly black communities in the subprime mortgage crisis. In both cases, the trials are fictional, but incorporate real witnesses, real judges, real attorneys. In both films, it is the dignity of the lowly, more than the facts, that denounces the cynicism of those in power. The human abyss is shocking.

This foray into the real testifies to a desire to grapple, as closely as possible, with those one is combating. Rather than attacking them head-on, they are given body. Being committed is no longer being against, but first and foremost espousing, and getting physically involved. The critical artist no longer resorts to repulsion, for it engenders an ambiguous play on disgust and fascination that leaves the spectator either unconcerned, or refusing outright what he or she is being offered. The problem with confrontation too is that in constructing ourselves and uniting against the enemy, we often end up letting ourselves be defined, or even legitimized by that enemy. We are what the enemy is not. What matters, on the contrary, is respecting one's subject whatever he or she may be, from an "attentive distance" (Comolli) that the strategies of adhering to the real allow, in the sense that Sun Tzu put it: "Those who are expert in the art of war vanquish the enemy without combat. They take towns without storming them."[53] This thus allows us to go from mimetic confrontation to resistance, which, rather than resorting to arms, consists of marking the enemy in a rationale of enlightening reflection.

This same tactic combining both involvement and distance replaces compassion toward the exploited and oppressed. Compassion is a projection onto the Other, a participatory mode that involves identification. This lack of externalization brings things back around to the self, and fails to transmit an experience. That is why the Situationists advocated the subversion of representative art by creating situations, which the visual arts developed in performances and installations. The digressions that divert our attention from the trial in *Bamako* have no other goal than to enhance the experiences that the witnesses recount. They are not illustrations of this, but re-creations of situations, which are too short and too off-beat (or even parodies, like the Western episode) to allow identification. This distancing prevents our critical senses from being undermined by our empathy with lived experiences. The immersion in the real, and the emotion that these poetic approaches provoke facilitate a direct understanding, however. The critical artist is no longer an observer

tackling the real; he or she proposes to share an experience with the spectator that draws on his or her own life.

As technological advances allow image-making to become more widespread, it is difficult for viewers to control an image's veracity. This veracity thus shifts from the documentary aspect to the film's auteur. Film in itself is no longer world truth. When the filmmaker is clearly identifiable in the enunciation, viewers are reassured as to the origin of the image. The filmmaker's subjectivity becomes a criteria of authenticity.

Where, then, does the solidarity that allows for a forging of connections between works and between spectators lie? For critics such as André Bazin or Serge Daney, filmic truth founded a cinema-loving family, a feeling of belonging, Daney's famous "Cine-son." Today, all creative acts imply that we must anchor our relation to the world in uniqueness, freedom, and individuation. "What I've thought of as dispersed and fragmented comes paradoxically to be the representative modern experience," wrote Stuart Hall.[54] A new visibility vis-à-vis the world is thus emerging, which does not deny diversity and banks on intersubjectivity. Removing the capitals from concepts opens up the individual's implication in the collective and alterity.

It is not surprising, therefore, given the newness of this context, that the filmmakers of the Guild ended up at loggerheads and that their organization fizzled out. They are all so different. Each is trying in his or her own way to resolve his/her equation to the world and its institutions. This individualistic turn has ended a certain political conception of cinema, but re-poses the question of form. "The period demands an awareness that requires reflection," stated Mahamat-Saleh Haroun. "We can't produce in order to raise awareness and so forth anymore. That's no longer enough. We have to have the humility to take the debate into the domain of film as an artistic creation unto itself, not just as a means for advancing causes" (4681). To which Jean-Pierre Bekolo added: "How can we make films that are inferior to *Yeelen* or *Hyenas* today? Masters and masterpieces exist; when we come along with vastly inferior projects, how can we defend them? We have to make room for a cinema that pushes the boundaries of form" (3944).

But in that case, a debate needs to take place: Where is criticism's place in the media? Where are the film reviews and journals? It does not suffice to marvel together at the likes of Sembene's pertinence, however stunning. A debate is needed, open to questionings and founding struggles. For a new element has come to increase the stakes!

1.4.2. The Ambiguities of a Spontaneous Generation

The technological leap that introduced digital film has given a multitude of young amateur video filmmakers the possibility of making images without outside help, which they attempt to distribute beyond their circle of friends. They are in competition with the system built around the name "African cinema," in which filmmakers whose reputations have been established in festivals and by the critics, build up—often with difficulty—a filmography of auteur films. Films produced without outside help, in the simple synergy of local means and by mobilizing willing souls, have thus entered a territory that was hitherto the reserve of an admirably willful and determinedly happy few.

In the same way that we posed the question of the death of cinema in the 1980s before the onslaught of television images, we are today witnessing a fundamental challenge to the auteur cinema that continues in sub-Saharan Africa—South Africa excluded—to be tied to the West's production fund commissions. "There is no death of cinema, nor thought," declared Gilles Deleuze, "there are only assassinations!"[55] Many reproach the established filmmakers for conforming to a model of what people expect films from Africa to be like, without realizing that this so-called subordination stems from the need for funds to guarantee quality, with all the ambiguity but also the necessity that this entails: expecting the projects presented to be artworks implies—without generally saying as much—a reflection on aesthetics.

The clear freedom taken today—if not to say parricide committed—thanks to the multiplication of digital productions without Western funding poses an essential question: what are the references of this new mass production of images? Kids in jeans do not aspire to go around in boubous; addressing an African audience does not mean returning to cultural authenticity. Manifestly, video producers adopt dominant audiovisual or Hollywoodian aesthetic codes, if not to say those of music clips and advertising, rather than developing their own codes. In their desire for effects, but also due to their lack of critical reflection, they often imitate a certain vision of the world that fundamentally thwarts the references and values of their culture of origin, often paradoxically inscribing them in the very thing that these youngsters loudly and radically seek to challenge: namely, globalization.

When they commercialize them, their works are a huge success. The Burkinabè journalist Boubakar Diallo has clocked up hit productions, with his 90-minute films that cost from $54,000 to $68,000. The films are funded through product placements:

mineral water, cell phones, motorbikes, etc. "The idea is to use genre cinema to entice audiences back into the theaters," he states. "If audiences don't go to see films, it's because we are not giving them what they want" (4431). He made a dozen films in just three years: the thriller *Traque à Ouaga/Ouaga Hunt*; the rom-coms *Sofia* and *La Belle, la brute et le berger/The Good, the Bad and the Herder*; the Western *L'Or des Youngas/Youngas Gold*; the political thriller *Code Phénix*, and so forth.

In Madagascar, the last celluloid production dates back to 1996, namely, Raymond Rajaonarivelo's *Quand les étoiles rencontrent la mer/When the Stars Meet the Sea*. At least a dozen video feature films have been produced in Malagasy every year since 2000. The public follows, not worried about the quality, for this locally made popular cinema combines upward social mobility, elevator music, love stories, and action (3598).

The rise of hit Nigerian video production since 1992, which has created a veritable film industry, is presented pretty much all over Africa as a local development model that can survive without outside funding. Lagos has supplanted Bombay! Reliable statistics for the number of features produced in Nigeria are hard to come by, but around 1,200 films are made a year, despite a fall in production after the 2009 crisis prompted by the audience's weariness with hyperformatted and repetitive products. Yet the fact that Nollywood has overtaken Bollywood changes nothing: even if it exports more and more, Nigerian video has not improved the reputation of African cinema. Like Bollywood, these highly coded films tell the same old stories ad nauseam (2764). The Ghanaian case is typical: video production essentially driven by profit-making developed with no correlation to Ghana's local talent, trained at the NAFTI film school in Accra. According to Kwaw Ansah, who enjoyed major successes with his hit movies *Love Brewed in the African Pot* (1980) and *Heritage Africa* (1987), "Hollywood did so much damage to the black race and now that we have the possibility to tell our own stories, we are doing more damage than Hollywood!" (4142).

These Nigerian films articulate the anguish of a society confronted with violence and the growing importance of occult powers and wealth, while also playing out dreams of social mobility and stories of jealousy. Yet we have little notion of the consequences that their unbridled representations of violence have on young people. They reproduce consumerist, social-climbing models, which often promote self-denial in favor of imported models. *Dangerous Twins* (Tade Ogidan, 2004) and *Osuofia in London* (Kingsley Ogoro, 2003) indeed both make unfavorable comparisons between the North and South; with several hundred thousand VCDs

sold, they are among the biggest all-time Nigerian hits, and were followed up by sequels destined to reap the same profits (3439).

A popular cinema is thus emerging, which the lack of a film industry had prevented from seeing the light of day; it is an often commercial cinema that—with some rare exceptions that we shall look at in chapter 6—is hardly concerned with subversion or a vision. This movement restores a salutary diversity to film, which may well lead to the structuring of an industry. Young filmmakers are spontaneously emerging—to whom we shall also come back—who may be the talent of the future. That endogenous images replace imported images, notably in television series, is unanimously welcomed as an advance, but it is clear that what is at issue today is questioning the content and improving these productions' aesthetic quality—in short, breathing more cinema into them as an art, which necessitates cultural policies and training. Without film schools and accessible film criticism, there will be no reflection on the image and representation, and no innovation—which is urgently needed.

1.4.3. Keeping the Spark Alive

Films are markers in many people's lives, sometimes structuring their thought or teaching them to ask questions. For film to play its role in awakening youth, an encounter is necessary—a solitary encounter that only takes place with a work of art. How many vocations have been sparked in film clubs? Or on school trips to the cinema? Or simply by a film one day? "I saw a Bollywood film in Abeche where a woman looked into the camera," Mahamat-Saleh Haroun told Manthia Diawara. "There were thousands of us there, but I had the impression that she was looking at me, and I knew that I had to do something with this. My games had changed. I was now an adult."[56]

Today, as the logic of cultural niches accessible only to the happy few has become generalized in Europe, only school can offer this encounter to youngsters, who otherwise devour just popcorn movies. If repeated, and as works are articulated with one another, these encounters gradually forge their taste (4679). They help inscribe a singular experience in an emerging universal. But what clout do African films have vis-à-vis blockbusters and television? It is impossible to reverse the balance of power. And it would be perfectly illusory to imagine that a few films can suddenly educate one's point of view.

What was it that led me to take the plunge? What was the spark that made the pleasure of understanding more important than the pleasure of consuming? I can remember. I was young, probably around twelve years old, when I saw a film on TV: John Ford's *How Green Was My Valley* (USA, 1941). I shed tears of emotion. The next day, I rushed to find the book by Richard Llewelyn from which the film was adapted. A paperback. I devoured it. And I devoured more: more books, more films. I cultivated myself—to taste this emotion once more.

I recently saw this film that started it all again, delighted to come across it once more. Disappointment. I did not relive the emotions of my childhood. But I did understand that I had found in it the image that was cruelly missing from my life, a father figure, a family community, a rootedness. I understand why I was receptive to the generosity, humanism, and poetry of Ford's lyricism.

I had encountered a work. It was the right moment. It could permeate me; I was ready to accept it. It helped me take a step. It was the bedrock on which I could build. Even if I have pretty much forgotten them, and would no longer cite such and such a film or novel as my references, they left an indelible trace in me that can be summed up in a few images and above all a powerful emotion. "We can be forced to study, but we cannot be forced to feel," wrote Alain Bergala.[57] The encounter with art is personal and cannot be programmed. But when it takes place, it is determinative. It helps us, as in Ridha Behi's *La Boîte magique/The Magic Box* (Tunisia, 2002), to accept the child's proposal to cross the sea, even though we do not know how to swim (2680).

Faced with a cinema that derealizes the world, and with the ambiguities of the advent of digital technology, film as an art, as a forum of debate, is more necessary than ever, and young people must be introduced to it. African film gestures are inscribed in a resistance that is radically changing position. As Patrick Chamoiseau puts it, it is no longer about being a rebel, but positioning oneself as a *Warrior of the Imagination*. "Between these two postures, there is an infinite distance. The rebel seeks power by reversing the terms of domination. The warrior, however, determines his or her battlefield, and tries to imagine another world. To imagine is to create. To truly resist is not to oppose, nor create in reaction against, it is simply to create"[58] (8067).

1.5. African Criticism?

> I've spent my whole life bugging you, and it's such a pleasure!
>
> —Ousmane Sembene, "Faat Kine: Sembène s'explique"

1.5.1. Revolutionizing Criticism

> Criticism has always been the spectator's conscience. . . . To the auteur of a work
> of art, it reveals his or her obligations to human society.
>
> —Jean-Pierre Dikongue-Pipa, Cameroonian filmmaker, in *Cahiers d'Afrique*

Who has the authority to speak? Whose voice is more legitimate than another's? In whose name? If the answer to these questions is rarely given, they nonetheless constantly resurface in criticism of critics, as soon as criticism upsets. What is at issue is cultural proximity, which authenticates a discourse, or a judgment. It can, of course, be answered that as cinema aims to be universal, all humans are concerned, and thus can legitimately write a reaction that reflects their own thought, which is, of course, criticizable. "Unless you give students notions of Malinke culture, you miss so much in Kourouma's work," says Jean-Marc Moura (1360). The way Malinke colors the text's French, the cultural associations, and so forth—of course sociological and political understanding helps better understand a work. "Otherwise, you lack rigor," adds Moura, who is a postcolonialism specialist, which he defines as a critical rather than historical concept. Criticism that strives to assess writing strategies that challenge colonial and imperial codes will reveal the influences and ties, but also the specificities. Those well-versed in the culture concerned will be better equipped, even if they should still question the validity and limits of their knowledge.

The legitimacy of writing does not reside in a belonging or a territory, which do not guarantee authenticity in themselves. Kourouma made it clear that he was not seeking to translate Malinke into French, but to create a literary work. He thus did not situate himself in terms of identity issues or politics.[59] Is there nonetheless an "African interpretation" of things? This often polemical expression, which borders on communitarianism, is hard to define and reeks of the fixation with a difference that must be preserved at all costs, quickly leading to the solitude of the dream of a world without the Other. It belongs to what Abdoulaye Imorou calls "the untouchable": expressions that reassure, ramparts against the deep-seated fear

of the colonial return, and which cannot be deconstructed without immediately being accused of playing into colonialism's hands and wanting to reinscribe Africa in the heart of darkness (9644).[60] If, on the other hand, a critic is from the same culture as the work, sharing a sensibility that is rooted in his or her own experiences and knowledge of the ground, he or she can draw on this to enrich the analysis, highlight specificities, and reveal hybridities, unquestionably affording quality and additional flavor to our understanding. All the same, this does not make such critics holders of a truth, just of knowledge, itself to possibly be taken with caution, akin to all knowledge served up by another voice. Their involved vision is essential to contribute to highlighting a work, but should not be dogmatic. Rather than positioning themselves as experts, which risks extracting them from the critical space, it is rather the poetry that they draw from their cultural proximity with the auteur that will constitute the force of their conviction.

A danger looms on the horizon, one that we all risk: that of accentuating alterity. For that would mean joining the dominant discourse on an Africa of the center and the margin, articulated in both the West and Africa. To be heard, this discourse has to highlight difference, to turn Africa into an alien world and Africans into a separate people. In short, to reduce or mask the similarities that would allow Africans to be inscribed on an equal footing in the world, and African societies to be governed by the same rules as everyone else. Clichés and illusions are not far, but this theme is deeply prevalent, for otherwise no one listens. The danger is thus of veering into an obligatory emotional discourse whose basic profession of faith is that we "love Africa" and must serve it. The stake, as Abdoulaye Imorou again suggests, is not to give a work the status of an emotive object, but an object of study unto itself.

Another danger would be to focus on betrayed reality; films always organize or reinvent reality. It is only when they become anachronistic, undermining the narrative intent, that it is meaningful to highlight this. However, it is essential to deconstruct the reductive visions on which discrimination is based. While critics generally all agree on this, it can be particularly destabilizing for filmmakers to be effectively denounced by critics from the countries where their films are shot or are about. Similarly, if African critics had enough visibility and mobilizing power, they could, for example, denounce the Cannes Film Festival official selection's[61] accommodation of humanitarian, sensationalizing, or outmoded visions of Africa that moreover have no aesthetic interest. Indeed, as soon as it is Africa we are looking at, it is the subject that matters and not its treatment. We could cite Jean

Van de Velde's *The Silent Army* (Belgium) in 2009 (8682), Oliver Schmitz's *Life, Above All* (South Africa) in 2010 (9515), or Hugh Hudson's *I Dreamed of Africa* (USA) in 2000 (1500). As critic Jean-Michel Frodon noted after the screening of *Delwende* (Burkina Faso, 2005):[62] "I was shocked when the person who presented Pierre Yaméogo's film said: 'I hope there will be more of you next year.' Pierre Yaméogo is one person, not a group. A film critic views every film as a work of art, as the singular gaze and act of one person that enables a film to take form; otherwise we are talking communications or propaganda, not cinema" (3855).

Choosing Jean-Stéphane Sauvaire's *Johnny Mad Dog* (France, 2007) to represent Africa at Cannes in 2008 was emblematic. Although the film was an adaptation of Emmanuel Dongala's novel *Johnny chien méchant*, Sauvaire managed to turn the child soldier tragedy into an appalling spectacle. "I didn't want to slip into journalism or a chronicle," Dongala told *Africultures*, "but to see how my characters suffer and react" (2727). Yet the film is light years away from this, so precisely does it resort to the chronicle in its effort to adhere to "reality" (7636). "I just wanted to approach the truth," Sauvaire claimed.[63] Here we have that old challenge of reconstituting violence to raise awareness, yet whose transposition on the screen is, we well know, destined to fail when it mobilizes viewers' voyeuristic impulses more than it does their autonomy to think. In Africa's case, there is the additional burden of clichés about the continent and its tragedies that mean that we tend to take any discourse on violence devoid of complexification as gospel. Encouraged to radicalize the film by his producer, Mathieu Kassovitz, Sauvaire conceded that he centered the story "there where I would have liked to have taken it toward something more sensitive and formal."

"I hate the idea that turns life in Africa simply into dispossession: an empty stomach and an unclad body waiting to be fed, clothed, healed, or housed," says Achille Mbembe (9028). Here, he identifies "a fundamental aspect of the development fiction that the West seeks to impose on the people it colonized." Even in precarity and incertitude, he points out, Africans develop a "personal daily experience with the immaterial world of the spirit." To resist "such underhand forms of dehumanization," he continues, "when millions of poor people really fight from day to day to survive, the task for theory, art, and culture is to trace the path for a quality practice of the imagination, a practice without which we shall have no name, face, or voice in History." There lies the need for criticism: "Without a cultural infrastructure composed of media, newspapers, cultural journals and a serious tradition of art criticism, without significant investment in critical theory,

our artistic production will not go beyond the realm of craft and we will always leave others the task of dictating the intellectual and political conditions of its recognition on the world stage."

What is needed then, as in art, is to rehabilitate criticism as a public good and to stop taking it as a luxury. Just so long as it stops repeating the same old refrains about commitment that lead criticism to constantly reenchant the myths of an "African film genre." U.S. Professor Ken Harrow draws up a list of such "sacred cows":

1. African film corrects past misrepresentations of history;
2. African film is important in countering Hollywood and mainstream media misrepresentations of Africa;
3. African film represents African society, African people, and African culture;
4. African film should be the site for truth;
5. African film is African.

For, writes Harrow, "it is time for a revolution in African film criticism. A revolution against the tired old formulas deployed in justification of filmmaking practices that have not substantially changed in forty years" (9463). What is needed, clearly, is to let go of the reassuring paradigm of authenticity, which postcolonial criticism has shown to be futile, and assert each auteur's intrinsic subjectivity, which is constructed out of multiple influences.[64] Likewise, the obligation to commitment generates a fixation with a dogmatic discourse and bridles experimentation along new paths in keeping with both present and future stakes. Relinquishing the comfort of what Harrow calls "truisms" conditions criticism's capacity to apprehend both new aesthetic experiences and the new Nollywood-type video and television practices that are burgeoning pretty much everywhere.

It should be noted that these truisms are not specific to a territory; they get repeated just as often in Africa as in the West and elsewhere. Their deconstruction, in the Derridean sense, requires analyzing their words, the language used, particularly to clarify the notion of Africanity and the different masks it wears (1838), for it is when we are willing to challenge it that this concept becomes a driving force and opens future perspectives.[65] As Achille Mbembe writes, "African identity does not exist in substance. It is constituted in varying forms, through a series of practices."[66] Fanon, for his part, stated: "My color is not the depositary of essential values." Moving away from the notion of identity defined as a constant, which carefully avoids self-criticism while also glorifying difference, and perceiving it on

the contrary as something in the making—that is to say, undefinable—helps stop considering one's own uniqueness as a hurdle to one's belonging in the world, not so as to blend into it, but to add what one is and enrich the world. African artists today are there where we least expect them; they meet us "elsewhere." Eschewing projections, they render themselves difficult to grasp, to better claim a place that is at last rid of folklore. What is needed is to understand their strategies, their way of being in step with the issues facing the world, without didactic pretensions, their aesthetics of incertitude, their off-beat exploration of intimate relations, in which deconstructions engage the rebalancing of men and women in society. That is where the heart of critical work lies, namely, to detect if and how a work invites spectators to construct themselves as subjects, leaving them the space to answer the question the film poses for themselves; in short, if it helps to build what Foucault called "practices of freedom."

As Jean-Pierre Bekolo suggests in *Le Complot d'Aristote/Aristotle's Plot* (Cameroon, 1996), which directly questions "African cinema," you don't win an audience's support by cutting yourself off from the world, by hiding behind an affiliation, genealogy, or heritage. He calls for the exploration of other forms, which he seeks in a jazz aesthetic akin to Spike Lee, just as the Ivorian playwright Koffi Kwahulé draws the structure of his writing from jazz, in a language in which the sounds, rhythm, musicality, tone of voice, and so forth, are as significant as the words.[67] His post-dramatic theater is in the vein of the rupture that Bekolo orchestrates vis-à-vis Sembenian drama. "Hitchcock said that it was better to start out from a cliché than to end in one. I believe you have to take what exists and destroy it," Bekolo claimed, using comedy, parody, and satire to do so (2477).

Balufu Bakupa Kanyinda's *Juju Factory* (DRC, 2005) starts out from this deconstruction of the clichés surrounding one's own history. Kongo Congo is confronted with a publisher who wants him to adopt a commercial approach to describe the reality of the Matonge neighborhood, a Congolese enclave in Brussels. How to remain in control of one's narrative? (4517). What Kongo Congo is seeking is faith in himself, "because in the ruins of exile," says Balufu, "you soon lose your illusions and your wings. For Kongo Congo, this faith is the 'juju' he is making. He wears it as protection, to remain standing in the chaos of history" (4558). Kongo Congo's neurosis is the reflection of an "African cinema" confronted with its obsessions and dreams, but also with its funders' expectations. Everything becomes mixed up, because everything is connected, because everything is contradictory: politics and the intimate, both of which are at the same time universal and specific, a

self-perpetuating, infernal duality. The structure and aesthetics of this abundant, lyrical, corrosive, torn film reflect the disarray of an author, and a cinema considered a genre with expected codes, a cinema itself caught in the market spiral.

Criticism needs tools to grasp such a work in its entirety. Rather than ignoring the diverse critical tools that are constantly being elaborated in debates, works, and journals, and rejecting them as Western, universalist, or even feminist, it is important to appropriate them to enrich one's own analysis. For the hybridity of these works engages the complexity of the world.

Juju Factory struggled to find funding. It is a significant part of a critic's work to testify to the play and stakes of power and the institutional relations that determine the production of images, notably by talking to the directors and their producers. Here too, strategies and new discourses are at work. The same can be said of distribution and film reception. As Michel Serceau suggests (9329), we should use the aesthetics of reception, which focus on the question of the spectator, as theorized by Hans-Robert Jauss and the Constance School, for whom the question of the public's taste engages not the form of films so much as the effect of the form in its difference from past forms.

Indeed, this is a complex negotiation, and the root of many a misunderstanding of African films (see 1.6), but the question must be posed, for without viewers, films do not exist other than on the shelf. All spectators who see a work renew it through their gaze and enable it to play its socializing role. The Constance School nonetheless neglects the spectator's subjectivity. For, just as critical work is illuminated by and illuminates a shot's off-screen realm and the incertitudes and interstices through which the voices of resistance and creativity emerge, films are full of empty zones into which the spectator can plunge. A painting is set on the canvas, but opens an array of sensibilities and pushes back the boundaries through abstraction. When a film is a work of art, it remains an auteur's singular vision, but is riddled with ellipses in meaning that the spectator can freely fill. That forces us to pose the question of audience in a new way, for it is in these interstices and cracks that public criticism undoubtedly lies, when from a common impulse, we identify and feel what breaks from the norm to engage a broadening of possibilities. And it is thus the critic's job to contribute to forging tastes, gazes, and thus culture, by finding the right words to help a film enter history by capturing this momentum on paper.

1.5.2. The Devouring Universality of Dominant Culture

> I believe we must abandon the idea of the universal. Universality is a foil, a deceitful dream. We need to conceive of the totality-world as a totality, that is to say, as a realized quantity, not as a value sublimated out of specific values.
>
> —Edouard Glissant, *Introduction à une poétique du divers*

As Glissant suggests, it is time to turn the page. Enlightenment (*Aufklärung*) defined a universal being. It defined a generic identity based on a nature shared by humans gifted with reason, and defined rights and values shared by all. But did Africans belong to the club, or were they different? Considering them as different legitimized their exploitation. But that led to the belief that if they were different, it was because they had something specific about them, namely, customs and traditions—a definition that was going to stick. To enter the circle of humanity, Africans needed to be converted to religion and civilization, or in other words, stripped of their specificity. This new humanism was to be reserved for only a chosen few, who would thereby achieve citizenship. "The idea of a universality different from Western rationality is never considered. In other words, there is no alternative to modernity," Achille Mbembe states.[68] Senghor, who rejected an abstract vision of the universal, called for a "rendezvous between giver and receiver" that would contribute "the values of black civilization." To participate in the universal and to escape "European reductionism," to cite Césaire, which reduces all humans to its own postulates, Negritude proposed to enrich Western rationality in a sharing that also respected singularities. In a speech given at the Sorbonne for the 50th anniversary of the Congress of Black Writers and Artists, Réné Depestre stated: "The 1956 Congress reflected the pan-humanist logic that made it possible to surpass claims based on the essentialisms and indigenism that took the abominable conjunction of violence and the sacred as its ignoble core."

The notion of the universal is problematic, then: "It is the moment when, through its instigation, specificity is surpassed, subliming it into a value that is valid for everyone," as Edouard Glissant put it (9981). It is a complete denial of difference, of course, but also a denial of the inhumanity of slavery, the slave trade, and colonization. "It is possible to be universal and to accept injustice and crime," Glissant adds. That amounts, as Césaire put it, to "cutting man off from the human, and isolating him, ultimately, in a suicidal pride, or a rational and scientific form of barbarity" (7530).

Today still, this "chauvinism of the universal" (Bourdieu) results in generalized denial: "People behave as if the colonial chapter belonged to another time and place, as if it had strictly nothing to teach us in understanding our own modernity, citizenship, democracy, and even the development of our humanities," states Mbembe. This denial is not without its consequences: "As a result," he continues, "France doesn't just find it difficult to talk about itself. Contemporary French thought no longer knows how to talk about the Other, let alone *to* the Other. It prefers, in accordance with good old colonial genealogy, to speak in place of the Other."[69] There are many examples: in 2005, the surreal debate about the so-called benefits of colonization and various politicians' declarations during the riots in the French *banlieue* (4099); in July 2007 President Sarkozy's speech in Dakar (6816 and 6864); in 2009–2010, the national identity debate (9109), and so on.

The alternative is not necessarily Anglo-American multiculturalism, which, in the name of recognizing all cultures to counter the domination of Western universalism, tends to confine individuals in an unsurpassable origin.[70] The alternative lies, rather, in a policy of similarity that implies recognizing the Other in his or her difference, surpassing oppositions between humans who are taking root, and those who define themselves by their roots alone (6680). A number of artists echo this concern—for example, Barthélémy Toguo, who declines cultural references in his watercolors and works on the signs of displacement, like when he traveled first class on the Paris-Brussels high-speed train dressed as a garbage collector (the other passengers asked the guard to throw him out), or in his series *Transits*, which he started when going through customs at Roissy Charles de Gaulle Airport in Paris with suitcases sculpted out of solid wood (7347). "My work is necessarily situated in claims and criticism," he told Virginie Andriamirado (3931).

Speaking in place of the Other: Mbembe's observation about French critical thought resounds in all the films based on ethnocentric stories brimming with good intentions, time and time again setting this universalizing image of the Other in predictable, tragic tales that lead to an exemplary final redemption. As the comments left on the *Africultures* website testified (5770 and 5771), a heated debate followed my virulent criticism of *Si le vent soulève les sables/Sounds of Sand* (Belgium, 2006) by Marion Hänsel, based on Marc Durin-Valois's novel *Chamelle*. Shot entirely in French due to the dictates of distribution marketing, this film that has the gall to turn a child's being sent into a minefield into a moment of suspense is a Manichaean, catch-all thriller. It depicts the tragedy of villagers being chased from their land for want of water, and thrust into the cruelty of civil war, yet nothing

is contextualized, from the conflicts portrayed, to whose side the shady soldiers whose paths we cross are on, to the reasons that drive the caricaturally stoned rebels to revolt. It may well not be cinema's role to give all the historic facts, but if it does show "baddies," it ought to state who they are. Child soldiers, arbitrary armies, extreme drought, all the ingredients are present, but of course, the ugliness lies just in the violence, not the landscapes. Marion Hänsel claimed to have looked for shooting locations in Morocco, but finally only found the beautiful sites and a people to her liking in Djibouti, regretting, however, that this was more expensive. This reminded me of Olivier Delahaye, the French screenwriter-producer of Ntshaveni Wa Luruli's *The Wooden Camera* (South Africa, 2003), who intended to shoot the film in a Rio favela before discovering that a township would suit the story just as well (3350). Stories that could happen anywhere are set in Africa. This vampirism seeks a setting for its own fiction, but the drama must be stunning! This contempt, albeit full of good intentions, endlessly fixes the univocal image of a pain- and conflict-ridden Africa churned out by television news in people's—and particularly young people's—minds.

We might compare these ethnocentric films with the honesty of a Pierre Verger, who, when questioned about his belief in the orishas, confessed in Luiz Buarque de Hollanda's *Pierre Fatumbi Verger, Messenger between Two Worlds* (Brazil, 2005) that he was unable to overcome the barrier of rationalism. This man, who went to extremes to try to discover the Other, is forced to face the obvious: he remains himself, unable to erase this alterity. He manages to be accepted and is initiated, despite being white, but is deeply aware of this highly instructive failure. We remain ourselves, in spite of everything. It is thanks to this experience that Verger respected this alterity despite being an ethnologist: he never revealed the interdict.

Critical practice must regularly recall that the Other is an other, and that it is important to respect his or her opacity and irreducibility, which poses to film the highly difficult question of making this perceptible. In *Le Silence de la forêt/The Forest* (Cameroon, 2003), by Bassek Ba Kobhio and Didier Ouenangaré, Gonaba goes to educate the Pygmies in a highly proactive manner. He discovers that you cannot bring people happiness in spite of themselves. The Pygmies show remarkable resistance to all attempts to influence them, and it is Gonaba who ends up learning from them. In recounting his experience as Marco Ferrari's assistant in *Les Pygmées de Carlo* (France, 2002), Radu Mihaileanu, who was asked by Ferreri to go to the Central African Republic to find Pygmies for a film he was shooting in Italy (2660), also constructs his story around the intractability of this people he learns to respect

(2661). Manifestly, he had forgotten all about this experience when he shot *La Source des femmes/The Source* (Maghreb, 2011), in which he appropriates an imaginary he qualified—just a tad over-generally—as "Arabic," so undifferentiated is it. Shot in Morocco with an almost $11 million budget, the film brings together a stunning cast for what is presented as a tale, with the film starting with the insert "Once upon a time." The village women stage a sex strike to force the men to address the question of the water that they have to fetch from a mountain stream. Bombastic music, noble sentiments, colorful confrontations, and postcard shots: this opera that claims to be feminist reduces its magnificent actresses to insipid second fiddles (10203).

The same question of alterity is posed when attempting to cure a person of a different culture's suffering. Tobie Nathan thus resumes the ethno-psychiatrist's position: to respect the patient by respecting his or her divinities, ways of doing, doctors, cult objects, and thus by considering that he or she is an exile.[71] Emmanuelle Ohniguian and Tobie Nathan's *Le Sexe des morts* (France, 2002) is an exceptional experience in this respect, entirely reenacted by actors as if they were in a real therapeutic session: two hours around a table in the company of Nathan, his assistant, and a family from Réunion Island confronted with their young daughter's wayward behavior. Gradually, a major absence is felt: that of the dead and buried grandfather, who returns and, obsessed with the painful experience of the runaway slaves, demands to speak. Here too is the edifying revelation of a culture's irreducibility, of the importance of treatment taking this into account, of confidence in the therapeutic instruments it has developed over time. Nathan tells us that we must not take everything at face value, but seek to understand why others believe in their rituals, without necessarily looking to our own explanatory schema.

Difference is in fact what we most share in the world. In his theory of dissemblance, Levi-Strauss challenged the Kantian categories that all humans are supposed to share. Jean Rouch applied this with his *ciné-transe,* adopting the position of the documentary filmmaker who is no longer outside, but not inside either, who is balanced on a wire; in other words, one who does not master what he wants to show, but confronts the viewer—and himself—with this lack of knowledge of the Other that he tries to apprehend. Rituals take place according to codes that are unfamiliar to us, but that the participants know and accept. Rouch avoids turning this into an externally viewed spectacle that could be deemed "savage." The stake is not necessarily to shed light on these rituals, but to recognize their pertinence for those concerned. And to thus open ourselves to the complexity of the world, putting aside oppositions, divisions, or disqualifications that tend to treat

traditional and modern peoples differently. For to not know or identify with is to stop seeking resemblances and allow the Other to exist independently. "Either you miss the Other, or you kill him/her," writes Eduardo Viveiros de Castro in *Cannibal Metaphysics*.[72] Missing the Other, in both senses of the term, is to still be capable of loving, and thus to be able to look for the other in the Other.

This *anti-Narcissus* position is vital in rejecting hostile, violent, or predatory behavior (9671). Anti-narcissism is not about conceiving the world in general categories and seeking how these are realized by Others. On the contrary, it is to accept the multiplicity of perspectives and thus opacity and irreducibility. It is even to consider opacity as a right, as a condition of new humanism. That does not mean that it is unsurpassable; it is not a form of apartheid. So long as opacity is not based on essentialism, relations are possible. It requires extreme experiences that documentary filmmakers experience directly so that they can transmit them to us. The *Mafrouza* series is exemplary in this respect. The importance of this groundbreaking, unclassifiable, and thus underfunded work cannot be overstated. It might be compared to Wang Bing's nine-hour-long *Tie Xi Qu: West of the Tracks* (China, 2003), which also documents the end of a world. Some twelve hours, divided into five films, capture the lives of the inhabitants of the Mafrouza slum, on the outskirts of Alexandria, built on the remains of a Greco-Roman necropolis (7559 and 10254). Emmanuelle Demoris spent the time needed there, scouting, making contacts, shooting for two years, and years of editing—in total a decade! The result is a polyphonic chronicle of extraordinary vitality.

If the *Mafrouza* series is essential to us here, it is because it radically explores possible paths for changing ways of looking at alterity. The films do not invite compassion, or even understanding. By rendering the irreducibility of a whole category of perfectly heterogeneous people perceptible—albeit united in a shared future—they give us a glimpse of the metaphysics of world chaos. The vitality of the extremely poor Mafrouza inhabitants, their inventiveness, their humane warmth, and also their propensity to give value to what Rancière called *la mésentente* (disagreement) as a critique of consensus,[73] encourages us to accept the unpredictability of our own future.

What is of course at stake is dropping our atavistic certitudes. This cathartic experience—in the sense that the emotion engendered constructs an autonomous gaze—is striking. Similarly, Gentille Menguizani Assih's *Itchombi* (Togo, 2009) subjects us to the cruelty and teeming chaos of the adult circumcision ritual, sparing us neither the blood nor the cut genitals. Suggesting the uncertainty of

the operation's outcome as she adheres to the movement of the crowd, and having already introduced doubt from the outset with a story of someone's genitals being severed during circumcision, Menguizani conveys her own distress before this violently masculine world to mobilize the stunned spectator. Unnerved to see a somewhat banal and pretty widespread ritual (circumcision) take on an unexpected dimension with these raw images, and subjected to the multiplication of scenes of an unusual length (not at all the fault of a slightly too slick montage, but the auteur's choice), viewers are forced to step back and question their relation to tradition and/ or to alterity. Confronted with the unfamiliar, they must recognize that this Other has his or her own life and logic, irreducible to what they believed to be universal.

Looking directly into the camera or addressing the filmmaker are perfect opportunities to show that the villagers are aware that a film is being made. So accustomed to the camera are they that during the circumcision gathering, the camera gives way to the ritual and, in the heat of the action, no one pays it any attention anymore. Gentille Assih is now just a member of the crowd trying to see better. She has to elbow her way forward so she can shoot. Thus caught in the tremors of a world that is no longer focused on her gaze and exists independently of her, her camera interpellates us. There is a toing and froing between she who films and we who see in the "look what I'm showing you; look what I am doing to show you" mode.

In this respect, is she following in the footsteps of Jean Rouch, Johan Van der Keuken, Chris Marker, or Agnès Varda, all of whom escaped so-called objectivity (which always masks the propaganda of a discourse) to claim this relationship on the screen, establishing a dialogue with the spectator shot by shot? Unlike these major documentary filmmakers, the young Gentille Assih does not directly address the spectator. In the vein of Rouch's *Maîtres fous/The Mad Masters*, shot in 1954, she above all does so via the cruelty of the images that destabilize the viewer, rather than spoon-feeding a truth. Her commentary at the end of the film, which states that shooting the film contributed to the knives now being washed to avoid transmitting diseases, shows that it is first and foremost the African spectator she is addressing. She does so without denouncing, but deliberately relaying this concern for young people's health. The film thus achieves two things: it helps a specific custom evolve, but also recalls that tradition is nothing other than a series of accumulated modernities, is in no way static, and is the result of modifications that generate conflicts around its own fixedness when it refuses to evolve. The film thereby becomes an example and surpasses the strict framework of its singularity.

By establishing a dialogue shot by shot with the viewer, filmmakers are no longer just witnesses, but become interlocutors, or even therapists who hold up a mirror. This brings to mind Serge Daney's famous phrase "these films that look at us." The magic of exchange takes hold, opening up emotion.

Renouncing a chauvinistic universalism thus imposes a rupture with the autonomy long asserted by art criticism, whose origins date back to modernity in the historic sense of the Enlightenment. In the nineteenth century, Enlightenment defined the conditions of human emancipation and progress. Artistic modernity resulted, that of the romanticism that Baudelaire theorized as an aesthetic category based on the new, the original. In the twentieth century, avant-garde art opposed Baudelairian dandyism, positioning itself as critical and emancipatory, and thus went beyond private pleasure to call for emancipation from tradition, alienation, and domination. Its prolongation in the twentieth century in the form of *art engagé* reinforced this opposition, rooting it in the social movement. But in each case, artists defined themselves as being on the outside, observing the world from above. This autonomy asserted in terms of independence was also isolating and risked disconnecting them from reality.

The ambiguity of the French critical revival of the 1950s, which gave birth to the New Wave, was rooted via André Bazin, then Serge Daney, in romantic art theory. Aesthetics of the beautiful were replaced by those of the true, accentuating a new gaze that benefited from the unveiling of hidden truths.[74] Art henceforth became a means of thinking the totality of the world. Godard drew up its critical genealogy: Denis Diderot, Charles Baudelaire, Elie Faure, and André Malraux.[75] The cinema that Canudo defined as the Seventh Art was thus a total art, to which Epstein attributed the power of revelation. For Bazin, the invisible ("the ambiguity of the real") was situated in an off-screen space that constitutes the image's mystery and fascination. Revealing the real, telling the truth of the world was henceforth the role of a cinema that Truffaut did not hesitate to define as a religion.

This sacralization, which goes well beyond an artistic mission, gave rise to a criticism admirative of genius. This in turn gave rise to a romantic conception whose excesses Bazin himself later denounced. It notably had the effect of sidelining other films and other directors. Hence the rejection by many of auteurism as elevating a chosen few, as a cult venerating auteurs who, today, "the critics present either as outside the structures and codes of production, or as transcending them," as Michel Serceau notes. He continues: "It is not by chance that informed Western critics, followed by informed Western audiences, promoted filmmakers despite,

or even in denial of, their countries' film cultures. It promoted them because it recognized itself in them, because it projected onto these personalities what was in keeping not only with its tastes, but also its spirit, its cultures, and its conception of civilization" (9329).

What Glissant says about the humanities also goes for cinema: beyond the generalization of technique, films draw on different cultural codes. "Film cultures are coded, not encrypted," Serceau adds. "All film cultures comprise a certain number of films that can be seen abroad. But the fact that they are visible does not make them necessarily or even entirely legible." The accusations leveled at so-called "legible" films are, however, perfectly unjustified. It is not because filmmakers are influenced, "convinced of the need for a universalist art," that they lose sight of their cultural codes, but rather that they chose what they consider to be the most pertinent codes to express what they want to encapsulate at a time when reception codes are increasingly hybrid too.

Must we systematically, through in-depth research and learned processes of explanation, decipher the codes of this "world of reference," this basis of "possible worlds" that the reader or viewer elaborates, and to which Umberto Eco alludes?[76] Or on the contrary, should we consider that symbols speak for themselves and receive them as we do? The risk is that exoticism or orientalism triumph. But as symbols and local inscriptions are not univocal, subjectivity, and thus one's own codes of reference, will in any case prevail. Henceforth, it is not difference, but the relation at play that matters.

Faced with the difficulty of dominant cultures' devouring universality, the temptation was for anti-racism to found its struggle on defending cultural differences built up into absolute values. The risk was of confining the Other in a place, a role, in mythical values. To free themselves from this, immigrants in France went from asserting the "right to difference" in the 1980s (incarnated by the SOS-Racisme movement), to the "right to indifference" the following decade. In other words, they demanded the same rights as every other Joe Blow when it came to society's discrimination and to quite simply be left alone at a time when racist discourse was becoming increasingly commonplace. That over 60 percent of French people describe themselves as racist in opinion polls is not worrying because they are racist, which we already knew, but because they do not mind openly admitting so. As Youssef El Ftouh put it, "Black-haters and black-lovers share the same logic of differentiating the Other" (0203).

Relations with black and Arabic people are poisoned by a whole host of

racist prejudices conveyed in both snide remarks and the choice of words and images, from the local bar to the most highbrow media, each with their specific projections. They reiterate a constant contradiction. On the one hand are the worrying, or even frightening archetypes: for black people, an unbridled animality due to their proximity with nature (brutality, transgression of the sacred through cannibalism, rampant sexuality, etc.), but at the same time, a source of fascination for Judeo-Christians frustrated in their relation to the body (suppression of natural urges, conjugal norms, behavior's social utility). For Arabs, aggressive, dangerous, untrustworthy, thieving, sly, which is today recycled into invading and delinquent Muslims, or fundamentalists and terrorists who threaten national identity. Added to this is a belief in the so-called moral duty to "civilize": paternalism toward the "childlike" good savage, who, at heart, only wants to be educated. The founding misunderstanding of French republican assimilation thus consists in "civilizing," while carefully keeping this Other subaltern, reducing him or her to reductive stereotypes: naive, primitive, contemplative, ingenuous, inexperienced, and thus ultimately intellectually limited (1215). This contradiction founds a relation to the Other made up of projections in which difference serves as a foil to forge one's own identity, but also offers an escape from mundane day-to-day reality.

Film criticism is no exception and frequently reflects this prejudice. It reiterates the same old ideas about African art first introduced by the Cubists, who in appropriating it, glorified it to better negate it, affording it the stature of work of art and thus confining it to their own aesthetic criteria: recognition and distancing, respect and reification (0138). Ultimately, the quest for authenticity remains at the service of a fundamentally inauthentic relation, in which seduction overrides comprehension. "Taking this a step further," notes Roland Louvel, "Africans were supposedly only capable of producing beauty in spite of themselves, whereas Westerners reserved to themselves the privilege of disinterested aesthetic production."[77] By exoticizing or folklorizing the Other, or more recently in criticizing their creations as backward-looking or academic, we shut them in their difference and make sure they stay put there. The French Republic, which defines itself as universalist and assimilationist, putting everyone on a same footing, paradoxically considers some of its members—its former colonial subjects—incapable of evolving and integrating the precepts of civilization.[78] It thereby protects itself from one of its recurrent fears, perceptible in the discourses of both the populists and extreme right: that the colonial relation will be reversed, encouraging the self-affirmation of the former colonial subjects who, bolstered by postcolonial analysis, will reappropriate a voice,

rewrite their history, and debunk the universalizing canons of Western centers of thought, thereby taking an equal place in society.

It is, then, truly about time that French academia and criticism broke away from the current marginalization and denial, and considered the former colonial subjects' literature, like their cinema, as enriching the patrimony of French expression, and studied them as autonomous disciplines.

1.5.3. Ending Self-Destructiveness

> We are a jaded lot, we in our world—our threatened world. We are good for irony and even cynicism. Some words and ideas we hardly use, so worn out have they become. But we may want to restore some words that have lost their potency.
> —Doris Lessing, Nobel Prize Acceptance Lecture, Stockholm, December 7, 2007

"The need to create intellectual surplus value has never been more pressing," says Achille Mbembe. "It is, in my opinion, African civil society's new task" (9139). This implies another thought paradigm: renouncing the logic of urgency (humanitarian interventions) and immediate needs that have until now, again according to Mbembe, "colonized the debate on Africa's future." And that involves the preservation of, or fight for, the invincibility of thought vis-à-vis the power of money and riches. As Fabien Eboussi Boulaga puts it, "When a society does not recognize intelligence as an implacable structuring value, there are no effective intellectuals" (4539).

Many filmmakers denounce the mediocrity of the debates. "We don't have this exchange with African critics because they don't see film aesthetics as a vector of meaning," Mahamat-Saleh Haroun noted (3685). Critics and filmmakers mutually blame one another: "Criticism can only thrive in an environment where there is enough room for creativity, quality creativity," said Nigerian critic Jahman Anikulapo (7111). In an environment that stifles creativity, neither the public's desire for quality, nor the criticism that generates artworks will develop.

During the 2011 FESPACO, Mahamat-Saleh Haroun criticized the paucity of the selection, whose "films had no place here or in any festival, films that take us back to the 1970s," calling the festival "a kind of Titanic where people revel in their own mediocrity," adding, "As far as I can see, people no longer reflect on cinema here, and if we don't reflect on our cinema anymore, it's difficult to take it elsewhere and to escape the ghetto we are trapped in" (10002). Jean-Marie Teno had already declared

in 1999, "It's inadmissible for someone to start making films today without having seen what his or her predecessors did before, and to repeat what has already been done a lot less well!" (2060).

Yet debate does take place, only rather than focusing on quality works, it often replaces criticism with unfounded accusations or attacks. Here too, the blame can be apportioned between both critics and filmmakers. Aesthetic questions are thus reduced to territorial concerns, with the old reproach of making films for the West, or in short, of being a traitor to the country. When Abderrahmane Sissako won the Golden Stallion Award at FESPACO in 2003 for *Heremakono*, he was hurt by the president of the jury Idrissa Ouedraogo's request that he "come back to us." "I answered that to come back, you first have to have left and that I never left."[79]

Filmmakers are enjoined to stop their underhand dealings and selling out to phantasmagorical Western demand. One critic wrote that with *Un été à la Goulette/A Summer in La Goulette* (Tunisia, 1996), Férid Boughedir had "bent over for the foreigners." He photocopied the article and left copies on the jury members' table at the Namur Film Festival in Belgium to stop them awarding the film a prize. "It's viciousness, self-destruction," Boughedir responded (2670). This diktat paradoxically invited a sociological reflection, but other accusations of demolishing a country's image, or, inversely, of being too politically correct, were soon brewing on the horizon. Tunisian national television thus announced that it had decided not to talk about Nouri Bouzid's *Poupées d'argile/Clay Dolls* (Tunisia, 2002) because it gave a bad image of Tunisian women.

In the absence of film journals, these attacks are carried out in the press, which is often in the hands of the political parties. "Why criticize the European press when we know that Arabic critics, particularly in the Middle East, do far more damage when they review our films?" Mahmoud Ben Mahmoud asked at a seminar in Tunis in 2002. "Themes of emancipation are declared guilty of dissidence, or even treason. *Siestes grenadines'* Africanity was interpreted in Damascus as a plot against our country's Arab integrity!" (2670). We must not generalize about "the sold-out filmmaker," he added. "I was shocked to read a Tunisian journalist's assertion that the most intimate documentary film I ever made, in which I explored my father's memory, was a film for tourists."

The situation is indeed destructive. "In the South, we are accused of having sold out to the North, and in the North we are not considered to belong to the global film aesthetic," Férid Boughedir added at the same seminar. As the Senegalese critic Baba Diop rightly pointed out at the seminar, "a lot of journalists are unfamiliar with

film language. If the film is atypical, they pan it because they haven't understood it and think it's badly made." Stopping the self-destructiveness requires respecting the work, not reducing it, and thus questioning one's presuppositions. "Just as major films confront us with our own ignorance, criticism confronts us with ourselves," added the Tunisian critic Hedi Khélil. That is, criticism as "writing, not commentary."

1.5.4. African Criticism Exists

Ours is a guilty conscience literature, the literature of France and the West's guilty conscience.

—Ahmadou Kourouma, in *Désir d'Afrique*, by Boniface Mongo-Mboussa

In the January 2010 edition of *Cahiers du Cinéma*, Nicolas Azalbert set out three "fundamental parameters" that led to the emergence of "New Argentinian Cinema" in the 2000s: the proliferation of film schools, a festival linked to the young cinema movement (BAFICI, the Buenos Aires International Independent Film Festival), and a film journal that revived film criticism.

In no African country do all three parameters exist. There are a few film schools, but they often need to be better organized and more professional; festivals rarely focus on young creation, and the rare film journals are generally little more than bulletins. Yet critics are fighting to exist. Always struggling to make a living, often forced to teach, they are few and far between. We shall focus more on film criticism than film critics, as it is by including critical works on cinema that we avoid excluding all those who do not find a place in the media, not through lack of talent, but because the press often prefers promotion, or is not interested in analysis at all. The issue is accompanying economically fragile film work, but also inscribing it in world criticism, both in terms of the themes addressed and the cultural level to reach.

It is symptomatic that when the Africiné network was launched—the only Pan-African initiative regrouping journalists writing about film—only one association was truly active on the continent and a member of FIPRESCI (the International Federation of Film Critics), namely, the Tunisian Association for the Promotion of Film Criticism (ATPCC), which disposes of offices, produces a bulletin, and organizes events and workshops. Thanks to its major film industry, Egypt is a case apart, with several associations.

The Africiné initiative—developed, with the backing of *Africultures*, out of critical exchange workshops held in Ouagadougou and Tunis in 2003—led to the

creation of the African Federation of Film Critics (FACC) at the Carthage Film Festival in October 2004. The Federation officially obtained its authorization to base its headquarters in Dakar in 2010. It includes some twenty national associations or groups that have emerged to join this dynamic. Its internal discussion forums bring together nearly three hundred French-speaking and about fifty English-speaking journalists. Its highly dynamic website, www.africine.org, lists over two thousand articles.

Its emergence in the context of the 2000s was not fortuitous—in a landscape marked by a profound transformation of the audiovisual domain, which saw both the explosion of local products of a very poor aesthetic quality, and the drastic rarefaction of art-house films. What is at stake today is clearly to reinstate a reflection on cinema to encourage the artistic dimension. It is also to organize journalists into a network to encourage mutual emulation in the effort to professionalize. Finally, it is to allow young people to emerge who are capable of representing these film bodies internationally thanks to their intimate knowledge of their local cultures.

"I lost my temper one day in Carthage over European criticism and the 'dictator-ship' it exerts on African readers," Ousmane Sembene once recalled in response to Guy Hennebelle's question about European critics. "But in fact, I think I was wrong. . . . What's needed is African criticism alongside European criticism, so that Africans are no longer mesmerized by it."[80] Let there be no mistake: for Sembene, who was perfectly aware of the limits on the ground and of the dangers of essentialization, it was not about restoring an endogenous truth, but appropriating a voice to challenge the misunderstandings prevalent in Western writing on African film, resulting from the often subconscious persistence of the colonial imagination. Moreover, filmmakers who make films in Africa as if going on a pleasure trip, clocking up anecdotes and clichés, would be less dilettante if confronted with shrewd and visible African critics.

"It is dangerous to assert that one critic is better equipped than another to read a film," said the famous Ivorian critic of Burkinabè origin Jean-Servais Bakyono, who died in 2006 (4361). But don't African critics draw on their culture to analyze works? Bakyono gave an example: "In *Dakan*, Mohamad Camara uses two historically marked music themes. The first was composed at the time of Almamy Samory Touré's fall to rehabilitate him. The second is inspired by the first, but with modern instruments and reusing Sory Kandia's kora. Such a theme does not simply illustrate the narrative, it gives it consistence. That no doubt escapes a

foreign critic, who would be likely to have a different reading of it, which nuances what I just said before!"

The discussion we had about Tade Ogidan's huge hit *Dangerous Twins* (Nigeria, 2004) at a film criticism workshop in Yaoundé in 2005 struck me as highly enlightening with regard to this question of specifically African criticism. The group divided into those for and against the film. Playing on the twins' interchangeability, the film is aesthetically very poor, but funny and full of twists. One brother, who lives in London, asks his twin, who lives in Lagos, to replace him to get his wife pregnant as he cannot. Predictably, the resourceful twin from Lagos succeeds in his life in London and no longer wants to go home, whereas the London twin, stuck in Lagos and limited by his Westernized principles, soon messes up his irrepressible brother's fruitful but murky business affairs. Some hailed the film's mocking of the expatriate's acculturation and inability to adapt in his own country as an updated, urban version of Cheikh Hamidou Kane's *Ambiguous Adventure* (6095). Others denounced this sad old stereotype of Africans that opposes brilliant Western civilization and African stagnation (6016).

The pertinence of these viewpoints seems to me sufficient to prove the importance of an endogenous gaze. Its specificity should not be reduced in its criteria, but in the thought contributed, which is not to be taken as truth, but as a sensibility. Who better than those first concerned to question the images that films convey of Africa and Africans, the traces of the colonial gaze, and call for vigilance? Who else can be sufficiently attentive to the place that films attribute, or not, to Africa in the contemporary world? Who is best placed to explain local cultural or production specificities? Who is familiar enough with African films to position a work within an auteur's filmography, evoke similar themes in other African films, and these films' aesthetic choices in dealing with a subject? Who is best placed to elucidate a film's necessity in the African context, its historical importance, and in which school of thought or research it is inscribed in contemporary African history? (3930).

Who else, naturally, than those who are plunged, by virtue of their intimate knowledge and daily experience, into the midst of African realities and the people's aspirations? So long, of course, as they associate culture with this, and distance and comparison. Often, this lack of culture and training is patent, manifested through the lack of attention paid to aesthetics as vectors of meaning, through the police-like way of approaching film style, handing out bonus points—or, on the contrary, injunctions; of examining the film from the perspective of one's personal values, or judging it without trying to understand it as an act of creation.

The articles published on the *Africiné* website are sometimes guilty of such failings, but also bear the traces of an essential positioning. While some reinforce conformism in thinking through hasty or complacent judgments, many break with the retreat into closed, identity-based questions to open new spaces of freedom, those of the affirmation of a singularity that goes beyond already-traced paths, of a radicalism free from leaders or ideology, based on straightforward reflection, with no presuppositions, on a present moment magnificently summed up by Césaire: "Who and what are we? A most worthy question!"[81]

1.6. Phantom Audiences

> In the word *écrivain* [writer], there is "écrire" [write] and "vain."
> We write in vain; no one reads us!
>
> —William Sassine, interview by Jacques Chevrier, *Jeune Afrique* 1241.

There is one haunting, recurrent accusation that mars discussions of "African cinema": that it does not address its audience. An array of critiques, which are perfectly contradictory in their perversity and dishonesty, hover behind this accusation: that this cinema is not African enough (it lacks authenticity); that it panders to the West (it is contaminated by the West; many filmmakers live there); that it defends nothing anymore (it has relinquished the fight to raise black awareness); that it is not popular (it is destined for intellectuals and those in search of exoticism); that it is self-serving (its gold-digging filmmakers are after Western money and easy publicity in the North); that young people do not like it (it is boring; not modern enough); that it is too rural (it should portray crisis-stricken, urban Africa; be rooted in the viewers' day-to-day lives); that it is other people's product (Western crews; Europe's money; the dictates of funding commissions), and so on.

1.6.1. When "Audience" Becomes an Attack

August 17, 1959. Jean-Luc Godard wrote to his producer, Georges de Beauregard: "The game of poker is about to begin." It was the first day of the *A Bout de souffle/ Breathless* shoot. The film's fiftieth anniversary was celebrated at the same time as the fiftieth anniversary of African Independence. The young French filmmaker used to show up at the shoot with a pad under his arm in which, day by day, he noted

the scenes and dialogues he wanted to shoot, the actors only discovering them then and there. The first day, after two hours, he shut his pad, declaring: "That's it for the day; I'm out of ideas."

Many of the world's major film auteurs cite this new, rule-breaking approach as a reference. In the autumn of 1958, John Cassavetes shot *Shadows* (USA) with the same creative freedom, capturing a group of black and mixed-race young people confronted with racial discrimination. While the New York New Wave practiced a form of *cinéma-vérité*, the French New Wave shot usually with hand-held cameras, out in the streets or natural settings, mixing the city sounds with the dialogues, subverting cinematic editing codes, and multiplying the jump cuts.

Ushering in the 2000s, Abderrahmane Sissako's *La Vie sur terre/Life on Earth* (Mauritania, 1998) and Mahamat-Saleh Haroun's *Bye Bye Africa* (Chad, 1999) were also thematically and formally revolutionary. The quality of both films is their use of improvisation. "I asked the actors to keep their real names and to use their own words," Haroun stated (2065). Sissako included characters who entered the frame by chance—the unforeseen encounters of a shoot—such as the woman on the bicycle in *La Vie sur terre*, or the man by the sea in *Heremakono*. Like Godard, Sissako works without a screenplay, lucky enough to have the trust of an ARTE producer who gives him carte blanche.

But while these films have been well received in festivals and by the critics (*Bye Bye Africa* received the Best First Film Award at the Venice Film Festival; *La Vie sur terre* was selected at the Cannes Directors' Fortnight), they did not revolutionize African cinema. "*Bye Bye Africa* is a homage to all the African cinema I have known, and an attempt to create a rupture," said Haroun, "but it did not spark a debate with filmmakers. I was disappointed in that. I told myself it wasn't the right moment and that I need to come back to something simpler" (3685). Haroun indeed returned to more conventional narrative forms. "It was a suicidal path," he noted (2065). Sissako pursued his formal experimentation, but has remained isolated.

Being innovative is to detach oneself from one's community, one's public, and that is tantamount to a crime, to treason. The pressure is incredible. Yet it is not that filmmakers do not pose the question. In *Bye Bye Africa*, Haroun's father tells him he does not understand his films an iota. "That brings us back to the fundamental question of knowing who we make our films for," says Haroun. "It's mooted in the film that Freud isn't universal. A message can't be hermetical. It must be comprehensible to the Other. I don't forget where I come from. I always think of my mother, who doesn't speak French; she remains my first spectator, Chad perhaps

symbolically being my own mother. Sartre says that a work of art is destined for a kind of family scattered across the world and that it isn't destined for those who don't like it. It's not a question of quality, but of decoding. There are those who decode and those who don't" (2065).

African filmmakers who still innovate today, or rather especially today, can be counted on the fingers of one hand, as can those who, like Haroun, think that "making films is to reveal, and if one is sincere, there is always a listening ear" (2065). Will we celebrate their contribution in fifty years' time, like we celebrated the fiftieth anniversary of *Breathless*? Nothing is less certain if we remain fixated on this question of audience.

To reveal: that is indeed the Sartrian understanding of *art engagé*: "What aspect of the world do you want to disclose? What change do you want to bring into the world by this disclosure? The 'engaged' writer knows that words are action. He knows that to reveal is to change and that one can reveal only by planning to change. He has given up the impossible dream of giving an impartial picture of Society and the human condition."[82] We have already seen the impasses of banner-waving messages and denunciation in 1.1.3, and the illusion of believing that artists can change the world. If revealing remains the stake, it is in the sense of mobilizing awareness, of sharing concerns, of a question posed without any other answer than the desire to apprehend the ensemble and thus initiate a dialogue.

The question of audience thus fundamentally remains that of how to make this dialogue possible, or, in short, as Daney put it, to exchange gazes. That is what aesthetic ruptures aim to do as they distance themselves from figures of identification, but in so doing, tend to reduce their audience to the circle of those who appreciate such an undertaking. Innovative works are thus readily accused of being elitist, without perceiving how much they advance both our understanding of our times and film in general, and without perceiving that in all artistic evolution, today's aesthetic innovations are tomorrow's norms.

The New Wave critics saw Hitchcock, Lang, Renoir, or Rossellini as auteurs who were as capable of moving audiences as they were encouraging reflection on film. Art was thus considered both noble and popular. Since, a dichotomy has emerged, opposing surface and depth. The surface believes it does not need criticism: people agree with, or poke fun at it; affinity or derision. All it wants is promotion. A prerogative of television, it has left profundity to the cinema, which has lost its mass-culture status. Thus cut off from the world, film has gained critical autonomy, but lost out in so-called pleasure. Pleasure is indeed reputed to be related

to the consumption of popular forms, without posing the question of the modes of producing entertainment. The more subtle pleasure associated with art is precisely seeing it as a historically marked act of creation and looking for traces of this. For the aesthetic experience is a powerful pleasure in the intensity of surpassing habitual experience. It is a form of participation, not of passive reception that encourages the possibility to in turn create. This is what makes it emancipatory. In this respect, a certain backing off on the part of the artist is necessary not to impose his or her model.

At the vanguard of postcolonial and Third World cinema, "father" Ousmane Sembene imposed African social realism as *the* reference, sweeping away in his wake the chances of a Djibril Diop Mambety to drive a movement that broke away from this serious, pedagogical, and politically committed cinema.[83] In Mambety's films, conversely, the spectator is invited to engage in active and playful participation, while the lightness of bodies opens the spaces of the possible. The film is henceforth a work to be completed in one's own life or head.

While acknowledging that it is out of the end of an old rope that a new one is woven, the new wave of films to have emerged and enjoyed international recognition in the 2000s is fundamentally different to Sembenian film. Mahamat-Saleh Haroun's *Un homme qui crie/A Screaming Man* (Chad, 2010), which won the Jury Award at Cannes, is no more or less realist than Sembene. It too reflects the burden of reality as an inescapable context. But there where Sembene proposed ethical guidelines to spectators faced with rotten leaders, patriarchy, or obsolete traditions, Haroun refrains from imposing a thing. His characters are full of contradictions and deeply human. They are never models or heroes we can identify with. They are a play of forces and attempts to get by, ingloriously, in this violent world, faced with issues that they can at least attempt to determine, if they are brave enough. And that is precisely where their problem lies: finding the courage, which is the difficulty for Adam, the pool attendant plunged into a Shakespearean conflict between fatherly love and sacrificing his own well-being. Like us, he is weak and irrational. Yet this does not absolve him of his moral responsibility. That is the role that the filmmaker adopts: to raise awareness, not to be didactic. Appealing to people's sense of responsibility, rather than creating models to follow, favors the individual over the collective; responsibility belongs to each and every one of us, whereas duty is that of the group (9479).

In this context, the accusation of elitism leveled at sub-Saharan African filmmakers continues to address aesthetics that diverge from the "father of African

cinema's" powerful model: that of the griot who speaks in the name of the community, embodied in Sembene's films by protagonists who take a stand against neocolonialism, dependency, and Eurocentrism, in a narrative mode that respects classical linearity. This pedagogical position—film as a "night school" and the filmmaker as teacher of the people—long defined what was supposed to be the African filmmaker's relationship to his or her public. The late Adama Drabo thus said of *Taafe Fanga/Skirt Power* (Mali, 1997), "I dedicate this film to Africa's women, as I recognize their efforts and the abuse they suffer. I fully acknowledge its didactic side to be sure that the message not be lost in artistic considerations. Thus perceiving things through the prism of my culture, I want to be allowed to express this in this way. For me, it is the best way to reach my audience. I don't have to copy a European film style. I want this film to change things and to make sure that it is fully understood" (2474).

Should one, as Jean-Marie Teno suggests in *Lieux saints/Sacred Places* (Cameroon, 2009), "return to the spirit of the pioneers, who referred to the griot as the memory and conscience of the people, as the prophet of the future?" While he concludes his disenchanted quest for bearings with this question, Teno does not, however, limit himself to it. Listening to the pulse of the St. Léon neighborhood in Ouagadougou, his film re-situates it, rather. Shouldn't one take inspiration from the craftsman instrument maker, with his pride in a job well done? Shouldn't one, in short, return to this spirit and this respect for the public that animated the great names of African film?

Teno's film focuses on a video parlor baptized "cine-club" and expertly run by Bouba, its creator, despite its very limited returns. His public prefers light entertainment films, but Bouba knows that it is above all courage he needs. It is this awareness that Teno wishes to capture. If the St. Léon cine-club is a sacred place, it is because people go there to enjoy a little poetry, and thus a little freedom, to get through the harshness of life (8412).

Abderrahmane Sissako, one of the filmmakers most frequently accused of elitism, said of his film *Bamako*: "In a film like this, in which speech is so central, I think you have to step back and aim for meaningful silence. You have to be aware of the spectator, to think about him/her, because it's a generous act coming to see something you don't know. In this exchange, I believe you have to be aware and careful not to abuse the viewer and to give him/her space, but also a space for reflection that may surpass him/her." He went on to add: "It is no doubt my most frontal film in terms of discourse. That isn't something I like; it isn't in my nature.

So I was careful to think of a counterpoint at all times. These counterpoints needed to be perceptible both to Africans and to anyone else" (4428).

In *Scheherazade, Tell Me a Story* (Egypt, 2009), Yousry Nasrallah broke away from his usual type of films to embrace a wider audience. He claimed that the screenplay appealed to him because it recounts how people settle their issues with modernity by trying to create stronger social ties: "The people who watch my films struggle to understand where these characters come from and how and why they behave as they do. There is an audience for the kind of films I made before, but I always felt that I was forced to explain why they act the way they do, and where they come from" (9287).

Winner of the FESPACO Golden Stallion Award in 2007, *Ezra*, a film about child soldiers, is marked by Newton Aduaka's desire to give spectators codes they can identify with, or, in other words, references to mainstream cinema, while at the same time taking them through the maze of dynamic reflection: "My goal is to find a balance.... To have substance but also to have an audience.... Otherwise, it doesn't change anything much, except for your own ego" (5879). Willingly embracing the romantic (the love story between Ezra and Mariam, aka Black Diamond) and not hesitating to orient the viewer in the direction he wants, Aduaka adeptly doses the ingredients of classic fiction and disarticulated narrative: the flashbacks to the Inquiry Commission hearings punctuate the film, adopting the trial formula so common in American films; yet the nonlinearity and the play on amnesia transcend this, forcing the spectator to be active, and attempting to penetrate this character's complexity too (5857).

These various statements reflect these exacting filmmakers' respect for the audience. This is equally true of popular filmmakers, such as Henri Duparc. His final film before his death, *Caramel* (Ivory Coast, 2004), is a touching farewell. True to his habitual derision, which draws on the minute observation of a milieu, use of the constant linguistic inventions of Ivorian French, and the vaudeville of Ivorian theatrical comedy, he as usual exaggerates his characters and situations to the point of caricature, to better produce a counter-discourse on current issues, denouncing intolerance and stupidity. Yet this parody always respects its characters, who conserve their humanity, the only way of inviting spectators to look themselves in the face and correct their shortcomings (4454).

1.6.2. A Nonexistent Audience?

In *Caramel*, Fred, who runs a movie theater, programs *Pride* (Mehboob Khan, 1952), a much screened all-time classic of Indian cinema that African women in particular so loved. It is for this film that the beautiful Caramel comes to the cinema and misses no screening. Even without understanding the dialogues, viewers used to end up knowing all the songs by heart, they saw the films so often, and loved these sentimental melodramas' dances and easy-to-follow plots. Nowadays, as can be seen from the accounts by journalists from the Federation of African Critics, television series have supplanted this cinema, and the reasons for this evolution shed new light on the question of audience.

Notwithstanding, with nearly 11 million viewers a day watching films exported to over one hundred countries, Bollywood's impact remains formidable. It denotes a genre that Salman Rushdie describes in *The Moor's Last Sigh* (1995) as "Epico-Mythico-Tragico-Comico-Super-Sexy-High-Masala-Art"—masala being the mix of spices used in a lot of Indian dishes—and that has permeated all forms of popular culture, starting with music. With over three hundred channels, television is one of its key vectors, broadcasting not only films but also programs on cinema that bring the stars to the public eye (there is now one television set per ten inhabitants, compared with one per twenty-six in 1992, 60 percent of which receive satellite TV; this makes India the third largest television market in the world after China and the United States).

In Africa, Bollywood films remain a huge hit among the Indian diaspora. In South Africa, there are over one million inhabitants of Indian origin. As the South African critic Nashen Moodley points out, "Bollywood is hugely popular in South Africa, handled by the two main distributors Ster Kinekor and Nu Metro, who release new films in the multiplexes each week. South Africa's screens are dominated by Hollywood and Bollywood, not to mention the pirated DVD circuit that is very well organized when it comes to Bollywood films."[84] Conversely, this diaspora now provides Bollywood with the terrain for the kind of stories that popular Indian cinema now favors, in which reality has long since given way to a self-fiction permeated with dreams of elsewhere and money.

With two to three releases a month, Bollywood is also very present in Mauritius, where actors such as Shah Rukh Khan and Hrithick Roshan are idolized. Films are found on DVD and in the movie theaters, but are also broadcast on national TV. The press is full of articles that follow the latest film and film-star news, which is

also given in-depth coverage in specialized magazines. More than a dozen films have been shot there by the Bollywood industry, including music videos and film songs. In East Africa, and notably Kenya and Tanzania, large Indian communities also guarantee these films' success.

It was often said that African audiences loved Indian films because they are full of music, romance, dreams, and action, not to mention the women's beautiful clothes, and the luxuriance and beauty of the well-orchestrated dances. It was also said that the films' modesty facilitated their access there where people were easily shocked by Hollywood sex scenes. This seems to me to feed into the same old patronizing condescension toward a public that people are all too ready to see as backwards. If the African public loved Bollywood, it is because they identified with popular Indian films and their non-Western way of dealing with themes that are also part of their reality. Be it the recurrent question of young people's independence in extended families, arranged marriages, impossible love between different castes, father-son conflicts, revenge, redemption, survival in the face of adversity, the importance of honor and self-respect, or the mission of perpetuating moral and religious values, Bollywood deals with issues that find an echo in traditional societies in the throes of globalization.

Although its heroes' systematic return to the fold of communal law makes Bollywood films bastions of conservatism, these films contributed to the emergence of the postcolonial nation.[85] They did so in a cultural framework that is not that of American film, in which the hero is the sole maker of his destiny. From film to film, they constructed an autonomous response that corresponded to an autonomous imagination, reworking India's epic texts and founding myths. The films' easily mockable overall aesthetics (melodrama, music, chasteness, etc.) are thus the vehicle and not the content. They are the mechanisms of a genre that, based on popular theater's existing structures, gradually developed without losing sight of the fluidity of their relationship with the audience.

In the 1970s, actor Amithab Bachchan literally united the whole nation around a pretty macho rebel character, carefully kept popular by the media, and plugged from film to film with extraordinary repetitiveness. In everybody's eyes, this modern hero—the angry young man—represented national reconciliation in an India disenchanted with the corruption of its elites. Working-class Indians who, as of the 1970s, were subjected to the effects of economic liberalization and the growing divide between rich and poor, saw in this antihero—despite his own bourgeois

origins in the Nehru/Gandhi dynasty—a reaction against the engulfing oppression, repression, and loss of hope; in other words, a symbol of their own aspirations.

All of this is in question today, given Bollywood's growing distance from both modest Indian audiences and the African public. The increasing imitation of American film form and content in increasingly industrially produced films that target an already highly globalized, affluent diaspora, and even attempt to compete with Hollywood on its own terrain, is emptying this cinema of precisely what constituted its quality: namely, its pertinence as a tool of postcolonial cultural resistance and its rebellious force. All that remains, often, are incredibly dumb products that are a pale and ridiculous copy of the worst mainstream cinema, with characters repeating the same old dialogues, in whichever city of the world they find themselves.

Of course, when it comes to distribution, piracy undermines business everywhere: "Morocco was unquestionably the most promising market," indicates Avtar Panesar, head of international sales at the major production company Yash Raj Films, "but it's now a dead market! DVD sales have fallen all over by 90 percent, so much so that we can no longer count on them!" But the films' success, even when pirated, has fallen: "In Ivory Coast," the late Fortuné Bationo pointed out, "Bollywood is completely absent from the pirate movie stalls. Hollywood predominates everywhere" (8107). This hegemony is occasionally contested by the sporadically released Ivorian video films.

It is the same situation in Mali, where the Babemba cinema in Bamako only rarely programs Bollywood films. The Office of Malian Radio and Television (ORTM) programs a Hindi feature every first Wednesday of the month, but often late at night. "The keenest spectators are women," notes Moussa Bolly, "but it has to be said that they now tend to prefer African sitcoms and Brazilian or Mexican soap operas."

In Senegal, the satellite channel B4U broadcasts both new Indian films and the classics twenty-four/seven. Two movie theaters screen predominantly musical Indian films in Dakar, which continue to draw a young, largely female audience. But, as Aboubacar Demba Cissokho notes, "It is still true that for the dozen or so popular cinemas still operational in Dakar and the regions, the films screened are those that are predominantly musical, but the audience is no longer only female, women having found other slots on the private television channels." The private Senegalese TV stations RDV (Radio Dunya Vision) and 2STV do not broadcast films, but do show weekly programs entirely devoted to Indian music. As in most other countries, Indian films can be found in the pirated circuit, but do not stand up to competition from American action movies.

According to Hector Todivokou and Espera Donouvossi, in Benin, popular Indian films are still holding out against the Nigerian productions' invasion of the market and can be found among any street hawker's wares. On television, however, every channel broadcasts two telenovelas a day on average, apart from Golfe TV, which alone continues to show a popular Indian film a week. In Cameroon, "Indian cinema is no longer consumed with the same fervor as in the past," confirms Jacques Bessala Manga. "In the popular imagination, Indian cinema nonetheless remains a cinema of contemplation, of the sublimation of love, of enchantment, but also of magic and witchcraft—themes that are taken up by Nollywood and popular African cinema."

The same echoes come from Togo, where Sitou Ayité indicates that Bollywood films are above all popular among the Muslim minority on VCD or DVD, and in the central region of the country's video parlors. The public, and notably women and young people, has thus turned to Nigerian films, which convey messages that are in keeping with their faith. In Guinea, Indian cinema was predominant until the 1990s, but today, as Fatoumata Sagnane reports, Nigerian films are taking root and American films now outstrip Indian films.

Sani Soulé Manzo from Niger perfectly sums up the example of his country: "Popular Indian films marked the 1970s and 1980s, despite competition from Westerns, Bruce Lee–type martial arts films, comedy movies by the likes of Eddy Murphy or Louis de Funès, and musicals. Indian actors such as Amithab Bachchan, Raj and Shashi Kapoor were liked for their fight for justice or for their mischievousness. Many Nigeriens learned Hindi words such as *atcha* and *nahi* thanks to these films, whose melodies many women knew by heart. When the movie theaters all shut down in the early 1990s—with the exception of the open-air theaters at the French Cultural Centers in Niamey and Zinder—video took over their broadcast until Hausa-language Nigerian films—the *Dandalin soyyaya*—arrived in Niger in the late 1990s, and whose actors openly imitate their Indian counterparts. Sung in Hausa to musical and visual backdrops copied from the in-vogue popular Indian films, these *Dandalin soyyaya* released on VCD now steal the limelight from the Hindi films on five of Niger television's six channels (Télé Sahel, Tal TV, Ténéré, Dunia, Canal 3; Bonferey does not broadcast any), which show one or two films a week. For some time now, female audiences have loved Brazilian, Mexican, or Peruvian series (*Da Cor do Pecado, Barbarita, Marimar, Muñeca Brava, Rubi, Por amor*, etc.), but also Beninois, Burkinabè, Ivorian, Malian, and Nigerien TV series coproduced by the French" (8107).

In Tunisia, Naceur Sardi notes, "the Tunisian public's relation to popular Indian cinema dates back to the second half of the 1960s. In 1965, Bourguiba's Palestine speech about accepting the division, and the UN's 242 decree created a political crisis between Tunisia and Egypt. Tunisia stopped importing Egyptian films, which until then, along with American, Italian, and a few French films, had been the mainstay of the hundred or so cinemas that still existed throughout Tunisia. To replace them, SATPEC (the State Film Import and Distribution Company) turned to two other sorts of cinema: Lebanese film, which saw the arrival of an Egyptian diaspora at odds with its government (including Youssef Chahine at one point), and popular Indian cinema. Very rapidly, the latter gained a wide audience due to its proximity to Egyptian cinema: languid melodramas full of dance, singing, and action. Even the type of film stock used was the same, which gave the same tints and luminosity. Since, this cinema has never disappeared from our screens, even if there have been ups and downs" (8107). Today, there are only a dozen cinemas left in Tunisia, replaced by DVD, Internet, and video. "Cinema is in crisis. Even the international blockbusters struggle to find an audience," Sardi comments. "There are said to be 30,000 pirate DVD copy shops! A large range of Indian films can be found in them, and the public is well-informed about all the latest releases thanks to the multiple Gulf country satellite TV channels, which love them."

In Morocco, the situation is the same, says Mohammed Bakrim: "For a long time, Bollywood was good business for the distributors. Hindi films were at the top of the box office! Today, there are some towns that now only have 'cinemas' that program Bollywood films. The Rif Cinema in Marrakesh, which is the leading cinema in terms of turnover, is a temple of Indian films" (8107).

In Africa's video parlors and bootleg stalls, competition between genres is thus fierce. And Bollywood is looking to Nollywood, and notably its distribution network, in which the Indians have good expertise, in the hope of conquering the Nigerian market.

Hollywood, Bollywood, Nollywood: major maneuverings are underway in these expansionistic film industries. But if Bollywood and Africa have fallen out of love, it is because the African public is losing interest in its films and no longer has access to them, as the multiplication of screens and piracy replaces the movie theaters. This progressive disaffection reflects the commercialization of a popular cinema that is moving further and further from what constituted its postcolonial pertinence: more than even the community's mobilization in a national vision, its conception

of the hero and of destiny, incarnated by actors such as Amithab Bachchan, was incomparable to cowboy heroes. Its reworking of myths spoke to peoples for whom they still had meaning. The sub-Saharan African public thus now prefers Nigerian video films that play on African society's anxieties (violence, lack of social mobility, the deficient state and its lack of protection, corruption, the burden of obsolete customs, superstitions, etc.) to the recent Bollywood productions, which, while highly professional, are often incredibly dumb. As for action films, Hollywood's professionalism continues to outstrip the rest of the world.

It is thus, of course, in the realm of the autonomous imagination that the competition lies. We often underestimate audiences. They determine their tastes and choices according to what moves or deeply animates them. They are only fascinated by special effects for a while. If Bollywood hopes to win back African hearts, it will no doubt have to think a little less market and a little more about its society's relation to the world.

If we have focused here at length on the divorce between Bollywood and Africa, it is because people often also evoke the divorce between African film and audiences. "People want to watch what they like, not what we offer them!" the Nigerien filmmaker Mustapha Alassane exclaimed (8943)—before adding: "African filmmakers need to move away from the abstract and take their spectators into account, while remaining faithful to their universe." Isn't this distinction where the problem lies? As long as filmmakers remain above the fray, as teachers or prophets, they set themselves apart from their audiences. The issue is not being popular, but being in touch with one's era. Questioned about the Tunisian public's interest in films that convey an image of people fleeing their responsibilities, director Nouri Bouzid said: "They have loved and supported powerful films in which the characters are sometimes negative and unflattering. Even if they criticize us, they come back and look forward to the next film. This public wants us to talk about their realities and for cinema to help them advance. It's a mature audience. If we take our spectators for kids, they don't like it and refuse to come. A film portraying a clean and problem-free Tunisia will only last a week in the cinemas." His producer Hassen Daldoul added: "We no longer believe in politics. Culture is the only cement that can unite people in a shared project" (2658).

That was before the Arab Spring. In Egypt, Yousry Nasrallah's 2009 *Scheherazade, Tell Me a Story* clearly said: "this society stinks because the political scene is rotten," but never slipped into denunciation. That would have been a waste of time:

everybody agreed that the authorities were weak and openly said so. But, by also directly attacking the oppression of women, Nasrallah took politics onto another terrain. The Egyptian fundamentalists understood this and cried scandal. But the public appropriated the debate and turned out en masse to see the film (9286).

Saâd Chraïbi's *Women . . . and Women* (Morocco, 1998) also focuses on the television presenter Zakia, a beautiful, active, and passionate woman who meets up again with the friends she had lost touch with: Leïla, Keltoum, and Ghita. While in the private sphere a tragedy occurs that the women react to together, Zakia's program is seriously under threat. The strength of the film comes from its imbrication of the public and private in a tight montage about women's conditions: the four women escape stereotypes, and their solidarity unites them in a kind of captivating choreography (0845).

Just as Manthia Diawara already suggested in his documentary *Bamako Sigi-kan* (Mali, 2001) (2741), Abderrahmane Sissako's *Bamako* shows that ordinary people are not fooled; they are aware of, and constantly reflect on, the world. They fully understand the words and issues of the trial of the international organizations that the film portrays, for they live them in their very flesh every day (4429). Let's stop patronizing the audience: people are not guilty of laziness or lack of culture. If people do not like a work, it is because it does not concern them. Filmmakers address universal spectators in the sense that they address all people, but as Sartre put it, "Whether he wants to or not, and even if he has his eyes on eternal laurels, the writer is speaking to his contemporaries and brothers of his class and race."[86] It is in this respect that Mahamat-Saleh Haroun claimed not to ask himself the question of who his films address: "They are fundamentally Chadian, they are rooted. I define myself as a man, I am couched in my identity, which is to say my neighborhood, my family. My fundamental question is how to find the mesh to show that we all belong to the same humanity" (3697). And when Katy Lena Ndiaye was asked for whom she made her beautiful 2003 documentary *Traces, empreintes de femmes/Traces, Women's Imprints* about the Kassena women of Burkina Faso, which, through the mural paintings, raises the issues of transmission, education, and memory, she answered: "For anyone who wishes to go beyond his or her preconceptions" (3075).

Another cause often evoked to explain the lack of audience is that the African public does not have access to African films. Idrissa Ouedraogo, for example, exclaimed: "My public exists, but cannot see the films. If I don't develop television

distribution on digital screens, I have no audience! I only have a potential audience! We are lying when we say we have a public!" (2758). The rapid closure of movie theaters in most countries has proved him right, while other forms of distribution tend to favor the most commercial forms, and unreliable Internet connections still hinder initiatives on the web. Magda Wassef noted that in the heart of Algiers' Bab el Oued district, the man on the street has never heard of Merzak Allouache's *Bab el Oued City* (Algeria, 1994), any more than his 1976 classic *Omar Gatlato* (2333). Yet in Ethiopia, where there is still a network of cinemas, people queue to see local films, and the public is even willing to pay more to see them. But as the director of photography Abraham Haile Biru points out, although the public loves seeing its landscapes, hearing its language and music, "now they say, 'hang on, the quality's rubbish, I can't hear the sound.' So there is a market, and we are trying to back young people who want to make films." He himself has opened a film school in Addis Ababa (9602).

At the 2003 FESPACO, the screening of Pierre Yaméogo's *Moi et mon Blanc/ Me and My White Man* provoked an unbelievable crush, whereas the whole of the previous week it showed to virtually empty houses in Ouagadougou's two main cinemas, the Neerwaya and the Burkina: no one knew it was on! This proves just how important properly mediatizing film launches is, and the role that well-trained cultural journalists can play. If audiences are always keen on films that portray their reality, they also enjoy an event. Ouagadougou's public closely follow the widely mediatized FESPACO and, like all audiences, wants to see the films they hear about (2807).

The pleasure of cinema has a knock-on effect: the more films you see, the more you want to see. It is thus popular cinema that creates an audience, as director Nabil Ayouch reminds us: "Since the mid-1990s, a few films have been huge box-office hits and the Moroccans have started thinking that film can be a vector of communication and identity, something with which they can identify and dream, like with American films" (2897). This desire for cinema is so great that some turn to directing with ridiculously limited budgets but incredible drive, like the memorable Moncef Kahloucha, who managed to mobilize his whole neighborhood to shoot genre films, and about whom Nejib Belkadhi made a documentary, *VHS–Kahloucha* (Tunisia, 2006) (4442).

A nonexistent audience? No, the audience is there, but it differentiates and is differentiated; not every film speaks to everyone. The efficiency of a film's

distribution is of course primordial; we shall come back to that in chapter 6.1. But while it is indispensable to adapt distribution to the film, imagining a film in function of its distribution always supposes a pedagogical intent. That was how Assane Kouyaté presented *Kabala* (Mali, 2002): "The film may be a little heavy-handed, because I wanted to introduce a degree of pedagogy. My film is aimed not at a festival audience, but at the rural masses in my country. My dream is to be able to show my film in the tiniest villages in Mali. That's why I was determined to essentially use villagers as actors. I wanted them to recognize themselves in this film and for it to help them see their problems with greater distance. I tackle the problem of water. I come from the Sahel, where there are places where every liter of water has to be managed as rainfall is so rare. That's why the main character of my film is the well" (2353).

To stop gauging films in terms of the historical griotic obligation and to embrace the diversity of approaches, isn't this essentially what the Cambodian filmmaker Rithy Panh said at the start of his master class at the Cinémas du Monde pavilion at the 2010 Cannes Film Festival: "I have no technique, nor method other than approaching characters, whatever their origin, so as to leave them their dignity"? (9541). Mahamat-Saleh Haroun concluded the *A Screaming Man* press conference, which was in competition at the festival that same year, by saying: "The films I make simply seek to restore Africa's humanity." Perhaps it is here that the confrontation between art and the market can be resolved. The subject's dignity, his or her inscription in humanity, is a matter of neither ideology nor consumerism. On the contrary, that is where a critical frontier is traced, which is not always the one that people try to establish between auteur and popular film.

"Let's get back to the crux of the matter," said Guinean director Mama Keïta. "You tell a story; it may be your own story, your obsessions, your fears. If it's true, if you put all your humanity into it, it will find an echo in the person who watches it, even if that person is of a different culture to you. I don't think the great storytellers worried whether they were addressing their people or not" (2063). For ultimately, as the Beninese filmmaker Jean Odoutan put it, "It's the emotion that counts. I don't like this discourse about low art, high art, TV this, 7th Art that. I don't make Westerns—slapstick, that's all!" (1194).

1.7. Defined by the Other?

> If you insist on washing a black face white, you'll only waste your washing powder.
>
> —Malian proverb

1.7.1. The Ambivalence of French Funding

> Dependent on us yesterday, and today our special friends, all the underdeveloped nations are requesting our aid and assistance. But why would we give them that aid and assistance if it weren't worth our while?
>
> —Charles de Gaulle, in the film *Françafrique*, directed by Patrick Benquet (France, 2010)

The Choice of Cultural Blending

African cinema, if we discount colonial cinema, began in the Independence era. The 1934 Laval Decree forbade filming in the French African colonies without prior authorization.[87] Even when made by Europeans, anticolonial films were banned, notably René Vautier's *Afrique 50/Africa 50* (France, 1950), for its denunciation of colonial atrocities, and the admirable play of black and white lighting that is *Les Statues meurent aussi/Statues Also Die*, by Chris Marker and Alain Resnais (France, 1955), whose crime was to show how colonial trade was killing sub-Saharan African art. While pioneers had begun making films in the 1920s in Tunisia and Egypt,[88] the beginning of sub-Saharan African filmmaking is generally dated back to the 1955 film *Afrique sur Seine*, shot in Paris. Other films preceded it, however. In Madagascar in 1937, Raberono filmed the commemoration of the centenary of the death of Rasalama Rafaravavy, the first Madagascan martyr.[89] Under the auspices of the Congolese Film Club, set up in 1950, Albert Mongita shot *La Leçon de cinéma/The Film Lesson* in 1951 on the lawn of the Léopoldville golf course in the Belgian Congo, and Emmanuel Lubalu shot *Les Pneus gonflés/ Pumped Tires* in 1953 with the actor Bumba.[90] In Guinea in 1953, Mamadou Touré shot the 23-minute, 16 mm short film *Mouramani*, based on a tale about this ancient Guinean king. It is striking to note, then, that one finds the same legend in film as in literature, for rather than looking any further afield, "black African" literature is considered to have begun in 1921 with *Batouala* by the Martinican René Maran. The origin of this myth no doubt lies in the novel's being awarded the Goncourt literary award.

So why do people refer only to *Afrique sur Seine*? The screenplay of this 21-minute, 16 mm short shot by the Senegalese filmmakers Mamadou Sarr and Paulin Soumanou Vieyra (born in Porto-Novo to a Dahomean mother and Brazilian father) was the product of the discussions of the Groupe africain de cinéma, set up in 1952.[91] Its scenes set in Africa are made up of ethnographic footage. As the credits specify, the film is presented "under the patronage of the Musée de l'Homme Ethnographic Film Committee." Opening with shots of rural Africa and children swimming in a river, the film begins with the following commentary: "To the sun and our ancestors, we cried our independence, jealous, carefree, unaware of the world that surrounded us." But it also, and not without bitterness, depicts "some aspects of African life in Paris," heralding other films on the immigrant experience that would be shot in the years to come, notably Désiré Ecaré's *Concerto pour un exil/Concerto for an Exile* (Ivory Coast, 1968) and *A nous deux, France/To Us, France* (1970), and *Paris, c'est joli/Paris Is Pretty* (Niger, 1974), by Inoussa Ousseini, which also features a vagrant.

"The Paris of days of hunger, of days of desperation," is shown in *Afrique sur Seine*; Mamadou Sarr and Paulin Vieyra's commentary juxtaposes the harsh realities of immigration (the vagrant, the street cleaner) and an edifying echo of colonial propaganda, inaugurating a filmic discourse of repulsion/fascination that positions the West as the land of both dreams and disillusionment.[92] Opening on shots of children diving into the Niger River and insisting on their unawareness of "the world around us," the film portrays Africans as carefree children, ignorant of the rest of the world. Describing Paris as "the center of hopes, of all hopes," the commentary proclaims: "In going to discover Paris, in going to seek Africa-on-Seine, we cherish the hope of finding ourselves, the hope of meeting, encountering civilization. Hail the genius of the men of freedom, the men of equality! Hail the peaceful victories of the men of peace! Hail all the monuments of Paris, witnesses to past and present glory!" The second film by the Groupe africain de cinéma, Paulin Soumanou Vieyra's *Môl*, was this time shot in Africa in 1956, but only completed in 1966; it confirms, as Henri-François Imbert suggests, that the main subject of the film is African access to progress.[93] *Afrique sur Seine* thus appears to be a very clear example of the colonized subject's adherence to French colonial humanism and assimilationism. But should it all the same be seen, as Elisabeth Lequeret describes it, as a manifesto of colonial alienation that portrays Paris as "the site of the loss of innocence and of a major immersion in civilization"?[94]

That is surely taking it a bit too far. Not only is this the first properly developed

film, but film historians' "overlooking" of earlier works indicates that *Afrique sur Seine* represented a break in the relationship between France and its former African colonies. Beyond the allegiance of the first part of the film, the second part shows young people who frequently mix in the Latin Quarter, and calls for a fraternal love that brings people together: "In the Latin Quarter, the world assembles, assimilates, in an attempt, beneath the sun of love, to break down the ancient barriers of prejudice and the monuments of hatred, to come together, to understand one another despite the classifications that men have made of the history of just people. Premeditated solidarity, empty and cold fraternity, make way for shared happiness, for terrestrial nourishment, the fruits of the earth for all, the fruits of culture for all. In this ancient district of literature and sciences, the winds of hope, of happiness, of love are blowing." Interracial love is evoked as we follow a beautiful blond on the back of the moped of one of the black protagonists, and in the commentary: "And together again, black and yellow friends, black and white friends, in our rounds of love, heart to heart, side by side, beyond the darkness, we were winning the battle of light before God, before others!"

This theme of love is more prosaically present in *Les Princes noirs de Saint-Germain-des-Prés/The Black Princes of Saint-Germain-des-Prés*, by Ben Diogaye Beye (Senegal, 1975), a film about handsome Africans picking up young French women, which ends with the intertitle "Fifteen years after independence, the same old fantasies," while *A nous deux, France* depicts a black woman who seeks to rival Parisian women. While colonial cinema constantly depicts colonial subject/French couples as impossible and—contrary to the propagandist discourse of a "marriage" with the colonies—never leading to intercultural mixing, which was considered a threat to the integrity of the civilization-bearing race,[95] the mixed couple is thus positioned as symbolic of the demand for an egalitarian relationship right from the earliest sub-Saharan African films.

If accepting the economic and artistic funding systems that were soon to develop resulted in what Elisabeth Lequeret qualifies as a "quasi-incestuous" relationship,[96] representing a form of alienation, this was in reality a strategy that was both pragmatic and pertinent. In the absence of national organizations and funding, French funding gave access to the means needed to make films in an effort to affirm both national independence and cultural autonomy. The first filmmakers lost no time in breaking the colonial monopoly of images of Africa and asserted their ability to replace them, using Paris as an instrument of validation.[97] This recognition was not about identity or ideology; it was artistic. The early decades of

African filmmaking saw the emergence of a number of masterpieces (7304). And recognition in the major international film festivals remained a form of validation that was impossible back home until the issue of film distribution was resolved, which was practically never to be the case. The rapid creation of the Journées cinématographiques de Carthage in 1966 and the Semaine de cinéma africain de Ouagadougou in 1969, renamed FESPACO in 1972, offered domestic opportunities for establishing a reputation, but they have continued to struggle for international recognition.

It is true that the work of the acclaimed and respected elder Ousmane Sembene was essentially a cinema of resistance. His radically anticolonialist position safeguarded him from all compromise. He constantly repeated that Europe was not his center, but that did not stop him from developing a vision open to exchanges with the world in its entirety. It is thus too simplistic to reduce the division that has permanently marked Francophone African film, sparking numerous accusations and verbal denunciations, to a simple opposition between those who collaborated and those who refused to, even if it was in these terms that debates were often articulated right up until the 1990s.[98]

Self-Interested Funding

Following the brutal and vain wars that their refusal to decolonize dragged them into, firstly in Indochina, then in Algeria, the French wanted to erase these military, political, and moral defeats. Moreover, the loss of empire reduced France to the rank of a subaltern nation. Through its cooperation policies and all the facets of neocolonialism, the aim was thus to restore a lasting relationship that would enable France to escape the subordination that the new situation engendered on the international level and to safeguard its existing economic relations.[99]

As Alec G. Hargreaves has noted, "Almost overnight, in an incredible turnaround, de Gaulle, who had presided over the liquidation of the colonial empire, sought to position France as its former colonies' (now rebaptized Third World countries) main defender against American imperialism."[100] In fact, the influence of the United States, whose way of life fascinated young people quick to adopt its codes, compelled France to support the cultures of the South. France, whose exports are often primarily cultural, was indeed waging a war against both cultural and economic domination, not demonstrating some form of generosity. It thus tried to rally its former colonies to its cause in international negotiations, notably

when it successfully managed to defend its concept of "cultural exception" during the World Trade Organization General Agreement on Tariffs and Trade (GATT) negotiations. This rebellious attitude against a "single school of thought" or the "American steamroller" to stop cultural products from being treated like any other on the world market was to become a constant of French policy until UNESCO adopted the Universal Declaration on Cultural Diversity in October 2005.

In early 1962, a film bureau and technical unit were set up at the French Ministry of Cooperation. Run by former Institut des hautes études cinématographiques (IDHEC) film school students Jean-René Debrix and Lucien Patry—in other words, graduates from the French school of a "universalist quality cinema"—it backed the emerging filmmakers, offering them administrative assistance, editing suites, and sound-dubbing equipment, "so that Africans who had finished shooting would feel reassured and wouldn't have a sword of Damocles over their heads in the form of a producer constantly telling them that 'time is money.'"[101] When the technical unit was destroyed in a fire, film editor Andrée Davanture took over in 1980, creating the nonprofit organization Atria, funded by the French Ministry of Cooperation and National Cinema Center (CNC). This autonomy was preferable to pressure from African governments sensitive to overtly critical films. Following the dispute between the Malian government and French Ministry of Cooperation over Souleymane Cissé's first film, *Den Muso/The Girl* (Mali, 1975), it had indeed become obligatory to present the latter with an authorization from the African states before assistance was granted (2539).

For African filmmakers, Atria became a highly useful resource center and a point of contact with French professionals until the withdrawal of its ministerial backing in 1999 forced it to shut down. On a ministerial level, funding from commissions gradually replaced the spontaneous backing of the early years of the technical unit. Some saw this as an influence on films' content and aesthetics because the commissions were composed of French professionals for a long time. Others saw it as a form of appropriation, with African film adopting the "French conception of cinema" as a universalist message, as the critic Jean-Michel Frodon suggests.[102] Whether chosen or imposed, this influence was seen as problematic right from the start. A criticism that remains recurrent right up to today started to form: that Francophone African filmmakers produce a cinema destined for Western audiences. Someone as prominent as Manthia Diawara, professor at the University of New York, has indeed claimed that Francophone films only target European audiences.[103]

Mimesis?

What does such an affirmation imply if not a calling into question of Africans' autonomy in developing their own cinematic language? And, above all, does it not confirm the ignoring of the strategy of recognition and validation mentioned above? A suspicion of treason henceforth shrouds all African creation in its relationship to the West: accused of the same mimesis typical of the elites that Ousmane Sembene pilloried in *Xala* (Senegal, 1974),[104] African cinema is accused of neglecting its own culture to adopt that of the former colonizer, and of thwarting its original force in order to sell to the enemy (the famous accusation of an appealingly exotic "calabash cinema"). Drawing on the difference that, informed by Western anthropology, the Negritude movement established between Hellenistic reason and black emotion, this attack rests, as Achille Mbembe points out, on "an ideology that glorifies difference and diversity and that fights for the preservation of customs and identities considered to be under threat" (4248). Initially encouraged by the missionaries and colonizers, this ideology has evolved, Mbembe continues, into "a form of bio-racism (natives versus non-natives) that, politically, feeds at the source on a certain conception of victimization and resentment." Diaspora filmmakers are constantly accused of selling their souls to the devil. This kind of aggressive attitude only leads to self-destructiveness, and that is exactly what has happened with film: by constantly questioning films' relevance to their audiences, the credibility of filmmakers and their works has been undermined in terms of both their funding and their access to that very audience. Beneath the accusation of mimesis also paradoxically lies a questioning of the contemporaneity of African creation; that is to say, deep down it affirms the certainty that when it comes to modernity, Africans are necessarily behind, trying to catch up with advancing creativity, trapped in the constraints of a magnificent, yes, but fossilizing tradition.

Dependency and Abandon

Unlike the state aids that have enabled the development of Moroccan and South African cinema and that, through thick and thin, have maintained national production in Tunisia, and with the exception of an Egyptian film industry that exports to the entire Arab world, the quasi-generalized absence of film funding policies in the African countries has left filmmakers dependent on international funding, and notably French funding, without which many films would never have been made.

This historical dependency has generated numerous misunderstandings, but also a feeling of humiliation. "Instead of spaces marked by reciprocity, recognition, and respect, all over the continent donor agencies have created innumerable networks based on a boss-client type relationship," Achille Mbembe notes. He continues: "These relations are not one-dimensional. They are characterized by deep levels of collusion and connivance, unequal transactions, at times suspicion, and always by a reciprocal instrumentalization" (9028). Cinema is no exception: power games have developed, involving significant financial stakes. The Ministry of Cooperation's film bureau, which disposed of considerable means of intervention in the form of direct aid—in other words, not dependent on commissions and their criteria—blew hot and cold until the end of the 1990s. They attempted to devise a global policy, but implemented it from case to case and never delegated a thing to outside organizations. "They put up with us more than they support us," said Andrée Davanture. Atria finally lost its funding in 1998 (2145). Personal contact with the heads of the film bureau, and thus regular presence in France, were factors that helped guarantee a proposal's success; the diaspora was thus favored while distance remained an obstacle, the French Cultural Center network only playing an informative role. Orchestrated refusals and the Parisianism of the process fueled frustrations and animosity. But ultimately, the main reproach concerned the policy adopted: "In the rare meetings that the representatives of the Ministry of Cooperation agreed to grant us in the 1990s, it became clear that the only films that found favor in their eyes were those likely 'to meet the French public' and be present in the European festivals and 'above all Cannes,'" Andrée Davanture again explained (2145). A schism grew between productions aimed at the international market, which would represent Africa but also testify to French investment, and the less ambitious productions that would soon take off with the advent of digital technology. "African filmmakers are responsible for their works and above all wish to meet an African audience, even if the consecration of their films in France and elsewhere is prestigious. I think it safe to say that this perspective has never been taken into account," Andrée Davanture added (2145). Whereas Atria backed all initiatives, until the Fonds Images-Afrique was set up in 2004, French funding clearly favored a "high-quality" cinema that met both its criteria of representation and its policy of defending cultural pluralism.

It was from a somewhat different perspective that Dominique Wallon's efforts to help structure both companies and public authorities were inscribed when he was head of the National Cinema Center (CNC) from 1989 to 1995. The bilateral

agreements thus signed with Burkina Faso, Ivory Coast, Cameroon, Senegal, and Guinea improved Franco-African coproduction conditions, notably allowing films access to the CNC *avance sur recettes* fund and including them in the television quotas reserved for European films.

France has applied these criteria of quality to the Fonds Sud Cinéma commission, a fund cofinanced by the CNC and the Foreign Affairs Ministry and destined to back coproduced feature films. Since the Ministry of Cooperation's fusion with the Foreign Affairs Ministry on January 1, 1999, the "sphere" countries (the former colonies) are in competition with most of the countries of the South. While the end of the colonial ghetto was something to celebrate, competition is tough and Africa has been rapidly marginalized, despite the introduction of professionals from the South in the commissions in response to accusations of ethnocentrism in the criteria of attribution. The Fonds Images-Afrique constituted an appreciable funding body: it contributed to the development of both public and private television stations and sub-Saharan production companies' national productions. Suspended in 2009 after the economic crisis forced a reining in of spending, and having been the object of an evaluation that led to the elaboration of a new project that is ready to be launched, it still has not been replaced to date.

The Fonds Images-Afrique reflected a belated awakening. The French Ministry of Cooperation had always refused to be told what to do in the film domain, despite the criticism its choices engendered, and its lack of assistance in structuring the sector in Africa. The failure of the Ecrans du Sud association, created in March 1992 and disbanded in December 1993, testified to its reticence in joining forces with other organizations and in delegating its functions—in other words, in losing control.[105] Guided by a quest for professionalization achieved by strengthening contacts between professionals from the North and South and facilitating coproductions, this organization, which was destined to become the sole funding office, was at least less of a state machine and more autonomous and didn't seek to keep filmmakers in a state of helpless dependency.

In 2002, the first retrospective evaluation of French cinema cooperation was carried out. It concerned the 1991–2001 period and showed that out of an average $3 million per year, 88 percent of the French grants were spent on film production.[106] "Devoid of technical assistance throughout the period, this funding contrasted significantly with many other sectors of cooperation," noted the report. In the countries concerned, French funding never really banked on structuring the sector, which never managed to evolve into an industry. The conclusions of this

evaluation opened the gateway to a global plan of attack: "Africa Cinémas" was launched with great pomp at the Cannes Film Festival in 2003, the joint creation of the Agence de la Francophonie and the European Union. This merging of funding bodies into a single program was quite a feat. Its reorientation toward the distribution of films and an elaborate backing of African television was a laudable novelty (2999). Alas, it was a lamentable flop. "I cannot be party to an attitude that serves neither African cinema nor its professionals, and even less the objectives for which I was nominated," its head, producer Toussaint Tiendrébéogo, explained in his letter of resignation on January 27, 2005.[107] The final report indicated: "The participants strongly manifested their feeling of being degraded and infantilized in the implementation of the current program, both in its management and in the treatment of its recipients. Moreover, the choices carried out concerning the functioning of the program and the management of its aid had no socioeconomic impact in the recipient countries and thus went against current cooperation and sustainable development policies."[108] Ill-adapted to the rapidly shrinking number of cinemas in Africa and the sector's decline, the program was not continued. And it wasn't replaced either. "We have an unbearable failing: we are convinced that we hold the Truth, Knowledge. With the best possible intentions in the world, we often go about telling others what to do and it's appalling; it even goes as far as thinking in another's place. This tendency is often clear in the comments made about screenplays" (2145); Andrée Davanture's remark could well conclude this never-ending chapter. For while noble intentions and a limitless commitment pave this complex tale of France's funding of African film, the issue remains the need to break away from preconceived ideas. These are deeply rooted, as Achille Mbembe points out: "Ultimately, the question of the association between African art, culture, aesthetics, and ethnicity, between the community or communalism arises, the dominant but false idea (shared by both a lot of Africans and donors) being that the act of creation is necessarily a collective act; that African art forms are not aesthetic objects in their own right, but secret codes giving access to a more abstract, fundamentally ethnographic, 'real' representation of Africa's ontological cultural difference, or its 'authenticity.' It is African 'difference' and this African 'authenticity' that the donors seek, support, and, if necessary, construct" (9028).

Ill-adapted funding based on production and not on structuring the sector, the progressive decline of distribution, power games and cronyism, Parisianism and arrogance—the impressive list of major films produced does not mask the murky aspects of the French funding of African cinema. Today, stripped of means by the

restructuring of the French administration, then by the world economic crisis, the heads of the French Ministry of Cooperation no longer have the means to influence the course of history; at the very most they can only follow it. They are aware of past mistakes and are questioning what their role might continue to be at a time when the massive surge in digital video has marginalized them by radically changing the situation of film production in Africa (7305). Based on Nigeria's Nollywood model, and proud of their independence, embryonic film industries are developing without foreign aid, in keeping with the expectations of audiences not put off by films' aesthetic mediocrity. From computers to mobile phones, the multiplication of screens is revolutionizing distribution. From cheaply made television series to guerrilla filmmaking, quality is no longer measured in terms of investment, but more than ever before in terms of creativity.

Is this creativity discernible? The major concern is not so much a lack of talent as the fall in means. First came the disinterest of the European television stations, then the long remodeling of Brussels's aid system: the reduction of available funding has seen the number of good films melt like shea butter in the sun. But those that do manage to emerge demonstrate a new stance in that they question the future of humanity in general, far from the expectations of the exoticism or authenticity already mentioned; the spectator is mobilized, not as an African identifying with a common discourse, but as a human *waiting for happiness* (7304).

It is this change in position that has marked the 2000s. Despite the suffering endured, and in an impressive display of maturity, the Independence generation did not seek a radical break, but on the contrary, a partnership in which it would find its place in the world. Even filmmakers who, in the tradition of Sembene, re-centered their focus on Africa sought to establish their autonomy, but without necessarily cutting the umbilical cord with the former colonizer, both an unavoidable historical reality and a springboard for accessing the world stage. All were conscious that it was not in their interest to isolate themselves, which was contrary to their all-encompassing and open cultures. Both champions of a South-South solidarity, and performing a balancing act between two worlds, dreaming of blending their values and the modernity that the Independence era hailed, all demanded respect and equality in a new relationship. Alas, France continued its interference at all levels and did not decolonize its thought, missing a fine opportunity to evolve and find a better place in the world. Conscious of a divorce that in the end was not their doing, and deeply preoccupied by the catastrophe in their countries, which is not just political and economic, but also human and cultural, the most eminent filmmakers

broke away from identity-based references to envisage the future of humanity in its entirety. It is this feat that needs to be recognized and documented at present.

1.7.2. Distorting Content

Independence is firstly that of the spirit.

—Edouard Glissant, in "Un Peuple Invisible pour Sauver le Monde Réel,"
interview by Héric Libond and Boniface Mongo-Mboussa

"Musicians have to perform a balancing act. They must sound different and foreground their origin and originality. But this difference has to be relatively minimal so as not to frighten off the potential buyer, who predominantly comes from the developed societies," notes Denis-Constant Martin, head of research at the Center for Sub-Saharan African Studies (CEAN) in Bordeaux.[109] He goes on to add: "The representations that the listener/client has of the artist are reinforced by the compromises that the artist concedes to, thinking that that is what his/her listener/client expects. This can at times lead to awfully banal music, at times to unexpected creations."

He who has meat to cook, goes where there is fire. Due to the lack of local funding, filmmakers apply for Western funding. Due to the lack of significant financial returns on the local market, but also because they wish to carry their voices all over the world, they court the Northern public. Does that necessarily mean making compromises, or even selling out? It is a commonly leveled accusation. Should critics blow the whistle? Here too, accusations of flouting authenticity and fomenting colonialist conspiracies abound. Yet any relationship implies letting go of one's habitual reflexes. A coproduction involves two actors, both of whom have a point of view. Contracts regulate funding. And an artist who travels broadens his or her horizons, which in turn influence his/her art.

Of course, the balance of power favors those with the fire. "If you go down the American road," said Zola Maseko, "you have to be willing to let a little of yourself go." To make *Drum*, winner of the Golden Stallion Award at the 2005 FESPACO, he had to agree, in an entirely South African story, to cast American actor Taye Diggs in the leading role of the 1950s black journalist, Henry Nxumalo. "When the budget exceeds a certain level, it becomes collective. A coproduction is a compromise. The Americans come with their conditions. I learned to understand the system. I don't think I'd do it again" (3773).

This leads to the "colonization of the viewpoint" that Raidu Mihaileanu evokes, where one ends up imitating the other (2660). Yet can we just go and claim, as Guinean filmmaker Mama Keïta once did, that African film is "made for a certain public, for certain commissions, for certain festivals or selections, and thus is a reductive cinema"? (2063). Rejecting the famous "calabash cinema" has lumped together many a sincere film whose fault was more a lack of cinematic mastery than selling out. If there is a distortion, it is more in a global positioning that affects not only the lost sheep, but the entire undertaking. "You don't need to define yourself when you are in a position of power," said Claire Andrade-Watkins, adding: "It is colonialism when our self-image is defined by the outside" (3799).

Difference structures us. We forge our unity by excluding the Other, who must be designated, as was the case in the colonial exhibitions' human zoos and the films that represent them. The history of the Western shows how much the United States needed "the savage" to constitute itself; today—and we shall come back to this—a new savage is sought in the Hollywood films shot in Africa. When Manthia Diawara comments in *African Film* that Ousmane Sembene opened the way to an "authentic" African self-representation, it is to insist on the fact that this was opposed to "the hollowness and racism of the bourgeois film grammar" perfected in the West.[10] Yet in thereby positioning Sembene as the herald of a "counter-image," Diawara positions him in a reactive, confrontational paradigm that is federating and galvanizing, but which has its shortcomings: in it, one is always defined by those one is opposing. Sembene's radicalism did not prevent him from being wary of an essentialist claim to authenticity.

After having been the symbol of cultural rooting and a distancing device in *La Noire de . . . /Black Girl*, in *Moolaade* masks are nothing more than a vision terrorizing the young girls: Africa does not question its traditions enough. It is not about spurning them, but about using them well, like the protecting *moolaade*. The women manage to do this, Sembene suggests, so let's listen to them, rather than suppressing them. It is thanks to their strength that a traditional ostrich egg can be replaced in the final image of the film by a TV aerial. Mature people know how to sort good from bad influences; there is no point in cutting oneself off from the world (3423).

"We are porous to all civilizations," Sembene said, citing Césaire. "So we need to synthesize."[11] His lucidity was not a rejection, but the awareness of a tension. He knew what he owed the colonizer's culture, as much as what he rejected of it.

What mattered to him was Africa's place, its right to autonomy and dignity beyond all cultural hierarchies (9317).

To face the world is to take charge of the relationship, rather than be subjected to it. "Our problem is knowing which shirt to choose, as in hot countries, you can't wear the same coats as in Europe!" said Bissau-Guinean filmmaker Flora Gomes (2186). It is a question of courage, that of "making our films the way we want to" (3799). With a Hollywood that crushes everything in its path, the world's populations live their imaginations through the images of Others. "That isn't necessarily negative," claimed Haitian filmmaker Raoul Peck. "On the contrary, it encourages a vivid imagination, as, when you live in a different milieu, you have to decode so that you can use these images in your daily world" (10741). "The influences are there, of course," Peck added. "My generation grew up with them. We had to learn to decode and subvert them."

It is more a question of "images for" than "images against." In appropriating the former master's codes to blend them with its own, postcolonial cinema embraces uncertainty and impurity, but, in the present, reinvents its place in the world.

Thematic Continuities and Ruptures

They want us to believe that we are "vegetating." Yet, this underground struggle, this struggle of the people—like the struggles of all other peoples—is what I call daily heroism. They are the heroes to whom no nation gives medals. No one ever builds them statues.

> —Ousmane Sembene, in "Le problème est plus mental qu'économique," interview by Samba Gadjigo, about *Moolade*

2.1. The Five Decades of African Film

We never write just one thing, we write what keeps us awake at night: how to relate history today?

> —Kossi Efoui, "Afrique noire: Ecritures contemporaines"

2.1.1. The 1960s: Mandatory Commitment

O brothers, if our syntax is not a cog of freedom
if our books still weigh on the docker's shoulder

if our voice is not a guiding star to railway workers or shepherds

if our poems are not the arms of justice in the hands

of our people;

O let us remain silent!

> —Jean Sénac, "Salut aux écrivains et artistes noirs," a letter-poem
> sent to the Congrès de Paris, September 22, 1956

On May 7, 1954, after an eight-year combat in Vietnam, the French army was defeated at Dien Bien Phu. After Ethiopia, Liberia, Egypt, Libya, Sudan, Morocco, Tunisia, Ghana, and Guinea, the Francophone African states gained independence in 1960, followed by Algeria and the remaining English-speaking states up until 1965. The Portuguese-speaking countries only gained independence in 1974–75, after armed struggle against the Salazar regime. Independence was not generously granted, but laboriously won through the determination of combative colonial subjects and anticolonialists, in a combination of unrest, revolt, trade unionism, and the development of nationalist ideas.

Writers had prepared the ground as they depicted the African continent's cultural wealth and denounced the colonial system. In 1921, Guianese René Maran denounced the wrongdoings of colonialism in *Batouala*, but still won the prestigious French Goncourt Literary Award. He did, however, lose his job as administrator in Oubangui-Chari. The 1930s Negritude movement led by Senghor, Césaire, and Damas overtly asserted its demands in committed and proselytizing works and in a discourse that sought to extricate the continent from the margins of history by exalting so-called "Negro" values that drew on a spiritual and poetic approach to the world. In the 1950s, Camara Laye (*L'Enfant noir/The African Child*) introduced autobiographical fiction, while Mongo Beti (*Ville cruelle/Cruel City*) perpetuated the virulence of his predecessors. A discourse emerged that considered the exaltation of a precolonial Africa, monolithic in its unanimism, as a trap destined to perpetuate the heirs of colonial power. After Independence, Yambo Ouologem (*Le Devoir de violence/Bound to Violence*) thus opted for a spirit of insolence and highlighted African responsibility, while Ahmadou Kourouma (*Les Soleils des indépendances/ The Suns of Independence*) probed the confrontation between traditional societies and the model of civilization imposed by the West.

Until the 1960s, the 1934 decree introduced by Laval, then Minister of the Colonies, made it obligatory for anyone wanting to shoot images in sub-Saharan Francophone Africa to obtain authorization from the authorities. Africans only

had access to ideologically loaded images of themselves produced by colonial filmmakers, ethnologists, and missionaries. The first African filmmakers thus had to fight the negation of their selves that these colonial images represented, in which Africans were the backdrop to stories that took place in spite of them, or were the "insects" that Ousmane Sembene and Med Hondo denounced. Their films were militant, but not "banner-waving," as they were aware of the need to reach a public not taken in by slogans. Denouncing both obsolete customs and corrupt elites, their aim was to replace "civilization" with "progress," or in other words, to resist manipulation and backwardness. Their cinema aimed to decolonize the gaze and mindset, reconquer its own space and images, but was also a cultural affirmation. Seeking to reappropriate and transmit the founding values of their new societies, their fiction films readily adopted a documentary gaze.

The same was the case in North Africa, which sought to eschew cinema's pre-Independence Orientalist visions and restore its own sociology and culture. As the protectorates of Tunisia and Morocco had, relatively speaking, respected Arab and traditional socio-educative systems, the pioneers' films there were less focused on ending assimilation than films in the former French department that had become Algeria. They all, however, shared the burden of rectifying the general amnesia surrounding colonial history and the liberation struggles. Omar Khlifi thus portrayed the insurrectionist events that led to Tunisian independence in *Al Fajr/The Dawn* (1966), and Algerian cinema focused on the liberation struggle with *Patrouille à l'Est* (Amar Laskri, 1971), *Le Vent des Aurès/The Winds of the Aures* (Mohamed Lakhdar Hamina, 1967), and later *Chronique des années de braise/Chronicle of the Years of Fire*, a film about the trials of colonial life before the war, and winner of the Golden Palm at the Cannes Film Festival in 1975. From Morocco's very first film, *L'Enfant maudit/The Cursed Child* (Mohamed Ousfour, 1958), Moroccan filmmakers, like the Tunisians, favored a postcolonial social vision in the fight against obscurantism.

The French colonial authorities left no filmmaking structures in place, and the film units left by the British were not maintained by states confronted with other urgencies: the first filmmakers were unknown quantities with no backing. They could only hope for coproductions, or success tied to popular theater forms in the case of the first Nigerian filmmakers, or overseas aid available only to filmmakers from the French-speaking countries.

In 1957, the Nigerien docker Oumarou Ganda was the main actor in Jean Rouch's *Moi, un Noir/I, a Negro*, celebrated by Godard as a "cinematic revolution." Denouncing what he saw as a distortion of his reality, Ganda took up the camera

and shot *Cabascabo* (1968), an autobiographical film about a war veteran's tragic return from Indochina. Mustapha Alassane had just shot *Le Retour de l'aventurier/ The Return of an Adventurer* in 1967, a brilliant parody of the influence of Westerns on young people. But the first to shoot in Africa was Ousmane Sembene, who, with *Borom Sarret* (1963), established the objectives of film in a Neorealist mirroring mode: the self-journey that this Dakar cart driver incarnates clashes with the power of elites who imitate the West.

As in literature, the victimized subject gradually gave way to an affirmation of cultural uniqueness. Anticolonial nationalism found its extension in progressive and radical ideologies, the nascent cinema taking off in the context of the fight against Western imperialism. Anticolonial nationalism, Marxist readings, and Pan-Africanism were the three paradigms that long structured intellectual and political discourse in Africa. In the same way that Chinua Achebe presented the writer as a teacher, African film was necessarily committed, as was film criticism. Under Sembene's influence, militant cinema opposed the rare stirrings of commercial cinema. As Kenneth Harrow has pointed out, the narrative structure of Sembene's films eliminates all divergence from the director's discourse. The predicament is introduced and the main protagonist subjected to oppositions; the solution found is not the right one until the most just solution conveys the film's message.[1]

In this context of reconstructing markers and references, the aim was to incite the population to take their collective destiny in hand. This cinema was openly inspired by Brecht. In other words, it combined creativity and civic commitment, while creating ties with the social sciences (hence, throughout his career, Sembene participated in numerous university seminars on his work). Here, realism reflected the desire to redefine the self; one of its dogmas was the belief that art could change society, which remained a predominant concept in the 1970s.

2.1.2. 1970s: Mirroring Society

> Our new nobility is not to dominate our people, but to be its rhythm and heart
> Not to graze the earth, but, like the millet seed, to rot in the soil
> Not to be the head of the people, but its trumpet and mouth.
>
> —Léopold Sédar Senghor, *Hosties noires* (1948)

In an echo of the Carthage Film Festival (JCC) created by Tahar Cheriaa in 1966, an African Film Week was held in Ouagadougou in 1969. The government of Upper

Volta's policy to back cinema led the filmmakers who had united together in the Pan-African Federation of Filmmakers (FEPACI) in 1970 to fix what in 1972 would become FESPACO (the Ouagadougou Pan-African Film Festival) in the country's capital. Under the leadership of the irrepressible Ababacar Samb Makharam (Senegal), FEPACI's discourse was both militant and Pan-African. Film was to be a tool of liberation for the colonized countries and a step towards complete African unity. But when Samb made the magnificent *Kodou* in 1971, it was anything but a slogan. Rejected by her village community for not having stood the pain during the initiatory gum tattooing ceremony, Kodou is firstly sent to the white man's psychiatric hospital, before a traditional exorcism ritual reintegrates her into the group. "The meaning of my film," said Samb, "is that we Africans need to surpass our culture while at the same time taking it as our foundation" (2189).[2]

Similarly, when Samb made the link between denouncing oppression and African cultural values in *Jom/Dignity* (1981), it was to insist on African *jom*, or honor, dignity, courage, and respect. So, even though FEPACI met in Algiers in 1975 and refused any form of commercial cinema, calling for unity with progressive filmmakers from other countries against neocolonialism and imperialism, the films first and foremost proposed to find the self. Senegalese Safi Faye's gentle panoramic visions of rural Africa in *Kaddu Beykat/Letter from My Village* (1975) and *Fad'jal* (1979) both close on the laboring villagers; Africa is no longer a setting, it is a place of human activity.

The risk would be to take refuge in a fixed identity, behind the barrier of authenticity. But these Negritudinist overtones did not lead to isolation from the world. Trained, like Sembene, at the Moscow Film School (VGIK), Malian Souley-mane Cissé follows a young engineer in *Baara* (1979), who attempts to improve conditions in the factory he works in, but ends up being assassinated. It is not the character's subjectivity that interests Cissé, but how he questions economic and political collusion. Social commitment comes before the sentimental; the world is the center of gravity.

The same trend was manifest in North African cinema, in which characters are the expression of a social force rather than contradictory personalities. While Algerian cinema on the whole exalted nationalism, during "the years of lead," Moroccan cinema placed the accent on the weight of traditions, making confinement a central figure, such as in the violent silence of Aïcha's house in *El Chergui* (Moumen Smihi, 1975). As for Tunisian cinema, it contrasted official discourse with reality in the "national disillusionment" vein, to cite Hélé Béji's expression[3]—for

example, in Ridha Behi's *Soleil des hyènes/The Hyena's Sun* (1976), which focused on the country's uncontrolled opening up to overseas tourism, or Néjia Ben Mabrouk's *La Trace/The Trace* (1982), which analyzes the disillusion of a woman who wants to go to university.[4]

One Senegalese director framed the question of society's founding values as a quest for imagination. To him, nonconformism was what allowed a reflection on one's origins. The surrealist and prophetic filmic manifesto *Touki Bouki* (Djibril Diop Mambety, 1973) marked all African filmmakers. Anta and Mory are both tempted by the adventure of the West ("Paris, Paris, a touch of paradise," repeats the song), but one finally takes the boat while the other returns to his roots. The film does not say which is the right choice, but captures the rending of a society whose people are torn between their own country and elsewhere.

Cited by all as a reference, Mambety's brilliant films nonetheless never constituted a school. Sembenian realism alone was considered a factor of social change. It was not until the 1980s that evolution came, thanks to the disillusionment of Independence.

2.1.3. The 1980s: Autofiction

People say that
In us beats a music
That we can never hear
Unless we silence our inner selves.

—Koffi Kwahulé, *Jaz*

Convening in Niamey in 1982, a group of filmmakers wrote a manifesto that called for the creation of a film industry, rather than anti-imperialist struggle. The notion of "economic operator" appeared. The CIDC—the first Inter-African Film Distribution Consortium—had been created in 1980 under the auspices of Inoussa Ousseini, and had bought distribution circuits from a branch of the French company UGC, which had a monopoly on film distribution in almost all of sub-Saharan Francophone Africa. But the effort was short-lived, as the CIDC went bankrupt in 1984.

Yet African films were a clear success: *Djeli* (Fadika Kramo-Lanciné, Ivory Coast, 1981) and *Finye/The Wind* (Souleymane Cissé, Mali, 1982) beat the box-office records in their countries and drew crowds elsewhere. Kwaw Ansah's comedy *Love Brewed in the African Pot* (Ghana, 1991) was a hit throughout English-speaking Africa. *Essaïda*

(Mohamed Zran, 1996) was a hit too, focusing on life in a working-class district. In Morocco, the comedy *A la recherche du mari de ma femme/Looking for My Wife's Husband* (Mohamed Abderrahman Tazi, 1993) was a huge popular hit, as were Nabil Ayouch's *Mektoub* in 1997 and *Ali Zaoua* in 2000.

In demanding that their states nationalize the sector, the FEPACI filmmakers had entered the lion's den. Nationalization engendered more bureaucracy and, in many countries, a state control that no longer let troublesome films through. The Niamey Manifesto sought to escape state tutelage by asking states to back national production, leaving the choice of the subjects to private producers.

The CIDC's liquidation was a reflection of Africa in the 1980s. Disillusion was bitter after the collapse of the dreams of independence, and criticizing the colonizer was replaced by denunciations of the "fathers of the nation." But the subversiveness that had characterized African cinema from the outset could not be expressed as freely as in literature—for example, in the works of Sony Labou Tansi, who introduced the figure of the dictator in his 1979 novel *La Vie et demi*, along with his bête noire, the immortal rebel. A new generation of filmmakers continued to mirror reality, but chose the subjectivity of fiction to apprehend it with emotion and sensuality. In *Yam Daabo* (*The Choice*, 1986) Burkinabè Idrissa Ouedraogo thus portrayed the trials and tribulations of a Sahelian family looking for a better life further south. The image suggests more than it shows, such as the off-screen death of young Ali, the family's son, run over by a car in the big city.

"All my films address people's humiliation, how they are broken. They are wounded characters," stated Tunisian Nouri Bouzid (2658). Since *Man of Ashes*, his first feature film in 1986, he has deconstructed what he calls "the myth of the Arab man." So too did Algerian Merzak Allouache in *Omar Gatlato* in 1976, in which a young man cannot muster the courage to initiate a romantic encounter. The spectator is trapped into identifying with ungratifying characters. Without abandoning the Neorealist vein of social cinema, North African film also veered towards greater subjective complexity.

Trauma leaves the child in *Wend Kuuni* (Gaston Kaboré, Burkina Faso, 1982) unable to speak. The child's gestures, eyes, and finally refound speech are all the more meaningful for it. By basing the film on the narrative structure and tempo of the tale, Kaboré explores the reasons behind acts, rather than simply showing them, and in the process asserts self-affirmation. The film calls for a different social order, but strives to place this in the order of things.

It was when films began to follow this path of stories rooted in myth that this

filmmaking, which was up until then restricted to a small circle of initiates, gained international recognition. The West's enthusiasm was overwhelming, and Cannes lauded this newly discovered cinema, giving Souleymane Cissé's *Yeelen* (*The Light*) the Jury Award in 1987. The film went on to attract 340,000 spectators in France.

2.1.4. The 1990s: The Individual versus the World

> How to speak the beauty of the world
> when life expectancy
> crumbles like pastry?
>
> —Tanella Boni, *L'Avenir a rendez-vous avec l'aube*

In the 1980s, African film brought a breath of fresh air and serenity to an increasingly bogged-down European cinema that, at a time of communications dogma, doubted its future. Seeking seduction rather than to really understand these films, the 1980s were a time of exotic projection, a folklorization that went hand in hand with an accentuation of difference. In defending cultural authenticity, the 1980s saw a reinforcement of the inauthenticity of relations to the Other. But the lines were definitively blurred: the growing unrest in the French *banlieues*, the loss of bearings, and the rise of the Far Right painfully echoed the crises affecting the torn continent. Expectations had changed; the 1990s saw a decline in the success of African films, with the exception of those that addressed the issue of women in the Arab countries, such as *Halfaouine* (Férid Boughedir, 1990), or *The Silences of the Palace* (Moufida Tlatli, 1994).

Idrissa Ouedraogo's *Tilai*, winner of the Cannes Jury Award in 1990, was the last film to garner real international acclaim. Beyond its critique of customs in the name of the very values that govern them, the film carries the pathos of an existential cry: that of a being in crisis. Although Cannes selected Rachid Bouchareb's films *Indigènes/Days of Glory* in 2006 (whose actors Sami Bouajila, Jamel Debbouze, Samy Naceri, Roschdy Zem, and Bernard Blancan won a joint Best Actor Award) and *Hors-la-loi/Outside the Law* in 2010, no sub-Saharan African film was selected in competition for twelve years, until 2010: Chadian Mahamat-Saleh Haroun's *Un homme qui crie/A Screaming Man*, winner of the Jury Award. Yet, up until 1997, Cannes did select a number of sub-Saharan African films. In 1992, Djibril Diop Mambety's *Hyenas* magnificently captured people's hyena-like cupidity. In 1993, South African Elaine Proctor painted the portrait of three radically different women

in *Friends*: a black teacher, a white activist, and an Afrikaner archeologist. In 1995, Souleymane Cissé's *Waati* combined initiatory quest and cultural memory to seek a route to African unity and solidarity. In 1996, *Po di Sangui*, by Bissau-Guinean Flora Gomes, celebrated the coming together of cultures, recalling that it is necessary to sacrifice part of oneself to embrace what is worthwhile in the Other, and called for a stop to undermining the environment and humankind. In 1997, *Kini & Adams* by Idrissa Ouedraogo explored the barriers between people in a torn society, between what it was and what it is becoming. These films' characters expressed their quest for individuality in a refusal of individualism, and it is in this respect that this cinema continued to be subversive. The same year, Youssef Chahine's *Destiny* (Egypt), a lyrical epic against intolerance and fundamentalism, won Cannes' 50th Anniversary Award.

Reinforcing the bitter disillusionment that the African continent had already experienced when it was nothing but a pawn in the Cold War, the democratic hopes that the National Conferences raised in the early 1990s led to yet another disillusionment, exacerbated by the tragedy of child soldiers and the Rwandan genocide. Cinema indeed explored beings in crisis, but free of all illusions to do with identity. Refusing to be trapped in their cultural difference, young filmmakers vigorously refused the label "African filmmaker." They discreetly applied Nigerian Wole Soyinka's famous expression "A tiger does not proclaim its tigritude, it pounces."

A new cinema appeared at the turn of the century, borne by a new generation and announced by films such as Mauritanian Abderrahmane Sissako's *La Vie sur terre/Life on Earth* (1998), or Chadian Mahamat-Saleh Haroun's *Bye Bye Africa* (1999), which were emblematic of a new style capable of taking risks in terms of both form and content, to ask questions with no ready answers, and to explore humankind with no concessions.

2.1.5. The 2000s: Towards Humanity

And in this century, we,
Winterbottom & Winterbottom,
Creators of emotions,
We are coming!!!

—Kossi Efoui, *Concessions*

To escape being relegated to one's difference and to challenge definitions of identity, this new cinema undertook a real return to its roots; it delved into its cultural

foundations to create an aesthetic to suit the contemporary needs of its discourse. In the same vein as *oraliture*, which Ahmadou Kourouma developed in literature, films also drew on the mechanisms of orality: the voluntary approximations in narration that connote a desired uncertainty; digressive parentheses that reflect on the narrative; direct camera address; creating the illusion of an audience's presence; and so forth.

The resulting rhythm was bluesy, in keeping with the themes of errantry. Already, from Souleymane Cissé to Idrissa Ouedraogo or Djibril Diop Mambety, films had adopted movement and permanent delocalization as key elements of their mise-en-scène. Films in the 2000s often use journeys across the world as a form of questioning. Their nomadism is a philosophy—that of understanding that the Other is enriching. In *L'Afrance* (2001), Alain Gomis subverts the message of *L'Aventure ambiguë/Ambiguous Adventure*, Cheikh Hamidou Kane's famous novel taught in all Senegalese schools, and which suggests that hybridity is deadly. Gomis, on the other hand, asserts that you do not die from encountering the West.

Similarly to Alain Mabanckou's award-winning novel *Verre Cassé/Broken Glass*, filmmakers have developed intertextual references to world cinema. To explore escaping the vicious circle of violence, Chadian Mahamat-Saleh Haroun developed a tense, minimalist aesthetic in *Daratt* (2006) that would have done Hitchcock proud. In *Bamako*, also made in 2006, Mauritanian Abderrahmane Sissako put globalization on trial in an African compound. In 2007, in *Rome plutôt que vous/Rome Rather Than You*, Tariq Teguia returned to the desert that the war on terrorism created in Algeria, and in 2008 sought new lifelines in *Inland*. This cinema is convinced that the solutions to the continent's crises cannot be separated from a more humane running of the world, and from a lucid vision of humanity. The program is hope, at all costs. It is based on a heightened awareness of the state of Africa to re-pose the question of its place in the world, rather than trying to exalt the force of its origins. Its marginality is no longer de rigueur; the contemporaneity of its cinema no longer needs to be proved; and its films vibrate with the complex and violent relationship with the West. Citing Césaire, *La Vie sur terre* denounces the way in which Westerners view Africa as a spectacle. The Sokolo villagers' tribulations as they try to telephone show that what matters is not the efficiency of the service, but the desire to communicate.

Capturing people's desire means being receptive to the poetry, which translates, when shooting, in the openness of the screenplay that may be changed according to chance encounters or questionings. The viewer is mobilized, not as an African

identifying with a shared discourse, but as a human being *waiting for happiness*. This cinema no longer constructs a truth, but invites us to reinvent it.

2.2. Filiation?

It isn't because the hare resembles the donkey that it is its son.

—West African proverb

2.2.1. A Breakdown in Transmission

If people don't want to express themselves through film, we shall do without it.

—Nour-Eddine Saïl, "Les Cinémas du Maghreb et leurs publics dans un contexte arabo-africain: Conception, perception, réception," Colloque international aux Journées cinématographiques de Carthage 2010

"An old man sitting sees farther than a standing child," says a proverb in *Delwende* (Pierre Yaméogo, 2005). The sitting old man has the experience of culture. Filmmakers who do not take a close interest in what film is capable of will necessarily be limited in both their ambitions and realizations. In her Nobel Acceptance Speech on December 7, 2007, Doris Lessing declared that the difficulty is that "Writing, writers, do not come out of houses without books. There is the gap, there is the difficulty," adding: "In order to write, in order to make literature, there must be a close connection with libraries, books, with the Tradition."

That is precisely one of the major shortcomings of African cinema: how to make films when you have not seen those of your own predecessors? And how to write about film when you do not have access to film books? In 2005, Senegalese Angèle Diabang shot her first short film about gum tattooing, *Mon beau sourire/My Beautiful Smile*, her first filmic gesture, which struck everyone with its originality and determination (she replaced the actress who could not bear the pain) (3952). When I mentioned *Kodou* (Ababacar Samb Makharam, 1971) to her, which starts with this ritual tattooing, she told me she had not seen it (3961). How could she have done in an Africa that has no access to its own cinematic patrimony? This amnesia is widespread: there are no cinematheques; no cinemas or television channels that show classic films; very few film journals, critical writings, or film history books; and very few film libraries. It takes considerable talent to build on nothing! As Tahar

Cheriaa said in Claude Haffner's *D'une fleur double et de quatre mille autres/From a Double Flower and Four Thousand Others* (France/DRC, 2005), a daughter's loving letter to her father, Pierre Haffner, one of the first French critics to seriously study African film: "all children are born from a mother" (3953).

Heritage is central in all artistic undertakings. It is both cultural and personal. Many filmmakers have chosen to devote a film to influential characters in their own families: in 1985, Cameroonian Jean-Marie Teno explored his father's traces in *Homage*; Guinean Gahité Fofana made his grandfather the subject of *Tanun* (1995); and in *Ouled Lenin* (2008), Tunisian Nadia El Fani questioned the future of political ideals through her relationship with her communist, activist father (8622). Daughter of Wasis Diop and niece of Djibril Diop Mambety, in 2008 Mati Diop presented the work in progress, *Mille soleils/A Thousand Suns*, about her relationship to her father, family, and country: "It's only now that I've really come to realize the weight of this heritage," she said. "*Touki Bouki* is Djibril, and is our whole story. That gives me the strength to make this film because I believe it's important for me, at this moment, to reappropriate my story. It shapes my identity and that of my films" (7669). In 2013, after a long process of maturation, the film was ready. It is an innovative and powerful work that met with critical acclaim. Through its aesthetics, colors, political determination, and sensitivity, it both pays its respects to a heritage, and is a manifesto for the new generation. It theorizes *Touki-Bouki's* legacy: conquer, without giving up (11649).

A seminal work is like a father, a mother, a family. Identified and labeled as such by converging critical voices, masterpieces share the fact that they "offer a freedom, they give a meaning that is never assigned, never the same, always fragile," as Marie-José Mondzain put it.[5] Their force is that they thus resist the erosion of time, in their ability to continue, without running out of steam, to tell us about the present. Albeit on the condition, of course, that they do not lose their magic in the scholastic academism of their presentation, and that, in their transmission, they espouse the passion that engendered them.

"It is the storyteller, the dream-maker, the myth-maker, that is our phoenix, that represents us at our best, and at our most creative," Doris Lessing went on to add.[6] It entails drawing that which constitutes one's culture from within. "A wadi always returns to its bed," we hear in Hassan Legzouli's *Tenja/Testament* (Morocco, 2004): returning to one's origins is necessary, especially when not aiming to stay fixed there (3580).[7] Yet this filiation is not easy, between acculturation, historical guilt, and diluting modernity, all of which generate uncertainty and a loss of references!

A man, center frame, is running in the desert at the foot of what might be a sacred mountain. He is following a scent: that of the place from which he comes. "If you don't follow your scent, it will suffocate you," a black slave woman tells him, she who is the memory of the grandfather and the guardian of the order of things, and who has been waiting for him for decades. This superb opening scene of *La Sueur des palmiers/The Sweat of the Palm Trees* by the late Radwan El-Kashef (Egypt, 1998) reminds us that filiation is a question of noses and hearts! (0969). "In my village," the director said of this poignant meditation on the self-destruction of a people's memory, "when a man would arrive, the women would smell him. To greet me, they would smell me. When someone died, they would keep his or her unwashed clothes so they could still smell their odor. Odor has a memory." He added: "I believe we need to know our roots to better define ourselves from within. We cannot live without memory. Knowing where I come from is not to be fanatical about my culture. It is a simple psychic analysis that allows me to sort the positive from the negative, and thus to exchange with other cultures" (0970).

As a Fulani proverb puts it: "the shit of a child without memory will always be runny." A cultural foundation is necessary; its frittering away or lack of transmission are painful. "I am perhaps fascinated by traditional societies because I feel an absence, a loss," Katy Lena Ndiaye said when talking about her documentary *Traces, empreintes de femmes/Traces, Women's Imprints* (Senegal, 2003). Focusing on the Kassena women of Burkina Faso's mural paintings, she captures the exchanges between three old women and the young Anetina, an unmarried mother, who is both thirsty for modernity and rooted in tradition. "Anetina is partly a projection of myself. The grandmothers are perhaps those I never knew. I am seeking to reconcile with tradition, certain aspects of which I reject" (3075). And the tradition speaks: as they repeatedly paint the walls of their houses, the Kassena women suggest that everything is changing in this world and that you need to be at one with its rhythm to embellish it (3074).

In *Yeelen* (Mali, 1987), Souleymane Cissé filmed this relationship with one's origins, making the archetypal opposition between father and son the emblem of a fatal lack of transmission. More political than people realized, behind the film's manifest symbolism, *Yeelen* denounced the breakdown in the transmission of knowledge. Looking for the father is a recurrent theme, a figure to rehabilitate, for example in Gaston Kaboré's *Buud Yam* (Burkina Faso, 1997), which is not about excusing, but rather embracing him. What could be more topical in our times when the notion of "killing the father," perpetuated by world crisis, prevents sons from

projecting themselves into positive images of masculinity, plunging them into self-destruction or driving them to seek surrogate father figures, be they dictators or fundamentalists (0161).

In an Africa in the making, marked by self-doubt and questioning, many films invoke the pact that still binds traditional society, calling to reactivate it as a platform for change. In *Bamako Sigi-Kan* (Mali, 2001), Manthia Diawara seeks to understand the ties that unite the people he meets and the aesthetics of the artists who reinforce these ties: the Bamako pact is not a contract, but a quest, a reflection in the making. It is a spirit that is at work, and in *L'Esprit de Mopti/Mopti Spirit* (Mali/France, 1999), Moussa Ouane and Pascal Letellier locate it in the respect shown for each trade, or in other words, each person's integrity. "The spirit of Ngor is, above all, respect," said Samba Félix Ndiaye referring to *Ngor, l'esprit des lieux/ Ngor, Spirit of the Place* (Senegal, 1994). "What interested me in a town like Ngor was seeing how knowledge is perpetuated. Not only oral tradition. In this society, there are also truly alive material supports that mean that people remain attached to this place, despite the generational conflicts or confrontations with the outside. It's a democracy that could serve as an example to the rest of the world!" (2454).

Initiation nonetheless remains contradictory. In *Kankouran* (Senegal, 2001), Malick Sy explores this desire to convey that paradoxically refuses to deliver its secrets. It is as if explaining initiation, removing its shroud of mystery, renders it null and void. It is as if spelling it out prevents people from believing in it, thus denying them a part of themselves, their cultural rootedness, their comforting integrity. A testimony about a practice that particularly binds the community—circumcision, which is just the first stage in learning absolute obedience to the group's norms— *Kankouran* unveils a bastion threatened by globalization. The mask will only be able to ward off evil spirits if the structuring myth is safeguarded (2441). Initiation rituals thus recall that, to assert a vision, the image must conserve the mystery of the real, and thus maintain the invisible, the absent, the off-screen. If viewers are to perceive the pact, the spirit, the invisible, and the spiritual, they must sharpen their gaze. "Word is heard, but thought is seen," wrote Saint Augustine in *De Trinitate*. Yet, "for thought to be seen, the viewer must hear," points out Marie-José Mondzain. "The difficulty comes from the way in which the construction of the gaze is the edification of listening."[8] An interpreter is needed. As Nancy Houston puts it, "the artist cannot be a disciple, or a soldier, Jesus or Judas; his/her role is to see good and evil, and to reveal them, to make sense of them."[9]

What is at stake, then, is learning to look at the hidden side of things. That is

what Laurence Attali suggests in her *Trilogie des amours/Trilogy of Love* (France, 1999–2003), a playful meditation on her (amorous) relationship with Africa. That requires acceptation and incertitude. "Never ask someone who knows the way: you'll never get lost," as fashion designer Oumou Sy puts it in part 3 of the trilogy, *Le Déchaussé/Barefoot*. It is only once we are lost that we can find ourselves (2791).

2.2.2. Inhabiting the Present

> The certitude that we are not going to come out of this alive and that that's life.
> —Djibril Diop Mambety, in "Interview with Djibril Diop Mambety," by Lucien Patry

Today, the father-son paradigm is very different to that in *Yeelen*. Mahamat-Saleh Haroun's *Un homme qui crie/A Screaming Man* (Chad, 2010) also portrays a father who fears that his son is going to take his place. He shares the name of the original man, Adam, and it is indeed this relationship to the origins that is in question. Yet he and his son Abdel are not at loggerheads; they are the best friends in the world. They work together in charge of a swimming pool until they are pitted against one another by the hotel's new Chinese owner. It is when militaristic-dictatorial arbitrariness, incarnated by the neighborhood chief, combines with that of globalization and the economic rationale imposed by the new owner that things go awry. Adam bites the apple he is offered. He who used to be nicknamed "Champ" proves himself incapable of protecting his son, just like his friend David, the cook, who is also unable to stand up to Goliath.

The strength of Haroun's film is to have made this a question of moral conscience when, for Cissé, it was a question of duty. Cissé indeed denounced a father who, in refusing to teach his son his magic powers, became a threat to his life. This marks an essential evolution in African film: it is no longer a question of reminding people of their duty in order to safeguard the future of the community—this independence that is being constructed, and which it is still difficult to evaluate fifty years on—but of putting them before their responsibilities in an increasingly harsh world (one that is fully aware of this sad state of affairs). This passage from a people to the world motivates both an individualization of the issues addressed and a new aesthetic, in keeping with the realities of African societies today (9479).

While for Cissé, "cinema can show the way" (4047), Haroun seeks only to develop each person's consciousness and responsibility. The narrative does not limit itself to a conclusion; it lets life continue, as it remains to be reinvented. Abdel's

secret girlfriend, Djénéba, is carrying their child. This is the coming generation that Adam and his wife Mariam take in, and that Adam will manage to love this time. The film does not set out a prophetic future, but rather a present that it will be built on.

The difference is considerable. When Tariq Teguia films a group of activists meeting in *Inland* (Algeria, 2008), confronting paths in the labyrinth of their thoughts, what might appear to be random chatting is life seeking its path amidst the contradictions; it is a new Algeria that does not erase the past, a hermaphroditic entity capable of combining masculine and feminine, autonomy and relations (8481). From this perspective, what might come across as indifference in the main character—the topographer Malek—becomes a soul-searching in this devastated country, torn between being rooted and wanting to escape. Right from the opening credit sequence, the camera follows the electricity lines in an unending movement of flight. Malek undertakes this quest, this search for vanishing points, in the company of a young black woman who has come from a country it is impossible to stay in, and whose name we shall never know. She has escaped from a group of illegal immigrants who stumble into a minefield, victims of both the relics of a war that is not their own and police harassment. They flee together to reach a new frontier whose contours remain uncertain. It is by accepting this incertitude that Malek, clandestine in his own land but attentive to resistance, escapes the ongoing atomization.

Teguia's work, like Haroun's, is not about mastering a situation, but living it in full awareness, or, in other words, inhabiting the present. The films have no endings. Their characters no longer believe, either, that it is possible to act in the way that the cowboy hero determines his destiny. They do not adhere to an idea, a program, a promise, a messianism that might lead them into confrontation or to take power. They might not refuse the violence that is necessary at a given moment, when it comes, for example, to overthrowing a dictator in the Arab Spring that started in December 2010, or to stopping President Wade from changing the Senegalese Constitution to his advantage in June 2011. Their resistance is not against a system itself, however, of which they know they are an integral part, as we all are. It is their place in this system that they challenge. Their enemy is above all themselves, in their capacity to let go and open the possibilities. This necessitates an awareness and the courage to overcome one's fears. Henceforth, their insular and singular experiences are no longer isolated bastions, but enter an archipelago of relations.

These films are in movement. This position presupposes a new topography, a new definition of territory in a world in which relations matter more than origins.

This is the rupture of the 2000s, before the powerlessness to change a system that is running this planet, and which Algerian artist Fayçal Baghriche represented at the 2011 Venice Biennial as a madly spinning globe. Questioning the self is replacing confrontation, engendering a multitude of alternative or oppositional practices that are only too ready to create a network in the hope of uniting as many people as possible; not in the belief of creating an alternative system—and thus awaiting its coming—or even just thinking about it, but in the constant regeneration of critical practices.

2.2.3. Mambetian Freedom

> I believe in the virtue of the wind. I believe in the wind's command. I know to wait
> for the wind because I love it, because I listen to it. I embrace the wind.
>
> —Djibril Diop Mambety, in *Djibril Diop Mambety ou l'ivresse irrépressible d'images*, DVD
> booklet with the film *La Petite Vendeuse de soleil/The Little Girl Who Sold the Sun* (1999)

Relinquishing the rationale of mimetic confrontation is nothing new. "The supreme art of war is to overcome the enemy without fighting. . . . to take cities without attacking," wrote Sun Tzu some 100 years B.C.[10] But unlike this strategic expert whose prime objective was taking power, embracing the uncertainty of constructing oneself implies non-manipulative tactics, in a new approach that we shall consider in detail in chapter 5.1. How to broach "he who knows no shame"—Sedar Senghor, in Serere—Samba Félix Ndiaye muses in *Lettre à Senghor/Letter to Senghor* (Senegal, 1998). Ndiaye reproaches Senghor for his immoderate love of the French language and contests Senghor's turning Negritude into a state doctrine (2100). He questions Djibril Diop Mambety; Mambety answers: "Our testimony should be worthy of the man and limit itself to what we know." But what do we know? "Why didn't I understand you?" asks Ndiaye. "Because we knew nothing about your own roots." He thus goes to Senghor's home village, meets his kin, realizes the Serere roots of Senghor's predilection for dialoguing with the invisible. This *Letter* reestablishes an intimate relation that a biography would have watered down.

Humanity, intimacy, honesty. They are three clear routes that do not eschew a return to the roots. Yet the path is not predetermined all the same. "The subject comes by itself; the subjects chose me. I didn't want to write anything else," said Algerian filmmaker Lyes Salem. "I love seeing things in the street that remind me of what I'm writing. I connect everything. Things happen in front of me and I simply

note and reassemble them, using them in a personal interpretation of what I am party to. Yes, I use my intuition a lot and it takes time" (8219). Mambety might have said the same thing. "When I asked him about professional actors," said critic Baba Diop, "he answered that he talked about dreams, about tales of encounters. 'So it's the actors who choose me, not vice versa,' Djibril said" (7976).

The same applies to both critical art and social change, which generally occur unaware of the rupture taking place, which only becomes manifest retrospectively. What is decisive is accepting the uncertainty that opens the realm of the possible: daring, taking the plunge, while at the same time learning from the freedom of masterpieces. "It was because I'd seen *Touki Bouki* that I was able to make *Bye Bye Africa* with such energy and conviction," Mahamat-Saleh Haroun told me. "I was contaminated by the film's waywardness and was able to take the plunge and make something unlike what we usually see in African film. It's a hard path to follow." The Nigerian Newton Aduaka has also insisted on the difficulty of following such a free artist, "who didn't give a damn about conventions." Why does Djibril Diop Mambety continue to inspire so many filmmakers? He who never worried about pleasing. He who systematically favored the human over requisite discourses. He for whom film was a lie. He who asserted from the outset that Africa could only make itself heard by reinventing form. He for whom the question of his films' Africanity was not an issue because they were first and foremost his vision, that of an African. For Abderrahmane Sissako, "freedom is not lightness. Avant-gardists are people who free themselves from all belongings and create their own form. For Djibril, as it has to be for me, film was an act of freedom." This implies relinquishing realism. Nar Sene recalls in his reverential book *Djibril Diop Mambety: La caméra . . . au bout du nez* that Mambety insisted that if he made films, it was to lie, to play with reality.[11] Or as Sony Labou Tansi put it: "words are often more dead than the dead unless they lie."[12]

With *Kinkeliba et biscuits de mer/Kinkeliba and Sea Biscuits* (Senegal, 2002), Alhamdou Sy followed in Mambety's footsteps, adopting a radically new style and parody to address the day-to-day effects of the devaluation of the CFA franc. But, while the freedom of tone of this accumulation of real or dreamed hyperbolic images and Wasis Diop's percussion are seductive, the systematically paradoxical images ultimately wear thin (2443). The creative act remains something singular; while Djibril remains a reference, he is inimitable.

In literature in the 1960s, Yambo Ouologuem and Ahmadou Kourouma laid the first milestones of a new derisive writing already mastered in English-speaking Africa by Amos Tutuola, and confirmed by the return of Chinua Achebe. Similarly

in Congo, Sony Labou Tansi followed in the footsteps of Tchicaya U Tam'si. In Mambety's work, contrary to the other predominantly linear and realist films made in Africa at the time, enunciation was full of paradoxes whose montage cyclically fragmented the subject and underscored the sublimely free image in a kind of lyrical explosion. *Touki Bouki*'s montage thus resembles a spiral in the vast circle of origins, symbolized from start to finish by the zebu, whose big horns connect the cosmos and the land of the ancestors. "It's a choice we have to make," Djibril said, "either to be very popular, and speak simply to people, or to look for and find an African language that excludes talkativeness and focuses more on image and sound." Parody—the art of superimposition and counterpoint—is the root of this language of rupture. In Greek, *parodia* means the ridiculing imitation of a poetic song. One could not better describe the way in which Mambety plays with lyricism and, while not eschewing them, with serious issues (7975).

Mambety explores these serious issues—politics, the lure of elsewhere, and finding grounding in one's roots—from the perspective of the hyena (*bouki*): a self-affirmation whose nonconformity recognizes the pertinence of his culture for the present. If Mory chooses to stay, it is because the symbolic references deployed throughout the film confirm that his culture is not marginal, and that he can consider it on a same footing as the rest, at the center of the world. This represents a veritable inversion of perspective, and this inversion can only be established through the radicalism of a style that, through its montage, and "beneath its apparent disorder," as André Gardies put it, reveals "a deep solidarity."[3]

"There are two parallel trends in Senegalese cultural life: classical and rebellious," stated critic Baba Diop. "In film, the classical have in general generated a school (Ababacar Samb Makharam, Paulin Soumanou Vieyra, Ousmane Sembene), while the rebels pay little attention to habitual constraints (Djibril Diop Mambety, Ahmet Diallo, Ben Diogaye Baye in his early work, and today elements of Moussa Sene Absa)" (7976). This group used to hang out on rue Félix-Faure in Dakar. Ken Bugul describes the street's effervescence in her eponymous philosophical thriller, in which Djib, the filmmaker, seeks to tell the story of the crime: "Rue Félix-Faure camouflaged everyone's stories and wove them a new story."[4]

"The rebels who follow Djibril Diop Mambety portray the lives of the little people; their setting is the backyard of underground Dakar life, with a dose of wackiness and of the unexpected," Baba Diop continued. "Their characters vehicle a creative destiny. They cultivate impertinence in the form they adopt for their subjects, the desire to free themselves from genre constraints to explore whatever imposes

itself on the creator. Many have not been to film school: when you make your own tools, you do so swiftly." To adopt freedom, then, you had to be a rebel. But as the Guinean Mama Keïta said, referring to Ousmane Sembene, "you can oppose the father, but you can't renounce him" (2676). The issue is not challenging that father, but challenging a fantasized image of Africa, like the young reporter, who plunges back into his childhood in a nihilistic anti-journey in Togolese author Kossi Efoui's *La Fabrique des cérémonies*: resisting starts by refusing to play one's assigned role.

For this, an imagination needs to be attained in itself. That was the subject of the screenplay *Le Fleuve tel une fracture*, originally written by David Achkar, and filmed by his friend Mama Keïta, when Achkar died one week before the shoot. An initiatory road movie, *Le Fleuve/The River* (2002) follows no specific chronology either; rather it is a relational and temporal web. For Alfa, the main character played by French rapper Stomy Bugsy, Africa is an escape from the vengeance of the brother of the dealer he killed, but also a place to find new balance in his life. Alfa carries all the despair in the world on his shoulders; his contemptuous silence towards his beautiful young cousin, Marie, gradually gives way to an openness to the Other, and to Marie, but without ever becoming moralistic. His opening up is that of a man who, confronted with the shock of danger, then the shock of Africa, examines it himself. As in Jean Renoir's eponymous film, the river is a revelation: it is a passage, light, and resource (2683).

Mambety's freedom has thus inspired younger filmmakers. The distance that these filmmakers create by subverting the traditional proximity between audience and character so that the latter becomes not us, but another, places the viewer in an inherently modern experience of this irreducible alterity that remains essential to understanding that Africa is not other people's idea of it, nor can it be reduced to the projections they imagine. Identification is thereby replaced by a poetic paper chase (3693).

Distance is thus needed if we are to challenge age-old prejudices. But a shift is also needed to relinquish the realist program of the interventionist film incarnated by Sembene, and which he defined in his 1992 interview with Christine Delorme in *Ousmane Sembene: Tout à la fois*: "Firstly, I create for my community. The artist must express his people's pulsations, otherwise he cannot reach out to other peoples." Making films, like Sembene, "with characters who fully assume themselves"—a desire for his people, refusing to beg or to be a victim—certainly rallies people and calls for action, but risks resulting only in an idealistic questioning. It is against this cinema of ready-traced paths that the filmmakers of distance and uncertainty

rebel, giving free rein to the creativity of the spectator, who is invited to take his or her place in the film.

2.2.4. A New Humanism

> The French language is a mistress with whom I make bastards.
> —Edouard Maunick, in *Désir d'Afrique*, by Boniface Mongo-Mboussa

When it comes to distance from the father, it was French cinema that Africans needed distance from; not per se, but in its claim to tell the world the truth. The Negritude writers of the 1930s first of all published in Paris, for which they were criticized. That did not undermine their ambition to be African or West Indian writers, but they also wanted to be writers of the twentieth century. Situating themselves in the realm of melancholy, they made the link with the romantic and neo-romantic literary traditions. Later, Rimbaud influenced the poetry of Tchicaya U Tam'si, who entitled one of his collections *Mauvais sang/Bad Blood*.[15] Does decolonization represent a rupture or continuity, then, as Mongo Beti asked? "Yesterday is in the footsteps of tomorrow," Tchicaya wrote in *Les Phalènes*, not hesitating to evoke colonization as the biggest revolution that Africa experienced in *Ces fruits si doux de l'arbre à pain*. While today, visas and ghettoization limit contact, the colonial period was a physical confrontation. It was painful, but dynamic. As Edouard Glissant put it, it was "encounter and shock" (8940).

We saw in part 1.7.1 that, anxious to claim their place in the world, Africa's filmmakers, just like its writers, sought recognition and validation in Paris. While asserting their thematic autonomy, they thus needed to position themselves vis-à-vis the tensions at play in a French cinema marked by the emergence of postwar modern cinema. The French New Wave introduced the vision, inspired by romantic theory, of a film art capable of capturing the real, and thus as an instrument for thinking the entire world. Believing in its capacity to see the truth, the *Cahiers du Cinéma* filmmaker-critics confused recognizing film as art and its sacralization, to the point of claiming, as Truffaut did, that film was not a profession, but a religion. That reinforced the love of film, but this romantic conception of genius led to a defense of auteurs in which admiration verged on deification: the famous "politique des auteurs."

The question of auteur cinema has been a source of constant conflict throughout the history of African film, with French backing being suspected of having

favored it to the detriment of popular cinema forms (see 1.7.1). Today, it is more than ever seen pejoratively, as a form of navel-gazing, as soporific, pretentious, exclusive, marginal, and elitist.[16] Yet, grass never grows on a road where everyone passes! "A film's richness is its consistency with its auteur," Gaston Kaboré claimed. "That's where a film finds its sincerity and truth" (3855). Another Burkinabè filmmaker, Dani Kouyaté, said as much in his own way: "When you are an auteur and sincere with yourself, you are afraid of nothing, you're like a bulldozer. If you have something to say, it's like vomiting: you can't hold it back!" (2775). For, claiming to be a film auteur is, as it is for the writer, "to claim full and entire responsibility for saying and for what is said."[17] But what the critics of "auteur mystique" reject is, in the primacy of mise-en-scène, the cult of the auteur-genius, seen as the sole creator of the film, to the detriment, for example, of the screenwriter.[18]

Fluctuations in Hollywood history, from lauding the auteur-director to the golden age of the screenwriter, are revealing in this respect, and have continued right up until recent times. While the success of independent cinema encouraged studios to open specialist branches to cash in on this trend, they were later closed down in the 2000s, signaling a re-centering on blockbuster business. Recently, however, media recognition of auteurs, and the public's weariness before the repetition of ready-made formulas, have given auteurs new margins of maneuverability in Hollywood.[19] It is in this respect that the space opened up by Spike Lee's successes since 1986 has fascinated numerous African directors. Cameroonian Jean-Pierre Bekolo openly cites Spike Lee as an influence, and Jean Odoutan (Benin) starts all his films with the intertitle "Jean Odoutan imposes," on the "Spike Lee joint" model that opens all of Lee's works. In Newton Aduaka's *Funeral* (Nigeria, 2003), which, in the shock of their director friend's suicide, leaves the young filmmaker characters arguing about what cinema should be, it is the black man who dreams of making Hollywoodian films while the white woman defends a cinema of day-to-day reality (2361). The ascension to such comfortable production conditions and a forum is not without its compromises, however, which are the object of fierce negotiations.[20]

For African filmmakers, defining themselves as auteurs simply signifies asserting their singularity in their efforts to create a conscious-raising, rallying cinema of resistance that questions and invites reflection. Experimentation is thus a necessity, and an investment that does not necessarily mirror the expectations of an increasingly formatted public, but whose innovation is worthwhile in that it advances cinema, and thus the capacity for self-representation.

Beyond the virulent attacks that film journals, and notably *Positif* and *Cahiers du Cinéma*, orchestrated, the strength of the New Wave's critical approach, which integrated a moral critique of mise-en-scène, was to restore the ethical and aesthetic unity of film. But while African cinema's pioneers were susceptible to this moral approach, they did not see the New Wave's focus on intimacy as a model. During a retrospective of his works at Pontarlier in 2005, Souleymane Cissé asked for *Les Statues meurent aussi/Statues Also Die* (Chris Marker, Alain Resnais, 1953) to also be screened, whose vision he shared (4047). The pioneers were indeed more susceptible to this other component of modern film: the *Nouveau cinéma* of Chris Marker, Alain Resnais, Armand Gatti, Georges Franju, Agnès Varda, etc., who at that time were, as Jean-Michel Frodon has described them, "'ideological artists, who were far more explicitly engaged in a political reflection on society.'"[21]

Ultimately, however, many filmmakers today still claim to be influenced more by Italian Neorealism, as was the French New Wave. We can feel the freedom of Neorealism in the freshness of Mahamat-Saleh Haroun's *Bye Bye Africa* (1998) and Abderrahmane Sissako's *La Vie sur terre/Life on Earth*, or in the unpolished zest of Zeka Laplaine's films from 1996 onwards. We also recognize its acting style, which is more about being than playing, with the frequent use of nonprofessional actors, in a cinema of incarnation that is further reinforced by its natural settings. This sharing of gazes with the audience indeed initiated a primordial quest: "In 1955, no one paid much attention to the little group of Africans and Europeans discussing film in the smoke-filled cafés of Europe," recounts Paulin Soumanou Vieyra. But gradually a cinema "capable of participating in the creation of a new African humanism" began to emerge.[22]

That was the stake at play. It is still the case today, and that is the key filiation. Confronting the so-called humanist universalism that defines what is or is not true, African thought has transformed the experience of slavery and colonization into the heart of a solidarity with all the oppressed. By refusing to essentialize this—"The Black is not. No more than is the White"—Fanon broke with victimist, ideological, or identity-obsessed discourses. Henceforth, as Edouard Glissant noted, "What is the world? The world is a vision, an intuition of what happened in the history of humanities." In other words, a consciousness of a double concomitant movement: that which has pitted communities against one another, and that which has brought them together. In the name of the Universal, the West justified its conquests, ravages, and massacres as "bringing civilization," and imposed this on the world. But, as Glissant continues, "colonization, unconsciously, inadvertently, brought about

world totality." Today, the dictates of the universal and this form of humanism are no longer credible. The political is hence only valid if rooted in a poetics; that is to say, in an intuition of the world that stems from the fundamental solitude of each and every one of us before the need, in globality, to group together in relationships.

"Seek knowledge, even as far as China," says the Prophet's *hadith*. By entitling his film about historical and scholastic filiation in Algeria *La Chine est encore loin/China Is Still Far*, Malek Bensmaïl, like so many others, opens up a horizon: an opening up to the world that is at the root of all questioning. But while communication tools bring the entire planet closer together, this opening is vertiginous. The issue today is making the unpredictable not just something that is worrying, but rather a stimulating asset for projecting ourselves in the world.

2.3. A New Relation to the Real

> In my head, the imaginary makes love with the real.
>
> —Kongo Congo (Dieudonné Kabongo), in *Juju Factory*,
> directed by Balufu Bakupa-Kanyinda (RDC, 2005)

2.3.1. Entertainment and Reality

> I feel my people's tribulations deep in my soul. I weep with the widows of Lounès the Kabyle and Ken Saro Wiwa, with the starving orphans of Darfur, Iraq and Palestine. I quake when an innocent soul is turned into a consenting victim. I bleed with the woman raped in Rwanda or Congo. I suffocate when a tyrant gags his brothers. I die every day with the thousands of AIDS sufferers who are buried with contempt and helplessness. I am trance-like before each detail of my people's lives.
>
> —Koulsy Lamko, in "Pour une Coopération Multiculturelle
> dans un monde globalisé," interview by Tanella Boni

Seduced by Poseidon in a temple devoted to Athena, Medusa is condemned by Athena to petrify all those who meet her eye. To decapitate her, Perseus avoids her gaze by using his shield as a mirror. The real petrifies. To not be mesmerized, we need a mirror, a distance, to restore our critical capacity. As Pierre Bourdieu demonstrated, to capture the real of his time, Flaubert chose to write it, not to describe it, thereby asserting art's autonomy vis-à-vis the realist mission of pure declension.[23]

As we saw in part 1.5.2, this autonomy that critical art claims is problematic, as it risks engendering a disconnected aesthetic. The solution is to physically capture the real, rather than reproducing it, or in other words, to invest it, to immerse oneself in it, which takes us on to the question of the body.

For the danger is to limit oneself to chronicling. Chronicles are what the North often asks of the South: a documentary sociology just one step better than a tourist guidebook. "Foregoing telling stories to just become a chronicler is a form of repression, of fear of life," retorted the Egyptian filmmaker Yousry Nasrallah (3424). It is possible to chronicle while telling stories, as the great Moumen Smihi did in *Chroniques marocaines/Moroccan Chronicles* (Morocco, 1993). In the film, he recounts reality as if it were a tale; in other words, he presents it in narrative form rather than by inventing stories that resemble it (1094). Before the urgency, however, the 2000s have seen a number of African chronicles. It was necessary, for example, to testify to the sequels of war and its human repercussions in Zézé Gamboa's *The Hero* (Angola, 2004), which follows war veteran Sergeant Vittorio, who has lost a leg in a land-mine explosion and whose prosthesis, which was so difficult to obtain from the local hospital, gets stolen. Chronicles tend to clock up the scenes, but here, pathos is always avoided and the film truly plunges us into this devastated country (3451).

This gaze is a reversal: "For the African filmmaker, freedom today is to take the time to examine the situation, to elaborate a gaze, and to expose it to Africans," said Senegalese filmmaker Moussa Touré (3065). The current tendency to return to the documentary reflects this concern. As Gaston Kaboré said: "Everything that Africa has experienced is an inevitable burden. We must urgently posit the elements of our own definition, so swamped are we in the West's gaze. We are condemned to testify; refusing to recognize this is in itself a reflection of a deeply significant unease, all things incorporating their contrary" (7209).

Some fictions thus dare to foray into reporting. In part 1.5.1, we discussed the meditation on Africa's relation to power and creation through the writer's relation to his or her publisher, as portrayed in Balufu Bakupa-Kanyinda's *Juju Factory* (DRC, 2005). Echoing this, Balufu captures the inhabitants' relation to their neighborhood, Matonge, a Congolese enclave in Brussels, named after a district of Kinshasa. The writer is called Kongo Congo: the specificity of a culture and the rhythm of rumba. Around him, a constellation of characters offer different neighborhood "truths" that dialogue with his own tale of exile. Typing on his computer, he documents the youth's confrontation with the police, which makes his publisher comment:

"inspiration is in love with you." This brings to mind the Senegalese *N'doep* according to which the spirit is so in love with the individual that it provokes disturbances that possession therapy seeks to remedy. It is the place that Balufu occupies: that of a creator who must speak in the first person, so tortured is he by both reality, projections about black people, and his full awareness of the state of Africa (4517).

Renewing fiction through documentary is not new: Neorealism and the New Wave prefigured it, and filmmakers such as Abbas Kiarostami have practiced it too. Their principle is to inscribe the real in fiction to better reveal power and its complexities. The stake is to de-idealize the real, or in other words, to break away from the belief that it has become too complex for us to be able to influence it still. The renewal of documentary goes in this same direction: that of a reconnected critical art, thumbing its nose at declarations of powerlessness.

If, in the 2000s, African filmmakers vociferously rejected "the obligation to testify," was it not in order to restore a distance from the real, and thus enhance belief in entertainment, not as a death of the real, but precisely as a "post-destruction spectacle," to use Jean-Louis Comolli's expression? Comolli indeed insists: "Each 'new' realism is thus supposedly an operation to deconstruct realities hitherto depicted and now destroyed."[24] In his article entitled "From Militant to Schizophrenic Cinema," Mahamat-Saleh Haroun denounced a cinema that, without admitting it, was leaving the domain of reality for entertainment, yet draping itself in the mantle of auteur film. In the article, he opposed "a cinema of people perfectly aware of where they are at and the combat at hand. That necessarily engenders a new aesthetic" (3685). The generalization of entertainment tends to disconnect us from the real. Reintroducing realism attempts, "amidst realist mise-en-scène," as Comolli put it, to restore the power to engage the viewer's active adherence with "the utopia of a real that cannot be staged."

Being rooted in the real is thus to choose one's entertainment well. "I have often carried out straw polls, microphone in hand, on the way out of screenings. The main criticism about African films is that they re-create images of day-to-day life; it's a criticism of the paucity of creation more than an aesthetic question," said critic Jean-Servais Bakyono (4361). The vocabulary pertaining to entertainment and aesthetics is not watertight, but what is essential is that the real resists and demands to be respected as such, not imitated or reproduced without being aware of the choices made, which always serve an objective.

"Writing is servile or captive when it favors what ought to be, to the detriment of what is," said Fabien Eboussi Boulaga (4539). Respecting the real is to eschew

didacticism and to open up to the subject that imposes, in the sense that Sartre wrote of Rebeyrolle: "For him, the intention existed since adolescence. That does not mean that he always knew that he wanted to paint, but rather that something would engulf him that would force him to paint."[25] The quest for the filmmaker is to recognize what imposes itself on him/her, without necessarily becoming fixated on the subject, but with that "little sensation" dear to Cézanne, the sentiments that reality inspired in him.

In *Vacances au pays/Trip to the Country* (Cameroon, 2000), Jean-Marie Teno arrives in his childhood village at the time of the "Congress," an annual festivity that has gone from being in the past a time of open discussion destined to resolve the village's conflicts and problems, to a kind of present-day beer festival. A football match is held, but no one has cut the grass. The cameraman offers to raise the camera so that we can see the players better, but Teno maintains the same height as in the rest of the film, so we can only see the players through a curtain of grass that they struggle to play in! It is this choice not to raise the camera, this desire to capture reality, to let it challenge the unfolding of a documentary—like when chance encounters disrupt the narrative thread—that creates a different aesthetic. It is a truly Godardian way of filming a shot in the sense that it does not answer the demands of the narrative, but rather the necessity of being there.[26] As with the Surrealists, it is not about constructing a form, but using it, which requires a sharp sense of incertitude, precariousness, and derision (1386).

In this undertaking, immediacy is essential, which challenges the director's proximity with reality: "I am not a historian, politician, or sociologist, and I hold no truth. So I could only recount the day-to-day, mine, and that of the people around me," Yamina Bachir-Chouikh said of *Rachida* (Algeria, 2002) (2356). Evoking the dark years of terror, the film is poignant and wrenching. It pulls no punches, but neither does it judge; the filmmaker does not try to give any lessons (2355). When Ramadan Suleman shot *Zulu Love Letter* (South Africa, 2004), he too addressed a dramatic situation: apartheid. "You can't re-create a reality," he said. "Filming irresponsibly would be like torturing a second time! Fiction must allow memory and identification, but in the sense that it helps progress towards hope" (3569).

"Our public needs hope," added Suleman. This is a considerable stake, as the intertitle at the start of Mohamed Zran's *Essaïda* (Tunisia, 1996) reminds us: "Look at us as we are, to be better than we are." That means creating a situation in which entertainment and life blend, the spectacle breaking with the crudeness of life—albeit without denying it—thereby inviting us to take it on board. A certain

ritualization is necessary, such as the trial of the international financial institutions that Abderrahmane Sissako stages in a Bamako yard. It was not scripted: the trial took place and the camera filmed, sometimes for two hours at a time. Each character played his/her role as he or she liked. "They believed in this court!" Sissako commented. "During the breaks, the witnesses would go to see the lawyers for the civil party, as if they were really expecting something from this trial" (4428).

This would not have been credible if the actors in the trial did not already bear the traces of the loss and degradation they evoke. This sensitive experience could only be achieved by letting the bodies express themselves freely (see 5.3.2). If this reality mobilizes rather than overwhelms us, and this in spite of the gravity of what is evoked, it is because, by respecting their right to speak out, these people's dignity is magnified in the beauty of how they are filmed, in the distance that allows the interlude scenes and flourishes of humor. In this cinematic process, life and death blend in these scarred, yet glorious bodies to enable us to rediscover our right to speak.

2.3.2. Ending the Tradition versus Modernity Opposition

> The labor of the people knows no rhetoric and no pause. Its future lies in its
> eagerness for a future. And its eagerness is also great patience.
>
> —Pier Paolo Pasolini, *Notes for an African Orestes* (Italy, 1969)

Fatou la Malienne/Fatou the Malian and *Fatou l'espoir/Fatou Hope*, Daniel Vigne's hit television dramas (France, 2001 and 2004) denouncing what Vigne called "a practice destined to turn Fatou into a second-class citizen," are both situated in the Stone Age of reflection on Africa. It is not that one shouldn't question coercive practices such as female genital mutilation or forced marriage, but because this dualistic discourse reinforces the tired old cliché of a backward Africa that needs civilizing. This brings us back to the virulently conflictual opposition today in the loaded political debate that, as Tobie Nathan puts it, is couched in France in terms of "communities or the Republic; culturalism or universalism." If we accept the idea that cultural groups have their own ways of changing their obsolete practices, the issue is not to escape the group to adopt the Other's culture (French society and its laws posited as a universal value), but to fight and assert oneself as a subject within one's own group so that things evolve. These films constantly reinforce the discourse of difference. Customs, magic, communitarian behavior all represent

an abyss that only individual emancipation can overcome. Just like in colonial cinema—for example, both versions of *La Maison du Maltais/Karina the Dancer* and *Sirocco* in which assimilation erases mixing—escaping one's culture to imitate the civilized is portrayed as the only salvation possible (2005 and 2839).

"What we call 'tradition' does not exist," states Achille Mbembe. "Islam, Christianity, ways of dressing, trading, speaking, or even dietary habits; none of them survived the steamroller of blending and vernacularization. And that was so well before colonization" (4290). Vernacularization is a process of appropriation that modifies something foreign to make it express one's own way of thinking or understanding. What mobilizes us in tradition is the relation to an origin, but this remains elusive. Tradition "relates to what is lacking, a nostalgia for what is no longer," says Fabien Eboussi Boulaga (4539). When tradition is operational, it represents a community's recognition in those who preceded us on earth, and our debt to them. That is its potential permanence, whereas mores evolve, one modernity quickly being replaced by a new one. As Gaston Kaboré put it, "modernity is waiting to reach its status of tradition" (7209).

These films do not pit modernity against tradition, even if they do readily denounce obsolete practices. It is short-sighted critics who so often reduce African films to this opposition. Village life is not archaic, waiting to be reformed by modernity; despite its arduousness, it is the basis of a possible future. In Yasmine Kassari's *L'Enfant endormi/The Sleeping Child* (Morocco, 2004), modernity infiltrates the remote setting's daily existence, not as a destabilizing model, but as a tool for self-affirmation; not as a perspective model, but as a possible appropriation on which to draw (3691).

When films do appear to be trapped in the tradition versus modernity thematic, we should look more closely at them. That is the case with Assane Kouyaté's *Kabala* (Mali, 2002), in which Hamalla has to convince the elders of the vital need to drill in the sacred well that is drying up. The film advocates rolling up one's sleeves to find one's own way, in accordance with one's means. This is not about duality, or withdrawing into a static culture; all the characters who advance the narrative are people who have left the village and who come back enriched by their time elsewhere (2352).

The same can be said of Cheick Fantamady Camara's *Il va pleuvoir sur Conakry/ Clouds over Conakry* (Guinea, 2006), in which the young Bangali, affectionately nicknamed Bibi by the two women who vie for his affections, is subjected to, but does not reject the traditions. Bangali is no rebel, despite the impertinence

of his caricatures published in the *Horizon* newspaper. He is submerged by a malaise that he does not know how to handle, caught between his desire to assert himself and the will of a father who wants to control him. He does not refuse his heritage, but attempts to negotiate its terms. When his father goes too far, using a village tradition to eliminate the child born out of wedlock, Bangali is tempted by parricidal vengeance, but refrains. Camara does not advocate murdering the father, but rather, determined patience. The freedom of tone is one path suggested: the overheated youth who are turned away from the pool have the beach instead; they have their insolence as a weapon, and their desire for free expression as a program (5862).

"The past conditions, but does not determine. Action is conjugated in the present," adds Eboussi Boulaga. Like the women in Yousry Nasrallah's *Scheherazade, Tell Me a Story* (Egypt, 2009), Africa's films are well and truly situated in the present. These four women share the desire to love, and to do so, must throw the dominant, repressive rules to the wind. But Nasrallah, all of whose characters take on board the disillusionment of the experience of modernity, does not focalize on a duality either. They live their individual complexity, advance in the dark, but have the passion of their desire. These women are Scheherazades on borrowed time, affected by their transgression and confronted with its consequences. By directly attacking women's oppression, Nasrallah's work is political while feigning not to be. Egypt's fundamentalists were not duped, and cried scandal. But the public appropriated the debate and turned out en masse to see the film (9286).

With desire as the driving force of these women's emancipation, the film follows the rhythm of their bodies, words, and hearts. This tension transcends the real and pushes back its boundaries. The source of their renaissance is not their culture in itself—cultural renaissance is the fortunate outcome of their action, rather—but the fact that, freeing themselves of constraints, their bodies begin to speak.

2.3.3. The Art of Metaphor

> Reality enters me through my mouth and deposits its words.
>
> —Raharimanana, *Des ruines . . .*

People set up cameras and film, but "what have we perceived of the real?," asks the Algerian filmmaker Tariq Teguia. "I never really know. To film is inevitably to miss something. These windows that come between the one who sees—in other words,

me—and the viewer, what is seen, recall the unsatisfactory condition of seeing obliquely, of having missed the moment, its duration. To frame is to miss what's off-screen. It's necessarily an adventure of the gaze, but a dissatisfied one" (9014). How, then, to reintroduce the real without falling into reporting?

Metaphors are a way of resolving this aporia. They enable an immersion in the real without merging with it, and thus restore a critical distance. The chair that the child, Mehdi, drags around with him for much of Faouzi Bensaïdi's *Mille mois/A Thousand Months* (Morocco, 2003) thus symbolizes a relation to the world. Every day, he brings it for his teacher, who does not have one to sit on in class. Mehdi—who is exiled to this village where he and his mother are taken in by his grandfather when his father, an opponent to the regime, is imprisoned—thus finds his own place. But the chair also represents his way of perceiving the world. He climbs up onto it to see the wonderful image of the town suddenly lighting up at night. And it is when this chair gets sold by his grandfather (whose lands have been confiscated since his son is in prison, and who has to sell practically all his furniture to survive) that the fragile equilibrium of this broken family crumbles (2912).

Similarly, there is a very beautiful scene (among many others) in Nouri Bouzid's *Poupées d'argile/Clay Dolls* (Tunisia, 2002): Omrane, a maid-dealer who brings the girls back from the village to rent them out to rich Tunisian families, discovers that Rebeh, one of these girls who has grown up into a woman and with whom he is in love, has been raped and fallen pregnant. He asks her to dig her teeth into his flesh. All the force of Bouzid's cinema, from *L'Homme de cendres/Man of Ashes* to *Sabots en or/Golden Horseshoes* lies here: he gives real body to his torn and disoriented characters. Hardly prolix, he finds gestural metaphors that enable them to express both their suffering and the fever that rages inside. The wine that Omrane slugs down is a salutary release in a climate of despair, but when he learns the news, he pours it on the ground because there is no going back, no possible reparation. Similarly, Fôdha, the six-year-old child who brings clay to continue modeling dolls as they did in the village, constantly makes and unmakes them. She constructs, deconstructs, and reconstructs repeatedly, in the image of all these women whose childhood is stolen. She incessantly remodels herself so as not to get trapped in the attitude of a submissive doll (2659).

Mona the goat shares the title of *Max and Mona* by Teddy Matera (South Africa, 2004). A passenger in a bush taxi names her when she does not stop bleating (moaning). She cannot be slaughtered because she is sacred. Far from being a

secondary character, she is thus the constant in a culture that has not said its last word. "When the goat is present, there's no need to bleat in its place," said Ahmadou Hampâté Bâ (6699).

Small things ring out loud, like in Joseph Kumbela's *Colis postal* (DRC, 1996). The play on ellipses and the unspoken in this ode to tolerance provokes an intense emotion. The message passes because it is served by a hand-held camera that integrates its subject in a city that is not just a decor, but a human place, through very simple attention to several details: a tear in the corner of an eye suffices to express an avowal, saying no to a shared solitude; a packet of rat poison, a losing of bearings; a woman's name, hope (2438).

It sometimes suffices to film the banal. The long, final tracking shot of Idrissou Mora-Kpaï's *Indochine, sur les traces d'une mère/Indochina, Traces of a Mother* (Benin, 2010), which travels to Vietnam to meet the descendants of African infantrymen who fought in the French army's colonial war in Indochina, is in this respect edifying. Guided by a respect for people and their words, Mora-Kpaï pieces together bit by bit a mosaic of testimonies. They would rapidly be too demanding if they were not the contradictory and living echoes—that is, humanly and historically powerful and glorifying no one—of the little-known reality of the ties between Africa and Asia that the current economic situation renders more present today. The montage progressively broadens these diverse facets, and Wasis Diop's music reinforces the melancholy that emanates, to such an extent that, beyond these lives, in this magnificent final shot that follows a humble dugout canoe in a big port, it is the planet that appears—that of an in-betweenness, that of people who cross waters, buffeted by history, and who have had no other choice than to take the world for their home (9886).

Metaphors also make it possible to broach the political there where repression is still rife. In *L'Ombre de Liberty/Liberty's Shadow*, by Imunga Ivanga (Gabon, 2005), Liberty, a mysterious straight-talker, pirates the national radio waves. He is the one who revives dreams. He is the elusive defender of the oppressed, an African Robin Hood—"He who sleeps on the ground isn't afraid of falling." But he is also the poetry of politics, a rebellious meditation, the hidden face of discourse, the mobilization of heart and spirit. He is the opposite of the three wise monkeys: he sees everything, hears everything, speaks everything. He is, in short, freedom of speech. Such freedom challenges the obscure powers that be, enmeshed with secret societies. The film orchestrates the hunt for him without telling us who he is, constructing a spiraling narrative, a puzzle that we have to resolve, like the still

images captured by the photographer, the sociology of a country that dreams of rupture. In the shelter of his red van, the irreducible Liberty is a myth that the *matiti* (working-class neighborhood) inhabitants vehemently defend from the police before being beaten up and arrested. Yet Liberty eludes capture. His voice can mutate into that of a man or woman, embracing a whole universe (4663).

2.3.4. The Poetics of Intuition

> Being a poet these days is to want, with all your force, all your soul, and all your
> flesh . . . that no facet of human reality be shoved under the silence of history.
>
> —Sony Labou Tansi, *Sept solitudes de Lorsa Lopez*

In the dark, a little girl opens and closes a refrigerator door. Light follows dark. "Am I imagining the world?" The child wants to understand. "When I shut my eyes, are people still there?" Imagining the world brings us back to cinema. In the darkness of the movie theater, *Petite Lumière/Little Light* (Senegal, 2003) challenges our so-called truths in a play of uncertainties in which light is both electric and illumination. Like the young Khatra in Abderrahmane Sissako's *Heremakono*, who chooses to bring light to his people by becoming an electrician, the child in *Petite Lumière* holds a lightbulb to the sun. She gets a slap for asking too many questions, as in life, but the relation is worth living. With this simple but acutely sensitive short film, Alain Gomis opens our senses and contributes to the world's light (2799).

Like the child at the end of Souleymane Cissé's *Yeelen/The Light*, who digs up the egg of knowledge before going to measure this against men, Khatra takes the lightbulb from the hand of the old electrician who has just died and takes it to the sea: it is poetry, perfectly convincing poetry. The waves wash the bulb back to him: he needs the light and he will transmit it. He is thinking of taking the train, but leaving is not necessarily the solution. Perhaps it lies in this gaze, in this openness to the Other, this sensibility, this sensuality, even, that the evocative bit of dune suggests in the final image of *Heremakono*, a superb film, a gift to the viewer, who will cherish it within like a treasure (2350).

Heremakono opens on a sandstorm, as if giving precedence to the wind, to uncertainty, to questions with no answers. "If this is clear from the start," said Sissako, "then I have achieved my aim. You have an intuition, but you never know if it works as you hoped." *Heremakono* has a subtitle: *Waiting for Happiness.* "My message isn't a desperate one, and it's not even a quest for happiness," Sissako

added. "The title plays with the concern that it not be taken at face value. The quest for happiness cannot be to reach Paris, or elsewhere; that would be too simple. We construct happiness differently, and we attain it when we have hope." Khatra's apprenticeship, like that of the young girl who learns to sing, prepares him for life, for the old man respects him as he would an adult. He is so strong that he can ask questions about life and death.

There is an extreme poetry in this cinema that helps us sublimate life in its ensemble, its sufferings and joys, the negative and positive, for it opens us to intuition. Poetry is not detached from the world; it reveals it by elevating our relation to the real. "Reality is unreal," said the Mozambican writer Mia Couto. "It is we who invent the feeling of reality. It is a perception based on cultural factors. African reality appears magical or fantastical in Europe. What I like about reality is that part of our consciousness that refers neither to reality or irreality, which is somewhere between the two" (0944). Indeed, the films based on his novels are deeply rooted in African reality and yet situated in another world, as if the facts were "ashamed of being real and demanded to become fiction." *The Gaze of the Stars* (João Ribeiro, 1997) portrays a young war orphan's search for his roots. He lives with his Uncle Salomao, who tells him that the stars in the sky are the watching eyes of those who died from love (0591). In *Terra Sonambula/Sleepwalking Land* (Teresa Prata, 2007), old Tuahir accompanies the young Muidinga as he goes looking for his parents and finds a diary tucked in the clothes of a passenger on a gunned-down bus. In *The Last Flight of the Flamingo* (João Ribeiro, 2010), UN soldiers get blown up left, right, and center! All that remains of their bodies are their highly visible penises. An officer carries out an inquiry, but the real resists as the surreal takes over. "In this country, appearances are rarely true," he is told when he thinks he has understood what is going on. Naturally; he can only understand by understanding the local culture, but "you can't learn a language in a day"! In Teresa Prata's film, rather than illustrating the narrative, the image and setting are stripped to the minimum to let the writer's universe transpire. In Ribeiro's films, by contrast, the image is saturated, culminating in an extremely kitsch finale (9562).

That, however, is perhaps precisely where this film touches us, without its attempts to take the magic of language and situations to an extreme. The end of Kamal Kamal's *La Symphonie marocaine/The Moroccan Symphony* (Morocco, 2005) also veers into a similar kitschiness, heaping on the candles and cherubs, which were sadly cut from the international version. That was a shame, because it was precisely the film's unbridled lyricism that made it worthwhile. The destitute

beggars, thieves, prostitutes, and outcasts who live in the old wagons of a scrapheap all play a classical instrument! It is, of course, the music that has us suspend our disbelief and that is so charming. "Only those who give from the heart remain in the people's memory," the one-man-band Kamal Kamal concludes in an intertitle, signing not only the film's direction, but also its screenplay, music, and editing. He so strongly believes in what he says that he almost convinces us to love one another and to pardon those who torment us! (4451). The risk with such an ardent belief in humanity before barbarity is, of course, to plunge into blind tolerance. It is the supernatural that saves this film. If the fantastical manifests the modern integration of technological advances, the supernatural—already developed in the Middle Ages—dreams reality to grasp its complexity and accept it. It introduces the supernatural without renouncing the real. There is ultimately a rational explication for the fantastic, and the supernatural plays the card of uncertainty and insolubility. By introducing the strange, it restores cultural differentiation.

"When I start a shoot, I barely know who will play which role," says Abderrahmane Sissako (4428). This incertitude introduces a poetics. In *Bamako*: "I was struck by the way people listened off-screen to what was being said. Every day I tried to bring this off-screen dimension into the frame. When I saw them listening, the next day I got them into the same position; it was often women." Bringing this listening into the frame is what filmmakers who intuitively perceive the poetry of the world do (from the Latin, *intuitio*, designating the action of seeing an image in the mirror). The storyline of Daoud Aoulad-Syad's *La Mosquée/The Mosque* (Morocco, 2010) is all the more simple as it is based on a true story. When he was shooting his previous film, *Waiting for Pasolini*, about a film shoot in a village where Pasolini himself shot in the past, a mosque set was built for the film. Lacking a real mosque, the villagers adopted it, even though it met none of the standards in force—a fantastic story! The owner of the plot wanted to pull down the set, but found himself confronted with various interests, the local authorities, the dogma, and his own contradictions. It was funny and moving at the same time, and if it is moving, it is because life can be funny if you get a distance on it, with this flair that Daoud has for the little things that are the poetry in life. A chameleon passes and that says it all. A disconcerting gaze reinforced by a perspective avoids verbal outpouring. A situation—for example, the dialogue with a man who will only come out of a well at the end of the sequence—says a lot more than what is actually said. Daoud the photographer composes his shots with Chaplin in mind: a structure choreographed with infinite precision, close attention to the frame

and objects, a humor from behind that is subtle because not insistent and because it plays on the unexpected, an overall social critique that does not renounce the characters' psychology, and finally a whole human metaphysical dimension in the close confines of a village (9894).

In Jean-Pierre Bekolo's *Les Saignantes/The Bloodettes* (Cameroon, 2005), it is not the film that is outlandish; it is reality that is. It is in keeping with the attempt, dear to Bekolo, to redefine a film form that is both African and contemporary. *Quartier Mozart* constituted a first rupture, and *Le Complot d'Aristote/Aristotle's Plot* defined it (2477). In *Les Saignantes* above all, as in French directors Caro and Jeunet's work—but without the same means—the bizarre is the new norm, the strange a new breviary, comics a new aesthetic, the subconscious an obligatory friend, and desire the locomotive. That would be a mishmash if it did not draw its consistency from the tragic reality of a torn continent. *Les Saignantes* is not the result of infinitely reproducible imagery whose mercantile intention is made manifest by the music video and advertising. On the contrary, this astonishing, provocative, insolent, playful, and perfectly paranoid film develops a real poetry out of codes recognizable by the very fans of imagery: young people. A poetry because it is a rewriting of the codes that it appropriates, not only aesthetically, but also in what it renews and even reconstructs of the image of Africa, and more particularly of the African city.

"Bodies, words, and money are the three agents of negotiation, a reflection of what is going on in Cameroonian society," as Bekolo put it (3944). Majolie and Chouchou, the two Bloodettes who wield sex and death galore, are not just stunning, tight, mini-dress-clad professional seductresses. They are more than fine bodies: each encounter is a choreography, each adventure a synergy, each gaze an exchange. They form a hellish couple who manage to master their destiny. This film is the product of the dawning century. If it multiplies the repetitions, signs, and effects, it is to cook up what might be an expression of rupture, a kind of highly fabricated formalist pyrotechnics, part comic, part Manga, undeniably beautiful, in which integrity is no longer to be found in the humanity emanating from it, but in the determination it proposes (3943). "When making this film, I kept in mind that the African population is predominantly under-15. I asked myself how to address this population," Bekolo added. In this cinema of the imaginary, pop video codes make it possible to break away from identification to inscribe a distance that is certainly reflexive, but also belongs to a model that, ultimately, is reassuring. If this formal ambiguity does not turn the spectator into a consumer of references, it is in the

subversion operated: a reconstruction is underway for an image of Africa that is radically different to the usual reductive representations.

"It's in African that I still find the thirst to dream the world," his actor Emile Abossolo M'Bo stated. Living in France, where he is a stage actor, he prioritizes roles in African films. "I prioritize Africa because there, for the moment, I still find that thirst, that quest to understand one another, to tell ourselves, to be born, to dream our world, with its limits, failings, and qualities. What I love in the African temperament is that I sense a much greater desire to live, to share a generosity rather than hatred or vengeance" (5955). If their poetic approach enables African cinema of the 2000s to delve into the human, fully aware of people's weaknesses and beauty, then it is to assert a determination that is to be entrusted to nothing but oneself. As Jacques Rancière put it, "it is actions that create dreams, not vice versa."[27] It is not about defining the goal, but rather contributing to a collective invention, a dynamic that "opens a space and a time in which the configuration of possibles finds itself transformed." The future will thus only be what we invent in the daily. Film has its place in this: through the force of its images, it offers, Bekolo reminds us, "the capacity to reinvent our future."

2.3.5. A Tauromachy of Viewpoint

> I stood in front of a mirror first to look at, and then to hit myself.
> With a mirror, you can confront yourself.
>
> —Sami Tchak, discussing his novel *Place des fêtes*, in
> *Désir d'Afrique*, by Boniface Mongo-Mboussa

Sami Tchak experiences literature as "a fight to the death with this reality that you cannot conquer." In other words, a tauromachy, to borrow Michel Leiris's expression. In cinema, the question of the right distance is posed with as much acuity as it is for the bullfighter, and, by extension, that of point of view vis-à-vis both oneself and the world. What is at stake in this relationship is the ethic of the relation to the viewer; the stake is to combine both a connection and distance that restores doubt as ferment for freedom.

This recalls the well-known Bantu proverb about hunting tales always being told from the point of view of the hunter. Didier Awadi's *Le Point de vue du lion/ The Lion's Viewpoint* (Senegal, 2010) indeed cites it. He illustrates these words with an avalanche of interviews, revealing the degree to which Africa's future escapes

Africans (10330). It remains highly ambiguous, then, to attach oneself to stories told by the colonizer, even if notable for their questioning of their certitudes or for their attempts to understand the milieu. That was Raymond Depardon's mistake when he adapted a book written by an officer in the French colonial army, Diego Brosset, in *Un homme sans l'Occident/Untouched by the West* (France, 2003): submission, trust, treachery—all the old chestnuts of colonial narrative are there, piling up the clichés of the time ("His warrior ancestry rekindled his courage"). Depardon himself seems to adopt Brosset's psychological gaze that readily attributes what he imagines the characteristics and reactions of Others to be, thereby denying the Other his/her alterity even when trying to highlight it (2736).

We will explore Western visions of Africa in chapter 3, but this ambiguity in the colonial viewpoint can also be found in certain African historical films, such as Djamel Bendeddouche's *Arezki l'indigène/Arezki the Native* (Algeria, 2007), which portrays late nineteenth-century Kabylia through the eyes of a French journalist (7496); or Nour-Eddine Lakhmari's *Le Regard/The Gaze* (Morocco, 2004), which adopts the sole point of view of a French journalist who, fifty years later, returns to the theater of the French army's acts of violence during the war for independence (4452). Is Souheil Ben Barka's *Les Amants de Mogador/The Mogador Lovers* (Morocco, 2002), which was screened on the opening night of the 2005 FESPACO, ambiguous too? The film follows a young French woman in colonial Morocco, but has the advantage of portraying (in cinemascope!) the passionate love between her and a Moroccan, whereas colonial cinema constantly orchestrated the impossibility of mixed couples in its desire to preserve racial purity.

Screenplay ambivalence can also have problematic effects on public debate. *Marock* (Laïla Marrakchi, 2005), for example, triggered a virulent debate by portraying Muslim Rita's amorous relationship with Youri, a Moroccan Jew. It was an opportunity to challenge prejudices, even if the relationship in the film does not surpass Mills & Boon or Harlequin-style romances. But the story is only resolved in the screenplay by Youri's elimination in an accident, which enables Rita to go to study in Paris. Their gazing into each other's eyes and passionate kisses thus do not bring about a deepening of their relationship, or something new that could have triggered a real debate in the country (3851).

Likewise, the image of women remains an issue from film to film (see 5.4). Certain endearing works are indeed not without their ambiguities. What distance does Mohamed Zran introduce in *Le Prince/The Prince* (Tunisia, 2004) with this female "bomb" character (to borrow the expression that the youth use in the film),

the object of Adel's ideal love, but who imitates the strong, male bankers' behavior at the service of capital? That puts what his friends say to him into perspective: "you have to win to keep our dreams alive!" (3574). And what to say of the image of the woman that Moussa Sene Absa proposes in *Madame Brouette* (Senegal, 2002), whose credits notwithstanding open with "Listen to this ode, fine woman"? An example of female determination, her story nonetheless ends tragically, as she once again lets herself be seduced. Do women simply exist, then, as an object of male desire? (2798).

And what to say of the narratives of disillusion, of desperation that bear down on the spectator? Like cynicism, disillusion overwhelms. Testifying to it is sterile if the film is not framed within a questioning or a perspective (3577). In *En terre étrangère/In Foreign Lands* (France, 2008), Christian Zerbib sniffs out migrants' despair, for example these young Senegalese who, having nearly died in pirogues and been robbed by traffickers, are stranded. We are left reeling, mouth dry, browbeaten before the state of the world. But here, this disenchantment creates a lack. For heaven's sake: political combat exists in Africa, even if politics itself is often corrupt. There are initiatives pretty much everywhere, even if they struggle to survive. There is culture and beauty by the shipload, ready to get ahead at the slightest opportunity, as soon as people organize and take themselves in hand. Didn't Sartre say that freedom is always at hand, that it only exists if faced with obstacles? In one way or another, individuals are always confronted with the choice of taking themselves in hand. And isn't it cinema's role to encourage them, rather than to crush them beneath the weight of destiny? (8827).

For Michel Leiris, tauromachy consisted in rejecting all fabrication, only admitting true facts (and not just plausible facts, as in the classic novel) as material. But he did insist that this return to the real has its dangers. To deal the final blow, the bullfighter must get close to the bull. To unveil the truth is to reveal what Deleuze called "its dirty little secrets," for the truth is not rosy, for anything or anyone. It needs to be looked at head-on. Restoring this intimacy henceforth means approaching the real from the subject's point of view. When Angèle Diabang and Laurence Gavron both, at practically the same time, made a documentary about Senghor's griotte, Yandé Codou Sène, they adopted two radically different points of view.[28] Whereas Diabang focused on the contradictions of a woman who was both strong and a servant, Gavron explored her incarnation and her transmission of Siné culture. Diabang looked for the woman, Gavron the diva. Gavron celebrated a culture and defended its transmission, whereas Diabang offered a reflection of

the female condition. Both create a rhythm in their films with the cadence of their approaches, with Yandé Codou Sène's words and song in counterpoint. While the diva fascinates, it is the woman who moves us (7639).

Diabang ends on an empty theater: "Who will sing your praises, mother Yandé?" Her dialectics of the subject—a personal questioning of the object of her film—does not lead to an individual question, the famous "who am I?," but to a movement that engages a multiplicity: "what becomes of us?" It is criticism's job to be wary of the isolating separation orchestrated by rigid identity-based assertions. What is at stake is showing how they fuel moralistic and hate-filled discourses. But they never come in isolation: their breeding ground is complex, and both sociopolitical and psychosocial. Restoring this complexity makes it possible to show that it is not enough to censor fanatics' discourses to resolve the problem. That is what Atef Hetata's *Les Portes fermées/The Closed Doors* (Egypt, 1998) compellingly shows, through this mother who sacrifices herself for her son without really understanding what he wants, and suggests that fundamentalist discourse becomes what it presents itself as: a refuge (1602).

Critical vigilance also needs to turn its skeptical gaze on all the grand unity nonsense. Glissant was wary of cosmopolitanism: "a negative avatar of the Relation." "Diversity is not the melting pot, it is differences that meet, adjust, oppose, attune, and produce the unforeseeable."[29] France's *Black-Blanc-Beur* (Black-White-Arabic) glorification—declared to be behind the country's 1998 World Cup victory—sealed, it later proved, a union that crystallized separation, not solidarity. For solidarity is not forged on podiums or in grand declarations, but in practices, and it is to these, how they are experienced and their contradictions, that film should testify.

2.3.6. Eschewing Territorial Fixation

> The country isn't the one that exists, but the one it's becoming.
>
> —Mia Couto, *The Last Flight of the Flamingo*

The crossing was violent. Black people's trajectories bear the traces of slavery, the slave trade, colonization, forced labor, apartheid, and exile. In this context, their path has necessarily been imagined beyond the continent; in other words, in relation to the world, rather than to their land. It was tempting to return (to the self, to one's territory), but, on the contrary, contemporary writing testifies to a reaching out to the elsewhere. As playwright Caya Makhélé put it, they "traverse the

world." They strive not to go from the specific to the universal, but from the place of departure to this totality that Glissant called the *Tout-monde* (Whole World), understood as a related diversity. "The place is not a territory. We agree to share a place; we conceive of it and live it in terms of errantry, even though/even when defending it against all adulteration."[30]

"I am wary of the words 'identity' and 'authenticity,' for they have such strong, loaded connotations as a result of Africa and the West's traumatic past relationships and today's ambiguous one," noted Gaston Kaboré (7209). Abdelkrim Bahloul contests these concepts too in honoring the poet Jean Sénac in *Le Soleil assassiné/ The Sun Assassinated* (Algeria, 2004). Forbidden to perform a play they have written because it is in French, a group of youths realize how emblematic Sénac is in Algeria's emerging force, namely, its rich cultural and linguistic diversity. The sea stretches into the sun from the very first images. Visible through the windows, it "frames," to borrow Fernand Braudel's expression.[31] It marks the entire film. This sea is the Mediterranean; it is both a link and a divide between Algeria and France. Souad Massi's voice invades the screen, triggering an intense melancholy. "A profoundly Mediterranean melancholy. Solar. A little tragic too" (3069).[32] This place is Algeria, the world is the Mediterranean, and doubtlessly further still—it is the planet of those who seek their way beyond frontiers.

In the 1930s, Dakar's youth were big film fans. Leni Riefenstahl's *Olympia* was a revelation for Ousmane Sembene in 1938. In it, we notably see African American Jesse Owens's triumph at the Munich Olympics. "It has to be said that this film was really well made. I remember at the time that it was *the* film among young people of my generation. By chance, at the last Munich games, I met . . . Jesse Owens and Leni Riefenstahl! I thanked them, even if this woman was on the Nazis' side and believed in the theories of racial superiority. I got her face-to-face with Jesse Owens and I shook her hand."[33] How did this Hitlerian propaganda film seduce Sembene and the Dakar youth to such a degree? Because it magnifies the fusion of a people through the bodies of its athletes, who, on the screen, are simply "instrumental personifications of an idea, the tools of a discourse."[34] After the war, Leni Riefenstahl signed several successful publications photographing the Nuba people of Sudan in the same mode. These disincarnated beauties were personifications, but never people.

In 1935, the Nazis commissioned a film by Willy Zielke to celebrate the centenary of the first German railway. *Das Stahltier/The Steel Animal* irritated Goebbels, and he had the director locked away in a psychiatric ward for seven years. He had dared to pay homage to the plurality of the European inventors of the railways. The force

of the film, Marie-José Mondzain points out, "arose from the fact that it addresses the spectator, who is free to construct his or her own place in a narrative space that combines dreams, hopes, and failures."[35] He had replaced the propaganda, which manipulates memory in an abstraction, with fiction, thereby restoring a human adventure and thought in a universality that surpasses frontiers.

When the Guinean Moussa Kémoko Diakité filmed *Fidel Castro, un voyage en Guinée/Fidel Castro: A Trip to Guinea* in 1972, he used all the mechanisms of propaganda film to introduce the themes: Castro and Sékou Touré's shared interest in national production; the population's permanent enthusiasm; portraits of men and women when the people's labors are evoked; superimposition of shots of crowds during speeches, etc. The convergence of the two revolutions announces a universal revolution (10080). "We weren't told exactly what we had to do; we ascertained it from the ambient ideology," the director said (10079). The national question scarcely marked film in Africa, however, even if African Independence was linked to nationalist and liberation movements. Algerian film aside, it was never really nationalist. Even Egyptian cinema was more Arabic than it was national during the Nasser period.[36] For African populations, the concept of nation as an ensemble that shares the same values only slowly progressed, and it was not the focus of identity explorations.

The issue today is no longer defending one nation or a group against another, but defending them all at the same time. Opposing the denaturalization of one's culture can only work in conjunction with all the cultures that need preserving. It requires networks and communications, and an awareness and respect of complexity, rather than organizations that seek to structure this complexity, thereby inevitably creating hierarchies and "a chosen few." It is thus essential to recognize the tendency to idealize, rather than incarnate and encourage thought—or in other words, the well-intentioned, identity-based, and territorial propagandist penchants discernible in many films. It is necessary, then, to challenge those who seek to perpetuate the eternal, mythical, and ineffective repetition of an original Africa that, it is hoped, will reinvigorate our lost world.[37] If it is clear that we are all fighting to preserve cultural diversity and to make culture a source of re-enchantment in the world, imagining mixing with the Other only as a loss causes an isolating withdrawal.

2.3.7. Self-Derision as a Weapon

> At the highest point of our oppression . . . we sat down and joked about it and
> laughed. It was the only way to deal with the pain.
> —Zakes Mda, in "Interview with Zakes Mda, by Boniface Mongo-Mboussa (South Africa)"

Humor is one possible response to tragedy, oppression, racism, and contempt. But when Independence gave way to confinement and dictatorship, other forms of derision predominated: Yambo Ouologuem's grotesque, Mongo Beti's irony, Ahmadou Kourouma's sarcasm, Henri Lopes's desacralization of crying-laughing, or Sony Labou Tansi's carnivalesque. This duality, which engenders the mirror play of self-derision, is still present; cynicism, however, which demobilizes, is not. Nor is it in film; there is no African Tarantino.

There is no chest-beating or lamenting either. "Flush and forget!," as the Radio Favela youth say after a deliberately destructive police bust in Helvécio Ratton's *Uma onda no ar/Something in the Air* (Brazil, 2003), which, unlike many Brazilian films, does not cash in on the ambient violence. Instead, it plunges into the real, combining personal implication and the distance of humor. The same can be said of Dumisani Phakathi. In *Wa'n wina* (South Africa, 2001), "a love letter to my street and the inhabitants of Soweto," which he approaches through the prism of sexuality in the AIDS era, a rhythm is established from one chance encounter to the next, all of which are full of life and the quotidian (3344). It brings to mind the words captured live in Djamila Sahraoui's films in Kabylia (*Algérie, la vie quand même/Algeria, Life All the Same,* 1998; *Algérie, la vie toujours/Algeria, Still Alive,* 2001; *Et les arbres poussent en Kabylie/And the Trees Grow in Kabylia,* 2004): the same proximity, the same familiarity (3041). In *Don't Fuck with Me, I Have 51 Brothers and Sisters* (2004), Phakathi adds a highly personal dimension, not only because he sets out to meet his fifty or so half brothers and sisters dotted around the country on his roaming ANC activist father's trail, but also in his directing style. By multiplying the hand-held shots of objects and people, edited in a tight rhythm with jolting cuts that give the impression of the proximity of amateur film, he establishes a fraternal, egalitarian relationship both with the spectator and, in situ, with his family that allows him to focus on the physical: "I love your eyes! Show me your legs, your arms!"—all of which is said in a burst of laughter, in the emotion of their reunions and embraces. When he decides to dress in the has-been style of this father discovered in the old photos found here and there, this theatrical revelation stirs emotions—an emotion

that makes us wonder once the lights come back on, how this country managed to oppress and brutalize such a lively people for so long (3957).

It is the combination of self-derision and an acute rooting in the real that works in Lyes Salem's *Mascarades/Masquerades* (Algeria, 2007). The Aurès mountain village where the film is set is not cited, but all Algerians recognize themselves in it, with all these masks that people love to wear to gain recognition or escape exposure. The hilarious dialogues in dialectal Arabic hit the mark every time. "Where is your veil?" Mounir asks his wife when they are about to go out. "I lost it," answers Habiba. "Mine was with hers," adds Rym. Neither victims, nor downtrodden, they destroy all our clichés about Algeria and this conservative society's constraints (8106).

In the twenty-three-day popular uprising led by the youth of the blogosphere, who surpass borders and are capable, as Abdelwahab Meddeb put it, "of making any periphery a center,"[38] Tunisia put an end to Ben Ali's twenty-three-year dictatorial regime. A revolution may be spontaneous, but it is the preceding long process of dissent that paves the way. If there was repression, it was because there were dissenters. Along with the political opponents, popular irony also constantly chipped away. Cinema managed to capture this irony, not in the disenchanted feature films that ultimately contributed to the social blockage, but in the profusion of short films by young directors (eighty-two were presented in the Carthage Film Festival selection in 2010!). Their quest for autonomy took the form of systematically deconstructing the dominant discourse, associated with an uncompromising, often ironic view of the self. *Condemnation* (Wald Attar, 15') was striking in this respect for its just tone and the force of its attack. Life in a Tunisian café is punctuated by the World Cup and the war in Gaza. From religious respect to normative discourses, the film, which is both a social portrait and sharp behavioral analysis, offers a delightfully insolent take on burning subjects.

These filmmakers thus turned irony into an art. In *Obsession* (Amin Chiboub, 14'), a young man discovers a button behind a painting in the old apartment he has just moved into; the button sets off both enchanting and horrific visions. The intensity, quality of the treatment, and suspense are constantly heightened: the film functions perfectly as entertainment. But it is also a social critique in its destabilization of this young, high-flying salesman, typical of an ambitious middle class in the liberal era, and calls for a surpassing of our fears to unleash our imaginations, to the point of escaping the repression of the authorities (9909).

While the December 2010–January 2011 Tunisian revolution was certainly a trigger, demonstrators—avid for freedom and democracy, and for the moralization

of political life in light of the corruption and enrichment of its leaders—did not occupy Tahrir ("liberation") Square in Cairo in simple imitation. This aspiration was deeply rooted in the country, as the new generation's feature films testify, starting with Ahmad Abdalla's *Microphone* (2010). "You left. You have several worlds, but we only have this one," one youth says to Khaled, who returns to Egypt after years in the United States. Guided by filmmaker Yousry Nasrallah, a group of students from Alexandria shoot a documentary on hip-hop and rock, an occasion to let young people speak out and to echo Khaled's point of view (played by Khaled Abol Naga, an actor who is hugely popular with young people in both Egypt and Tunisia), as they discover the extent to which their counterculture is a form of resistance. The film was shot with a small crew of eight, a shoestring budget, and a Canon D7—an SLR that also shoots video—which allowed them the necessary discretion to capture daily life in the streets. The film thus documents the realities of the highly active youth, annunciatory of the subversive force of the revolution to come.

Yousry Nasrallah's overt appearance in the film as a guardian figure is no accident: in Alexandria, as in Cairo, this close-knit group of independent filmmakers who are renovating Egyptian cinema are part of the tolerant and multicultural tradition defended by Chahine, to whom Nasrallah was an assistant, then his co-scriptwriter. Fiction and documentary mutually enrich one another. There is humor in both the putting in perspective and the anachronisms, as there is in *Ein Shams*, which Ibrahim El Batout shot in 2007 and Abdalla edited. Through the eyes of an eleven-year-old leukemia sufferer, El Batout documents both the sadness and magic of Egyptian life, blending social reality and political maneuvering with real poetry. In a toing-and-froing that mixes the Iraq War and the ups and downs of the neighborhood, Ramadan's taxi becomes a world hub. The changes in register nourish a plural vision of day-to-day life, but when Ramadan speaks out at a local political meeting, it is to recall that the neighborhood's problems, from child cancer to pollution, are problems throughout the world. By ironically subverting the codes of Egyptian cinema, Ibrahim El Batout delivers an ever acerbic critique, but one that is always from within, and never head-on. His meditation on the state of the world highlights its madness, but without contempt. By anchoring his film in the day-to-day, he declares himself an integral part of it.

A $30,000 budget: a shoestring. "We knew we had nothing," Batout declared. "To make a film that was close to us, we had to work with something of value: people's lives." Rather than spending years gathering funding, he preferred to work in digital, as quickly as possible. Shot in 2010 just before the revolution, *Hawi* is in the same

vein: a tiny budget, documentary-like images, a realist air, and the concerns of a stifled youth fighting day by day to create the space to breathe (9941, 10491, 10597, and interview 10576).

Self-mockery is also the force of *Un homme qui crie/A Screaming Man* (Chad, 2010); throughout the film, Mahamat-Saleh Haroun regularly adds touches of humor that, far from undermining the dramatic nature of the narrative, on the contrary strengthen it. Like Hitchcock, Haroun believes in the amplifying force of humor and triviality. Little details that might seem anodyne, on the contrary, contribute highly effectively to accentuating the tension far more than the dramatic music or paroxysms of violence that Western films set in Africa so readily resort to. *Un homme qui crie* is not somber: Adam evolves in the light, in clarity. The touches of humor, like the diving mask he wears in place of motorcycle goggles, make him more familiar and relax the viewer, who shares his tension. This is a very fine and difficult balancing act, which shows the measure of this director's mastery—a director fully aware that the little details in life construct a narrative more than pedantic explanations. Ellipses and uncertainty henceforth destabilize us sufficiently for us to remain constantly engaged (9479).

2.3.8. The Risks of Immersion

> We film as if with a gun to our heads.
>
> —Mahamat-Saleh Haroun

The image is striking: in the early hours of the morning, a group of kids emerge from under the stalls of a still-deserted Brazzaville market. They are "The Dirty Seven," as they have dubbed themselves. To shoot *Poussières de ville/City Dust* (Senegal, 2001), Moussa Touré felt the need to share their time and living space; he even went so far as to sleep in the same place as them and share their breakfast. Little by little, these street kids thus reveal themselves through the relation established with the director. It is not just their condition that appears as a result, but souls wounded by the war, who nonetheless still have their needs, dreams, games, rules, and desires. There is no longer any need for zooms, slow motion, freeze-frames, silent faces, or lingering gazes: these children swim, dance, and play football. They are no longer victims, but lively and active beings (2657).

"People film animals better than they do poor people; it's terrible!" exclaimed Cambodian filmmaker Rithy Panh. "If people are in the dirt, and you are far away,

sheltered behind a zoom lens, there can be no respect!" (9541). An immersion is necessary. The success of a film like *Benda Bilili!*, by Renaud Barret and Florent de La Tullaye (France, 2010), is precisely that they dared get their feet wet: an immersion in the streets of Kinshasa in the company of an incredible group of wheelchair-bound paraplegic musicians. It does not take huge means to portray poor people's capacity to invent their own future. These paraplegics and street folk, who do not give up, make our complaints ridiculous and our compassion derisory. They are not anecdotal or exotic; they are the energy that enjoins us to bounce back (9503).

In armed conflict, immersion is risky. Yamina Bachir-Chouikh relativized the risk she took in shooting *Rachida* in 2002 to denounce Algerian terrorism: "When you live in a country where, when you go out of your house, you're not sure you'll make it back, making a film or not hardly changes the risk!" She added, however, that she did have the whole crew with her, concluding: "You can't advance if you don't take risks!" That was the condition in order to "give hope and testify in film" (2356). Mahamat-Saleh Haroun has more than once been confronted with the arrival of rebels in N'Djamena, Chad, for example, when he had to interrupt the shooting of *Daratt* in 2006 until calm was restored—a film whose theme is precisely the repetition of violence. Rebels were in the vicinity as they were shooting the final scene in the desert. "Ultimately," Haroun said, "what is it that differentiates a good actor from someone who's just in a film? It is quite simply that, at a given moment, the actors realize—and it's painful—that this instant you are creating, which is brief, which is fictive, is in fact inscribed in eternity. And when you realize this, you give more than necessary. We had already won this war because what we were doing is inscribed in eternity. That was what gave us the strength to continue to make the film, to brave the insecurity" (4681).

Is it out of narcissism, then, that filmmakers play roles in their own films? Or, on the contrary, is it not a risky immersion? In *(Paris: xy)* (DRC, 2001), Zeka Laplaine plays Max, a man whose wife leaves him because he is never there. Always off at work, with his mistress, hanging in bars, or with his buddies: the usual. Destabilized, he tries to pull himself together, which will not be without its subterfuges. "Stop being scared," cries the seer in the street, played by Moussa Sene Absa, for that is indeed what is at stake when Max makes up his mind about the journey that his wife forces him to make: to question his own virility (2067). On the screen, these director-actors thus effectively incarnate the very thing they are questioning. In *Bye Bye Africa* (Chad, 1998), the filmmaker that Mahamat-Saleh Haroun plays spurns Isabelle, the actress with whom he has had a relationship,

when she asks him to take her away with him. By getting her to play the role of an AIDS sufferer, he has put her in danger, as the public takes the condition for real. Uncompromisingly incarnating human weakness in this way thus enables the director to help each and every one of us look ourselves in the face and take responsibility. And he does so by questioning his own status and by representing himself, in situ, on the screen.

Paradoxically, climbing down from one's pedestal and playing oneself as a being and a body in the film creates a distance between the director and the viewer that disrupts identification, especially with negative roles where any complicity makes us uncomfortable. The spectator is called upon as a witness, rather, at a distance from both the character and the filmmaker. Control changes hands. While classic cinema gave the spectator control (which television continues to do in general), the filmmaker takes it back. "To find the tone I wanted for the film, to convey the tune I had in my head, it was better that I played the role myself," Gahité Fofana said, speaking of *I.T.—Immatriculation temporaire* (Guinea, 2001) (2069). In it, he descends into the turbulent urban milieu of Conakry looking for his father. He is close, but has to wait, understand, listen, feel, let himself be carried along, to participate in what is around him, to penetrate this Africa that escapes him, this part of himself he knows so little about. This is not mysterious Africa; it is an Africa without the clichés, the very real Africa of scams and daily difficulties, the Africa of the night (2070).

It is a bit like an insider nod, like when Hitchcock appeared in each of his films. In these new film styles, the filmmaker seeks another form of complicity, but one that remains close to identification: "To espouse a gaze, you have to have seen this gaze's body," Christian Metz wrote.[39] It is a way for the director to position him/herself as the auteur of the film, so that the viewer becomes a cinephile. It is no longer only the actor who plays a role, but a filmmaker who proposes a vision, enriched by his or her filmography and possible public aura. Visual artists play on surprise in the same way: Congolese Chéri Samba depicts himself with a certain crudity in his paintings, and Cameroonian Samuel Fosso photographs himself in outlandish outfits, or even naked. Self-portraits prepare the reception of the work and augment its impact: the more the artist seems to take risks, the more he or she attracts media attention. By playing his or her own role, the filmmaker, who, as the auteur, already controls the whole film, makes him/herself a star.

African filmmakers do not take themselves for Dali, however; they cultivate commitment more than they do media eccentricities. "For *Mascarades*, I wrote

and truly embodied the role of Mounir and told myself that if there was a risk to be taken, I was the one who should take it," Lyes Salem indicated (8219). For Amor Hakkar, the reason for playing the leading role in *La Maison jaune/The Yellow House* (Algeria, 2007) was not only a question of wanting to, but also a way of resolving his budget difficulties! (7303). As for the Moroccan Faouzi Bensaïdi, it was a way of being "there" with the other actors. "I hear better, I live each moment with them, I can feel when it's not right, when it's not responding, and so it is ultimately a comfortable position even for directing the scenes" (10298).

2.4. New Intuitions

I am the bastard who saves you.

—Saindoune Ben Ali, *Testaments de transhumance*

2.4.1. Escaping the Margins

The only danger I see is not that we were marginalizing ourselves with regard to a territory that excludes us, but that we were sinking body and soul into the absence of ourselves.

—Gaston Kaboré, "L'Afrique va nécessairement trouver son tempo et son souffle bientôt," interview, Olivier Barlet with Gaston Kaboré

"I'm not interested in heroes," claimed Faouzi Bensaïdi, who in his films shows "particular affection for losers and dropouts." His film *Mille Mois/A Thousand Months* (Morocco, 2003) leaves anything that might be explanatory of the political context off-screen. "The film focuses on traces, on wounds, on the battlefield after the battle, on ruins, and on these people who are affected in the very depths of their flesh, who are destroyed" (10298). This journey into the human in African cinema of the 2000s is in itself a positioning, a continuity in the historical solidarity with the oppressed. Doesn't this awareness of the wounds of history and the suffering of the world, this sensitivity towards those on the edges of progress, imply claiming oneself to be outside the mechanisms of domination, outside the centers of power? On the contrary, "adopting a discourse of marginality vis-à-vis the world because they are so subjected to it is a problem for artists," Mahamat-Saleh Haroun stated. What is at stake in the twenty-first century is putting Africa back at the center: "We belong

to an underrepresented part of the world, but one that we wish to put at the center by asserting that there is a place for us there" (3685).

Only here is the rub: artists have embraced the margins. Momar Désiré Kane showed the extent to which marginality structures Africa's literary and cinematic discourse.[40] It is not surprising, therefore, that Africans are not expected to come out of their bush, and that they are constantly asked the question of their Africanity. Is it not contradictory, hence, to want to escape the margins to assert one's place in the world when the margins structure one's identity? Just as cultural blending suggests hierarchical, dualistic thought, marginality implies two poles: a savage and threatening exterior versus a reassuring center. Wanting to free Africa of its historical marginality means challenging the imagination that underlies this vision (3727).

It is a combat against the Other's gaze: "We find ourselves before funding bodies that all consider us the same way: as poor filmmakers who need to be helped," Mahamat-Saleh again states. The whole "African cinema" system ghettoizes films in a circuit of specialized festivals that guarantees them visibility, for want of anything better, but in which they find themselves marginalized. Haroun adds: "We are born marginal, and we end up marginal. No self-respecting filmmaker dreams of that" (10002). The demands for equality so present in the early films has finally led only to the maintaining of hierarchy (see 1.7.1). "The crux of the problem is precisely starting out from this desire to be equal to the Other, as it is born out of a complex," Haroun insists. "We take the Other's point of view, and try to prove to him that we are his equal. This complex gives rise to a certain type of cinema that loses itself in its intentions rather than narrating the world from an original point of view that touches and moves us." What is at stake, then, is to assume one's history and to make it a richness and a force, not a hurdle.

It is not an easy task: that is indeed what Yacine comes up against in Alain Gomis's *Andalucia* (Senegal, 2007). His eyes and mouth wide open, he looks at the world around him, eternally astonished, clownish. But when a man is attacked in the subway, he fails to step in. A "space king," he remains unattached. His home is a caravan. In both work and love, he is rootless; nothing lasts, even if he knows how to live the intensity of the present, even if he is open to encounters and the richness of the moment, even if he knows how to jump on his prey. The margin attracts him, because it is above time, but he does not revel in it all the same. His experiences are multiple, his wounds latent, his references drawn from the resistance of Lumumba, or Tommie Smith and John Carlos, the African American 200-meter runners who

rose their fists at the '68 Olympics, the images of a memory that he covers the walls of his caravan with, yet which do not constitute a place (7254).

For errantry is like exile: uncertain and a potential source of anxiety. "I am travelling to know why I am invisible," wrote Ben Okri.[41] Yacine is an unstructured man who runs till he is breathless, a *Sweet Bad Ass* who cannot keep still. He needs to overcome obstacles, to be astute, feint, like when Pele used to dribble toward the goalkeeper and then score as he got round him. His quirkiness brings him close to being a visionary. He is an endlessly spinning dervish, seeking an ecstasy that never comes. His quest for a state that connects him to the world confronts him with the mystical. He lets himself be guided towards the unknown lands of Andalucia, where he will find his incandescence, as if El Greco had painted his portrait. Going from a busy procession to solitude, he physically experiments with this state of suspension, this state of nimbus, of in-betweenness that is that today of those who navigate between worlds and cultures as a result of their cultures and multiple belongings.

Becoming aware of and asserting this is an obligatory path for surpassing one's frustrations. This is no doubt why mixed-race Alain Gomis undertook an artistic quest for this state right from his very first short film, *Tourbillons/Whirlwinds* (2003), about a torn Senegalese student in Paris, who is an outsider in both his host and home countries. He developed the theme brilliantly in *L'Afrance/As a Man*, in which El Hadj, who inadvertently finds himself undocumented, sees his own image of himself crumble, driven to do things he would have never imagined. This quest is not rooted in certitudes or a territory. In *Andalucia*, it takes the form of a deconstruction of the narrative to capture the puzzle that all members of what we call the visible minorities are confronted with, a cinematic style of the immediate and tension, counterpoint, and improvisation, resonating with the desire to occupy a place in the world that is at last free of other people's prejudices and fixations with the self.

Refusing to stay on the edges of the world, refusing a culture of the margins, refusing to bury oneself in a reified past means looking at oneself unindulgently; that is to say, accepting oneself with all one's memory. African film in the 2000s banks on intimacy and opts increasingly for the documentary.

"The continent's cultural history cannot be understood outside the paradigm of itinerancy, mobility, and movement," says Achille Mbembe. "It is, for that matter, this culture of mobility that colonization, in its time, strove to arrest through the modern institution of the border" (4290). Indeed, people walk a lot in African films. "There is always someone who walks in my films," remarked the Bissau-Guinean filmmaker Flora Gomes. "In *Mortu Nega*, a woman walks. *The Blue Eyes of Yonta*

starts at the end of a journey. *Po di Sangui* is marked by an exodus. *Na Falah* is also the story of movement" (2332).

Errantry does not signify dispersion, but ties, rallying together, solidarity. It is to have "an appetite for the world," as Glissant put it.[42] In *Le Cheval de vent/The Wind Horse* by Daoud Aoulad-Syad (Morocco, 2001), Tahar and Driss are torn between stagnation and uncertainty. They know they must leave, move, rove to try to piece together the scattered fragments of their understanding of the world. "I'd need another life to understand humankind," Tahar confides. They have to move to try to exist. "I am like the pilgrim who cannot turn back because his footprints have been erased behind him," Tahar says to the sleeping Driss. Their quest is endless, their goal a pretext; it is becoming that matters, for their errantry is that of a society seeking itself, that has been denied memory, whose filial relation needs reinventing. It is a Morocco in the making, but a lost Morocco, tragically cut off from its values, which struggles, due to this lack of bearings, to invent its modernity.

If accepting the vertiginous is an answer, it can only be poetic. Formerly a photographer, Daoud Aoulad-Syad carefully selected wild landscapes, walls that vanish into the distance, a bare and signifying environment. This bareness echoes modern anonymity, the orchestrated dehumanization of rootless places. Immersed in a world in which any encounter seems only to be a confrontation with oneself, Tahar and Driss share a solitude, which is the foundation of their solidarity (2242).

Escaping marginality does not signify abandoning an empathy with the marginal and the oppressed, but suggests an exploration of human relations and practices in which solidarity is elaborated. It is not about seeking a new and abstract universal (the global, a system of thought), but about contributing to elaborating grassroots hypotheses. Starting from the local, the alliance of singularities of the real is stronger than the virtuality of entertainment. Floating in the world can be a condition of the affirmation of diversity, which is not a denial of the self nor a fixation, but an intuition of a poetry that can guide us.

2.4.2. The Wise Fool

It is not doubt that is at the origin of insanity, it is certitude.

—Nietzsche

"And 2 and 2 make 5" said Césaire, mocking Western reason. In *Notebook of a Return to the Native Land*, he reiterated Baudelaire's provocations: "Because we hate you and

your reason, we claim kinship with the dementia praecox of the flaming madness of persistent cannibalism." Are Africans condemned to laugh and dance to be heard? Or isn't it, rather, to alleviate the grief of pain, like the madman that Ramadan Suleman adds to Njabulo Ndebele's narrative in *Fools*, the first post-apartheid feature film made by a black South African in 1996? (0158).

In both film and literature, when it comes to Africa, the madman is never far, a recurrent character in both screenplays and novels. "If you want to know the truth, listen to the madmen," says the proverb. Bernard Mouralis nonetheless highlighted the strength of Europe's temptation to assimilate Africa with madness: the land beyond all reason, the land of trance, that does not distinguish subject from object. Europe, on the contrary, is the gatekeeper of reason, the lot of the white man. African fiction answers this reduction to psychosis and illness by rooting itself in the real and claiming it as the "body and soul of films," as Gaston Kaboré has often repeated.

But Mouralis also surpassed the supremely derogatory view that he describes. This recurrent reductive image of black people indeed denotes "an incapacity to think the Other, and thus to think the self, and thus to think period!"[43] This clinical vision of psychotic black people confines them to an intractability, even if they remain human, becoming the object of science via anthropology. What counter-discourses have African artists produced vis-à-vis this contradiction? They firstly integrated this negative projection, seeing themselves as the world's madmen—a position they adopted to escape difference and reintegrate the human family. This affirmation of belonging to the universal allowed them to give free rein to their human subjectivity without having to insist on their intractability. But this was to participate in a hierarchical system of thought that continued to treat them with contempt. Their response today is to magnify their human dignity while at the same time claiming their diversity; that is to say, conjugating two complementary, not opposing, movements as this double recognition is a prerequisite for all solidarity.

Denying their irreducibility comes down, in effect, to denying their culture, their values, and their memory and thus to plunge them into schizophrenia, like the ex-colonial infantrymen in Blaise N'Djehoya's 1988 book *Le Nègre Potemkine*, invited to participate in the Bastille Day celebrations in Paris. Or the colonial infantryman who descends into madness on return to his village in Momar Thiam's *Sarzan* (Senegal, 1963), adapted from the final tale in Birago Diop's *Contes d'Amadou Koumba/Tales of Amadou Koumba*. What the village community perceives as madness stems from his getting it into his head to reform everything. It is thus, as

Mouralis points out, "an itinerary that takes him less from reason to loss of reason, than from loss of reason to reason!" He is finally cured by the *ndoep*, a possession ritual that allows the reintegration not only of the person, but also and above all of the mysterious power that animates us.

Traces of both colonial heritage and the liberation struggle are at the root of the psychiatric dimension that Mahmoud Ben Mahmoud and Kamal Dehane added to their adaptation of *Les Vigiles/The Watchers*, by Tahar Djaout, whose assassination by fundamentalists on May 26, 1993, sent Algeria into mourning. Directed by Dehane, the film adaptation was entitled *Les Suspects/The Suspects* (Algeria, 2004). Old age does not treat these war veterans well: they are tormented by old demons that are manifestly related to the current blockages of a society in which vigilance is little by little giving way to suspicion (3599).

"Your stomach is an abyss. Seek the path, seek your heart," the madman says to the fishermen in *Les Méduses/The Madman and the Medusa* by Tchicaya U Tam'si. It is in the meanders of history, in the relationship to the Other, that this disquiet nestles. The colonial chasm was yoke and suffering; despite its passion for frontiers, it pushed the oppressed to assemble. Despite their differences, they spoke with one voice to throw off this yoke. Rather than giving voice to politicians and making their films a discourse, filmmakers gave voice to the madman, who also represented a form of resistance by escaping the imposed norm. "Don't say that you didn't know. Don't say I didn't talk," continues the madman in *Medusa*. Both writers and filmmakers have cultivated this figure of the enlightened madman; madness is no longer clinical here. From *One Flew over the Cuckoo's Nest* (Milos Forman, United States, 1975) to *Fleur d'oubli/Flower of Oblivion* (Selma Baccar, Tunisia, 2006), the representations of mad people are always caricatural, confronted with the unrepresentable. The enlightened madman, however, is metaphoric: his madness is no longer the projection of the Other, but the claiming of a difference that adopts not the voice of reason, but, like Sarzan, that of poetry.

The figures are multiple, but all are characterized by their poetic intuition that allies the memory of trauma and the illumination of the present. The madman in Daniel Sanou Kollo's *Tasuma* (Burkina Faso, 2003) persists in photographing what he sees from a quirky angle, but is capable of teaching and foreseeing, with a lucidity superior to everyone else's. While the women's song sums up the narrative, the madman announces the developments, dividing the film according to days of the week. The scars of the veteran's wound remain painful: it is the madman who mirrors them (2749). The madman in *Delwende* (Pierre Yaméogo, Burkina Faso, 2005)

is the only one who listens to the radio and thus identifies the case of meningitis that the villagers interpret as a curse, the perfect opportunity to accuse the woman who bothers them of witchcraft and to chase her away. But no one listens to him (3850). In Assane Kouyaté's *Kabala* (Mali, 2002), Hamalla, who is expelled from the village because he is illegitimate, returns pretending to be mad so that they do not reject him. He is the one who reveals the fixations with identity and jingoistic attitudes (2352). El Moutanabi finds himself alone on a boat in the middle of the desert. He awaits the flood that will turn his wreck into the Ark while he becomes Noah. He is "a madman outside his time, who awaits a violence from the sky unknown to him on earth," explained Mohamed Chouikh. *L'Arche du désert/The Ark of the Desert* (Algeria, 1999) is a splendid and terrible metaphor that surpasses the Algerian tragedy even to evoke all the tragedies that affect the poor countries of the planet (0108).

Abbo, the eccentric in Jean-Marie Teno's *Lieux saints/Sacred Places* (Cameroon, 2009), who every day chalks up his thoughts and maxims on the metal gates across the road for all to share, as if on a screen, is far from being clinically mad. He reflects, as Sarzan did for Birago Diop, the filmmaker and his questioning (8412). Cinema gives him access to the visible, like the madman in Isabelle Thomas's *Maïsama m'a dit/Maïsama Told Me* (France, 2006) who, for nearly thirty years, lives outside and draws on the walls of Dakar's streets. "The world is my job, my whole body, my fingers, my eyes, my legs, my ears. My feet are like radar!" How to capture Maïsama's world? "I managed to harvest the stars. When the world is beautiful, remember it's me who filled it" (6847).

"The madman represents the truth, because the truth itself is crazy," said Burkinabè filmmaker Dani Kouyaté (2293). Rabah Ameur-Zaïmeche's *Bled Number One/Back Home* (Algeria, 2006) focuses on the glut of madness stemming from the wounds inflicted by intolerance and patriarchy. In the asylum where Louisa is shut away, the women sing that the real madmen are outside (6776). That was what Malek Bensmaïl already had suggested in *Alienations* (Algeria, 2003), in which the psychiatric hospital is a prism reflecting the surrounding society; the Algerian tragedy is central, to the extent that 90 percent of the pathologies are forms of politico-religious delirium, unlike in the West, where solitude and the consequences of alcohol predominate (3454).

How to reconstruct oneself after the trauma of apartheid? In *Zulu Love Letter* (Ramadan Suleman, South Africa, 2004), Thandeka wants to end the grieving that is stuck in her head and paralyzing her life, to find a voice when everyone around

her seems to have lost theirs. She is like Douda D., the visionary madman who wonders where the wind starts blowing from (3570). The madman can go as far as a sacrificial act to assume the burdens of those he is the reflection and double of, like the madman in Faouzi Bensaïdi's *Mille Mois/A Thousand Months* (Morocco, 2003). As Bensaïdi states, "This madman who builds his mosque is, in a sense, the one who pays for everyone; it's as if he dies for them" (2911).

Between the jester-griot and the sovereign is the old mirror play: the griot says what ordinary people cannot and places the ruler face-to-face with himself. If the madman grates, it is not so much because he tells the truth, but because he represents what the ruler will never attain: that touch of madness he so needs not to get bogged down in conservatism and inertia. "Nothing consistent is possible without madness," says Dani Kouyaté; but if power descends into madness, it is no longer power (2775). That is what he illustrates in *Sia, le rêve du python/Sia, the Dream of the Python* (Burkina Faso, 2001), adapted from the Mauritanian Moussa Diagana's play, itself inspired by the legend of Wagadu. "Madness is not given to everyone," the madman Kerfa says to the king when the king wants to cash in on his wisdom at the end of a memorable confrontation. "They are incensed by my tongue, yet they break my nose," cries Kerfa, protected by his madness, but who challenges everything: both power and the way the myth is twisted and abused. For Sia also questions the epic tales handed down by the griots, singing the praises of these epic characters whose bloodthirsty, totalitarian bents are often lauded on the pretext that they bolster nationalist sentiment (2292). In becoming a flatterer, the griot loses his role of critical jester. Burkinabè Missa Hébié echoed this critique in 2010 in his adaptation of Ahmadou Kourouma's *En attendant le vote des bêtes sauvages/Waiting for the Wild Beasts to Vote.* He portrays the cathartic nights of the Koyaga donsomana, in which the dictator of the Gulf Republic, a leftover of the old single parties, "as generous as a goat's ass," listens dumbfounded as his griot tells his cruel history straight (10009).

In 1804, the Haitian Revolution preceded Independence by a long time, but the country was caught in its tragic neurosis. The question of power was central there too. In *Royal Bonbon* (France, 2001), Charles Najman follows Henry I, King of Haiti, a former slave who secured the island's independence and was Haiti's first self-proclaimed black king. Yet Najman does so through a madman, who claims to be the king today and who, in the ruins of his castle, leads a form of collective therapy. Najman explores the close and obsessive relation between the grandeur of the past and the dream of reality that prevents people from grasping it, and which

ends up being deadly, in the image of this brutal despot who committed suicide after a popular revolt plunged him into abandonment and isolation (2890).

In Christian and Kabbalistic tradition, Moloch is a demon who throws newborns into the blaze. When he is in power and the masks fall, it is his people that a tyrant sacrifices to try to restore the authority that his power no longer guarantees. Raoul Peck's *Moloch Tropical* (Haiti, 2010) portrays this clinching moment when power loses its grip, its rituals no longer able to mask its futility. It is at this point that insanity tragically gets the upper hand and precipitates its own end. "You were the hope of the people, you were a priest, you dirtied the dream"; Peck is directly targeting Jean-Bertrand Aristide, but also—and there are many of them—all the men of power who lose a grip on reality in the hyper-protected, closed world of the upper echelons of society. In the film, he too invests the symbolic site that is King Henry's Citadel Laferrière. It becomes the site of parody, the only way to avoid making this tyrant, who so terribly sums up human weakness, too tangible. With panache, Peck depicts the madness and uncommunicative repression of a sinister power that turns inwards to no longer see the reality it faces (9728).

From the madness of the real to the mad deviancy of power, cinema can be therapeutic, for it uses this "mad energy" of the image that Deleuze referred to: "What matters in the image is not the poor content, but the mad, ready-to-burst energy captured, which means that images never last long. They melt into the detonation, the combustion, the dissipation of their condensed energy."[44] It is this tension at play in the image that filmmakers use to rework the real without denying the energy of the world. As for madness, only the mentally unstable know how to capture it, like Khady Sylla in *Une fenêtre sur le monde/Window on the World* (Senegal, 2005). The director of remarkable films (*Colobane Express, Les Bijoux*) and an excellent writer (*Le Jeu de la mer*), she spiraled into illness: "I was delirious; I would feel myself dissolving in the light." She confides in the camera, in a dialogue with her peer, Aminata, and tries for her own therapy to push the limits of the indescribable. "I saw what others didn't see; how to explain this to those who haven't felt it? Pain invaded the world." She adds, in her faltering voice, echoing all these characters who walk in African cinema: "You can get better by walking. Wandering mad folk are not wise Magi: even their walking is a form of resistance."

2.4.3. From Language to Language

He who speaks sows; he who listens harvests.

—Senegalese proverb

The highly progressive South African constitution recognizes eleven official languages. As the SABC, the state television channel, has to divide airtime up strictly in proportion to the size of each population group, screenwriters have to be ingenious and find situations where characters can jump from one language to another depending on who they are speaking to. Out in the South African streets, language is extremely diverse, and while English is the common denominator, it remains the second or third language for most South Africans. The affirmation of local languages is considered an essential advance in the country, a kind of revenge against the imposition of Afrikaans and the marginalization of indigenous languages.

In 2006, the Oscar for Best Foreign Language Film went to *My Name Is Tsotsi* (Gavin Hood, 2005), while *Yesterday*—the name of the HIV-infected heroine who fights to still be there the day her daughter starts school—by Darrel Roodt, was selected in 2005, and Mark Dornford-May's *U-Carmen* (Bizet's opera sung in a township) won the Berlin Golden Bear Award in 2005. This international acclaim—both new and unexpected—for a South African cinema made by whites, with black actors, thus consecrated a specific choice: that of shooting international films in local languages. *U-Carmen* was the first feature film shot in Xhosa; *Yesterday* was shot in Zulu, and *Tsotsi* in Zulu, Xhosa, and Afrikaans. They are considerably more sincere for it. Which is not to say, however, that black spectators flocked to see them. In a 90 percent black South Africa, only one viewer in six is black, a legacy of apartheid, which restricted the major screens to the white-only neighborhoods. Hollywood cinema is the mainstay, representing 93 percent of films screened, and a film like *Yesterday*, which earned $350,000 in the country—a record for a South African film—cost three times more to make in twenty-six days. For these films, the problem is thus meeting international criteria to guarantee funding, which considerably aligns them with Hollywood products (4403).

Imposing one's languages in Hollywood is no small victory, since it is usually the opposite. It is also somewhat like thumbing one's nose. For *Alexandria . . . New York* in 2003, Youssef Chahine chose Egyptian actors and shot in Arabic, even in the scenes that take place in America! Even the American, Ginger, is played by

the magnificent Yousra. This reversal is important: the margins rebel against the imposition of the center's criteria. Similarly, forty-four writers signed the *Manifeste pour une littérature-monde en français* (Manifesto for World Literature in French) in 2007, declaring the death of Francophonia: "We believe the time has come for a renaissance, for a dialogue in a vast polyphonic ensemble, without worrying about who knows what combat for or against the preeminence of such and such a language, or about 'cultural imperialism' of any sort. With the center relegated amidst other centers, we are witnessing the formation of a constellation, in which language, freed of its exclusive pact with the nation, free henceforth of all power other than that of poetry and the imagination, will have no other frontiers than those of the spirit."[45]

This movement opposes the persistence of colonial designs that place French at the center as a vehicle of universal values. It triggered an interesting polemic (9863), but nothing like the gesture of writers who have switched from writing in colonial to local languages, which very rapidly poses the question of circulation. Boubacar Boris Diop wrote a book in Wolof that he later translated into French. Ferdinand Oyono wrote *Une vie de boy/Houseboy* in Ewondo before translating it into French. Ngugi Wa Thiongo stopped writing in English to write in Kikuyu, but soon realized that he had practically no readers in this language. Raphaël Confiant alternates between Creole and French, but has a much wider readership in French. They see a persistent factor of alienation in their historically imposed colonial language and claim linguistic autonomy. But as Alain Mabanckou writes, "Sub-Saharan African literature only emerged when Africans subverted the colonizer's language to recount the world themselves."[46] If Nadir Moknèche shot *Viva Laldjérie/Viva Algeria* or *Délice Paloma* (Algeria, 2004 and 2006) in French, it is because he did not see the value of rejecting a language that has become part of the self, even if it was born out of a painful era (5931).

In the city streets, French has been creolized to the point of becoming "an African language unto itself," as Achille Mbembe points out, through a process of vernacularization "that conveys new resources, in terms of the imagination, representation, and thought."[47] When Joséphine Ndagnou made *Paris à tout prix* (Cameroon, 2007), she captured the highly specific French of Cameroon's working-class neighborhoods. "I didn't want to subtitle it, because when a Belgian or a Canadian speaks, I make the effort to understand," she said (7657). But the lack of subtitles does not only encourage reciprocity; it conveys the belief that a language transmits more than just the meaning of its words. In Laurent Cantet's *Entre les*

murs/The Class (France, 2008), a kind of docu-fiction shot with real pupils and a real teacher in class and often improvised, even though based on the teacher's novel, each character has the gift of the gab and everyone has got their bit to say, usually wanting to have the last word. But the exchanges are not in vain: intelligence is exchanged, arguments refined, expression created, and, by taking on a meaning, words reveal themselves to be useful. And when exchange verges into the dramatic, feeding a truly cinematographic tension, it is again words that are in question, suddenly inflated with a meaning that surpasses them (7619).

In speaking, we communicate with more than words. In Jim Jarmusch's *Ghost Dog: The Way of the Samurai* (USA, 1999), actors Forest Whitaker and Isaach de Bankolé each speak in their own language—English and French—and yet understand each other very well, each repeating what the other just said without realizing that they have (0971). In the same way, intellectuals from opposing peoples communicate without translation in Jean-Luc Godard's *Notre musique/Our Music* (France, 2003). In Abderrahmane Sissako's *Bamako* (Mauritania, 2006), the height of expression and emotion is reached when farmer Zegué Bamba can no longer contain his words and, whirling his fly whisk, delivers a long, spoken-sung lament. We are all the more attentive to his words because they are not subtitled, thereby escaping any exotic projection and reductionism. Heart-rending and profoundly dignified, his cry has the amplitude of an Africa that is suffering, but unyielding.

Spoken language notwithstanding, it is language as expression that emerges, which, going beyond spoken language, makes it possible to understand one another. Shot in Tunisia and Iran, *Bab'Aziz—The Prince That Contemplated His Soul*, by Nacer Khemir (Tunisia, 2005), mixes Farsi, Arabic, and other languages, but the characters understand one another because they speak the same spiritual language: they communicate through their bodies (4381). Differentiating the language we speak and language as a system of expression is relevant because, despite today's ambition to achieve universal communication, there is no single tongue, no chosen one that is capable of conveying the language of everything or of truth. If there was, it would necessarily be a dominating, contemptuous, oppressive language of Babylonian pretensions. Even divine law requires a separation of tongues for God's tongue to be heard.[48] Language does not deny the different tongues, but unites their speakers in a common poetic intuition.

Does that mean that it is possible to shoot a film with actors who express themselves in a language you do not understand, as was the case with the South

African films cited? That is what Darrell James Roodt claimed, talking about *Zimbabwe* (2008), a film about an undocumented immigrant forced to work as a cleaning lady for an abusive employer: "If you want to make a film about Jesus Christ, do you have to have lived when Jesus was alive? The answer is no! If you have an informed opinion about a culture, or a time or a place, you can make that movie. I don't understand the language they speak in the film at all, which is Shona. However, we know when there's a truth and when there's not. For example, there's a truth when they repeat themselves or when they're stumbling, because you're watching carefully" (7684). Yet nothing can replace shared cultural proximity. The same issue arises in documentary, where technical prowess is often necessary. During the shooting of Christian Lelong's *Justice à Agadez/Justice in Agadez* (France, 2004), which follows the hearings in an Islamic tribunal in Niger, a fixed microphone caught the verbal exchanges, and the two cameramen were equipped with an earpiece linked up to a simultaneous translator in another room, who could hear the sound, as it was recorded, in his headphones (3956).

Lee Isaac Chung faced the same problem when he ended up teaching film to a dozen student filmmakers one summer in order to accompany his wife, who was involved in a humanitarian camp for street children in Rwanda. He came with the basic outlines of a film project that found its final form, content, and actors among the refugees of the camp. Shot entirely in Kinyarwanda, *Munyurangabo* (USA, 2007) was chosen for the official selection at Cannes. Deeply sensitive, the film speaks the language of the heart (5965): "It's always been interesting to me to have a communication barrier with someone I'm close to," Chung stated. "My parents are Korean and I'm Korean-American and my Korean is not entirely perfect. I don't communicate very well with my parents. It's interesting to have a very deep and loving relationship with yet a verbal communication barrier. My short films have been in other languages that I don't speak and I worked through translators and I enjoy connecting beyond that barrier" (5964).

The question of language has thus evolved in the 2000s. Using the colonial language is no longer considered a form of alienation, but experienced as a practice of appropriation. The awareness of the cultural diversity stemming from globalization means that it is now established that a film can be shot in vernacular languages. The stake is now its translation; to not consider it mechanically, but to make this a tool of familiarization; in other words, integrate the multiculturality at play in all languages. Rather than the purity of language, it is, on the contrary, its creolization that translation can convey, as Edouard Glissant stated: "The translator

invents a language needed from one language to another, just as the poet invents a language in his/her own language."[49]

2.4.4. A Moral Relationship to the Sacred

Cinema creates a relationship with something other than itself; that is why we enjoy it.

—Roberto Rossellini

On July 26, 2007, the then French president Nicolas Sarkozy gave a speech in Dakar to "Africa's youth": "Africa's tragedy is that African man has not sufficiently entered history. . . . In this imagination where everything begins again eternally, there is no room for human adventure, nor for the notion of progress." Further on he continued: "Beyond the crimes and faults that were committed in their name, and which are not excusable, Muslim civilization, Christianity, and colonization opened African hearts and minds to the universal and to history" (6785). This Hegelian conception of an ahistorical world, prisoner to a natural spirit and saved by the revealed religions and civilization, is based on shortcomings of "the African man" as opposed to the attributes of "the modern man" (read white man), and based on an unfathomable ignorance of the modernities developed in both past and present African realities.

"Since Fanon, we know that it is the entire world's past that we must reexamine; that we cannot laud the past at the expense of our present and future; that 'the black soul' is a white invention; that the black man does not exist any more than the white man; and that we are our own foundation," Achille Mbembe wrote in his remarkable analysis of this speech (6816). That has not stopped a certain faction of the French Right, but also the intelligentsia, from tranquilly respinning the colonial web. The huge success in France of *Des hommes et des dieux/Of Gods and Men* (Xavier Beauvois, France 2010) shows the degree to which France continues to mystify its history with Africa. In this respect, the film avoids any critical reflection, instead favoring the nostalgia of a paternalist and altruistic relationship in which French presence purportedly brought the benefits of civilization, when in reality, the Tibhirine monks were all scarred by the horror of colonial relations and the Algerian War for Independence.

The fascination with the sacred is a mask, just like in the debates that have gripped Tunisia regarding secularism in the post-revolutionary constitution. The fact of having made a film on the subject (originally provocatively entitled *Ni Allah*

ni maître!/Neither Allah nor Master!) put its director, Nadia El Fani, in danger, and she was threatened by fundamentalists because she dared to declare on television that she did not believe in God. *Laïcité Inch'Allah/Secularism Inch'Allah* uncovers and challenges hypocrisy, notably that surrounding the Ramadan fast. The film overtly positions itself in a political battle to be won: to convince that only secularism can enable a multicultural society not to divide into separate communities. But that does not require just judicial affirmation; a pedagogy of secularism is needed for it to become a civic virtue and not just a political principal (10203, 10491, and interview 10571).

The relationship between beliefs and politics is controversial, and few have the courage to broach this subject. In *L'Ombre des marabouts/The Shadow of the Marabouts* (Senegal, 2010), Cheikh N'Diaye looks into the growing power of the Mourides. Using colonial texts and archives, he documents the Muslim Brotherhood's growing influence. But he also creates an archive as he documents the irresistible rise of Modou Kara Mbacké, the Mouride marabout who created the Party for Truth and Development (PVD), defender of "Wolof identity," supporter of President Wade, and whose militia, known as the "Peace Commandos," regularly hits the news. "Abandon yourself to your marabout like a corpse to a corpse washer and you will be happy," says a Mouride precept. The film indeed addresses power, but the subject is so sensitive that the film does not go as far as it could. Its fascination with the sacred and crowd dynamics risks undermining its attempts to warn the public of the possible hazards of the power at play, not to mention the danger that any direct attack on an influential brotherhood that enjoys a very powerful aura among the Senegalese population would represent (9671). In 1999, Malick Sy focused on a specific abuse in *Les Pilules du mal/The Pills of Evil*; namely, the selling of out-of-date medication by traders, protected, as Sy reveals, by their Mouride status (2449).

Film can, however, play a role regarding the religious authorities' attempts to conquer the public space. Documentaries have been made on the proliferation of churches and the manipulations at work, but they are often reductive and condescending, playing on the sensational without accounting for religion's force of resistance in disorganized and oppressed societies. One documentary with the catchy title *Marchands de miracles/Miracle Sellers* (Gilles Remiche, Belgium, 2006) thus banked on the inevitably spectacular aspect of the Pentecostal churches in the DRC, Kinshasa appearing in the film as a new Court of Miracles. We learn very little about the followers, however. Their "desperate naïveté," as the film's synopsis puts

it, is supposed to speak for itself. And yet, aren't these "naive people" the subject: how is a people hoodwinked, which Thierry Michel already explored in *Mobutu, roi du Zaïre/Mobutu, King of Zaire* (Belgium, 1999), a film about the dictatorship? What subtle complicity is at play between a population and those who exploit them? That would have no doubt required more time and a proximity that a young documentary filmmaker popping up in Africa in 2003 found it difficult to take on (4600).

For if these Pentecostal churches are so popular, it is not due to the pseudo-naïveté of their followers, but rather to their appeal to the popular imagination, offering people not only hope amidst the harshness of their living conditions, but also integrity rather than the contempt that they have always historically been subject to. The sacred rituals thus need to be seen as a means of controlling one's environment and physically restructuring oneself. The interdicts and obligations incite moral effort for the well-being of the community. In the absence of a regulating state, or confronted with corruption, religion protects against the ambient violence.

The multiplicity of approaches testifies to creativity, rather than confusion. "There are as many paths that lead to God as men on the earth," Nacer Khemir reminds us in *Bab'Aziz—The Prince Who Contemplated His Soul* (Tunisia, 2006). He readily multiplies symbolism, references, and visions. The filmic puzzle finds its unity through the Sufi sage Bab'Aziz and his vision of a universal quest for the meaning of life, which draws on love and the grand movement of world order (4381).

"It's not me who is lying, but those before us," says the first storyteller. *Angano . . . Angano . . . nouvelles de Madagascar/Short Stories from Madagascar,* shot by Marie-Clémence and César Paes in 1989, indeed starts with a tale about the origins of the world set to incredibly beautiful landscapes, but then goes on to the harshness of farmers' lives interminably stuck in the rice paddies. And when the Famadihana festivities bring families together to exhume their forefathers to joyfully change their shrouds and parade them in a swarming choreography in which the living dare to take the remains of the dead in their hands, a culture of ties and kinship is revealed that an elder insists upon. He indeed recalls that we are all passing strangers—an essential relativity and a spirituality to help survive the suffering that etches faces and leaves eyes staring into the distance (4703). It is not surprising that the Brazilian Césare Paes joined forces with Madagascan director Raymond Najaoranivelo to make *Mahaleo* in 2005. In his two feature films *Tabataba* and *When the Stars Meet the Sea*, Najaoranivelo had also developed this way of giving nature's elements the status of signifiers unto themselves, of making them speak and vibrate. Nature is not a setting, but the driving force of a harmony

that benefits human activity. The magnificent images of *Angano . . . Angano . . .* are thus never illustrations of the tales that constitute its narrative thread, but a second narrative, while the soundtrack resonates more with day-to-day noises than with the accompanying music. This is an impressionist cinema, in the sense of a painting that foregrounds fleeting impressions and the movement of things, while remaining rooted in social reality. Rather than immortalizing narratives and people, this film renders them present, to the point of seeing the storytellers laugh as they hear themselves in their headphones.

"In rural culture, people belong to their land more than they own it," says Gaston Kaboré. It is in the awareness of this intelligence of the relationship to things, the earth, and to people that he has developed his cinema: "How can we develop without losing ourselves, while continuing to reinvent ourselves each day?" (6627). He found his answer by drawing on tales: "The force of the tale is that it is constantly renewed and roots itself in contemporary reality" (7209). Rather than mindlessly reducing this to an attachment to the past, it is a question, in short, of seeing the testimonies of an insatiable repetition and actualization in ancestral words and myths, just like in cave paintings and engravings. This, according to Edouard Glissant, is played over again with every poet: "Writing a poem, or singing, or dreaming it, is to consent to this unverifiable truth that the poem itself is contemporaneous with the first fires of the earth."[50]

To write a poem, make a film, or produce an image is to establish a link, for it takes two to see the world. The original gesture, the trace left on a wall by a hand sprayed with colored clay, is a symbolic proposition that awaits recognition, a spectator. It founds a relationship. As Marie-José Mondzain writes: "Homo sapiens produced the signs that enabled him to hear and see, to be heard, and show the movements of his desire and thought."[51] Henceforth, the death of the spectator is the death of humanity, which is what an entertainment industry that little by little obliterates the spectator's resources will lead to. The stake is thus that images restitute the spectator as "a citizen capable of judging what he/she sees and deciding what he/she wants with others."

Films that develop a moral code of respect in their aesthetics, which implies tact and distance, are in this vein. "While I filmed on the fly in *Bye Bye Africa*, eking out images, here I wanted everything in the frame to be significant, to achieve a dimension of the order of the sacred," Mahamat-Saleh Haroun said of *Abouna* (Chad, 2002). Hollywood films contain thousands of shots; there must be about two hundred in *Abouna*. "Yet it's not a slowness. You capture people when you give

them time. To give a character his full dimension, he needs to be in his space, his truth. So I refuse to clock up close-ups that often give me the impression that they are violating the character. A shirt, a setting can also define them," Haroun stated (2358). Every one of *Abouna*'s images exudes a request for respect by itself showing respect for the subject. This can be felt in the angles chosen, which integrate the elements of the setting and the play of light to reveal just the essential without ever violating the person—the silences and glances, the fraternity and filial sentiment too. This can also be felt in Ali Farka Touré's music, which is contemplative. All this converges towards a moral code that is not at all narrow, a code of respect, a proposition to the spectator. Henceforth, there is no need to demonstrate or spell things out: the image speaks for itself (2357).

By making the sacred Night of Qadr (Destiny) the paroxysm of *Mille mois/A Thousand Months* (Morocco, 2003) and thus placing the film within the time frame of Ramadan, Faouzi Bensaïdi managed to evoke the religious dimension without having to create a character. "On this night, which is meant to be a night of purity, when Satan is banished from the earth, great temptations lie in store for human beings. It's a way of saying that humans are weak and that's what's beautiful about them" (2911). By portraying the relationship between a man and a sacred goat in *Max and Mona* (South Africa, 2004) (6699), Teddy Matera wanted to mix humor and the sacred: "I think God is the biggest comedian and we are too blind to see the comedy that our Creator has tried to give us." Humor is the best remedy against suffering: "that's what kept us alive during apartheid" (5739).

There is a circularity between life and death. "People continue to live after their deaths through the traces they leave in those who loved them," said the Mozambican writer Mia Couto. "In Africa, it is not what is beyond that matters, but rather the quest for this harmony with the dead" (3246). In the Kasaï, where filmmaker Balufu Bakupa-Kanyinda comes from, at funerals the griot calls once, twice, three times and complains that the deceased is not answering. "He shows the living, in a poetic way, that this is death we are talking about, and he starts to tell the dead person's history, which is the history of the living: the elders, the parents, the ancestors, up to the present. In the circle of the wake, he positions each person in his or her place, taking, for example, a past misdeed, and always continuing on from this leitmotif: we are the links of a single chain (2068).

Nedia Touijer's *Le Refuge/The Refuge* (Tunisia, 2003) begins with the chaos of a camera that is forbidden to film: feet, hands, movements, and a filmmaker who defends her work before men who demand the cassette or the camera. These

odd-jobbers, who can be found in all North African cemeteries, are unemployed youth who make a dime or two cleaning up tombstones or selling water, incense, or the bread used in rituals, or even reciting a few suras of the Qur'an. "The hand that receives money is always underhand"; with no legal status, this is in reality a form of begging. Images put them at risk; they fear that if published in the papers, they will be unmasked. The filmmaker respects this interdict; we never see the person who speaks, other than occasionally his furtive shadow, even though this is the only voice in the film. The taboo of the image, whose resonance in Islamic lands is well-known, serves as a point of view. Constantly devoted to a man's words, this film only shows us what he sees (3479). By taking its time from the start, and concentrating on elements in the cemetery (traces of time, white tombs, trees, the play of light, burials filmed from afar), these fixed shots propose a meditation, open us to this voice that speaks of elevation, a veritable philosophy of the relation to the world and death acquired in this daily and founding experience of respect for the dead. And the more it speaks to us, the more the image darkens in the night until there is just a dot of light in the middle of the black screen.

Survival becomes a spiritual experience here, a learning of respect. This survival that draws its energy from respect for death transforms it into a life force. Through its aesthetic choices, *Le Refuge*, which could have just been a sociological description of an urban phenomenon, thus becomes a magnificent evocation, both poetic and mystical, of the distance that awareness of our moral destiny engenders.

2.4.5. Uncertainty

> What is destiny, other than a kindly drunk led by the blind?
>
> —Mia Couto, in "Mia Couto ou la fable du chaos," by Bernard Magnier

"What inspires me to write is what is not fixed, the loopholes, what trembles, what surprises. The reader must necessarily agree to traverse a universe that is not just reassuring, familiar, or transparent," said the Togolese novelist and playwright Kossi Efoui.[52] At the end of these two chapters, it is this incertitude that stands out, which is due not just to the chaos of the world, but also to the artists of the 2000s' claim to it as a path of reflection.

"Incertitude isn't a weakness; it allows us to enter complexities," Glissant remarked, talking to Manthia Diawara in the film *Edouard Glissant: One World in Relation* (Mali, 2010). The uncertainty of today's chaos is the subject Zeka Laplaine

chose for his first feature film, *Macadam Tribu* (DRC, 1996). Between the obligatory heritage of a past of being dominated, and the hesitation of opening up to the world, the film bears witness to a generation's difficulty and will to embrace its hybridity in the contemporary world. It is not the chronicle of a poor neighborhood in Kinshasa, but singles out a family and pulls us along with them: the mother who drinks; Mike, the sweet-talking son fresh out of prison; Kapa, the boxer son whose fight goes badly; but the whites too: a French, an Italian, and a mixed-race man. Beyond the zest for life that avoids the miserabilistic, and the humor that unites the community, being torn between two cultures is unquestionably these endearing characters' most marked feature. "Cultural mixing is primordial for Africans," states Laplaine. "They know the West better than the West knows them. This gives them a better understanding of white society. The risk is losing their way, like the character in the film who no longer knows which way to turn between two cultures and who embraces humor to try to manage this uncertainty" (2439).

The films of incertitude propose no solutions. Spike Lee's films often even suggest that there is no solution. This is not defeatist; Lee simply refuses to offer the black community the positive images it expects, or to deliver a ready-made discourse. The characters in these films of incertitude are complex and their messages ambiguous. The viewer is forced to formulate his or her own reflection. Muddying the usual, reassuring tracks, they oppose systems of thought, and install a hesitancy that is rich in openings and determines both the aesthetic and the narrative treatment. Tariq Teguia's first feature film captures this suspended moment of expectation. *Rome plutôt que vous/Rome Rather Than You* (Algeria, 2007) is more a labyrinth than a cry: the monochromatic streets of nighttime Algiers or the Madrague suburb district; a jumble of half-built houses, of concrete interiors, of upright metal rods (like in his meditative short film *Ferrailles d'attente/Waiting Scrap Metal*, 1998); sandy exteriors; Algeria as a construction site, a desert that Zina and Kamel traverse to find Bosco; the mirage of a false passport to Europe. To capture life, but also to capture the walls that confine it, Teguia allows gestures time, lets uncertainty and expectation hover, and, through a play of ellipses, unrolls the narrative in spirals in which the real is tinted with the imaginary, a dream that actors and viewers share through the physical experiences of a time that dilates in this deleterious climate. The mise-en-scène loops and readily mixes registers, and Teguia deliberately films from behind—not only his characters, but also the other character that inhabits them: Algiers and Algeria. He allows himself astonishing freedom, de facto amplifying the effect produced by a car driving in the night or

a game of football improvised on the beach. The freeze-frame shot of Zina's face that ends the film is all the stronger for it. It is not the frozenness of death; it is, like the ending of Truffaut's *400 coups/The 400 Blows*, a breath before what comes next, which will be painful, but which, because it is rooted in freedom, has still to be constructed (7458).

For uncertainty's state of suspension is neither absence nor void. Zina and Kamel are constantly on the move, as is Malek in *Inland*. Their quest is anything but static or idle. It sketches a topography that is no longer a territory and certainly not the nation, but a desire to be inscribed in the world. On screen, as in life, it opens perspectives. As Edouard Glissant again wrote: "Frequenting the thought of the unpredictable is to manage to escape the upheaval that the unexpected in the world incites in us, and moreover, to become more and more ingenious in creating, in these interruptions of the real, a continuous possibility of human action."[53]

This time of active waiting also characterizes *Tarfaya*, by Daoud Aoulad-Syad (Morocco, 2004). As in *Adieu forain/Farewell Traveling Player* and *Le Cheval de vent/The Wind Horse*, what interested him was not constructing a dramaturgy, but representing this instant in which bodies float in expectation or in quest, this instant that lasts because they remain unfulfilled. Poet-like, he explores the tensions of this foray into the subtlety of the memory of bodies that carry their past without opening their future. Unlike so many North African filmmakers, Daoud Aoulad-Syad does not portray confinement in a closed space; he prefers the shot of cricket song in the desert, the fixedness of derelict houses in a sea of sand, the horizon of omnipresent waves (4689). The same is true in his fourth feature film: a plastic bag snags on a bush before being blown away by the wind. Where *Waiting for Pasolini* begins, *Tarfaya* continues. We find the same photographic image attentive to objects and signs, the creation of perspective through the use of vast open spaces, the time of beings rather than of the narrative, an imaginary in-betweenness that magnifies the characters, a general floatingness of waiting and quest, a latent sensuality, poetry as both a writing and a vision of the world (8198). As in Abderrahmane Sissako's *Heremakono*, this aesthetic of the wind that blows and of in-betweenness fixes nothing, judges no one, establishes no certitudes, sets out no solution, contenting itself with this zone of sensitivity and listening.

Do these films of the uncertain form a school? "Ruptures result from a group dynamic," says Mahamat-Saleh Haroun. "Godard or Truffaut alone would no doubt not have had the same impact. A synergy is necessary and that is what we are lacking" (3685). But the New Wave filmmakers found a truth in cinema that gave

the impression of belonging to both a family and to history, that of cinephilia. "No player in today's generation—apart maybe from those of the Dogma—inscribes their filmmaking in a collective approach capable of surpassing the singularity of their experience."[54] These are vertiginous times of solitude. Cinema places us before our shared individuation, in keeping with an unpredictable world in which each and every one of us must resolve both ethical and social questions ourselves, without being able to refer to the unanimity of a group or civilization. This solitude of existence is also that of the viewer, who starts to expect a self-understanding from cinema that might enable him or her to find peace; in other words, a psychological cinema.

Yet this expectation is untenable, in that it is that of an individual and not a person, to borrow Miguel Benasayag's distinction.[55] While a person is constituted out of his or her ties with the world, the individual is separated, isolated from it. Convinced by the consumer system that he or she is capable of dominating the world, he/she lives as an abstract entity, free of his/her choices. Henceforth, he or she spends his/her time sadly wondering why he/she is a man or woman, or why he/she is black or white. Devoid of ties, he or she is lost and powerless. He or she lives his/her destiny as a fatality, whereas the awareness of his/her ties would enable him or her to espouse the movements of his/her time. For, as the Mahaleao sang, "the night here is not calm / each for himself, we won't make it / resolve it." What is at stake is reestablishing this tie, and film has a role to play as it is capable of establishing the relationship between the planet's places. It is thanks to film that we can know and feel the web of cultures and the fiber of the living in all their multiplicity, to "flutter from the very fluttering of the world," as Aimé Césaire put it.

In his final film before his death—*Questions à la terre natale/Questions to the Native Land* (Senegal, 2007)—Samba Félix N'Diaye asked himself, before the chaos of Independence, where hope lay. His old activist friend Serigne Babacar Mbow, who had retreated to the village of Ndem to develop an artisans' cooperative capable of exporting, and of all kinds of educational activities, formulates a simple idea: "Utopia is the twin sister of resistance" (4706). This implies remaining flexible to avoid rigidity and thus to address these tremors that are both the vibrations and tremors of the world. "The power of imagination is utopia each day; it is realist when it prefigures what will, for a long time, allow us to accompany *the actions that do not tremble*," wrote Glissant.[56] Samba Félix N'Diaye's utopia is film, this gaze that incites reflection, to "preserve the humanism when we become developed."

The path of independence is not an easy one. It is still open. It is young people's turn. Reality can be terribly harsh, but film is not there to point the finger. Rachida, in Yamina Bachir-Chouikh's eponymous film (Algeria, 2002), has no ready-made solutions; she can only try to give hope and courage. For there is life, in each person. We need, in spite of the horror, to see these children set out on the path to school again, and to see this teacher take up her chalk. The camera frames the blackboard: another film opens, the director's, Algeria's (2355). For as Fidel Castro said to Wole Soyinka: "You are right to lose hope sometimes, but you have not the right to lose hope" (5541).

Postcolonial Clichés

I am the other, the stranger who upsets that humanity gig. Who laughs for no apparent reason. The unkempt face of the void. The irritating face of your twisted constructions, the shadow of your unconscious that has oozed from your oh so perfect imaginations. Erupted real to test you headiness.

—Raharimanana, *Les Cauchemars du gecko*

3.1. A Persistent Misunderstanding

They say Africans are not ready for democracy. So I wonder: have they ever been ready for dictatorship?

—Wole Soyinka, in the film *Black Business*, directed by Osvalde Lewat (Cameroon, 2007)

3.1.1. Colonial Revisionism

"Africa is a more or less dangerous *guignol*," Roland Barthes wrote ironically in his article "Bichon and the Blacks," published in *Mythologies*. That was in 1957, on the eve of African Independence. But have such viewpoints changed today? Film as

a medium has played a considerable role in entrenching the colonial clichés on which discrimination is founded. Things are changing, but film still contributes to this process.

Combining remarkable iconographic research that has given rise to exhibitions, books, and films, and historical analysis identifying trends and characteristics, ACHAC (the Association for the Understanding of Contemporary African History) has revived essential memory in order to deconstruct imaginations and representations born out of the colonial encounter. In *Paris couleurs—un siècle d'immigration en images/Paris Colors—A Century of Immigration in Images* (France, 2005), Pascal Blanchard and Eric Deroo examine the archives to document the filmic stereotypes constructed in the nineteenth century: the black-skinned African is a big child who knows how to dance; the brown-skinned Arab is fanatical and dangerous, making constant demands. These paternalistic, racist clichés have fed a whole host of collective fantasies reiterated in film. In cinema, black people are never thinkers, they are performers—for example, Josephine Baker with her string of bananas around her waist during the interwar "Negro Vogue." Having disappeared completely from ads in a post-Independence flurry of guilt, they returned with a vengeance in 1980s advertising, following the same old schema: sports and rhythm. Black fashion signaled the end of the collective guilty conscience and the decline of Third-Worldism. As the *Negripub* exhibition demonstrated, the same paternalistic and racist images made their comeback without the slightest protest (1364).[1] "Today, integration, discrimination, communitarianism, fundamentalism and racial division have replaced the figures of the native, the child of the colonies and the noble savage to mark our relation to the Other in new stereotypes that draw on the old," state Blanchard and Deroo.

As such stereotypes take hold, discrimination and the banalization of extremist discourse are facilitated. Extreme right-wing leader Jean-Marie Le Pen's arrival in the second round of the French presidential elections in 2002 revealed how a considerable fringe of the population was willing to vote for ideas not dissimilar to those that the previous generation had fought against, and lost their lives over, when Fascism took hold in Europe. This banalization is often conveyed in jokes nonchalantly exchanged among friends, who use expressions like those that the French hotel owners in Melvin Van Peebles's *Bellyful* (USA, 1999) constantly apologize for saying (a "little black," for a coffee, the "black sheep" of the family, etc.) in front of the Congolese waitress they have found in an orphanage. Faced with her reaction, the mask of their hypocrisy slips: "You can take a girl out of the

jungle, but you can't take the jungle out of a girl" (1552). The black man remains a savage, and it is savagely that Timothy (Isaach de Bankolé) takes Grace (Bryce Dallas Howard) in Lars von Trier's *Manderlay* (Denmark, 2004), succumbing to the blond white woman's fantasies, both terrified and fascinated by savage nature, a theme largely developed in *Tarzan* and the like. The ambiguities do not end there, the film depicting a plantation scene in which the slaves prefer to renounce abolition than face a new condition (4113). Saartjie Bartman too, who is exhibited in fairgrounds and salons, is constantly denied the possibility of being an artist and reduced to her "savage nature" in Abdellatif Kechiche's *Vénus noire/Black Venus* (Tunisia, 2010) (9829).

As for Arab women, they are generally portrayed as the brutalized or oppressed victims of Arab men. Hassen Daldoul, producer of Mahmoud Ben Mahmoud's *Les Siestes grenadines/Grenadine Siestas* (Tunisia, 1999), pointed out how hard it was to get funding in the North because the young woman in the film is the very opposite: she has the necessary vitality to challenge moral codes and unmask hypocrisy. Her mother is French, her father Tunisian; she speaks Arabic, but comes from Dakar and is into African dance (0036). "This is a permanent misunderstanding," the director commented. "We make films that are really hard to fund, but which are necessary, for this is the only memory we have to offer our children as the politicians confiscate all other creations" (2905).

In chapter 2.4.4, we already evoked Nicolas Sarkozy's infamous speech given in Dakar in July 2007, which triggered a fierce debate. *Africultures* published the speech (6785) along with Achille Mbembe's analysis of it, an analysis that was frequently cited and drew numerous comments (6784, 6816). That led Mbembe to further develop his reflection in an article entitled "The Idiocies That Divide Us" (6864). This analysis of the attempts to rehabilitate colonialism is vital, considering that a revisionism is at play, which legitimizes and reinforces the aforementioned stereotypes even further. In this process, colonialism is hence no longer considered a crime, but rather a fault, tempered by the so-called unfairly overlooked devotion of the colonizers and their good deeds. The refusal to repent eschews any form of critique, which is accused of being the doing of those who *blacken* history. This work nonetheless widely exists, but is relegated to the margins, because "black people" are an abstract being.

Old qualifications die hard, which is why Osvalde Lewat entitled her documentary on the roundups orchestrated by the Cameroonian government in Douala in 2000 *Une affaire de nègres/Black Business* (Cameroon, 2007): "I wasn't borrowing the

colonial term by using the word 'nègre' [Negro], but an absolutely contemporary term. Even though they think it, people don't have the guts to say 'Negro,' but it is translated in their acts, in their disinterest" (7695). It is better to cultivate a reductive image to preserve the interests of the *Françafrique*. The loss of empire remains a trauma for many, which former colonial subjects inflame when they claim to be intrinsically human. It is by excluding the Other that people define themselves: qualifying someone as savage establishes one's own superiority. People forge their unity by excluding that which is different.

3.1.2. Decontextualization

This happens in extreme arrogance and with the best intentions in the world. Royal de Luxe, the biggest street theater company in Europe, has marked the imaginations of thousands of people. The birth of the "Giant," his capture, his flight, and his return brought the Gulliver myth back to life for generations of adults and children. In Dominique Deluze's *Royal de Luxe, retour d'Afrique* (France, 1999), the troupe goes to Africa, the "magical continent, full of dreams and rituals" (to cite the synopsis), and more specifically to Cameroon to "blend imaginations" as the puppets perform tales. Rather than setting out to meet another imaginary, however, the film reveals Europeans out to conquer the imagination of Africans, considered ignorant because they lack theater traditions (a complete falsehood!). Rather than exchanges and encounters, Deluze offers only images of young Cameroonians alarmed by the spectacularly imposing giant, and interviews spectators, one by one, with a photo-booth framing, retaining only the laughably ingenuous and awkward answers (1348).

Ah, the derisory force of the anecdotal, which maintains Others at a distance, shutting them in their difference! French director Laurent Chevallier cannot be accused of treating Africa through the prism of poverty or aestheticism, the two congenital flaws of the Western gaze when focused on Africa. But, in his adaptation of Guinean writer Camara Laye's *L'Enfant noir/The Dark Child* in 1995, he began the film with a whole string of clichéd images: the harvest, the goldsmith, the departure sacrifice, the circumcision ceremony, the bush taxi, the chaotic roads, etc. The light is dusky, the tones predominantly ocher, the kora enchanting as the grandfather's words crown the ensemble. No cliché is forgotten, as if to reassure us, saying: "This is Africa" ("our home," says the black child) (3046). He thus seeks to show while claiming to instruct us, yet this kind of image bears no knowledge and is not at all

self-evident; it claims to inform, but as an imaginary construct, in reality it makes believe (and, when it adopts the institutionalized discourse, has us comply). In his 2004 documentary *Voyage au pays des peaux blanches/Trip to the Land of the White Skinned* (2004), Chevallier again follows Baba, now aged twenty-two, on his journey to France to meet junior-high-school pupils who have watched *L'Enfant noir*. The result is dreadful: the noble savage discovers technology (oh, the high-speed train goes very, very fast), is awkward (he does not know how to do up his seat belt on the plane—close-up shot of the seat belt), ignorant (Are they sheep? No, they're cows!), and we are going to have to educate him (his guide is the paragon of well-meaning paternalism) (3054). Chevallier retains sensational anecdotes, just as he explains regretting not having been able to film Baba's discovery of an elevator in Conakry in *L'Enfant noir*. Preceded by this film that "charms" the audience by offering it a fantasy of origins rather than real origins (what cave paintings are to the image, in other words, anything but spectacle: the illustrated awareness of the fragility of mankind that encourages it towards more humanity), it was quite a burden for poor Baba to remain himself before so many projections. He comes out of it pretty well, for that matter, but the film barely focuses on this, Chevallier being too busy ridiculing his surprise and his fears (3038).[2]

Anecdotes, a characteristic of the chronicle, amuse or edify; they trap the real in cliché and decontextualize, in the sense that they revolve around themselves. This is contrary to the function that is essential in film, and notably documentary, namely, helping to understand how a situation or state arose, which is the only way of reinforcing courage, as it inscribes facts in a history in the making. *Kafka au Congo/Kafka in Congo,* Marlène Rabaud and Arnaud Zajtman's first film (Belgium, 2010), draws a parallel, in Kinshasa, between a brave woman who unsuccessfully goes to court to try to get back her home plot that the local chiefs have sold to someone else, and the parliamentary elections, and notably the election of the parliamentary administrator who is in charge of accounts, and who dishes out favors according to often obscure rules, in a reign of cronyism. The fact that the directors were France 24 journalists posted to Kinshasa enabled them "not to be limited to filming in the street," as Arnaud Zajtman noted somewhat condescendingly to all those who so readily film tracking shots of African streets from their taxi windows. Parliament is portrayed as the haunt of a bunch of crooks who speak nothing but money, while a canvassing candidate hands out banknotes all round. This Kafkaesque description of corrupt institutions is perfectly disheartening for the Congolese, and for Westerners, and confirms all the usual deeply rooted clichés (9671).

Sad Tropics? This was not what Levi-Strauss meant. The sadness he was evoking was the melancholy of seeing cultures perish, not this reductive, static stereotype. Congolese reality is unquestionably sad; but not content just to evacuate all complexity, the film does not contextualize either. This is how reports are made, not cinema. "That is what cinema is; the present never exists in it, except in bad films," said Godard (8862). For, without putting things in perspective, no future can be envisaged that makes it possible to stimulate potential. There are shots that are categorical, like the elected representatives asleep in the chamber. Incompetence, irresponsibility, corruption, nepotism—nothing is missing. Decontextualized, these become character traits, determinism, as if inscribed in their genes! How, in this light, can one imagine that Africans are capable of managing their affairs for themselves? The diversity of ways in which the democratic system is applied throughout the world is inseparable from the artifices and expertise that put it into practice, and it remains deeply dependent on the play of interests and the vicissitudes of history. *Kafka au Congo* amounts to seeing how, in DRC, a supposedly virtuous model is hijacked; in other words, it is anthropology that takes the "savage" as an object to question his or her capacity to enter the schema of civilization. How, then, to understand a title that recalls *Tintin in the Congo*? It participates in the derealization of the world to better express our fantasy of it.

3.1.3. Ethnocentrism

The road to hell is paved with good intentions. In the 1980s, I was a translator. In this capacity, I adapted several German-language children's novels written by Westerners about children or teenagers from the South. I didn't realize quite how ethnocentric these entirely fictional stories were at the time. The author developed the point of view of a young person from another culture as if talking about himself. Full of good intentions and without realizing the incongruity of his approach any more than I did, despite reading and translating it, he developed characters that a young Western reader was meant to identify with; in other words, with all forms of alterity erased from their feelings, ways of acting, logic, strategies, or conclusions. Gerardo Olivares's *14 Kilometers* (Spain, 2007) starts out from the same premise, which is unfortunately not unusual in both literature and film. The result is distressing, for rather than contributing to an understanding that might foster solidarity, it cultivates misunderstanding and reduces the Other—the immigrant—to a Manichaean posture of victim that elicits only truly passive and

sterile compassion. The desire to describe the difficulties of the path that illegal immigration takes in Africa—notably, crossing the desert and borders—is bogged down here in a pathetic, touristy vision, the shots alternating between the agony of migrants dying of thirst and aerial shots that aestheticize the wild aridness of the desert. The perfectly improbable romance between the two main characters undermines any attempt to give them any depth with regard to their own stories. To advance the plot, our heroes overcome the obstacles and gain the pity of the police. This just makes you angry, the film so distorts the tragic reality to meet the needs of a slushy story that has the cheek to close on a happy ending! (8306).

My virulent criticism of Marion Hänsel's *Si le vent soulève les sables/Sounds of Sand* (Belgium, 2006) provoked a fierce debate that can be read on the website (5771 and 5770). How did she have the gall to turn a child made to walk through a mine field into a sequence of suspense? And to insist on turning Africa's tragedies into a Manichaean, ragbag thriller, in this case the tragedy of villagers driven out of their village by drought and thrust into the cruelties of civil war? Child soldiers, military arbitrariness, extreme drought: all the ingredients are present, but, of course, this ugliness is the ugliness of violence, not of the landscape. Marion Hänsel stated that she looked for locations in Morocco, but in the end found the beautiful sites and suitable faces she was looking for in Djibouti, regretting, however, that Djibouti was more expensive. This reminds me of the French screenwriter-producer of *The Wooden Camera* (Ntshaveni Wa Luruli, South Africa, 2003), who had planned to shoot in a Rio favela, then on a British housing estate, before finally deciding that a South African township would do the job and was cheaper (3350).

In literature, as in film, this fiction of Africa takes two forms. Either people use Africa as an excuse to harp on about the universal, because Africa is a beautiful setting and there is no need to explain why people suffer there, which is meant to be obvious. Stories that could be set anywhere are thus set in Africa: in Marion Hänsel's film, we have an ecological tragedy doubled with the story of a father who learns to recognize his daughter. Or people read up on and construct a fiction to bring to light a local issue, which is necessarily dramatic. A voluntarist approach, this second scenario more often than not veers into didacticism and superficiality. It is the dramatization of a message, rather than humans in crisis.

By thus constructing survival fictions in a decontextualized Africa, we do not hear or see the vision, story, or words of the people filmed, but a translation constructed in another imagination that thinks it knows and thus takes over. This is pathetically self-important and arrogant. The tragedy is that, thanks to marketing

and good intentions, these films often target young audiences in whom they plant deep prejudices. These youths are invited to identify with these nice young people from elsewhere with no distance, because they talk like the young audiences do. This is the epitome of manipulative illusion: what I share with the Other is an image of myself and not what or who the Other actually is. Dubbing completes this ethnocentric projection. Such films are legion, and their timelessness enables them to be broadcast again and again on television for years. Jacques Dubuisson's *Imuhar, une légende/Imuhar: A Legend* (France, 1997) admires Tuaregs so much that the director freezes them in picture-postcard images and stereotypical dialogues. Everybody is beautiful, and there is nothing conflictual in this idyllic portrait of what is presented as an unchanging society (0191). *Massai, les guerriers de la pluie/ Masai: The Rain Warriors* by Pascal Plisson (France, 2004) documents Masai culture through a group of adolescents' passage to adulthood. Here too, the ocher filters plunge the African landscape into a stylization that reinforces it as a backdrop. Africa is trapped in a vision of the origins it cannot escape because this origin is not understood as a passage, but as a constant. The origin here is not the source of values that are useful for the present (myth), it is the very component of alterity. It is a bit like saying to Africans that they are (and can only be) the raw material, and that we, on the other hand, are the processed product (3668). In Eric Valli's *La Piste/The Trail* (France, 2004), the young Grace comes to live with her geologist grandfather in Namibia, but he disappears in the desert. Accompanied by an African guide, she sets out to find him. Valli, who used to be a photographer for *National Geographic,* seeks an effect in every image. Pivot to the right: goodness, giraffes! Pivot to the left: fancy that, zebras! We sense his fascination with wild nature, both beautiful and threatening—and for men, both tender and cruel. And in this mishmash of hackneyed adventures, pompous lyricism, and patronizing sentimentalism, the film claims to introduce us to Africa! (4287).

In Alexander Abela's *Makibefo* (UK, 2001), Madagascan villagers perform a Macbeth whose ambition drives him to murder. They are completely disembodied, a visual setting that meets the canons of photographic aestheticism in a story that is not their own. The director was apparently interested in their so-called naïveté, as if he needed to go and find "primitives" at the ends of the earth to better illustrate the universality of the theme (1862). This kind of approach is not uncommon either, for example in *Blue Bird*, by Gust Van den Berghe (Belgium, 2011), who adapted an old play by Maurice Maeterlinck, a classic of Flemish literature set in Russia, and transposed it to Togo. "In Africa, there is a kind of natural simplicity that's impossible

to find in Europe," he wrote in the press kit. The problem is that choosing Africa is not innocuous in the historical and intellectual context of Euro-African relations. Presented as an African tale about life and death, and shot entirely in blue tones, the film simply steals Africans' image from them without even allowing them their true colors! (10203)

The eye of the camera is like the eye of the beholder: it is truly worthwhile when it changes our outlook. On a French cultural television talk show, *Le Cercle de minuit*, presented by Laure Adler on September 26, 1996, French filmmaker Raymond Depardon became incensed when the African filmmakers present criticized his film *Afriques, comment ça va avec la douleur?/Africa, How Are You with Pain?* Mauritanian Abderrahmane Sissako and Malian Adama Drabo rejected Depardon's yet again partial gaze. Although his African guide was full of life, Depardon filmed only pain. Depardon brandished his lack of miserabilism like a certificate of good conduct, but in the honesty of his personal errantry and touching incertitude, he filmed only what interested him. He made a selection and defended this choice. In his eyes, then, Africa is just pain, both an echo and mirror of his own, even though the question "How are you with the pain?," traditionally asked in certain African countries, is a question of life: "How are you managing with life? Are you in peace?" In the film, the women carrying heavy loads of wood become voiceless exploited figures. Indeed, this gaze that makes everything about the director does not account for these women's consciousness or their daily combat to change their condition (2431).

African pain can also be regenerating for lost Westerners, in the image of the doctor played by Richard Bohringer in *Libre/Free* by Jean-Pierre Sauné (France, 2002), which follows three Dakar street children. Underlying the film is the Christian-like commonplace so often heard: through their determination and humility, the wretched allow us to surpass our individualism and self-centeredness, to see within ourselves more clearly, and to mend our ways (2450). This kind of generous approach builds readily on African solidarity, the community spirit, human warmth, and respect for the elders, which we know in reality are considerably more complex and contradictory than the generally evoked tropes.

3.1.4. Demobilization

Hubert Sauper's *Darwin's Nightmare* (Austria, 2004) denounces a Tanzanian traffic in which Nile perch fished in Lake Victoria are traded to Western buyers in exchange

for arms. The basic argument is that Western countries pillage resources in under-developed countries, selling their people weapons with which to kill themselves. On the ground, in addition to ecological disaster, are AIDS, prostitution, famine, abandoned children, and so forth. Due to the film's huge box-office success, Western consumers hitherto partial to Tanzanian perch started to boycott it, devastating the local economy. "I already had this film in mind before filming it," Sauper stated. Hence his decision to "audition," to use his expression, to find good examples and good characters who confirmed what he wished to demonstrate. Why was the film such a hit? Sauper offered an answer: "it is the film's aesthetic form that attracted attention." Indeed, it is very powerful in the way it imposes Sauper's vision as truth. Never does he question his point of view. On the contrary, the frequent comparisons made by juxtaposing shots work to present reality as unequivocal: it is self-evident; one only has to wade right in and capture it. And indeed, it cannot be denied that is precisely what Sauper does, right down to filming a refuse truck full of unsavory fish waste. He is not the kind of filmmaker to make a film in Africa as if he were going on vacation. His previous documentary, *Kisangani Diary* (1997), on the trail of Rwandan refugees in Zaire, was a veritable descent into hell, a sincere testimony to his dismay.

Zero commentary. Occasionally a few bits of information given in intertitles. No on-screen appearances either: Sauper is not Michael Moore. It is not about him, even if he does produce images that sell well. Sauper's art is to intuitively draw the viewer into his state of alarm, which is truly nightmarish. No figures, no economic arguments, no interviews, no reporting, but an immersion, rather. Through successive encounters, Sauper moves further and further away from his initial subject (fishing) to better encapsulate his overall intuition. His pedagogy is in the emotional shock of what can only be reality and the truth.

"It's incredible what you can do on the editing table," Sauper says in the interview in the DVD bonuses. A woman stacking unsavory carcasses on drying racks has one eye, the empty socket hidden by a cloth. The ammonia gases that the rotting fish give off attack the eyes; even if this was not staged, the uncovering of this damaged eye plunges the spectator into a state of horror. All the more so as the film shows that the local population can no longer afford the fish once it has been fileted in modern factories, and are left with just the fish heads, which people eat all over the country. Street children grab handfuls of a meal too paltry to feed them all. Sauper thus triggers a sentiment of shame in the viewer-consumer, who finds him/herself an involuntary actor in the world's disorder.

That is the fundamental ambiguity: do deliberately shocking images mobilize? Ultimately, this film overwhelms us and sparks a feeling of resignation. Guilt serves the ego: we are only crying over ourselves. And the audience calls out for more; an astonishing phenomenon of self-flagellation causes people to rush out to see a film that they well know is upsetting, and from which they will not be able to extricate themselves. With the bracing exception of a few skeptics, the critics were unanimous: "Don't miss this stunning indictment that calmly carries out an autopsy of horror" (*Première*); "this superb thrilleresque documentary" (*Télérama*, which declared it the film of the year); "this new apocalyptic vision of Africa" (*Les Inrockuptibles*); "this suffocating immersion in the major powers' cynicism and the guts of poverty" (*Rolling Stone*); "This topic is as tense as a thriller, as edgy as a detective story, and as engrossing as a melodrama" (*Ouest France*); or "a dark and gripping film" (*Libération*). What, then, is the strange fascination for a truth hammered out even though we are all already aware of it: the dereliction and terrible immorality of the world? If audiences were keen on demonstrations of North-South relations, they would have flocked to see Olivier Zuchuat's excellent *Djourou, une corde à ton cou/Djourou, a Rope around Your Neck* (Switzerland, 2004), which slipped by unnoticed (3866). How, conversely, is it possible to affirm *Darwin's Nightmare*'s "objective evaluation" or "self-evidence" (*Chronic'art*)? Since when is an image objective or self-evident given that it is always a construction?

If the director says so, these weapons and planes necessarily exist. There is no rigor of a journalistic (or any other kind of) inquiry here: we take his images at face value.[3] And thus measure the real place that Sauper allocates us: that of sharing his certitude, not rationally, but intuitively. As viewers' brow-beaten demeanor showed on the way out of the movie theaters, the film leaves us speechless and disillusioned, discouraged and disgusted. Is our vision of the world thus built on rumor? We are aware that capitalism is never tender anywhere, but should this rob the issue of all complexity? Is Mwanza only this display of poverty that the film rolls out? By presenting the global system in black and white, *Darwin's Nightmare* posits Africa as the continent of pain more than it calls on the viewer to react (4319).

3.2. A Troubling Western Gaze

> At least look me in the eye. For the first and last time. Show me at last from which
> darkness sparkles that love. At least show me your eyes.
>
> —Koffi Kwahulé, *Misterioso 119*

It is not a rule, but rather a trend: films on Africa by Western directors find their justness and their pertinence when they take their own relation to Africans as the subject. Of the films made in the 2000s, Chantal Richard's *Lili et le Baobab/Lili and the Baobab* (France, 2004) strikes me as a reference in this respect because it addresses this relation as the subject from the outset (4380).

Julie, known to everyone as Lili, a town hall photographer in a small town near La Hague in Normandy, is sent to photograph installations funded in the twin town, Agnam Lidoubé, in Senegal. She thus finds herself transported to an unfamiliar world, and the opening shot of the film shows her, head out of the window of the taxi that is taking her to the village, as she closes her eyes to "drink in" the heat. We indeed see best with our hearts, and Lili arrives completely open.

Welcomed by the entire village, Lili takes photos. She does her job, but also lets Africa make its mark on her. Her gaze is panoramic, for instance when she climbs up the water tower, giving a view of the distant bush bathed in sunlight. She is constantly in the picture: she is the subject, her feelings, her gaze. The film espouses her rhythm, and it is because she takes the time to observe without judging that it settles into a tempo where each detail is significant. The African language is not subtitled: we hear it as Lili does. The image is often fixed, or accompanies people's movements. There is no tourist bluff, no sunsets, no spicy anecdotes, not even the sociology of daily chores that films on Africa are full of.

She quickly overcomes the language barrier and becomes friendly with Aminata, no doubt because she recognizes herself in the solitude of this woman who is at the service of others. Aminata gives her a gift: a ring. In *Itto* (Jean Benoît-Lévy and Marie Epstein, France, 1934), one of the classics of colonial cinema, the French major takes a ring from his little finger and puts it on that of the chief of an Atlas mountain tribe, as a symbol of their new alliance, following the revolt led notably by Itto, a woman. Wasn't colonization destined to seal "the marriage between Africa and the West"? When Aminata offers Lili a ring, it is not an impossible or unequal relationship; it is the simple expression of sharing.

But an event occurs that forces Lili to get more involved. It is in what she perceives of African culture that Lili will draw her response, at the foot of the baobab. This response is perfectly just: that of a possible, intimate, and subtle relationship based on solidarity, in the image of this beautiful film.

Laurence Attali has long explored this relationship and her love affair with Senegal, making her aforementioned *Trilogie des amours/Trilogy of Love*. In *Le Temps d'un film/Film Time* (France, 2007), she sketches a picture: with great sensitivity, she draws the lines of this dream of the third film, which will, in the end, be the product of a hard negotiation with various constraints, a painful birthing to be sure, but also a joyful and beneficial journey. And because love is like that, it is also a bereavement of a project that keeps on dying, only to be reborn—sort of—so true is it that there is no creation without uncertainty (7195).

For Stanislas Adotevi, "the only ethnology possible is that which studies the anthropophagous behavior of the white man."[4] That is what Frédéric Chignac does in *Le Temps de la kermesse est terminé/The Time of the Charity Fete Is Over* (France, 2009), the charity fete being colonialism. Caught by a blackout in a tiny, sweltering village lost in the middle of the desert somewhere in West Africa, Alex (Stéphane Guillon) is despicable, but we know that truth is stranger than fiction: he sums up everything that white people still inflict on a torn Africa. He is unbearable, but remains complex, so much so that he is not a caricature and the film does not wade into self-flagellation. Alex (short for Alexander, the Roman emperor) is the product of what the derisory power of money does to humans; he represents inequality and the contempt that it allows. Lieutenant Bado (Eriq Ebouaney), who runs the little barracks, takes it on himself to put him in his place; he will not be bought or wooed, and represents an upright, necessarily voluntarist Africa that is not without its own contradictions (9274). Although the film is deeply disturbing, it is always shot from Alex's point of view, positioning the viewer in this situation in which, while the time of the charity fete is over, the charity fete itself is still there.

To disturb is also what Laurent Cantet's *Vers le Sud/Heading South* (France, 2005) sets out to do. The film is an adaptation of Dany Laferrière's eponymous novel, itself based on his 1997 collection of short stories, *La Chair du maître/The Master's Flesh*. Set in Haiti, it portrays the master-slave dialectic through the desire at play in the relationships between white women and young black men. If both film and novel disturb, it is that they are anything but Manichaean, which would simply have produced a treatise on sexual tourism. This shared desire is founded on suffering:

the women of the North are subjected to patriarchy and puritanism; the young men of the South suffer the cruelty of their country (4278). Yet, as Nimrod points out, the women dominate through their money, but also in their ability to arouse desire, unaware or indifferent to the risk at which they put their objects: the slave who gives in to the master's advances is condemned (6735).

What is exoticism? An idea of the Other, a projection of the unfamiliar—be it a person or a landscape—the setting of our desires, our fantasies, our utopias. An image, in other words. Exoticism demands postcard images: these settings where we can project our representations, those of the barbarian, the savage, the primitive, always a combination of fascination and rejection. How to break this so very natural and yet so very vicious circle of imaginary representation to explore what the Other is in all simplicity, unto him or herself, without needing a translation? As it seeks to do so, Gaëlle Vu and Mariata Abdallah's *La Maison de Mariata/Mariata's House* (France/Comoros, 2007) is also a disturbing film. The fruit of an alliance between a Franco-Vietnamese filmmaker and her Comoran subject, both of whom live in Marseille, it adopts radical choices, like not subtitling the lengthy scenes shot in Comoros, to demonstrate the insoluble part of alterity. In return, Mariata casts off customary local clothing to speak her pain and to open the range of possibilities. It is paradoxically by asserting herself as an alter ego, an Other of her kind, that she reclaims her freedom (5910).

"I was seeking to put aside what differentiated us." Awareness of the Other's opacity was an essential turning point for Denis Gheerbrant in *Après (Un voyage dans le Rwanda)/After (A Journey through Rwanda)* (France, 2003) (3435). This journey ten years after the genocide and his first ever to sub-Saharan Africa was, in his mind, "to physically experience what understanding is." The entire film is hence based on the dialectic between seeing and understanding. The image is not there to attest or to illustrate, but on the contrary to see in order to get to know and to understand, and indeed the voice-over never precedes the actual experience. "Going to shoot in this country is only meaningful if the aim is to represent it in our eyes as a people, not a victim, as Other, not as a stranger," Gheerbrant stated (3482).

Marginalized in international geopolitics and the object of diplomatic compromises destined not to alienate Morocco or Algeria, which oppose one another over this conflict, Western Sahara appears, since the 1991 ceasefire, to be bogged down in a confrontation that time and the rooting of the populations settled there are gradually rendering derisory. This is paradoxically what makes Western Sahara so alluring and interests the Belgian director Pierre-Yves Vandeweerd, who

has been knocking around in the region for quite some time. In Mauritania in 2000, he shot *Némadis, des années sans nouvelles/Nemadis: The Years without News* about nomadic life (4568); *Racines lointaines/Distant Roots* in 2002 on the cultural relationship to nature (3051); *Le Cercle des noyés/The Circle of the Drowned* in 2007 about black political prisoners and their jail (4568); and passages of *Les Dormants/ The Sleepers* in 2009, in which he films people who sleep on graves to hear their dead (8057). His films show a unifying sensitivity, but also a strong evolution towards an aesthetic that goes beyond the simple and necessary respect for people (which already constitutes an achievement in itself and renders all these films magnificent), establishing a quasi-ritualization of the relation to them. Through his metaphoric evocations and ecstatic shots that make us hear the meanders of the desert wind and see the silent portraits etched by the light, Vandeweerd shares a meditation on life and death with the viewer in *Territoire perdu/Lost Land*, completed in 2011. But he does not do so to the detriment of his subject, nor, above all, the men and women he films. They are never just settings or objects; on the contrary, they are at the heart of the discourse, present in their words and gazes, which are constantly magnified in their beauty. But they are also conveyors of a terribly painful memory: that of past massacres and of the exile of the present (10058).

3.3. African Responses

> Creating a new culture; that is where we are at! But we don't have the solution. We have centuries of extermination, of subjection behind us, which it's hard to extract ourselves from! We have to move forwards, and that is wrenching!
>
> —Ousmane Sembene, "*Faat Kine*: Sembene s'explique," edited by Olivier Barlet

When he was still a lawyer, Nelson Mandela was the only black person whose suits were made by the same tailor who served the richest man in the country, the gold and gem magnate Harry Oppenheimer. As its most extreme expressions testify— South Africa's *Swenkas*, the Congolese *Sapeurs* (the Society of Ambiance-Makers and Elegant People–SAPE, whose ambassador is Papa Wemba), or the Ivorian *Boucantiers*—African clothing is a form of resistance. It is not by chance that these movements emerged in these countries; clothing was always a message sent to the colonialists and dictators. In this context, and in its celebration of the self, the dandy commits an act of impertinence, "the last spark of heroism" possible, as Baudelaire

put it.[5] Drawing on the carnivalesque, colonial *Sapeurs* ironically imitated the white master in an attempt to reverse power relations by Africanizing their clothing codes. In Zaire, SAPE aesthetically opposed Mobutu's *abacost* authenticity drive (from the French "à bas le costume," literally "down with suits") to throw off symbols of Western colonization. Refinement and distinction created distance from the decadence of living conditions, thereby restoring a sense of self-worth, dignity, and individuality.

African attempts to challenge demeaning representations and reject other people's projections are inscribed within this reversal of relations. For artists, it is a veritable Sisyphean task. They propose a whole range of responses, but all face this challenge to some degree or another, given that racism still structures human thought.

Yet rarely do African filmmakers take Westerners for their subject. Zeka Laplaine did in *Le Jardin de papa/The Garden* (DRC, 2004). The title evokes "the colonial settlers or their children who consider Africa their own garden where they can do whatever they like, but also some of our leaders who run their countries like their own yard," Laplaine stated (3071). Returning with Marie to Senegal where he spent his childhood, Jean, who "loves Africa," turns out to be the archetypal modern colonizer: cocky, contemptuous, trying to pay his way through any obstacle, handing out "baksheesh" left, right, and center. An accident plunges the couple into a nocturnal psychodrama behind closed doors. When dawn comes and the fool's game of electioneering starts up again, only the women are capable of building a relationship. Having rid herself of her burdensome companion, strengthened by this initiatory night, Marie will be able to return one day to live out a dream that remains possible (3070).

It is better to laugh, many might say, not forgetting to laugh at themselves, like Ibrahim Letaïef in the excellent short film *Visa* (Tunisia, 2004). France is very good at reducing Africans to cultural nobodies, and making sure they know so by randomly complicating its procedures. Here, Rachid has to take a French dictation test, the results of which will determine whether or not he gets a visa. The laughter is a little wry, this being so close to home (3600). The first part of *Moi et mon Blanc/Me and My White Guy*, by Pierre Yaméogo (Burkina Faso, 2000), which is set in France before the two pals Mamadi and Franck are forced to flee to Africa to escape dangerous dealers, is a long list of the clichés, approximations, generalizations, and prejudices about Africa that swamp Western discourse. Here, however, it is hard to laugh, even though it is meant to be funny (2808). It is not cliché itself we laugh at, but rather the distance that anachronism reveals, like with the theatrical misunderstandings of Ignace Yechenou and Claude Balogun's *Ayaba* (Benin, 2004), in which a white guy

is turned black by witchcraft, losing his privileges and finding himself confronted with discrimination (3368). The idea was also taken up in Etienne Chatiliez's *Agathe Cléry* (France, 2008), in which Valérie Lemercier's skin turns dark due to an extreme form of Addison's disease, but this upbeat portrait of an ideal world in which discrimination is wiped away as soon as one points out how dumb it is remains superficial and illusory: a new avatar of the self-importance of a society that, by claiming to address the problem of colonial defects head-on, thinks it can shirk questioning its own history (8225).

It is not forbidden to dream. Sylvestre Amoussou's sci-fi *Africa Paradise* (Benin, 2005) inverts the North-South relation. It is 2033 and Europeans are trying to emigrate to the African Eldorado! Europe's conflicts have brought it to its knees, while African unity has fostered prosperity. In both Abdourahman Waberi's novel *Aux Etats-Unis d'Afrique/The United States of Africa*, published in 2006, and *Africa Paradise*, it is the realization of the old Pan-African dream of economic and political union that brings about a reversal of wealth. "Africa cannot take in all the wretched of the earth": the film simply transposes to better criticize European ideology and discrimination of the 2000s (4577). Nadia El Fani's *Bedwin Hacker* (Tunisia, 2002) also turns to sci-fi: a skilled TV hacker, Kalt manages to scramble Western television images and to insert heartfelt messages in them, such as "We are not mirages!" Utopia is not far: what if the people of the South did conquer their freedom of movement in the world themselves? (2436). That is what Dany Laferrière portrays in *Comment conquérir l'Amérique en une nuit/How to Conquer America in One Night* (Haiti, 2004), in which the young Gégé does so using love, the poor man's weapon! It is with the photo of a blond girl taken from a magazine that he leaves Haiti and manages to get through immigration at Quebec. One recognizes the same comic devices of the newly arrived immigrant in Moussa Touré's *Toubab bi* (Senegal, 1991) or Henri Duparc's *Une couleur café/Coffee Color* (Ivory Coast, 1997); Laferrière also transforms his character's apparent naïveté into knowing how to get by and subtlety. The film thus multiplies reverse gazes, beginning with projections surrounding the black body. As seduction is the sword of conquest, he switches roles. But Gégé has to defend himself from the wrath of the two highly Fellinian neighboring sisters, and save himself for his target, quickly spotted on the giant television screen that is never switched off (3875).

While sub-Saharan African filmmakers reverse exoticism, North African filmmakers reverse Orientalism. Nabil Ayouch's *Whatever Lola Wants* (Morocco, 2007) pulls off getting a young American postal worker, Lola, to become passionate

about Egyptian belly-dancing, against the grain of current fears, but founded on Western clichés about sensuality that the film will of course deconstruct. She convinces the retired dancer Ismahane to come back to life; by reiterating the old Hollywood schema of the American helping the African to advance, Ayouche plays with the Western audience right there where the rub is, for it is uncomfortable identifying with Lola, who never gets over her incredible naïveté. She does quickly understand, however, that her life is elsewhere and that she needs to let people live as they like (7180).

These African responses thus essentially involve a playful reversal of power relations to deconstruct stereotypes. A few Western examples can also be cited, such as Jean-Philippe Gaud's *Mabrouk Moussa!* (France, 1999), set in a couscous restaurant where the boss wants to fire his black dishwasher. A client arrives, her dazzling charm transporting the boss. But she wants to eat boeuf bourguignon, which is of course not on the menu. Only the black dishwasher knows how to make it, so the boss has to wash up in his place—at least for the time it takes to make this dish (1388). While this works for a short film, this kind of simple reversal generally engulfs the screenplay to the detriment of any complexity. Rather than taking reversal as the subject, it is by developing their own logic, ultimately, without any preconceived intent, that films refute the falsehoods and disingenuousness of Western representations of Africa. For the danger is imagining an alternative that, as we have seen, does not fundamentally differ from what already exists, such fables readily relying on a so-called African authenticity. What is at stake, then, is simply "being on a level worthy of people and filming lovingly," as Mahamat-Saleh Haroun put it (2065).

This reversal is thus an aesthetic, but also involves choices in filmic treatment. In *Traces, empreintes de femmes/Traces, Women's Imprints* (Senegal, 2003), Katy Lena Ndiaye foregrounds the women rather than the product of their labors; their female condition rather than the overall sociology of the village; the modernness of their thought, which respects tradition but does not blindly follow it; their self-awareness rather than indifferentiation; implication rather than mystery; and human energy rather than the rigid gaze so often trained on Africa. This translates into fixed shots of the women facing the camera, who are allowed the time to exist as subjects rather than objects, who are given the time to present their genealogy, who can laugh on screen, but also ask for the camera to stop filming—or refuse (in the rowdy scenes) to rehearse in front of the camera for the needs of the film. The choice of adopting series of close-up shots that offer a highly corporal perception

of the women's work deconstructs the reductive Western gaze in the sense that this way of magnifying the spontaneity of their creativity positions them not only as women but also as artists, working to model the world. From the specific, then, readily emerges an overall understanding that is in keeping with women's struggles the world over (3074).

In this approach centered on listening, sharing, and respect, and whether making a documentary or a fiction, filmmakers do not claim to write history, as the powerful have often done after winning battles. Nor do they claim to draw a moral from the story, other than for themselves, for their narratives do not have ready-made morals and they draw on no variable scales. If they inscribe their singularity in the world, it is alone, but also in solidarity with all those who share their desire for a new humanism, through the autonomy of their consciousness and the force of their imaginations.

3.4. The Burden of Hollywood

> Until the colour of a man's skin is of no more significance than the colour of his eyes—me say war.
>
> —Bob Marley, "War," from the *Rastaman Vibration* album

One hundred billion dollars at the box office a year: while the Ouarzazate studios in Morocco, or the Latrache studios near to Hammamet in Tunisia compete for shoots needing settings and extras, American cinema continues to inspire those who dream of rivaling it, while at the same time copying its name, from Bollywood (Bombay), to Nollywood (Nigeria), or Riverwood (River Road, Nairobi). On the banks of the River Nile too, where the Misr Studios used to be a mini-Hollywood. As Saïda Boukhemal shows in *Hollywood sur Nil—regards sur le cinéma musical arabe/Hollywood on the Nile: Arabic Musical Films* (Egypt, 2004), Egyptian cinema's foremost genre in the 1950s was popular throughout the Arab countries (3236). Nostalgia for this past grandeur still haunts Cairo's producers, who regularly bring out big, lyrical, consensual productions destined for this market, and which are essentially biopics. Starring Ahmed Zaki, made in homage to Anwar el-Sadat and dedicated to his successor, Hosni Mubarak, *Days of Sadat* (Mohamed Khan, 2003) strives to portray an honest man, consumed by his relationship with Nasser, but also concerned for his family's welfare (2677). Idealization and dramatization are de

rigueur, and the overabundant dialogues and violins culminate in the deification of a living legend in *Halim* (Sherif Arafa, 2006), devoted to the Egyptian singer Abdel Halim Hafez. Like the 1930s stars, he was a legend beleaguered by impossible love (4439).

In *Reel Injun* (USA, 2009), Neil Diamond explores the permanently evolving image of the Native Americans, forged in the approximately four thousand films made about them. The original cliché associated horseback riding; spiritual, primitive people; and wild nature. In early silent film, the Indian is noble, the "good savage." During the 1930s slump, however, he became a bloodthirsty, backward, cruel brute and an obstacle to progress. In *Stagecoach* (John Ford, 1939), the Indians speak an invented gibberish. With the 1960s, the rise of hippie culture and its Indian-inspired fashions and headbands (which, in fact, only existed in films to hold actors' wigs in place when they fell off their horses), Native Americans became the symbol of the oppressed. After the Occupation of Alcatraz in 1969–71 and that of Wounded Knee in 1973, the vengeful Indian emerged, but as a symbol of freedom. It was only in the 1980s–1990s that Native Americans became complex characters, but *Dances with Wolves* (Kevin Costner, 1990) is yet again the story of a white man who meets a white woman living with the Sioux! Today still, Native Americans do not necessarily want to be good and noble in films, just human beings.

The parallel with the image of black people in melting-pot America is striking. In 1964, Sidney Poitier was the first black actor to receive the Oscar for Best Actor for his role in *Lilies of the Field* in which, dressed entirely in white, he comes to the rescue of a community of freshly immigrated German nuns and builds them a chapel in the desert. The image of a servile Sidney Poitier relayed by the Black Power movement is nonetheless seriously challenged in Catherine Arnaud's *Sidney Poitier, an Outsider in Hollywood* (France, 2008). He used to refuse to answer questions about being black in press conferences because he wanted to be judged simply as a contemporary American actor, and never stopped fighting racism with progressive filmmakers. He even got the producers to agree to him slapping a white character in *In the Heat of the Night* (Norman Jewison, 1966) (7674).

Before the Wall Street Crash, black filmmakers reacted to the racism in *Birth of a Nation* (D.W. Griffith, 1915) by making "race movies," which were produced by independent black producers, but also by competing white producers, an inversion that has repeated itself throughout the history of American cinema every time filmmakers have managed to escape the margins. They achieved their moment of glory with the Blaxploitation genre of the early 1970s. Following the success of *Sweet*

Sweetback's Baadasssss Song and *Shaft* in 1971 and *Superfly* in 1972, three films made by black directors (Melvin Van Peebles, Gordon Parks, and his son, Gordon Parks Jr.) about the condition of the poor black urban population, the Hollywood studios jumped on the bandwagon, producing a flurry of low-budget movies, predominantly produced and directed by white filmmakers. In a flamboyant display of sex and violence, they portrayed the vengeful desire of a black American youth in revolt against the harshness of life in the inner cities. As Anne Crémieux points out, in a Hollywood that was still 99.9 percent white, black directors were very rapidly sidelined. Soon criticized both by the censors and the black population, tired of the negative images that these films perpetuated, Blaxploitation was short-lived. It was not until Spike Lee (*Do the Right Thing*, 1989), John Singleton (*Boyz 'n the Hood*, 1990), Mario Van Peebles (*New Jack City*, 1991), or the Hughes brothers (*Menace II Society*, 1993) that poor young black men's short life expectancy became a subject of interest again in films that the French press dubbed "ghetto cinema." But very rapidly, as in the 1970s, the new generation of African American filmmakers gave way to filmmakers of all origins, one of the most famous of whom is Ridley Scott (*American Gangster*, 2007) (7082).

A fan of Blaxploitation, Quentin Tarantino paid parodic homage to the genre with *Jackie Brown* in 1997, played by 1970s muse Pam Grier (0383). Although not without their ambiguity, these films restored the sexuality of the black body that Sydney Poitier and Harry Belafonte were certainly never allowed to express in the previous decade. But they did so by shutting this body in excesses in which to project—and all the better tame—fears of a brutal primitivism and the threat of hypersexuality. Black independent filmmakers have constantly fought to counter the image of black people conveyed by Hollywood. Their vastly diverse films have often been the object of debate within the community—itself divided—but all have their marginalization in common. The underrepresentation of black people has of course improved since the introduction of quotas, but it has given way to the problem of misrepresentation: "From the very outset of cinema, the degree of independence vis-à-vis white producers has largely determined the content and impact of films made by African Americans."[6]

The first Blaxploitation films were veritable critiques of the American Dream at a time of economic slump and political struggle. When he is asked what his problem is, Shaft answers that he has two: he is born poor and he is black. Yet Melvin van Peebles claimed, "I didn't make *Sweet Sweetback's Baadasssss Song* as a black man," but it happens that van Peebles is black and has a wicked sense of humor: "I

was reworking white America's biggest nightmares!" he said before adding: "In my opinion, not much has changed in society. A few black people have made it here and there, and there are some improvements, but with every step forward, we often take two steps back!" As for "ghetto cinema," he considers it "a cinema dictated by whites; if you don't have this kind of screenplay, you won't get any funding in Hollywood" (2496).

If a few black directors have made it today in Hollywood—often relegated to comedy and urban movies—this isn't without its ambiguities. Spike Lee frequently lobs bricks at Hollywood's gleaming windows, but continues, like Mookie in *Inside Man* (2005), to accept the salary he is owed, despite his disapproval of his boss's methods (4378). Gordon Parks's Shaft, a kind of black James Bond ready to take no end of risks, a Robin Hood who never loses sight of his own interests, allowed a whole generation to identify with an unconventional rebel figure who was hard to recognize in the virtuous cop of John Singleton's 2000 remake (2461).

The French avatars of Blaxploitation or Hood films do not escape cliché either. *Bronx-Barbès*, by French anthropologist Eliane de Latour (2000)—made with youth from the ghettos of Abidjan, nicknamed Bronx or Barbès—was a big hit in Africa, but is just a pale imitation of New Jack cinema (1659). *Black* (Pierre Laffargue, France, 2008) imitated the Blaxploitation superhero tradition, but still fell into the usual stereotypes of a mythical Africa (8749).

Shaft in Africa (John Guillermin, USA, 1973) is set in Ethiopia, and has Shaft fighting against people traffickers. It is not this heavy-handedly portrayed social theme that is striking, but rather the way in which the film clocks up all the current clichés about Africa. These were established, and are constantly recycled, by box-office hits popular the world over: *Tarzan the Ape Man* (W.S. van Dyke, USA, 1932), *King Kong* (Merian C. Cooper, USA, 1933), *African Queen* (John Huston, USA, 1951), *The Snows of Kilimanjaro* (Henry King, USA, 1952), *Mogambo* (John Ford, USA, 1953), *Tanganyika* (André de Toth, USA, 1954), *Hatari* (Howard Hawks, USA,1962), *Greystoke* (Hugh Hudson, UK/USA, 1984), and *White Hunter Black Heart* (Clint Eastwood, USA,1990). There are, of course, notable evolutions in the way in which these movies film Africa—virgin and frightening in the early days, and always both an object of fascination and a theater of conflicts. What predominates, however, is the continuing hierarchical relationship to the African, while Africa remains the backdrop for the West's passions.

Films have continued, in the 2000s, to repeat the success of *Out of Africa* (Sydney Pollack, USA, 1985), adapted from Karen Blixen's eponymous autobiographical

novel. Both novel and film are based on a true story, but one in which Africa remains a fascinating decor that reinforces the feeling of solitude and loss of control experienced by the main character. A heavy-handed, tear-jerking melodrama, *I Dreamed of Africa* (Hugh Hudson, USA, 2000) describes, in the words of the director, "a blessed land, virgin, mysterious and enchanting, but also a merciless and wild country" (press kit). Before a magnificent landscape of wild expanses and equally wild animals, Kim Basinger, sitting on the roof of a speeding Land Rover, shouts "Africa!," not unlike DiCaprio shouting "I'm the king of the world!" in *Titanic*. With the exception of the wicked poachers, the black characters are all jolly nice, perfectly domesticated, at the service of Madame, for, as it again states in the press kit, "all life in this corner of Africa is under her responsibility." Equally terrible is *Nowhere in Africa* by Caroline Link (Germany, 2003). The subject could potentially have been interesting: the forced immigration of Jews fleeing the Nazis and their encounter with the colonizers. But the relation to the boy cook reflects the film. Unlike the one played by Isaach de Bankolé in Claire Denis's *Chocolat*, Owuor is completely shallow. He is simply an image of Africa that people want to see: an Africa of traditions, mystery, kindness, obedience, and devotion to the white man. He is kind, obliging, ready to sacrifice himself for his masters, humble, and altruistic; he is the model Good African in an Africa free of conflicts, an Africa of safaris and fabulous images (0620).

Did *The Constant Gardener* by Fernando Meirelles (Brazil, 2005), a romantic political thriller adapted from John Le Carré's eponymous novel published in late 2000, represent a change? With the Kibera slum, we are thrust into a suffering Africa, the helpless victim of the play of international interests. Here we have the same logic as *Darwin's Nightmare* or *Lord of War* (Andrew Niccol, USA, 2005): the reality is even more terrible than we could have imagined. It could not be more evident on the screen, and yet it is demoralizing, for in portraying how rotten everyone is, there seems no hope possible in the grand world disorder. An African doctor revolts, but is quickly assassinated. Like all Hollywood films about Africa, *The Constant Gardener* magnifies the landscapes, often shot from a plane, but like the flocks of flamingos, the Africans are just a crowd in which only the children's staring faces are singled out. Like in *City of God*, which opened the doors of Hollywood to Meirelles because his style clearly illustrated the violence of the favelas, the circular montage of the narrative, the breathtaking rhythm of the images, the high-angle shots and close-ups, the stylization of the colors, and the epic passages deliberately place the film in the baroque, mannerism and excess. Spectacle takes over and, far from rallying

the audience, *The Constant Gardener* is ultimately a pure entertainment product that revels in the bitter observation of a decrepit world (4255).

The only hope in this chaos for Africans is the providential intervention of outside activists. True to the good old Hollywood *Cry Freedom*–type schema (Richard Attenborough, UK, 1987), it is as if Africa were incapable of resisting itself, and as if it eternally needed good, aware whites to enlighten, accompany, guide, or even save it, or simply to alleviate its sufferings. Despite their differing scenarios, no film escapes this in Hollywood, not even Martinican Euzhan Palcy's *A Dry White Season* (1989), who nonetheless insisted that only African actors play the black roles (10158). Even if the white character is crooked, he has a kind heart and even goes as far as sacrificing himself, like in *Blood Diamond* (Edward Zwick, 2006). Here, violence and slavery appear to be congenitally linked to Africa, and Africans still have no voice. Just as Salomon (Djimon Hounsou) does not translate for Danny (Leonardo DiCaprio) the words of the old villager, who is afraid that they will find oil and that things will deteriorate even more, the film cuts him when he is about to testify at the Kimberley conference in South Africa, where the international certification of diamonds is in question: all that is left are the film's credits (4705).

This white appropriation of voice was common even in the United States during the civil rights movement. In *Sergeant Rutledge*, shot by John Ford in 1960, a black sergeant is wrongly accused of raping a white girl and murdering her father. At his trial, he is defended by his white superior, Lieutenant Cantrell, who delivers a fine tirade against racism (6845). Black characters can only get out of their predicaments if white characters help them. That is precisely the scenario of *Hurricane Carter* (Norman Jewison, 1999), in which justice triumphs thanks to the support of good whites and the United States Constitution (1385), or in *Amistad* (Steven Spielberg, 1997), in which even a former president defends the slaves. On all levels, white people are mediators; black people can only be understood through translation, orchestrated by generous whites. At the end of the film, a tear-jerking scene has the black character say thank you, and the white character manages an African expression. When, like E.T., the *Amistad* slaves can at last go home, they are clad in white, immaculate and unreal beings. They return to an age-old Africa, a white image of this unchanging, fixed Africa that it is so easy to exoticize. As usual, the economic and political contradictions that led to abolition after four centuries of torture are erased. The ideal of American freedom is once again posited as the universal model (0320).

Did Idi Amin Dada love Scotland because he resented the English? This is the

argument by which the fictional character of a Scot becomes Amin Dada's personal doctor and adviser in *The Last King of Scotland* (2006), made by the Scot Kevin Macdonald. Western audiences can thus identify with this innocent character and, with him, discover the hidden face of the gentle giant who turns into a diabolical dictator. Producers believe that white audiences find it hard to identify with black characters; Africa is, as always, only perceptible by means of an explorer figure (4707). He is the one who will be saved in extremis and will escape to warn the world of the abuses taking place. This deliverance by the white man is a historical falsehood, however. Amin Dada fell when Tanzania responded to his attack in 1978, forcing the field marshal to flee.

Hollywood thus simply plays out its own fictions in Africa, the worst example of which remains *Black Hawk Down* (Ridley Scott, USA, 2001), which recounts the American army's Ranger operation in Mogadishu on October 3, 1993, to end the fighting in Somalia. The spectator had better not hope to learn more about the tragic conflict or its stakes: the Somalians remain nothing but a rampaging horde, cynical businessmen, or shady militia. We are told in the end that over a thousand Somalians died, but it is the list of nineteen Americans who died in combat that we are given; Africa remains the continent of the nameless dead. They remain this stranger for whom we fight without knowing them, for it is not them we are defending, but an idea, the famous American-style democracy, so that they become like us (3571).

When African American filmmakers manage to avoid this fool's game, they focus on the African American community, and more generally on minority social and identity issues. Rarely separatist, they are more concerned with egalitarian, radical, or gradual integration, depending on the case, than with a distant Africa. Despite the African American "back to Africa" and its cultural roots fad, their cinema remains distant from Africa and only addresses it from the angle of roots and slavery with major films such as *Sankofa* (Haile Gerima, Ethiopia, 1995) or the profoundly beautiful *Daughters of the Dust* (Julie Dash, USA, 1991).

If Hollywood has shot a number of films in Africa in the 2000s, it is no doubt because 9/11 durably externalized the field of spectacle and violence; the mystification of Africa, in this respect, offered a perfect theater for such projections. The fear of its savage nature has easily transformed into horror before the blind violence that cinema helps maintain through its play of representations and distancing effect. Whether in its violence or its volatility, it reflects our uncertain world. Repeating that it is the Other who is savage helps reconstitute one's own unity within one's own

myth, part of which is coming to their help, and thus maintains the legitimacy of hegemony. This self-referencing cinema is incapable of grasping the contemporary stakes of Africa and its people. It echoes a derealized vision while at the same time presenting its apparition as reality, and thus contributes the world over to fixing stereotypes and marginalizing the continent. As such, it remains an effective vehicle of American economic and cultural domination.

3.5. Minority Actors' Long Road

> Actors are like cooking. Do you ask a woman how she prepared her dish? It does or doesn't taste good.
>
> —Ousmane Sembene, "Le renouvellement de l'Afrique se fera par la culture," press conference at the festival Ecrans noirs, Yaoundé, June 6, 2004, ed. Olivier Barlet

3.5.1. The Overblown American Example

It is illusory to believe that America's black actors have a better deal than elsewhere. In the United States too, it is hard to escape the tacit code whereby the goodies are light-skinned and the baddies dark. And not only in white cinema: Oscar Micheaux, the most prolific black filmmaker of the first half of the twentieth century, had integrated this rule, and it is still true in a number of films made by black directors, even when their films feature practically all-black casts. During the Blaxploitation era, most of whose films were shot by white directors, the darkness of a character's skin was meant to attest to strength, courage, and sexual prowess. With the exception of Vin Diesel or Ice T, the major African American male actors are not mixed-race; the women, however, often are, as everyone (black and white) favors light skin and straight hair.

In both cinema and real life, skin color determines social mobility today, it being easier for the lighter-skinned to get ahead. So much so that in film, virtuous black characters have to be Black and Proud, but also to get out of the ghetto to succeed in white society by dint of conviction, like in *The Pursuit of Happyness* (Gabriele Muccino, 2006). Of course, we no longer have black baddies enhancing the goodness, courage, and purity of the white hero, but racist representations are still rife, as Spike Lee remarkably portrays in *Bamboozled* (*The Very Black Show*, 2000). In it, Pierre Delacroix is the only black television manager working at a station

whose ratings are in free fall. His white boss, Dunwitty, refuses his programs, whose characters are not "black enough." Delacroix thus writes the most racist screenplay possible, hoping to trigger a lawsuit to bankrupt Dunwitty. He restages a minstrel show, in which, from 1820 to the 1950s, white, then black actors put on blackface to perform black stereotypes. But the show is a huge hit! *Bamboozled* portrays a white American society that loves black culture, but which is blind to the racist images it approves, and which believes that you only have to put on blackface to be black, in the image of the double conscience that W. E. B Du Bois wrote about to describe the psychosocial divisions of American society (4363).

Where it notably differs from European society is that an actor like Will Smith can play roles originally written for white characters, as was the case, for example, in *I, Robot*; *Wild Wild West*; or *Men in Black*. Black supermen remain rare, however, to the extent that his performance in *Hancock* (Peter Berg, 2008) was practically the first blockbuster of its kind (7968). Does this erase racism? The question remains of who is telling the story. The narrator of *Glory* (Edward Zwick, 1989) is not one of the black soldiers of the 54th Regiment, but their white officer. The main character of *Amistad* is not the slave, Cinqué, but Baldwin, the attorney who defends him. Likewise, in the white high school forced to take in black pupils in *Remember the Titans* (Boaz Yakin, 2000), the narrator is none other than the daughter of the white football coach who gets replaced by Denzel Washington.

It is nonetheless true that, even though their roles remain stereotypical, an African American child can identify with black film and television actors; that the 13.2 percent African American population have representatives in all domains, and that Barack Obama's election showed that American society was mature enough to vote, in its majority, for a black man to run the country. In France, we are a long way from that.

3.5.2. Pale Screens and Stereotypes

The question of diversity in French cinema and the media has long been in the cards, however. We will not go into a very slowly evolving reality here, which we already examined at length in the *Black Actors* edition of *Africultures* (April 27, 2000). In 1998, the "Collectif Egalité," regrouping black actors and writers, denounced their poor representation in film and television (1321), after which Hervé Bourges, president of the Conseil supérieur de l'audiovisuel, commissioned a report. Up until then, in keeping with the republican notion of equality, it was believed that differences

should not be highlighted. This report confirmed the Collectif Egalité's accusations: black people were restricted to sports and music, and in their rare appearances in fiction films, they never played the leading roles. As for Arabs and Asians, they were almost totally absent. A major seminar was held in April 2004 to remedy the "pale screens" (3361), to no great avail other than the arrival of a few token news anchors. The report published by the 2010 "Media and Diversity" commission revealed that nonwhite characters represented only 8 percent of fictional roles and only 5 percent of main roles.[7] But if we consider the part that Arabs represent in French advertising and fiction, the figure falls to 1 percent.[8] In these circumstances, French "television is not participating in integrating ethnic minorities in the social body because it reinforces their feeling of exclusion and, as a result, the risk of communitarian division," Marie-France Malonga pointed out (1319). She highlights a few improvements today, but which remain limited in scope: positive black heroes in television dramas or series, mixed-race couples, multicultural programs, and the increased presence of ethnic minorities in advertising.

The debate about whether "ethnic statistics" should be introduced or not saw the reaffirmation of republican colorblindness. Yet, the riots that inflamed the *banlieue* housing projects in 2005 were seen as reflecting a crisis of the French integration model. The so-called "Equal Opportunities" law of March 31, 2006, made it obligatory for television programs to reflect diversity. But framing the question in terms of the number of black or Arab people on-screen is a racial approach, when what is more important is whether or not the content is racist. Not to mention that the multiplicity of skin colors counters monitoring criteria. Hence, we have gone, in France, from what were termed the "visible minorities" to "diversity" without taking the discrimination at play in representations as a real criterion.

The stereotypes thus remain. Black males remain savage, delinquent, or victims. Arabs are associated with terrorism, and are thus dangerous and underhand, and a threat to national unity. According to Hubert Koundé, this results from the fact that "ethnic mixing exists in reality, but we refuse to concede it in our minds. That creates a practically schizophrenic situation, because we refuse what is" (2900). Would *The Intouchables* (Olivier Nakache, Eric Toledano, France, 2011) have drawn nearly 19 million viewers in France in the first three months if it had stuck to the real story that it is based on, in which the quadriplegic aristocrat's carer is Moroccan? The film's perfectly unrealistic rosy consensus and the magic of the screenplay in which French society plays out its myth of national unity would not have been so effective (10507). The Moroccan had to be replaced by a black character, the noble savage,

but without deferring to the usual distancing clichés. Driss (Omar Sy), who is from the *banlieue* projects, is fresh out of prison (a delinquent) and only shows up for the interview to get his form signed to prove that he is looking for work (a parasite), and whose family life is close to what politician Jacques Chirac once famously described as "noisy and smelly" (alterity). Driss is reminiscent of the mouthy black wisecracker character played by Isaach de Bankolé in *Black mic-mac* (Thomas Gilou, France, 1986), and the cleaning lady (Firmine Richard) who gives the depressed CEO back a taste for life in *Romuald and Juliette* (Coline Serreau, France, 1998).

For black actresses, audition calls remain surrealist. "We get: 'Looking for a pretty black woman' (the three words are inseparable) to play an undocumented immigrant/prostitute/nurse/cleaning lady. . . . After a while, it's really irritating," Mata Gabin points out (3567). The lack of projects for black or Arabic actors and actresses shows the degree to which imaginations need to evolve. It is not that projects do not exist, but rather that the television commissions need to be more multicultural. For Pascal Blanchard, the crux of the question lies elsewhere, however: "The question of diversity focuses on individuals. But considering that a black or Arabic person will change the nature of a program is essentialist." He continues: "Diversity isn't a matter of skin color, it's a question of affect, of perception. France still does not consider itself cosmopolitan, when it has been for a long time."[9]

Should quotas be introduced? The risk is that they become counterproductive and demeaning. How to know if a role is given due to one's talent, or because of a quota? "We have to bring about the revolution ourselves; we mustn't beg," Eriq Ebouaney stated (2910). In the meanwhile, it is an uphill struggle. Aïssa Maïga, who regularly gets roles, says she gets the impression she is "a walking miracle!" (3679). Sonia Rolland, who was elected Miss France, would like to escape the superficial or seductive roles: "I would like to be able to act pain, deep feelings, violence" (3362). Unlike in the United States, but in keeping with colonial clichés, African women have to be very dark: "There are people who won't cast me because I'm not dark-skinned enough!" Fatoumata Diawara stated (7637). And when Nadège Beausson-Diagne goes to casting calls, she often gets told she is not African enough: "An African woman is expected to be very dark, a certain type of beauty, when in Africa, there are a whole range of colors and types" (2899).

When it was heard in 2010 that Safy Nebbou had chosen Gérard Depardieu to play Alexandre Dumas in *L'Autre Dumas/The Other Dumas*, there was an outcry. The famous novelist's father was a West Indian slave who became a general and

a Revolutionary War hero, but was ousted by Bonaparte because of the color of his skin. Caricatures of Alexandre Dumas during his life insisted on his crinkly hair and black traits. The actors' reaction was neither corporatist nor a victimary posture: it denounced both their invisibility and a society that refuses to recognize its diversity. Nebbou whitened Dumas just as De Gaulle whitened the army that defeated Nazi Germany. In the colonial context, De Gaulle did not want the African *tirailleur* infantrymen who had liberated southeast France to join the troops coming from the Normandy landings, and kept them in the Vosges, as the documentary *Ils étaient la France libre/They Liberated France* (Eric Blanchot, France, 2004) (3963) and the feature *Indigènes/Days of Glory* (Rachid Bouchareb, France, 2005) (4433) reveal. The French playwright Bernard-Marie Koltès insisted that the black and Arabic characters in his plays indeed be played by black and Arabic actors. "You don't 'play' a race any more than you do a gender," he used to say. "I realized that, while it seemed obvious to everyone that a man play a man's role, an old person an old person's role, a young woman a young woman's role, it was habitual to think that anyone could play a black man's role."[10]

Despite certain parties' vote-seeking stigmatization of the Other, things are far from being set in stone. It is also a question of lucidity: "Diversity works!" Pascal Blanchard insists. "We need to focus on the contents, modes of treatment, angles of approach in all genres: fiction, news, entertainment, etc.," in other words, to ask the question: "what can find an echo?" It is simply a question of embracing the Other. It won't resolve discrimination overnight, which requires specific measures, but it would make the terrain more favorable, on the condition that it does not uniformize everything by erasing expressions of difference. To start with, we need to be open-minded enough to stop trying to whiten everything.

3.5.3. In Africa

The 2003 FESPACO chose actors as its theme. "Who would ever have believed that African actors would be honored one day?" Rasmane Ouedraogo exclaimed during his speech at the festival's opening ceremony in Ouagadougou's 4 Août stadium. "Someone got forgotten at the bottom of the ladder and fifty years later, we've noticed the lack of training and support for actors." In this auteur cinema in which only the director is given the limelight, African actors—underpaid and underemployed—dream of the profession becoming organized. "We are not asking for an inaccessible ivory tower, just a judicial, regulatory framework to no longer be

overlooked" (2813). They have not obtained this, and the federating organization they dreamed of has never been set up. Even the initiatives to create databases of casting calls have all fallen into a state of lethargy (Casting Sud, Afrociné, Autr'Horizons). Yet, "if filmmakers want black actors, there's a real pool, a real breeding ground of actors here," Ouedraogo added. He played in the Dardenne brothers' *La Promesse*: "They wanted a black character caught in the trials of immigration. A black actor from Europe wouldn't have played the character the same way" (2783).

Actors are still at the bottom of the wage ladder, with no union or trade organization. "When he first told me the film's financial conditions, I confess I refused!" said Tella Kpomahou, lead actress in Cheick Fantamady Camara's *Il va pleuvoir sur Conakry/Clouds over Conakry* (Guinea, 2006). "He called me, poured out his heart, and we spoke for an hour on the phone and I said: 'Forget the money side; give me what you can and let's make this film!'" (7658). "Only African directors give us real roles," she added, "not clichéd ones." Actors aspire to character roles, which are rare when films often give way to chronicles or contemplation. Directors prefer to use nonprofessionals, who are cheaper and who play what they are in real life. "For a long time, I wondered if I had the right to make this film with real street kids, or whether I should preserve them from that," Nabil Ayouch said of *Ali Zaoua* (Morocco, 2000), ultimately not regretting his choice (2897).

That can be very demanding. "These roles leave their mark, inhabit those who play them," Mahamat-Saleh Haroun said of his actors in *Daratt* (2006). Ali Bacha Barkaï, who played the young Atim, told Haroun one day that he no longer knew who he was. As for Youssouf Djaoro, the baker Nassara, he was in tears at the end of the shoot (4681). One of Senegalese cinema's leading actresses, Rokhaya Niang, recounted: "An old actor warned me that one day I'd find myself crying in my room alone!" (4556).

Moreover, recognition for actors remains limited. Their names are often absent from the posters, where only the director's name is highlighted. They are not invited to festivals: "All of my films were shown in Ouagadougou, but I've never been!" regretted the late Isseu Niang, who was one of Senegal's greatest actresses (2473). While certain actors guarantee a film's popular success in their countries, no real star system has developed, apart from in Nigeria, where video films are marketed on the reputation of the cast, who grab the limelight on the posters and DVD covers (2807).

3.6. New Immigrant Representations

> It is highly barbaric to insist that a community of immigrants "integrates" into
> the host community. Creolization is not a fusion; it implies that each component
> continues, even as it is already changing. Integration is a centralizing and autocratic
> dream.... A creolizing country does not become uniform.... Multiplicity enhances
> a country's beauty.
>
> —Edouard Glissant, *Traité du Tout-monde: Poétique IV*

Why does Brahim the Algerian never bother to learn Arabic? Why is Wassila forced
to leave her family to find a real meaning to her life? How to explain Gaby's desire
to marry a virgin Muslim? And above all, from where does the fantasy of an Algeria
where the grass is greener come? Behind the humor, Mahmoud Zemmouri's *Beur,
Blanc, Rouge/Arab, White, Red* (Algeria, 2005) pinpoints a real complexity incarnated
by these questions that dog North Africans in France (4410). The answer to reductive
gazes and discrimination is to turn clichés into humane questions.

May 1968 marks the emergence of the immigrant figure in the French public
space. The militant films of '68 nevertheless reflect the strict confines of a struggle
whose actors did not determine the terms or modalities. Often intimidated by the
camera and interview setup, expressing themselves hesitantly in French, immigrants
are more often wretched and unhappy objects in these films than subjects (7613). It
was unquestionably against this cinematographic framing and display of intentions
that African immigrant filmmakers reacted when they restored the first person
"I" in their own films, such as in *Nationalité: Immigré/Nationality: Immigrant,* by
Mauritanian Sidney Sokhona, in 1975. In it, Sokhona plays his own role of the
immigrant as he experienced it.

African filmmakers have sought to find a form capable of expressing their
experience from within. Algerian Ali Ghalem denounced North African immigrants'
living conditions in *Mektoub* in 1970. Similarly, Tunisian Naceur Ktari portrayed the
tragedies of racism in *Les Ambassadeurs/The Ambassadors* in 1975. Mauritanian Med
Hondo shared a similarly political approach, but adopted cutting-edge aesthetics.
In 1969, he shot *Soleil O* to hammer home his revolt against the trafficking and
oppression that Africans are victim to in "sweet France." He reiterated his revolt
in *Les Bicots-nègres, vos voisins/Arabs, Niggers, Your Neighbors* (1974): "You need
to listen, understand, and love them; they are human!" In 1971, the Algerian Derri
Berkani shot *Poulou le magnifique/Poulou the Magnificent,* which describes the

underground world of Algerian immigration in Paris, centered on three friends living by their wits. "My heroes are animated solely by a sentiment of individual revolt," he said, clearly differentiating them from Ali Ghalem's.[11]

On the whole, until the 2000s, immigrant figures were no more present than colonized subjects in French cinema as real humans who live, think, love, and are contradictory, despite immigration becoming a major political issue. And where immigration was the subject of a film—which was rare—the immigrants remain largely invisible or reduced to stereotypical roles. It is the filmmakers of immigrant descent who have challenged this, as they have sought to challenge colonial archetypes.

A handful of French filmmakers did tackle immigration and racism in fiction films, but their impact remained minimal: *O Salto/Voyage of Silence* (Christian de Chalonge, 1967), *Elise ou la vraie vie/Elise, or Real Life* (Michel Drach, 1969), *Les Trois Cousins/Three Cousins* (René Vautier, *1970*), *Les Ajoncs/Gorse* (René Vautier, 1971), or the documentary *Les Passagers/The Passengers* (Annie Tresgot, 1971), with commentary by Mohamed Chouikh. The success of *Dupont Lajoie/The Common Man* (Yves Boisset, 1974), about a petit-bourgeois who cannot stand Arabs, contributed to raising awareness of ordinary racism, but there too, the Other is an absent victim: "Without realizing it, the film contributes to the stereotypical image of the Other that perpetuates the same old clichés even when trying to combat them."[12]

When François Mitterrand was elected president of the Republic in 1981, and following the success of *La Balance/The Nark* (Bob Swaim, 1982) which won three César Awards in 1983, fifty or so fiction films opposing outlaw North Africans and the police who chase them reinforced the *out-of-France* image of the immigrant.[13] It was to combat this exclusion that the second-generation children of North African immigrants took up their cameras at the time of the 1983 "Marche des Beurs" ("Beurs March," *beur* being the back slang for Arab). They were clubbed together under the label of *beur cinema*: *Un thé au Harem d'Archimède/Tea in the Harem of Archimed* (Mehdi Charef, France, 1984), which was a big commercial hit; *Le Thé à la Menthe/Mint Tea* (Abdelkrim Bahloul, France, 1984); *Bâton rouge* (Rachid Bouchareb, France, 1985); and *Miss Mona* (Mehdi Charef, France, 1986). With narratives capable of reaching a wide audience, they tended towards comedy to chronicle tough life in the *banlieue* projects, avoiding heavy-handed discourses and only just occasionally touching on racism. Friendship is their characters' passport; escape is what drives them, and tenderness is their ambition. The young immigrants share the same difficulties as the other kids in the projects and generally seek to integrate.

In this logic, the actors of Arabic origin who emerged in the 1990s, including Roschdy Zem, Samy Naceri, and Sami Bouajila, rarely cultivated their difference. If they made it in French cinema, it was precisely thanks to their lack of identification with their Arabness, just like the television news anchor Rachid Arhab or the politician Rachida Dati, even if she was appointed to broaden the government to include "diversity" ministers. They "could be white," as Eric Macé put it.[14] It was only in 2006 when they were jointly awarded the Cannes Best Actor Award along with Jamel Debbouze for their roles in Rachid Bouchareb's *Indigènes/Days of Glory* that these actors distanced themselves from this counter-stereotype that erased their origins to assimilate them into the white norm. In a sign of the times, Debbouze, on the contrary, founded his success in the 2000s by mocking the current clichés held by both whites and "Others." The 2000s have, in addition, been marked by filmmakers such as Abdellatif Kechiche and Rabah Ameur-Zaïmeche's recognition as true auteurs (9924).

In the press kit of the 2007 hit movie *La Graine et le mulet/The Secret of the Grain*, Abdellatif Kechiche declared: "I hope to one day end up making films that go beyond these issues, these claims for equality, to express myself more freely. But as society has so absolutely not dealt with them, I feel morally obliged to keep addressing them." Kechiche does so by giving his characters back their dignity. Right from *La Faute à Voltaire/Poetical Refugee* in 2000, he has instigated a complicity that turns the viewer not into a compassionate witness, or someone who identifies with the characters, but rather their brother or sister, creating a physical understanding of the immigrant condition that opens us all to what is lacking: to our own loss of identity (1754). Behind their constant insults, the youth in the *banlieue* projects in *L'Esquive/Games of Love and Chance*, his second feature film, shot in 2003, fall in love and seek who they are (3258). In *La Graine et le mulet/The Secret of the Grain*, Slimane, the aging immigrant, who, through Rym, joins forces with a younger generation that is the seed of the future, finds himself embarked on a project that enables him to exist in his difference without denying who he is (7125). With *Vénus noire/Black Venus* in 2010, Kechiche addresses society's propensity to get a thrill from opening a window onto the intimacy of the Other (9829).

Discovered in 2001 with the release of his film *Wesh Wesh, qu'est-ce qui se passe!/ Wesh Wesh, What's Up!*, an uncompromising vision of life in the *banlieue* projects (2297), Rabah Ameur-Zaïmeche soon left the realm of the chronicle. In *Bled Number One/Back Home* (France, 2005), he confronts the profound intolerance of his native village in eastern Algeria. The character he plays wants to settle, but fails, like the

rusty ships washed up on the sand. His exile resounds like Rodolphe Burger's deaf-ening guitar, whose wildly electric echoes fail to produce any harmony (6776). Not hesitating to play the role of the ambiguous boss in order to tackle, with a certain derision, immigrant workers' labor conditions and the complexity of religious phenomena in *Dernier maquis/The Last Hide-Out*, in 2007, Ameur-Zaïmeche has a wall of red pallets built in the night, transpierced by light, a last barricade possible in resisting archaism (7627). Taking up an ancient libertarian lament, whose chorus repeats over and over, "Can you hear me?" in *Les Chants de Mandrin/Smugglers' Songs* (France, 2011), he takes on the role of an enlightened eighteenth-century rebel on a par with the indignation and revolts rocking the world today (10526).

These singular approaches differ radically from the *banlieue* film, which, after *La Haine* (Mathieu Kassovitz, France, 1995) drew two million viewers, became a genre verging on the sensationalist urban Western in *La Squale* (Fabrice Génestal, France, 2000) (1704), and declined into a spectacle of violence in a series of films, such as *Banlieue 13* (Pierre Morel, France, 2004), or in the eight episodes of the series *La Commune*, written by Abdel Raouf Dafri in 2007. Unlike films such as *Wesh wesh* that deconstruct clichés, *La Haine* largely contributes to reinforcing them. Delinquency and violence are essentialized in the film, with no reference to the relations of domination at play, unlike in *Hexagone* (Malick Chibane, France, 1992). Yet, it is precisely the definition of a stereotype to be the expression of a power relationship. Like in the video by the Algerian visual artist Zoulikha Bouabdellah, which shows an Arab woman's hips belly-dancing to the French *Marseillaise* anthem, what is at stake for new representations of the immigrant is to restore this balance of power; in other words, not to let oneself be defined by the outside, but rather to claim one's own image in the here and now, to be the subject and not just the object of the Other's gaze. And that without necessarily falling into essentialism, or believing in a pure duality, because the subject internalizes the Other's gaze in a complex whole, like the young Djib's bubbly grandmother in Jean Odoutan's *Djib* (Benin, 2000), a film that paints a lively portrait of young people's lives in a *banlieue* where "it's joyous, it's fireworks!" "Because of people like you, people think we're monkeys!" she exclaims, before continuing:

> When he says "Negro," he thinks slave, he thinks dirty, he thinks ape, he thinks not smart, but I am smart, more than he is.
>
> Djib, when are you going to learn that you have to take yourself in hand, you have to be yourself, not copy others, not blindly follow the bad boys who yo-yo up

and down the street, "I'm a rapper and I fuck your mother"? When are you going to understand that I don't want you to end up like your parents: brainless? They wanted to be like whites, to smoke pot, to drink rancid alcohol, to make love on the sidewalk in front of everyone, to fool around, to live the life, to shout their revolt even more than the whites. Where are they now? For ten years, I've been dragging my bones behind this wall where no one shows you any respect, giving you every last thing I've got! Ten years! You, my grandson, I want to make you a patrimony, a monument, I want you to end up like Léopold Sédar Senghor, like Nelson Mandela. Your place isn't here in the projects! (1604)

Self-mockery is the key ingredient in Nabil Ben Yadir's *Les Barons/The Barons* (Morocco, 2009) and is what makes what he undertakes work, without falling into a trap, with the film's references to cell-phone and cartoon culture. When they are not snoozing, the Barons shoot the breeze. To kill time, to fill the void, they crack lame jokes, or endlessly pick over and over the minutiae of day-to-day life in their Brussels neighborhood. But *Les Baron*s does not clock up the usual stereotypes; it dynamizes them, shows that they are flexible, evolving, that they are alive and not definitive (9161). Their positivity is the very opposite of the reductive image of the *Black mic-mac* immigrant (Thomas Gilou, France, 1986). Their positivity is like the characters in Mahamat-Saleh Haroun's *Sexe, gombo et beurre salé/Sex, Okra and Salted Butter* (Chad, 2008), who joyfully evolve in an interculturality that everyone embraces (7683).

For the immigrant in these new representations no longer cultivates opposites; he or she is no longer torn between a here and there, but rather integrates the there in the here, and the here in the there. Beyond the indifferentiation that denies the reality of discrimination—official discourse's dream of a colorblind France—the immigrant positions him/herself, in complete lucidity, in the complexity of his or her difference, but also in a positivity, in the footsteps of Jean-Paul Sartre's famous words: what matters is not what we make of a man, but what a man makes of himself. It is this conjuration of a ready-traced destiny that Alice Diop's *La Mort de Danton/The Death of Danton* (Senegal, 2011) shows through the path and doubts of Steve Tientcheu, a big black guy from the projects in the northern *banlieue* of Paris, who is in a three-year acting course. "I keep my mouth shut so I don't get violent," Steve confides. The symbolic violence that his teacher's mental ghetto confronts him with—a teacher who only sees him in stereotypical black roles (slave, driver, gangster, black activist, and so forth)—is emblematic of the prejudices of all of

French society. In this neocolonial France, there is no point in waiting for freedom; it has to be taken. But that requires an awareness, which is not automatic, and feelings that have to be put into words (10465 and interview 10466).

It is this self-awareness that is important in order to overcome the barriers. Dyana Gaye's *Des étoiles/Under the Starry Sky* (France/Senegal, 2013) is a film about errantry. It is about the circulation of men and women in the world, their hopes and deceptions. It is about the things that connect and separate them, these lonely stars that aspire to meaning as they come together in a shared humanity. And it is indeed this cosmic gaze that Dyana Gaye trains on our world of millions of moving stars seeking to meet and love and build solidarities—our archipelagic constellations. People do not collide in Dyana Gaye's films, which makes them a little consensual and fairy tale–like. They are not driven by conflict, but rather harmony and, often, chance, in a dynamic of encounters and crossed paths, there where the loves that thwart solitude and isolation—here of immigration—are woven. In this respect, *Des étoiles* continues the choreographic and musical approach of *Un transport en commun/Saint-Louis Blues* (2009) on an intercontinental scale: people voyage, are forced to confront one another. Rather than a shock, however, it's a ballet that evolves, a polyphonic song in which each person has a voice, a path, a desire in a shared and commonly embraced adventure. If the main characters ought to be close as spouses and cousins, they in fact never meet. They keep missing one another. The journeys separate them, but in not meeting up, opportunities to evolve, or to discover themselves, open up. The first version of the film's screenplay included letters—the correspondence between the exiles and their countries of departure—echoing, in a way, Dyana Gaye's first short film, *Une Femme pour Souleymane/A Wife for Souleymane* (2001). But the director finally opted for stories in universes that she is familiar with and that are dear to her and her origins: Dakar (her father is Senegalese), Turin (her mother is of Italian descent and her mother tongue is Italian), and New York, a city she simply admires and where she always dreamed of shooting. In a parallel montage that offers few transitions and constantly switches from one place to the next, the three stories are entwined between these three cities in the form of a chronicle that evokes both the vicissitudes of immigration and the hazard of both encounters and misfortune. The Europe-Africa-America triangle is not accidental, as is confirmed by a visit to the Gorée Island slave house and the moment of silent meditation at the door of no return before the sea that, on the other side of the ocean, illegal immigrant Abdoulaye stares at after finally ditching his pride. But if the harsh logic of immigration evokes old attributions, an inversion

of directions is at play; it is from America to Africa, from Europe to America, or from Africa to Europe that the characters move. Beyond economic necessity, the fascination with an elsewhere imposes the initiatory quest of journeying: "You can't stop them from going to see with their own eyes," says a character. But once in orbit, this initial trajectory comes up against reality, where both deceptions and solidarities lie. Plans change, with unexpected encounters creating new destinations. And the more they advance, the harder these unforeseen paths are to justify, to explain to family and friends. But it is precisely out of the unforeseen that these characters' energy is forged, their force being to face up to and appropriate the unexpected, turning it into an asset, in a universe where chance and necessity strike a fragile balance. Unlike Alejandro González Inárritu's *Babel* (Mexico, 2006), in which the galaxy of characters only share the despair of isolation and pain, the mosaic-like polyphony of *Des étoiles* on the contrary asserts itself as an—albeit melancholy—song, conscious of sufferings, but one that is incredibly dynamic: that of a positioning in the world that, without renouncing its origins, is no longer attached to a territory. Fatou, the teen with a crush on the good-looking Thierno from America, claims to live in New York too. She too is ready to uproot, even for countries that have their own poverty, as suggests the figure of the down-and-out who shares a patch of sidewalk with the homeless Abdoulaye. For it is on journeys that the stars assemble. A hymn to movement and meetings, *Des étoiles* is also a vibrant cry against the walls that separate and enclose people (11857).

This combination of self-awareness and overcoming barriers is expressed in all these films that speak in images rather than letting others speak in their place, like, for example, the Tribudom Collective's short films. Made collectively in workshops, they are always the result of a personal approach based on young people's experiences. Expressing oneself is also the aim of *Rue des cités/City Street* (Carine May and Hakim Zouhani, France, 2011), in which the fictional scenes are often verbal jousts. As in *L'Esquive*, the difference that comes from the onslaught of words and the aggressiveness of the language is no longer a disembodied impasse, but an attempt at self-expression and its affect. Interviews make it possible to restore what is often forgotten—the history of the *banlieue* projects—and thus to establish bridges with the older population there where they tend to crumble. This is essential, for it is in this temporality that we escape a purely current perception and embrace an imagination. As the novelist Didier Daeninckx, who has been interviewed too, puts it, it is this imagination that allows people to exist (10173 and interview 10174).

This is the importance of films that retrace or refer to the history of immigration. *Les Héritiers du silence/The Heirs of Silence* (Saïd Bahig and Rachid Akiyahou, 2008) thus mixes poetry, realism, and a spoonful of humor to weave the history of Val Fourré, a public housing project in the Mantes-la-Jolie suburb of Paris, built to house the cohorts of immigrant workers who came to work at the Renault-Flins and Peugeot-Poissy plants to the west of Paris. It is only by retracing its history that the *banlieue* breaks the silence and begins to exist in the French space (10081). This establishing of markers and claim to a place are essential, without which the new generations will continue to feel marginalized, and trapped in the clichés of rap and petty crime. The black population has been erased and the Arab population further stigmatized; both are caught in a subalternity related to a racialization of cultural perceptions, the sign of a France that "has not mentally decolonized," as Jean-Marie Teno points out. It has decolonized without decolonizing itself, and is still, Achille Mbembe writes, "imbued with its own racial prejudices but blind to the acts through which it practices racism."[15]

A violence is at play: that of rejection and contempt. Yet this violence meets that of the foreigner in his or her desire to exist. Claire Denis's *L'Intrus/The Intruder* (France, 2004) is a puzzle of signs in which the figure of the foreigner and its variants—strangeness, interference, intrusion, danger, plotting—multiply. "Embracing what is foreign also engenders a sense of intrusion," said the philosopher Jean-Luc Nancy, whose book, written after a heart transplant, inspired the film.[16] "*Métissage* [blending] is a word that is foreign to me—no pun intended. It's a concept, a result. It sounds soothing, when it in fact involves a lot of violence," Claire Denis added. The violence felt comes from the fact that the intrusion is imagined as coming from outside, but in fact takes place within, a product of its own history; it also comes from the fact that it is akin to death, as it causes one to lose one's integrity. "It is thus I who become my intruder," "an unverifiable and impalpable chain of events," Nancy adds. We are strangers to ourselves: this awareness is vital so that the humanity needed to live together can emerge in us.

Memory and Reconciliation

There is no better homage
to all this past
—at the same time simple
and composed—than tenderness
the infinite tenderness
that aims to survive it.

—Léon-Gontran Damas, in the film *Des Noirs et des hommes*,
by Amélie Brunet and Philippe Goma (France, 2010)

4.1. Forgive, Not Forget

Populations who have frequented the abyss do not boast that they are chosen. They do not believe they engender the power of modernities. They live the Relation, which they decipher as the forgotten abyss comes to them and as their memory is strengthened.

—Edouard Glissant, *Poétique de la relation: Poétique III*

4.1.1. The Vitality of the Past

Which memory
but that perforated by roads of fiery substance.

—William Souny, *Sahan*

"Yesterday is in the arms of tomorrow," as Tchicaya U Tam'si poetically put it in *Phalènes*. The future stems from the past, just as the past bears the future. Memory is inscribed within this dialectic, which is declined in the present. But without images, the past is overpowering and doesn't allow the future to be invented. "Cinema constructs memories"; citing Godard in *Bye Bye Africa* (0901),[1] Mahamat-Saleh Haroun reaffirms the essential function of cinema, namely, being the memory of a people from whom it has been stolen. "The more Africa falls into oblivion, the more we must recall it to the memory of the world" (9501). If the dream of a decolonized Africa present on the world stage is melting into the depths of the night, emerging from the darkness requires a reviving of memory and a reseizing of the original meaning of decolonization, as Achille Mbembe proposes. In *Kuxa Kanema: The Birth of Cinema* (Portugal, 2004), Margerida Cardoso revisits a dream of cinema. The people we see on the screen—the makers of independent Mozambique's cinema—recognize that they were ideologues at the service of an idea, a conception, a party. And they are reproached for it today. But they accept responsibility for having believed in this. Opening with images of Samoro Machel's speeches, the film concludes on the same images, having come full circle. This man was the incarnation of an idea—that of a country, but also that of a politically engaged cinema, at the service of the people. The nostalgia felt is not that of a lost ideological model, but of the end of a commitment, in today's ambient sense of resignation: "Deprived today of its own image by a television that is not at all Godardian, people are forgetting their past and present. No one talks about dreams any more," concludes the film (3049). If it is to restore a community that is on its feet, the task that faces memory is to turn the page of illusions and intolerance and to walk, as Fanon suggested, "all the time, night and day, in the company of men, all men."[2]

So what has become of this now-forgotten independence energy? That is the question that Monique Mbeka Phoba asks in *Un rêve d'indépendance/To Dream of Independence* (DRC, 1998). Mbeka Phoba addresses history, not by delving into the archives, but by taking up her camera and going to see her family, who, together, decide to awaken the memory of the father—her grandfather—who was a medical

assistant (a black person could not be a doctor). A requiem mass is celebrated, and this down-to-earth activist's path evoked. "Our country has gone back 30 years; we should weep, but it's our country and we're going to rebuild it!" (1138). A requiem: a ritual is needed to rekindle energy! The same approach is found in Mourad Ben Cheikh's work when he takes stock of the Tunisian revolution in *No More Fear* (Tunisia, 2011). Rather than focusing on images of the demonstrations, he records the memories of lawyer Radhia Nasraoui, who went on hunger strike to protest against torture, and of her oft-imprisoned husband, Hamma Hammami. He films them in the intimacy of their home and thereby roots these human-rights activists' risky struggle within a long, daily combat. Similarly, he follows the trails of blogger Lina Ben Mhenni and independent journalist Karem Cherif. All have had to surpass their fear, and it is to this collective courage that Tunisia owes its advancement (10203). Focusing these films on people, rather than on the historical, promulgates this brave mobilization. In this sense, "the importance of film is of the same nature as that of poets, writers, musicians, philosophers," Marie-José Mondzain stated during a seminar at the Lussas documentary film festival in France. "All wish to give people a voice and to build individual and collective memory to produce a community of emotions founded on an awareness of danger and courage. There is no art of fear, only art of bravery" (3961).

In *Juju Factory* (DRC, 2005), Balufu Bakupa-Kanyinda appears to seek the salutatory *juju*, or talisman, capable of protecting from monsters, and which must be lurking somewhere out there in the culture reinterpreted to today's tunes. It is the role of tortured artists to undertake this, in the bleakness of internal exile, attuned to their exile as immigrants or outcasts. The outrageous Balufu takes pleasure in setting us on this path with his vibrant, lyrical, exhilarating, and wayward film (4517). And it is true that films sometimes manage to bolster our courage, notably by retracing the destiny of figures who did so themselves; that is the importance of historical films, beyond the urgency of addressing the present.[3] We need the people who came before us, whose determination and sacrifices can help us, so long as we avoid mystifying or reifying them! Aliker, the tragic hero portrayed by Guy Deslauriers in his eponymous film (Martinique, 2007), was tormented by the thought that his fear caused the death of several of his comrades in the war. The film shows how he turns his fear into bravery (8595). How could one forget that other incarnation of bravery, twice recalled to our memories by Haitian Raoul Peck, first very personally and magnificently in *Lumumba, la mort d'un prophète/Lumumba: Death of a Prophet* (France, 1991), which evokes Peck's own childhood memories,

and then with utmost authority in *Lumumba* (1998), which seeks to shed light on the conditions of his assassination (1551). This reminder of bravery gives us the energy to continue, to invent, and to avoid repeating. *Lumumba* represents a rupture with classic narrative structure: this voice of a man who recounts his story in the present forces the viewer to reconstruct it him/herself, rather than just swallowing it.

"Who built Thebes of the seven gates? In books, you will find the names of kings. Did the kings haul up the lumps of rock?" asked Bertolt Brecht.[4] It is people who make history, not kings! With *Algérie, histoires à ne pas dire/Algeria, Unspoken Stories* (Algeria/France, 2007), Jean-Pierre Lledo does not carry out the work of a historian, but focuses on the men and women who share a common history, that of a wounded country that finds it hard to face its contradictions. Is another future possible? Perhaps, but what Lledo appears to suggest is that it is still time to put the question of the future on the table. Through his respect for the subject and the filmed subjects, he thwarts the accusations that he manipulates opinions, as was claimed when his film was banned in Algeria and a media campaign was whipped up against him. And it is thanks to this respect that his film surpasses the specific Algerian context to ask two burningly topical questions: that of the future consequences of the means that freedom movements adopt, and that of nationalism, built on identity-based definitions that deny diversity (7416). The film was a continuation of Lledo's 2003 reflection in *Un rêve algérien/An Algerian Dream* (Algeria/France), in which Henri Alleg represents that French component that espoused the Algerian combat.

In 1998, Djamila Sahraoui returned to her hometown to capture the lives of young people during the massacres and state terrorism. When these youth saw the resultant film, *Algérie, la vie quand même/Algeria, Life All the Same,* broadcast on ARTE television, they realized that their town looked like a slum. So they made a deal with her that she would return, on the condition that they spruced the place up. In *Algérie, la vie toujours/Algeria, Still Alive* (2001), the deal was kept: the young people painted the walls and planted trees! She left her nephew Mourad a camera and came back nine months later to collect the images and edit. Mourad had completely appropriated the film. Everyone had gotten used to his presence. In 2004, *Et les arbres poussent en Kabylie/And the Trees Grow in Kabylia* repeated the same setup to film the same Cité des Martyrs district, but added the burning question: "why are you filming?" Year after year, Djamila Sahraoui and her nephew Mourad documented the country's terrible decline, but their tender gaze, directed at simple folk—a gaze that is never condescending or anecdotal—gives events their

human dimension (3041). It is always fascinating to inscribe documentary in the long-term. Amos Gitaï, for example, painted an edifying portrait of the degradation of Arab-Jewish relations in Israel in *Wadi* (Israel, 1981/1991/2001), filmed at ten-year intervals. Ahmed Lallem filmed Algerian high-school girls in 1966 in *Elles/The Women*, then returned to find them thirty years on. Long extracts of the first film underlay the meetings with the women, who rediscover their youthful declarations, positions, and hopes. *Algériennes, trente ans après (Elles 2)* is moving and full of pathos. The outcome for the women mirrors the female condition in Algeria over the last thirty years (3237).

4.1.2. Countering Oblivion

> Atmospheric, or rather historical pressure
> Intensifies my ills to the extreme
> Even if it renders some of my words sumptuous.
>
> —Aimé Césaire, "Calendrier lagunaire," in *Anthologie poétique*

We have inherited the past, but rather than fixating on it, should we not forget? It is indeed important to forget in order to constitute oneself as a subject, but forgetting does not mean erasing, burying, or denying the past. It is, on the contrary, about giving oneself the possibility of advancing in order to invent. Art thus plays an essential role in bringing us back to the present. In 1998, the Congolese governmental army used heavy artillery on the rebels, chasing them into the forest, where the population had also taken refuge from the fighting. The people fled to the other side of the river, into the DRC, to escape being slaughtered. Under the auspices of the UN High Commission for Refugees, their repatriation was then organized, but some were burned and their bodies thrown, in bags, into the river, or dumped in a container that was then sunk. Impunity and oblivion: this affair has still not been elucidated. In *On n'oublie pas, on pardonne/You Don't Forget, You Forgive* (Congo, 2010), Annette Kouamba Matondo paints the portrait of a Congolese actress, playwright, and director, Sylvie Dyclo-Pomos, who based a play on the "beach disappearance affair," entitled *La Folie de Janus/Janus' Madness*, "to rid us of the ghosts that haunt us." Leaders can be dangerous and the risk major: "We have to speak. I write. We all die one day," she said. A rehearsal with an actor intersperses her monologue three times: "to yourself, to someone, to the leaders." Each focuses on these tragic events and the pain is present. "We cannot free ourselves from the past.

We should forgive, but not forget," states Sylvie Dyclo-Pomos. In using Mandela's words in the title, Annette Kouamba Matondo clearly announces the film's choice: rather than limiting herself to a commissioned piece—the portrait of talent—she takes her subject's courage on board and even takes this courage as her subject. Here lies the film's force, for as soon as one touches on the political in local productions, one is treading a fine line and the stakes become implicit. The film was coproduced by a private television company run by an army general. It could not, then, be as explicit as Aliénor Vallet's *Congo Brazzaville, violence extrême en héritage/Congo Brazzaville, Heritage of Extreme Violence* (France, 2009). The film includes long extracts of *La Folie de Janus,* but also, and above all, long testimonies, analysis, and denunciations recorded during a public intervention. But this explicitness, which seeks to counter oblivion, loses here in cinema what it gains in enunciation (9671).

When confronted with the denial of history, with the organized erasure of a people's memory, taking up one's camera aims to reverse the relationship. That is the case with Christian Lara's work, who, from film to film, revives Guadeloupean history in the light of its absence from the French national narrative: namely, *Vivre libre ou mourir/Live Free or Die* in 1979, *Sucre amer/Bitter Sugar* in 1998 (2294), and *1802: L'épopée guadeloupéenne/1802: The Guadeloupean Epic* in 2004 (3475). But doesn't reversing official history to restitute the resistance of the oppressed re-create a new official discourse if it focuses on the epic, rather than on the multiplicity of transversal memories? A good dose of lyricism is indeed needed for these black officers who swear to fight to the bitter end, proclaiming as the violins drop out of the sky: "to the whole universe the last cry of innocence and despair." The myth is nonetheless tempered by the fact that some of the black officers join the Napoleonic troops, putting their knowledge of the terrain and of the population at the service of defeating their side. This ability to look history in the face brings us back to the present, that of out-and-out corruption, as a way of exploring how to overcome it. "Memory isn't only a memory of the roots," states Marie-José Mondzain. "What memory should be is a vitality of the past in the present. The present only stems from its solidarity with the narrative we are able to construct about what came before us and got us here, and which feeds the narrative or constituent fiction that we create so that, when we are no longer here, something will also connect" (4565).

It must be said that historical narrative has never been particularly favored in African cinema and that it is becoming increasingly rare. Costume dramas cost a lot, of course, but the reason lies more in the question of awareness, as Ken Harrow puts it: "There is no history to represent, to correct, in film. There is only authority

that represents itself" (9463). The days of this kind of committed cinema—for example, an anticolonial resistance film such as Ousmane Sembene's *Emitaï* (Senegal, 1971)—appear to be behind us. Documentary, however, in its ability to go back in time via archives and testimonies, is more apt to offer an answer to the question of knowing why we got where we are. But, like fiction, it is the product of an authorized thought, and is enunciatory of truth. Ultimately, it is the aesthetic choices that determine the freedom left to viewers. If their freedom of thought and speech are not denied, if the complexity of opinions and experiences is not glossed over, the matter and the images that are proposed will help them position themselves and construct a possible imaginary of coexistence.

Memory films are thus above all a means of recalling the denials and omissions that limit our understanding of the present. Jean-Marie Teno's highlighting of the 1904–1907 Herero genocide in *Le Malentendu colonial/Colonial Misunderstanding* (Cameroon, 2004), which Germany officially asked forgiveness for in 2004, shows that it is in this horror that ideologies of white superiority were put into practice— ideologies that paved the way to the absurd and suicidal Nazi attempt to achieve "a pure Aryan race." Rounding up the Herero, the Germans used the "concentration camp" concept for the first time. It is significant to realize that it was under colonial domination that the century's violence was experimented with (3477 and 3942). These distant deaths mirror those of all colonial abuses, from the slave trade and slavery to apartheid and repression and war of all kinds. The memory of these is essential as it reestablishes a continuity of suffering between the past and the present. Memory reconstructs the duration and restores the link between the living via the link reestablished with the dead. It thus gives meaning and founds culture. It is not inward-looking; it is a recognition. By recalling the sacrifice of the dead or the suffering of those sacrificed, it appeals to our responsibility in the present.

"*Mémoire en détention* [*Detained Memory*] is not in the plural; it is the collective memory, that of an entire people. Those who have suffered, died, campaigned, whatever their ideology, have fought for an ideal. I had to intervene to be at peace with those people to in turn do something, even if it is too late" (4384). Explaining the undertaking of his 2004 film in these words, Jillali Ferhati opened a path that does not oppose one memory to another; there can be no rehabilitation of memory without calling on all other memories. Like Glissant, he thus opposed the notorious "competition of memories," this utter stupidity that pits one memory against another—notably, for example, Jewish memory against black memory (6680). It is in this dynamic that Morocco opened the doors to its painful memory, that of the

"Years of Lead" of the 1970s when political opponents were arbitrarily imprisoned like beasts by the merciless authorities.

Strengthened by this opening up, Moroccan cinema entered this breach unhesitatingly, and six films were made in a very short space of time. Two of them attempted the delicate exercise of historical reconstitution, at the risk of freezing memory in the restoration of a bygone era: *La Chambre noire/The Black Room* (Hassan Ben Jelloun, 2004) and *Jawhara/Jail Girl* (Saad Chraïbi, 2003), which both portray the abysmal jails and the prisoners' terror. Four others, however, took greater cinematic distance, focusing more on the afflictions of memory and their effect on the present. The admirable *Mille mois/A Thousand Months* (Faouzi Bensaïdi, 2003) conveys, without ever showing, how the repression leaves traces that taint a wounded generation's vision of the world. In 2003, Abdelkader Lagtaâ also focused on the amnesia that this wound causes in his character Kamal in *Face à face/Face to Face*. With *Mona Saber* in 2001, Abdelhaï Laraki also sought a confiscated memory through a young French woman looking for her real father locked away during the Years of Lead. And with *Mémoire en détention*, Jillali Ferhati progressively constructs a relation with this torn past, this imprisoned memory, there too through the amnesiac Mokhtar, whose body alone remembers (4386).

In January 2004, the new king set up the Equity and Reconciliation Commission. In 2008, Leïla Kilani devoted her *Nos lieux interdits/Our Forbidden Places* to it. Yet it is from the point of view of the victims, the families, the Moroccan people that the filmmaker—originally trained as a historian—decided to place herself, despite being commissioned and funded by the Commission, which was expecting a report on its works. While the Commission unleashed speech, *Nos lieux interdits/Our Forbidden Places* documents the silence: how the lack of memory weighs on Moroccan society. This very verbal film's subject is thus the difficulties of speech. It testifies to the youth who are mobilizing today in order to understand, to the fascination that those who dared to rebel and say "no" forty years ago still exert (8199).

"Our daily role has to be reconciliation," Abderrahmane Sissako stated. "We are strong when we are united," echoing the proverb that he often cites: "Water irrigates the land to feed humans. Culture irrigates their souls so they can be reconciled."[5] To work towards reconciliation is to propose a utopia. In *Daratt* (Chad, 2006), Mahamat-Saleh Haroun focuses on Atim's free will, which allows him to escape the infernal cycle of violence. He does not, in the Christian sense of the term, pardon the man who killed his father; refusing to be commanded by his grandfather, who gives him the gun of vengeance, he creates on his own initiative the scene that will

allow him to escape its repetition. "Why do Westerners spend their time asking for forgiveness?" Ousmane Sembene asked me. "In whose name? I say to Africans, you can forgive, but you cannot forget. It is the Western culture of absolution that makes people ask forgiveness." Before adding: "Africans were complicit at all levels of the slavery chain, but when you say that, it makes them angry!" (2506).

To forgive, but not forget? Mandela too referred to the new humanism of a culture of living together. In Kinyarwanda, forgiveness is expressed by a word that signifies two people who cry together. One cries because of his/her acts, and the other because that pains him or her. Forgiveness can only come from one side, but should come from both. This shared dynamic corrects the unilateralism of both repentance and pardon. As Achille Mbembe wrote: "Many of us, from Franz Fanon to Françoise Vergès, have always said that repentance and reparations produce victims. The vulgate of repentance perpetuates the image of the other as an unspeaking body, as a body with no energy or life. And that is not us. For we are not just the victims of our own tragedy. We are also the actors and witnesses" (6864).

4.2. Vanquishing Slavery and the Slave Trade

Where are your monuments, your battles, martyrs?
Where is your tribal memory? Sirs,
in that grey vault. The sea. The sea
has locked them up. The sea is History.
—Derek Walcott, "The Sea is History," in *Collected Poems, 1948–1984*

4.2.1. History's Stutterings

Prolix on so many topics, cinema does not know how to address slavery and the slave trade (0305). Confirmation of this came in the 2000s: it is one of the great absences of world memory (0299). In 1998, the French Guyanese parliamentary deputy Christiane Taubira introduced a bill that was only adopted on May 21, 2001, "recognizing the slave trade and slavery as a crime against humanity." "There was a lot of resistance and guile" concerning its application, Christiane Taubira noted; she has incessantly faced attacks against this law.[6]

It was not until 2006 that the article establishing a national annual commemoration—May 10, the date the law was unanimously adopted by the Senate—was

applied. Changes to school programs and textbooks only came in in 2006 (10141). This law specifies that textbooks must give this history "the place it deserves"; it does not stipulate how it is to be taught. It is a law of reconciliation, contrary to the 2005 law that imposed the teaching of the "positive aspects of colonization" before the resulting national uproar forced then President Chirac to remove this paragraph (while retaining Article 1, which pays homage to France's overseas accomplishments).[7]

Without this law, French children were condemned to discovering the harsh historical reality themselves, unguided, and at the risk of awakening hatred or despair in the descendants of deported slaves—like the two youths, Silex and Josua, who look at the old prints in the house they ransack in Jean-Claude Flamand Barny's *Nèg Maron* (Guadeloupe, 2004) (3674). Unemployed, marginalized, from broken families, they do not care about big celebrations like the commemoration of the 150th anniversary of the abolition of slavery. Yet these remembrance laws and celebrations concern them, for in seeking to restore national unity, they assert their equality as citizens against all discrimination. For such advances to become possible in texts, considering the denial, silence, and shame, history had to be restored. Filmmakers have contributed to this—for example, Med Hondo, with *West Indies: Les nègres marrons de la liberté* (Mauritania, 1979), daring "a musical tragicomedy" in the single setting of a ship, a radical chronicle based on the play by Martinican playwright Daniel Boukman. The film aims to reestablish the truth about the economic interests, to cite the abominations, and to deconstruct the myths. Ousmane Sembene offered an ode to resistance in *Ceddo* (Senegal, 1977), in which the slaves are branded with a hot iron, the definitive inscription of their condition in their flesh. Rather than being filmed as a submissive and passive crowd, the slaves in Haile Gerima's *Sankofa* (Ethiopia, 1993) are individuals with their desires, love, and hate. Rather than insisting on just their corporal and spiritual alienation—the eternal humanitarian, paternalistic vision—the film portrays them as the contradictory and dynamic players in a liberation struggle.

This reversal is fundamental: when Guy Deslauriers shot *Le Passage du milieu/ The Middle Passage* (Martinique, 1999), based on a screenplay by Patrick Chamoiseau, he adopted the point of view of the slave ship's hold, and not its bridge, to describe the crossing. With frequent use of slow motion, flashes, and jerky images, it reflects more than it shows. Its restraint in filming the bodies avoids treating them like cattle. The details suffice to suggest the whole. The film concentrates on faces, eyes, the swell, the sounds so that we can grasp what it must have been like

to endure this for so long. Out of the hold, marked, transformed people emerge. For this point of view is also that of the slaves' revolt against the death they are subjected to (1755).

That is the crux of this memory: it is thanks to their revolts that they finally brought about abolition. In the desire to contribute to black people's affirmation of a positive self-image, black filmmakers have multiplied the number of historical films about slave revolts and Maroons. In part 4.1, we already mentioned Christian Lara's characters in the Guadeloupean revolts, who appropriated the French revolutionary ideals of liberty and equality: "May the colonies perish, rather than a principle," Robespierre exclaimed. If only these principles had been translated into actions! Brazilian Carlos Diegues's trilogy about Afro-Brazilian resistance, *Zumba* (1963), revolves around a fugitive slave who discovers that he is the grandson of the king of Quilombo of Palmares, a self-sufficient republic of fugitive slaves that for a century, from 1595 to 1695, managed to survive the repeated assaults of the Dutch and Portuguese, and which comprised 20,222 members at its apogee, with a territory a third of the size of Portugal. *Silva* (1976) and *Quilombo* (1984), also about Palmares, are conceived as *samba enredos* (plots constructed like a samba school: song, dance, costume, and words forming a coherent, popular narration). That was also the case with *Chico Rei* (Walter Lima Jr., 1982), a German-Brazilian coproduction about an African slave king buying his freedom and successfully exploiting the Encardideira mine, becoming king of his region again while maintaining his nonviolent African methods. Black Cuban Sergio Giral also made a trilogy in which he tried to restore an insider reading of slavery in Cuba by also adopting the slave's point of view: *El Otro Francisco* (1975), *El Rancheador* (1976), and *Maluala* (1979).

In *Les Caprices d'un fleuve/The Unpredictable Nature of the River* (1996), Bernard Giraudeau attempted to explore his fascination with Africa as the lover of a pretty slave, but did not escape the clichés or an overly beautified image. In *La Côte des esclaves/Slave Coast* (1994), which focuses on the descendants of those who played an active role in the slave trade, Elio Suhamy sought the social traces of slavery in Benin. This theme of slavery in Africa was also explored by Christian Richard in *Le Courage des autres/The Courage of Others* (1987), starring Sotigui Kouyaté, made while he was a teacher at INAFEC, the defunct Ouagadougou film school, and also produced by the equally defunct Cinafric: a silent film that depicts a column of slaves' revolt against their African captors. Its presentation on the opening night of FESPACO provoked a fierce debate: did showing the enslavement of Africans by Africans amount to justifying the slave trade?

It is effectively through the question of the image that François Woukoache's highly powerful *Asientos* (Cameroon, 1995) opens: on a slanted, unstable television screen, Western photographers shoot the genocidal horror in Rwanda. History stutters: "It's starting again." The filmmaker surfs to find a just image, to avoid the pitfalls of the sordid, the age-old vision of subjection and passivity. "Why doesn't the sea spit out these corpses?" There is nothing to see of the slave trade, nothing to show. The camera caresses the bare walls of Gorée Island. Only the sea's complaint can evoke that of the chained slaves. A child runs to the words of Césaire: "In my memory are lagoons. . . . My memory has a belt of corpses."

4.2.2. Exorcising Memory

Must one resort to guile for you to hear *this pain*?

—Raharimanana, *Des ruines . . .*

When Ivorian Kitia Touré questioned the descendant of a Nantes slave trader in *Les Anneaux de la mémoire/The Rings of Memory* (1994), he was shocked to find "neither remorse nor compassion." An edifying anthology of the instruments of the slave trade, the film examines the astounding erasure of the slave port's memory. For, ultimately, the subject is not the slave trade, but its memory. And addressing memory revives the present: the ravages of Colbert's *Code Noir* (Black Code) continue, as Tony Coco-Viloin proclaims in *Le Cri des Neg Mawon/The Maroons' Cry* (Guadeloupe, 1993), an impressionistic nightmare of a black diasporan man. "Maroons are still on the run in this land," and will be as long as they remain scared of their history, and until it is exorcised—which will only be possible when history is told not from outside, but from within. For there is a contradiction: "The paradox," as Coco-Viloin puts it, "is that when you're part of the yolk, you don't know the egg" (2508).

For Patrick Chamoiseau, "The American plantations invented ontological discredit and the damnation of a phenotype, and all black people in the world are still suffering the effects. The descendants of slaves internalized this and believed that by forgetting, we would be able to reintegrate humanity more quickly. It became an obscure memory that fueled many a summary impulse, and played on consciences. We internalized inferiority, self-hatred, or at least a collective self-underestimation. Exorcism became indispensable!"[8] What is called for, then, is accepting introspection while conserving the question of origin; in short, playing out a return to the future, like in Julie Dash's admirable *Daughters of the Dust* (USA, 1991). A radical break from the (*Amistad*-style) Hollywood aesthetic, which couches its belief in progress's

continuity in a temporal linearity, *Daughters of the Dust* cinematographically translates an oral tradition based on a cyclical conception of time. The characters find their identity in the rhythm of the close-up shots of faces, the general shots of the landscapes, and an image that systematically relates the community to its surrounding space: on a Gullah island off South Carolina, a slave-trading hub. Julie Dash thus detaches herself from the Italian Neorealist–inspired aesthetic developed at UCLA, which transposed the colonization of African Americans to the urban ghetto (for example Haile Gerima's *Bush Mama*), situating the film on Ibo Island, where the former slaves developed a community and their own culture. It is in this space that the black women articulate their relation to Africa, their survival, and their way of living in the United States. Dramatic confrontations punctuate the sufferings of America's black population, finally looking to a multiple identity that embraces the complexity of history. In a syncretic ritual around a Bible enhanced with the ancestors' mojo, the family members translate the reconciliation of both different cultural influences and the past and future. The aesthetic of this essential film thus portrays a real ethic of cultural resistance and, without ever showing the slaves, tackles the issue of slavery in the present, too (0401).

4.2.3. Exist

This is not possible without confronting the past. Which brings us back to *Asientos*: "To be quiet, he says, to listen to the silence, to learn again to look to see the unspeakable." But isn't looking at the past head-on also to look oneself in the face? That considerably widens the circle of films that deal with the subject! Slavery in all its forms is monstrous, but it created a creolization that bears the future. That does not outweigh the suffering, but it does make it possible to emerge from the shame and hatred of the victims, as Edouard Glissant put it: "What is at stake with all emancipation is indeed first and foremost the freedom to mix, of *métissage*, of creolization, which the racist and slaver abhor with unflagging determination. To vanquish slavery is also to understand the nature and function of creolization and to understand that the slavers' world is one of a rabid self-solitude."[9]

"We do not like ourselves!," Michel Rogers—the astonishing, self-taught gene-alogist who works on black families' surnames—exclaims in Sylvaine Dampierre's *Le Pays à l'envers/The Country in Reverse* (Guadeloupe, 2008). To know oneself is to give oneself recognition, to accept and be able to love oneself. Here, then, Sylvaine Dampierre, whose name is that of a place near to Gosiers, a plantation of 135 slaves, sets out to recover this memory that, she suggests, is the basis of self-esteem. "Tell

me your name and I will tell you who you are," as the griots say. When Moses wanted to know God's name, God replied: "I am he who is." It is precisely this being that is missing for the descendants of slaves. Article 44 of the Code Noir designated slaves as furniture, that is to say, goods that could be bought, sold, given, or seized. Article 12 stipulated that a child born to slave parents in turn became a slave. But those who drew up the Code Noir believed that black people were humans, with a soul and susceptible to salvation, and thus needed to be baptized (but forbidden from worshiping the Protestant faith!). A contradiction was established: contrary to what they were subjected to suggests, slaves were not objects. Work your own existence out! Today, it is at the heart of this contradiction and not in denying it that their descendants, robbed of their names, seek their being (8600).

It is not about trying to restore a unique and fixed identity, but about taking the both individual and collective interrelated identities that stem from *métissage* (mixing) as a foundation, a projection of tomorrow's identity, and thus as a message for the world. As Glissant shows, the history of all slavery is an assembly of transversal histories, a rhizomatic memory that is still to be discovered. "I am not a slave to the slavery that dehumanized my ancestors," Fanon wrote in *Black Skin, White Masks*. An essential discrepancy is at play here: rather than a memory that asserts that we are its past, it is a question of mobilizing one's past so that it is audible in the multiplicity of the present. The French national narrative—that of Enlightenment and the Republic—is silent when it comes to the slave trade and the periods of abolition followed by the restoration of slavery. The stake is to revive these to illuminate the present (6680).

In Africa too, slavery is occulted by griots and grand narratives alike. A process of memory is necessary: "I'm talking to you about a land that served up the best of its sons to the four winds," says screenwriter Patrick Chamoiseau in *Le Passage du milieu/The Middle Passage.* It is important to surpass a radical vision: abductions and raids carried out inland provided the slave traders with slaves. Roger Gnoan Mbala's *Adanggaman* (Ivory Coast, 2000) dared to tackle the subject frontally, adding a romance between a murderous Amazon and a slave. More than a historical reconstruction insisting on the different parties' guilt, the film is a reflection on the link between slavery and power. "Slavery was already practiced in African kingdoms when the slave traders came and exploited the complicity of these kings," Mbala noted (0957). The slave trade is thus not a stroke of destiny, but a participation in one's own history, the fraternal crime, the divided city-state. In addition, Ibrahima Thioub indicates, "the African elites used the slave trade to redefine power relations on the continent."[10] But the crossing also marks a frontier in the repression of

memories. "It's a people there in my gut," as Fabienne Kanor put it (3689); those deported bear the suffering of what Glissant called the three chasms of slavery: not knowing why, how deep the sea was, nor the destination. This traumatic experience marks their difference from those who stayed behind.

When Lionel Steketee, Thomas Ngijol, and Fabrice Eboué released *Case départ/ Starting Block* (France, 2011), it was completely unprecedented. Other than the French television series *Tropiques amers/Bitter Tropics,* by Jean-Claude Flamand Barny, no French fiction film directly addressed Antillean slavery in the 2000s. Doing so on a comic register sparked fierce reactions and calls for a boycott. The film was reproached for not testifying to the harsh reality of slavery. It is true, given that the two heroes are magically transported across the Atlantic by an aunt angry at their lack of respect for the family memory, that they are spared the crossing. The film was originally meant to have been shot in Martinique, but the Béké landowners—descendants of the major white owners of the slave era—opposed this. The film was thus finally shot in Cuba. Each character is given his or her chance to prove their true humanity; the aim is not to condemn anyone, but to use humor to lighten the burden of memory, while at the same time restoring it to the public place. Historical exactitude is bypassed on this unrealistically nice and clean plantation: the film is only a first step to further pedagogy or personal research (10319). The elites' mixophobia reflects the political refusal of creolization, but it is at the level of the population that the practices that found a new humanity are inscribed. Accepting our memory gives us a surer footing. From France's 1982 March for Equality to today's rappers, the youth have realized that with a critical spirit, they can vanquish slavery.

4.3. The Colonial Lie

This wild Africa has but two facets: populated, it is barbaric; deserted, it is savage.... This universe that scared the Romans attracted the French.... Come, people! Grab this land. Take it. From whom? From no one. Take this land from God. God gives man the land. God offers Africa to Europe. Take it. Spill out into this Africa, and at the same time resolve your social questions. Turn your proletariat into landowners.

Go ahead, do it! Go forth, colonize, multiply!

—Victor Hugo, speech given on May 18, 1879, at a banquet
for the commemoration of the abolition of slavery

4.3.1. The Absent Colonial Subject

Caroline Eades lists approximately fifty French films made since Independence and set in the colonial period.[11] Often set at the time of the fall of the empire, these films criticize colonial ideology and the persistence of its imaginary representations. They demystify African colonial history, at times virulently, for example in *La Victoire en chantant/Black and White in Color* (Jean-Jacques Annaud, 1976), *L'Etat sauvage/ The Savage State* (Francis Girot, 1978), or *Coup de torchon* (Bertrand Tavernier, 1981). But even though they highlight racist contempt and exploitation, these caricatural films do not portray the interactions at work, nor their stakes, which *Chocolat* (Claire Denis, 1987) does with great finesse. With the exception of Alain Corneau, who situated *Fort Saganne* (1983), his film about the fight against the revolt of the Saharan tribes in 1911, and Serge Moati, who made a television drama about the 1899 Voulet-Chanoine column (*Capitaines des ténèbres/Captains of Darkness*, 2005), very few filmmakers have focused on colonial history, and even less, colonial conquest, the root of deep animosity. This cruel memory is evacuated from the French national narrative, thereby excluding those who bear its mark today: immigrants, former soldiers, French overseas workers, *pieds-noirs*, *harkis*, and their descendants who desperately want to understand their family history. In other words, millions of people. The battle for memory that the media, historians, and politicians have been fighting since the mid-1990s have rarely inspired the cinema, and when it has, the major subject has remained the Algerian War.

This war was first approached from a distance, in a series of films that evoke what was then referred to as "the events," such as Jean-Luc Godard's *Le Petit Soldat* (1960), Alain Cavalier's *Le Combat dans l'île/Fire and Ice* (1961) and *L'Insoumis/The Unvanquished* (1964), Alain Resnais's *Muriel, ou le temps d'un retour/Muriel, or the Time of Return* (1963), Jacques Rozier's *Adieu Philippine* (1963). Then followed reconstructions that returned to the vertiginous experiences of France's conscript soldiers and torture, such as René Vautier's *Avoir 20 ans dans les Aurès/To Be 20 in the Aures* (1972), Yves Boisset's *R.A.S./Nothing to Report* (1973), Laurent Heynemann's *La Question/The Question* (1976), or through a trial in Pierre Schoendoerffer's *L'Honneur d'un capitaine/A Captain's Honor* (1982). Alexandre Arcady evoked the repatriation of the *pieds-noirs* in *Le Coup de sirocco* (1978). Then, thanks to the attention focused on the question by the considerable work undertaken by researchers from the mid-1980s onwards, which resulted in France's recognition of the term "war" in

June 1999, other filmmakers made fiction works about this war, notably Gérard Mordillat (*Cher Frangin/Dear Bro'*, 1989), Brigitte Roüan (*Outremer/Overseas*, 1989), Gilles Béhat (*Le Vent de la Toussaint/All Saints Wind* 1991), and Alain Tasma (*Nuit noire, 17 octobre 1961/October 17, 1961*). France's postcolonial relations with Algeria were also the subject of Dominique Cabrera's *L'Autre Côté de la mer/The Other Shore*, 1961). Benjamin Stora has listed some forty French films on the Algerian war, but notes that it is often claimed that there are very few.[12] According to Stora, this impression of absence results from the fact that, generally, neither the war itself nor the deaths involved are shown; the enemy remains invisible, or the Algerians are never true characters unto themselves. This lack of figuration helps to create "a derealization of countries which evaporate, becoming almost abstract." It is on both these levels that a rupture can be noted in the 2000s. Before that, French films adopted a French point of view, and Algerian films, an Algerian one. This separation was still visible in *Mon colonel/The Colonel* (Laurent Herbiet, 2006), which focuses on torture through the remorse of a conscript soldier (4666). It is also present in François Luciani's television dramas: *L'Algérie des chimères/Algeria of Mirages* in 2000, on the period in which the republican colonizers took over Algeria despite Napoleon III's decision to make the colony an Arab kingdom; and *L'Adieu* in 2003, on the spiraling descent of a soldier carrying out his military service in Algeria in 1960, and who loses his republican values (2884).

In *La Trahison/The Betrayal* (Philippe Faucon, 2005), on the other hand, we follow four French soldiers of North African origin, their suffering and doubts (4271). A double betrayal is at stake: the betrayal of one's country of origin, and France's betrayal. The film is emblematic of the ambiguities of the first generation who came to work in France. "The following generations, who felt betrayed by France, preferred to stand up for themselves. This translated into a speaking out in all senses of the term," Faucon stated (4272). Faucon indeed focuses on this speaking out in *Samia* (2000), a film about a fifteen-year-old girl who is suffocating in her Algerian family in the suburbs of Marseille. *L'Ennemi intime/Intimate Enemy* (Florent Emilio Siri, 2007), which breaks radically with former portrayals of the war, is a frontal shock that plunges us into the horrors of combat and both sides' acts of violence. This spectacular representation ultimately derealizes the war, however, so that all we see is the violence, undermining the processing of memory (6946).

Like Faucon, Mehdi Charef takes Franco-Algerian relations as the theme of *Cartouches gauloises/Summer of '62* (2006), based on his childhood memories. He

indeed adopts eleven-year-old Ali's point of view, the son of one of the National Liberation Army leaders (ALN) during this critical period of the first years of Independence. But Ali is torn between his friendship with Nico and his other French friends, who one by one leave the country-in-the-making, and the colors of whose flag he has to ask his mother about. This feeling of being torn of course announces the difficulty that both Ali and Algeria will experience in moving on from the colonial graft, which not only is a source of pain, but also, over time, has necessarily become part of the self. Ali is the stunned, silent, traumatized witness of both French and Algerian acts of violence. The gang of friends gradually disintegrates before the pressure of death, hatred, and tragedies. The carefree world unravels in the face of violence, as political opposition obliterates human relations (5957).

The film provoked an outcry in Algeria and, like all those that tackle this subject, won limited critical acclaim in France. Similarly, Rachid Bouchareb's *Hors-la-loi/ Outside the Law* (2010) did not repeat *Indigènes/Days of Glory*'s three million entries at the box office. While the *tirailleurs'* contribution to France's liberation effortlessly won the nation's unanimous approval, the same cannot be said of recalling colonial abuses! France's populist right wing criticized an erroneous vision of the Sétif massacres, rejecting the entire film in passing, without mentioning its honest portrayal of the conditions of the Algerian independence struggle in mainland France[13] (9500, 9498, and 9541). This touches on the absolution/recognition dialectic, this new political discourse incarnated by Nicolas Sarkozy's Dakar Speech, which claims that "colonization was of course reprehensible, but France colonized without exploiting."[14] This "rind of clear conscience," as Césaire put it, refutes all moral responsibility for acts perpetrated by the state, and perpetuates the acute misrepresentation of reality that structures colonial ideology, this constant lie about colonialism, whose acts, like slavery, totally contradict European humanism. This dual discourse is a falsification of history, and what is at stake is revealing so. Albert Memmi clearly showed that "colonization deprives the colonized, and that all deprivations maintain and feed off one another."[15] Césaire spoke of both colonial *thingification*, of the *decivilization* of the colonizer, and the duplicity of those who strive to start the *forgetting machine*. For Achille Mbembe, the native is a thing "which is, but which only is so long as it is nothing."[16] Inequality was institutionalized by the Code de l'indigénat (Code of Indigenous Status), forced labor, and the racial segregation of the colonized. This system established a structurally asymmetric relationship, which cancels out the existence of "goodies" and

"baddies," a fabrication that swamped colonial cinema and founded the invention of the notion of "the positive aspects of colonization."

4.3.2. The Past in the Present

This lack of colonial memory fuels the interest of a public wanting reliable historical information. Various documentaries have attempted to respond, not without their contradictions. *Le Roi blanc, le caoutchouc rouge, la mort noire/The White King, Red Rubber, Black Death* (Peter Bate, UK, 2003), for example, carefully constructed an indictment of the terrible acts of violence orchestrated by Belgian King Leopold II, who turned the Congo into a vast forced-labor camp to serve his own interests. The film is deliberately bombastic, with dramatic music, reenactments, and damning texts read to a Leopold II in a courtroom setting.

But this demonstrative film, coproduced by the major European television stations (BBC, ARTE, ZDF, RTBF, etc.), places the entire responsibility for this oppression on the king, as if with his death, justice was done. It denounces the past without putting it into perspective with the present. It makes it a history of individuals, when it was in reality a system that has continued into the present. In denouncing only the white king, it masks black resistance (3477). *Mémoire entre deux rives/Memory between Two Shores* (Frédéric Savoye and Wolimité Sié Palenfo, 2002), alternatively, adopts the opposite approach: it puts the accounts of French conquerors into perspective with those of the Lobi population of Burkina Faso, who opposed and were repressed, as handed down through orature. The colonial era continues beyond independence: the "civilizing" system is perpetuated in different forms, and its consequences are individual, social, and religious (3349). Similarly, by revealing that, sixty years on, the suffering and resentment is still alive in *Les 16 de Basse-Pointe/The Basse-Pointe 16*, shot during the forty-four-day 2008 strike organized by the Guadeloupean "Movement against *Pwofitasyon*" in protest at the high cost of living, Camille Mauduech clearly confirmed the continuing colonial relations. The trial of sixteen Basse-Pointe black sugarcane cutters, accused of killing the white Creole plantation overseer in 1948, was the first trial of French colonialism in the Antilles (8445).

In *Le Malentendu colonial/The Colonial Misunderstanding* (Cameroon, 2004), Jean-Marie Teno revisits the colonial history that he first addressed in *Afrique, je te plumerai/Africa, I Will Fleece You* in 1992, continuing his analytical contextualizing work in order to fight against the erosion of black consciousness, to reestablish

self-esteem, to encourage critical self-examination (cf. *Le Mariage d'Alex/Alex's Wedding*, 2002), to deconstruct hierarchies (cf. *Chef!/Chief*, 1999), and to reappropriate education (cf. *Vacances au pays/A Trip to the Country*, 1999). "The film aims to put African history back at the heart of European history and humanity," he stated (6865). He reveals the extent to which the missionaries integrated state colonialism, becoming emblematic of the duplicity and double discourse already mentioned. That, according to Teno, is the source of the colonial misunderstanding: this alliance between the missionaries' will and the colonialists' arms, between Christian ethics and commercial interests (3942). Teno echoes *Guelwaar* (Ousmane Sembene, 1992) in the combat against injustice that renders charity pointless, refusing the food aid that places Africans outside humanity. In her 2003 film *Les Maux de la faim/The Price of Aid*, the Egyptian documentary filmmaker Jihan El Tahri evoked the example of Zambia, which one day dared to refuse American food aid. The United States solves the problem of its mountains of food and delivers genetically modified grains that then have to be used as seed by the local farmers, preventing them from exporting to Europe. As the Zambian president stated: "When two elephants fight, it is the grass that gets crushed" (3020).

It is this continuity between colonialism and neocolonialism that matters in the present, so much so that, as when evoking slavery, the filmic time span is fragmented and focuses on the perpetuation of past behavior in the present. *Raja* (Jacques Doillon, France, 2002) is in this respect disturbing in a deeply interesting way: Fred, a French dandy with a beautiful villa in Morocco, attempts to seduce Raja, a young, orphaned gardener, in the hope of some "no strings attached sex," as he puts it, even if he has to pay. Neither speaks the other's language. Raja accepts her master's gifts, but refuses to give herself to him, even if she is flattered by his advances. An ambiguous play of desire is set in motion that involves both protagonists, in the framework of a power relationship that is ultimately uncertain. This brings to mind the themes of Bernard-Marie Koltès's plays, from the solitude of power to the confrontation with alterity. Just like *Ramata* (Léandre-Alain Baker, Congo, 2008), *Raja* is like an Africa that is too alluring for its own good. She belongs, as Baker puts it, to a "people of fractures and fissures" (8465). Without referring specifically to colonialism, these films evoke the ambivalence of a relationship in which fascination injects desire into what is otherwise a clearly hierarchical relationship. The denial of humanity authorizes all possession, until the colonized resist, modifying the master-slave dialectic.

4.3.3. Desiring the Other

Colonial film classics brimmed with exotic desire, with an impossible passion, in which it was easy and dangerous to lose oneself. It would be reductive to rate colonial cinema as purely propaganda film. It indeed crystallized the colonial myth and reinforced a racial imagery that is still alive today, celebrating and reinforcing the subjugation of the colonies through its images. Yet, in exploring the emotional relationship that France maintained with the colonies through multiple intimate relationships, it also represented a particularly lucid introspection into the profound ambivalence of colonial domination. In it, it is a question of maternal relationships, of the marriage between two cultures, while also revealing an absolute phobia for the resultant interracial relations. Republican colonization, which advocated assimilation in the name of the values of equality and fraternity, in reality constantly insisted on the incompatibility between the two cultures. Colonial cinema was, in that respect, a mirror that revealed the impossibility of an adventure that could only be tragic in the long run. Premonitory, its fictions thus bore the seeds of decolonization (56).

In Zeka Laplaine's *Le Jardin de papa/The Garden* (DRC, 2004), Jean believes he knows all. He proves himself to be the archetypal modern colonialist: self-assured, contemptuous, wanting to pay his way out of any situation, believing that bribes are appropriate in all circumstances. In the African night, pushed to the extreme in the face of danger, he is like a phantom of the past come back to haunt his lands: a slave trader open to corruption and convinced of the power of money, deep down only considering the black people he loves as apes, disappointed to no longer find his lost paradise. The brutal violence of his stupidity is met with another violence and another stupidity of another nature: that of the neighborhood thugs who want to lynch the taxi driver who ran over a child, and rough up the white passenger couple. Africa's ghosts are indeed present: the colonizer and this unbridled self-destruction that stems from the daily problems and chaos. It is hardly surprising, then, that all this seems like the blues, and that the image is impressionistic, constantly playing on the blur of night lights to highlight the shadows and emphasize the uncertainty. It is not surprising either that the camera hugs the characters, marrying their rhythm, or that it caresses the bodies closely, as if feeling their pulse. For the film seeks to portray them as desiring beings, not unfeeling machines. The African impasse lies in the violence of a history that repeats itself, and what people have internalized of it. We go round in circles in the meanders of the neighborhood to finally construct

a psychodrama behind closed doors, a perfect schizophrenia in which desire is no longer creative, but about possession (3070).

Like Fred in *Raja*, Jean is victim to his own complacency. Confronted with unexpected resistance, these characters go round in circles. They too reveal a contradiction that can only be resolved by decolonizing minds, which is also linked to economic and political power relations. That is the stake of this colonial memory, whether that of the past, or today's repercussions: restoring the colonized in their capacity to resist and thus in their human dignity.

Do grand biopic projects about heroes who resisted colonial conquest meet this objective? Ousmane Sembene tried all his life without ever finding the funding to make a film about Samory Touré, the Mandingo sovereign of Wassoulou, who fought against colonization. Idrissa Ouedraogo ended up renouncing his project to make a film about Boukari Koutou (aka Ouobgho), brother of Naba Sanem, who refused to sign the treaty proposed by Binger in 1891 and who led a guerrilla offensive against the French until 1898. After looking for funding for ten years, he instead made *La Colère des dieux/Anger of the Gods* in 2003, before deciding to give up making big feature films. As a result, the subject of the film is not resistance, but the reasons for the defeat of the resistance fighters, of Africa before the onslaught of the invaders, and of Africa in the world today. Divisions and internal power struggles have undermined Africans' capacity to resist, and can only result in stirring the anger of the gods (2809). "For the new generations, the hero isn't necessarily the one who resists," claimed Ouedraogo. "You can't go on resisting guns with arrows and spears. When we see the great hero Lumumba with Mobutu, we see someone who was politically naive; he did everything to get himself killed! You have to be extremely careful with the images that represent our past to not fall into the opposite of what we want to express" (2782).

It would thus be illusory to confine resistance to valiant heroes: "Everybody knows that if the white man conquered easily, it's because he benefited from a lot of complicity," Ouedraogo adds. The reasons for the defeat were deep-seated: "The Voulet-Chanoine column comprised five whites and 400 African *tirailleurs*, who faced five million inhabitants. They had run out of courage and fear had set in." One has to go further back, then, to slavery, to the racialization of domination, while avoiding portraying colonial history as purely passive subjection; there were constant revolts and uprisings, and awareness was acute. Restoring history, then, comes down to depicting not only warrior-like resistance, but also and above all the power and aspiration of rebuilding one's own values, the motor of this quest that

Césaire called a "wider fraternity" and "humanism on a world level." "But for this experience of journeying and exodus to have meaning," Achille Mbembe points out, "it has to devote a key part to Africa. It needs to bring us back to Africa, or at least to stop off in Africa, this double of the world whose time, we know, will come" (7530).

In both a playful and pertinent proposition, Zézé Gamboa adopts a quirky approach to the end of Portuguese colonization in Luanda in his film *The Great Kilapy* (Angola, 2012). What is the right distance for evoking this? Farce, replies Gamboa. We thus find ourselves embarked in a burlesque biopic about a professional swindler—a "kilapy" in the local language—whose main preoccupations are money and (white) women. The film indicates that the character really existed and that this is a loose adaptation of the life of this king con man, who pulled off being a successful black man in carefree white Angola by frequenting the upper classes in a particularly hostile context, thumbing his nose at the secret police breathing down his neck. It is an engaging evocation, Gamboa choosing as his hero a character who is at the same time fascinating and exasperating, far from the charismatic or emblematic figures of the anticolonial struggle that his friends take part in, and which he determinedly stays out of. The film cultivates elegance to the lascivious rhythm of 1970s Angolan music and turns its *kilapy*'s impertinent humor into a weapon against convention. His swindles targeting the establishment get him thrown in prison, the crook thus becoming subversive, a liberation-struggle hero! Gamboa mischievously articulates a vision of the independence heroes that is as mocking as it is bitter. We follow the intrigues with pleasure, and the celebrated transgressions reveal the extent to which the contradictions of the colony already bore the seeds of decolonization and, more widely, how all dictatorial systems intrinsically bear the very seeds of what will bring them down (11483).

Addressing colonial memory does not imply focusing on an antagonism then, but, on the contrary, on these troubling and destabilizing zones of contact where, beyond the cruelty of the relationship, a culture of plurality was forged. Without idealizing anything, intimate relations did exist. Films that refuse to ignore this were born out of their ambiguity, and thus from their very existence. More than the confrontation between the French lieutenant, his photographer wife, and the nationalists, it is thus their human relations in a village in southern Morocco in 1954 that constitute the action of Saäd Chraïbi's *Soif/Thirst* (Morocco, 2000) (2631). It is this desire to meet and mingle, that resonates in André Téchiné's *Loin/ Far* (France, 2001), set in the same country in the present. In this nomadic film, each moves towards the other, and each evolves on a personal level. Its subject is

this desire that inhabits us all and that cannot be restrained (0040). Serge loves Sarah. Saïd wants to cross the straits to Europe. Sarah hesitates to stay in Tangiers. In this relational puzzle, Sarah is Jewish, Saïd is Arabic, Serge is French; as in the colonies, one's belonging influences circulations and defines territories, but they fail to compartmentalize the desire for the Other. If memory is limited to that of one's own community, we become shut in a rapidly victimized communitarianism, in competition with other communities. In the competition between memories, which overlooks the power of the state, it is the Other who becomes the guilty party. A lack of knowledge of colonial history leads to inter-community confrontation and fundamentalism. Knowledge of it restores both a respect for differences and a sharing of singularities that define the possibility of living together.

4.4. Tirailleurs, the Original Migrants

> Gowi nyi fala nyi compini wé / In the Franco-German war
> Sa té dyuwa ka yénana wé / Have gone to die
> Indégo s'azo n'awani w'azo / Our loves . . . our children . . .
>
> Igowi nyi fala nyi compini wé / In the Franco-German war
> Mandè dyuwa mandè tola / Who dies? Who survives?
> Aboti w'azo n'awani w'azo / Our elders . . . Our elders . . . [17]
> —"Igowi nyi fala nyi compini" (In the Franco-German War), sung in Omyènè (Gabon)

Who knows today that 175,000 African soldiers fought in Europe during the First World War? That over 200,000 were mobilized in French West Africa in the Second World War? Who recalls that in 1945, on General de Gaulle's orders, 20,000 African *tirailleurs* were unceremoniously sidelined to "whiten" the French army and give the French a sense of victory? That the prisoners freed from the German stalags were interned in one of six camps in central and southern France before being repatriated to Africa? That before the repeated refusal to pay them the arrears they were owed, they refused their officers' orders to clean the decks before disembarking?[18]

It is truly time, as Senghor demanded, to tear the Banania brand grin from all the walls of France. There has been a sense of underlying urgency for several years now to gather the testimonies and images of the last *tirailleurs* so that they do not fade into oblivion. Imunga Ivanga, the son of a *tirailleur* himself, explored the

motivations that led four elders to sign up in *Les Tirailleurs d'ailleurs/The Elsewhere Tirailleurs* (Gabon, 1998). Having gone to discover the world, their courage and their service were met only with contempt. One of them evokes the shock that the Thiaroye Camp tragedy represented in Africa, immortalized by Ousmane Sembene (*Camp de Thiaroye*, Senegal, 1985). By portraying the *tirailleurs'* revolt and the French army's repression in the Senegalese camp where they awaited their pay and demobilization, Sembene not only recalls a memory that had been obliterated, but also posits racism at the heart of his discourse. The historical events become symbols: the demand that the *tirailleurs* remove their American uniforms and put back on their red fezzes reduces them to their humiliating condition of colonized Africans, whereas the African American sergeant, of the same skin color, does not suffer the same discrimination; the unfair exchange rate applied to their savings (only 250 FCFA for 1,000 FF, instead of 500 FCFA) reveals—as Sergeant Diatta points out—"two rules in the army, one for black soldiers, the other for whites." The disgusting food they are served sends out the message that they are considered racially inferior; the evocation of their past sufferings indicates the extent of the contempt to which they have been subjected.

The barbed wire that surrounds the camp testifies to this exclusion, this imprisonment bordering on madness. This madness is incarnated by the character "Pays" ("country"), played by Sidiki Bakaba, whose inability to speak following his war traumas proves to be a highly lucid madness, as he is the one later to inform his fellows of the dangers they do not realize they are facing. The film's message is explosive, and Sembene only found funding for it in the South, making one of the rare purely African coproductions (Algeria, Tunisia, Senegal). Its real subject is not rebellion per se, but how this resistance is inscribed in the long history of African resistance in an effort to restore human dignity. Nonetheless, the film does not address the presence of *tirailleurs* in the tanks that fired on the camp. This truncated memory, served by a narrative mode that excludes any counter-discourse, is thus tied to the message that Sembene wished to deliver: the radicalism of rejection imposed in the light of neocolonialism (1220).[19]

At the time of decolonization in 1960, France froze the disability pensions owed to veterans from its former colonies at their 1959 level. This freezing of their pensions gradually created a glaring inequality that caused great bitterness, with the *tirailleur* being paid as much as ten times less. Amadou Diop, a former *tirailleur*, sued France, and in 2001 the Conseil d'Etat paid him the totality of his pension—posthumously. In 2002, French public television broadcast a television drama based on a screenplay

by Erik Orsenna, *La Dette/Debt* (Fabrice Cazeneuve, 2000), which does not tread lightly: the film evokes Africans being used as cannon fodder; their accidentally being bombed when they advanced more rapidly than expected; their being erased from the records; and above all, the scandal of the freezing of their pensions. Successive governments made commitments that they only partially kept, indexing the pensions to the countries' standard of living, until the success of Rachid Bouchareb's *Indigènes/ Days of Glory* (France) at Cannes convinced President Chirac to abolish the discrimination between the war veterans, as was officially announced by the deputy minister, Hamlaoui Mekachera, after the Council of Ministers on September 27, 2006, which coincided with the film's release in French cinemas. This unfreezing only became fully effective in 2001, however, and was not retroactive. *La Reconnaissance—Anciens combattants, une histoire d'hommes/Recognition: Veterans, a Story of Men*, by Didier Bergounhoux and Claude Hivernon (France, 2005) shows, moreover, that it is no easy task for many to find the necessary administrative documents for their pension applications when these have been abandoned in desperation in the corner of a hut, in an advanced state of rot! (4265).

There are no commemorative plaques, no mention in the history books or museums: "I fought for four years for the French government to recognize these young people's acts," said Euzhan Palcy (10158). It took her determination to pay homage, in *Parcours de dissidents/Dissident Paths* (Martinique, 2006), to the black men and women who, at the risk of their lives, went to St. Martin and St. Lucia in response to "General Microphone's" June 18 Appeal in an anti-Fascist, patriotic, and republican fervor. They were trained by the Americans and fought in American uniforms (4266). The *tirailleurs* were often sent out first to fight the enemy to limit losses in the French ranks. Moreover, in violation of the Geneva Convention on war prisoners, Africans were often executed by the Germans. These racist acts remain widely unknown, even if a few commemorative monuments have now been erected. It was based on one of these that Mireille Hannon restored this memory in her 2011 film *Les 43 tirailleurs/The 43 Tirailleurs*, drawing a parallel with Senegal and the Thiaroye massacre.

Accompanied up the red carpet by ex-*tirailleurs* when *Indigènes* was selected in the official competition at Cannes in 2006, Rachid Bouchareb stated: "They always told me that, in spite of everything, if history was repeated, they'd do it again" (4434). That is because their adventure represented "a fantastic human encounter with the French people." However, of the four *tirailleurs* in *Indigènes*, only one survives. "The message of the film," Bouchareb said, "is this old man who ends up in his room, waiting. His time has come, and I wanted to inscribe him completely in the

history of France." Rather than ending the film on the Sétif massacre, as he had at first envisaged (which is the start of *Hors-la-loi*), he preferred to root his film in the present. Yet if *Indigènes* is so deeply inscribed in the present, it is because it shows the contempt with which these African soldiers, who died to save the "Mother Country," were treated. With the phobia of interracial mixing, everything was done to stop couples' relationships from lasting, and also to stop *tirailleurs* from rising in rank (4433). In *La Couleur du sacrifice/The Color of Sacrifice* (Algeria, 2006), Mourad Boucif goes to visit those who are forced to stay living in France to be able to claim their pensions. The end of the film refers to the unrest in the French *banlieues* in 2005, establishing a continuity between the violence inflicted on these youth and that experienced by their parents and grandparents. Not recognizing themselves in official readings of history, these young people lack self-esteem and turn their violence on themselves and their own infrastructures (4600).

If Sogo, the ex-*tirailleur* in Daniel Sanou Kollo's *Tasuma* (Burkina Faso, 2003) continues to wear his uniform, it is more to bear witness to what he has been through than to claim any form of superiority. The confrontation with an elsewhere opens his eyes and orients him towards the essential. An anti-conformist and a pacifist, he invests his efforts in the village's well-being by buying a grinding machine to lessen the women's work load. But he does so on credit, tired of waiting to receive a pension that the French administration delays in paying him. He is completely politically aware, but the traces of his wounds are raw (2749). It is within this constellation that the memory of the *tirailleurs* is inscribed: it is active, avid for recognition, but has no illusions, and is bitter before the continuing contempt. Colonial conscription was both the ultimate experience of the colonial domination of bodies, and the dream of the Other and elsewhere. Whether volunteers or forced conscripts, the *tirailleurs* were the first *harragas*, the first burners. And they were very often shipwrecked, and broken by the backwash.

4.5. South African Reconciliation

Human Wrongs into Human Rights
—Painted on the wall of Desmond Tutu's house in Cape Town

The 1984 Nobel Peace Prize–winning South African bishop's leitmotif, "How to turn human wrongs into human rights," served as a basis for both the South African Constitution and the Truth and Reconciliation Commission (TRC) that sealed

national reconciliation. In both cases, the turnaround revolved around speaking, and speaking out is a factor of humanization. No model is exportable per se, but the South African example is an impressive reference, as it used a judicial process to activate the form of shared humanity referred to in Bantu languages by the concept of *ubuntu*. Reconciliation, thus, is not an empty wish, but a practical process that an entire nation is called upon to put into action.

Negotiated reconciliation precedes national reconciliation. International isolation, the fear of the situation exploding, and political realism led to a compromise and to Nelson Mandela's release on February 11, 1990. The suspension of the state of emergency elicited the suspension of the armed struggle. Against a backdrop of extreme violence, notably between the ANC and the Zulu Inkatha movement, a "negotiated solution" was concluded in 1993 in the form of a five-year government of national union and a provisional constitution that enabled the installation of a transitional executive council, general elections in April 1994, and the adoption of the current constitution in 1996. The TRC was set up by a law voted by the parliament elected in 1994.

André Van In's fascinating documentary *La Commission de la vérité/The Truth Commission* (Belgium, 1999), whose director of photography was the South African Donne Rundle, shows that this took bitter negotiations. At a moment when South Africa's extreme right wing threatened to block the 1994 elections, its neutralization was exchanged for the amnesty, but the ANC only accepted this on the condition of complete transparency. The TRC was thus born: victims testified to the violence suffered, and the perpetrators admitted their crimes in exchange for amnesty. An unimaginable portrait of apartheid thus emerged, an extraordinary testimony for future generations. The film steers clear of the conventional path of official political discourse to pinpoint the contradictions. Many feared that the amnesty would benefit the guilty parties by accusing only the small fry, while the victims lost their right to attack perpetrators in justice and ask for indemnities.[20] And one understands how the leaders of the National Party—who pleaded, contrary to all the evidence, that they did not know (De Klerk did not ask for amnesty because that was akin to pleading guilty)—lost all possibility of participating in the political future of the country (1022).

Unlike Nuremberg in 1945–1946, the TRC was not a tribunal. It functioned on the key understanding that what was amnestiable was not a crime against humanity (which the UN declared apartheid to be in 1973), but violence in the exercise of political action. This implied that it was "the social body in its entirety

that needed healing, everyone being reputed both guilty and a victim of the same collective passion for civil war."[21] As the signs in the public sessions declared, the aim was "to heal our country." It was at this price that the "Rainbow Nation" discourse incarnated by Nelson Mandela represented not South Africa's divisive past (between black and whites, but also between black groups), but the future of the national community, based on, as the epilogue of the interim constitution stated, "a need for understanding but not for vengeance, a need for reparation but not for retaliation, a need for ubuntu but not for victimisation."[22] Film, in this context, strove to explore the paths of this difficult reconciliation advocated by the political and judicial process in the intimate sphere. "Ritual is necessary, because it involves an entourage. The vibration of those who gather for a private ritual manifests a human unity," claimed Ramadan Suleman (3569). There are thus images of the TRC in his 2004 film *Zulu Love Letter*, set in 1996, but the trauma that Thandeka cannot get out of her head, and which eats at her life, needs another complementary but vital process: a private ritual that will enable her to make her peace. A journalist, she was part of the struggle and suffered the worst atrocities in prison, resulting in her giving birth to a deaf daughter who is also unable to speak. It is necessary to purge the past from both her body and family (3570). While the TRC proposed moving from the singularity of horror to a collective reconciliation, film returns to this singularity to make this possible.

The first gesture of black South African filmmakers, forbidden from filmmaking during apartheid, was not to stigmatize white people, but to develop introspection, in the wake of the "rediscovering the ordinary" literary movement, named after the title of a critical essay published by writer Njabulo Ndebele in 1991. In it, he called for the surpassing of the theme of black-white relations to focus on the contradictions that exist within the black community. That meant fully confronting one's internalization of violence in a violent society. "We owe what we are to apartheid," said the poet Lesego Rampolokeng. In 1993, Mickey Madoba Dube, exiled in the United States, confronted black-on-black violence in *Imbazo, the Axe*. The film depicts a son's relation to his father, who, to survive, joins the squads of hired killers paid by the regime to terrorize the black ghettos. In 1997, Zola Maseko devoted his short film *The Foreigner* to the xenophobia towards newly arrived immigrants from other African countries after the end of apartheid, a theme brilliantly developed by Khalo Matabane in 2005 in *Conversations on a Sunday Afternoon* (4387). *Fools* (Ramadan Suleman, 1996), the first feature made by a black South African director,[23] is based on an eponymous novella by Njabulo Ndebele, who stated: "the purity of the wishes

that Zamani formulates for the children in his class is proportional to his incapacity to free himself from the corruption that marks his own life" (0250). *Fools* explores the teacher Zamani's relationship with Zani, who happens to be the brother of a pupil he raped in a moment of madness long ago in the past. Like Ndebele himself in the past, the educated and determined Zani returns from Swaziland, where the black elite used to send its children to spare them the substandard education imposed on the black population. A difficult encounter ensues between this fifty-five-year-old former anti-apartheid militant, eaten by the vacuity of his life, and the student activist exasperated by those who do not share his sense of urgency. In the mirror-foil that each holds up to the other, they will learn to recognize themselves. Suleman excels in his use of settings, be it the vertical lines of the interiors or the vanishing points of the township streets, to explore the tension that the two men share and the way in which the women view them. Zamani's renouncement in the final scene of avoiding a whipping by an incensed Boer brings to mind the extraordinary final expiatory scene of Ousmane Sembene's *Xala*, in which El Hadji chooses to regain his force and his dignity by allowing himself to be spat upon. The grieving process is not without fresh pains, and takes courage (0158).

As we already saw with *Daratt* (Mahamat-Saleh Haroun, Chad, 2006), breaking the circle of violence and the law of retaliation takes a creativity that avoids turning the violence one has suffered against others. That does not necessarily imply forgiveness, but the desire to peacefully coexist. That does not necessarily imply reconciliation, but at least justice, which aims for crimes to be confessed so that they can be punished, and begins with the shame of bringing them to the public eye. The big question, of course, was whether the TRC's reparative justice would thwart the demands for a justice capable of satisfying the retributive (and punishing) justice that many were waiting for. If the TRC did go further, it is because it was designed to deliver the country from hatred—not only from this addiction that the hatred of others becomes when we only see ourselves as victims, but also from this self-hatred that perpetrators and victims share. Reconciliation means reaching out to the other. Mandela did so quite literally in a television duel with De Klerk, in which he sensed he had been too harsh: he took De Klerk's hand, saying, "I am proud to hold your hand so that we can move forward." He repeated over and over in his autobiography *Long Walk to Freedom* that this equally concerns both oppressors and oppressed. That is what Clint Eastwood emphasizes in *Invictus* (United States, 2009); Mandela's clairvoyance and determination drive the film's plot. It is as a true leader that he galvanizes the captain of the Springboks so that he

in turn leads his team—hated for having been exclusively white—to win the World Rugby Cup in 1995, uniting the nation around a truly far from guaranteed victory. The film's force is to progressively subject its aesthetic to the national reconciliation discourse insisted upon by Madiba. The outcome of the final match is a foregone conclusion, but the scrums, acrobatically filmed from the ground, are the mirror image of a nation in the making (9135).

Did the TRC's revelations threaten reconciliation, as was feared? They did not whip up the desire for revenge. Beneath the outward appearance of a rip-roaring comedy, John Kani took this exigency of truth even farther in *Nothing but the Truth* (2008) by showing how a family can conserve its unity even when the hard truth is revealed. Once again, this family is not the victim of others, but of itself in its emotional blackmailing and underhand blows, which are normally shrouded in silence. But this film, like so many others, creates a resonance between the private and collective levels. The return of Themba, the exiled ANC hero brother's ashes when the family was expecting a coffin to bury, echoes the wider-scale mystification to which Sipho (John Kani) was victim. It is ultimately the heroes of the anti-apartheid struggle who are in question, not for their devotion, but for their opportunism, which manifests itself in today's new privileged classes (9462). Egyptian Jihan El Tahri demonstrates this with brio in *Behind the Rainbow* (2009) by analyzing the way in which the ANC's economic and political choices have often become distant from the original aim of reducing poverty, as proclaimed during the struggle (8530). This enduring economic injustice means that memory remains unhealed and reconciliation derealized, for without a real belief in it, and if it fails to translate into concrete acts, it is nothing but a poetic desire. This is the fragility of this "new" South Africa, where coexistence risks deteriorating. Hence the importance of artistic expressions that invite us to revisit the past, to embrace differences, to reflect on sensitive issues, and to envisage the future.

As Jacques Derrida pointed out, with the TRC, "amnesty becomes forgiveness, a forgiveness preceded by a testimony coupled with repentance," which represents a Christianization of the process. As forgiveness and truth are destined to heal the social body, repentance is a condition; elsewhere, where the cohesion of the nation-state is unthreatened, it is not necessarily required.[24] In film, this translates into a recurrent mise-en-scène of guilt in films made by white directors. At the entrance to the Goodman Gallery in Johannesburg—a gallery known for having exhibited black artists during apartheid—is an illustration of a black village chief saying: "If another white artist puts me in a portfolio full of his guilt, identity

crises, and memory, I'm going to vomit!"[25] This is the feeling elicited by films such as *Promised Land* (Jason Xenopoulos, 2002), an autopsy of an unraveling group of Afrikaner farmers shot in an avalanche of heavy-handed effects that border on the horror movie (2800). It was also the case with *Forgiveness* (Ian Gabriel, 2004), in which a white ex-policeman amnestied by the TRC seeks forgiveness for murdering a black activist by going to find his family. Other films emerged, reiterating the Andrew Steyn character in *The Gods Must Be Crazy* (James Uys, 1980), a film that had international audiences in stitches (5.9 million tickets sold in France) without anyone realizing the extent to which it was perpetrating the ideology of apartheid: the peaceful scientist in the wilderness personifying a South Africa that knows the black man's culture and reveals it to him in order to civilize him. One such example is the musicologist Frankie in *Letting Go* (Bernard Joffa, 2004), who teaches Nolutando the meaning of his name ("loved by all") and who helps him reconnect with his African roots (0843).

The Bang Bang Club (*Shots of War*, Steven Silver, 2010) retraces the biographies of four South African photographers, two of whom won Pulitzer Prizes. They took incalculable risks photographing the fighting between ANC activists and the Zulu Inkatha Movement, otherwise portrayed as raging masses who only thought of fighting in the townships. These photos' importance in revealing the apartheid government's manipulation of Inkatha is so under-contextualized that this action film only foregrounds the performance and doubts of four white people. Similarly, it is striking to see the degree to which *Goodbye Bafana* (Bille August, 2007), based on the memoirs of Nelson Mandela's jailer, simply retranscribes the fantasies of a government employee anxious to absolve himself of this internationally shared guilt. As a result, it is not a film about Mandela, of course, but about his jailer, who wishes to share the fame of the man whose private life he intimately knew after systematically censoring his mail. Bille August's Nelson Mandela is almost inscribed in the "magic Negro"[26] tradition of American cinema: these characters who put their supernatural powers at the service of the white hero for no apparent reason other than the hero's infinite goodness, of which *The Legend of Bagger Vance* (Robert Redford, 2000, with Will Smith) could be described as the canonical example (5889).

Goodbye Bafana's improbable fraternity recalls the tear-jerking ecumenical discourse of *Cry, the Beloved Country*, Darell J. Roodt's 1995 adaptation of Alan Patton's best-selling novel published in 1948 (which Zoltan Korda had already adapted to the screen in 1952, featuring Sidney Poitier). In it, the black Anglican priest Kumalo goes to Johannesburg, where he discovers that his sister has fallen into prostitution

and that his son was involved in the murder of the son of his white, pro-apartheid, land-owning neighbor, who finally finds his humanity (0972). The white man's repentance is a constant, often represented by a positive white character who undergoes a political awakening, and whose role will be determining for the black community. This is the Kevin Kline of *Cry Freedom* (Richard Attenborough, 1987), the liberal journalist who supports Steve Biko. It is the Ben du Toit of *A Dry White Season* (Euzhan Palcy, 1989), the schoolteacher who rallies to defend his black gardener's son. It is the Sarah Barcant of *Red Dust* (Tom Hooper, 2004), the human rights lawyer who defends a member of parliament and a black family against a corrupt policeman seeking to amnesty his acts of torture at the TRC. It is the Anna Malan of *In My Country* (John Boorman, 2004), in which Juliette Binoche plays the role of South African writer Antjie Krog, who carried out vast work on memory and the TRC, and whose book, *Country of My Skull*, the film adapts.

If there is such an onus on portraying repentance, in a ritual destined for the dominant, it is because it is not self-evident. The white community practiced—and still practices—multiple forms of denial, dissimulation, and repression. This is to miss out on the beauty of the act of reconciliation, and thus accessing the beauty of the world, as *Skoonheid* (Oliver Hermanus, 2011) beautifully suggests—the title indeed meaning "beauty"—a chronicle of self-destruction exacerbated by hatred both of the Other and of the self (10233). The film is not a form of self-flagellation: "it's important for any society to be honest and exposed and . . . not hiding anything anymore," Hermanus stated (10237). *Skoonheid* recounts the internal turmoil of an unspectacular man who is perfectly disillusioned, and who is wrong and wronged in every possible way, and who is primed by this violence to exercise violence when desire erupts and throws him. A portrait that is neither indulgent nor pitying, the film does not judge and remains profoundly human. It is shot in Afrikaans, the Boer language so hated by black South Africans who were forced to learn it in schools and use it in administrations. "It's a very advanced and beautiful language and for me it's interesting how it's a part of South Africa [even though it's] possibly dying, because a lot of young people speak English," Hermanus added, even though he is not from this culture himself.

Introspection of this kind necessarily revolves around the body. Like anger, silence is a body language; lapses of memory result from physical trauma. Hermanus's previous film, *Shirley Adams* (2009), was about a quadriplegic man. Avoiding all pathos, it portrayed a mother's tireless combat to keep her son alive after he is shot by a stray bullet fired in a clash between rival gangs. François Verster also

takes the body as a subject in *Sea Point Days* (2008), a documentary shot around the swimming pools of a Cape Town seaside suburb that were white-only until the end of apartheid. Nowadays, different skin colors are found side by side at the pools in apparent equality. Beyond the appearances, however, the bodies reveal the social hierarchies at play and the sufferings accumulated, but also feelings of belonging and a desire for peace.

In *Triomf* (2008), Zimbabwean Michael Raeburn adapted Marlene Van Niekerk's eponymous Noma Award–winning novel, an astonishing, carnivalesque, and outlandish allegory of the end of apartheid and the birth of a new world. In the poor white Benade family, both death and rebirth are at play. They are hopeless cases, capable of the worst extremes out of the frustration from not having realized their dreams. They are in a rut and scorned by all. Steeped in prejudice, they are not just a caricature of apartheid, they are a reflection of the world. This spectacle of racism has an archival function: that of both memory and getting over it. *Red Dust* ends on Desmond Tutu's famous words "Having looked the beast of the past in the eye, having asked and received forgiveness and having made amends, let us shut the door on the past, not in order to forget it, but to not allow it to imprison us." The TRC produced archives of state racism so that the future generations can move forwards in freedom. The cinema does the same: it is a return to the future.

4.6. Representing the Itsembabwoko

> this tie
> that unites us
> is the shadow of a shadow
> —there is no doubt—
> but it is engorged
> with blood and storms
>
> —Umar Timol, "Poèmes 'Sans Titre'"

The Kinyarwandan word *itsembabwoko* did not exist before the genocide. The Rwandan government and survivor groups invented it to describe the genocide. *Itsemba* means "to decimate," and *bwoko* is the term for the Rwandans' social identity before they were divided into ethnic groups. It equally designates regional belonging, profession, or clan. Surely the Rwandan genocide should be called by

the name that the Rwandans themselves chose for it. Today, certainly, they still oft en refer to the "war" rather than the genocide, and say "patrols" for the gangs of killers. This military vocabulary, which suggests an extermination perpetrated by the elite rather than the people, will only evolve through a long, multidisciplinary, artistic processing of memory that reveals the singularity of the *itsembabwoko*. The word *shoah* ("catastrophe" in Hebrew) was chosen by the Israeli parliament in 1951 to designate the "Final Solution," but only caught on in 1985 thanks to Claude Lanzmann's monumental work, which defined itself as a film on the topicality of the genocide.[27] Before that, the word *holocaust* ("sacrifice") was most widely used, boosted by the international success of the American television series of the same name, followed by an estimated 220 million viewers in 1978. The term holocaust remains widespread in the Anglo-American world. As Jean-Michel Frodon writes, then, "a film and a television series were behind the two now commonly accepted terms used to describe this major event."[28] Here, we shall discuss ten feature films and several of the many documentaries shot to date, for cinema has repeatedly addressed the *itsembabwoko*. Up until now, this has mainly been at the initiative of foreigners, and above all Westerners. None as yet appear to have imposed a name that is capable of capturing the event's singularity.

Aside from those of corpses, there are few images of the *itsembabwoko* killings. There are few images of the killers in action, therefore, with the exception of the one shot of someone being murdered with a machete at a roadblock, filmed using a zoom lens from eight hundred meters away by the British reporter Nick Hughes, and broadcast the world over. Yet, from April 6 to July 4, 1994, at the very moment that Nelson Mandela was elected president of South Africa on April 27, huge numbers of predominantly rural-dwelling Rwandans were exterminated en masse by their neighbors because they were Tutsi or Tutsi-sympathizers. The United Nations esti-mates the number of those killed to be 800,000, a massacre perpetrated far from the cameras. Lists of victims had been prepared and the *itsembabwoko* was planned in advance. Thousands of radios had even been distributed to facilitate indoctrination. The Radio Television Libre des Mille Collines (RTLM) openly advocated the elimina-tion of the *inyenzi* ("roaches"). Calling the *itsembabwoko* a tribal or an ethnic war is a terrible error: it amounts to repeating the same racist logic of its perpetrators. The notion of ethnic group is a remnant of colonial ideology. It is an invention designed to categorize populations and cultures that define themselves differently, notably in terms of their lineage, history, founding myths, religion, economic specialties, and so forth. This classification set in stone something that was fluid, and turned it into

something essentialist: people become "such and such." In the 1930s in Rwanda, the colonial administration introduced a pass bearing the inscription "Hutu," "Tutsi," or "Twa" to better regulate tax collection. Rwandans started defining themselves in these terms as a result of this contact with the Europeans. Yet Rwandans all share the same language, culture, religion, and territory, and claim to descend from the same mythical ancestor. The categories Hutu, Tutsi, or Twa are only one element in a far more complex social identity summed up by the term *bwoko*, and it was possible to move from one category to another through marriage or a change in activity (0332). In the mind of the colonizer, the ethnic group represented a primitive stage that needed to be organized in order to civilize, rigidifying something that was fluid and porous, thus dividing to better conquer. It is thus that the Rwandan genocide is inscribed in colonial history, bringing its cycle of exterminations full circle, but this time before the eyes of the entire world.

Haitian Raoul Peck re-created this single image of genocidal killing in *Sometimes in April* (2005), for his film focuses notably on the power of images and the international community's nonintervention. The film opens with a Martin Luther King Jr. quotation: "In the end, we will remember not the words of our enemies, but the silence of our friends." It continues with an explanatory historical text set against the backdrop of a colonial map of Africa as the camera zooms slowly in on Rwanda. Colonial archive footage follows as the commentary describes "a history of cupidity, arrogance and power." Next comes a school, where the children watch a video of President Clinton's speech on the genocide. The film starts and ends in the same classroom: this memory is to be inscribed in the present. Indeed, if cinema has a role to play, it is to help us live the present so that we can freely define a future. In Rwanda, where the survivors mingle daily with those who murdered their nearest and dearest, and all over the planet, that means living together.

Films made about the *itsembabwoko* can thus be seen in conjunction with films that deal with racist violence. What is the point of twisting knives in wounds? Such films are only meaningful if they mobilize the spectator in a spirit of peace. By portraying and letting us sense the singularity of destinies, cinema risks simply eliciting a feeling of horror, a passive compassion. Set in 2004, *Sometimes in April* follows Augustin, the school teacher who is asked by a pupil if the genocide could have been prevented. He is at a loss for an answer. And yet he lived through it himself. The film repeatedly draws on his tragic past in an attempt to find an answer, leaving the spectator to be sole judge. It does not shy away from depicting the cruelty to contextualize the trauma, but without ever overstepping the line where

the shock of the horror prevents reflection. By tackling the personal tragedy and political scandal, the day-to-day heroism, and the indescribable genocidal horror, the film restores the complexity that the media and state propaganda denied, and that cinema has also often glossed over.

Peck's film does not portray good victims on the one hand, and evil genocide perpetrators on the other. Through the relationship between two brothers, Augustin and Honoré, who make opposite choices, Peck reveals the complexity of a country gone astray. They are not heroes who try to prevent the horror in "real event"–inspired reenactments; they are the multiple facets of a nonlinear narrative that is entirely invented to evoke the different layers of reality. From the International Criminal Tribunal in Arusha to the Rwandan *gacaca* community courts, justice plays a considerable role, as it is the only place where things can and must be said. This, like this film, is necessary for the Rwandan people, for it does not dispossess them of their memory, nor does it appropriate it; on the contrary, it answers their need to tell the world what they learned from their terrible experience (4516).

It required a specific approach: "I could only make this film with the Rwandans and in complete freedom," Raoul Peck stated. "If the Rwandans appropriated the film, then it became possible. In Rwanda, I found myself in a little church where two thousand people had died, surrounded by objects left behind from these people's lives: clothes, utensils, toothbrushes. A lad showed me the hole he had escaped through, while his parents were killed. At first, the reality completely devastates you. But people come to you and give what, for any artist, is an absolute treasure. Civilians and associations welcomed me as if I were a Rwandan. Everyone had seen *Lumumba* and I was introduced by trusted Rwandan friends" (4649).

The *itsembabwoko* was only possible because Rwanda was abandoned by the international community. The film clearly denounces two scandals. Firstly, the role of France, responsible for training the army and supplying arms, before then going on to protect those guilty of the genocide during the Operation Turquoise human shield once the French had evacuated their nationals, and only their nationals. And secondly, the UN's inability to intervene, bogged down by its lack of knowledge of the terrain and hindered by the American administration's quibbling over definitions, which would have been laughable if not so tragic. Indeed, despite full knowledge of what proved on the ground to be the organized massacre of hundreds of thousands of people, the administration was reluctant to use the term genocide (and thus to act). But Augustin and Honoré also conjointly represent the complexity of a country that slid inexorably into the unspeakable without realizing where it

was heading. Genocide is the ultimate tragedy, and there is no happy ending to the film. It is together that people have to find the means to survive, like the laughter that the pupils share as they watch Chaplin's *The Dictator*. And, above all, people have to find the strength to testify so that no future revisionist tendencies can deny the martyrdom and suicide of a people, and so that we remain on our guard, for as Brecht concluded in *The Resistible Rise of Arturo Ui*, "the womb from which the vile beast emerged is still fertile."

4.6.1. Victims and Perpetrators

"Going to shoot a film in this country is only meaningful if the aim is to represent it in our eyes as a people, not a victim, as Other, not as a stranger," the French documentary filmmaker Denis Gheerbrant stated (3482). That meant constantly analyzing his own position as he shot *Après/After (A Journey through Rwanda*, 2003). In the film, he tries to find his place, like, for example, at this crossroads where he doesn't know where to put his camera. He acknowledges the importance of a fixer, who is both a guide and a translator, and his desire for cinema before the eyes that scrutinize him. He does not take the real as a fact to be captured, but as a presence to be represented. Filming simply the process of trying to understand, Gheerbrant proposes an aporetic cinema, which does not have the resources to provide an answer, leaving us in a state of perplexity. His film is not an exposition; it is a fragile veil in the philosophical sense of *durcharbeitung*, of working through, of a painful process to reach clarification (3477).

Victims have the power to testify, yet the filmmaker needs to convey this power while avoiding sordid sensationalism at all costs. Moussa Touré's *Nous sommes nombreuses/We Are Many* (Senegal, 2003) listens to women who have been repeatedly raped during the Congo war. Their tales are heart-rending. Some have undergone torture. They are surrounded by the children born out of their forced pregnancies. They have been infected with the AIDS virus. Touré's camera restores their dignity: he frames their faces frontally, avoiding any superfluous zooms or effects. He films at their level and at an infinitely respectful distance, without lingering on their silent faces. One simple scene is repeated twice: a woman and her children saying grace before a meal. The choice is clear: this is the simple testimony of interiority (2666).

The same quality is found in Marie-Violaine Brincard's *Au nom du père, de tous, du ciel/In the Name of the Father, of Us All, of Heaven* (France, 2010), a film about the Hutu who hid Tutsis at the risk of their own lives. All of these Righteous, also known

as "the Benefactors" (*Abagizeneza*), testify face on, and in complete dignity. There are no commentaries, no complex structures, no close-ups: the film's minimalism does justice to their simplicity. And yet, the tragic statement of loss asserts itself, which concerns us just as much: not only can we not bring back the dead, but fraternity among the living has also been undermined. And that is something that not even the Righteous can restore (9381).

Life must go on. It is thus necessary to understand the root of the problem. Understanding is also a means of avoiding its recurrence. It is thus essential to understand how it came to this, without forgetting what a Rwandan proverb reminds us: Nta wiyanga nk'uwanga undi (No one hates himself more than he who hates others). This is true of survivors and killers alike. If one is to live with one's enemy, it is impossible to maintain the posture of victim. The great difficulty is not to try to pardon the killers, but to reintegrate them into the human community. The perpetrators' humanity has to be restored. The tribunals enabled them to end their denial and to express the horror perpetrated. It thus enabled them to expose the folly of their acts and thereby assume responsibility. Cinema gives this formulation a corporal dimension, focused on acts, making it impossible to skirt the issue. In Rithy Panh's *S-21: The Khmer Rouge Killing Machine* (Cambodia, 2002), torturers mime the tortures they carried out before the camera. In Osvalde Lewat's *Une affaire de nègres/Black Business* (Cameroon, 2006), a soldier acts out the nighttime roundup operations. These gestures are a confession. This way of filming the perpetrators at the scene of their crimes, where no one sheds a tear, opens the present tense of memory. It reveals the mechanisms of a repressive machine that prevents the torturer from thinking; to differing degrees, this machine is still at work in the world today. This documentary reenactment is not dressed up as reality. The places have changed, and time has passed. We do not see the words articulated on the screen; they are the fruit of a situation structured by the filmmaker's gaze and authenticated, or not, by that of the spectator. The image thus bears no inherent truth, but opens up a relation whose stake is this invisible word. This is what matters, for it is about the perpetrators recognizing their crime, the only words that can ease the survivors' pain.

Very few films capture what the perpetrators have to say. "They are consumed by shame. We wish they would speak to us," say the women in *Au Rwanda on dit . . . La famille qui ne parle pas meurt/In Rwanda We Say . . . The Family That Does Not Speak Dies* (Anne Aghion, 2004), the government having freed 16,000 repentant genocide perpetrators in 2003. They do not speak to say where they hid the dead,

to say they repent, to say that they are humans and that they were taken in by the propaganda, or could not resist pillaging, or speak to ask forgiveness; instead they remain silent. The tribunals remain the site of speech. In 2001, faced with 130,000 prisoners to judge and lacking the means necessary, the Rwandan government set up the gacacas ("clean-cut grass" in Kinyarwanda, the meeting place), an updated version of the traditional conflict-resolution system that consisted of bringing together all the parties involved in the tragedy at the very site of the massacres: survivors, witnesses, and the alleged culprits.

The debates were supervised by the *inyangamugayo*, elected from respected members of the community, and were able to deliver sentences ranging from community work to life imprisonment. In 2005, about 8,000 *gacacas* were added to the 750 existing ones. Some films set out to question their value. In Roger Beeckmans's *Nos coeurs sont vos tombes/Our Hearts Are Your Tombs* (Belgium, 2004), women explain that in some cases, the judges themselves had participated in the genocide. Summary executions and threatening letters were reported (3477). But by only denouncing these failings, the film creates divisions rather than unity. The same goes for *Rwanda: Les collines parlent/Rwanda: The Hills Speak*, by Bernard Bellefroid (Belgium, 2005). Based on the slogan of a poster advertising the *gacacas*—Truth, Justice, Reconciliation—the film prides itself, as the title indicates, on showing how these tribunals facilitated a freeing of speech. But by focusing on the detainees' strategies of asking forgiveness in order to be let off, the presence of members of one of the defendant's family in the tribunal, or the refusal of a recognized genocide perpetrator to change his discourse, the film instead demonstrates that lies triumphed, that there were flagrant injustices, and that the *gacacas* only resulted in a disheartening semblance of reconciliation (4568).

Comparatively, Anne Aghion's work emerges as fundamental in restoring the essential. The tribunal scenes in her film are never a spectacle; she avoids shots that might dramatize or be theatrical, tightly framing those who speak and respecting everyone's dignity, whether victim or perpetrator. Shot over a period of nearly ten years on the same hill, and edited from 350 hours of footage, *Mon Voisin, Mon Tueur/My Neighbor, My Killer* (France, 2009) retraces the *gacacas*' impact on both survivors and perpetrators.

Anne Aghion does not seek to question the merits of the Rwandan approach, nor to denounce the ambiguities of tribunals where neighbors judge one another. The film does not mask the approximate truths; it focuses on the emotional path to coexistence. The tribunals may have had their limits, but if they were cathartic

and thus made it possible to hope to restore social ties, it is because they mobilized rather than devastated. In other words, they freed expression more than they prevented or controlled it (8680). The unity of the film's location enables it to follow specific characters: the accused, but also Félicité and Euphrasie, two women whose families were wiped out, but who themselves were spared because they are Hutu; two women "roaming in solitude." "They are like ghosts. They are conscious that they are a lost generation. But the survivors' motivation to go to the *gacacas* and to go through this process concerns the future generations," said Anne Aghion (8681).

Certain nongovernmental organizations and Amnesty International qualified the *gacacas* as unjust, describing them as judicial dead-ends.[29] Yet neither the Arusha International Criminal Tribunal for Rwanda (ICTR), nor the twelve chambers specializing in genocidal affairs set up within the Rwandan Courts of First Instance were able to rapidly translate into action the government's commitment to fighting all impunity. The *gacacas* cannot be written off, then, without taking into account the determining political context. Christophe Gargot's *D'Arusha à Arusha/From Arusha to Arusha* (France, 2007) evokes the political limitations of the tribunal, which has not been able to examine accusations made against the Rwandan Patriotic Front (FPR), in power since the genocide. Chief prosecutor Carla Del Ponte indicates that she was not given the authorization to carry out inquiries in Rwanda (8971). Making a film about the tools of justice cannot overlook the political context in both senses of the term: the exercise of power and the ties on which a community is founded.

The genocidal ideology was only able to take hold through fear. Its propaganda incessantly evoked the threat of civil war that the FPR represented. Kill before being killed. But it required coordinated organization in the form of the media, arms, lists, and chiefs. That is why the historical and political contexts cannot be overlooked: while violence itself is carried out by individuals, it is always the product of a system that can be constructed and thought through. Parking people in narrow cells like cattle, subjecting them to repeated naked body searches, restricting access to any communications and appeal procedures, giving people documents of consent to sign when they cannot read, roughly bundling them onto return flights, admonishing and shouting: the administrative violence inflicted on illegal immigrants as described in Nicolas Klotz's *La Blessure/The Wound* (France, 2003) is indeed physical. The police are not bad guys, just instruments—or, as the filmmaker puts it, "abstract men." They do not say, "we are taking them to the plane," but to the "loading departure." Klotz could have made the film epic. He could have

enhanced the emotion through slick montage and rapid camera movements. But the journey back to the plane is filmed like the rest of the film: in fixed shots that verge on sequence shots. He does not try to elicit identification, but rather the distance necessary to awaken awareness (3431).

"The arms have fallen silent, but your gut is still crying," exclaims a rapper in the beautiful *Angola Saudade*, by Richard Paklepa (Namibia, 2005). In many places, being at war has become inscribed as a permanent feature of the African experience. "There are two worlds: the one we live in and the one we are fighting for," says Koni in Issa Serge Coelo's *Daresalam* (Chad, 2000), the title of which means "the house of peace." This war film indeed talks about an intense desire for peace. The villagers who rebel against the brutality of an exploitative regime focus solely on that idea, and revolution thus seems a lesser evil. Two friends, Djimi and Koni, are caught up in the cycle of violence. They are willing to get involved, to confront the challenges, to believe in ideals, to progress, to understand, but they become opposed in their choices. Coelo does not at any moment judge either of them, but this tension is never resolved, for "poverty is not defeated." The film appeals for energies to be mobilized in "something other than mopping up blood" (2071). In times of war, everyone internalizes this violence that traumatizes, obsesses, unbalances, and acculturates. In *Bè Kunko* (*Our Problems*), by Cheick Fantamady Camara (Guinea, 2004), which follows a group of teenagers in a UN refugee camp, the young women prostitute themselves and the guys carry out holdups. These youngsters bear the burden of being uprooted, of being adrift in the world, of the loss of their parents. The film depicts the tragic rhythm of these youth who, like the Conakry gang members (see *Mathias: The Gang Trial*, by Gahité Fofana, 1997; and *Kiti: Justice in Guinea*, by David Achkar, 1996), are driven by the recklessness of all teenagers, but are also a product of that world, and explode from their lack of freedom to live their lives, committing instead a slow suicide (3436).

4.6.2. On-Screen Violence

As explanations from the perpetrators elude us, it is necessary to work in their absence, for the issue at stake remains avoiding oblivion and revisionism. Images cannot replace the real, however. Their force, on the contrary, is that they are not real: "To incarnate is to give flesh, not body," writes Marie-José Mondzain.[30] Yet, as she adds, "the only image that has the force to transform violence into critical freedom is the image that incarnates it." This reflection is at the heart of the question of

representing violence, central to films on the *itsembabwoko*. A denial of the humane, annihilation erases all traces and leaves no archives. The temptation for cinema is to create them, based on the faith of the testimonies of survivors. Fiction films thus plead their legitimacy by stating that they are based on true events. That is the case with two feature films that employ Hollywood narrative codes: *Hotel Rwanda* (Terry Georges, 2004) and *Shooting Dogs* (Michael Caton-Jones, 2006), the latter adding in an insert that it is "shot in the same location where the events took place." Indeed, whereas *Hotel Rwanda* was shot in the suburbs of Johannesburg, *Shooting Dogs* was shot in Rwanda, which caused some regrettable incidents, the neighbors not having always been forewarned. Survivor groups denounced the traumatic violence of film shoots that opened old wounds.[31] Raoul Peck was sensitive to this: "We talked a lot, worked with therapists, were careful of fairly allocating salaries to maintain harmony and to avoid simply being a foreign production making its film and then disappearing like Attila, to ensure that the film had a very strong local rooting" (4649).

Hotel Rwanda did not spark the same controversy as *Schindler's List* (Steven Spielberg, 1993), which told the tale of a Nazi industrialist who managed to save 1,100 Jews from extermination. Yet the two films have a lot in common: the linearity of the narrative, the suspense, the initially aloof hero who turns virtuous, and, above all, a second-rate happy ending that is at the very least anachronistic in a film that claims to contribute to the memory of an extermination. *Hotel Rwanda* is indeed centered on Paul Rusesabagina's successful struggle to save not only his own family, but also the thousand Tutsis who have taken refuge in the hotel he runs. This rapidly evolves into an unlikely suspense in which those who have taken refuge try to escape their aggressors, who are nothing more than an undifferentiated mass of evil, the out-of-control, loathsome *interahamwe* ("those who fight together") militiamen. This vision brings us back to the ambient discourse on ethnic war as a repercussion of an African atavism of bestial force that modernity has not yet managed to stamp out (3776). We find the same bloodthirsty, drugged-up crowds in *Shooting Dogs*, which sees its Christ-like hero die, but not before he saves the children he was protecting (4298). Seen from the point of view of two Europeans—a young, idealistic teacher and an elderly priest attached to his orphanage—the film induces a state of permanent shock: "Elicit emotion to generate understanding," says Caton-Jones. But what emotion, and for what understanding? The film reiterates the two main thrusts of Western discourse on the genocide: despair and guilt.

Caton-Jones opts for the sordid, panning across the bleeding bodies left by the massacres whose cruel brutality he has just shown. "To suffer is one thing; another thing is living with the photographed images of suffering, which does not necessarily strengthen conscience and the ability to be compassionate. It can also corrupt them," Susan Sontag wrote, adding, "Images transfix. Images anesthetize."[32] The problem is a recurrent one. In *State of Violence* (South Africa, 2010), in which a man looks for his wife's murderer only to realize that this crime was linked to his own past, and in which the subject is thus the country's past and present violence, Khalo Matabane tackles the question head-on: "I've been held up at gunpoint. I wanted the audience to feel the same thing that I felt when I was violated," he stated (10300). Yet this violation of distance is in itself a form of violence inflicted on the spectator. In the words of Marie-José Mondzain, "screen violence starts when the screen no longer screens."[33] Without distance, violence becomes a spectacle. It only elicits destructive and fusional urges instead of freeing the spectator from this mortifying pressure. Inundating viewers with images of violence only leads to despair; it doesn't mobilize. The need for films on the genocide—and for all films seeking to stop barbarity being perpetrated—does not warrant reproducing barbarity on the screen. When Issa Serge Coelo films a torturer's atrocities in *N'Djamena City* (Chad, 2006), he plunges the spectator into the perverse and manipulative fascination of voyeurism more than he gives victims a voice, even if his aim was to unmask a historical taboo by cinematically providing proof of the abuse of authority, in order to thwart revisionism and impunity. He does restore a laudable distance, on the other hand, when the torturer dreams that he is shrouded in bubbles, sheltered from but dominating the world, or when he carries out airy choreographic movements as he does his gym workout, just as the legionnaires' physical training in *Beau travail* (Claire Denis, 1999) resembles a ritual ballet (5969).

"An image's violence is strengthening when it doesn't dispossess the spectator of his/her place as a speaking subject," Marie-José Mondzain again writes. Yet exactly the opposite occurs in *100 Days* (USA, 2001), the first feature film made on the genocide, directed by Nick Hughes, the British photographer who was witness to it, and coproduced by the Rwandan director Eric Kabera. Hughes had participated in documentaries, testified at the Arusha tribunal and, with this film, wanted to widen the impact through fiction. With a modest $1.5 million budget, the film re-creates the massacres. The film takes the spectator hostage: it plunges him or her into a hypnotic state that prevents all reflection. Anything goes to pump up the emotion: zooms, filters, lighting, close-ups, slow motion, and hemoglobin. These are

the techniques of historical reconstructions that offer no distance in their realism. The point of view is that of the characters living the scene, recomposed by a mass of extras. Long shots pave the way for shots in which the camera is planted in the terror of the hustle. The details guarantee veracity. We already know everything that is shown, but it takes on the feeling of the unknown: the spectacle gives the impression of being there, and pathos takes over. Yet such massacres do not stand up well to transparency: it undermines their implacable opacity. During the film's screening at FESPACO, the Ouagalese audience walked out before the end of the film. A healthy reaction! (2786). Why show horror if only to record it in all its distressing despair? The violence is not in the images, it is in the violence that the spectator experiences while watching them. "Pain is not a star," said Godard in *Histoires du cinéma*. Nick Hughes also produced Eric Kabera's *Gardiens de la mémoire/Keepers of Memory* in 2004. The film demonstrates the same concern for representation, blatantly contradicting a psychologist interviewed in the film, who declares that it is too private a suffering to be externalized: archive images of the genocide, tracking shots of the dead, harrowing testimonies, tears, a graveness that is accentuated by the slowness of the pace, and dramatic music. This sacralization of a terrifying memory only conveys its horror and risks in turn engendering violence. It loses sight of the meaning of genocide in history, and thus the possibility of drawing any lessons from it, of resituating it in the present to be able to construct a future.

As Sony Labou Tansi said, it is not a question of reflecting the violence of the world, but of entering into violent contact with the world. That is what Ibéa Atondi and Karim Miské do in *Contes cruels de la guerre/Cruel War Tales* (Congo/Mauritania, 2006). They avoid voyeurism without condoning the silence that the warlords wish for. Back in Congo, Ibéa Atondi gathers the testimonies of both victims and perpetrators, such as her friend Jules, a Cobra militiaman, who mercilessly killed civilians that he referred to as "the infiltrated." "I liked him; I still like him," she says. The violent scenes that could have been provided by archives are replaced by the predation of insects: bees, ants pulling a beetle to bits, and so forth. These images evoke the grim reality better than reality itself (2738). In the same vein, and in the footsteps of Djibril Diop Mambety, whose *Touki Bouki* opened with a similar sequence, Samba Félix Ndiaye preferred to film the Kigali abattoir in *Rwanda pour mémoire/Rwanda in Memory* (Senegal, 2003), rather than the unburied bodies of the Rwandan genocide: blood flows copiously and runs down to the river, mingling with its waters. A cow dies in close-up (2824). The film is an indictment of those who use death to manipulate the living. Shot on the occasion of a writing residence initiated

in Rwanda in May 2000 by the Lille-based literary festival Fest'Africa (France),[34] the film questions why corpses were kept exhibited at the sites of the genocide. Families were forbidden from burying their kin, on the pretext that, as instruments of memory, they no longer belonged to them. Yet, recalls the Chadian writer Koulsy Lamko, "the dead must be buried, otherwise the night-flying moths will continue to torment the living." He speaks of a "voyeuristic gaze that seems to be a kind of desecration." Yves Simon denounces the "macabre, violent and cynical figuration" of the exhibition of the dead. "To maximize on our guilty conscience, the Rwandan state is taking its dead hostage," said Samba Félix Ndiaye (1468).

4.6.3. The Power of Images

In April 1994, Jean-Christophe Klotz was in Kigali working as an independent reporter when he shot a report on Tutsi children crammed into a Catholic parish. The report was broadcast on the French television channel Antenne 2. Earlier, on January 28, 1993, on the same channel's prime-time evening news, Jean Carbonare, president of the association Survie, had given an emotional account of the organized massacres that were already beginning to take place. The world knew, before and during the genocide, and yet these images did not stop the killing. What, then, was the point of risking one's life to film them? Klotz asks in *Kigali, des images contre un massacre/Kigali: Images against a Massacre* (France, 2005). Klotz got caught in the crossfire and was taken to a hospital. Two days later, the parish children were exterminated. He would never be able to forget. Ten years later, Klotz returned to Kigali, looking for the survivors, who could be counted on the fingers of one hand, and attempted a reflection on the role of images (4653). Politicians only react under the pressure of a public outcry. That, in theory, is the power of the media. But when it came to Rwanda, neither the public nor the politicians reacted. Why didn't public opinion, which mobilized so strongly after the tsunami, react to the Rwandan genocide? Because Africa seems condemned to its tragedies? The film's observation is stark: even when irrefutable, images only mobilize if they are accepted by those who view them, no doubt because there is no evidence in an image. Images are always the product of a gaze and are perceived as such. Images have no power per se; their power lies in the relation they create with the person looking at them. Through the distancing prism of a media discourse that focused on an Africa of tribal wars, these images had no hope of moving anyone.

In 2009, Klotz revisited his traumatic experience in the feature film *Lignes de front/Frontlines*. The central object of the film is the camera of his filmic alter ego, Antoine. It is a kind of prosthesis that he immediately turns on as soon as he senses an opportunity to capture the real, an event that can be formatted to fit into a television slot. When he persists in filming massacred bodies in close-up in the middle of the film, it is because he realizes (literally) his powerlessness to transcribe this reality that hits him in the face. One does not choose to be a witness; one is, in spite of oneself. It is only when he abandons his camera and alone faces his return into the horror that fiction becomes possible. And then the film changes viewpoint to focus not only on the victims, but on what motivates the perpetrators. He thus throws himself into the lion's den. This confrontation erases the distance that was shielding him from reality, and he nearly loses both his life and his mind in the process (9412).

Images of the genocide were rare, but there was abundant coverage of Operation Turquoise. "The world did not realize that these images of thousands of displaced people were not the victims, but the killers or their accomplices," stated Raoul Peck (4649). Commissioned by the French television channel Canal Plus, Alain Tasma's *Operation Turquoise* (France, 2007) was about France's role in Rwanda, which the majority of fiction films portray very negatively, depicting the arming and backing of the Hutus, and the abandoning of their endangered Tutsi fellow workers. Tasma also frontally attacks the hypocrisy at play in this so-called humanitarian mission and accuses the army of having stood by as the Bisesero massacres took place. "The world was beside itself with emotion before these images of flight and started sending aid," continues Peck, "which created even greater suffering in the refugee camps because the murderers trafficked the aid to the Congolese population notably, and thereby continued to control the refugees. That is where the degree to which images can be manipulated becomes clear."

In Robert Favreau's *Un dimanche à Kigali/A Sunday in Kigali* (Canada, 2006), based on Gil Courtemanche's best-selling eponymous 2000 novel, which was presented as "a fiction based on real events," the Quebec journalist Bernard Valcourt insists on filming: "We need images to stop this madness. I don't have the right not to try." Yet he is a disillusioned character. Like the AIDS virus he was supposed to be making a documentary about, the genocide mutilates the country in its flesh, but serves above all in the film to counter the naïveté of Valcourt's adolescent relationship to Africa. Shot entirely in Rwanda, the film remains the projected fiction of a relationship with the self, which Africa both reveals and serves as the

tragic setting for, but with the notable difference that the entire film is placed under the sign of a sense of complicity: "You thought we were animals; now you know we are humans." At one point Valcourt says, "a camera is useless before a machete," but the film answers him back to the contrary: it is completely constructed out of a belief in the pedagogical power of the cinema. Humanistic and generous, *Un dimanche à Kigali* is in the image of Valcourt's behavior: an ode to redemption through goodness (5897).

4.6.4. Confronting the Terror

The humanization palpable in certain films attempts to abate the terror felt when confronted with the force of the inhuman, this "shame of being men" that Primo Levi wrote about. "If one does not feel this shame, there is no reason to create art," said Gilles Deleuze.[35] The inhuman is the only measure of our humanity, therefore, and it is art's role to free life from the prisons that man himself creates. It is in this respect that art is a form of resistance. Cinema, however, often exudes the sentimental illusion that humans are essentially good, and that the solution is to rekindle the flame of goodness in them. But this remains an empty wish, for violence is an enigma that we shall never cease to try to resolve; it is what, referring to Adolf Eichmann, Hanna Arendt called "the banality of evil." Mandated to supervise the implementation of the Arusha Accords prior to the *itsembabwoko*, UN Force Commander and Lieutenant General Roméo Dallaire, who features in both *Hotel Rwanda* and *Un dimanche à Kigali/A Sunday in Kigali*, wrote an autobiographical account on which Roger Spottiswoode's eponymous film *Shake Hands with the Devil* (Canada, 2007) is based. Dallaire spiraled into depression and tried to commit suicide several times. The film is based on a session with a psychiatrist in which his traumatic memories surface, and focuses on his sense of guilt. He thus bears the guilt of the international community. But guilt only amounts to crocodile tears if it does not elicit vigilance, for the issue remains stopping the repetition of horror. It is distressing to realize, as Dallaire does, that, in the event of a new crisis, the massacres could happen again, in Rwanda or elsewhere. Only artworks can build hope, for they alone pave the way to an emotion that constructs the freedom to think and resist. It is in this respect that more films are necessary to constantly renew the way in which the question of inhumanity is posed.

This implies not considering the genocide as an absolute that cannot be represented in the Adornian sense, but as a source of reflection that enables us to

surpass terror and despair. It is thus unsurprising that *Rwanda, le jour où Dieu est parti en voyage/The Day God Walked Away* (Belgium, 2009) was directed by Philippe Van Leeuw, a cameraman—in other words, someone from the film world whose profession is images. That also no doubt motivated the fact that the film is almost entirely wordless. This is indisputably its pertinence and force, for this silence is that of the dead. It is also God's silence, as the title suggests. The genocide digs a bottomless pit, a gaping wound that affects the very meaning of human existence. In *Nyamirambo!* Nocky Djedanoum (Chad) wrote: "Our insomnia-swollen eyes implore the void before the swamp of collective madness." Like Guinean writer Tierno Monenembo in *The Oldest Orphan*, or Chadian Koulsy Lamko in *La Phalène des collines/The Butterfly of the Hills*, the film does not directly address the *itsembabwoko*, which is nonetheless at the heart of every shot. God signifies the hope of being able to love. It is precisely what the murder of her children has taken from Jacqueline, and which leaves her with no choice but to throw away the cross she wears around her neck and to seek to destroy what brings her back to life. She needs to perform an act, and the paradox is that it is in portraying this directly, but from an appropriate distance, that the film gives us back the speech that, like her, we had lost. This Christic act wards off the defeat of God because it makes us wonder how we can trust in ourselves or want to be human and in which language, in which thought. Her final act of refound freedom in returning to what her village has become thus opens the sphere of possibilities for a future to be constructed that differs from the models that led to the tragedy. Her decision suggests that, ultimately, the life of another is untouchable because taking that life does not suffice to protect oneself from it, or to appropriate it. The dead are not dead: they come, like the hill butterflies, to haunt the world of the living (8627).

In Bernard Auguste Kouemo Yanghu's *Waramutseho!/Hello!* (Cameroon, 2008), silence also characterizes Kabera and Uwamungu—two Rwandan childhood friends who live together in Toulouse, France, one working, the other studying—when they discover the genocide in the media. This silence is the silence of their terror, their intense concern for their relatives, the abyss that the terror etches in each of them, the unspeakable when one discovers what the other does not know. The unspeakable undermines their relationship, breaking their ties and triggering violence. They end up at loggerheads, a painful echo of the Rwandan theater. But they are still there, side by side, forced to live together. An exchange of looks suffices to suggest that hope lies in the recognition of what we share (8974). What creativity must be deployed to make reconciliation possible? It is a highly concrete question for the

young Rwandans, who cannot just sideline this heritage of suffering and hatred. In Lee Isaac Chung's *Munyurangabo* (USA, 2007), Sangwa and Munyurangabo are also the best friends in the world until the old demons of the genocide end up opposing them. Rejected, Munyurangabo ends up questioning his own name, which means "warrior": "What is your combat?" The need for violence may thus find another resolution. This first feature film shot in Kinyarwanda was made during a workshop in a camp for street children. It was written collectively, a writing that, while focusing on memory, is inscribed in the present (5965).

The genocide's present, which does not attempt to create any form of archive, gives Rwanda a new cinema. Production companies have emerged thanks to foreign film shoots, and are run by a handful of young filmmakers, most of whom are *itsembabwoko* survivors, to the extent that people now refer to *Hillywood*, after hill and Hollywood.[36] Eric Kabera's creation of the Rwandan Film Center (CCR) in 2002 has guaranteed backing for training programs and the implementation of a traveling cinema and an annual film festival in Kigali. "The genocide is present in every screenplay I read, in every film idea," he stated.[37] Certain films have started touring international festivals, such as Kivu Ruhorahoza's *Grey Matter* in 2011, the first feature film entirely produced in Rwanda, and which retraces the battle and doubts of a filmmaker who wants to make a film about the trauma of violence. It is indeed by putting in critical perspective memory and the memorial process, questions of representation and the productiveness of the symbol, articulations of meaning, and the need to remain vigilant and concerned that Rwandan filmmakers will manage to produce a cinema of reconciliation.

Styles and Strategies

If the rhythm of the music changes, the tempo of the dance must follow.

—Proverb, in "Universel comme le conte," interview,
Olivier Barlet with Dani Kouyaté

5.1. Innovative Films

5.1.1. Love Thy Spectator

We don't ask: will the spectator like the film,
but rather: will the film like the spectator?

—Luc Dardenne, *Au dos de nos images*

Mille mois/A Thousand Months (Morocco, 2003) opens with a sequence of eight shots in which the villagers gather on the hillside, scrutinizing the horizon. They are there to sight the new moon, which signals the start of Ramadan, but we do not know it yet. "I like toying with the audience in this way to thwart its expectations," said Faouzi Bensaïdi. Not disposing of all the visible elements, the audience is invited to imagine its own film. "I sometimes work on established schema that I gradually

undermine. I love doing this, this feeling of entering something established and seeing if it might lead to something more interesting, more innovative, less familiar, less safe, like this story itself, for that matter" (10298).[1] That is indeed what he also does in *WWW: What a Wonderful World* (2007): "Everything in this film is a choreography, even the cars and buses!" (4599). This playing around with filmmaking heralds a new relationship with the spectator that all of the key filmmakers of the 2000s have developed in their own way. This playfulness is destabilizing; it takes us beyond the habitual realm of narration and requires active participation on the part of the spectator. Held at a distance, in a position of observation, challenged, the spectator is forced to react to find his or her place. But, "a labyrinth is a place that we emerge from lost," Roland Barthes liked to say. The aim is not to resolve an enigma, or to piece together a puzzle, but rather to plunge us into uncertainty. Where does Zeka Laplaine wish to take us in *Kinshasa Palace* (DRC, 2006)? A man named Kaze evokes his family through the story of a brother who has disappeared, and whom he sets out to find. Is it just a regular storyline? No, everything about it feels strange and we can no longer distinguish the truth from the fiction. But the experience is a pleasurable one, as we enter into the game. And this pleasure is not vain; it is a way of evoking the complexity without didacticism. In a documentary style, Kaze introduces us to his parents—a mother in Kinshasa and a father in Lisbon—and suddenly we find ourselves plunged into the complexities of a colonial history that converge to better separate this black woman and white man. A paper chase on the brother's trail unfolds, all the way to Cambodia, based on a photo that serves as a missing-persons notice, a needle in a haystack, but also a link, an opportunity to talk, and thus to advance, to construct a world other than our contemporary solitude. The brothers and sisters enter the picture, complicating things further, mirroring this historical and cultural in-betweenness where biological mixing does not signify cultural blending, but rather the quest for a new autonomous imagination, beyond the hierarchies and condescension. We are not looking at a fixed imaginary, then, but an unending quest. Dedicated to the father, the film accepts the ambiguities of the past and a filiation that, far from being portrayed as a parenthesis, establishes cultural markers and thereby opens up new possibilities (6788).

The film never divulges whether or not this brother truly exists, or whether he is in fact Zeka Laplaine's double, and thus simply an opportunity to explore an imagination. Kaze is the anagram of Zeka, and the character is played by the director himself. The filmmaker nudges his way in between the spectator and the film, turning the relation into a three-way affair. This is so striking in 2000 film

aesthetics that filmmakers go as far as staging themselves, not in a form of self-representation, but rather to heighten the confusion. "As the character is very close to me, and the film constantly plays on fiction and reality, I thought I might scramble the tracks even more by playing the character myself and naming him Haroun," Mahamat-Saleh Haroun said of *Bye Bye Africa* (Chad, 1998). The director thus took the risk of playing the rather unpleasant character himself. Of course in *Stromboli*, Rossellini already portrayed an Ingrid Bergman who hardly elicited identification, her painful resistance drawing the spectator into a difficult ambivalence. Ever since Neorealism challenged classicism, it has been a constant of engaged cinema to portray problematic and even irritating characters, subverting identification to engage the spectator. Abdallah in Abderrahmane Sissako's *Heremakono* (Mauritania, 2002) can be placed in this category: he is apathetic, hesitant, does not speak, and is shy before women. Waiting for an uncertain happiness that he believes lies in leaving, whereas others seek it where they are, his is in suspense, in limbo in an Africa that is too chaotic to be rationally understood. "Do they really need light?" asks Maata, the aging electrician who cannot make his lamp work. His young apprentice, Khatra, firmly believes so, he who wants to become an electrician himself. The light bulb he takes from the deceased Maata and throws into the sea comes bobbing back to him: he needs light and he will transmit it. But it won't be the glittering light of imported television images; it won't even be that of traveling to the elsewhere where the train he is prevented from getting on would have taken him. Khatra takes the lamp to make it a tool. If the film ends on the sensual curve of a dune, it is because the future lies in such sensitivity. His apprenticeship is essential, as is that of the girl who learns to sing. It is this poetic act itself that enjoins us to face up to ourselves, to rebalance the masculine and feminine everywhere, and this is undoubtedly where the future of the world lies (2350). The negative reactions to *Heremakono* winning the Golden Stallion Award at FESPACO in 2003 were not at all surprising. It is not easy for the spectator to take being sidelined, with no identification possible. Sissako creates distance rather than depicting proximity. A large dose of documentary is thus inscribed in the film; we become spectators of bodies in movement that are no longer us, but an Other, a modern experience of an irreducible alterity, essential for understanding—be it in Europe or Africa—that Africa is not the projection we imagine.

The stake is making the spectator a producer of meaning, not a consumer. Roland Barthes qualifies all "readerly" texts as "classic," because such texts do not leave space for the reader's creative input. To this, he opposes "scriptible" or

"writerly" texts: "the writerly text is *ourselves writing*, before the infinite play of the world (the world as function) is traversed, intercepted, stopped, plasticized by some singular system (Ideology, Genus, Criticism) which reduces the plurality of entrances, the opening of networks, the infinity of languages."[2] In cinema, this infiniteness of languages manifests itself in aesthetics, but also in the directing of actors. "I asked them to keep their real, everyday names and to express themselves in their own words," Haroun commented in reference to *Bye Bye Africa*. "For example, I asked one of them to show that he loved the other, in his own words and gestures. We constantly improvised to remain true to life" (2065). While one of the injunctions demanded of African cinema was that it should achieve the technical accomplishment of "well-made" films, the 2000s have seen the emergence of films that have moved away from these codes, not to become mediocre, but to become freer. In so doing, they have sought to restore the rhythm of life so that spectators better perceive what the film conveys, rather than what it says. Enhancing the characters' freedom in this way liberates them from the constraints of the screenplay, letting life flood into every shot. The unforeseeable that the actors thus cope with during the shoot conserves a degree of mystery in the characters, and opens up a realm of uncertainty that spectators can enter without having to intellectualize this. "I broached this subject by asking the actors to improvise. I didn't want to write the film," Zeka Laplaine said of *(Paris: xy)* (DRC, 2001). "That is perhaps what gives the film its highly intimate note, its impression of being autobiographical. Improvisation encourages the actors to draw on things that are close to them." It also determines the choice of actors. "I worked with actors who, like me, are familiar with the Actors Studio method, which consists of finding the character based on an experience, a sensory memory, which enhances this intimacy" (2066).

A director's presence onscreen in the lead role is risky; it can generate confusion about the roles. Jean Renoir delighted in playing games when he took the role of Octave in *La Règle du jeu/The Rules of the Game* (France, 1939). Decked out in his hilarious bear costume, Octave is marginalized by the order of the chateau, opening eyes and prompting a critique of the rules of a dying society. This presence/absence, actor/spectator, allows the filmmaker to inflect the narrative. As Gilles Mouëllic suggests, it is Rabah Ameur-Zaïmeche's presence as leading actor, both central and decentered in all his films, that enables him both to orient his actors' improvisation in the direction he wants, and to inject a distance that makes it possible to focus on the essential.[3] As he withdraws from the scene in which

the village men throw a party to welcome Kamel in *Bled Number One*, the fiction becomes a documentary, bringing out the cruelty of the absence of women and the alcohol-fueled sadness. Playing the role of Bellisard in *Les Chants de Mandrin/ Smugglers' Songs* allows him to constantly influence the narrative to make this enlightened eighteenth-century rebel an inspiring voice for the present (10526). It is not at all a sign of arrogance, but rather a way of guiding the film without bridling the fecundity of the unexpected.

In Morocco, after the dark days of colonialism came the repression of dissidents. This repression is the object today of an attempt at justice and reconciliation, to cite the terms of the commission created to this effect. With his second feature film, *C'est eux les chiens/They Are the Dogs*, Hicham Lasri addresses this in a highly original and coherent manner. Lasri injects chaos into everything to testify both to the state of the country and this scarred memory. The film's title in itself is provocative, but simply testifies to the state of things. *C'est eux les chiens* is the story of a cortege: a TV crew is filming live on the ground, reporting on the Arab Spring, when the journalist becomes more interested in Majhoul, a fascinating character in constant flight. We gradually learn that he was imprisoned during the 1981 hunger riots, rotted away in prison for some thirty years, before resurfacing at the height of the country's political upheaval, looking for his family. He is scarred and unhinged, a modern Odysseus, a ghost, most of whose life has been amputated, but who will not give up until he has re-created this necessarily painful tie. The film is coherent in the way it espouses the ambient chaos, with its hand-held camera constantly trying to keep up with Majhoul, who thinks only of escaping; its endless toing and froing between the television and film cameras, which places us alternately in the position of witness and television viewer; its mike that only works when it wants to, despite the importance of words; a Casablanca in the midst of construction works and political upheaval; and a "YouTubian" approach, to borrow the director's expression, that directly catches the real as would a cell-phone camera. Everything seems improvised, but although the film was indeed shot guerrilla-style, everything was in fact well planned and prepared, with eighteen months' work on the screenplay, in liaison with Nabil Ayouch, who produced the film. The editing too was a real piece of craftsmanship. Burlesque rivals the tragic to offer a rereading of history rooted in the present. The result is a highly personal and original cinema that is profoundly independent and in keeping with the changes in society. Professional actors mingle with passersby without us knowing any longer who is acting and who is not. As for the budget—peanuts—it was self-funded as, in a desire to remain independent,

but also to not have to wait, no funding was requested from the Moroccan funding bodies. Although he has a tombstone in the Martyrs' Cemetery, Majhoul is no hero, nor a model. He is a contradictory character who resurrects and little by little reveals himself. He is constantly on the go, as are those around him. Only the radio and television dish up a fixed discourse, so formatted that it becomes comical. For ultimately, it is politics that this film is about, without appearing to be—about the state of Morocco through the different facets of the city, about the ongoing gulf of the memory of the repression, and about the hopes borne by these youth who lose a shoe in the demonstrations (11520 and interview 12057).

Improvisation is not a prerequisite, but rather a path that is often chosen to allow the actors to appropriate the fiction, in the same way that Jean Rouch suggested situations to his characters, leaving them free to "fabricate," without knowing where this would lead. When three *banlieue* homies in *Wesh Wesh, Qu'est-ce qui se passe?* start mimicking TV golfers on a lawn in front of the high-rise projects they live in, they take the reins of the film in complete freedom, "injecting the symbolic into the banality of the day-to-day."[4] Djinn Carrénard also adopted this approach in *Donoma* (Haiti, 2010), an invigorating film about romances made with a group of friends and no budget: "We improvised and that generated a flow of energy that allowed me to see where the actors were at. My work was then to adapt their roles accordingly" (9526). It is in this sense that Daoud Aoulad-Syad says he does not direct his actors: "I tell them to do their work, explaining the situation they have to act out. As—coming from photography—I work a lot on space, I choose the frame. That's the most important. After, I try to adapt to them, rather than asking them to adapt to me" (9895). This abandoning of models involves what Michel de Certeau calls the "tactics" of everyday life. The actor no longer plays, but exits "the machinery of representation . . . that binds bodies into a norm."[5] This freeing of bodies invites spectators to share this experimental play, and enjoins them to surpass the passivity of consuming a spectacle. The film refocuses on the actors' experience during the shoot, and thereby becomes shaped by a dynamic external to its writing, or even its project. For *Mort à vendre/Death for Sale* (Morocco, 2011), Faouzi Bensaïdi asked the three main actors to come to the town where the shoot was to take place, and asked them "to go to the rough neighborhoods and smoke joints"! They came back saying that they had made friends with a dealer, who had taken them to eat a local bean dish. "I wanted them to play the three thugs in the film, the three losers, and for them to appropriate this town," said Bensaïdi. "They experienced things you can't make up. It shows on the screen" (10298). This

immersion in real situations helps reinject the rhythm of life into the fiction, in the same way that Ibrahim El Batout asked his actors to blend into a real wedding party to shoot one of the scenes in *Ein Shams* (Egypt, 2007), which he could never have afforded to stage. He shot among the guests with his DV camera, and the result is truer than life! (8622). "What interested me was working on people's energies," Dyana Gaye said of her musical *Un transport en commun/Saint Louis Blues* (Senegal, 2009). "On this premise, I didn't necessarily find myself working with professionals, but with people who had the will" (9013). One thus surpasses the recurrent debate on working or not with professionals; the issue resolves itself at the casting call, depending on people rather than on their skills.

Algerian director Tariq Teguia uses a method close to that of Jean Renoir, who used to get his actors to read their lines over and over until they lost all expression, so that they could then achieve the intonation that he wanted:[6] "I try to get them to drop what they think the expression should be. I want them to resonate like Bresson's models, who are human; for a pickpocket, a light touch, a rapidity of movement. Moreover, these actors aren't actors. Maybe they become so with the film. I don't know what "amateur" means, but they are models, traversed. On the shoot, we start over and over again until we exhaust, dry, desertify, but absolutely do not fossilize the acting. You maybe have to break down the actor to achieve this!" (9014). If film consists, a priori, of telling a story in which meaning is woven out of the relationships between the characters, everything is reconstructed to convey this meaning: the space, rhythm, and atmosphere. So much so that, as Tunisian Nouri Bouzid put it, "cinema is first and foremost the form. That is where the difference between a filmmaker who conveys something and one who tells a story lies" (2658). Such cinema is not verbose. It does not convey meaning through words, but through an inhabitual cinematographic grammar in which painting, music, and literary inspiration weave a web that enhances the gestures and bodies. This highly carnal cinema is demanding, naturally, yet it constantly offers stunningly beautiful images. It is demanding in the way it destabilizes the spectator, forcing us to construct from what we receive; namely, a perception, not an explanation, a sensory representation whose poetry opens all possibilities. The distance generated by this rupture with a cinema that seeks to comfort the viewer in a cozy complicity with the characters plunges the spectator into a meditative disequilibrium, a mobilization that, if the viewer does not bail, puts him or her in a position of understanding the displacement experienced by this stranger whom the cinema takes as subject.

For Oliver Hermanus, focusing on the accessible character of the long-suffering mother in his beautiful first feature film, *Shirley Adams*, was not complicated: she is a victim with whom the spectator can identify. The challenge in *Skoonheid* (South Africa, 2011), which portrays an older man who falls in love with a young man, was to get "the audience to go: 'yes, I like him,' then 'no, I don't like him,' then 'maybe I like him,'" as Hermanus put it (10237). As Marie-José Mondzain writes, "it is cinema's task to reestablish the authority of the spectator, giving him/her back the lost power of truth and action."[7] This spectator is "a citizen capable of judging what he/she sees and deciding what he/she wants with others." In *Entre les murs/ The Class*, by Laurent Cantet (France, 2008), the camera is always situated on the same side of the classroom, facing the windows. This positions us in the place of the arbitrator, and it is indeed the position that Cantet gives us: not the position of judge, but that of a person who will wonder about the question—which constantly needs re-posing—of the rules and limits of education and life in general (7619).

Never in African film has a filmmaker so directly invited the spectator to stop being just a spectator and to share in the questioning of his creative undertaking as Nouri Bouzid in *Making Of* (Tunisia, 2006). Interrupting his narrative three times, he depicts his lead character's revolt against the role of the fundamentalist he has him play (see 1.3.2). It is so powerful and unexpected that we believe in it, with Lotfi Abdelli's acting contributing significantly to making these digressions work. When he asks the director what he is getting him into, he becomes a mirror and a mouthpiece for the questions of an artist who wants to share his doubts with the spectator, as if he needed to negotiate his rejection in advance. Behind the actor, we thus glimpse a director, anxious not to accomplish what he set out to do (4688). This anxiety is that of all artists, and their desire to share this intimacy with the spectator is symptomatic, as Haroun put it, of a "loving relationship, a relationship that one finds in certain filmmakers all over the world" (2065). Who better than Youssef Chahine incarnates this way of bringing the viewer into the director's confidence? As in *Silence... We're Rolling* (Egypt, 2001), he plays on suspense rather than surprise, to get the spectator to appropriate the process and participate in its strategies (0070).[8]

This necessitates a gaze that rises above the world's agitation to assert its own rhythm. In this context, minimalism is one means of resisting making a spectacle of the world and of finding a time frame and space in which the body can flourish. It is in this sense that film runs counter to the increasingly virtual nature of the world. "The more we simplify, the more just a film becomes," as Abderrahmane Sissako put

it.[9] Yet, as he added elsewhere, "If you make things too easy for the spectator, you don't help him or her advance." Viewing, then, requires an effort. Sissako continued: "Unlike efficient American cinema, we help the viewer enter the frame and see the character's face without necessarily showing it in close-up. This kind of framing doesn't make it longer, but the wider the frame, the more time multiplies. I thus try to quickly leave the scene to focus on something that has nothing to do with what's going on in the scene. This elliptical form of leaving and going elsewhere, only to come back again later, is a way of asking the spectator to remain attentive; there's a door, but there's also another door, and one has to come back again. For me, the editing is vital, to try to find a kind of justness, a harmony, that does not turn slowness into a style" (2351).

This slow style of African cinema has been so reproached, without people perceiving what this simplicity confers. Referring to his first film, *Wend Kuuni* (Burkina Faso, 1982), Gaston Kaboré said: "My aim was to strip the film down to the bare minimum, for a depth to remain behind this extreme simplicity" (3363). Tales teach us to go beyond the surface to seek substance. What is at stake remains engaging the viewer. "I take great pleasure in composing highly minimalistic, un-moving shots in which the bodies that enter that space are highly choreographed," said Faouzi Bensaïdi, adding: "I sometimes like not following the character, letting him/her exit and then reenter the frame. This constantly calls on the spectator's intelligence and imagination" (2911). The aim is not only to ensure a transmission, but also and above all to engage a dialogue. As the Senegalese storyteller and actor Makena Diop put it, "the mouth that moves and the ear that listens are both possessed by the living word." For communication to exist, you need both a speaker and a willing listener. "Then the imagination can be unleashed" (6633). The late Samba Félix Ndiaye always loved citing his grandmother, who used to say, "a worthwhile word always finds ears" (7956). A word without ears is not a word, considering, as his grandmother also used to say, that "you cannot sit on the head of someone who is speaking to you." Loving one's spectators is to give them the chance to speak, and to listen to them.

5.1.2. Divert, Reverse, Subvert

> Fall without breaking
> Stand without a prop
> Hugged-tight
> Roly-poly.
>
> —Kossi Efoui, *Io* (*tragedy*)

Where, in postmodernity, does one class the figures who escape the confines of reductive self-representations and assert their place as actors in the world, and not just on the margins? In the 2000s, unclassifiable, off-beat, unusual, provocative films have emerged whose lexicon is rupture and diffraction. They dynamite classical cinematic forms.[10] During the 2010 Dakar Biennial, artists such as Kitenge Banza from Congo confirmed their uninhibited approach to the various mediums, readily mixing painting and video in both installations and performances. Artists of the younger generation are also working with mixed media, such as Senegalese Solly Cissé or Cameroonian Barthélémy Toguo. Collectives have emerged, such as Eza Possibles in Kinshasa, or the Cercle Kapiski in Douala, in an attempt to bring art to the streets and to favor encounters and visibility. In theater, as Sylvie Chalaye has pointed out, "narratives of somersaults and subversion" are asserting themselves. To rid itself of backward-looking representations of Africa and to claim identities in the making, playwrights revere dynamic iconoclast Sony Labou Tansy's impertinence. The agenda has become countering and subverting. Koffi Kwahulé works on a deconstruction of dialogue, in which the meaning escapes us; Kossi Efoui questions amnesia and reminiscences by unfurling his dialogues in snippets. This same quest for idiosyncrasy is found in the Caribbean in the epistolary writing of Gerty Dambury or Simone Schwartz-Bart. "These writings work on shifts and the off-beat, a dynamic that is akin to a gasp, to the syncopated, to the rhythm of the in-between, to the void that opens beneath the feet of those artists subjected to having been torn apart by a colonial past that erased an entire stretch of their history."[11] In film, we have seen, Djibril Diop Mambety's poetry announced this losing the spectator, this formal detachment that casts a caustic gaze on African reality. As the Senegalese critic Baba Diop pointed out, since *Badou Boy*, Mambety developed a subversion of both things and meanings: "The Chamber of Commerce resembles a theater, while the Daniel Sorano Theater looks like a public housing block. Kermel Market stands out from the city's architecture like a sore thumb;

everything is topsy-turvy. The characters are subverted too: the policeman is not svelte, he has a paunch and wobbles along with difficulty, and the dandy who pushes the city bus looks like Fred Astaire or a magician" (7976). This cinema of subversion manifests itself today in the appropriation and recycling of the signs of modernity, in the same way that African societies appropriate technology and reclaim everything, from clothing brands to satellite channels, while cell phones abound in all walks of life. *WWW: What a Wonderful World* (Morocco, 2007) reflects this: technology is everywhere, and appropriated to one's own ends, for, as Faouzi Bensaïdi states, "the film focuses on this society and on where we are going" (4599). By multiplying the cinematic references in an intertextual weave, he mixes references to world cinema and a modernist imagery, proposing a rupture with an identity-fixated vision of "African" film, Morocco, and Africa. If he challenges perspectives and develops new spaces of representation, it is to develop a new aesthetic lexicon in which the weird and strange hover over the reassuring old norms (4602). The agenda is rupture, for it is urgent to rethink African modernity in order to escape mimetism, but without cutting oneself off from the world, appropriating its references to serve the vital representation of the tragic, with reality needing constantly to be recalled. The sense of wonder elicited by the ship from Federico Fellini's *Amarcord* (Italy, 1973), which Bensaïdi reconstructs shot by shot, is subverted when it nearly sinks a group of migrants. Humor and parody are never far in "this film in which we laugh very caustically," for the film does not take itself seriously, but rather attempts to explore the ambivalence of our nascent century. This probing use of genre codes becomes a subversion: "There are action scenes, chase scenes, scenes that come from a highly coded and codified cinema, but we did not use what could have positioned the film in that perspective. We took it elsewhere, quite deliberately" (10298).

Even in a sci-fi film like *District 9* (South Africa, 2008), Neill Blomkamp, who adopts a documentary approach, reverses the norm: far from representing a threat, the extraterrestrials are poor lost wretches, their huge space ship having broken down over Johannesburg (9189). And when Abderrahmane Sissako inserts a hilarious Spaghetti Western episode in the middle of *Bamako* (Mauritania, 2006), featuring actor Danny Glover and the filmmakers Elia Suleiman and Zeka Laplaine, it is to both playfully and seriously echo the interventions of the international institutions denounced in the film's staged trial. It is Africans who, under this pressure, eliminate the "one teacher too many." Far from a discourse of victimization, Sissako recalls Africa's participation in the continent's suicide (4429). Developing

and debating the arguments, the trial in *Bamako* is in itself a reappropriation of the trial scenes that abound in American movies, but this time used to denounce the deceit of the G8 countries, who proclaim their goodwill as they grant widely mediatized debt reductions, while this debt—already amply paid off—continues to bleed the countries caught in its stranglehold dry, stopping them from providing education and social services. The trial in *Bamako* is a lure: it pretends to be what it borrows its form from, in the same way that, in *Cleveland versus Wall Street* (Switzerland, 2010), Jean-Stéphane Bron filmed as closely to reality as possible the trial that the city of Cleveland attempted for years to hold to indict the twenty-one banks it holds responsible for the property repossessions that devastated the city (9541). This form of reappropriation is a strategy of resistance that remodels the existent to subvert its logic; it is no longer as victims, but on an equal footing, that the protagonists confront their enemies.

The advantage of reappropriation is that it avoids manipulation. It is not new; art has always practiced this, taking inspiration from others. What it does bring in the 2000s, however, is a positioning. Rather than situating itself on the outside, as an unconnected alternative, in an illusory autonomy, critical art situates itself within, in the heart of the real, in a confrontation on the ground, an intestine protest. It is thus in keeping with the sociopolitical movements that acknowledge the failure of modeling strategies, encouraging instead the emergence of a reconfiguration of the real. To resist is to inhabit the present in an attempt to modify it, and in a multitude of practices that claim uncertainty as a condition of their becoming, with no guarantee of the result. "It is not awareness that determines life, but life that determines awareness."[12]

"He cannot help but deviate," Youssef Chahine's producer, Marian Khoury, used to say of him. Fiercely independent, he exploded linear narrativity, not bothered about whether or not that suited tastes. "He constructs floating bubbles that bob away one by one as the narrative advances. This form of narration is accepted in the West, but not in Egypt." Why was Chahine misunderstood in his own country? "Essentially because of his way of bringing together opposites, of making the impossible possible, of imposing his own personal convictions" (2670). Original approaches are less consensual, but help avoid identity-based traps. In Mama Keïta's *Le nème commandement/nth Commandment* (Guinea, 1997), a Rivettian puzzle of relationships falls into place, to only become clear at the end of the film. The montage delights in juggling with questions of filiation, relationships, memory, and faithfulness, but not with the question of people's origins, for while these are

varied, the relations between the characters have nothing to do with skin color (2064). To divert, reverse, and subvert is to destabilize. In Teddy Matera's *Max and Mona* (South Africa, 2004), the array of shady characters, who are as dubious as they are extreme, results in a film that is both serious and comic, but also totally out-there. Matera reworks the codes of advertising and pumped-up music videos in a highly personal style, as if calling for a new and different cinema. Readily playing on perspective and on vertical planes that the low- and high-angle shots and filters accentuate, Matera creates a comic-strip aesthetic.

Fast urban music also drives the rhythm of the film, while inserts announce the stages of the "King of Tears'" irresistible ascension—he who will have the last laugh! The film becomes increasingly burlesque with each sequence, while the derision hints at the essence of the story and portrays the milieu. The same can be said of Jean-Pierre Bekolo's *Les Saignantes/The Bloodettes* (Cameroon, 2005), which follows in the footsteps of Japanese Takeshi Kitano: a cold-lighted, ruthless burlesque to trump death. Bekolo does not hesitate to clock up the ellipses, and systematically fragments the shots to impose a rhythm, slows down or jerks the image, breaks or alternates the plot, resorts to the ambivalence of half-clad bodies that constantly sashay or dance around, invents lighting to dot the shady night with stained-glass-like bright colors, follows the lines, and provokes perspectives. The screen becomes an abstract composition, closer to a comic book than reality. And yet it is reality that is reinvented: that of Yaoundé by night, that of corruption and scams, that in which women take revenge on men to try to define themselves a future (3943).

These are thus films that mark a radical rupture with the safeness of narrative linearity, and which, through montage and ellipses, experiment with these alterations of perception, absences, and voids that awaken the spectator, needling him or her into reflection. One does not belong to the invisible people for nothing. History does not condemn people to errantry without that rubbing off on artistic creation. These films are journeys, a reversal of the gaze. There where the West believes it can find plenitude in its experience of Africa, these filmmakers explore the void, the absences in history and their singular stories, these deficits of peace, democracy, transmission, and filiation. And they do so not just to deplore this void, but to assert its fecundity. It is these unnerving voids that generate self-questioning, the need for the Other, an openness to the world, an aspiration to progress. It is not about catching up, but about finding the paths of one's own affirmation. Africa inhabits them, even if they do not necessarily inhabit Africa.

It sometimes happens that they draw out time. With the pressure of hegemonic U.S. cinema, television, advertising, and music videos, we have grown unaccustomed to a cinema that takes its time. Late director Raoul Ruiz used to say that "boredom is alternative cinema's secret weapon." Unlike Antonioni, who drew out time to represent the impossibility of human communication, this can be a quest for communication, as, for example, with the people who try to telephone in Abderrahmane Sissako's *La Vie sur terre/Life on Earth* (Mauritania, 1998). It is also a way of capturing the uncertainty of globalized life. When, at the start of Tariq Teguia's *Rome plutôt que vous/Rome Rather Than You* (Algeria, 2007), Zina prepares some coffee in the kitchen, we wonder if we are going to still be there until the coffee brews, and indeed we are! We have time to reflect on the details, to notice that there was no running water, that Algerian matches do not work, and that it is best to buy Spanish! "But there is gas!" Teguia retorted jokingly during his master class at the Apt Film Festival in France, adding: "It's a good example for judging the value of the lengthiness that I sometimes seem to impose. I'm trying to capture life itself, but at the same time, I'd readily quote what one critic said about the American photographer Robert Franck: 'he photographed what shouldn't have been.' That's precisely my concern. Normally, we should have filmed only what's necessary to show that she's making herself a coffee, then quickly move on to something else. What I'm interested in are the empty moments, the moment when the shot seems to peter out and where I linger a moment, because it becomes something" (9014). What it becomes—like when in the same film, the young people look in vain for a house in the labyrinthine suburbs of Algiers—is the boredom and vacuity of these existences that seek an escape. It is a gapingness, a suspension that such moments of drawn-out time reveal, the hollowness of an existence in a country that offers no future to its youth, a cinema that reveals and makes us feel the abyss.

5.1.3. Opting for Orality

He who speaks sows; he who listens reaps.

—Senegalese proverb

Orality cannot simply be reduced to what is said, even if it is true that it starts with the spoken word: greetings, hailing, and banter signify far more than would appear from the triviality of their content. Their accompanying intonations, turns of phrase, gestures, and looks make them not just spoken tongue, but language. That is true too

of the many dialogues that may mistakenly appear vacuous at first glance. As Gaston Kaboré comments: "People often say that Africans talk a lot, yet in spite of what it may seem, when we speak, it's to say something important" (6627). Popular orality develops a very direct form of address, which Balufu Bakupa-Kanyinda celebrates in *Le Damier/The Draughtsmen Clash* (DRC, 1996). The film portrays the clash between a cussing checker champion from the hoods and the country's dictatorial "Father of the Nation," glorifying this verve even as it becomes the instrument of the former's victory (2466). During certain celebrations, the Egyptian youth from the poor districts climb up on their friends' shoulders and battle in verbal jousts. During demonstrations, leaders call out the authorities as if in a trance, chanting slogans that the other demonstrators take up in unison. Subtitles often fail to capture such linguistic flourishes, which are hard to translate, unless the subtitled language is appropriated in a way that fully renders the savor intended. "When you listen, it goes straight through your heart"; a film such as *Amour, sexe et mobylette/Love, Sex and Moped*, by Maria Silvia Bazzoli and Christian Lelong (France, 2008), multiplies such expressions throughout its inquiry into love and seduction in Burkina Faso: "If only you'd grant me a visa to your love"; "You are the pilot-in-command of my soul," and so forth (8231). The translation needs to be of the same poetic order; it is a language to pass from one language to another, while conserving a trace of both. Its key stake is to convey both the opacity and the richness of a culture. In other words, a translation should not claim to be unique and rigid, but, on the contrary, unpredictable and open. This is particularly true of proverbs. Gaston Kaboré often evokes his difficulty in switching from Mòoré to French, for example in *Rabi* (Burkina Faso, 1992). The film portrays the friendship between a young boy and an old man, who in his youth fell in love, but was not able to live this love to the full. The boy convinces him to get back in contact with his sweetheart from sixty years earlier. When he finally decides to go to see her, she looks at him and says: "Does the dog that ate the skin of the drum dare to show his face the next day at the party?" In other words, when you have offended someone, you should avoid coming back to rub their nose in it. The old man thinks and replies: "If a man comes back from the market and sets his full granary alight, know that he must have learned that he'll make a bigger profit from the ash than from the grain"—a way of saying that he has swallowed his pride to carry out what appears to be an act of folly because he thinks that it will ultimately be worth it! (6627). It was in the same spirit that Kaboré named his following film *Buud Yam* (1997). In Mòoré, *buud* means both "the ancestors" and "the descendants," and *yam* "spirit" or "intelligence." The expression

thus associates understanding and belonging, and the film takes the form of an initiatory tale. Myths answer the loss of bearings and energy by referring one back, in all simplicity, to the foundations of the human adventure.[13] Films that adopt tale structures are not naive or backward-looking, then, but on the contrary, a pertinent contribution to our fumbling efforts to unravel the threads of our destiny.

Orality, however, is living word; it is accompanied by gestures and body movements. Repetitions and redundancies impose a rhythm, keep us on tenterhooks, create a circularity. It is the art of digression and fantasy, from which films that deconstruct the narrative readily take inspiration. Speaking of *Bye Bye Africa* (Chad, 1998), Mahamat-Saleh Haroun stated: "It was a risk to take, opting for orality" (2065). As in Ahmadou Kourouma's novels, which have been referred to as "orature," film indeed draws its grammar from oral literature. Deliberate approximations in the narrative that connote a sought-after incertitude; precisions and digressions as parentheses that inform the narrative; direct camera address; the maintaining of the illusion of a double gaze, with video cameras recalling the presence of the audience: all these techniques engage the viewer, who is constantly addressed by the narrator's voice-over. In a complex construction that combines apposition and coordination to multiply the parallelisms, the film creates a poetry that is akin to meditative song, or even the blues, a musical form that is characteristic of a lot of films, one fine example of which being the docu-fiction Senegalese immigrants in Milan, *Waalo fendo/There Where the Earth Freezes* (1998), by the Algerian Mohamed Soudani. There too, the testimonies delivered directly to the camera, the rhythmic rather than linear narrative construction, and the sensitive images of the urban environment, intercut with flashes of Africa, punctuate the film with visual questionings in a deconstruction of discourse that reflects both creolization and the linguistic tension characteristic of living in exile.

In Kourouma's work, as in Haroun's, the articulation between oral tradition and narrative process is elaborated in an uncertain space that combines errantry, constant questioning, and learning. This search for the self cannot be linear. It advances in spirals or is plaited together, as Balufu Bakupa-Kanyinda put it, referring to the *kasala* griotic language of central Africa: "you sow seed that you gather by killing the first proposition" (9073). In *Juju Factory* (DRC, 2005), the character Kinshasa buys a 500-euro pair of shoes, and that is just about all we know of him. As the writer Kongo Congo has a visibly younger wife, one might have imagined that this dandy is her lover, but the narrative takes another turn. It is simply suggested, then, inviting the spectator to find his or her own rhythm and pace.

After experimenting radically with sequence shots in his 2000 short film *Le Mur/The Wall*, Faouzi Bensaïdi took this even further in *Mille mois/A Thousand Months* (Morocco, 2003), letting the characters enter and exit the fixed frame, often expressing themselves off-screen. It is as if the spectator were at the theater, then, following an unfolding live experience that appears to be both the product of a style and something that surpasses the viewer, something random. An invigorating contradiction emerges between the distance that this highly constructed approach implies, and the implication that its impression of uncertainty confers. It is at the same time the precision of a musical score and the emotion of music. Other sequence shots—moving this time—follow a character, establishing a human relationship in duration. The arid landscapes are filmed in general shots in which the characters or cars move in the distance, the environment in harmony with the narrative and what becomes of the people. The editing favors digression, picking a character and then dropping him or her, only to return again later, thereby constructing the film as a polyphonic puzzle. The essence of the film is not fragmented by this, however—this mosaic of destinies, of the absurd, of the burlesque, of drama converging into one single score. We indeed come out of this beautiful film with a sensitive awareness of the traces left by the Years of Lead, and with the desire to work towards the future of humankind (2912).

Some cultivate the orality's characteristic narrative assonance by challenging vision, using jerky images. Ramadan Suleman does this in *Zulu Love Letter* (South Africa, 2004) to express the trauma of the violence suffered during apartheid; the flashbacks cannot be filmed in the fixed shots of a rigid past (3570). Similarly, touristy images could not have captured the rhythm of Bamako. Manthia Diawara entrusts the camera to Arthur Jaffa in both *Bamako Sigi-kan* (2001) and *Conakry-Kas* (2004). It spins from shadow to light, silhouette to color; Bamako is captured in a breath, a series of snapshots, far from the obvious. There are none of the typical tracking shots of streets and people filmed from cars, nor an anecdotal search for astonishing details. At risk of being too systematic in its highly visible emphasis on aesthetics, the film adopts the broken rhythm of uncertainty, becoming a vision of a fleeting reality (2741).

The oralization of cinema is thus a mental disposition that draws on its cultural sources to open up the realm of the possible. "You cannot make films if you aren't someone who doubts," Abderrahmane Sissako stated (2796). Moving away from agendas and intentions, filmmakers are on the lookout for signs of their times, favoring encounters and seizing chance opportunities. The setting is not built on

a will, but emerges from the past in places whose opportunities have to be spotted. The actors are sometimes those met on the ground, such as Makam, who keeps watch in the makeshift building by the sea in *Heremakono* (Mauritania, 2002). The film thus becomes a product of time spent with people who end up featuring in it. It is not about chance, but encounters and embracing them. The death of Maata, the old electrician, was not in the screenplay. "It was guided by the unconscious," Sissako stated. Nouri Bouzid similarly said of *Poupées d'argile/Clay Dolls* (Tunisia, 2002): "I can't explain certain shots. If they can be explained, I cut them! I need this breath, the cry of Omrane and of the horse. There are horses in several of my films. I can't explain why. What I can explain is about the order of the narrative" (2658).

This culture of the irrational is based on a destructuring, on a deconstruction of what Jacques Derrida called "logo-centrism," the ethnocentric primacy of Western reason. The irrational, poetry, the eschewing of linear narrative, and drawing on the narrative techniques of orality constitute an aesthetic opposition to the belief in a predetermined progress. Confronting this theory of the absolute with a theory of transcendence, this "creative anguish," as Edouard Glissant suggested, "is the opposite of the 'metaphysical' pessimism or despair born in the theory of the being."[14] Injecting orality into film thus opens up a poetics of diversity and counters standardization and banalization.

This considerably reverses the debate, while writing on African cinema brims with anthropological tendencies in elaborating criteria and definitions! By identifying orality as the root of African film narrative, people shut these films in a language and a genre that they laboriously have to fight out of to belong to the world. To escape the criteria of authenticity, identity, and the single root implicit in the term "African filmmaker," filmmakers in the 1990s claimed the undifferentiated status of "filmmaker, period," which paradoxically amounted to denying their specificity. As the label "African" is their principal selling point vis-à-vis funding bodies, festivals, and audiences alike, filmmakers have been trying to pull off a delicate balancing act between asserting their Africanness and wanting to escape it to thwart other people's projections. Avoiding being limited to their difference is the source of new misunderstandings. On the one hand is the risk of a lack of differentiation when filmmakers everywhere explore their roots, their origins, to tease out the specificities that define their *originality*; on the other is the fantasy of an essentialized status, as if a "filmmaker" existed unto him or herself, stripped of cultural contingencies, and outside the power relations of the postcolonial situation. To counter being shut in their difference and trapped in prejudice, embracing the aesthetics of

orality, defined as a quest, a constantly evolving cultural in-betweenness, a shifting hybridity between cultures, is a good way of covering one's tracks (1369).

The oralization of cinema is thus one possibility, but it is not the prerogative of African filmmakers alone. It is an affirmation of equal status without being accused of imitation and mimetism. It is the assertion of a new aesthetic to break with the dominance of the spectacular and consumerism. This is not to reject the past, but to position oneself in the present. It is an evolution from "it is so" cinema, to borrow André Gardies's expression, to a cinema of scars where the trace of the real replaces its exhibition,[15] in order to open polysemy. Orality should not be taken simply as a cultural entity, then, but situated within the worldwide strategies of filmmakers who resist standardization and uniformity.

Resorting to orality thus needs to be inscribed in the consideration of contemporary questionings. As the Senegalese writer Boubacar Boris Diop pointed out, the *Istembabwoko* created a before and after in African self-reflection (1465). "We are no longer what we were," Samba Félix Ndiaye said, speaking in his film *Rwanda pour mémoire/Rwanda for Memory* (Senegal, 2003). "We used to think that Europe was barbaric ... and today, we have attained the supreme stage of Europe's barbaric acts in the last century. And so, there is a sense of shame, of guilt and the fact that we have to hold our heads high nonetheless, even if we submit, because it is too hard to admit that!" (5460). Henceforth, what matters for art is no longer, as Jean Godefroy Bidima wrote, "to show the pertinence of a glorified African tradition," but an "aesthetic of the void" seen as a disposition in which "the (non)sense is always in transit and, subjected to the corrosion of time, is not localized in any particular space."[16] In this "philosophy of the Crossing," errantry constitutes an aesthetic that can no longer be reduced to characters who walk or travel in long transitions, community discussions, tilt shots from the foot to the top of the baobab or kapok, or any other such shots that replaced ellipses and ended up becoming irritating, stigmatized under the contemptuous label of a "calabash cinema" made to meet the exotic expectations of Western audiences looking for some soulfulness, but whose expectations change as the world lurches from one crisis to the next. These shots had the weight of, and were infused with, cultural connotation. While they were meaningful at the time of asserting identity, their repetition has become a trap, a fixation soon accused of trying to please. The aesthetic of emptiness, on the other hand, whose slow pace is also clearly asserted, but as a refusal to dramatize the intrigue, is in the vein of Japanese director Yasujiro Ozu, in keeping with Chantal Ackerman from Belgium, Pedro Costa from Portugal, Jia Zang-Ke from China,

Vimukhti Jayasundara from Sri Lanka, Apichatpong Weerasethakul from Thailand, and many more, all of whom are celebrated by world critics, and who explore the paths of a new vision of reality. In Slow Cinema—a cinema of silence and fixed shots, but also a cinema of the unstable—the intimate and the quotidian replace spectacle, questions take precedence over responses, territory is ambiguous, and errantry conjugates memory in the present. This aesthetic of emptiness that draws on orality because it is capable of conveying both historical and contemporary African experience has enabled African films of the 2000s to avoid the trap of being confined to an origin.

5.2. Documentary Stakes

> We try as laborers of dreams to speak the body of man's soul, with words, sounds, gestures, and silence.
>
> —Sony Labou Tansi, *Paroles inédites*

5.2.1. The Conscious Camera

The eminent documentary filmmaker Samba Félix Ndiaye, who died prematurely in 2009, cited his grandmother in *Ngor, l'esprit des lieux* (Senegal, 1994): "What matters in what we say is the reception our words receive" (7956). He who used to say "I only film people I like" (3252) taught us how very much shooting a documentary means listening to the people filmed. This machine that is the camera, whatever its size, is the vector; it needs to be visible and present. A hidden camera turns the spectator into a voyeur, as candid camera sketches demonstrate. When Belkacem Hadjadj hides his camera in *Une femme-taxi à Sidi Bel Abbès/A Female Cabby in Sidi Bel Abbès* (Algeria, 2000) to secretly capture the passengers' reactions to the taxi driver being a woman, he steals the words of people unaware that they are being filmed (even if he did later ask permission to include them in the film). This illusion of reality perverts the documentary relation because it undermines awareness of the setup. And when a hidden camera films violence on the pretext of denouncing it, there is a danger. How many conflicts have been exacerbated by horrifying images whose brute force fuels the thirst for revenge? Images construct meaning, highlighting certain elements and excluding other potentially modifying details from the frame. To film is indeed always to stage. In fiction, the actor is meant to ignore the

camera, but in documentary, an awareness of its presence enables the spectator to become the filmed person's interlocutor. The filmed subject thus addresses not only the people around him or her and/or the filmmaker (who chooses whether or not to appear in the frame), but also all those who go to see the film. The camera thus exists like another person, capable of challenging the rest. If the spectator is protected by the spectacle, which gives an illusion of being in control while holding the spectator at a distance, he or she cannot respond and the person filmed will simply speak into the void.

The camera affects how people talk and behave, and thus the real, but it clarifies the relationship, which becomes a subject unto itself. "In films about Africa, we can no longer ignore the relationship that unites us; it needs to appear so that spectators can find their place," the Belgian documentary filmmaker Pierre-Yves Vandeweerd said during the debate following the screening of his film *Closed District* at the Lussas Documentary Film Festival in 2005 (3477). In 1996, aged just twenty-eight, he went to Darfur to film a war that has caused two million deaths in thirty years. In the general chaos, his translators abandoned him and he continued filming alone, without knowing what people were saying to him. Overwhelmed by emotion, he was convinced that he could not offer a fair analysis of this conflict and, on return home, put everything he had shot away in a drawer. Later, he learned that the people he had filmed had been killed in a raid. He got back out his rushes, had them translated, only to discover that what these people were saying was completely different to what he had imagined, that they had understood what this film could offer and were calling for help. But he also realized that this footage showed how much war transforms people's behavior. What he had taken, for example, for a war or a love song, which two men danced to in front of the camera, turned out to be an obscene and provocative litany of their macho fantasies, a stunning and extremely harsh scene whose words were born out of the violence of war. This brings to mind Jean Rouch's *Maîtres fous/ The Mad Masters*: an aporia-like, disturbing ritual. Based on his experience of Antonin Artaud's "theater of cruelty," Rouch believed at the time—1954—that it was necessary to shock the colonial spirit entrenched in every European's head with at times cruel images of the "elsewhere." Colonial mentality is still alive, and "inexcusable images—to borrow documentary filmmaker Johan van der Keuken's expression—are at times still necessary today to challenge certitudes.

That is indeed the issue here: brave enough to reveal just how very wrong he was, Vandeweerd offers us these images, which radically question the relationship

between filmmaker and filmed subject, but also give the viewer back a place, engaging him or her through both the director's self-critical commentary and the destabilizing images. For everything in this film disturbs: the death that hovers over this village reduced to chaos; the sham combat practice; the filmmaker being invited to participate in the showing of force, and who does; the sacrifice of a cow allegedly possessed by an evil spirit; and so forth. If Vandeweerd oversteps the line, he does so with precaution, being careful to precisely establish the parameters of his gaze, while constantly questioning it: "Would I have gotten so close to these men with my camera if I'd understood what they were saying?" No, of course not. A distance has to be found that respects the person filmed, that avoids zooming in on their tears or anger, but that also undermines the power of the camera, and thus undermines the filmmaker/subject hierarchy, akin to what Foucault describes in his *History of Madness*: the "doctor"/"healer" is all-powerful before the "patient," who has no rights over the former.

The camera, thus, poses a question: how does one choose to behave? What is at play is moving away from overbearing demonstrativeness or judgment to instead opt for implication, that of a present body, a visible camera, of this question posed that makes documentary not a subject, but a series of questions. This implies addressing these questions, and thus writing the project not as a film in the making, but as an inquiry. It is later at the editing stage that the intimacy of the auteur's approach emerges. For the meaning of images and words often only emerges later on. When Idrissou Mora Kpaï went to Arlit in Niger at the time when Areva had not yet restarted exploiting the huge open-cast uranium mine, he did not go as an expert or a journalist; he had researched the subject, but did not have a predetermined notion of what he was going to film. *Arlit, deuxième Paris/Arlit, Little Paris* (Benin, 2005) shows the consequences of modern slavery, but if he focused on medical issues, it was not to denounce them with scientific rigor, but through a gaze (3700). That allowed him to avoid a sociological pseudo-neutrality and to adopt a "documented viewpoint," as Jean Vigo defined it: a filmmaker's gaze challenged by the state of the world. This gaze scrutinizes the human consequences, rather than veering into the demonstrative. This requires taking the time necessary to capture interiority and to allow us to perceive the pain without the sentimentality that would make it about us, while expunging alterity. For in the Other there is both communality and dissimilarity, an inalienable distance that ought to be respected, undoubtedly in the sense that Sartre meant when he said that the Other is a hole in the world.

5.2.2. Respecting Opacity

The opacity of the Other, who does not let him/herself be filmed, is essential. It is a right, an "opacity that cannot be defined, or commented upon," as Glissant wrote.[17] It is a determining criteria that shows whether the filmmaker respects the person being filmed, if he or she films them with dignity, respects the uniqueness in each individual, the distinction of each body, the singularity of experiences. Is a "confrontational" method appropriate? That was the debate sparked by *Nanga def*, the film that the Apt African Film Festival in France commissioned from the Senegalese filmmaker Moussa Touré, presented in 2005. Exchanges between the filmmaker and the seventh-grade vocational pupils began via the Internet. Then, once he was in Apt, and true to his approach, Touré showed up in front of these thirteen-year-olds in this so-called "drop-out" class with his little DV camera and goaded them: "What do you want to tell me?" He egged them on to discuss intimate subjects, notably their relationships with divorced parents, and suddenly these kids who rarely spoke about themselves opened up (3948).

It is not unusual for tongues to loosen in front of the camera: people stage themselves, sometimes saying more than they intended. But that is also the result of an unequal state of play between the person filming and the person being filmed. Does the person filming manipulate the person filmed to achieve a sensational effect, to ridicule the subject, to poke fun at or to win the support of a third party—the spectator—who is also the one who buys a ticket, the market? This question sparked a heated debate over whether this confrontational approach that "forces" interlocutors to speak—be they the Apt pupils or the polygamous wives in *5x5*—coerces or reveals them (4240). Some felt that Moussa ensnares his filmed subjects, and considered that, reduced to their status as co-wives, these women in *5x5* who avert their eyes and remain silent were forced, pursued, and reduced to a purely sexual approach to polygamy. This takes us back to the days when Godard reversed Luc Moullet's statement ("morality is a question of tracking shots"), turning it around to suggest that each cinematic gesture is what Rossellini called "the moral gaze": "the tracking shot is a matter of morals." For Moullet, morality was a matter of form, whereas for Godard, it is cinema that bears this moral. It is a significant difference: Godard was not enouncing a code of good conduct, but a desire to focus on the work itself, on the place that it leaves for the spectator, on the autonomy that it preserves for them.

Fettered in a polygamous situation ruled over by the husband, the women

in *5x5* are unable to reveal Senegalese women's characteristic self-assurance and exuberance in front of the camera. Similarly, the children in *Nanga def* cannot behave in a classroom as they would in a schoolyard. Are they limited by it? In their hesitation to speak out, in their awkwardness and silence, don't these women reveal the macho mechanisms? In their sparse, hesitant words, don't these kids send out distress signals concerning certain fathers' abandonment? The school teacher in Bakel, where *Nawaari*, the Senegalese version of *Nanga def*, was shot, only realized thanks to the film that some of his pupils' parents were divorced, with all the issues that can involve!

These films do not use the aestheticizing reframing or tracking shots that the "Young Turks" of the *Cahiers du Cinéma* denounced in the 1950s. They cannot be treated with the contempt that Rivette expressed for "the obscenity" of the tracking shot in Gillo Pontecorvo's *Kapo* (Italy, 1959).[18] On the contrary, they are magnified by their significant minimalism and a remarkable clarity in mise-en-scène. It is this simplicity in relation to the filmed subject that generates emotion. The mise-en-scène of places that are familiar to them, the framing that establishes a just distance are strategies so each can situate him/herself. With each person filmed, an intimate space is created; this is the condition perhaps not of free speech if it is unnatural, but of a mise-en-scène of one's own veiling. The kids in *Nanga def* show their bedrooms and their favorite objects. The women in *5 x 5* are encountered in the shelter of their rooms, one by one.

A danger is nonetheless perceptible in this period of Moussa Touré's work, namely, that of making a system out of this, or its becoming a facility. Street kids (*Poussières de ville/City Dust*, 2001), rape victims (*Nous sommes nombreuses/We Are Many*, 2003), polygamy (*5x5*, 2004): the subjects are catchy and controversial. Made alone, quickly, and on shoestring budgets, these films found an audience and were released in Senegal, on television, and in festivals. Yet each subject deserves its own aesthetic, its own original approach, and a time for silence before the time of making. Is the unique relationship between director and subject, in a frontal camera-subject relation, always appropriate? In 2006, Moussa Touré shot *Nosaltres*, using an institutional invitation to Catalonia to focus on the Malians who flit like shadows around the quaint little seaside town of San Feliu, thirty-five kilometers from Barcelona. An edifying café scene shows how much people rein in their words in front of others to absolve themselves of any racism or exclusion. It is here that Touré's approach is convincing: in his nerve in prodding people until the masks drop. Little by little, they reveal their prejudice, their close-mindedness, their ignorance

of the Other (where's Mali?), and their preconceptions, notably about religious difference. However, as he only had a short time there, Touré was limited to spur-of-the-moment declarations. The film lacks events, conflicts, drama. Subsequently, he was forced to make an exception himself. Getting the mayor to bring together the villagers and the Malians, he provoked an encounter that would never have taken place otherwise, and where things are said that would otherwise never have been said. In other words, he organized an otherwise impossible encounter. And to crown it all, rather than focusing on the lack of relation to get to its root, he asks them, voluntarily, to embrace! (4513).

A line is clearly crossed here. "You have to give a person the image that they want to give," Mahamat-Saleh Haroun said to film critic Michel Amarger at the Apt Film Festival. Letting the people one films be the actors of their reality means not taking them as the objects of curiosity. Avoiding the spectacular and focusing on the human implies a double contract: allowing the subject to be master of his or her image and words, and leaving the spectator free to adhere to or criticize the filmmaker's gaze. Putting people on display risks resulting in a negation of what they have to say and convey if the filmmaker has them at his or her mercy. But are the women in *5x5*'s unveiling only a pretense of reality? Their truth seems to me to be in their veil itself, in their awkwardness and silences, which are perhaps less caused by a provocative filmmaker than by their subtle way of negotiating the divide between patriarchy and their unaccomplished desires. It is this lack that is moving, and thus speaks and reveals the realities of polygamy, and ultimately deconstructs the highly codified discourse of their charming husband. "I needle, I look people in the eye, and that sometimes makes them uncomfortable," says Moussa Touré. His quest for frontality has him frame his subjects in the center of the shot. By asking the kids in *Nanga def* what they want to say to him, he opens a forum for exchange in which the intimate and its revelatory force for us all is at stake. The shoot in Apt was short, but in preparation, Touré asked the teacher to get the kids to write a personal presentation that already went in this direction. As for the women in *5x5*, Moussa, who is himself from a polygamous family, had known them since 1997. His familiarity with the women in the film opened the doors to the intimate during the shoot. "In Africa," he said, "you can ask anything, but you have to find the right way to ask." For Touré, the trick is getting straight to the point: "I don't beat about the bush, so no one feels uncomfortable. Polygamy is so deeply rooted that I tackle the question head-on to provoke a debate." And out of this particular case, he provokes society itself (3959).

Isn't that where the reflection on the morals of the image should lie? Not in rules about limits and what can be shown, or in definitive norms on how to film people—that would make the critic, as Jean-Michel Frodon puts it, a cop "with a whistle in his mouth and fine book in hand"[19]—but by respecting the singular approach of a filmmaker who proposes a relationship with the spectator, this relationship becoming the very object of criticism. In short, shouldn't one analyze the strategies of mise-en-scène that the filmmaker develops to stir an emotion to see if this emotion is an end unto itself, or, on the contrary, a way of engaging the spectator's ability to think autonomously?

5.2.3. Engaging the Spectator

The clash between two documentary filmmakers at the same 2005 Apt Festival—namely, Jean-Marie Teno (Cameroon) and Thierry Michel (Belgium)—over the *Making Of* of Michel's film *Congo River*, was, in this respect, exemplary. This filmic diary of the shoot focuses so much on the epic resolution of the film crew's problems on the Congo River that it finally comes over as just a performance. While *Congo River* focuses more, and to a better end, on the river people (4072), these at-times surreptitiously filmed images of the endless negotiations to obtain copiously stamped authorizations and to thwart the request for under-the-table bribes reinforce the image of a corrupt Africa, in an invasive, blanket portrayal that masks the diversity of practices. Moreover, the shots of the face of a raped child were the object of the clash on deontology and representation. Where is the distancing that allows us to clarify the context? Where is the symbolization that makes it possible to understand the real through an artistic filter, and not to have it thrust in our faces, without being able to react? Nothing is unrepresentable, but there is a legitimate question of necessity, which can only be resolved collectively. What does the community founded in the film spectacle take from this? There too, what is the meaning of the emotion shared? To cite Frodon's "L'Horizon éthique" again: "Nothing is 'unfilmable' in absolute terms, but every film, every sequence, every shot calls, and will continue to call on the judgment of every one of us with regard to the way in which it seeks to mobilize (catharsis) or immobilize (shock, gratification of urges)."

The ethic of the image, then, is to conceive of the relationship with the spectator as a form of sharing. There is no documentary truth, and it is through poetry that one best accesses this embracing understanding. The resulting emotion depends on the dignity left to the people, on the direct sound and restitution of

the interlocutors' words, on a camera that finds the right distance to be close to the bodies without violating their intimacy, on the freedom left to the spectator, and thus on abandoning an omniscient commentary. This is the very opposite of Michael Moore's cinema, which in both its montage and framing distributes the roles, fragments and organizes the testimonies into advocacy, designates the guilty parties, stages a spectacle of which Moore remains the conductor, a kind of wizard of truth. The increasingly frequent presence of directors in their films is symptomatic of a different undertaking—namely, the awareness that the documentary filmmaker cannot stay shut in his or her ivory tower, denouncing or demonstrating from on high, but needs to be right in the world, with whose contradictions the filmmaker is in touch. In the United States, on the contrary, one finds a whole host of visibly commissioned television documentaries, usually portraits, in which the commentary alternates with ever-moving interview extracts, or even archive photos. The accumulation of information and documents eliminates any doubt, and snatches of sentences from here and there are strung together to create a linear discourse that leaves the viewer no choice but to subscribe, the subject handled with an enveloping lyricism, reinforced by catchy music and a series of effects that cloak reality. The Other is only acceptable in such works if he or she resembles us; marginality itself is rarely addressed, unlike in documentaries that seek to embrace the people and things that societies prefer to reject.

5.2.4. Restoring the Human

The maturity of the late St. Clair Bourne's work is striking in an America where African American radicalism is often de rigueur in the light of a still-discriminatory society, and where the first documentaries presented one-dimensional heroes in an attempt to counter the criminal image attributed to black men.[20] When he made *Paul Robeson: Here I Stand* in 1999, he presented the famous actor and singer, who marked North American cultural life from the 1920s to 1970s, as a contradictory being who was ambiguous in his political positions—notably in his refusal to acknowledge the Soviet purges—and, like the eponymous character in *Ray*, by Taylor Hackford, prone to moments of weakness with all the Desdemonas in the world. He portrayed him as a human being, in other words (3801). Bourne's films bear the trace of an encounter, albeit with a deceased figure, without sliding into the decontextualized idealization immortalized by the Harcourt Studio photos of actors that used to line the corridors of the movie theaters.

The stake is to restore the human in all his or her weaknesses and complexities, and thus not to stop at a superficial sociology. It is only thus that documentaries escape Western viewers' eternal expectations of a real that they claim to already know, and give themselves the means to challenge deeply rooted clichés and prejudices in order to bring Africans back into the fold of humanity. Documentaries risk falling into sociology when their treatment of the singularity of the real fails to elicit an emotion that enables the spectator, who is distant from these realities, to resonate in unison or, on the contrary, to perceive an opacity to respect. The real can in itself be poignant, bracing, edifying, but if the film remains at the level of nonconflictual sociology, it shuts the Other in his or her difference. Bridges thus become impossible as the distance of exoticism sets in, and our own vision is never questioned as we simply watch the spectacle of the world, without being able to interact with it. A space is lacking in which a dialogue could be engaged through the workings of cinema, the spectator being called upon to enter the interstices, these questions that the uncertainties and unpredictability of life represent. When the real is slick and seamless, it fixes the Other in an improbable essentialism.

"Make sure your film mirrors our reality, wishes, and hopes," a fisherman said to Mohamed Zran when he was shooting *Le Chant du millénaire/Millennium Song* (Tunisia, 2002), "a hymn to words, in a country where we can no longer speak." Zran introduces his films by stating: "I need to film something that resembles me today, something that reconciles me with my country." In a mosaic of encounters, this song is a celebration of those who want to realize, undertake, or simply get by (2424). When he returned to his native town, Zarzis, in 2009 and made *Vivre ici/ Being Here*, it was to get to the heart of "the simple things," "just next door," to revisit "these extraordinary characters who fed my childhood, my imagination" (9289). Also a mosaic of encounters with those who still manage to dream, *Vivre ici* revolves around the store of Simon, an elderly Jewish grocer who people come to see as he knows the secret of plants. He is one of those who still knows how to listen, who have not lost a sense of generosity (9288). Here, the camera is at a human level, in all senses of the term.

5.2.5. A Shared Proximity

Proximity facilitates this exchange. It is at the same time a choice given the urgency of representing voices and giving visibility, at times an economic necessity, but also and above all the desire to better know and understand one's environment. As

Jacques Rancière wrote, for documentary, "the real is not an effect to be produced," as it is in fiction. "It is a fact to be understood."[21] This endogenous gaze is not an exclusivity, the property of an origin, but the effort both to go deeper and to counter the reductions and clichés, or equally obsolete customs. When this proximity is of the domain of the intimate, vistas that have as yet been little explored in African film open up. These films find their pertinence in bringing together the state of the world and the intimacy of a gaze, which Mamadou Sellou Diallo manages, for example, in *Le Collier et la perle/The Necklace and the Bead* (Senegal, 2009), a father's letter to the baby daughter who will soon be born. Witnessing the violence inflicted on women, backed up by newspaper clippings, he is afraid for her and wants to prepare her for this eventuality. How to eschew this deathly logic, other than by returning to the essential: childbirth, the mystery of life? To do so, he creates encounters. Filming the taut skin of his wife's stomach at the end of her pregnancy in extreme close-up, excluding for a long moment any wider shots to favor this proximity, he creates a direct interference; we indiscreetly observe the camera's caress. Our eyes, the stomach; nothing else is needed to capture the mystery, or to deplore abuse.

This violence is all the more present as it is off-screen, anachronistic, and scandalous. And the mystery is all the more present as his wife complains she is in pain, that childbirth is also a suffering. Sellou Diallo alternates his exchange with his wife, his gentle and attentive everyday words, with a meditative voice-over. The different forms of massage practiced on both mother and child after the birth, destined to restore or give their femininity, also participate in this poetic translation; through infinite feminine grace comes the tragedy of the female condition. The close-up shot of his wife's stretch marks and caesarian-section scar equally create a space of encounter, like an impressionist painting, in a purely optical relationship in which the light is as important as the subject (8862).

This first-person positioning defines a new cinematic function, in solidarity with other documentary filmmakers to have emerged in the 2000s, "in the sense of a profanation, a psychological and historical questioning of our place in the world," as Mamadou Sellou Diallo put it. Addressing the intimate, family relationships, rituals, etc., makes it possible to rethink the cultural upheavals that affect society. "This requires a transgression. It's not about criticizing for criticism's sake, but to make things advance and to wake people up" (8861). And that is urgent. Alassane Diago described his film as "indispensable." Adhering to the oppressive rhythm of waiting and uncertainty, *Les Larmes de l'émigration/Tears of Emigration* (Senegal, 2010) captures an incredible tension. Diago returns to his village to film his mother,

still waiting for a husband who left twenty-three years ago. In so doing, the twenty-four-year-old director testifies to his own angst around this absent father, in this attempt to put the pieces back together. He follows the repetition of daily gestures of washing, of praying to signify passing time, and confronts his mother, asking her memories in a magnificent shot as she sits eating her breakfast on a mat. The wind blows the cloth at the door; the mother flicks away the flies, and turns her head so we cannot see her tears as she recounts in sparse words how hard it was not to have been able to feed her children. These tears do not stymy Diago's radicalism: he wants to know, to hear, for us to hear; he wants his mother to say what made her resonate. And to get out the suitcase of things and photos of this man she cannot get over. It is heartbreaking. His film is indispensable as a personal therapy, of course, but also because the same thing risks happening to his sister, whose husband also left two years earlier, and who has not given any news or sent any money, even though their child was only one month old at the time (9671).

Through its coherence and its radicalism, this cinema constructs an awareness. It is rooted in an intimate relationship with beings and things. "Filming a landscape is a way of recounting it. It is my history. Through it, I express a deep relationship," Moroccan filmmaker Yasmine Kassari stated. "It's a being that lives in us, a light, a smell, a home, an origin" (3702). A documentary is "creative" when, contrary to the general formatting, it restores a singular voice. Putting these intimate words (notably about love and sexuality) into perspective in the motifs they paint on the walls of their homes confers an edifying visuality and a sovereign fecundity to Katy Lena Ndiaye's *En attendant les hommes/Waiting for Men* (Senegal, 2007) (7202). The director does not appear on the screen, but her questions are so present that it is as if she does. Not only does she reveal the transparency of her relationship with the women filmed, but also her way of positioning herself as an integral part of what she shoots. The film is shot in Mauritania, just as her earlier film *Traces* was shot in Burkina Faso. Her proximity with women of other cultures is also a way of asserting that she is there where she is not, both a stranger and at home everywhere, in an interrelation.

Proximity is thus not necessarily geographic or cultural, but a sharing of claiming voice. In 2011, an Italian documentary filmmaker thus made a film about the Egyptian revolution that constitutes a veritable archive for future generations. Stefano Savona's *Tahrir, Liberation Square* is neither a report nor a historical explanation; there is no commentary, no labeling of the images. It simply shares the demonstrators' courage in throwing themselves into those eighteen days of

improbable and uncertain chaos. Every person on this square showed this courage, fully aware of the danger. We encounter those bloody from the stones thrown by Mubarak's thugs, at times from rooftops. Savona introduces us to several people he became acquainted with and who agreed to be filmed. They are only emblematic of themselves, but represent the general determined mood. They are not heroes, but humans like you and me. When the camera follows a young woman from behind, who has picked up stones and hurries through the crowd to the heart of the confrontation before getting blocked and dropping them, we are in the fray with her, with the crowd. If this shot draws its spectacular power from the fact of being at the same time movement and depth, it is also because it combines both political and human force. The contrary of a propaganda film, its meaning only comes from itself; it does not mask a message, but simply testifies to the courageous gesture of a young woman who engages in the battle until she can go no further, to the point that she is immediately reproached for having dropped her stones midway. If this shot is in the film, it is because, just like the rest, it testifies to this logic of the moment that grips everyone in the square, this improvisation in the struggle, that also prepares the way for pain and blood, fatigue and tears, for the future is an unknown quantity. By filming the square through everyone's singularity and the uncertainty of the struggle, plus a keen visual and narrative sense, Savona goes well beyond the images of the crowds shown on television.

As in all his films, it is not only the struggle that interests Savona, but the words that constitute life and make it possible to seize not the goals, but the ins and out and the contradictions—a political discourse, in other words. This discourse of freedom, which connects the people, is an unstoppable flow. It founds and seals in each and everyone a change that knows no return. The slogans are just a small part, but their importance is not in their first-degree meaning. It is by shouting, "The people want the regime to fall" that this people is constituted as a people; words that are so new and wonderful that a mother teaches them to her child so that they are engraved in her mind as a possible future. Another woman shouts: "Here, the people are a wonderful spectacle!" It is thus through unitarian slogans that the people are present, the people who before were absent, as Deleuze put it.[22]

This "absent people" constitutes itself as a force, galvanized to affront the henchmen, and ends up shouting and jumping up and down: "Here come the Egyptians"—as if they had doubted. This people, no longer a crowd, keeps celebrating its unity in its diversity, this people who were so long divided to the point that they could not exist as a people: "One hand!" And this people speaks out, to the point of

sitting on the ground and taking notes: "who is going to represent us?," or to fear that the revolution ultimately will be confiscated if they leave the square (10372).

It is important at times to show the crowd as a unification of force, as a people in the making. That is what *Togo: Autopsie d'une succession/Togo: Autopsy of the Succession*, by Augustin Talakaena (2008), does in collaboration with the journalist Luc Abaki Koumeabalo. A commentary of archive images, it retraces the tragic events that followed Togolese President Eyadema's death on February 5, 2005, after being in power for thirty-eight years. By showing the huge demonstrations sparked by Eyadema's son's hijacking of power, it testifies to the extent of a phenomenon that could no longer be described as marginal. In a context of disinformation and the censorship of images, the general shot (or the sequence, panoramic, and tracking shots) shows a crowd that cannot be disputed. That was Hitchcock's advice to Sydney Bernstein, whom the British army put in charge of preparing shots of the liberation of the Bergen-Belsen concentration camp in the spring of 1945: to testify to the extent of the horror. The image of a demonstrating crowd is proof; that of assassinations would be less so, subjected to the natural credulity of the viewer, aware of possible manipulations (see the infamous Timisoara mass grave affair in Romania, meant to point the finger at the Ceausescu regime when these were in fact corpses that had been autopsied by an ordinary morgue). Knowledge does not reside in seeing, but in showing (8862).

5.2.6. Defying the Powers That Be

"Lack of funding forces us to make do with NGO funding for films about women, AIDS, etc.," noted the Mozambican director Sol de Carvalho (4510). Haitian director Rachèle Magloire echoed this: "We try to avoid commentary, but commissions impose it. It's the voice of the institution" (6820). Commentary, or how not to comment; the objectifying discourse imposed by television formatting implies that meaning does not transpire from the framing, depth-of-field, the succession of shots, the editing, and so forth—in other words, everything that constitutes a film's very essence. An explanatory voice-over adds notices to the images, intercut with interviews with specialists. In Haiti, one often has to pay the television channels to broadcast documentaries, in a perversion of a system where the NGOs are willing to pull out all the stops to spread their messages (6820). The situation is hardly better in Africa, where documentaries remain a rarity on television as soon as they leave the beaten track of patrimony or folklore.

In this desert, only a few renowned documentary filmmakers like Jean-Marie Teno or Samba Félix Ndiaye have managed to make their mark. From 2004 to 2005, the latter generously invested in the Forut Media Center in Dakar, offering year-long training courses. The initiative fell prey to internal conflicts, but not before training a number of television technicians and preparing the emergence of several documentary filmmakers who did break through. Also focusing its activities on Dakar, the French not-for-profit group Ardêche Images set up the Africadoc training program, which quickly established its reputation, creating a network of young documentary filmmakers in some twenty African countries, infusing a new impulse. This initiative started out from a double observation: the strong desire among young directors to artistically express their relation to their reality, and the political issue of representations that are too often mediated through other people's gazes. The digital revolution made this equation possible. Since the first contacts in 2001, courses have been set up, focusing on what Jean-Marie Barbe calls "the three links: accompanying the directors' writing process and learning of cinema; training producers, selecting them from the directors wishing to produce their own films, but also insisting on the fact that production is first and foremost an artistic endeavor; and then, with these producers and directors, constituting pairs who will go and pitch their films to African and international distributors and funders, so that these films get seen and distributed" (9970). Annual sessions in St. Louis, Senegal (where the university offers a master's in documentary filmmaking, in partnership with Grenoble University in France) comprising a *Tënk* (Wolof for "sum up your thoughts"), facilitate contacts with producers and distributors. Fifteen to twenty creative documentaries are thus made each year.

Concerns have been raised by those who see this as neocolonial intervention, formatting African minds and practices. The young directors' response to this is quite clear, asserting their maturity (9557). These accusations of formatting on the part of directors who were themselves trained in the West re-poses the question of transmission and the power of the elders who, Raoul Peck has claimed, have not carried out "this process of reflection, transmission, and self-critique" (9970). Beyond the reproaches that are easily countered by the diversity of the productions concerned, one issue does remain for Africadoc, however, which remains a training program: the level of accomplishment of their projects. While a few works stand out with brio, many others remain *works in progress*. Rather than too much intervention, the issue in fact appears to be a lack of follow-up and accompaniment. The choice of the producers involved to intervene as little as possible in the films' content,

and the multiplication of projects they try to handle do not facilitate the essential relationship between an individual creator and his or her producer, who is there not only to manage the financial constraints, but also to be the voice of a potential audience, and his or her own too, of course (10372).

A reactive producer is also ready to act in the event of a problem. If documentary cinema's major questions are to understand how we arrived at the state we are in and, consequently, how to give a damaged humanity back hope—in other words, how to turn fears into courage—the creative act will follow; it represents a real risk when the subject and its treatment clash with the powers that be. There are plenty of examples of threatened filmmakers, but also of considerable solidarity in trying to protect them. Documentary's stakes remain highly political: advancing democracy, developing resistance, backing hopes. As television represents documentary's principal market, everything depends on its degree of control. The Arab revolutions have changed a situation that until now allowed only didactic and politically correct products. Only works from the diaspora escaped the formatting imposed by this mode of distribution (3452 and 3460).

But in Western democracies now too, documentary is controlled by market forces. Even a cultural television channel like the Franco-German channel ARTE is subjected to an annual objective of a 3.5 percent share of audience ratings. Yet, the public is asserting its desire for "the real," to the extent that, since 2006, the French channels have all created thematic documentary slots. These force directors to work only within this framework, dealing with themes that are close to television audiences (the local, the day-to-day, and current affairs). "Societal" documentaries have thus gained in importance: 45 percent in 2009, compared to 26 percent in 2003, produced by press agencies or the subsidiaries of the major press groups. Remits are more and more constraining, demanding a narrative style that is efficient and to the point, close to journalism in style, with a voice-over explaining what is seen. We have thus gone from a logic of offer to a logic of demand.[23] Henceforth, standardization erases all subjectivity, which is lauded, however, in fiction film. Documentary disturbs as soon as it refuses to format information and encourages forms of resistance. In the media world, the battle between dominant representations of the world and a plurality of ways of reflecting upon it as offered by documentary is ruthless. It is indeed as a critical tool that documentary is fragilized and marginalized in niches. It is asked to verge into journalism or reporting, to treat facets of a "subject," to stick to the alibi news item. All that triumphs are films that wield the weapons of scandal and irony, without enabling spectators to politically construct their gaze.

These documentaries disturb no one, addressing an undifferentiated audience, alterity being erased in a gesture in which, notwithstanding, we are invited to recognize ourselves.

Documentary broadcasting is thus a measure of democracy, notably on state television. The banning of Jean-Pierre Lledo or Malek Bensmaïl's films in Algeria are emblematic in this respect, but in France too, a film by the latter was also taken off the schedule, namely, *Le Grand Jeu/The Big Game*, about the 2004 Algerian presidential campaign. The multiplication of satellite dishes makes a mockery of such censorship, even if it remains more acute in the press. Cameroonian Osvalde Lewat thus remarked: "Documentary allows me to adopt a real position, which was impossible in journalism." She added: "As a filmmaker, my approach is to make films in Africa, with Africans, so that they are aware that their destiny is in their hands" (7695). For documentary awakens the critical spirit and raises awareness. It is in documenting forms of courage that it reveals the richness of cultures and the complexity of the world. In *Cafichanta* (Tunisia, 1999), Hichem Ben Ammar revealed the extent to which popular expression in the entertainment cafés flouts good manners and taboos in a society that keeps itself on a tight rein (2573). The fishermen in the very beautiful *Raïs Labhar/Captain of the Seas* (2002) see the world before them and adhere to it in the complexity of the real, without denying its harshness or beauty (3459). And the boxers in *Choft Ennoujoum fil Quaïla/I've Seen a Star or Two* (2006) marked Tunisian history through their multicultural affirmation and their revolt against social injustice (4700). Ben Ammar manages to conjure this part of mystery and myth that is the very essence of major documentaries: in keeping with their dialectic of betraying norms and remaining faithful to values, he portrays the living memory of the enlightening paradoxes and rich transgressions that advance society, while at the same time respecting the ethics that structure it. "In documentary," he stated, "try as we might to adopt the mechanisms of reporting, with a pure concern for anthropological research, it is also the magic that we try to eke out. . . . The best moments, when the intensity of the interview combines with good camera work, are like nuggets, or as François Truffaut would have said, 'stolen kisses'" (4701).

5.2.7. A Discordant Spectacle

Scenes in which the person we are following onscreen returns to his or her family, and all the members act out the emotion of the reunion in front of the camera as

if it were not there, are always labored. Everyone pretends it is the first time, when everything has in fact been orchestrated in advance. Documentary mise-en-scène is awkward. Yet, many films use it as a way of transcending the limits of representing the real. And some do it well: for example, Sani Elhadj Magori in *Pour le meilleur et pour l'oignon!/For Better and for the Onion* (Niger, 2008). To better frame the narrative, he gets the people in the film to replay various situations. Is mise-en-scène permissible in documentary? These setups are surprising, because we always wonder how the characters can throw themselves into at times unflattering roles before the camera, like the abrasive farmer who criticizes his wife and workers so sharply that he could truly be a fictional character (8862). Put in their roles, the protagonists perform as if in real life!

These apparently fictional incursions are paradoxically the most documentary; they consist in capturing people in situ. These people oscillate between person and character, between reality and representation. We become party to, or arbitrators of this play in our quest for truth. This ambivalence introduces subjectivity, and hence human desire and depth. The screen no longer offers us "the truth" of the real, but a truth in the making, born out of an interference between the real and the film, which is at the heart of cinema. It is in this sense that these documentaries are "creative"; they testify to the desire for a related creativity, that of the filmmaker and filmed subjects combined—one creating a situation, and the other playing his or her role. No one is the same in front of a camera, just as, in real life, all new encounters change life. That is where presentation and representation are articulated. "I is another," said Rimbaud. The play is permanent. The art of documentary is not to have us believe in the real, but to reveal its scope, and thus to broaden time, not to separate the present from what came before and after the action. That is what Deleuze pointed out when he spoke about the goal of direct cinema being "not to achieve a real as it would exist independently of the image, but to achieve a before and an after as they coexist with the image, as they are inseparable from the image."[24]

These interferences between the real and fiction, and between objective and subjective, construct this relation to time that constitutes the pertinence of film. Hence the interest of a dramatic dimension, of a story in the documentary. Another incursion of fiction is thus suspense. The title *For Better and for the Onion!* evokes marriage, and indeed the film revolves around the farmer marrying off his son. The onion price determines his wealth, and thus his ability to organize the wedding that the future in-laws are ostensibly demanding. Ignoring the advice of the buyers,

he decides to wait for prices to rise before harvesting, but we watch as the price continues inexorably to fall. This narrative thread that combines the intimate and the economic adds remarkable force to the story, which meticulously respects the shooting schedule planned before the shoot. Indeed, Sani Elhadj Magori knew exactly what he wanted to film. He is an agronomist and grew up in this village of Galmi, famous throughout West Africa for its onions. It is by filming his family that he manages to obtain the characters' confidence. All the villagers who saw the film now want to be in his coming works, so faithfully does it reflect their experiences!

Similarly, *Koukan Kourcia: The Cry of the Turtle Dove*, which Sani Magori shot in 2010, plays on a dual suspense: finding his father and bringing him home. Here too, he recounts a personal story (his father's departure for Ivory Coast, and his ensuing absence) and a broader economic and political question (the historic exile of the Nigeriens). He has the wonderful idea of asking the celebrated singer Zabia Hussey, the turtle dove who encouraged young men to seek their fortunes elsewhere, to now sing a call to return. She has to be convinced, of course. And in the meantime, we discover a page of the country's history, and its current economic issues. All the elements are combined for the spectator to be gripped by the story, and to feel concerned too. As François Niney writes, "Unlike in fiction, where the world is in the frame, with documentary, the frame is in the world."[25] In this interaction with the world, the filmmaker's presence in a film, whether he or she appears physically or is only suggested, is in question. And it reflects the porosity between the filmed world and that in which one films and sometimes re-creates situations. This embraced continuity challenges objectivity, and thus paradoxically manipulation, the issue being to subtly make the filmmaker's presence visible in ways that create a dialogue with the spectator. The director is no longer just a witness, but an interlocutor, or even a therapist in his or her mirroring role.

Unlike fiction, documentary thrives on life's chance happenings. These are sometimes more spectacular than fiction. But whether one is in the right place at the right time or not, spectacle cannot be absent from documentary, at risk of making the film dull. Restoring the reality of the world risks losing the spectacle, whose absence generates boredom. Yet at the same time, the spectacular risks propelling the film into commercial artificiality. Some documentaries are thus packed with anecdotes, or veer into sensationalism. That is where the difference between documentary and fiction grows thin: both try to resolve the difficult equation linking the real to spectacle, in this famous adage of the viewer who is aware of the manipulation, but who still wants to believe in it: "I know, but all the

same." Cinema's stake remains, henceforth, to weave a subtle web between spectacle and criticism, the "discordant sounds" that Samba Félix Ndiaye evoked (7956).

5.3. An Awareness of Bodies

> Before filming, you need to take a human interest in the person, to drink water together, to eat bread, to share something. Then you can film that person.
>
> —Abderrahmane Sissako, in the film *Abderrahmane Sissako: Une fenêtre sur le monde*, by Charles Castella (France, 2010)

5.3.1. The Emergence of the Intimate

> There are two things to throw out of the house in the morning: the trash and the men.
>
> —Mauritanian proverb

The way was already being paved beforehand, but it was in the 2000s that the intimate became generalized; and nowadays, it is through this intimate gaze that African films articulate their critiques. Challenging patriarchy is nothing new. Ousmane Sembene said of his film *Faat Kiné* (Senegal, 1999), about a modern woman who has been left by her husband and who is raising her kids alone: "There is a certain freedom in the form in Africa, but deep down we aren't free; authority is the pants in people's heads. At night, it's worse than before. Men have to understand that women have the same rights!" (2629). From film to film, the image of menfolk is put through its paces as the symbol of a hypocritical society's virility. This is a constant in North African film. Nouri Bouzid challenged men right from his very first feature film, *L'Homme de cendres/Man of Ashes* (Tunisia, 1986), in the context of the end of the Bourguiba regime. In all his films, he portrays men who suffer, and repressed women. He penetrates the medina and roots himself in daily life to better revolt against the powers that mistreat the Arab individual, be they patriarchal, political, or religious. He claims the freedom of bodies and documents the youth's despair before the burden of authority and the excesses of religion. His protagonists are not heroes with a gift for collective contagion; the scars are deep and they affect the individual. Bouzid himself has said that he makes "a cinema of the defeat of bodies" (4387).

Daring the intimate in the Arab world is a strategy to counter the incomprehension that the rest of the world shows it. "It is important to show our intimate image, our individuality," the Lebanese filmmaker Danielle Arbid declared on receiving the top award at the Arab Film Biennial in 2004 for her film *Dans les champs de bataille/In the Battlefields* (3460). But it is also a strategy in sub-Saharan Africa, where patriarchy is fragilized, challenged in films by intrepid young women like the protagonists in *Les Saignantes/The Bloodettes* (Jean-Pierre Bekolo, Cameroon, 2005). "As an African," said Zeka Laplaine, "I know that I am part of a world subjected at all levels to the supremacy of the rich nations. I fight that, and as a result cannot accept man's supremacy over women" (2066). In *(Paris: xy)* (DRC, 2001), Max gradually surpasses his fears and becomes aware of his weaknesses. His wife forces him to go on the journey he was refusing to make: that of questioning his virility. An intimate account of the breaking up of a couple with children, this introspection braves uncertainty and improvisation, gaining in interiority and sincerity, the issue being man becoming responsible (2067).

Certain reversals are thus at work. "M'Hamed's quasi-effeminateness comes from my desire to invert the women being protected by the men that we find in so many other films, with a Tunisian woman who is not featureless, languorous, and submissive," Abellatif Ben Ammar said of *Le Chant de la Noria/Melody of the Waterwheel* (Tunisia, 2002) (2315). The power relations are reversed, and the men lose their splendor. In *La Fumée dans les yeux/Smoke in Your Eyes* (Cameroon, 1998), François Woukoache portrays the young African filmmaker Bwesi's desire for Malou, who comes to spend a weekend at his place. The camera plays on sensual close-ups of hands slicing onions and tomatoes, establishing a tension in the kitchen as the meal is made. But the same knife will keep Bwesi at a distance when he kisses Malou's neck. Later, racked with desire, Bwesi listens to his friend Vital's advice: "Force her!" It is, of course, not the right approach.

> "If you want what everybody has had, you can have it, but you won't have the frills that go with it!"
>
> "I'm sorry . . ."
>
> "Why? Tell me why you're sorry!"
>
> "I don't know. It's not what I wanted."
>
> "Yes it is."
>
> "No, it's not what I wanted."
>
> "Of course it is. You've got sex on the brain, right." (1738)

In *Fragments de vie/Fragments of Life* (Cameroon, 2000), Woukoache pursues his reflection on the consequences and violence of macho models, editing together a succession of flashes of shots conveyed by the media and comics.

The explosion of popular cinema in the digital era has opened the way to comedies of manners that focus on intimate relationships. In *Jealous Lovers* (Adim Williams, Nigeria, 2003), for example, Chioma (played by the immensely popular star Geneviève Nnaji) loves her fiancé Nonso, but he turns jealous and violent. Chioma's brothers intervene to get her to break up with him. She is then wooed by a rich industrialist, then a drug-addict rapper. One day, she discovers that her ex-fiancé was manipulated by one of his cousins, who, bad-talking Chioma, fanned Nonso's jealousy. While most Nigerian video films propose a highly conformist, if not to say stultifying social model, *Jealous Lovers* portrays man's brutality vis-à-vis strong-headed women who refuse to let men walk over them. In Chioma, we have the positive female model developed by the hit Adoras popular novel collection published by the Nouvelles Editions Ivoiriennes (NEI): a successful woman who lives her love life autonomously, acting as men's equal. But her success is only possible within an imaginary frame in which affection, sexuality, and economics represent romantic nirvana.

Their filmic adaptations offer luxury settings for idealized love stories. The main song in *Cache-cache l'amour/Hide and Seek with Love* (Didier Aufort and Siriki Baïkro, Ivory Coast, 2000), a turbulent, romantic story about a marriage of convenience that turns an Abidjan student's life upside down, hence states: "As soon as their eyes met, they knew they were trapped, come what may. Nothing could tear them apart," before concluding, "It's the joy of those who love." In *Le Pari de l'amour/Betting on Love* (Didier Aufort, Ivory Coast, 2002), Caroline is a hairdresser, wins a fortune in the lottery, is suddenly thrust into the world of winners, succumbs to the charms of a man who wants her money and cheats on her, will leave the man she was meant to marry, but painfully opens her eyes and goes back to her first love, who awaits her with open arms. With costumes designed by Alphadi, Claire Kane, and other famous fashion designers, actors and actresses who are each more beautiful than the next, champagne in every glass, and palaces all around the globe (Abidjan, Paris, Dakar), what happens to Caroline is the impossible come true: the enunciation of a perfect dream tarnished only by the trials and tribulations of love. The problem is simply not to let oneself by duped by a man, but also by one's own desires. *Le Pari de l'amour* thus embodies the contradictions of a modern-day griot: it is both an emancipatory initiation and an alienating tale of integration (3818).

Le Mec idéal/The Perfect Guy, by Owell Brown (Ivory Coast, 2011), achieves its success from the guaranteed laughter of an audience won over by the vitality and inventiveness of a jilted lover faced with the competition of his wealthy friend. What is great with Brown is that he does not look down on his characters. They are stereotyped, to be sure, but not stupid. The succession of vaudeville-like sketches full of misunderstandings has no other pretension than for the collusion of comedy to come off each time. Of course, the message is totally conventional (find the ideal man), apolitical (underlying reality is absent), misogynistic (only the women are fooled), and untruthful (love is the solution to all). But far from any realist sociology, or credibility, Estelle is a woman who determines her own life and does not necessarily choose the path of reason. Even if the form is purely audiovisual and never goes beyond pure efficiency, the film does set the record straight on social-climbing strategies.

5.3.2. Freeing the Body

I wanted the skin to speak!

—Zeka Laplaine, in "Je voulais que la peau parle!," interview, Olivier Barlet with Zeka Laplaine, about *Jardin de Papa*

"What prompted me to write and shoot my first feature film, *Un amour à Casablanca/Love in Casablanca*, was the impression that the characters in Moroccan films released until the mid-1980s were *grosso modo* asexual. They showed no amorous or sexual desire, and the bodies in them were used like simple vectors for the narrative," Abdelkader Lagtaâ stated in his article "Le corps est-il soluble dans la narration?" (3560). Sexualizing characters who do not renounce their desire and urges despite the confines of tradition, religion, taboo, and censorship became the stake not only of Lagtaâ's cinema (3242), but also of African film in the 2000s. And all the more so, as Senegalese Katy Lena Ndiaye put it, given "the profusion of both reductive and negative images of Africa," that led her to "use close-up shots, linger on faces, eyes, hands, feet, skin; to put the human at the heart of the film" (3075). "In *Le Collier et la perle*," said Senegalese Sellou Diallo, "I am in a highly intimate relationship with the strangeness I feel when I look at my pregnant wife's stomach, or the body of my mother that bears the traces of her life: her tattoo, her earrings, her wrinkles. When I film them, I can't help but get as close as possible. The camera enables me to caress them, to kiss them, to touch them in a way the cultural relation would not allow me to" (8861).

Homing in on the body is not just about the scale of the camera shots, but in the very undertaking of cinema. "What I'm interested in is focusing on what is on the outside, on the skin. I mean tactile relationships, smells, gestures, ruffles, collapses," Algerian Tariq Teguia stated (9014). Raja Amari beautifully captures this body language in *Les Secrets/Buried Secrets* (Tunisia, 2009): "The body pierces the highly coded language of film style," she stated (9015). The camera keeps up with the moving bodies, espouses the frantic rhythm of their gestures, as in Leïla Kilani's *Sur la planche/On the Edge* (Morocco, 2011), in which thirst for life is conveyed as much through the unbridled language as it is through the characters' acts. Workers by day, the young women in the film go looking for men and fun at night. By day, they survive; by night they thrive. This gripping film is shot on the go, as close as possible to these bodies that, to escape confinement, only want to live for the moment (10203).

In *Scheherazade, Tell Me a Story* (Egypt, 2009), Yousry Nasrallah wanted "to film bodies." "The stake was to make these characters, these actors exist, to give them something they could work with, other than the dialogues. To do so, very lengthy shots were needed, hence this highly constructed mise-en-scène. The shots are complicated because I needed to give them markers, to always give them something to do. One might imagine that this made their work more difficult, but in fact it facilitated their acting; they knew what to do with their hands, their bodies, and as a result, the film becomes embodied, I believe!" (9287). The stake is to film bodies without reifying them, as Abdellatif Kechiche manages. His cinema loves bodies; the tight montage espouses life's constant flow, and the actors are filmed in close-up, with such sensuality and empathy that they resonate with tension even in the most trivial scenes.

To free the body is to eroticize it. The fascination with, or revulsion towards the black body originates from projections about its so-called savage nature, without realizing that its gestures express resistance. But this engenders another relation to the body. In France, from the 1920s onwards, the music hall Bal Nègre and Josephine Baker's unclad routines at the Folies Bergères liberated Western women from their corsets. In the United States, black musicians and dancers have profoundly influenced shows right up until the present. In the eighteenth century, white artists in blackface imitated slave songs and dances in the minstrel shows. As Gilles Mouëllic writes, these were "an expression of the fear of the Other, of this disturbing alterity, a fear that expressed itself in contempt and caricature, and the great strength of black American culture was to turn this violence around by

reappropriating the minstrels" (2617). African influences have thus marked both dance and music, and well beyond the realm of jazz. African American dancer Bill Robinson developed the tap dance routines that both made Fred Astaire famous and helped musicals triumph over classical dance. As for Frank Sinatra, he always acknowledged the influence of Louis Armstrong.

5.3.3. Degeneration and Resistance of the Body

My final prayer:
O body, make of me a man who always questions!

—Frantz Fanon, *Black Skin, White Masks*

"I have never seen my body." Dunia's (her name means "the universe") confession, during an audition in which she is criticized for not feeling the text, could be that of many Arab women. Set in Egypt, Jocelyne Saab's *Dunia* (Lebanon, 2005) does not just denounce female genital mutilation (FGM) (a final insert informs us that Egypt has a 97 percent practice rate, Egypt and Sudan being the two Arab countries where FGM is still widely carried out), but contextualizes it in an Arab intellectual world that, out of conformity or fear, masks its own history and withdraws into taboos. *Dunia's* program is thus to evoke the *Arabian Nights* and Sufi love poetry, today sidelined as "pornographic," and the mysticism and sensuality of Oriental dance and music to fight against the ambient conservatism, raise awareness, and call on women to seek their own paths. Deliberately colorful, and even kitsch, the decor pays homage to Oriental artistic effervescence, while the proximity of bodies and the ambient sensuality reproduce it in the opening of the senses that it once encouraged (4345). In her documentary *Le Jardin parfumé/The Perfumed Garden* (Algeria, 2000), which takes the name of Cheikh Nefzaoui's thirteenth-century erotic manual, Yamina Benguigui already evoked the fact that from the ninth to sixteenth centuries, religious leaders were erotologists, who theorized love and sexuality. Her film is interspersed with testimonies concerning young people's sexuality, specialist viewpoints, sensual excerpts of Egyptian cinema, and touching scenes filmed in a Marseille steam bath.

Cinema hence expresses the voices of these denied bodies and gives them back their flesh. Hicham Lasri's *The End* (Morocco, 2011) testifies to the fall of the body. He sketches the broad strokes of the lanky young Miki's malaise, a generation seeking something in 1999, a pivotal period at the end of Hassan II's regime, a

period in which everyone felt fed up and stifled, and in which there was a sense that the lid was about to blow off. In other words, it is completely topical. Miki is in love with a black woman, who gets kidnapped by three unscrupulous brothers, and is at the service of a violent police captain brimming with tenderness for his handicapped wife. It is in these contradictions that the film unfolds, with no major plot other than establishing an adversity: Miki is antinomic to this world of power and robbery; he is a counterculture unto himself. Like Yacine in Alain Gomis's *Andalucia* (Senegal, 2007), he is a stranger to this world that he looks upon with no illusions. But although he is against it, he is not a marginal figure: he is inside it, but different. He is embedded. Lasri elongates his perspectives to the point of inverting the images to better destabilize reality and stylize the violence at play. The references to both cinema and reality are constant; the language is crude, and the fantasies are the driving force of a film that manages to create a universe that is both endearing and disturbing. *The End* portrays a decaying world in which people fleece each other unmercifully, and in which the existential affirmation of young people who want to live, love, and risk to the full can only take the form of hyperbole and delirium.

It is the body that poverty, racism, oppression, and patriarchy ravage first. The women in Moufida Tlatli's *La Saison des hommes/The Season of Men* (Tunisia, 2000) are caught between confinement in the enclosed places in which they wait, and their need for a man, for men who remain what they are. Her previous film, *Les Silences du Palais/The Silences of the Palace*, had already made a considerable impact in 1994, drawing over 200,000 viewers in France. This second film, guided by the doubts and questions of the filmmaker's own daughter turned adolescent, developed this autobiographical reflection (1660). All of Raoul Peck's films capture this violence inflicted on bodies in great simplicity, notably *Corps plongés/It's Not about Love* (Haiti, 1998). "To let oneself dive into the moment and feel the full brunt of its force, all the violence, like a body plunged in a liquid," the medical examiner Chase writes in his diary. *It's Not about Love* conjures a thriller atmosphere with absolute precision, superposing on the detective realm of murders, inquiries, and politico-financial influences a second level of narrative, on the order of an immersion: Chase's headiness before the omnipresent death, his weariness before the blackmail and corruption, his disgust for the violence suffered by the underprivileged, and notably the black population (0550).

Why shoot a thriller in Kinshasa if not to testify to this degeneration of the body? Djo Tunda wa Munga's *Viva Riva!* (DRC, 2011) descends into a world of truants and

corrupt police, where everything can be paid for, including sentiments. Before the tragic, Riva has no other choice if he is to exist than to charge ahead, sacrificing his body on the altar of the big city. For it is indeed his body that is at stake and that is the crux of this film: this pursued body, torn asunder, tortured in the play of forces that quickly overtake his too-down-to-earth dreams. If he tries to escape norms, it is those of the crooks' pitiless laws, which have become society's too. His attempt is destined to fail because he adopts the same arms as his enemies, and he too is only chasing after money. A body tossed about by futile battles, there is no hope for Riva, or the other protagonists, or even the country if it follows the same path (10467). The colonial body was already a category apart, subjected over and over again. Once decolonized, these bodies have remained determined by this uncertainty of constantly experiencing danger, be it internal or external. They have no other alternative than to escape the established norms and rules and to embrace their instability, reconstructing themselves by dint of their imaginations to dream and to hope. It is the confounding grandeur of a culture in which, like the fresco motifs that the women paint in Katy Lena Ndiaye's *En attendant les hommes/Waiting for Men* (Senegal, 2007), the essential is expressed through art.

As it documents the chaos of the world, documentary cinema makes the bitter observation of loss, not so that we feel desperate, but to encourage us to build on the unpredictability of our own future. The awareness of loss henceforth engenders another relationship to the world, which restores the awareness of death that sensational or report images constantly deny. When in *D'une rive à l'autre/From One Riverbank to the Other* (Congo, 2009), Delphe Kifouani films the handicapped people's incessant toing and froing between the opposite banks of the Congo River, where Brazzaville and Kinshasa sit across from one another, a symphony of experiences imposes itself, a determined resourcefulness in which both determination and inventiveness and vitality weave possibilities. By filming them in a way that avoids wretchedness, showing their life force and their spiritual force, Kifouani eschews all sense of hopelessness. His encounter with Staff Benda Bilili, the now famous band of handicapped musicians, confirms this. He could have, like Abdallah Badis in *Le Chemin noir/The Black Path* (Algeria, 2009), used the power of Archie Shepp's sax and husky voice, they so resonate with this transcendence of the degeneration of the body. The bodies in *The Black Path* are those of Algerian steelworkers, a sector the filmmaker himself comes from, those of retirees who watch the rest of their lives pass by, wondering where they will be buried. The contact point is the repairing of a Peugeot 404 car, which lends the film its coherence. For memory is a long gesture

of repair, whereas the relation between France and Algeria remains very broken. His film has the openness of improvised jazz: his poetic approach invites us to let go of the blockages of the past, so that the consciousness of loss and death put life back into perspective (9671).

5.3.4. Representing Homosexuality

In sub-Saharan Africa, homosexuality is the ultimate taboo. The patriarchal system castigates homosexuality as a perversion, an affliction, the result of witchcraft, or a Western import. Homosexuality is illegal in many African countries. Repression is fierce, and leaders vilify it in their speeches (8630). Films that introduce homosexual characters to caricature or to mock them deserve nothing more than our contempt. Critical vigilance is necessary, as this rejection of the Other takes the lowest accoutrements of racism and conditions the public to accept or perpetrate violence. Films that dare to address the theme of homosexuality, on the other hand, are incredibly rare. Guinean Mohamed Camara, who had already tackled the question of incest in *Denko* (1992), followed by child abuse and suicide in *Minka* (1994), tackled the subject head-on in *Dakan* in 1997, depicting a love scene between two young men in Conakry. The Guinean government withdrew its funding when it got wind of the content, and the shoot was disrupted by demonstrators. However, in his attempt to reveal the subject, Camara immediately covers it back up. In order "to introduce a delicate subject simply and discreetly" (1735), he strips his characters to the bare minimum to the point of disembodying them, and ultimately desexualizing them (0841). Contrasting with *Dakan* is *Woubi chéri*, the documentary by Philip Brooks and Laurent Bocahut (France, 1998), in which Ivorian homosexuals and transgender people are totally alive, resonating as human beings, not as mythological heroes. Anne Lescot and Laurence Magloire similarly focused on Haitian homosexuals and transgender individuals, known as *masisis*, in *Des hommes et des dieux/Men and Gods* (2002), testifying to their vitality. In voodoo, they find a space of freedom and expression where their sexual orientation does not prevent them from finding protection and comfort. "That's not to the liking of those who like to consider voodoo as something pure," Anne Lescot specified, to the point that the film, which was screened before thousands of people on the Champ de Mars square in Port-au-Prince, provoked great controversy in the press. Deliberately situating itself from the transgender individuals' point of view, the film respects them and emphasizes their humanity (6820).

When Jo Gaye Ramaka released *Karmen Geï* (Senegal, 2001) in Dakar, he too faced fierce opposition. Criticism focused on his use of a sung sura, written by Ahmadou Bamba, founder of the Mouride brotherhood, to accompany the female prison director's corpse being carried out of the prison. The film was confiscated after the violent attacks, because the prison director is Christian, but above all because the film portrays her amorous relationship with Karmen (0271).

There is only one country in sub-Saharan Africa where homosexuality is tolerated, to the point even that its constitution is the first in the world to stipulate that no one be discriminated against for their sexual orientation, in the same way that they not be discriminated against for the color of their skin: South Africa. *Simon and I* (South Africa, 2004), by Beverley Palesa Ditsie and Nickie Newman, focuses on the gay and lesbian movement Glow, founded by Simon and his friends, which regularly hit the South African headlines a good decade before obtaining the decriminalization of homosexuality. Today still, it is not easy to declare one's homosexuality in Soweto, but the South African homosexual movement has managed to impose its Gay Pride, like that of the United States, Europe, or Mauritius. It is part of the public debate. Homosexual marriage has been authorized since 2006, and a gay and lesbian film festival takes place each year in Cape Town and Johannesburg. Consequently, from South Africa, and only South Africa, films that openly take the question of homosexuality as a theme have emerged in recent years, such as *Skoonheid* (Oliver Hermanus, 2011), or earlier, *The World Unseen* (Shamim Sarif, 2007), and *Proteus* (John Greyson, 2003).

Homosexuality poses a problem in North Africa, as it does across the rest of the continent. In 1998, Abdelkader Lagtaâ was told by the Moroccan censors to cut the extremely coy scenes that evoked one of the character's homosexuality too clearly from his film *La Porte close/The Closed Door* (3560). But a difference originates from the Western fantasy that sees a feminized being, a potential homosexual in every Arab male. As Julien Gaertner demonstrates, this archetype originated in colonial cinema, which itself drew on medieval imagination, emasculating the North African warrior and turning him into a sly and cowardly *fellagha*, while symbolizing the land as a woman to be conquered. In the 1990s, French cinema multiplied iconic young homosexual characters of North African heritage, culminating with the huge 2003 hit *Chouchou* (Merzak Allouache, Algeria), which drew four million viewers.[26] Throughout his lines, Chouchou insists heavily on his North African origins, and this reference repositions the subject: the transgender is an undocumented immigrant, and his sexual difference humanizes his cultural difference. He stands out from the

crowd. Chouchou is an individual, a case, with an agenda like the slogan on the film's poster: "Meet him and you'll love him!" (2825).

As a result, he is quickly confined to this both culturally and sexually deviant difference. This Western sexual projection is part of the same logic of dual rejection and attraction that characterizes the relation to the African immigrant, positioning him or her as a being apart, unable to adapt to the host society. The films that directly address homosexuality do so with great care not to culturally anchor their stories in North African connotations, while at the same time not denying their roots. It is because Amal Bedjaoui's *Un fils/A Son* (Algeria, 2003) is free of the habitual references in the music or interiors that it becomes a meditation on man and becomes universal. As a result, North African identity opens up. Selim prostitutes himself to gather the necessary sum for an operation that will save his father, but the father shuts himself off in his rejection of the son. This highly intimate and physical cinema allows a profound questioning of the consequences of the father's inability to communicate (3433). Malik's sexual, affective, and cultural disconnection, which manifests itself on his return to Tunisia, is the subject of *Le Fil/The String* (Mehdi Ben Attia, 2007). As Patricia Caillé points out, considering that it was impossible to screen the film in North Africa, it is ultimately destined for Western audiences, and thus remains caught in the ambivalence of the gaze in the postcolonial context (9467).

Diaspora North African filmmakers address the question of homosexuality obliquely, not head-on, in films that they hope will cross the Mediterranean. Jean Sénac's homosexuality does not feature as a subject in Abdelkrim Bahloul's *Le Soleil assassiné/The Assassinated Sun* (Algeria, 2004); he evokes it from a distance, simply signaling it as a part of his character's richness, his way of living his homosexuality while reinforcing his dignity. One can imagine what a Chéreau or a Pasolini would have done with the film, reestablishing the corporeality that this distance takes from him (3069). The same restraint is visible in Ismaël Ferroukhi's *Les Hommes libres/ Free Men* (Morocco, 2011), which traces the young Younès's growing implication in the Resistance during the Occupation and his contribution to saving Jewish families of North African origin, with the backing of the rector of the Paris mosque. His friendship with the gay Jewish singer Salim Halali remains ambivalent. It nonetheless introduces a rich uncertainty. By articulating the reference to a reductive archetype, Ferroukhi escapes the overly cautious agenda of an edifying historical reconstruction to situate his film in the contradictions of the clichés that remain even today (10427).

5.4. Female Silence

I hear the din of this female silence, I sense the rumbling of their squall, I feel the fury of their revolt.

—Thomas Sankara, in the film *Poussière de femmes*, by Lucie Thierry (France, 2007)

5.4.1. Challenging Misogyny

Is woman, with her powers of seduction, the devil's accomplice? The monotheistic religions blame her for man's fall. Eve gives Adam the apple. By designating woman as the dangerous sex, the male imagination legitimates her social subordination. Sexism shares the same structures as racism, inducing a complex and a despising of women and their very bodies. If there is an issue to have emerged in the 2000s, it is well and truly deconstructing the reminiscences of the hatred of women and their bodies: "Ni Putes Ni Soumises" ("Neither Whores nor Submissive"), to borrow the name chosen by the French women's movement for secularism, equality, and mixedness. Colonial stereotypes indeed still govern male fantasies. Colonial postcards, then cinema, forged a submissive, passive, and lascivious image of the African woman, to which has been added the myth of the young women from the *banlieues*' rampant sexuality. It is racism we are looking at here. In *The Second Sex*, Simone de Beauvoir insisted on the profound analogies between the condition of women and black people.

Ignoring feminist advances, misogyny has slipped back in through the door of gangster rap and the so-called ghetto films of the 1990s. John Singleton developed the same conservative misogyny in *Baby Boy* in 2001 as in *Boyz 'n the Hood* in 1990 (2834). In France, "banlieue films" do not escape this ambiguity. In *La Squale* (Fabrice Génestal, 2000), Désirée, a young black woman, rebels against everything and everyone: her mother, school, the other youth, which does not stop her from wanting to seduce the local gang leader. But to avenge his cruelty, she whips up the men's hatred for one another, until the fatal outcome. Revenge is again shown as a female thing! (1704). The same strategy is found in *Black* (Pierre Maraval, 2001), an urban Western in Cuba, where the female character uses her charms to take revenge on men (2822). The message is repeated in the short film *Jesus and the Giant*, by Akin Omotoso (Nigeria/South Africa, 2008), filmed with a digital photo camera, in which the woman reverses the violence she suffers as the only means of taking control and fighting injustice (8348). A paltry program at odds with Maryse Condé's

blend of openness and firmness, when she says: "Our past is marked by slavery and colonization, which root us in reality differently. We perhaps contribute values of tolerance that other women do not necessarily have to show. We also, even if it's contradictory, have a sort of aggressiveness that isn't a rejection of others, but a way of asserting that we are different. Tolerance and aggressiveness, that more or less sums up black women."[27]

"The female body has to be conquered, vanquished, annihilated. It can only exist in maternity," we hear in *Contes cruels de la guerre/Cruel War Tales* by Ibéa Atondi and Karim Miské (Congo/Mauritania, 2006). Violence and rape are entwined. In exceptional circumstances, man can be bestial, as the shots of preying insects suggest in the film. The warriors today raise the children of the women they raped (2738). In war, the violence inflicted on women is extreme, as Osvalde Lewat's *Un amour pendant la guerre/A Love during the War* (Cameroon, 2005) testifies, asking how it is possible to reconstruct oneself after such trauma. In this unending war in the east of ex-Zaire, the women are the main victims. The Center Against Sexual Violence has identified nine thousand cases of rape, and often mutilation (3954). And what to say of the Rwandan women? In cinematic representations of the *Itsembabwoko*, and even though many women also participated in the genocide or occupied positions of responsibility, "Rwandan women's expression of the trauma becomes an essential key for entering the complexity of the genocide," writes François-Xavier Destors.[28] Rape was systematically used there as a weapon to isolate, humiliate, and destroy Tutsi women. The UN estimates that 250,000 women were raped. At the end of Robert Favreau's *Un dimanche à Kigali/A Sunday in Kigali* (Canada, 2006), Gentille asks her husband to kill her. Brutally raped and tortured, disfigured and infected with AIDS, she can no longer be a woman (5897).

But how to portray rape in film? Realism would turn the spectator into a voyeur. The moving image does not have the distance of a visual artwork, such as the bloodied vaginas painted by Congolese artist Bill Kouélany in 1997 in memory of the forgotten victims of the civil war. And yet, the evocation of these victims was censored.[29] When Willie Owusu made rape the subject of his short film *Extracts of Me* (Kenya, 2007), in which a woman recounts her rape by two men, she perfectly controls the image and narration to shock the viewer, in an attempt to deconstruct the desire to rape (7003). But by aestheticizing and multiplying the camera angles, she undermines what she sets out to achieve, rather than developing a metaphor, as Sokhna Amar admirably did in *Pourquoi?/Why?* (Senegal, 2004), an eight-minute fixed shot of a boat battling the waves as it sets out to sea at sunset. Offscreen, a

woman writes to her sister to tell her the secret she has painfully been carrying for ten years. "Women are like the sea, and it is up to men to know how to navigate to bring their boats to shore," an inset concludes at the end of the film, calling on the spectator to reflect on what they have just heard. But for the duration of the film, while this fisherman maneuvers so well to get past the rolling sea, which, in all cultures, suggests sensuality, the choice of a fixed shot engages the spectator on two levels: the metaphysical apprehension of the message and concentration on the narrative, which the voice-over recounts in highly personal terms (3958).

Women are expected to sleep their way up. That is the destiny of the young women who, to pass their exams, have to agree to sex with their teacher in *O Jardim do outro homem/Another Man's Garden*, by Sol de Carvalho (Mozambique, 2006), which tells the story of Sofia, "a gazelle the lions want to eat, but who remains resistant" (4511 and interview 4510). An educational film, it was backed by the Ministry of Education and was seen by 500,000 pupils. In *Riches* (2001), Zimbabwean Ingrid Sinclair adapts South African writer Bessie Head's story in which, in a painful echo of the apartheid regime she has just fled, a woman teacher finds herself in a school dominated by a head teacher who abuses the female staff (2691). The film was one of six in the *Mama Africa* series on women's conditions. We tend to reduce the word to a simple chronicle of reality; "condition" comes from the Latin *condere*: to found. Cinema needs to be founding. It is in this sense that, in literature, Malraux wrote *The Human Condition*. In *La Condition ouvrière* (*The Condition of the Working Woman*), Simone Weil distinguishes between the submission of the body and lack of submission of the possible. In *The Human Condition*, Hannah Arendt posits humans as unconditioned beings: the finiteness of this condition does not stop humans from achieving an unlimited dimension. That is unquestionably the stake for a cinema that claims to be feminist: to move away from a necessarily realist vision of the female condition in order, through imaginary stories and artistic visions of the possible, to tease out the utopia of a new equilibrium between the masculine and feminine in society. That would free us of the hypocritical opposition cried to the four winds—of the "women are the future of men," or "if women ran the world, everything would be just fine" type—when we witness that women running states do so the same as men. This kind of discourse is founded on a hard-to-pin-down essentialist, naturalist, age-old vision, given that belonging to a sex does not determine a type. The issue is not to replace one with the other, or to confuse genders, or to no longer be able to distinguish them, but to find a balance between both within us all, and subsequently in society at large (3561).

Ending the hypocrisy: that's quite a program! That is what Anne-Elisabeth Ngo Minka attempts in *Le Prix du sang/The Price of Blood* (Senegal, 2010). Her implication is total: sitting cross-legged on the bed, she looks us straight in the eye. Her voice-over denounces the vanity of a man to whom she gave her virginity and who rejects her because she does not bleed. This infamous issue of bleeding the first time is the starting point of a reflection on confidence that culminates in the film being dedicated at the end "to all women, who have nothing to prove"![30] The interviews randomly carried out on the street are instructive: most men are wary of a woman who is not a virgin out of fear that she will continue to play around. The question of their own faithfulness is never posed, even though both the imam and the priest pose it point-blank, recalling that both spouses are meant to be chaste at marriage. A doctor is called upon to explain why breaking the hymen does not always cause bleeding. These "specialists" thus challenge commonly held preconceptions, and the film, by combining this double airing of an institutional and a public voice, is compelling. Made at the end of a documentary training course at the Gaston Berger University in St. Louis, Senegal, it is a perfect example of the way in which, with highly limited means, filmmakers who work with their heartfelt convictions can intervene in the real in their immediate environment (9671).

With his final film, *Moolaade* (Senegal, 2003), master filmmaker Sembene delivered an epic lesson on the hypocrisy of the obsolete practice of FGM carried out on young girls. If the girls take refuge in Colle Ardo's compound, it is because they know that she chose not to have her own daughter, Amsatou, cut, from which she draws the strength to oppose the men's verdict. Colle Ardo takes a red and yellow rope and bars the entrance to her home. The symbol is laid down, and although it could easily be crossed, everyone respects it. But her husband, the village elders, and the traditional cutters unite to try to get her to pronounce the word that undoes the protection. To get her to give in, they first try persuasion, then give her a flogging in a memorable but chilling scene that brings the tension to its climax. It has to be seen: Colle Ardo takes the blows, encouraged by all the women who urge her not to relent ("Resist, don't say it!"), while her husband whips her harder and harder, shouting "Say it!," egged on by the elders' "Break her!" and the cutters' "Show her! "Wassa!" ("we've won") the women chant on their victory against the "little girl killers." While the film seems to be saying that FGM is above all to be condemned for the accidents it causes, it is indeed its barbarity and mutilation that Sembene evokes. The question of female pleasure is not mentioned, but Sembene's alternation of the cutting scene and Colle Ardo's husband's roughness

when he makes love to her speaks for itself. It is the same female blood that flows (3423). Sembene does not set his discourse in the more contemporary context of the women's groups that are fighting everywhere, as seen in Fabiola Maldonado's *Maïmouna, la vie devant moi/Maimouna, My Life Ahead* (Honduras, 2007), which follows a Burkinabè activist who carries out awareness campaigns from village to village (6846). Sembene prefers an emblematic situation. He makes the filmic choice of addressing the collective through the destiny of an individual to whom he pays constant homage through the gentleness of his framing and the attention he pays to her face and gestures. Wielding the force of speech like a razor blade, without ever letting it replace the action, allowing each character to maintain the profundity of their contradictions—and thus avoiding stereotypes—guiding his actors with an iron rod, multiplying the flashbacks to pose the argument of the film better, Sembene neglects nothing that encourages our adhesion. When Ibrahima, the chief's son, says to his father in conclusion, "The time of kinglets is over," we understand that it is on the terrain of power that Sembene positions himself, his female characters opposing not all men, but those who follow the elders and the cutters who benefit from the established order.[31]

5.4.2. Reintroducing Complexity

The risk with this type of flag-waving, optimistic cinema is, we have seen, preaching only to the converted, or reducing the debate to the overly simplistic schema of emancipating oppressed women. By adopting a female point of view and wielding ferocious humor, Jean Odoutan reverses the representations in *La Valse des gros derrières/The Waltz of the Big Behinds* (Benin, 2002). Akwélé is anything but servile, which Rod encourages: "I don't want the woman who shares my bed to be my cleaning lady!" But, frustrated at seeing her resist whenever she feels like it, Rod—played by Odoutan himself—starts being the wily macho, harassing her and giving her the opportunity to air her voice. And we root for Akwélé and her friend Assiba, who send packing everything that reduces them, from demeaning and thankless jobs to "the useless guys who take us for trash," and finally assert themselves, in all their beauty: "You are grace incarnate; you just have to love yourself as God created you, nothing more, basta!" (3442).

Another highly different approach to exploring the complexities are the amorous meanders of Joseph Gaye Ramaka's *Karmen Geï* (Senegal, 2001). This enigmatic femme fatale struggles to find the love she is looking for. Desire is

represented, evoked by all the visual signs and sounds, a desire that converges on this "strange woman," to use the expression of one of her suitors. "No more than the other women," retorts Karmen, "only they don't show it so as to not make waves." Karmen, on the other hand, does show and assert it, subversive in both her smuggling activities and her corporal expression (2442). Playing on desire in this way eschews the social and psychological realism that is de rigeur when it comes to female victims of oppressive patriarchal societies caught in their lack of affection and internalized violence. "There is a tendency to encourage North African, and African films in general, towards this social representation that freezes the filmmakers' work and blocks them in their artistic undertakings," Tunisian filmmaker Raja Amari claimed (9015). In her films, the oppression comes from the characters themselves, and it is desire that drives emancipation. By giving us the time to share Lilia's fascination with transgression in *Satin rouge/Red Satin* (2000), Amari breaks away from the oft-evoked initiatory journey of determination versus alienation. This widow, whose body demands to dance, to express itself, but which everything stops from doing so, is finally drawn into the cabaret, where she is taken on as a dancer. At her daughter's wedding at the end of the film, it is no longer for men that she dances, but for herself, for all the women (2296). In 2009, with *Les Secrets/Buried Secrets*, Raja Amari entered the realm of the fairy tale, re-creating *Cinderella* in a strange chateau whose complex layout echoes the social contingencies between downstairs, where the recluse lower-class women live secreted away, and upstairs, where high society parades. Aïcha's quest for femininity must take the paths of desire to understand the terrible buried secrets and to free herself from the maternal clutches (8975).

5.4.3. Underground Female Resistance

When the Zimbabwean dancer Nora Chipaumire returns to the places of her childhood memories in *Nora Chipaumire: A Physical Biography*, by Alla Kovgan and David Hinton (USA/Russia, 2008), she dances her desire for emancipation and the conflicts that that has provoked. The result is stunning. There is a distance that restores complexity, while at the same time introducing humor and poetry. Like Lilia in *Satin Rouge*, Nora dances her resistance. This celebration participates in an emancipation, which begins by its own representation. There are now legions of films by and about women, but as Christine Eyene writes, "recognition of the marginalization of African women within the globality of the art world is neither

a hallucination, nor a heresy."[32] Appropriating the camera remains a combat for women. "Women are great managers, but no banker trusts them!" Ivorian actress and playwright Naky Sy Savané remarked. Yet, "we never hear of women embezzling the funds!" (3591).

In this combat, the first reflex is introspection. "I want to tell you what I couldn't express years ago. I was scared, and you didn't see that fear," says Fatima Jebli Ouazzani at the start of *Dans la maison de mon père/In My Father's House* (Morocco, 1998). Having left home before her father could force a husband on her, the director sends a filmed letter to her father, a way of exploring her choice and an introspection on the places of her childhood (1504). The first combat is to explore the complexity of one's own psyche, confronted with male fantasies, as Fabienne and Véronique Kanor do in *La Noiraude/The Darky* (Martinique, 2004). Everything intertwines and blends: the web of prejudices according to which white men see black women as African statues, the trauma experienced by parents who immigrated to France only to find rejection and racism, the need to be a warrior, and deception before the "wolfish," underhand behavior of men (3688).

Introspection does not mean painting a non-challenging portrait of women who, faced with the burden of their frustrations, free themselves from norms; it means, rather, playing on the subtleties. In Yasmine Kassari's *L'Enfant endormi/ The Sleeping Child* (Morocco, 2004), Zeinab decides, in conformity with Islamic tradition, to put her fetus to sleep and await the return of her emigré husband. When she finally wakes it, in spite of this male absence, the film tells us that there is no return from this return to life. By deciding to give birth or not to her child, Zeinab invites all women to a new world based on self-awareness (3691). Her friend Halima, who revolts openly, is less fortunate. She disappears from the screen once her so-called fault is punished. Her impossible revolt has no future. She withdraws off-screen. Such is the destiny reserved for women who frontally oppose the still terribly repressive patriarchy.

One scene in Rachida Krim's *Sous les pieds des femmes/Under Women's Feet* (Algeria, 1997) is most enlightening: Amin recites the Qur'an and admits to Aya that he cannot read Arabic. Aya is this woman who, in 1956, engages wholeheartedly in the FLN (National Liberation Front) in France, collecting funds, carrying arms, and going as far, even, as killing, despite having been married at sixteen to a man she did not know, despite expecting nothing from love and being destined to bear children. But the love that, in the struggle, binds her to her husband Amin is strong enough to move mountains. Aya understands, however, that Amin is full of ambiguities,

torn between tradition and modernity; that he will not live "his" revolution as she manages to; that he will ultimately return to the system's fold and accept the Family Code. She will not follow him back to Algeria, raising her children in France instead, encouraging them to assimilate both cultures. It is a broken Amin who returns, looking for the 1956 Aya in 1996, and draws the strength to fight again. "We all have our share of responsibility," she tells him. "You for having said nothing, and me for having fled" (0216).

We did not listen to the women. That is what René Vautier confided to me in 1998 when we discussed Algeria's decade of civil war. "There are many things that I didn't recount in time, for example these stories of Algerian women that I have to write now because I didn't shoot them in time. I think they are necessary to understand Algeria. The documents I shot were the only ones of the Algerian underground. They show female nurses who were taken to the border, officially to improve their training. But I know that young ALN [National Liberation Army] officers were brought and told to choose and marry them, without asking the women's opinion. That was how women were conceived of, even in the ranks of the Algerian revolutionary forces, a sure way of keeping women in a well-guarded role. We failed to show the dangers that this involved for the country's evolution. I failed to transmit these stories that the women confided in me, no doubt because I was different, a foreigner. People told me it wasn't the right moment, and I believed so too. But I realize now that I should have and that it's too late" (0501).

Similarly, in 1970, Guadeloupean director Sarah Maldoror spent three months on the Bissau-Guinean Bissagos Islands shooting *Des fusils pour Banta/Guns for Banta*, a film that the Algerian National Trade and Film Office commissioned to document the PAIGC (African Party for the Independence of Guinea and Cape Verde) struggle against the colonial authorities, for independence. Following fighters from one village, her film focused on Awa, a young woman who joins the Party. In the film, we see women carrying arms and even bombs, but also their domestic chores. On Maldoror's return, and on completion of the first cut—which, it was deemed, gave too much importance to the women in the guerrilla movement—the army deported Maldoror from Algeria and confiscated her reels of film. The footage has never been recovered. An exhibition in London by Guyanese artist Mathieu Kleyebe Abonnenc highlighted this silencing in 2011, devoting a feature film to it entitled *A la recherche d'Awa/Looking for Awa*.

Today still, the virile rhetoric of the Arab Spring "is neither new, nor unique," Ibtissam Bouachrine points out, according to whom Mohamed Bouazizi's

self-immolation, which triggered the Tunisian riots, was for him a way of regaining his honor and virility (*rujula*) after being slapped by a policewoman, apparently after a sexist remark when she confiscated the scales he was using to weigh his fruit. "Being humiliated by a woman heightens the humiliation and makes it far worse than a slow and painful death."[33] Notwithstanding, beyond their aspirations to democracy, these revolutions drew on the long efforts to challenge the social patriarchy, reinforced by the political patriarchy, efforts to which women's film-making has constantly attested.

Known for her excellent documentaries (*La Moitié du ciel d'Allah/Half of Allah's Sky*; *Algérie, la vie toujours/Algeria, Life Still*; *Et les arbres poussent en Kabylie/And Trees Grow in Kabylia*), Djamila Sahraoui decided to turn to fiction to explore the violence at play in Algerian society without the limitations of what cannot be said in front of a camera, and to pull the alarm bells by entitling her film *Barakat! (Enough!*, 2006). Not content to expunge this violence, the film repeats that Algeria's malaise resides in its contempt for women. The women in the film repeatedly show their bravery. They dare to cause a scandal in a café, to show themselves freely in the streets, and above all, like Khadidja, to repeat the risks undertaken during the war for independence by going to an Islamist underground group to try to find Amel's husband, a kidnapped journalist (4443). *Douar de femmes/Hamlet of Women*, Mohamed Chouikh's seventh film (Algeria, 2005), is an amusing and touching evocation of a village harassed by the terrorists, a hyperbolic microcosm, a ravaged and still threatened world behind closed doors, and a metonymy of a country that lived like an entrenched camp for so long. The film portrays a village deserted by the menfolk, who have gone off to work in a factory, and where only the old men remain, entrusted with keeping watch over the women, if only they can find their specs! It illustrates the ability to resist alienation with the distance of steadfast humor to exorcise the years of terror. It takes the grand finale of the hilariously funny men's return to reconnect with the time of history and its stake: will all of this have changed anything, and on what should a different future be built? (4069).

At the other end of the continent in Zimbabwe, in a film screened at Cannes in 1996, Ingrid Sinclair depicted how the women fighters of the *Chimurenga*—the freedom struggle against white Rhodesia—today continue to challenge patriarchal society. *Flame* caused a scandal in Zimbabwe, and nearly never got made. Resistance remains strong before men decide to look a little closer under women's feet. When they do, colorful marginal characters result, but torn by contingencies, they throw themselves headlong towards an elusive free horizon, burning their wings. This

existential melancholy imposes its themes and rhythm on films that often start out gung-ho, but very quickly calm to espouse the intimate breath of these strong-willed yet necessarily lucid women. It is thus among women that Nadir Moknèche finds the energy to challenge and the bitterness of lost combats that traverse his films (*Le Harem de Mme Osmane/The Harem of Madame Osmane*, 2000; *Viva laldjérie/Viva Algeria*, 2004; *Délice Paloma*, 2007). His two faithful actresses—Biyouna and Nadia Kaci—embody the complex dynamic of a society that longs for change, while at the same time multiplying the hurdles. By making a possessive and immoral Mrs. Aldjéria so familiar and likable, Moknèche avoids the temptation of ethical rejection to suggest that it is by building on its own chaos that society will define a future. This means accepting its shady zones, its history, and its blending to surpass purist, identity-based discourses and to find a place in the world (5931).

"Ever since my first short film, my female characters have been highly free," stated Nadia El Fani. "For me, showing women's freedom as commonplace is the best way to establish it in people's minds in North Africa" (2511). In *Bedwin Hacker* (Tunisia, 2002), which parodies the spy film to reverse North-South technological relations, El Fani undermines the clichés. Kalt represents freedom, offering Arab women a positive and empowering female character who is free and strong-willed, unrestrained by conditioning, and perfectly competent (2436). It is no dream: increasingly, women have greater access to learning, high-level professions, activist activities, and positions of combat. "If these women continue on this highly paradoxical path of accepting outward signs of submission and inward signs of modernization, a time will come when this equilibrium will no longer be manageable," Marie-José Mondzain noted, continuing: "Considering what women have been for centuries, when they do gain access to learning and expertise, they develop them in underground forms that gradually gain in visibility" (4565).

But today still, "things are not done in a frontal way," Leïla Kilani notes. Yet, "Moroccan women are gutsy, subversive and smart."[34] It is these women that she portrays in *Sur la planche/On the Edge* (Morocco, 2011), following Badia, who slams in voice-over: "I don't steal, I pay myself back. I don't burgle, I salvage. I don't deal, I trade. I don't prostitute myself out, I invite myself in." She reflects all these youth who participated in the Arab revolutions, who have nothing to lose but a ruined life and everything to gain from forging ahead: "I'm already what I'll be. I'm just ahead on the truth: mine." In filming these edgy young women, Leïla Kilani does not adopt a psychological or sociological approach. Her aim is not to explain. The film is on the surface, not in a superficial way, but in a tactile, carnal, epidermal way! It is a

way of telling us that we can only understand the current transformations in this sense, that all discourse will come up against a wall, that these societies will spiral into violence if they do not offer their youth a future (10545).

5.4.4. Nego-Feminism

On the political terrain, and in this context, secularism is not only a way of allowing a multicultural society to escape hypocrisy and avoid fragmenting into separate communities, as is shown in Nadia El Fani's *Laïcité Inch'Allah/Secularism, Inch'Allah* (Tunisia, 2011), but also an essential judicial step for women to escape the confines of Wahhabism and a caricatural and alienating Islamization. That is what the Algerian lawyer and writer Wassyla Tamzali insists: "The headscarf, the burqa are traps that we exhaust ourselves on. Only secularism can reverse the oppressive relations that women and men suffer in Muslim societies. Religious education crams into young children's heads the idea that God wants women to be dominated. Today, people only stand up to assert their identity, and in general that of victim."[35]

The eternal violence inflicted on women is combated by the law. Or at least so long as it is applied, as the strong-headed women judges guarantee in Florence Ayissi and Kim Longinotto's *Sisters in Law* (Cameroon/UK, 2005). The film is not all one-way; one of the cases concerns a woman who beats her child with a coat hanger (4261). Reality is complex and diverse, as Angèle Diabang demonstrates in *Sénégalaises et Islam/Senegalese Women and Islam* (Senegal, 2007). The women who testify assert a tolerance based on an understanding of the religion itself that escapes the widely mediatized dogmatism. But a counterpoint is notwithstanding gently imposed: that of a society in which religion increasingly occupies the public space; radicalization is progressing, encouraging greater social control; and where exterior signs count more, to the point of being taken as obligations. It is of course in these self-confident women's paradoxical valorization of a hegemony over their lives and a restriction of their freedom of expression and movement that this film perturbs. Angèle Diabang does not ring alarm bells; she contents herself with placing her camera at a just distance to give the women as much voice as possible and, through the montage, presents a picture in the form of a question mark (5871).

With *Amours zoulous/Zulu Love Affairs* (France, 2002), Emmanuelle Bidou, who is married to a Zulu musician and speaks the language of Natal, offers a filmic testimony on the women in a village who remain alone eleven months of the year while their husbands work on the building sites of Johannesburg or Durban. "I

didn't marry to be fed, but to have sex!" exclaims one woman. That says it all. These husbands are far away, but everything revolves around them, these macho men who run the show when they come home, going from one woman to the next, according to the rules of polygamy. But in their absence, the women run things themselves. The film listens to them respectfully, fascinated even, gently capturing their pain and their humor (3040). The same logic is at play in Katy Lena Ndiaye's *En attendant les hommes/Waiting for Men* (Senegal, 2007), a contemplation without commentary on the frescoes that Mauritanian women paint to welcome back their husbands who have gone off to work; it listens to their intimate words (7202). In the same way that apartheid forced black men to work in mines far from their homes, economic insecurity often forces men to leave for long periods, during which they have to delegate their family responsibilities to their wives. Since slavery, this male exploitation has engendered the racist ideology of the "black matriarch," with black families organized around the womenfolk, while men are considered to be abdicators, immature, irresponsible, and violent. But this collection of stereotypes, from mama to worthless man—characters that have historically been propagated in film—ought not mask this African female reality that Obioma Nnaemeka calls "nego-feminism," or a negotiated, ego-free feminism.[36] Negotiation and compromise to circumvent repression: this pragmatic principle imposes in the light of a patriarchy that, historically, is reinforced by a subjugation of black men that relativizes male domination of women and undermines the feminist struggle.

Seduction, in this light, is no longer a form of alienation, but a negotiation, as Alice Diop's *Les Sénégalaises et la Sénégauloise/Senegalese Meet Sene-Gallic* (Senegal, 2007) shows, detailing the rules and tools of seduction that render the different women in the compound sufficiently attractive for their husbands not to take a second wife (8134). The women's freedom of tone and clarity is impressive. "Men are irremediable egotists, big babies. Women have changed, but men haven't. They're all polygamists!" one of them says in Fabintou Diop's *Mariage et ménage/ Heart and Home* (Senegal, 2001). It is through this free speech that a society unmasks itself, surpassing taboos, and thus opening the way to invigorating changes (3346).

"I'm angry, but not lacking in imagination," Leïla declares in Samia Meskaldji's *La Voie lente/The Way Out* (Algeria, 2000) (2325). It is in utopia that the struggle lies. Not in the naturalist, differentiating, victimized feminism that gradually took hold in Western society in the 1980s, but in the assertion of women's economic, political, and cultural independence in a combative feminism that fights for equality. If "the dictatorship of balls," to cite Calixthe Beyala, induces solitude,

marginality, sentimental and moral errantry, these are all paths for examining the universal human condition. Women's issues are hence no longer an obligatory subject for a feminist film, which now favors women who are in solidarity with all oppressed peoples, in an affirmation of alternative thought and values. Intimate testimony opens the way to an aporetic vision, not offering solutions, but revealing the contradictions and tensions. For the Franco-Senegalese writer Sylvie Kandé, it is in unrooting that poetry is rooted, surpassing the denunciation of oppression to open a new creative space of reappropriation and empowerment. Through the multiplicity of testimonies that are inscribed in a collective history, the immigrant women of all origins in Christian Zerbib's *Nos ancêtres les Gauloises/Our Ancestors the Gauls* (France, 2011), for example, reveal through acting the extent to which their individual stories converge. They thus escape the invisibility of women who do not fit the norm, as incarnated by Dallande in *La Femme invisible/The Invisible Woman*, a short film by Pascale Obolo (Cameroon, 2008). She so does not recognize herself in the movie stars in the posters that she begins to veer into madness. As in *Si-Gueriki, the Queen Mother*, by Idrissou Mora-Kpaï (Benin, 2002), while the women keep meaningfully silent, they also have sharp tongues (2298). Even in the most remote of places, they are completely aware. By confronting their singularity in their diversity, women may manifest their sisterhood, without it being taken for granted, as a possibility, so long as it is based on mutual respect. These expressions are essential, not just because cinema remains a male domain, but also, as the celebrated Tunisian-born feminist lawyer Gisèle Halimi put it, after being subjected to racism as soon as she arrived in France, "there is no example of the oppressed being liberated by anyone other than themselves."[37]

5.5. Music Time

> I can still sing!
>
> —Marwan, the poet-singer, victim of an assassination attempt in
> the film *Destiny*, directed by Youssef Chahine (Egypt, 1997)

5.5.1. The Vitality of Memory

Marwan's resistance is not in his music, but in his persistence in singing when they try to muzzle him. A certain mysticism has it that music is in itself a form of

resistance, when all it does is emanate sounds. Its power of resistance resides in its transgressions, in the words applied to it, or the sociopolitical meaning it is given. It is indeed the lyrics of Gnawa Diffusion, whose music haunts and augments the film, that ring out like a promise in Merzak Allouache's *L'Autre monde/The Other World* (Algeria, 2001): "The shadows of the past refuse to disappear; one Algeria is dying in another emerging" (0041). Through their commitment, songs, singers, or groups thus carry the hopes of a people. The magnificent *Mahaleo* by César Paes and Raymond Najaoranivelo (Brazil/Madagascar, 2005) follows the members of this mythic group that, through its songs, contributed to the fall of the neocolonial regime in 1972, and who are still activists (3682). Their blues is that of this vast island, marked by political struggles and deception.

Certain music thus conveys populations' resistance, through the history of those who forge and convey it. The odyssey retraced by *The Blues*, a series of seven films produced by Martin Scorsese in 2003, recounts in music the history of the African Americans, oppressed by the slave trade and segregation. It is both this memory and the capacity to survive that Mahamat-Saleh Haroun evokes when he uses Ali Farka Touré's blues in *Abouna* (Chad, 2002). "Writing the screenplay, I had it in my head," the director stated (2358). As Scorsese shows in *Feel Like Going Home*, it was after discovering African American music, listening to John Lee Hooker's albums, that Ali Farka Touré tried to rediscover the Malian roots of the blues (3330). Babacar Traoré's life, which Jacques Sarrazin sensitively portrays in *Je chanterai pour toi/I'll Sing for You* (France, 2002), takes the form of a blues song itself—he to whom all the Malians used to sing along at the time of Independence—and the whole film adopts its rhythm (2732).

In the French colonies, the Catholic Church banned "licentious and dishonest" dances. This drove black West Indians to thwart the ban by blending Parisian dances and animist-Christian rhythms, thereby creating beguine. This is the music that "sweeps" Saint-Pierre in Guy Deslauriers's *Biguine*, which tells its story with Patrick Chamoiseau (Martinique, 2004). When Mount Pelée erupted "in a thunderbolt" one morning in May 1902, the telluric force of the "Antillean magma" had already exploded into new forms of magical syncretism (3675). Not subjected to the same ban, black music came to enrich the patrimony of the American congregational churches. Jazz thus emerged from a fusion of the music of former Catholicized slaves from New Orleans and that of the Protestant slaves who developed the Negro spirituals.[38] Was the toing and froing between America and Africa the same as that between Cuba and Ghanaian and Nigerian high life and Congolese rumba? Followed

by Pierre-Yves Borgeaud in his expedition on the traces of the slave route in *Retour à Gorée/Return to Gorée* (France, 2007), (6848) Youssou N'dour is not the first African to have collaborated with jazzmen, but previously, it was more often the latter who made the trip back to Africa, and notably to West Africa, producing some memorable recordings: the pianist Hank Jones with the Malian keyboard player Cheikh Tidiane Seck; the double-bass player Ira Coleman with the Senegalese kora player Kaouding Cissoko; bluesman Taj Mahal blending his guitar with Ali Farka Touré's or Toumani Diabaté's kora in Mali, and so forth. In Africa itself, other than the South African jazz that developed from the 1930s onwards, the presence of the word "jazz" in band names, such as Guinea's Bembeya Jazz National, or Congo's T.P.O.K. Jazz, reflects more of a Cuban influence. As Laurent Chevallier's *Momo le doyen/Momo the Elder* (France, 2006) shows, saxophonist Momo Wandel Soumah created an interesting fusion in Guinea, while Abdoulaye Diabaté, Djeli Moussa Diawara, and Moussa Cissoko's Kora Jazz Trio created a "jazz tinted with traditional sounds." Otherwise, however, the presence of jazz itself in general has remained rather diffuse.[39]

In the 2000s, however, jazz became one of the main references of the new generation of sub-Saharan African filmmakers. The pioneers had already embarked on this path. When Ousmane Sembene asked Manu Dibango in Abidjan to compose the music for *Ceddo* (Senegal, 1976), Dibango initially refused, fearing they would not understand one another as Sembene was from the savannah, and Dibango from the forest. They nonetheless agreed on what Dibango called a "soundscape," creating a counterpoint to the image and engaging the spectator.[40] Dibango later composed the music for works by Ivorians, including Henri Duparc (*L'Herbe sauvage/Wild Grass*, 1977, and *Bal poussière/Dancing in the Dust*, 1988) and Sidiki Bakaba (*Roues Libres/Free Wheels*, 2000), before returning to West Africa with Idrissa Ouedraogo's *La Colère des dieux/Anger of the Gods* (Burkina Faso, 2003). Like Sembene, Ouedraogo wanted "a modern music that draws on traditional sources," insisting that "in many films set in villages, the images crush the sound. . . . Everything sounds the same, everything is imitated when it comes to rhythm and effects." He finally retained only one jazz composition from the many that Dibango composed "to tip the film into the modern era with the arrival of the white man" (2782).

Another composer has made his mark after working with his brother Djibril Diop Mambety on *Hyènes/Hyenas* (Senegal, 1992). Wasis Diop's music and voice, for example, envelop the emancipatory march of the young Pougbila in *Delwende*, by S. Pierre Yaméogo (Burkina Faso, 2005), elevating it to a cosmic dimension (3850). Diop regularly works with filmmakers of all origins, but often with Africans,

notably Mahamat-Saleh Haroun (*Daratt*, 2006; *Sexe, gombo et beurre salé/Sex, Okra and Salted Butter*, 2007; *Un Homme qui crie/A Screaming Man*, 2010), Henri-Joseph Koumba Bididi (*Les Couilles de l'éléphant/The Elephant's Balls*, 2001), Moussa Touré (*TGV*, 1997), Mansour Sora Wade (*Le Prix du pardon/The Price of Forgiveness*, 2001), Léandre-Alain Baker (*Ramata*, 2008), and Missa Hébié (*En attendant le vote . . . / Waiting for the Vote*, 2010). His music always swings, is rhythmic without becoming redundant; it is interrupted by phrases that break with this safeness to reintroduce worry and doubt. These changes of course introduce a complexity proportionate to the stakes of a music that is not just a backing track, but intends to participate in the life of the narrative. It is in this discontinuity that the music asserts itself. Just like the story, the music thus needs time to connote the fractures of history.

5.5.2. The Diffracted Time of Jazz

Gilles Mouëllic, whose writing on the relation between jazz and film is a reference, constantly insists on the oral dimension at the root of jazz, or its "living memory." He has also studied the relation of Ivorian playwright Koffi Kwahulé's writing to jazz, "a diversity of figures that one only finds in oral texts: multiple changes in tempo, sudden diversions, several layers of iteration, of contradictions."[41] This writing's model is thus "jazz improvisation, rightly considered not as a discourse, but as a *controlled word* that circulates between musicians." Kwahulé indeed looks to both Thelonious Monk and John Coltrane: "To the first's aesthetic of silence, of suspended time, answers the second's obsession with fullness, with uninterrupted flow." Similarly in film, jazz represents an autonomous voice superposed on the image, another layer of voice in the narrative. It may be an internal monologue, as in Gaston Kaboré's *Buud Yam* (Burkina Faso, 1997), in which Michel Portal's clarinet improvises with the balafon, kora, sanza, and a calabash guitar to reinforce the characters' interior turmoil. It perfectly follows the camera down the village streets or accompanies Wend Kuuni's horse (0161). But its rhythm becomes frantic when the wild jazz of Archie Shepp or Ornette Coleman alone can apprehend the real in Tariq Teguia's *Rome Rather Than You* (Algeria, 2007), adding a landscape of sounds to the geography of indefinite spaces that the images evoke. The long sequence shots thus resonate with a plenitude that does not only come from the play on shadow and light (7458).

It is time that is challenged, like in oral narratives. Linearity, chronology, logic, and coherence go out the window, showing that what we see is not what we believe;

that is, that the real resists preconceptions. When Katy Lena Ndiaye asked the Belgian jazzman Erwin Vann to compose the music for her films, it was to avoid the women she portrays being reduced to their African dimension: "I wanted to challenge the clichés about Africa by showing the modernity you can find in a village" (3075). It is a stance: "If you mix John Surman's pieces that you can hear in *Ngor* and Abby's trance on the beach, it is not antinomical, there is no distance," Samba Felix Ndiaye stated (7956). Yet this position, which is resolutely opposed to identity-based reductions, is also the expression of an "untranquility." In Rabah Ameur-Zaïmeche's *Bled Number One* (Algeria, 2005), it is after Kamel and Bouzid's argument in defense of his cousin Louisa that we hear Rodolphe Burger sing "The Little Vagabond," a poem by William Blake, which in 1794 denounced the Catholic Church's manipulative power. At the end of the film, before leaving for Tunisia where his quest for freedom takes him, Kamel, playing on the uncertainty induced by his status as both actor and director, sits behind Rodolphe Burger—electric guitar in hand, mike and amp by his side—listening to Burger improvise. The same wrenching dissonance rings out as Kamel, on the hillside in the dusk, watches and follows as the women return from the fields in the background (6776).

Jazz is thus indeed inscribed in an aesthetic of protest. Cameroonian filmmaker Jean-Pierre Bekolo claimed that it was thanks to "*She's Gotta Have It* [Spike Lee, 1986] that we learned that we could make filmic jazz, in a black aesthetic that was our own."[42] This recourse to spontaneity to break with Sembenian cinema is radical, aiming to invent a new aesthetic that gives sound additional importance, as it encourages a reading of the film that adds to its simple perception. Jazz is thus seen here not only as music, but as a filmic undertaking in which the sound also integrates other elements of life. Some films are thus completely devoid of music, yet the real resonates in them through the quality of the work on their soundtracks. Not a single note accompanies the two hours and five minutes of *Mille Mois/A Thousand Months* (Morocco, 2003), but "there is musicality, even if there is no music," as Faouzi Bensaïdi put it. "There is the music of the ambiances, of how they are edited" (10298). His work with sound engineer Patrick Mendez is remarkable in this respect, so much so "that it's as if the actor plays a D and the sound plays an E."

The sound thus becomes a permanent negotiation between chance and need, in a desire to let the real enter the film freely, while encouraging this process as much as possible, and thus restoring a desire for film style. Questioned on the presence of jazz in his films, Samba Félix Ndiaye answered: "Jazz is my music! When I make a film, there's often a music in my head. It's not always the one that I'll put

in the film, but I hear it. I used to work with Magette Salla, the sound engineer, who sadly passed away. In Rwanda, I asked him to add the small sounds and cries I could hear, this country's pain. He re-created them. In *Lettre à Senghor* [*Letter to Senghor*], I asked him for a slight wind, words, critical but light. He added wind all the way through the film." He did not, for that matter, consider it different from the aesthetic of the image. "The same goes for the images; we talk about life, not the framing. In spite of my and the cameraman's different cultural origins, we have something in common that makes it possible to talk about an image and create it. This is a quest for aesthetics, for a form capable of conveying the subject. It starts long before the film itself with a friendship, a fraternity, a companionship" (7956). The sound design is thus just as important as the montage, as in Tariq Teguia's films, which go from "sound apnea" to very powerful exuberance: "There is no formula to it either, like launching the bass notes to catch a client who's already run off! No, it's always a question of how to organize the shots and how they answer one another. At the moment of splicing, you can reduce, add, you can add intensity to a shot. That's why the editing is so long. It's not about respecting the grammatical rules of narrative, but of measuring how each shot reinvents the film, in terms of tonality, to find a general frequency that is already present in the fragment. It's this obsession that people call musical, or in any case rhythmic. The same goes for the sound. One principle would be to say that the more you remove it, the better you hear it, to the point of hearing the inaudible, just as some people try to show the invisible" (9014).

5.5.3. A Cinema of Live Bodies

This unifying principle, this overall coherence might seem the antithesis of jazz improvisation, but in its ability to resist the image, it sneaks back in through the window as a perturbing force that undermines the narrative when it risks becoming too one-dimensional. This musical contradiction is at the root of the disequilibrium vital to cinema, in the same way that Federico Fellini used to ask Nino Rota, his longtime composer, to write "a sad joyful theme." The music thus becomes a way of inviting the spectator to move with the film. "Even if I often find the music after shooting, I think a lot about the music when I shoot a shot," Abderrahmane Sissako stated. "I know when the music will come in, and which one we shall see. That gives the viewer the stamina to walk with you" (2351). Swing, which reconciles us with time, is hence an essential contribution. The opening of Newton Aduaka's

Ezra (Nigeria, 2006) is remarkable in this respect. Before the rebels attack the school to capture those destined to become child soldiers, the soundtrack conveys a tension that is at odds with the still morning calm through the crystalline beats of metallic percussion, akin to a heartbeat. The cinematic time of this film, with its perturbed chronology—perturbed like Ezra, who is unable to face the horrors perpetrated—is hence regulated by this pulse, echoed in the reggae musician Bob Marley's "No More Trouble."

This conjugating of the self-confidence of swing and the historic anxiety conveyed by jazz defines the musical approach of the 2000s and echoes the polyphonic approach of many films that multiply the origins of their music. In Amor Hakkar's *La Maison jaune/The Yellow House* (Algeria, 2007), entirely shot in Tamazigh, the traditional Chaoui songs cohabit with jazz, oud, Basile Ntsika's African song, and Joseph Macera's Armenian song without any sense of anachronism, the film coming from the filmmaker's guts, not a single culture. "As the film addresses a universal subject," Hakkar commented, "the music should serve it" (7303). This is how a film conjugates past and present, the music adding a historical rooting. The stake is thus to manifest the cultural diversity that nationalism so readily denies. The work of excavators like Izza Genini is hence essential. Amidst its Tamazigh, Andalusian, sub-Saharan African, Jewish, and Muslim influences, she reveals from film to film that Morocco is the product of an encounter, and highlights the wealth and importance of cultural exchange in the development of the Arab world.

By capturing off-stage moments in her films, she extracts the music she documents from a folkloric perspective to inscribe it in a contemporary temporality, in the footsteps of novelist and filmmaker Assia Djebar, in whose 1978 work *La Nouba des femmes du Mont Chenoua/The Nouba of the Women of Mount Chenoua* the sung texts have the same status as the chirping of birds, children's shouts, and sheep's bleats, inviting another way of seeing and listening to women's songs and blending them into the real. The listening is no longer the same, for it is life that is there, in the bodies at work, like in the magnificent scene that Abderrahmane Sissako offers us in *Heremakono/Waiting for Happiness* (Mauritania, 2002) when a young girl learns to sing.

Song or dance can also be physically highlighted in the narrative. In the tradition of African films,[43] a polyphonic choir thus serves as a counterpoint and a cultural reference in Senegalese Moussa Sene Absa's films, *Tableau Ferraille* (1995), *Madame Brouette* (2002), and *Teranga Blues* (2006). But this vein is not so common today. Similarly, the musical has never really taken off in the sub-Saharan context.[44] This

terrain was indeed already occupied by Egyptian or Bollywood musicals. With the exception of *Nha Fala* by Flora Gomes (Guinea Bissau, 2003), starring Fatou Ndiaye, who had to take singing lessons for the film; or musicals from a country with a choir tradition—South Africa—such as *Sarafina* (Darrell James Roodt, 1992), starring Whoopi Goldberg; or the operatic adaptation *U-Carmen eKhayelitsha* (Mark Dornford-May, 2005), starring singer Pauline Malefane, one looks in vain for films in which the music occupies such a place. Historically, one can only cite *Naïtou* (Moussa Kemoko Diakité, 1982), which follows Guinea's National African Ballet troupe, or *La Vie est belle/Life Is Beautiful* (Dieudonné Ngangura Mweze and Benoît Lamy, 1987), starring Papa Wemba. Mweze returned to the musical in 2004 with *Les Habits neufs du gouverneur/The Governor's New Clothes*, also starring Papa Wemba as a Makassi griot ("force," in Lingala), which tells a musical tale about the corruption of power, loosely adapted from a tale by the nineteenth-century Danish storyteller H. C. Andersen (3802). The film was shot on a low budget in Kinshasa and in conditions themselves akin to a comedy. *Jit*, by Michael Raeburn (Zimbabwe, 1991), comprises a succession of musical scenes, while in 1975, Nigerian Ola Balogun broadened the reach of his militant cinema by working Duro Lapido's songs and music into *Ajani Ogun*.

With *Un transport en commun/Saint-Louis Blues* (Senegal, 2009), Dyana Gaye created a surprise by blending musical registers (out of the eight songs in the 48-minute film, only two are set to African rhythms), also choosing nonprofessional singers and dancers, and lyrics of a certain seriousness about the social situation. The difference with musicals, which remains the reference, is total, and the result striking, for what is at issue is not just imitating a genre, but mobilizing everyone's energy (9520 and interview 9013). Films about music of course have the advantage of playing us music and song, so long as they actually do just that; many, out of concern for the film's rhythm, cut short the songs, frustrating the viewer—for example in Mika Kaurismäki's albeit well-documented films on Afro-Brazilian music (*Moro no Brasil*, 2003, and *Brasileirinho*, 2008) (2925 and 3951), and his documentary on Miriam Makeba (*Mama Africa*, Finland, 2011). On the contrary, in *Maria Bethânia, música é perfume/Maria Bethânia: Music Is Perfume* (France, 2004), pianist-director Georges Gachot works live: he openly films with a single big 16/9 digital Beta camera as close as he can get, and thus takes the same risks as the singer onstage. Limiting shot changes as much as possible, he films within the time of creation or performance, restoring the corporeality of the concert, of contact, of vision. Rather than a flow of images, he offers a harmony in which every shot change resonates

with the romantic samba songs that draw on the traditional Northeast region's music that sings the past and slavery (4342).

Being jazzy is thus not about cranking up the rhythm to clip the song. Sometimes, there is no need to accelerate! Joey Garfield's *Breath Control: The History of the Human Beat Box* (USA, 2004) documents this branch of hip-hop that needs no instruments, the musician using his or her vocal chords instead. The origin of beat-boxing lies in the communication of Africa's Pygmy populations. The result is breathtaking! (2888). Similarly, *Rize* by David LaChapelle (USA, 2004) documents the dance battles between those who practice clowning and krumping, more recent forms of break-dancing. Here too, the roots are African, as they also are in Brazilian and Caribbean capoeira, the jitterbugging that developed on the plantations, jazz dance of the 1920s, or the lindy hop danced by the likes of Malcolm X. As Anne Crémieux writes: "Like their predecessors, clowning and krumping are resistance dances, where the act is in its gestures" (4040).

The power of rhythm is its ability to regenerate. According to traditional African thought, the movement of the body prepares the movement of the mind. As in Raja Amari's *Satin rouge/Red Satin* (Tunisia, 2000), the life force of music and dance is a transgression. It is this pleasure that is proposed by the "singing café" evoked by Papicha in Nadir Moknèche's *Viva laldjérie/Viva Algeria* (Algeria, 2004). It needed the quality of Biyouna's acting to convey the loss of no longer having, due to pressure from fundamentalists, these "releases necessary for society to function properly," to borrow Denise Brahimi's expression.[45] The challenge for cinema, as it is for art criticism, is thus to find in both the sound and image the musical time capable of restoring the spontaneity of the tempo of live bodies.

Economic Perspectives

Populations with no resources hold the secret of the future of humanity, for they have the vocation of sharing and exchanging.

—Edouard Glissant, "L'Epreuve du bateau négrier," interview, Roger Rotmann with Edouard Glissant, 2006

6.1. The New African Film Market

All problems have two ends to them.

—Malian proverb, in the film *Taafe Fanga*, directed by Adama Drabo (1997)

It is often said that there is no market for African film. Indeed, the rare films that do get produced struggle to make it in the North, while in the South, the situation is deteriorating: cinemas are closing, piracy is rampant, television does not broadcast them, governments are not reacting, and audiences prefer American movies or local, popular productions. Does this mark the end of reflective cinema in Africa?

6.1.1. Independent Cinemas

"Our cinema no longer has a home," as Beninese director Idrissou Mora Kpaï put it. Under pressure from the international financial institutions and their structural adjustment plans, African governments withdrew their backing from the arts from the late 1970s onwards. In many countries, the state-run cinemas were privatized, and their new managers sought only to make a quick profit. When video emerged, they did not maintain the movie theaters, or divide them up into smaller units. The cinemas spiraled into decline and were sold off, their town-center locations ensuring that they fetched a good price. "We are paying for past mistakes," head of Moroccan cinema Nour-Eddine Saïl stated (8967).[1]

Yet simply reopening cinemas would not alone suffice. "Cinema closure was inevitable. Even if multiplexes can be profitable, they wouldn't make huge returns, let there be no mistake!" noted Frédéric Massin, who ran the last three movie theaters in Cameroon before they closed (4084). With cinema having becoming more a place to go out than a place of culture, only a handful of comfortable cinemas in town centers just barely survive, when they have not disappeared completely. Mahamat-Saleh Haroun's *Bye Bye Africa* (Chad, 1998) showed the regrettable state of dereliction of the Normandie, and the closure of all Chad's other cinemas (9763). But thanks to the international success of his films, the country's oil revenues, and the efforts of the Chadian film milieu, the Normandie was entirely renovated and reopened in style in January 2011 (9918). With practically all the Ivorian cinemas having shut after ten years of political instability, and Dakar's city-center cinemas having shut for economic reasons, there are barely twenty cinemas worth their name in French-speaking sub-Saharan Africa. In the English-speaking countries, South Africa is the exception. Ster Kinekor operates 360 screens and Nu-Metro 250, with multiplexes of up to fifteen screens, such as Menlyn Park in Tshwane, two of which are equipped with seats like "airline business class"! Are multiplexes a solution, better equipped to expand the offerings and draw a diverse audience? Nu-Metro, which also distributes American and Indian films, also regularly opens multiplexes in other English-speaking countries (5801). The success of the fourteen-screen Megarama in Casablanca appears to confirm that, as in India, the middle classes continue to frequent up-market cinemas, which become spots for couples or young people to go out, while poorer classes are deserting the big historic cinemas, and turning instead to video parlors and other forms of collective home viewing on TV screens (3077). But auteur films stand little chance of being distributed in either.

Is reopening cinemas for this type of film a nostalgic lost cause given the implacability of market demands? Abderrahmane Sissako with his "Cinemas for Africa" initiative, starting with the renovation of the Soudan in Bamako, is well aware of the economic difficulties. Cinemas are thus no longer seen just as screening places, but as lively cultural venues and meeting places, an antidote to the dumbing-down of television and other consumerist forms. That is the difference with the multiplexes: community groups, associations, and schools can invest in an independent cinema, organizing special meetings and events, and following current affairs with debates, thus encouraging democracy. The Cinémafricart example in Tunis is emblematic in this respect; it has become a site of experimentation, a place where young people interested in filmmaking meet, and a film club with a core group who never miss a film. "There were full houses for the film cycles, and even Godard was a hit!" noted its director Habib Bel Hedi (8967). He was nonetheless injured and the cinema vandalized on June 26, 2011, when a group of extremists tried to prevent the screening of Nadia El Fani's *Laïcité Inch'Allah/Secularism, Inch'Allah*.

A new economic rationale remains to be developed. Rather than multiplying poorly attended screenings, a cinema can become a permanent festival with regular discussions and events. It can serve as a relay for festivals so that they continue their activities throughout the year, and for associative groups so that they can expand their programs. It can hold cinema days, discovery events, with the relation to film becoming increasingly event-oriented. That is also the case with itinerant cinema, which we see being announced by a public crier in *Abderrahmane Sissako: Une fenêtre sur le monde/Abderrahmane Sissako: A Window on the World* (Charles Castella, France, 2010): "We've made a film that addresses everyone. Please honor us with your presence. Try to bring a chair, as we don't have enough. With thanks in advance!" The Cinéma numérique ambulant (CNA) travels the roads of many countries, along with other initiatives. The Mozambican Association of Filmmakers created *Cinema Arena*, which tours DVDs of Mozambican films, shown on big screens from the north to the south of the country (4510). There is no point in waiting for lethargic governments to provide: energy is breathed back through self-organization. Hence, the tragic statistics on cinema closures can be read differently; it is not the number of cinemas or even screenings that counts, but what is going on at them.

Férid Boughedir proposes the concept of "festivality" in order to reconnect with audiences. "Cultural diversity is what's at stake," he said (3855). That is indeed the crux of the matter: creating niches that are parallel to the market and where

democracy can be fostered, or, in other words, a dialogue that helps envisage living together. It is indeed this notion of collectivity that is at the heart of film reception. "Watching together constructs a 'similitude,' a shared moment for seeing and for choosing what we are going to love or hate together in the working through of affect," Marie-José Mondzain writes.[2] Watching together thus constructs life in society, not around what is seen on the screen, but around what we experience together. That does not preclude the critical confrontation of opinions and points of view, but this confrontation can only occur because we watch something together. "The cinema is immortal," as Nour-Eddine Saïl put it, because it is a site of "intelligent consumption, which constitutes a sharing that gives the social individual an existence, reinforced in his/her individuality because he/she feels the same thing as others" (8967). While television has become the main vector of sharing emotions in families, it is at the cinema that collective generational sociabilities are constructed.[3] We often go to the cinema with someone, and young people go in a group to construct shared references or to learn to deal with their emotions together.

The facts confirm cinema's dual social role: box-office hits are usually the American blockbusters, which mix action and romance, but also national films with which everyone can identify. The mirror dimension is crucial. Even a reputedly difficult film such as *Heremakono* was a big hit in Mauritania thanks to traveling DVD screenings. *Buud yam* (Gaston Kaboré, 1997) officially totaled 637,000 admissions in Burkina Faso, "which is the figure given by the cinemas, and thus the lowest estimate because they base their calculations of what they owe me on that! In reality, that represents 1.5 million spectators in Burkina" (3363). National films often break all the box-office records, as in Morocco: in 2003, *Les Bandits* by comedian Saïd Naciri totaled almost one million admissions with his kind-hearted crook character (3368, and interview 3351); *Casanegra* (Nour-Eddine Lakhmari, 2007) was also a huge hit with its evocation of the Casablanca underworld. Only James Cameron surpassed these figures! *Femmes . . . et femmes/Women . . . and Women,* by Saad Chraïbi, ranked second in Morocco after *Titanic*, while *Avatar* is the only film to have surpassed *Ije: The Journey* in Nigeria's multiplexes (Chineze Anyaene, 2010) (10299). "As we have sixteen national languages, films are shot in these local languages and are a huge success," Mozambican director Sol de Carvalho pointed out (4510). Seeing films in one's own language is a gauge of success everywhere. "In Eritrea, astonishingly, everyone goes to the cinema at the weekend to see the local films," noted filmmaker Rahel Tewelde (7693). But audiences tire of the same old popular formulas being repeated time and time again: "Audiences are falling at the

cinemas. There aren't the same long queues as at the start," Malagasy filmmaker Henry Randrianierenana commented back in 2004 (3598). It is then that DVDs took over. It would be illusory to believe, however, that these national films cross borders, even when they have been dubbed, despite the cost; while a continental sense of belonging is strong, cultural and linguistic differences are often too acute for this to be translated into audience tastes, despite the Pan-Africanist assertions that one hears here and there.

So movie theaters must be inscribed within society. The growing number of local initiatives succeed when they combine screenings and other events. These potential social spots draw people, be they indoor or open-air, depending on conditions. In general, the move is towards itinerant screenings, but the ReaGilè Mini-Cinema Project in South Africa offers a good example of permanent structure: 1,200 complexes have been created in rural areas and the townships, in public venues or schools, with each prefabricated structure being equipped for education and entertainment activities, with 60 cinema or theater places, 30 computer workstations, plus a community health center and a meeting hall. Each installation is run by twenty-five members from the local community, which benefits from medical care and shares all the profits generated by the project (10548).

6.1.2. International Distribution

If it is essential then to conserve a network of cinemas for the pleasure and impact of viewing together, and for independent cinemas to reinforce democracy, the latter only represent micro-niches for auteur cinema and do not guarantee sufficient returns to perpetuate it. Yet, virtually all over the world, people wish to discover such works. That is their force vis-à-vis a commercial cinema that only interests very local audiences. The stake, then, is to reach beyond national territories and to aim for international distribution among the community of those interested in diversity. This cinephile community is significant and constitutes a real market. Video on demand (VOD) on the Internet does not replace cinema distribution, but complements it—or at least will complement it in Africa when broadband becomes widely available. But the real leap forward is coming from cell phones, which—as was the case with telecommunications and banking operations—are fast becoming the main vector for sharing images. Cell phones are considerably more widespread than computers, and the generation of tactile phones are turning them into an advertising and broadcasting medium; trailers urge us to go to see

films, and soon we will be able to see the films themselves. This multiplication of screens represents a considerable economic stake that has not gone unnoticed by the private South African television station M-Net. It has indeed not hesitated in investing considerable sums of money in buying the exclusive broadcast rights of all the major films in the African repertoire for the African territory and on these new screens too. Contacted one by one, directors have signed unconscionable contracts, ceding their rights for an unusually long duration (twenty to thirty years) for a flat fee, rather than for a percentage of sales. In the space of three years, nearly six hundred key films from a repertoire of eighty filmmakers were bought up. Even Sembene sold his rights, considering this a good means of raising money on films that were no longer making any revenue. Neither the Pan-African Federation of Filmmakers nor overseas cooperation organizations saw it coming quickly enough to warn filmmakers of their loss in earnings. M-Net now offers the films on VOD, under the African Film Library label, and is gradually organizing its offerings.

Filmmakers lost out on a market that they could have conserved if they had mobilized. It is impossible to moralize the market; we have to live with that and thus must organize without getting devoured. In that respect, the notion of territory is no longer pertinent: VOD is planetary. Yet visibility is necessary to stand out from the crowd. One pleasure has developed on the Internet: creating a buzz. Finding the rare gem and sharing it with one's friends has become a key activity. While both in the North and South, cinemas no longer want auteur films, communities are creating new, adventurous audiences in parallel circuits. Trailers and extracts play a key role in promotions and tempting the audience. As it gains ground, VOD is opening possibilities for revenue, which participate in a film's funding at a time when international buyers are no longer willing to pay minimum guarantees for auteur films. Distributors too are refusing, with films becoming increasingly short-lived on the screens. As for television sales, they are shrinking, as cinema no longer attracts audiences. Europe's thematic channels pay less than $10,000 to broadcast a film, its value being indexed to its success in the cinemas. A film's general release is thus still an obligatory stage for a film to exist; it orchestrates its critical reception and helps measure its impact. It also prepares its DVD and now VOD release, with the latter gradually replacing the former. But in France, where there are 5,500 cinema screens, clocking up more than 30,000 admissions is a feat in itself! Non-national and non-American films are losing ground pretty much everywhere. In France, only 12 percent of films recoup their costs. Without the French state's equalization scheme, auteur film would not exist, and that is not new, its nonprofitability being

structural. In Hollywood, only two out of fifteen films are a success and fund the rest. A redistributive rationale is thus still in vigor.

6.1.3. Beyond Piracy

Even with dirty water you can put out a fire.

—Cameroonian proverb

A new distribution culture needs to be established. Chasing after the achievements of the past is a lost cause, and it is self-punishing to trot out statistics on cinema closures. In the same way that a free album encourages young people to go to see a concert, excerpts allow us to see if we want to go to see a film at the cinema or purchase it on VOD. In Asia, new forms of corporate sponsorship or festivals are even making films freely available on VOD. It is true that VOD sales are still insignificant, and it is hard to imagine them increasing so long as things remain predominantly free on the Internet. But are repressive laws such as the Hadopi law in France desirable? Jean-Luc Godard, who considers that "the only right the auteur has is the duty to create," has deemed it "ridiculous and criminal."[4] Destined to safeguard takings and thus the virtuous circle of the equalization of funding that guarantees the diversity of French cinema, it is barking up the wrong tree: with 215 million tickets sold in France in 2011—the highest figure since the mid-1960s—and no doubt as many downloads, piracy is clearly not undermining cinema-going. Studies show that serial downloaders are also big consumers of cultural products. The DVD market, on the other hand, is collapsing. The first effect of Hadopi was to steer Internet users away from free peer-to-peer, or P2P, film and series downloading to online viewing without downloading (streaming), which at present escapes all control. Couldn't the money that this highly expensive measure costs (around $13 million a year) be used differently to facilitate access to cultural products, for instance? Defenders of global (or creative commons) licenses consider that a moderate rise in the price of monthly phone and broadband subscriptions would make it possible to create a fair redistribution process, paying royalties in accordance with the number of downloads (music, films, books, press), reinforced by a qualitative redistribution to encourage cultural diversity. The major advantage of this would be that revenues would be paid directly to the rights-holders and not the distributors, which would reduce artists' dependency and, in Africa, limit the flight of revenue to external operators. A moderate increase

in Internet subscriptions (shared by subscribers and Internet providers) would suffice to compensate the losses, based on the current system of an advance on earnings, run by the French National Film Center (CNC). Independent film funding would thus be better guaranteed.

The stakes are considerable, as the issue is cultural democratization and access to a diversity of works. More than a sanctioning device that criminalizes web users and equates downloading with theft, its regulated legalization would make cultural products accessible to all at a time when television is increasingly poor in this respect. What the industry loses in cultural product sales, it earns back by commercializing the viewing equipment, whose technology is constantly evolving. Going to the cinema remains a social activity that downloading cannot rival. And we would spare the energy spent trying to outdo the inventiveness of the pirates, who crack protection systems one after the other.

The global license would also have the advantage of breaking the fusional link in France between cinema and television, which only made sense in resisting American hegemony by guaranteeing film funding up until 2000, notably thanks to the obligation Canal+ had to cofinance films so it could show them exclusively before the other channels.[5] Downloading would be possible on a united platform four months after general release, as is currently the case with VOD.

In the southern countries, the ravages of piracy are more severe. All cultural products get pirated, including those of the South.[6] Piracy is often carried out by companies with ties to organized crime, which reaps considerable benefits from piracy. Many artists have joined together to ask their governments to stamp it out—for example, singer Rokia Traoré, who mobilized Malian artists in a peaceful march in February 2000, to no particular avail. She was also up against West African forms of socialization that do not recognize the notion of individual intellectual property. But it is less the artists' rights that are defended by the repressive interventions than the interests of traders and countries who ardently protect copyright, starting with the United States.

A communal funding mechanism would shake up media production internationally, but the countries opting for this would benefit directly from this free promotion of their culture and artworks. Moreover, many African artists are already registered on the redistribution lists of European, and notably French, royalties organizations, and would benefit from not having to wait for distributions. African bodies defending artist royalties could act as the rights-holders' representatives vis-à-vis bodies in the allocating countries, while a policy of support could be pushed

forwards in cooperation agreements. If they evolved in their way of seeing things, the international organizations could allocate the money they spend on fighting piracy to feasibility studies and support for global licenses in the South.

It is often forgotten that piracy enables everyone to access works that low living standards render inaccessible, and to such an extent that buying pirated works has long been rooted in consumer practices, spawning a powerful informal economy and jobs that often operate perfectly openly. All over Africa, stalls offer to copy CDs and DVDs, or sell industrially pirated copies. The video parlors like the one that Jean-Marie Teno shot in *Lieux saints/Sacred Places* (Cameroon, 2008) have become commonplace in both towns and rural areas (see 3930 for the Cameroonian example). As the film shows, the informal circuit can be a vector for film-lovers and attract a regular audience to African films (8412). In North Africa, notably, pirated decoders have broken the hegemony of state media and encouraged an opening up to the world. But piracy also encourages a standardization of tastes, crushing local productions in favor of Western products. The pirated products' sound and image quality is, moreover, often very poor, which led Tunisian director Nouri Bouzid to provide the informal network with high-quality copies of his films so that they would at least be viewed in better conditions!

In the South, as in the North, what is at stake, then, is surpassing piracy to facilitate access for as many people as possible to cultural works in conditions that do not undermine their production. This is the only way, as Ousmane Sembene put it, that "Africa's renewal will take place through culture" (3440). Rather than continuing to trot out outdated, repressive discourses, the reflection engaged around global licenses needs to be heard on an international level.

6.2. Television: A Trap, a Shark, or an Opportunity?

What will we wash the dirty water with?

—Ousmane Sembene

6.2.1. Ending the Flow Rationale

In the past, filmmakers and critics looked down at it: working for television was considered treason! Generally, its rationale is to broadcast, not produce, a singular gaze looking at the world. It was felt that shark-like television stopped viewers from

thinking and, in that, was radically opposed to cinema. It was this renouncing of critique that Jean-Louis Comolli condemned when he observed the rise in chronicling. The incessant flow of TV images—which, according to Médiamétrie, French people watched an average 3 hours, 32 minutes of a day in 2010 (an hour more in the United States and Japan)—is an escape, an "endless zapping of a present that nothing fixes, stops, repeats, goes back over. A presence-less present."[7] What is at stake for a critic, then, is to pick out and analyze objects from this consumer flow, from this "tipping into oblivion."

In this flow, Africa is presented in the North through an inescapable filter. The environment, economy, culture, and education are considered of no interest. In 2010 in France, 645 of the 1,500 subjects that focused on African news stories in thirty-six of the continent's countries concerned the World Cup in South Africa, 201 the dramatic presidential election in Ivory Coast, 147 the French hostage-taking in Niger, and 314 armed conflicts.[8] In documentary, Africa only enters the "discovery/travel" category, like the other continents, for that matter. The world is absent from TV screens. If it is present, the overabundance of commentaries fixes the vision more than it questions it. The critical stake henceforth is to question audiovisual objects for what they show, or mask, of the state of the world.

In Africa, Sembene used to say, "television serves as a rally for the head of state, which means that no one watches it. Our states only contain folklore and football. Our heads of state are scared of reflection, and even more so if a woman is doing the thinking!" (3440). Focusing on events deflects from taking daily problems into account. The abundance of images produced elsewhere plunges viewers into a self-dispossession. Fictions narrate the lives of other societies, and the heroes identified with are decentered. Yet the stake for television ought to be to mirror African societies and to testify to Africa's place in modernity (3970).

While some countries are still hesitating to invest in it, the television landscape has considerably evolved in the 2000s with the development of private television companies. They propose refreshingly diverse offerings and emulate public television stations. "Unfortunately, these media are facing difficulties, which can be felt in their programming," noted Rémi Atangana, director of a television-program festival in Cameroon (4413). They have barely benefited from the proliferation of TV and other screens. In a highly competitive context, they are creating more and more music shows and series (2716).

6.2.2. The Power of Series

All over the world, and in Africa notably, soap opera and series[9] appear to be television's new horizon, to the detriment of cinema movies. African series are emerging all over the continent, taking over from Brazilian telenovelas. In Burkina Faso, actress Mimi Diallo, lauded for her role as a strong-willed woman in *Kadi Jolie*, directed by Idrissa Ouedraogo in the early 2000s, recounts: "people used to schedule their rendezvous after *Marimar*" (2291). Today, it is African sitcoms that empty the streets at given times. They often have pedagogical overtones, but it is only really in South Africa that they are the object of market surveys beforehand and audience reviews after, in a logic of "edutainment" (3747). That, according to a September 2009 study, has not stopped nearly 80 percent of South African sitcom characters from having multiple sex partners while the AIDS risk that is ravaging the country is evoked in only 2 percent of cases. In 2006, in *Isidingo*, a series that started back in 1998, an HIV-positive character was seen for the first time, showing that it is possible to live with the illness. It was also the first series to portray a homosexual character, a mixed-race marriage, and a gay marriage.

While superheroes dominated series in the past, today's series' characters are like us. The characters are more important than the action, but that does not mean that series are realistic. Characters face a torrent of amusing or dramatic situations and have to overcome innumerable obstacles; as these more often than not take place in the domestic space, however, or in highly coded social spaces, a sense of familiarity pervades. We are nonetheless staggered by what these characters get up to, and become hooked; not only do we want to know what happens next (to which there is no end), but we fill in the blanks in the narrative. We find ourselves on the edge of our seats, imagining the missing details, the mystery surrounding certain characters that the best series manage to create. We experience series like a major novel: their organization into episodes and chapters inhabits us night and day. It is thus a relief to be able to share this tension. Communities of fans form, with websites and Facebook pages, where people share their evaluations of each character, so as, like them, to learn to live. Seriephilia has replaced cinephilia.

Series criticism cannot ignore the novelty of this novelistic approach, and ought to connect it to present-day evolutions. In the same way that the passage to the novelistic constituted a turning point in African cinema in the 1980s, allowing films to move on from the obligatory commitment to better testify to the postcolonial contradictions at play, the advent of series has taken over from film as a reference in

the popular relation to fictional images, and thus in dominant self-representation. The world shrinks to our world, but new forms of narration restore the questions of our time. From homosexuality to corruption or the environment, from social hierarchies to their racist extensions, the sociopolitical context forms the basis of a story that tirelessly reworks the confrontation of human weaknesses and the surpassing of them. This age-old repetition of truth's triumph over lies in both relationships between couples and social relationships eases and consoles the failings of a society that does not progress as fast. The triviality of situations anchors these little proxy victories in the human. In the series' circle of family and friends, the spectator symbolically shares reassuring commonplaces with his or her near and dear ones. As series are of many origins, spectators understand that, distance aside, they can unite with the entire planet in the rejection of negative forces. It is thus that conspiracy and plots often structure series' stories, translating their intrigues and strategies onto the level of the private sphere.

Designed for the television screen, series do not suffer in the same way that movies do when reduced to the small screen and at last have given television cultural legitimacy. Medium shots and close-ups highlight the intimacy of our relationship to highly voluble characters in confined spaces; landscapes do not work well on the small screen. But this restriction is not only geographical; our mental space shrinks too. Reaching up to a thousand times more viewers than a cinema movie, series favor a fantasized relation to the real in society. On their denial of social reality, they build a veneer of optimism. Women identify positive, assertive models in them; men experience defeats, but ultimately come out pretty well. The powers that be are ridiculed, but to no serious end; the endless twists in the narrative guarantee an opening of possibilities and give the strength to go on. Yet let that not mislead us—and that is where a critical spirit comes in—series in fact often promote toeing the line and conformity. The emancipation held up for women and youths more often than not fits nicely into conservative roles and espouses dominant models, while clichés about foreigners or homosexuals abound. It is in the innuendos, jokes, commonplaces, and stereotyping of characters or situations that the unhealthy power of a number of series made to please hides. As they perpetuate clichés, they limit the emancipation of those they claim to support, and lay the ground for violence towards foreigners when tensions surface.

6.2.3. An Anthropophagous Relationship

Following in the footsteps of cinema, certain American series in turn explore the founding myths of American society, questioning them in the present. This at times engenders fascinating work. While many African television dramas and series also address contemporary issues in their plots, the result is less probing. Not straying from the domestic terrain, or from love stories, the best work on political tensions usually denounces the rampant corruption present at all levels of society. Produced on low budgets, many of these television dramas adopt an aesthetic whose theatrical acting is accentuated by the fixed camera shots, linear montage, and alternation of dialogued scenes and journeys. The image is flat and lacking in perspective, the music dramatic and overbearing, and both metaphors and the off-screen realm absent. As these productions do not necessarily have television backing, and are distributed in cinemas where they are often a big hit, it becomes hard to distinguish between audiovisual products and cinema movies, as the evolution of film in Burkina Faso—host to the biggest African film festival—emblematically testifies. The selection of Boubakar Diallo's political thriller *Code Phénix* in the 2007 FESPACO competition caused some debate, but in 2009, wishing to testify to Burkinabè cinema, the festival again selected Missa Hébié's *Le Fauteuil/The Armchair*. The Burkinabè audience loved it, awarding the film the RFI Audience Award. Little did the purely television aesthetic matter, in which, accentuated by the wooden mise-en-scène, the crux of the film lies in the dialogues, made even more theatrical by the use of French. What did matter was living one's hopes, incarnated by this passionate student turned business woman without losing her soul, who, into the bargain, incarnates the determined, yet touchingly fragile woman faced with the uphill struggle of both her work and relationship. That the jury awarded the film the Oumarou Ganda Award for the Best First Feature Film was, on the other hand, more worrying, considering that this prize in theory awards a cinematographic perspective. Missa Hébié is indeed no novice: he made a career in television series, cowriting the twenty episodes of *Commissariat de Tampi/Tampi Police Department,* and directing the forty episodes of *L'As du lycée/High-school Ace*, which won the Best TV/Video Series Award at the same FESPACO.

The decision to award the European Union Award to Boubakar Diallo's tenth feature film, *Cœur de lion/Lion Heart*—a choice not appreciated by the EU representatives—posed the question of taking this award destined to defend European

values back in hand, reinstating the EU's own jury, its tasks having been delegated during previous editions to the feature film jury. Having been a member of the European Union jury in 2001 and of the FESPACO feature film jury in 2005, this differentiation struck me as a welcome move, the European Union Award—albeit a considerable sum—having become a kind of consolation prize, or the object of a compromise, for films that did not win a Stallion Award. Shot on HD with a 150 million CFA budget ($25,000), international funding included, *Cœur de lion* is set in the seventeenth century, and is not without a nod to its illustrious predecessors, such as Idrissa Ouedraogo's *Tilaï*. *Tilaï's* characters' universal depth is nonetheless replaced by a sentimental romance that starts most prosaically in bed when Samba's wife asks him to sell a cow so they can replace the bedspread! The descent into trivia is constant, thanks to the recourse to the genre film codes that made Diallo's previous nine films a hit. *Cœur de lion* is at the same time a soap opera and a historical-romantic thriller. The plot is little more than a picture book, as the Disney-style opening and closing of a book at the start and end suggest. All that remains of the deep-rooted cultural values of *Tilaï's* narrative are jealousy and consensual goodwill.

Code Phénix was already problematic. In it, a human rights advocate, clearly identified as the assassinated journalist Norbert Zongo, hatches a villainous coup d'état, while a virtuous judge fights to restore the power of a notoriously alcoholic president completely cut off from reality! In addition to its soap-opera aesthetic, the film conveys the unpleasant message that all politicians and the military "are a bad bunch," echoing populist discourse. Critical vigilance is thus primordial in the light of the disturbing incoherence of screenplays that yield more to the need to create plot intrigues than they offer spectators a responsible discourse. If the African critics' *Africiné* bulletin, published daily during a training workshop at FESPACO since 2003, entitled its special report on cinema and television "An Anthropophagous Relationship," it was indeed in direct reference to the shark-like television that critic Serge Daney evoked in his time to stress the extent to which television norms and rationales vampirize cinematographic creation: space is reduced to fit the small screen, dialogues replace metaphors, and the imagination is fixed without allowing the viewer any distance. A work has to please at all costs. Being an audience hit has become a criterion of cinematographic success that certain journalists and funders stress today as absolute. "A film's appreciation does not depend on the number of people who go to see it," Abderrahmane Sissako pointed out during a panel on popular versus auteur cinema at the same FESPACO. "The artist's role is to render

a reality visible and comprehensible," he added. "Every society needs mirrors that enable it to question its own situation" (8467).

It is the mirror's deformations that the critic is attentive to. But a deformation can in itself be a refreshing questioning, like the reversed polygamy in *Une femme pas comme les autres/An Exceptional Woman* (Burkina Faso, 2008), by Abdoulaye Dao, who is famous for his television series such as *Quand les éléphants se battent/ When the Elephants Clash* (2006). Here, a rich woman decides to take co-husbands! Here too, however, the methods are questionable (infidelity used to teach a lesson), ultimately conveying a retrograde image of the woman. The acting is hammed up, the sound catastrophic; the mise-en-scène runs out of steam as quickly as the screenplay. The film did the rounds of festivals that do not hesitate to afford highly uncinematographic TV dramas the status of cinema. Let us be clear: there are excellent TV dramas that are real works of art, and many mediocre films. The key criteria of a good film remain what it elicits in the spectator, or whether the emotion that the film conveys rouses the spectator's desire to assume his or her place as a citizen and responsible person. But the emotion does not lie in the message; it comes from an aesthetic that turns a discourse into a work of art. It is a question of mise-en-scène, metaphor, pertinence, vision of the world, imagination, and the actors who convey it.

6.2.4. The Festival Question

The same issues pertain when it comes to the artistic selection of festivals. This question was at the heart of a stiff debate relayed on the *Africultures* website in 2011 between award-winning filmmaker Mahamat-Saleh Haroun, who called for a boycott of FESPACO (10002) and its then director general, Michel Ouedraogo (10007): in its demand for quality, was the biggest African film festival contributing to a renaissance of filmmaking trapped in its estrangement from its immediate audience, or ratifying it? The question was, in short, of whether FESPACO should continue to support an auteur cinema that addresses both the world and Africa (and thus promotes its voice in the world), or opt for an inward-looking cinema. And thus, ultimately, whether FESPACO should opt, through cinema, to develop a critical spirit, or conservatism (10009). In reference to the anthropophagous relationship they had already evoked, the Federation of African Critics published an editorial in their *Africiné* bulletin on March 4 at the 2011 FESPACO entitled "FESPACO: An Editorial Urgency," stating: "Far be it our wish to denigrate these hit films, and it is

refreshing to see audiences responding to what takes place on the screen to this degree; laughter bonds the audience with a benevolent reflection of its own realities or dreams. But it cannot be ignored that the mise-en-scène and direction of the actors are often the poor relatives in this kind of cinema. The risk for the festival is that the most demanding or polished films end up feeling that they no longer have their place here and forsake Ouaga in favor of other rendezvous, bringing an end to a long and prestigious history."

FESPACO has become a huge machine that struggles to remain focused on cinema. That is the crux of the debate that crystallized in the Haroun-Ouedraogo confrontation. We should nonetheless avoid the opposition between auteur and popular cinema. Haroun indeed pointed out in our interview that in the history of cinema, popular cinema does not mean poor quality. In his article "Une promesse non tenue" ("A Broken Promise"), published in *Cahiers du cinéma* in February 2011, he identified a deliberately maintained marginality in the confusion between video and cinema, as if Africa had no voice to contribute to the world, and denounced FESPACO as an "audiovisual festival." To him, the root of the problem comes from the fact that funding "does not worry about accompanying auteurs, but encourages the production of African images." He called to "put culture, training, art history—in short cinephilia—back at the heart of our cinema" and thereby end its marginality.

It is thus not a case of highbrow cinema against a cinema of the masses, but the eminently critical question of film's reach, which is a question of both content and aesthetics. The debate is not about being condescending to anybody. Sylvestre Amoussou's film *Un pas en avant—les dessous de la corruption/A Step Ahead* (Benin), which was very officially presented at the opening of the 2011 FESPACO, is an eminently respectable film, like all his previous works. The choice of opening film is a delicate exercise for any festival, as it announces the tone to come. While sometimes a homage, it is usually the moment to highlight a direction, a perspective, or an opening. Festivals generally avoid demanding works, choosing instead to celebrate the magic of a cinema that manages to unite an audience without infantilizing them. The choice to open with Amoussou's film was baffling, however, its reach being as limited in its form as in its reflection. Despite its cast of a number of excellent African actors and its upbeat tempo that mixes suspense and chases, this tale of an apolitical shopkeeper who inadvertently finds himself caught up in a humanitarian aid scam struggles to mobilize. Corruption is denounced, but the film does not explore the complexity of the real, only a seamless story woven so

that the good, upright shopkeeper finally triumphs over the baddies. In portraying a simple man turned hero, Amoussou sincerely seeks to give us confidence in our ability to change the world. But this confidence cannot come from a discourse alone, albeit one turned into a movie. It can only be built in a very real combat in which we learn to overcome our fear and seek to understand. It is not certitudes we need then, but on the contrary, incertitudes to resolve for ourselves. Yet the film offers only certitudes, both in its discourse and its slick television drama feel in which, losing all depth and all perspective, the image conveys only what is shown, rather than suggesting anything that might enable us to enter it. It composes the music, as it were, but does not let us perform it. If audiences did respond to the film, it was more through their empathy for a tender hero than through any emotion, a dimension that was completely absent from the film.

At the time of writing, it is impossible to foresee the coming chapters that history will write in the countries effected by the Arab Spring, and thus the future of the Carthage Film Festival (JCC), FESPACO's historic sister biennial festival. As with FESPACO, gaining autonomy from the state would make it possible to free both festivals from their control. But even under Ben Ali, Carthage had the advantage of mobilizing young people and favored debates more, notably after the documentary screenings. The Tunisian short-filmmakers' bubbling creativity also offered a renewal that has been cruelly lacking at a FESPACO cut off from the countries' realities, as the 2011 edition demonstrated, which took place in a carefully neutralized bubble at a time when revolts were brewing across the country (10009). This renewal did not signal the triumph of audiovisual over cinema, but rather the advance of cinema as a means of expressing the gut feelings of a country on a tight leash. Even if directors turned to digital to alleviate funding constraints, or turned to a cinema funded by advertising contracts or clips, this revival—even though at times tempted by exercises in style—did not adopt the reductive norms mentioned above and was thus bursting with creativity. Whereas FESPACO persisted in limiting its horizons, both cinematographically and in terms of places to socialize, the JCC was, in the limits of the possible and in a delicate confrontation with state control, a work of resistance.

6.2.5. Cracking Television

> You can't cross a river without getting wet.
>
> —Kabyle Proverb

This critical appraisal of television works begs to be countered by worthwhile products. They do exist. In the United States, some of the most interesting directors have migrated from Hollywood to the pay cable channels that offer them opportunities they no longer had. They also attract artists from the South. It was thanks to HBO that Raoul Peck was able to make *Sometimes in April*. In France, he not only worked with ARTE on *Moloch Tropical*, but also directed several-episode television dramas for channels such as France 3 or Canal+ on subjects not necessarily expected from a director from the South (*L'Ecole du pouvoir*, *L'Affaire Villemin*). Since *Lumumba* in 1998, all his films have been produced by television stations. "I've always felt," he said during his master class at the Apt film festival, "that you have to make the most of doors that open, but transform what you're given into something personal. That was my condition. And within all these institutions, you always find people who fight." It is possible for television to marry content, form, and professionalism while also reaching out to the audience. That is to be defended. "It enables," Peck continued, "things we can't do in cinema, and increasingly less so because dominant cinema has become a cinema of profit, of commerce, in which the content is totally subjected to the ability to make money."

Television as a means of addressing an audience that cannot be reached in niche cinema: that is the rationale of a popular cinema that seeks to "open a little window," to borrow Peck's expression. Or in other words, as Leonard Cohen sings in *Anthem*, to "ring the bells that still can ring"! But that still supposes slipping in through the back window, of pirating television as it were, given that its overall logic is so subjected to audience ratings. It is clear that ARTE sometimes enables auteurs to find a slot, as was the case for *Sexe, Gombo et beurre salé/Sex, Okra and Salted Butter* (Mahamat-Saleh Haroun, 2007), a film about the compromises of integration. Funny and light, avoiding both cliché and flagrant exoticism, the film inscribes France's African population in a positivity that is contrary to the reductive image of the immigrant in films such as *Black mic-mac* (Thomas Gilou, France, 1986). Rather than a population of wheeler-dealers, Haroun portrays an interculturality that excludes no one, not even homosexuals. This not falling into so-called funny clichés is not the least of the film's qualities (7683). The same alchemy operates

in Arnold Antonin's *Le Président a-t-il le sida?/Does the President Have AIDS* (Haiti, 2006), an unpretentious educational film that nonetheless is gripping and upbeat, mixing romance and social issues.

Given the mediocrity of Haitian productions, which are a big hit with audiences longing for their own images, Antonin asked, in the columns of *Africultures*: "Yet what if Haitian cinema fundamentally is these video fictions that continue in the vein of popular farce or vaudeville, with all their technical and aesthetic failings? And what if this primitive cinema, which is naive, kitsch, and often inspired by stereotypes and slushy stories, wasn't a dud, but the prerequisite for a popular mass cinema to flourish?" (6821). Wrong! We shall come back in detail to the Nigerian example that proves the contrary. "What we see in the Tana cinemas are audiovisual products, definitely not cinema. This confusion in terms is dangerous," answers Laza, head of the Antananarivo Short Film Festival (4414). The creativity that allows people to break out of their ghetto and take their place in the world does not emerge from an ocean of mediocrity. It is only when auteurs appropriate a medium—whatever that may be—that this creativity can assert itself; only when they "use it without losing their souls," as Dani Kouyaté suggested (2293). Asserting this does not mean falling into the *politique des auteurs*, or auteur policy; it is to believe in cinema as a singular vision of the world inscribed in a fitting aesthetic experimentation. That requires an effort that is a far cry from amateurism, imitation, or pure technique.

Funds are needed to pay for a crew's work—this alliance of technicians and actors who together put their expertise at the service of an auteur's vision. It happens, of course, that some zero-budget, unclassifiable works do make it, made in a "guerrilla filmmaking" logic. The example of Djinn Carrénard's *Donoma* (Haiti, 2010) shows that by mobilizing the efforts of an unpaid team, and thanks to a method that mixed making-do, intuition, and improvisation, a good film is possible—but also that, without its auteur, it would not exist. And while it was indeed the whole *Donoma* crew who toured France to get the film seen, above all Djinn Carrénard remained the one who answered the questions (10491). It is possible to make one "zero budget" film, but not two, and definitely not three! It is exhausting and limited, because while actors are willing to jump on the bandwagon to gain visibility, or in the hope of a share of the earnings—a phenomenon not unknown even among certain major Hollywood actors, who have also started shouldering a film's risks—technicians are harder to mobilize. So much so, even, that Carrénard formed the entire technical crew alone (9526). The different versions of the film arose from the fact that there

was initially no professional editor. Being the director of a one-man show is more a response to a lack than an asset. A new culture is nonetheless possible, in which the lack of means is no longer considered an insurmountable handicap. Beninese Jean Odoutan has proved so in a series of shoestring-budget films. In South Africa, Darrell James Roodt, who made big budget films in the past, now makes films for next to nothing, such as *Meisie* in 2007 or *Zimbabwe* in 2008. "DV8 was the original inspiration for this type of filmmaking," he stated. "But even then, they were talking in a million of ranges; you know, possibly to make films with no money" (7684).

What is rare is talent, and that is what makes the difference. But in this logic of guerrilla filmmaking, talent rests on a great freedom of tone in the acting. Collectively depending on one's own resources and thus sidestepping all forms of control is playful, euphoric, joyful. Improvisation and the mobilization of bodies brings a work to life, and it is this life that no show can capture that constitutes its force. Mobility and a small crew do the rest. If digital has thus opened up possibilities in terms of freedom of production, it does not—or not yet, at any rate—resolve the question of distribution, and the *Donoma* crew could spend years touring and campaigning on the streets to get people to come and watch the film. For that is indeed the crunch: while people continue to produce, distribution has become the stumbling block in independent cinema. Television thus remains an absolute hope for filmmakers, both to fund and distribute their films. But there too, avenues for a questioning, visionary cinema are closing. Even at ARTE. What happened to Michael Raeburn has become a familiar refrain. He first of all envisaged *Zimbabwe Countdown* (Zimbabwe, 2003) as a documentary report, thinking he would be able to sell it to a television station. The English-speaking channels wanted it to be more sensational; the French-speaking channels were not interested in this country they did not know. Then ARTE told him it was too much of a report format. "So I re-edited it to include the personal elements that I hadn't dared include, to make it more sellable!" (3044). The film was thus enriched with his own story and his implication in this country that is his own. Pierrette Ominetti, head of the Documentary Unit at ARTE France declared: "The slot hasn't been reduced, but our angle has changed. ARTE France is now building its signature image on historical documentaries, and less on works based on an auteur's point of view."[10]

This evolution is related to the fact that viewers increasingly struggle with programs that require concentration: "Television dictates a particular kind of relationship to the image, which is floating and detached," Michel Reilhac notes.[11] Even ARTE now dubs rather than impose original-language subtitled versions. No

French version, no hope: "The major difficulty for a film that's not in French is that it excludes us from television," producer Serge Zeïtoun said back in 2003 of Flora Gomes's *Nha Fala* (Guinea-Bissau), a musical that could have had a fine television career (2332). Increasingly cautious, the TV companies now often wait for a film to go on general release before deciding whether or not to buy it; they test the film's reception and avoid all risks. The stake is, then, to renew the vectors of audience interest that also create a space of reflection and action. But can we satisfy ourselves with a television space limited to niches carved out thanks to the intermittent understanding of those in charge who are open to risk and willing to defend it? Are there strategies that could facilitate the multiplication of transgressive and resistant productions? Should we believe in the possibility of an alternative, of autonomous—or even separate—spaces, of globalized rationales?

Here lies the altermondialist illusion of the possibility of another world according to models in the making, like nineteenth-century utopian socialism: theoretical girders disconnected from the meaning of history, as Marx reproached; an improbable future and negation of the present. Resistance from within is more preferable, even if this is exceptional and the feat of fierce struggles; not victims, then, but living players, who do not claim to reinvent the world, but to make it evolve from within through pertinent strategies of contagion, shiftings, and inclusion of the margins, of performative subversions and confidence in the weight of the ephemeral. As we have already seen, this way of creating situations implies abandoning the certitude of a brighter future, and mastering the future so as to embrace the unforeseeable. The objective is no longer autonomy in art, but to be in keeping with the context, rooted in the real, not necessarily to produce a realist work, but to explore, rather than simply demand, the possible changes in it. The force of works of resistance lies, as it does in film, in their singularity; appropriating television does not signify revolutionizing or taking it over, but finding the necessary supports and ensuring the success of this delicate alchemy that roots a work in life's realities rather than in its spectacle, in the practice of the political rather than in its theory, in complexity rather than superficiality.

The terrain is difficult, especially in Africa, where the bridge linking cinema and television remains to be invented. Directors could say they work in television to fund independent films, but the passage from one to the other is difficult, as producer Bridget Pickering confirms talking about South Africa: "Television work is not paying you enough so you can say, one television project, then for three or four months I will try to develop my other film" (7961). But anyway, it's still rare

for an African television company to be willing to pay to broadcast a film! That is the result of bad habits stemming from audiovisual cooperation agreements. In the Francophone world, CFI and TV5 give television stations free packages of TV programs that they buy up cheap for that purpose. CFI's restructuring in 2009 limited the effects, but did not do away with them. That long dispensed the African channels from investing in production. To limit the adverse effects of this, efforts were made to help restructure advertising airtime in order to generate resources that could be devoted to local production, but this has not so far been conclusive (5829).

Coming technological evolutions in television broadcasting may add new elements to investing in the different stages of production. By becoming multimedia groups, television companies will be able to delinearize their programs, offering them free for a week on the Internet before then charging a fee. Their offer will become that of collector DVD bonuses, with interviews, cut scenes, analysis, "making ofs," and chapters so that a film can be watched in parts. Interactive debates are being envisaged. The edges of films are being cropped to make it easier to watch them on cell phones. Different versions will be available to watch on the Internet. A multitude of web applications are in preparation, which will accompany a new way of watching television: it will be possible via networks to fragment and share images with friends, images adapted so they can be seen direct or later. The TV viewer is thus becoming an actor and not a simple consumer. With web-connected television, information threads, video clubs, content from movie sites competes with established programs. In their need for content, web operators have thus also become investors. Google and YouTube already coproduce series.

It may be feared, as it may be hoped, that like all technological evolutions, these changes will have positive and negative effects on auteur cinema. They may represent extra opportunities for distribution, but also a generalized dumbing-down into consumer products; the equation is unlikely to fundamentally change. And there too, it is creativity that will make the difference when cracking television.

6.3. The Ravages of the Nollywood Myth

6.3.1. Market Rule

In 2002, in an effort to evaluate France's film cooperation policy (finally to no end, because the intention was simply to confirm decisions already taken), the Ministry of Foreign Affairs sent me as an expert to Lagos to see whether the Nigerian home

video model was exportable, and thus if it was really a model. My conclusion was no (2764). It must be said that at this time, the sector was in crisis, faced with falling sales. After a tacit agreement, production had stopped for three months to siphon off stocks in order "to clean up the sector." Then, as with every not-thought-through crisis, it was back to business as usual. Today, with the rise in piracy and audience demands for better quality, there is a fresh crisis.

What is the situation in Nigeria? Nigerian—or essentially Yoruba—cinema's development came to a halt with the end of the oil boom, the deterioration of the trade balance, and the rise in the value of the dollar as the naira fell. Celluloid film production costs became prohibitive. With the scarcity of available currency following the introduction of the Structural Adjustment Program in 1986, no more films were imported to, or shot in Nigeria. The military dictatorship, moreover, drove filmmakers abroad, who tried their luck in London or New York. Finally, rampant criminality and corruption created so much insecurity in the city streets at night that people were forced to stay at home. Conditions were ripe for home video to take off, an ideal means of entertainment without the risks. Cinemas shut one by one, or were taken over by the churches that also develop in times of crisis and loss of bearings.

In this context, and as American action movies remained the staple of satellite TV, particularly in South Africa, three types of film emerged to satisfy audience demand. On the one hand, those which draw on its cultural roots, essentially by modernizing legendary tales. Drawing on the Yoruba cultural wealth, and shot in this language, these films portray traditional hierarchical structures, while laying on the cheap special effects, and resorting to witchcraft to explain social ascension in a society where it remains the prerogative of the dominant classes. These are known as *juju videos*, from the Yoruba word for "magic." Secondly, those that rework the fears generated by urban violence, which mainly depict clashes between vigilante gangs in the absence of an effective police force. They are shot in Pidgin English to target as wide an audience as possible, and are mainly produced by Lagos-based Igbo. Finally, those that offer an endogenous take on social or romance problems. In addition to the innumerable moralistic comedy-of-manners and social dramas found all over the country, Bollywood musical–inspired films shot in Hausa and produced in the north in Kano explore the consequences of traditional practices, such as forced marriage, in moralizing melodramas.

Nigerian videos seem less incongruous to African audiences than to European ones, used as they are to the importance of popular theater. They are indeed deeply

marked—as were the major Nigerian films at the time of Ola Balogun (*Ajani Ogun*, 1975, based on a play by Duro Ladipo), Hubert Ogunde, or Ade Folayan—by the Yoruba traveling theater tradition, with highly archetypal characters and theatrical narrative constructions. Whereas these troupes had already been shooting videos of their plays with growing success since 1988, the birth of the Nollywood phenomenon is attributed to an Igbo businessman, Kenneth Nnebue, whom the playwright and director Ishola Ogunsola asked to record a Yoruba play, *Aje Ni Iya Mi*, in 1991. Nnebue had a cargo of blank Taiwanese VHS cassettes to hand and had heard of the profits made from selling prerecorded video tapes in Ghana (notably *Zinoba*, which was a huge public hit in 1987). In the absence of movie production, Nigerians had turned to sentimental television soap operas, which had given rise to a veritable star system. But financial conflicts opposed producers and the television stations, and these soaps had disappeared from the screens. While the national television started replacing them with Mexican soap operas, Nnebue, bolstered by the success of his first production, gathered a cast of TV stars to shoot *Living in Bondage* in Igbo in 1992. Directed by Chris Obi Rapu, the film tells the story of a man who joins a secret cult, kills his wife in a ritual sacrifice, gains enormous wealth as a reward, and is afterwards haunted by the dead wife's ghost. It was an immediate hit: figures vary from 200,000 to 750,000 cassettes sold, depending on the source. *Living in Bondage II* was shot several months later. By 1994, the censors board listed 177 films. VCR sellers from the Idumota central market district in Lagos, who had the necessary equipment to duplicate the cassettes, made their fortune distributing them.[12]

These films are distributed directly on video, without being released in the cinemas, which dispenses them from the technical demands of quality cinema. They are produced in a completely artisanal manner, with cheap or even amateur equipment. In a pure logic of production where no one worries about plagiarism, the quest for profit has always been, and remains, the main impetus. Video production, which supplies a multitude of video parlors and first VHS, now VCD sellers[13] all over this country of 140 million inhabitants, is funded, with no other backing than the returns made, by those who distributed the video films: the "marketers," or traders, who in general have control over the editing and contents. In Nigeria, people say that obtaining precise statistics is like trying to squeeze blood from a stone, but the number of feature-length fiction films registered at the censors board exceeded 1,000 in 2004, reaching 1,711 in 2006, and 1,770 in 2008 (with a maximum of thirty or so documentaries a year).[14] Many films are not even presented to the board, but

given the abundance of production, the expression "Nollywood" (from Nigeria and Hollywood) took hold. This incredible success among a wide audience made the marketers rich, but the abundance of productions quickly made it difficult for a film to be profitable, reducing budgets even further (on average, approximately $17,000) and diminishing quality.[15] One of the biggest recent hits, Kunle Afolayan's *The Figurine* (2009), about the repercussions of a statute that grants seven years' happiness, but not a minute more, cost 10 million naira ($54,200). Even if the dramatic intensity of the screenplays means that films captivate their audience, by 2010, audiences were growing tired of overly repetitive products—the systematic use of the same old recipes—and a staggering mediocrity: flat, poorly lit images, chancy framing, pedantic camera effects, series of short scenes strung together in highly theatrical narrative constructions, ham acting and vociferation, endless dialogues and scenes, terrible sound quality, incoherent montage, thundering music, nonexistent mixing and color correction, and so on. Production fell to some twenty feature films a month, and the average number of VCDs sold per film from 20,000 to 10,000. This informal commercialism ignores films with any artistic ambition, even if voices are speaking out to improve quality in order to target international markets previously limited to the Nigerian diaspora. For, beyond special programs that seek to shed light on the phenomenon, festivals outside Nigeria only rarely screen Nollywood films.

This question of quality is a niggling one, but it is only thought out in Nollywood in terms of the market. *Tsotsi*'s (Gavin Hood, 2005) winning of Best Foreign Movie Oscar got the Nigerians dreaming: this South African film could just as easily have been set in the poor neighborhoods of Lagos (4534). The accent has thus been placed on technical quality. The historic producer Mahmood Ali Balogun shot the romantic comedy *Tango with Me* (2011) on celluloid, using an American crew. Two years were spent on the screenplay, five weeks shooting in a country where shoots generally last less than a week; superstar Geneviève Nnaji played the lead role, and the budget totaled $217,000, funded by producing films for NGOs. Jeta Amataa, for his part, managed to seal coproduction deals, like for example in 2011 for *Black Gold*, a film about corruption and the petrol companies' ecological destruction of the Niger Delta. When he shot *The Amazing Grace* in 2005 about a slave trader's redemption (the first film shot on 35 mm in twenty-six years in Nigeria), he was only thirty-two years old, but already had over forty films to his name! Yet these films circulated little outside Nigeria. The issue is not a technical one. The International Film Forum held each year by the ITPAN (Independent Television Producers Association of

Nigeria) in Lagos invited the eminent playwright, writer, and lecturer Professor Femi Osofisan to introduce the debates. He made no concessions, describing video as a continuation of popular traveling theater (4533). Fascinated by a phenomenon "that began almost by accident," without government or foreign backing, and capable, with ridiculously tiny budgets, of displacing both Hollywood and Bollywood, he analyzed its profound ambiguity: "why this unceasing preoccupation with juju, this relentless celebration of dark rituals and diabolical cults?" No one can prove it, but everyone believes it exists. In hyperbolic dramatizations, the films portray "grotesque murders and cacophonous chants and bizarre incantations," promoting superstitious customs rather than participation in social struggles. As for those wanting to set themselves apart, they replace representations of brutal cults by a prudish Christianity, or as Osofisan adds, a "mythology . . . imported from abroad simply replaces the barbaric local variant. Tarzan is reborn, only this time in black skin . . . the filmmakers themselves are blissfully unaware of the racist and cultural implications of this fare they offer to the public!"

If we can put aside our curiosity or excitement about the Nollywood phenomenon of endogenous productions finding their audience, the essential critical question is this: what are the consequences for society of the mythologies developed, but also the escalation of violence portrayed to remain competitive? While the board of censors rates most of the films as adult-only, which prevents them from being shown on TV, the fact that they are viewed at home frees the films from these public media restrictions. While they thus more easily tackle contentious subjects such as corruption, religious fanaticism, or social scourges, they are full of traumatizing scenes of murders, suicides, torture, rape, incest, infanticide, hostage-taking, and so forth. Moreover, many films encourage an inferiority complex vis-à-vis the West, exacerbating cultural alienation, and reduce women to their so-called diabolic nature, without questioning patriarchy. In a country where crime is rife and intercommunitarian conflict particularly brutal, it is highly problematic to present sacrificial rituals (notably of humans) as effective. While the producers assert that this is to demystify, the films' lack of aesthetic distancing and the cruelty of the images means that audiences take them at face value, these rituals being presented as a means of achieving what one does not have (wealth, love, marital happiness, social success, etc.), but also of handling problems of jealousy or polygamy. The criminal nature of the acts represented is rarely highlighted (3439). The films are constructed on fabrications based on rumors surrounding the mysteries of life, illness, sterility, or our powerlessness before the loss of our nearest and dearest.

Religious influence means there is no nudity, but on the other hand, sexuality is omnipresent, stylized, from dancing in bars to the evocation of the multiple transgressions that the scenarios forge, or even in the ostentation of wealth or the violence that explodes all limits.[16] What can be hoped of a film production conceived "as a means merely of . . . raking a quick profit . . . and so cannot be bothered by the larger aesthetic or ontological dimensions," Femi Osofisan asked, while advising filmmakers to draw on the considerable literary wealth of Nigeria's novelists and playwrights.

Little has evolved since, other than Nollywood organizing its own promotion in grand galas and widely mediatized awards ceremonies, its star system benefiting from the many magazines devoted to it, and this industry, which is said to have been worth 600 million dollars in 2010, invading and destabilizing practically all the sub-Saharan markets with its aggressive dumping and marketing practices. Private television companies in various countries broadcast Nigerian films, and the poor-quality dubbing is sometimes carried out by the pirates themselves! This success with no outside backing is a powerful source of national pride, celebrated in most filmmakers' statements abroad. "For the first time, our films are not shot for Europeans, but tell the African truth," declared producer Teco Benson in Cairo (8197). "I'm proud of Nigeria," Jeta Amata told me when we discussed Nollywood and his film *The Amazing Grace* (5751). But this film unoriginally screens a desperately dualistic scenario of good versus evil, in which the dialogues ram home the moralizing message, and develops a truly Hollywood vision in which the good white guy, shut away with the slaves, teaches them English (4514). The issue is not to oppose the North and South, but to question the quality, the workings, and the social impact of the cinema produced. It is understandable that Nigerians are proud of the success of the films they produce when the country is continually discredited by corruption, banditry, interethnic and religious conflicts; but it is important to question this national reflex in terms of the films' impact on the younger African generations.

6.3.2. Fascination and Imitation

Without any form of critical analysis, many young sub-Saharan African filmmakers laud Nollywood as a postcolonial response and aspire to this autonomy. It is here too that Nollywood is wreaking havoc, not through the endogenous economic model it represents, but through the popularized confusion among Nigerians themselves

between anticolonial cinema and national cinema, with this model transforming into something inward-looking, rather than being open to the world. Postcolonial cinema is a political stance that allows solidarities beyond frontiers and identities among all those who share the fight against dominant universalism. It is not about the territorial authenticity of "an African truth" against "a European perspective," both terms remaining impossible to define. The simple fact of producing without outside funding is not a truth unto itself, and this autonomy only all the more compellingly re-poses the question of what a film mobilizes in a viewer when there is no longer a confrontation with an alterity. The lack of distribution, and thus of outside reception, reinforces the danger of getting trapped in conservatism. But rather than being aware of these dangers, certain young filmmakers simply spin a discourse against a so-called manipulation or domination, rather than further exploring the paths of introspection, in the sense in which Edouard Glissant reminded us that "this intimate being is inseparable from the future of the community."[17]

It is this facile victimhood that encourages filmmakers pumped up with pride in an indeed undeniable industrial accomplishment, but who only concede the need for technical improvements. Over and over again, they position cinema under market rule. We need to demystify Nollywood: we have seen the Nigerian political, economic, and paradigmatic contradictions that this phenomenon was born out of, and the role that it plays in that society. A connection with challenging Nigerian filmmakers who work on an international level has not formed. Nollywood's success is purely mercantile and spills beyond its borders, crushing artists in other countries. How can Djingarey Maïga continue to make quality entertainment films in a Niger invaded by Nigerian Hausa-language productions? The sociological workings, tendencies, and categories identifiable in the Nollywoodian phenomenon do need to be studied, but Nollywood does not represent a cinematic model for Africa or for the world, either in its training processes or the aesthetics it develops, and even less in the way its scenarios explore social issues.

So long as they are not wearing their critic's hat, both filmmakers and funders are fascinated by Nollywood's audience success. A national cinema is not forged "against" the rest, but incarnates the contradictions at play in the construction of a nation; in other words, this famous national narrative that populations seek as they unify in all their plurality. From *October* to *Gone with the Wind*, the national narratives have been revolutions or civil wars, where one world is supplanted by another. For films to convey something new, they too have to testify to or convey rupture.

Today, Nollywood is in a transitional phase and is trying to reinvent itself to reconnect with its market. "We've gone around festivals and we've come back empty-handed. We want respect, and to get it, we've got to improve quality. So people are beginning to rethink," commented director-producer Victor Okhai (10299). That means distribution in the multiplexes that have reopened in Nigeria. *Ije: The Journey* (Chineze Anyaene, 2010), a crime story about two sisters, shot in Nigeria and the United States with the two biggest Nollywood stars, Geneviève Nnaji and Omotola Jalade Ekeinde, came just behind the box-office record *Avatar* in the Silverbird cinemas, and was Nigerian cinema's second-highest-grossing film. "Before, if you put a popular face on a poster or the sleeve of the CD or DVD, people would buy it. . . . Now people want to know if it's a good story, with great actors, scripts, and techniques," Okhai added.

The progressive opening of multiplexes in Nigerian towns restores the perspective of box-office earnings: *Ije* thus grossed approximately $240,000 in four months. That opens an industrial perspective, which is essential. For if Nollywood is not a model, it is also due to the inherent informality of its mode of development. Indeed, its artisanal and uncoordinated character guarantees the spontaneity and dynamism of the sector and stops political or religious powers from controlling it, even if many churches do invest in films to convey their messages. But internationalizing Nollywood film will require a lasting structuring of a film industry, which in turn requires a conducive cultural policy. Even though they now only represent a small proportion of a film's earnings given the multiplication of modes of distribution, movie theaters—whose importance as a unifying social force we have seen—remain an essential perspective. It is the closure of cinemas that causes the fall in quality film production in Africa, and not the contrary. Under the combined effects of declining purchasing power, economic precariousness, the rise in religiousness—which undermines libertarian expression—increased competition from collective modes of watching television, the intensive pirating of films, their generalized sale on the streets, oversized cinemas far from residential areas, Africa is the only continent where cinemas are losing spectators and closing en masse, to the point of disappearing completely in some countries. Everywhere else, after a forty-year decline, cinema-going has been rising since the mid- and especially late 1990s, and backing production.[18]

While Nollywood may not be an exportable model, nor one to imitate, the element of resistance in the autonomous production of one's own images is not to be underestimated, and that is the reason for the fascination that Nollywood exerts

pretty much all over Africa. It has opened up possibilities. We are thus witnessing the emergence of minority cinema forms, which are imposing their language and culture. Forty or so Tamazigh-language films are now being shot every year in Morocco and distributed locally on video or in local festivals, characteristic of these low-budget productions (4698). Amateurism remains the norm—like in Madagascar, where, with Malgache-language films that cost on average 14 million ariary ($6,000), video tends towards quantity rather than quality, but has nonetheless relaunched filmmaking (4359, 4414, and 5775). In certain regions, such as the African Great Lakes, effervescence is such that training initiatives and productions are springing up left, right, and center (3882). But the Nigerian lesson is often taken literally; Cameroonian Narcisse Mbarga, for example, has understood the recipe: "You need action, money, sex, and violence if you want people to like it" (3524). In Kenya, the term "Riverwood" has been coined to describe the spontaneous production of local language videos, whose marketers are concentrated on River Road in Nairobi. Production remains informal to escape taxation. With two to four features produced a month, these comedies, musicals, and serious dramas flood the market. Like Nollywood, Riverwood has encouraged others throughout East Africa, with mixed results, from which sometimes emerge films whose screenplays save them from a mediocrity that is not just technical or aesthetic, but also due to the moralizing good intentions (7003). Bob Nyanja's *Malooned* (Kenya, 2007) stands out from the rest. A man and a woman, the latter due to get married on the Monday, get locked in the restrooms of a skyscraper all weekend. She is Gikuyu and he is Dholuo, two rival peoples. Their initially aggressive relationship inevitably improves. Released in Kenyan cinemas, the film only garnered 2,000 spectators, whereas in the same period, the U.S. blockbuster *Spider-Man* drew ten times more in three days. About 2,500 DVDs of the film sold in three months. Bob Nyanja refused to sell *Malooned* to the South African satellite channel Africa Magic, which only offered him $1,200 for a three-month license. He did, however, sign with the Kenyan channel Citizen. Moreover, Pretty Pictures International agreed to buy the film for $26,500 to show it at Sundance and Berlin after redoing the soundtrack and editing the film from 115 minutes down to 95 minutes.

Just like everywhere else, young African filmmakers cannot circumvent reflection on the pertinence of their content and the adequacy of their aesthetics. In other words, they cannot avoid critical questions. In addition to the questions posed by short films, and of course the films of leading filmmakers, they would gain from dialoguing with the video artists emerging in various countries and their diasporas

and who, as artists engaged in a political vision couched in radical aesthetics, offer a contemporary vision. We already cited the Moroccan Mounir Fatmi in chapter 1.2; one could also mention the Egyptians Khaled Hafez, who has Anubis, the god-dog of the dead, wander the country's cities; Waël Shawky, who films puppets to revisit the Arab crusades; or Amal Kenamy and her animations. Or the Algerians: Zineb Sedira, who confronts her parents' memory (9846, 10379, and 10389); Mehdi Meddaci, who shows an immersed body between two shores; Kader Attia, who puts Algerian and French ways of life in perspective; Soufiane Adel, who goes looking for his father in bistros; Katia Kameli, who studies a transcultural language in nomadism; Adel Abdessemed, who marries critical vigilance and poetic contractions to represent the authorities; Amina Zoubir, who goes up to people to provoke their reactions; and so forth (9400). Or again Rina Ralay-Ranaivo from Madagascar, who shares sensations; Malian Bakary Diallo, who uses lemons to represent people fighting for democracy; Beninese Dimitri Fagbohoun, who questions illegal immigration or the rise in revolutions; Cameroonian Em'kal Eyongakpa, who constantly questions the obvious; South African Brent Meistre, who, following his country's roads, questions its directions; Kenyan Grace Ndiritu, who seeks to give her subjects back their lost dignity, and so on. In *Cinemahantra: The Poor Man's Cinema* (Madagascar, 2009), Manohiray Randriamananjo tells a thrilling story with a torch lighter during a power cut; the modesty of means does not exclude creativity. In freeing itself from models, visual art and experimental film ceaselessly shake up cinema by re-posing the question of representation as a critical art.

6.4. Cultural Policies and Cooperation

The hand that begs is always underneath.

—Fulani proverb, Burkina Faso

6.4.1. No Distribution Structures, No Salvation!

I don't have a solution unless things change in our countries. There's money. People prefer to buy chateaus in Europe or to take two or three wives than to invest in film!

—Ousmane Sembene, "Le renouvellement de l'Afrique se fera par la culture," press conference with Ousmane Sembene at the festival Ecrans noirs, Yaoundé, June 6, 2004, ed. Olivier Barlet

"It must always be remembered," Mahamat-Saleh Haroun remarked, "that Africa's film problems are not due to the filmmakers' careers or choices, but to the lack, or even total absence, of film policies in our respective countries" (3697). Rather than being backed in their own countries and thus able to take on the world, filmmakers have on the contrary had to make do alone and find the force abroad to return home. Few are lucky enough, yet "a person without culture is like a zebra without stripes." This lack of cultural policy reflects governments' inability to grasp that it is through culture that their citizens imagine a future and articulate their engagement. "The ruling elites are convinced that art and culture refers only to patrimony, tourism, and local practices," Achille Mbembe pointed out (9028). "They agree with the international financial institutions in seeing it only as contributing to development."

"Many representatives of the South fail to realize that engaging the battle for images is a strategic stake, akin to water or public health," Richard Boidin stated back in 2003 when he was in charge of cinema at the French Ministry of Foreign Affairs (2917). But can we reasonably expect governments to back this transgressive art? "Film is too revolutionary for them to back it and find that tomorrow films are criticizing the very people who backed it," Haroun added. "We are faced with the African political authorities' deliberate and programmed assassination of cinema" (3697). The stake is thus clearly political, and nothing is to be expected from governments that do not encourage citizens to participate in public life, for as Marie-José Mondzain points out, "democracy is firstly access to speech for all, and to the other's gaze to instigate equality in dignity and freedom. Installing everyone in his/her language, accompanying the singular stages that determine one's self-image in the recognition offered by the other's gaze, such are the founding conditions for all access for all people to a culture that is first of all plural before being common."[19]

Accessing expression presupposes being heard, and thus that films be distributed. That implies a virtuous economic chain of production/distribution/exploitation/broadcast, or in other words a cultural industry backed by a legislative and fiscal framework that organizes re-injecting revenue into the circuit of production. Yet the television companies do not purchase broadcasting rights; some pirate films, or even ask to be paid to broadcast them, and the cinemas have shut down one by one before securitized ticket offices ever were able to return earnings without fraud. If African audiences have gradually deserted the cinemas, it is through lack of time and money: pauperization and the multiplication of activities just to survive. It is also due to increasing insecurity and residential areas' increasing distance. The development of TV and home video, plus the proximity of video parlors, have

also limited outings to the cinema, while piracy and insufficient publicity have undermined the attractiveness of the new. But lack of cultural policy has left cinema owners without a framework within which to act and renew their offerings: often crippled by taxes and with no access to loans at reasonable rates, they have not reinvested their profits in their cinemas and have not updated them to keep up with innovations in projection technology or demands for comfort. They have not divided up the oversized theaters to diversify their film offerings, and have not shored up their revenues from complementary offerings that turn going to see a film into a veritable outing. Owned by the state, they have failed to secure a regular audience. After vegetating, they have closed down and been sold off to the highest bidder.

Cinema no longer has a home, but worse still, does not generate the revenues that would perpetuate it. Piracy is killing the DVD market, and the online market awaits the development of computer and Internet access. No stratagem to feed revenue back into the system works. As for the flourishing informal sector, it escapes all control and benefits only itself; mainstream hits do not support art-house cinema, as is the case in well-structured circuits. The success of Joséphine Ndagnou's film *Paris à tout prix/Paris at All Costs*, which drew 70,000 spectators in Cameroon in 2009 before the last remaining cinemas closed down, was greatly reinforced by her personal renown as an actress in popular TV series, which facilitated a huge media buzz. But she had to organize a national tour herself with a video projector that could be adapted to all sorts of venues to protect her film from the bootleggers and to exploit it on DVD.[20]

Beyond certain exceptional cases, the quality film sector thus cannot get a return on its investments without solid outside funding and distribution in the North. Long gone are the days when filmmakers organized themselves to distribute their films through the short-lived CIDC (see 2.1.3); the Pan-African Federation of Filmmakers (FEPACI) was only held together by ideological motivations and failed to adapt to the changes introduced by technological evolutions (8742). "We were caught blindsided by the onslaught of this new wave," pointed out its president Charles Mensah, whose sudden death shook the whole milieu in 2011 (4529). After a period of revitalization from 1985 to 1997 linked to Gaston Kaboré's tireless commitment (8744), FEPACI was dragged into a punishing clash between the two contenders for his succession, namely, directors Bassek Ba Kobhio and Cheick Oumar Sissoko. "When two elephants fight, it's the grass that gets crushed," says an Angolan proverb. FEPACI finally opted for collective—but ineffective—leadership until the Tshwane African Film Summit in April 2006 (4397). The decision to

move its headquarters to South Africa had "a negative impact on coordination with FESPACO," however, as its general secretary Seipati Bulane-Hopa pointed out (8743), Burkina Faso being less inclined to facilitate the FEPACI congresses during the festival. Although FEPACI recently initiated a Pan-African Film Fund project, to be jointly managed by the African Union, this is again only a production aid, not backing to organize distribution. "If you want honey, you have to be brave enough to face the bees," says a Senegalese proverb. Without pressure from FEPACI and from united filmmakers in each country, states will not move an inch on cultural policy. "We cannot do without this obligatory awareness-raising and long-term lobbying, and only FEPACI has the moral and technical legitimacy to do so," Gaston Kaboré has repeated (7209). "But today FEPACI is no longer representative," Michel Ouedraogo, former delegate general of FESPACO, interjected, putting the decision to remove the condition stipulating that films in competition be screened in 35 mm in the filmmakers' court (10043). Criticized from all quarters, this fixation with a format that no longer corresponds to shooting realities, nor to distribution methods in Africa, could not, according to Ouedraogo, evolve until the filmmakers jointly requested so, in other words via FEPACI. Meanwhile, while awaiting a reaction from this "unrepresentative" FEPACI, the situation stagnated! And every FESPACO edition, films continued to be removed from competition and thus excluded from the awards list because their 35 mm copies did not reach the festival. Given the implosion of the African Guild of Directors and Producers and FEPACI's inertia, reviving the sector's self-organization remains a crucial prerequisite in shaking things up.

6.4.2. Challenging the Censors

> He who spits in the air spits on himself.
>
> —Ivorian proverb

As filmmakers often oppose their governments' policies in their works, they are reluctant to request their backing. Yet that is nonetheless what needs to be possible, in the name of free speech for all in democracy. FEPACI can back demands when they are formulated collectively; what is needed, then, is to form pressure groups while demanding the preservation of a healthy distance between cinema and the state. A balance of power is possible. In *Les Saignantes/The Bloodettes*, Jean-Pierre Bekolo directly attacks the Cameroonian authorities. "How to make a futuristic

movie in a country with no future? How to make a crime movie in a country where it's impossible to investigate?" Judging the film to be "anti-regime" and "pornographic," the Cameroonian censorship commission reported back to the Minister of Culture, the writer Ferdinand Oyono, that cuts should be made and the film banned to under-eighteens. But Bekolo's categorical refusal to make any cuts, and the mobilization of the Cameroonian press and other African journalists orchestrated by the African Federation of Critics (9867), overcame this threat. The film was released, uncut, in 2006, banned to under-thirteens, and carrying a warning message at the start of the film.[21]

Given his international renown, it was difficult for the Egyptian censors to ban a Youssef Chahine film, so for his last film, *This Is Chaos*, they focused on specific scenes. To avoid hindering the film's release, "we agreed to cut ten seconds, which we replaced with a clearly identifiable black frame so that the spectators would know where the incriminating passage was," codirector Khaled Youssef indicated (7212). But Chahine fought all his life against the censors, both at the Al-Alzhar University and the state, without giving in (7984). "The problem now is really religion and sexuality; people are obsessed with both. And strangely, they oppose one to the other," Yousry Nasrallah stated (9287). It is thus often in the name of religion that any sexuality is banned from films. When in *Les Ciseaux/ The Scissors*, video artist Mounir Fatmi took censored images from the sex scene in Nabil Ayouch's *Une minute de soleil en moins/A Minute of Sun Less* (Morocco 2002) and mixed them with the lively images of a wedding, a running boy, the energy of kids on a see-saw, a reversed dripping tap, and so forth, he turned these images into a critical argument. And by intertwining them, he gave them the power of dissidence. By superposing the censored images of bodies coming together with a love poem by Musset, he highlighted the ideology that encourages censorship (8622).

September 8, 2001: Joseph Gaï Ramaka's *Karmen Geï* (Senegal, 2001), an adaptation of Prosper Mérimée's *Carmen* and Bizet's opera, had been in the Bel'Arte cinema in Dakar for three months. Certain risqué scenes were considered shocking: the imprisoned Karmen's dances seduce the female prison warder, who commits suicide over her. But if the Mouride *talibe*, armed with machetes, bludgeons, and knives, wanted to slash the film and attack the filmmaker and the cinema, it was because the mortuary prayer for the dead warden is a sung sura, written by their spiritual guide Cheikh Ahmadou Bamba. Accusations of "provocation," "profanation," "blasphemy" were flung about, and the movement's leaders managed to get the authorities to

ban the film throughout the country. As the copy was seized, the film's release in other African cities was canceled (1861 and 2171).

October 7, 2011: shortly before the October 23 elections for the Tunisian constituent assembly, the private television station Nessma TV broadcast Franco-Iranian Marjane Satrapi's animation film *Persepolis*, a critique of Ayatollah Khomeini's regime, followed by a debate on religious fundamentalism. Two days later, Nessma's headquarters were assailed by several hundred people, mainly Salafists, who attempted to burn down the building. On Facebook, they called for Nessma to be burnt down and to kill its journalists, and demonstrations were held. The reason evoked was the representation of God as an old bearded man in the young heroine of the film's dream. Under pressure, Nessma's CEO, Nebil Karoui, canceled the second broadcast and issued a public apology, but his own house was attacked on October 14 and his family threatened. He was then dragged before the courts for "breaching public morality" and "public disturbance."

In both cases, disrespect for religious symbols was invoked to justify violent censorship, then reinforced by legal censorship, prompted by fear. The underlying political stake is the control of current norms by religious groups who readily exploit the emotions provoked by artistic transgression. The critical position is delicate: should freedom of expression be defended at all costs? It is when it is ideological—in other words when it violates thought and speech—that censorship must be challenged, be it state censorship or that of the people. It is not the image content that is problematic, but whether the images allow room for people's discernment. "The critique of images is founded on the community's political channeling of passions. It should never be a tribunal for a moral expunging of content, which would bring all exercise of the freedom of the gaze to an end," Marie-José Mondzain writes. Censorship should only ever be a safeguard against irresponsibility, then, when images subjugate by only calling upon impulses. The decision to censor thus needs to be the object of a public, and even judicial, debate and cannot be left for the street to decide. But while state censorship is necessary as an ultimate safeguard, it "can never, by decree, replace educating the gaze, or the need for productions to be ethical."[22]

6.4.3. Rethinking Backing to the Sector

Beggars can't be choosers.

—Proverb

"Without a new ethic based on recognition, solidarity, and reciprocity, the way in which most Western cultural funding agencies—and similarly those that fund development—operate will only further destroy the continent's ability to impose itself culturally and artistically in the world," Achille Mbembe has pointed out (9028). This reflects their conception of Africa and of the action needed, Mbembe continues, according to a "vicious ideology that promulgates a vision of Africa as a *tabula rasa*, a condemned and hopeless continent, waiting to be rescued and 'saved.'" Artistic creation is thus expected to serve humanitarian objectives relayed by the African governments themselves. Creation is henceforth no longer considered a sensitive act of looking at oneself and the world, but a vehicle for efficiently spreading a message formatted by outsiders. "Playwrights, filmmakers, singers, and sometimes writers have been asked to raise the population's awareness about schooling girls, ending female genital mutilation, or stopping the spread of AIDS," Burkinabè playwright and theater director Etienne Minoungou stated (8542).

Culture is absent from many key texts, such as the Millennium Development Goals or the NEPAD, but things are evolving. International organizations' new credo is that culture can be a vector of development via a cultural industry (8734). That is true, but to only have this credo in mind signifies that culture must necessarily be sellable, an imperative that leads to a systematic commodification. "What we need right now is a critical cultural policy, which confronts 'development' theory and reveals its deeply reactionary nature," Mbembe adds. For the international organizations' arsenal of requirements in terms of both methodology and cofunding proposals is entirely subjected to this colonization. As Minoungou again points out, they "automatically marginalize and exclude many players and cultural operators whose work focuses on issues that are more modest, more local, but often closer and more pertinent to their target population." With very large sums awarded to a chosen few, they induce a formidable imbalance between cultural operators, some suddenly receiving huge backing to intervene. But their backing is always short-term, meaning that there is no guarantee that their development will be sustained, and thus they are essentially ineffective in terms of structuring the sector. Moreover, the formalities of these funding mechanisms—and notably the European

ones—are so complex that the procedure predominates over the project, under the wing of project creation experts who are rarely *au fait* with the discipline or the local context. If ever their project does get chosen, it is the cultural operators who have to undertake part of this work, which should be done by the civil servants who fund them. The result is that the money remains in the North, in the hands of organizations specializing in these procedures.

While applications for funding from the OIF (International Organization of Francophonie) are now entirely submitted online, the disconnect with on-the-ground realities reaches new heights when it comes to European funding. Applications are subjected to the same procedures as every other call for projects from all sectors of cooperation, so much so that films have been accepted or rejected predominantly on the criteria of their "pertinence"! For want of time after having accumulated the delays, the first two phases of the ACPfilms call for projects (a succinct note for the preliminary selection, followed by a full, highly detailed application if selected) could not be differentiated, and the entire application was expected in one go. Alas, recommendations to change the procedures are made in vain (9108). Many cultural programs (both local and international) mounted with European funding do not respect the announced schedule, and the delays have a knock-on effect on the beneficiaries, when they are not simply canceled after the applications have been made. In a message delivered during the Film and Audiovisual Workshop at the "Culture and Creation: Factors of Development" conference held in Brussels during April 1–3, 2009, Mahamat-Saleh Haroun wrote: "My application to the ACPfilms program was selected, as I was informed on March 20, and I was given until April 9 to submit the proof that I'd found 60 percent of my project's funding! This complex funding is increasingly disconnected from all reality! It took ACPfilms five months to give an answer. That forced me to lower the funding asked for. This program forces us to make films on the cheap." The film in question was *Un homme qui crie/A Screaming Man*, which went on to win an award at Cannes in 2010.[23] Cheick Fantamady Camara also reported, in reference to *Il va pleuvoir sur Conakry/Clouds over Conakry* (Guinea, 2006): "The European Union gave us funding, but it had to be spent within the year. The pressure was terrible. We had to shoot almost then and there in order not to lose the said $107,500!" (7308).

Submitting the sector to such ill-adapted procedures is problematic in a context in which funding is drying up. "Rather than creating art," Achille Mbembe confirms, "many artists on the continent see themselves forced to spend time, incredible energy, and resources filling in useless application forms or trying desperately to

adapt to whims and changing policies, when they aren't busy constantly worrying about the state of mind of 'cultural attachés' who are often oversensitive and capricious, or Western consultants whose backing they hope for" (9028). The geckos all contend for tiny morsels on the same wall, and it is the force of their autonomous creativity that suffers. They are faced with a vicious circle: international cultural cooperation programs absolve states from having to take charge of the sector and diminish their responsibility, to the extent that if this cooperation is withdrawn, there is nothing left but a void. The only alternative is thus the rise of an organized artistic and cultural civil society, and that is what cooperation programs should be focusing on. It is because they have never sufficiently sought to restructure the sector and organize it professionally that things are going round in circles today. It is that which has allowed them to claim the positions of authority that have served their strategic interests, rather than really answering needs on the ground.

While in the 1960s–1980s the general philosophy behind French cooperation was to entrust centralized states with the role of driving development, France's policy of film cooperation, based on an awareness that the filmmakers upset their governments, instigated a dual relationship with artists revolving uniquely around production funding and backing the international visibility of funded films, accompanied by training initiatives.[24] It was in this continuity, and also in an attempt to help structure companies as public bodies, that Dominique Wallon's efforts lay when he was at the head of the French National Film Center (CNC) from 1989 to 1995. The bilateral agreements thus signed with Burkina Faso, Ivory Coast, Cameroon, Senegal, and Guinea improved the conditions of Franco-African coproductions there where there was a national film center to deal with, notably allowing films from these countries to apply for the CNC advance-on-earnings fund and including them in the quotas reserved for European films on French television. But the film cooperation policy was forced in the 2000s to comply with the progressive abandoning of a direct management of production funds in favor of multilateral Francophone and European funds. At the time of writing, other than the Fonds des Cinémas du Monde (which replaced the Fonds Sud),[25] the French Ministry of Foreign Affairs' funding is entirely centered on backing training structures. In these times of economic restriction, it will only be able to offer production funding again if the European Union in return increases existing funds while at the same time renouncing its overcomplicated controls.

Backing training is of course essential, given the dearth of capitalizing on expertise and talent. Gaston Kabore's Imagine center in Ouagadougou proposes

quality brush-up courses. But the few existing initiatives are often insufficient; nothing can replace real film schools that offer three-year courses, and which are places of exchange and hotbeds of excellence, such as the ESAV in Marrakesh. It is not by chance that Osvalde Lewat went to the Israeli-Gaza border to shoot *Sderot, Last Exit* (Cameroon, 2011); what is at play in this unconventional film school is not only artistic, but it also revolves around the principle of living together. For it is there that the crux of training lies: a collective energy that generates the elaboration of a cinema capable of speaking of our world, in the confrontations and syntheses that found contemporaneity.

For want of candidates, the ESAV could not create its planned master's in production; the profession remains too unknown (9970). Yet that is the crunch; producers are needed to accompany directors who are too isolated in their filmmaking process. Producers are also needed to initiate or seal coproduction agreements in the major rendezvous that the main festivals' professional film markets constitute, such as the CineMart in Rotterdam, and thus enable ambitious films to emerge.[26] "Private production companies need to be at the center of developing images in Africa," Idrissa Ouedraogo stated (2758). Reevaluating production also requires an organization of the sector that gives this job the means of its action: a national professional interlocutor in the form of a film board, adapted fiscal and customs measures, and national production funds. Egypt, South Africa, Morocco, Tunisia— these funds are still rare but do exist. In an original initiative, an association was set up in Burkina Faso in 2011 with Swiss backing to run the "Fonds succès cinéma," which boosts low-budget film production destined for the local audience. If a film totals over 10,000 admissions, funding for the next film can automatically be obtained. This encourages maintaining the cinemas and backs active producers. A reliable box-office system was also created for the occasion, which should well work as it is in the cinemas' interest to continue to have films that draw the public.

"It is vital that funding comes with the condition that the states involve themselves and show a willingness to implement national policies. That would avoid spreading funding too thinly by only backing states who do so," Toussaint Tiendrebeogo commented. "That would be stimulating for professional organizations in their lobbying work, and it would enable cooperation policies to be more efficient in the long term" (5829). That is where demands for "good governance" and "sustainability" would be meaningful: a new paradigm needs to be established for a cooperation that, without substituting them, would encourage the instigation of cultural policies that help structure the sector. There is a lot to be done; the African

states are dragging their feet on signing the Charter for African Cultural Renaissance adopted by the African Union in 2006, which can only be applied once two-thirds of the members have ratified it. This charter promises to create a Culture Fund.

"A single piece of wood makes smoke, but not fire," says an Ethiopian proverb. The objective of a single application for all production-fund bodies is not utopian; it would considerably lighten the burden on professionals, who could concentrate on creation rather than exhausting themselves on ill-adapted dossiers and looking for funding, which Jean Odoutan described with verve in the press kit of *La Valse des gros derrières/The Waltz of the Big Behinds* (Benin, 2002), explaining that he spent his time running after "the bread, the bucks, the dough, dragging my bones round the pits of Paris to spin and sock home the same old empty tune, like a bluesman whining and crying buckets!" While no one is advocating splashing out onerous handouts, a regular consultation with professionals is essential, which would be facilitated by the resurrection of FEPACI. There too, coordinating the different funding bodies would avoid dispersion. Things need to be shaken up; the economic crisis is forcing an evolution. Deregulation, lack of infrastructures, and tepid criticism is leading, as Yacouba Konate put it, to "an integral catastrophe," with anyone being able to proclaim themselves a filmmaker without the necessary training or reflection (8734).

6.4.4. The Modernity of Criticism

A whisper rings louder than a cry.

—Mauritanian proverb

Film criticism can also be considered a firewall against catastrophe, so that art can assert itself as a stimulating, questioning force, a site of construction of one's relation to the self, one's environment, and the world, capable of defusing conflicts by restoring an intercultural dialogue and opening paths to new solidarities. Even in situations as deadlocked as the Israeli-Palestinian conflict, art opens little windows, like the act of listening that Nabil Ayouch creates in *My Land* (Morocco, 2011), in which he gets Israelis who live on their land to listen to the testimony of deported Palestinians. It is a simple questioning, a path, a gesture that can no doubt change little on the ground, but that contributes to all the other initiatives striving for dialogue. Only art can restore a dialogue there where different discourses clash (10593).

Criticism henceforth is not only the exploration of the articulation of aesthetics and content, but the promotion of this act of listening, of recognition and respect for the Other in order to encourage living together. A critic is above all a journalist; his or her word is important in promoting films that, tackling the real and the human head-on, facilitate social cohesion and democratic participation in society. Often overlooked in programs to back the sector, training critics is nonetheless essential to give weight to the mediatization of works without which a film's commercialization is impossible. As for filmmakers, the elaboration of a personal reflection is necessary and needs to be rooted in culture.

The African Federation of Critics is making a considerable effort to give African films visibility via its *Africiné* website, in partnership with *Africultures* comprising an almost exhaustive database (common to the multidisciplinary Southplanet database), a day-to-day news thread, editorials accompanying films and festivals, interviews, and analysis. If the means were available, histories of national film bodies could be written, which websites could document with images and sounds, before this memory gets forgotten and documents disappear as the players leave us. With these elders, libraries indeed burn. If young filmmakers do not know the history of African cinema and that of their forebears, if they do not have access to the critical debates that stimulate creativity, where will they find the material to measure up to?

Conclusion

Here a breath sums me up, and my tongue finally corrupted
With algae shall nourish the immensity.

<div align="right">

—Kateb Yacine, *Le Cercle des représailles*

</div>

While new technologies permit the emergence of multiple postcolonial cinematic forms in Africa, the critical stake is more than ever to encourage these forms to allow emancipation, in order to progress and to define the outlines of a new critical art. The ruptures at work during the 2000s mark a turning point for film works still tempted by the essentialist concepts of nationalism or cultural Pan-Africanism that accompanied Independence. Before the current tyranny of pragmatism, this reconfiguration opens the path to the essential reconciliation of doubt and hope.

"At the very least, this is what happens: identity equates with immunity, one identifies with the other. To abase one is to abase the other," wrote Jean-Luc Nancy.[1] African film's intrusive propulsion into world cinema deconstructs single identity discourses in both the North and South. A chasm has been opened, which ongoing globalization will stop from closing. Everyone has lost some of their immunity, but gains in perspectives, starting with those of together, and in equal dignity, living a world that is at last recognized in all its complexity.

"The intruder," Nancy added, "is none other than myself and man. Not another than the same, who keeps on changing, both sharpened and exhausted, laid bare and over-equipped, an intruder in both the world and himself, a worrying growth of the strange, *conatus* of an excrescent infinity." It is this vitality of the Spinozian *conatus* that African films of the 2000s engages us to mobilize, a self-affirmation freed of fixations and withdrawals.

Criticism should, hence, accompany the decolonization of imaginations, in both the South and North. That requires constituting the spectator as a speaking being, who participates in completing the work he or she receives, on the condition that it is, as Umberto Eco suggests, an *open work*, born out of an auteur's singular vision, but without the hierarchy that enunciates an elite—no longer a space of denunciation, but a critical space, both an experience of being thrown into crisis and a utopia.

While cinema already actively strives for this, criticism must still find the paths of this horizontality that allows sharing and debate to be, in the image of the works, a practice of freedom. Whether that occurs in the new, live spaces of cinema or on the Internet, everything has still to be invented.

Notes

Preface

1. Olivier Barlet, *Les Cinémas d'Afrique noire: Le regard en question* (Paris: L'Harmattan, 1996), awarded the French National Film Center (CNC) Art and Essay Prize in 1997. Translations of this title include *African Cinemas: Decolonizing the Gaze* (New York: Zed Books, 2000), *Afrikanische Kinowelten: Die Dekolonisierung des Blicks* (Horlemann/Arte, 2001), and *Il Cinema Africano: Lo sguardo in questione* (Turin: L'Harmattan Italia/COE, 1998), and currently it is being translated into Korean.
2. See explanation of reference numbers at the end of this chapter and in the bibliography.
3. Pierre Haffner, "D'une fleur double et de quatre mille autres: Sur le développement du cinéma africain," *Afrique Contemporaine* 196 (October–December 2000): 27–35.
4. Mahamat-Saleh Haroun, "Du cinéma militant au cinéma schizophrène," *Géopolitique africaine* 13 (Winter 2004).

Chapter 1. The Question of Criticism

1. The numbers in parentheses correspond to the *Africultures* website. See full explanation in the bibliography.
2. Renaud de Rochebrune, "Entretien avec Mahamat-Saleh Haroun," *Jeune Afrique* (September 26, 2010): 98–100. Interestingly, after *Daratt* won the Jury Award at the

Venice Film Festival, the Chadian government, which now disposes of oil revenues, decided to create a film fund. The awarding of the Cannes Jury Prize to *A Screaming Man* convinced them to mandate Haroun to set up a film and television school.

3. Jacques Rancière, *Aesthetics and Its Discontents*, trans. Steven Corcoran (Cambridge: Polity Press, 2009), 45.

4. Edouard Loeb, *Cinéma et politique: L'effet Indigènes* (Paris: Editions INA, 2011).

5. Theodor W. Adorno, *Aesthetic Theory*, trans. Robert Hullot-Kentor (New York: Continuum, 2002), 242.

6. Hans-Robert Jauss, *Toward an Aesthetic of Reception*, trans. Timothy Bahti (Minneapolis: University of Minnesota Press, 1982).

7. Rancière, *Aesthetics and Its Discontents*, 45.

8. Jean-Louis Comolli, *Voir et pouvoir: L'innocence perdue: Cinéma, télévision, fiction, documentaire* (Paris: Verdier, 2004), 400. Also see 272–82 and 387–400 for more on this question.

9. Michel Reilhac, *Plaidoyer pour l'avenir du cinéma d'auteur: Entretiens avec Frédéric Sojcher* (Paris: Klincksieck, 2009).

10. Marie-José Mondzain, *Homo spectator* (Paris: Bayard, 2007).

11. Patrick Chamoiseau, *Le Monde des livres*, October 30, 2009, 7.

12. *Linguere* means *queen* in Wolof. Kettly Noël's face evokes that of Linguere Ramatou in Djibril Diop Mambety's *Hyènes/Hyenas*, an outcast-cum-queen who sits contemplating the horizon.

13. Edouard Glissant, *Introduction à une poétique du divers* (Paris: Gallimard, 1996), 57.

14. See Olivier Barlet, "Les cinémas d'Afrique noire: Le nouveau malentendu," *Cinémathèque* 14 (1998); Olivier Barlet, "Postcolonialism and Cinema: From Difference to Relationships," in *Film Studies: The Essential Resource*, ed. Pete Wall, Andrew Hickman, and Peter Bennett (London: Routledge, 2006); Olivier Barlet, "Le regard occidental sur les images d'Afrique," *Passerelles* 16 (1998).

15. Jean-Jacques Rousseau, *Emile; or, Concerning Education*. Extracts, trans. Eleanor Worthington (Boston: D.C. Heath & Co., 1889), 89.

16. Played by the Malian Djénéba Koné, who was killed in an automobile accident on December 21, 2011.

17. Henri Lopes, *Sur l'autre rive* (Paris: Le Seuil, 1992), 102.

18. Momar Désiré Kane, *Marginalité et errance dans la littérature et le cinéma africains francophones: Les carrefours mobiles* (Paris: L'Harmattan, 2003), 317.

19. See Balufu Bakupa-Kanyinda, Issa Serge Coelo, Mahamat-Saleh Haroun, Mama Keïta, Zeka Laplaine, Fanta Régina Nacro, Jean-Marie Teno, and François Woukoache,

"L'insoutenable invisibilité des Noirs en France," *Bulletin de la Guilde africaine* 1 (March 2000). This echoed the debate launched in France in 1998 by the "Collectif Egalité," a group of black actors and writers who demanded greater visibility on French screens.

20. "Pour un nouveau cinéma africain," in *Afrique 50: Singularités d'un cinéma pluriel* (Paris: L'Harmattan, Images plurielles, 2005), 269–71.

21. See Achille Mbembe, "African Modes of Self-Writing," trans. Steven Rendall, *Identity, Culture and Politics* 2, n°1 (January 2001): 1–37.

22. See "The Origin, Akin to a Passage," in *African Cinemas: Decolonizing the Gaze*, by Olivier Barlet (New York: Zed Books, 2000), 3–33.

23. Boniface Mongo-Mboussa, *L'Indocilité: Supplément à Désir d'Afrique* (Paris: Gallimard, 2005), 121.

24. This argument is developed in Olivier Barlet, "Femmes et hommes dans les cinémas d'Afrique noire," *Africultures* 35 (February 2001): 49–56.

25. Férid Boughedir, *Le Cinéma africain de A à Z* (Brussels: OCIC 1987).

26. Gabriel Teshome, *Third Cinema and the Third World: The Aesthetics of Liberation* (Ann Arbor, MI: UMI Research Press, 1982).

27. Lizbeth Malkmus and Roy Armes, *Arab and African Filmmaking* (New York: Zed Books, 1991).

28. Manthia Diawara, *African Cinema, Politics, and Culture* (Bloomington: Indiana University Press, 1992).

29. Stephen Zacks, "The Theoretical Construction of African Cinema," in *African Cinema: Postcolonial and Feminist Readings*, ed. Kenneth W. Harrow (Lawrenceville, NJ: Africa World Press, 1999), 3–19.

30. Nwachukwu Frank Ukadike, *Questioning African Cinema: Conversations with Filmmakers* (Minneapolis: University of Minnesota Press, 2002), xix.

31. For an analysis of this prejudice, see Nicolas Bancel and Pascal Blanchard, "Sauvage ou assimilé?," *Africultures* 25 (February 2000): 36–43.

32. This argument is developed in Olivier Barlet, "Postcolonialisme et cinéma: De la différence à la relation," *Africultures* 28 (May 2000): 6–60.

33. See the DVD that accompanies Manthia Diawara, *African Film: New Forms of Aesthetics and Politics* (New York: Prestel, 2010).

34. In an article entitled "Favoriser les expressions dissidentes," published in *Le Monde* on June 19, 2010, historian Pap Ndiaye cited the American sociologist Louis Wirth's definition of a minority as a group that, "because of its physical or cultural characteristics, is subjected to differentiated treatments in society and considers itself to be the object of collective discrimination."

35. See *Cahiers du Cinéma* 126 (December 1961).

36. Marie-José Mondzain, "Qu'est-ce que la critique?," in *L'œil critique: Le journaliste critique de télévision*, ed. Jérôme Bourdon and Jean-Michel Frodon (Brussels: De Boeck, 2002), 17–26.

37. Jean-Michel Frodon, *Horizon cinéma: L'art du cinéma dans le monde contemporain à l'âge du numérique et de la mondialisation* (Paris: Ed. Cahiers du cinéma, 2006), 47.

38. "An idol is any planned visibility that communicates a message and claims a presence. An icon is any image that offers itself to the freedom of the gaze of subjects endowed with speech, and who in this offer renounce all presence." Mondzain, "Qu'est-ce que la critique?," 20.

39. Alain Bergala, *Le Cinéma comment ça va?* (Paris: Petite Bibliothèque des Cahiers du Cinéma, 2005), 34.

40. Jean Douchet, *L'Art d'aimer* (Paris: Petite Bibliothèque des Cahiers du Cinéma, 2003), 23.

41. Speaking on *Le Masque et la Plume*, France Inter.

42. George Steiner, *Real Presences* (Chicago: University of Chicago Press, 1989), 15.

43. Jacques Rivette, "L'Art de la fugue," *Cahiers du cinéma* 26 (August–September 1953).

44. In *Le Commerce des regards*, Marie-José Mondzain reworks the translation of Aristotle to reject the idea that he considered passions as something that needed to be expunged through catharsis. She identifies "a process of working-through (*durcharbeitung*) affect through a symbolic clarification based on the *logos*. *Katharsis* designates the process of distancing, and cannot be separated from the political function of visual works, which, in a common space, produce pleasure and pain"; Mondzain, *Le Commerce des regards* (Paris: Seuil, 2003), 119.

45. Steiner, *Real Presences*, 39.

46. Robert Bresson, *Notes on Cinematography*, trans. Jonathan Griffin (New York: Urizen Books, 1977), 14 and 72.

47. André Gardies, *Cinéma d'Afrique noire francophone: L'espace-miroir* (Paris: L'Harmattan, 1999).

48. Graham Huggan, *The Postcolonial Exotic: Marketing the Margins* (London: Routledge, 2001).

49. Mbembe, "African Modes of Self-Writing," 18.

50. V. Y. Mudimbe, *The Invention of Africa* (Bloomington: Indiana University Press, 1988), and *The Idea of Africa* (Bloomington: Indiana University Press, 1994).

51. Vincent Amiel, Pascal Couté, *Formes et obsessions du cinéma américain contemporain* (Paris: Klincksieck, 2003), 20.

52. Jean-Louis Comolli, *Voir et pouvoir* (Lagrasse: Verdier, 2004), 178.

53. Sun Tzu, *L'Art de la guerre* (Paris: Champs Flammarion, 1972), chap. 3, §10.

54. Stuart Hall, "Minimal Selves," in *Identity: The Real Me*, ed. Lisa Appignanesi (London: Institute of Contemporary Art Documents, 1987).

55. In *Abécédaire de Gilles Deleuze*, a film by Pierre-André Boutang (France, 1996); interviews filmed in 1988–89, here *R for Resistance*.

56. "Filmmakers in Conversation," the DVD accompanying Manthia Diawara, *African Film: New Forms of Aesthetics and Politics* (Berlin: Prestel, 2010).

57. Alain Bergala, *L'Hypothèse cinéma* (Paris: Editions Cahiers du Cinéma, 2002), 63.

58. This is also the theme of Florence Aubenas and Miguel Benasayag's work *Résister, c'est créer* (Paris: Editions La Découverte, 2008).

59. Abdoulaye Imourou, "Un cas d'indépendance réussie: La littérature africaine," *Africultures* 83 (2010): 44–53.

60. Abdoulaye Imourou, "La Tâche affective: De l'Afrique comme objet d'étude," *Africultures* 82 (2010): 41–49.

61. The festival's selection, not its competition: we are talking here about the *Un certain regard* selection.

62. *Delwende* deals with the rejection of women accused of witchcraft, and contains a documentary part. Selected in 2004, Ousmane Sembene's *Moolaade* (Senegal, 2003) dealt with female circumcision. The quality of these films notwithstanding, both met Western expectations of works that document "African tragedies."

63. From the interview in the film's press kit.

64. See "Postcolonialisme: Inventaire et débats," *Africultures* 28 (2000).

65. See "L'Africanité en questions," *Africultures* 41 (2001).

66. Mbembe, "African Modes of Self-Writing," 33.

67. See "Fratries Kwahulé: Scène contemporaine choeur à corps," *Africultures* 77–78 (2009).

68. Mbembe, "African Modes of Self-Writing," 13.

69. Olivier Mongin, Nathalie Lempereur, and Jean-Louis Schlegel, "Qu'est-ce que la pensée postcoloniale? Interview with Achille Mbembe," *Esprit* (December 2006).

70. See Nicola Bourriaud, *Radicant: Pour une esthétique de la mondialisation* (Paris: Denoël, 2009).

71. Tobie Nathan, *L'Influence qui guérit* (Paris: Editions Odile Jacob, 1994), 332.

72. Edouard Viveiros de Castro, *Metaphysiques cannibales* (Paris: Presses universitaires de France, 2009).

73. Jacques Rancière, *Disagreement: Politics and Philosophy*, trans. Julie Rose (Minneapolis: University of Minnesota Press, 1999).

74. See Jean-François Pigoullié, *Serge Daney ou la morale d'un ciné-fils* (Paris: Aléas, 2006), 9.

75. Jean-Luc Godard, "La boucle donc se boucle, Denis, Charles, Elie, André, André encore et Serge," in *Jean-Luc Godard par Jean-Luc Godard*, vol. 2, *1984–1988* (Paris: Editions Cahiers du cinéma, 1998), 320. In *Pierrot le fou*, Godard has Jean-Paul Belmondo read an extract of *Histoire de l'Art* on Velasquez as he sits in his bath.

76. Umberto Eco, *Lector in fabula* (Paris: Livre de Poche Biblio, 1999).

77. Roland Louvel, *L'Afrique noire et la différence culturelle* (Paris: L'Harmattan, 1996), 30.

78. See Nicolas Bancel and Pascal Blanchard, "De l'Indigène à l'Immigré: Images, messages et réalités," *Hommes et Migrations* 1207 (May–June 1997): 8.

79. In Charles Castella, *Abderrahmane Sissako: Une fenêtre sur le monde* (France: Caïmans Productions, 2010, 52').

80. Guy Hennebelle, *Cinémas africains en 1972* (Conakry: Société africaine d'édition, 1972), 207.

81. Aimé Césaire, *Notebook of a Return to the Native Land*, trans. Clayton Eshleman and Annette Smith (Middletown, CT: Wesleyan University Press, 2001), 23.

82. Jean-Paul Sartre, *What Is Literature?*, trans. Bernard Frechtman (New York: Philosophical Library, 1965), 23.

83. See Kenneth Harrow, *Postcolonial African Cinema* (Bloomington: Indiana University Press, 2007), 2.

84. This and all the following critics' statements come from an Africiné forum discussion on the question. See Olivier Barlet, "Bollywood/Africa: A Divorce?," *Africultures*, 10036.

85. See the full analysis developed in Olivier Barlet, "Bollywood/Africa: A Divorce?," *Africultures*, 10036.

86. Sartre, *What Is Literature?*, 68.

87. "The Decree regulating the organization and control of cinema films, phonographic records, film shoots and audio recordings in French West Africa," *Journal Officiel de la République française* (March 11, 1934): 2541.

88. The Tunisian film pioneer Albert Samam-Chikli shot his first short film, *Zohra*, in 1922. Egyptian cinema really took off in 1928 with the fiction film *Laila*, by Aziza Amir, but films directed by Mohammed Bayoumi have also been found dating to the 1920s. In Morocco, it was not until 1958 that Mohamed Ousfour shot the first Moroccan feature film, *The Cursed Son*. Algerian national cinema did not emerge until the War of Independence.

89. See Paulin Soumanou Vieyra, *Le Cinéma africain des origines à 1973* (Paris: Présence Africaine, 1975), 15.

90. See Rik Otten, *Le Cinéma au Zaïre, au Rwanda et au Burundi* (Paris: OCIC/L'Harmattan, 1984), 22.

91. The group also included Jacques Melo Kane (Senegal; credited as continuity supervisor), Robert Caristan (Guyana; cameraman in the credits), and the North American actress Gypsis, who acted in the film and who later became known under the name of Marpessa Dawn for her role as Eurydice in Marcel Camus's *Orfeo Negro* (France, 1959). See Paulin Soumanou Vieyra, *Le Cinéma au Sénégal* (Paris: OCIC/L'Harmattan, 1983), 53.

92. Paulin Vieyra attributed this contradiction to the "duality of authority" that resulted from this joint collaboration, and which ultimately gave an "awkward and style-less" film. In *Le Cinéma africain des origines à 1973*, 156.

93. Henri-François Imbert, *Samba Félix Ndiaye, cinéaste documentariste africain* (Paris: L'Harmattan, 2007), 81.

94. Elisabeth Lequeret, *Le Cinéma africain: Un continent à la recherche de son propre regard* (Paris: Editions Cahiers du Cinéma/SCEREN-CNDP, 2003), 8.

95. See Olivier Barlet and Pascal Blanchard, "Cinéma colonial: L'impossible tentation," *Culture coloniale, 1871–1931* (Paris: Autrement, 2003).

96. Elisabeth Lequeret, *Le Cinéma africain*, 9.

97. The same question remains today. Visual artist Hervé Youmbi recently told Virginie Andriamirado: "We young Africans today—children of the Third World—must fight to find the ways and means of establishing validating authorities in our countries so that Europe is no longer the center of our universe" (9877).

98. See *Sembene Ousmane (1923–2007)*, *Africultures* 76 (February 2009).

99. Efforts to guarantee France's energy independence was one of the main economic reasons behind de Gaulle's turnaround, Elf having lost its main oil field with Algerian Independence in 1962. France above all focused its attention on Gabon, where the French state guaranteed the stability of a regime that remained loyal to France, but incurred France's financial implication in conflicts affecting the petrol-producing countries, notably the Biafra War in Nigeria, and the civil wars in Congo-Brazzaville and Angola. See the films *Elf: Une Afrique sous influence* (136') and *Elf: Les chasses au trésor* (87'), by Jean-Michel Meurisse and Fabrizio Calvi (France, 2000); *Elf, la pompe Afrique* (120'), a filmed performance by Nicolas Lambert (France, 2006); Lucas Belvaux's TV drama *Les Prédateurs* (France, 2007, 2 x 110'), which retraces the events and judge Eva Joly's investigation into the Elf affair; and more recently the documentaries *Foccart, l'homme qui dirigeait l'Afrique*, by Cédric Tourbe (France, 2010, 90'), and Patrick Benquet's *Françafrique* (France, 2010, 2 x 80').

100. Alec G. Hargreaves, "Vers une reconnaissance de la postcolonialité en France," *Mouvements* 51 (September-October 2007): 26.

101. Lucien Patry, interview with the author, 1996, Paris.

102. Jean-Michel Frodon, *La Projection nationale* (Paris: Odile Jacob, 1998), 87.

103. *Self-Representation in African Cinema*, in the *Africa Remix* exhibition catalog, a major exhibition of contemporary African art that toured from Dusseldorf to London, Paris, and Tokyo from July 2004 to June 2006.

104. Typical of an elite that seeks both to benefit from and imitate the West, El Hadji lives above his means when he takes a third wife. The contempt he shows the beggars and disabled echoes his refusal of tradition. They take revenge by casting a curse, the *xala*, that leaves him impotent. In both business and polygamy, El Hadji loses the virility he took for granted. The diviner in his driver's village cures him, but the check he pays him with bounces. His impotency reinstated, he realizes that virility does not stem from the desire to be powerful; it takes respect for values. He manages to regain it by refusing alienation and by accepting in an extraordinary expiatory scene that the outcasts spit all over him.

105. See its description in Olivier Barlet, *African Cinemas: Decolonizing the Gaze* (New York: Zed Books, 2000), 267–68.

106. Frédéric Lefebvre-Naré, Olivier Barlet, Lucie Pothin, and Paulin Yameogo, *Soutenir le cinéma des pays du Sud: Evaluation rétrospective de la coopération française dans la Zone de Solidarité Prioritaire (1991–2001)* (Paris: Ministère des Affaires étrangères, April 2003), *Africultures*, 1377.

107. See *Africultures*, 2043.

108. Ibid.

109. Interview with François Bensignor in *Cité musiques*, the Paris Cité de la Musique journal, 62 (January–March 2010).

110. Diawara, *African Film: New Forms of Aesthetics and Politics*, 29.

111. In a 1992 filmed interview with Christine Delorme, in *Ousmane Sembene: Tout à la fois* (France, 2010).

Chapter 2. Thematic Continuities and Ruptures

1. Kenneth W. Harrow, *Postcolonial African Cinema* (Bloomington: Indiana University Press, 2007), 1.

2. The numbers in parentheses correspond to the *Africultures* website. See full explanation in the bibliography.

3. Hélé Béji, *Désenchantement national: Essai sur la décolonisation* (Paris: François Maspero, 1982).

4. See Denise Brahimi's analysis of these films in *50 ans de cinéma maghrébin* (Paris: Minerve, 2009).

5. Marie-José Mondzain, *L'image peut-elle tuer?* (Paris: Bayard, 2002), 44.

6. Doris Lessing, Nobel Prize Acceptance Lecture, Stockholm, December 7, 2007.

7. This question was examined in detail in "The Origin, Akin to a Passage," part 1 of Olivier Barlet, *African Cinemas: Decolonizing the Gaze* (New York: Zed, 2001), 1.

8. Marie-José Mondzain, *Homo spectator* (Paris: Bayard, 2007), 144.

9. Nancy Houston, "L'art éclaire nos lanternes," *Le Monde*, November 28–29, 2010, 26.

10. Sun Tzu, *The Art of War.*

11. Nar Sene, *Djibril Diop Mambety: La caméra . . . au bout du nez* (Paris: La Bibliothèque d'Africultures/L'Harmattan, 2001).

12. Sony Labou Tansi, *La Vie et demie* (Paris: Le Seuil, 1979), 124.

13. André Gardies, "Le montage comme fondement de la cohérence textuelle," in *Regards sur le cinéma négro-africain*, ed. André Gardies and Pierre Haffner (Brussels: Editions OCIC, 1987), 163.

14. Ken Bugul, *Rue Félix Faure* (Paris: Editions Hoëbecke, 2005), 67.

15. See interview with Bernard Mouralis in Boniface Mongo-Mboussa, *Désir d'Afrique* (Paris: Gallimard, 2002), 270.

16. See Michel Reilhac, *Plaidoyer pour l'avenir du cinéma d'auteur: Entretiens avec Frédéric Sojcher* (Paris: Archimbaud/Klincksieck, 2009), 17.

17. Jacques Aumont, *Moderne?* (Paris: Editions Cahiers du cinéma, 2007), 36.

18. Alain Badiou, "Du cinéma comme emblème démocratique," in *Cinéphilosophie, Critique* 692–93 (January–February 2005): 13.

19. In "Indépendants, de Sundance à iTunes," *Cahiers du cinéma* 670 (September 2011): 94. Elisabeth Lequeret specifies that "certain low-budget films do hit the jackpot in the movie theaters, but generally, the money comes from the blockbusters." In 2010, some 5,000 films were produced in Hollywood; 603 were distributed, even though the market can only absorb 300 to 400. The alternative is thus to distribute oneself, usually via Internet VOD or DVD.

20. See Anne Crémieux, *Les Cinéastes noirs américains et le rêve hollywoodien* (Paris: L'Harmattan, Images plurielles, 2004).

21. See Jean-Michel Frodon, *Le Cinéma français de la Nouvelle Vague à nos jours* (Paris: Editions Cahiers du cinéma, 2010), 30.

22. Paulin Soumanou Vieyra, *Le Cinéma et l'Afrique* (Paris: Présence Africaine, 1969), 9.

23. Pierre Bourdieu, *Les Règles de l'art: Genèse et structure du champ littéraire* (Paris: Le Seuil/ Points essais, 1998).

24. Jean-Louis Comolli, *Voir et pouvoir: L'innocence perdue: Cinéma, télévision, fiction, documentaire* (Lagrasse: Verdier, 2004), 385.

25. Jean-Paul Sartre, "Coexistences," in *Situation IX* (Paris: Gallimard-NRF, 1970).

26. See Alain Bergala's comments on the question in "Le Choix de Godard," in *Les Cahiers du cinéma*, special *Histoire(s) du cinéma* supplement to 537 (July-August, 1999).

27. In his editorial on May 68, *Libération*, May 24–25, 2008.

28. Angèle Diabang, *Yandé Codou, la griotte de Senghor* (Senegal, 2008); and Laurence Gavron, *Yandé Codou Sène, diva séeréer* (France, 2008).

29. Edouard Glissant, *Introduction à une poétique du divers* (Paris: Gallimard, 1996), 88–89.

30. Ibid., 105.

31. Fernand Braudel, "L'histoire de l'Algérie et l'iconographie," *Gazette des beaux-arts* (June 1930): 388–409.

32. Raphaël Millet, *Cinémas de la Méditerranée, cinémas de la mélancolie* (Paris: L'Harmattan, 2002).

33. Guy Hennebelle and Catherine Ruelle, "Cinéastes d'Afrique noire," *L'Afrique Littéraire et Artistique* 49 (1978): 115.

34. Marie-José Mondzain, *L'Image peut-elle tuer?* (Paris: Bayard 2003), 77.

35. Ibid., 62.

36. See Jean-Michel Frodon, *La Projection nationale: Cinéma et nation* (Paris: Odile Jacob, 1998), 76.

37. See author's review of Patrick Béhin's film *Les Enfants de Babel—Trace du Mali* (7602).

38. Abdelwahab Meddeb, "La 'révolution du jasmin,' signe de la métamorphose de l'histoire," *Le Monde*, January 18, 2011, 25.

39. Christian Metz, *L'Enonciation impersonnelle ou le site du film* (Paris: Klincksieck, 1991), 117.

40. Momar Désiré Kane, *Marginalité et errance dans la littérature et le cinéma africains francophones: Les carrefours mobiles* (Paris: L'Harmattan, 2004).

41. Ben Okri, *Astonishing the Gods* (London: Phoenix, 1995), 4. Cited by the Guild in its manifesto "Pour un nouveau cinéma africain," *Bulletin de la guilde africaine* 3 (March 2001).

42. Glissant, *Introduction à une poétique du divers*, 130.

43. Bernard Mouralis, *L'Europe, l'Afrique et la folie* (Paris: Présence Africaine, 1993), 13, 175.

44. Gilles Deleuze, "L'épuisé," in *Samuel Beckett: Quad et autres pièces pour la télévision* (Paris: Editions de Minuit, 1992), 70–71.

45. *Le Monde des Livres*, March 16, 2007.

46. Alain Mabankou, *Le Monde*, April 14, 2010.

47. Achille Mbembe, *Sortir de la grande nuit: Essai sur l'Afrique décolonisée* (Paris: La Découverte, 2010), 103.

48. See Mondzain, *Homo spectator*, 134.

49. Glissant, *Introduction à une poétique du divers*, 45.

50. Edouard Glissant, *Philosophie de la relation—poésie en étendue* (Paris: Gallimard, 2009), 12.

51. Mondzain, *Homo spectator*, 11, 15.

52. In an interview by Boniface Mongo-Mboussa in *Désir d'Afrique* (Paris: Gallimard, 2002), 145.

53. Glissant, *Philosophie de la relation*, 68.

54. Jean-François Pigoullié, *Serge Daney ou la morale d'un ciné-fils* (Lyon: Aléas, 2006), 38.

55. Miguel Benasayag, *Le Mythe de l'individu* (Paris: La Découverte, 2004), 16–19.

56. Glissant, *Philosophie de la relation*, 56.

Chapter 3. Postcolonial Clichés

1. The numbers in parentheses correspond to the *Africultures* website. See full explanation in the bibliography.

2. My relationship with Laurent Chevallier is both conflictual and friendly, and we have had many disagreements by e-mail or on the *Africultures* website (see our debate on how he ridicules the wife of the French ambassador to Guinea in *Hadja Moï*, article 3955).

3. The Franco-Swiss historian François Garson deconstructed the workings of this film and denounced its fabrications in an article published in *Les Temps Modernes* in 2005. Following the debate the article triggered, he then took the inquiry further in his book *Enquête sur le cauchemar de Darwin* (Paris: Flammarion, 2006).

4. Stanislas Adotevi, *Négritudes et négrologues* (Paris: UGE 10/18, 1972), 182.

5. Charles Baudelaire, "The Dandy," in *The Painter of Modern Life*, trans. Jonathan Mayne (1863; London: Phaidon Press, 1970), 28.

6. Anne Crémieux, *Les Cinéastes noirs américains et le rêve hollywoodien* (Paris: L'Harmattan, 2004), 7.

7. *Le Monde Télévision*, April 25–26, 2010, 7. An annual report is drawn up by the Club Averroes, available at www.clubaverroes.com.

8. Eric Macé, "Postcolonialité et francité dans les imaginaires télévisuels de la nation," in *Ruptures postcoloniales: Les nouveaux visages de la société française*, ed. Nicolas Bancel, Florence Bernault, Pascal Blanchard, Ahmed Boubeker, Achille Mbembe, Françoise Vergès (Paris: La Découverte, 2010), 397.

9. In Samuel Gontier, "Pourquoi 'télé' ne rime toujours pas avec 'diversité,'" *Télérama* 3096 (May 12, 2009).

10. Bernard-Marie Koltès, cited by Georges Lavaudant, "Respectons la volonté de Koltès," *Le Monde*, June 3–4, 2007.

11. In "Cinémas de l'émigration," *CinémAction* 8 (Summer 1979), 87.

12. Pascal Blanchard, "L'image des Maghrébins dans les films postcoloniaux français traitant du temps colonial ou de la Guerre d'Algérie," *Migrance* 37, *Images et représentations des Maghrébins dans le cinéma en France* (Paris: Editions Mémoire-Génériques, 2011), 18.

13. To borrow Julien Gaertner's expression (*hors-la-France*) in "Vitalité artistique et poids économique des Français d'origine maghrébine dans le paysage cinématographique français," *Migrance* 37, *Images et représentations des Maghrébins dans le cinéma en France*, 69.

14. Macé, "Postcolonialité et francité dans les imaginaires télévisuels de la nation," 399.

15. Achille Mbembe, *Sortir de la grande nuit: Essai sur l'Afrique décolonisée* (Paris: La Découverte, 2010), 118. See also Mbembe, "La République et l'impensé de la 'race,'" in *Ruptures postcoloniales: Les nouveaux visages de la société française*, ed. Nicolas Bancel, Florence Bernault, Pascal Blanchard, Ahmed Boubeker, Achille Mbembe, Françoise Vergès (Paris: La Découverte, 2010), 205–16.

16. Jean-Luc Nancy, *L'Intrus* (Paris: Editions Galilée, 2000), 2, 35. The book inspired two films in 2005: *La Blessure/The Wound*, by Nicolas Klotz, and *L'Intrus/The Intruder*, by Claire Denis.

Chapter 4. Memory and Reconciliation

1. The numbers in parentheses correspond to the *Africultures* website. See full explanation in the bibliography.

2. *The Wretched of the Earth*, cited by Achille Mbembe, *Sortir de la grande nuit—essai sur l'Afrique décolonisée* (Paris: La Découverte, 2010), 17.

3. In *Namibia: The Struggle for Liberation* (2007), Charles Burnett retraces the path of Namibian independence leader Sam Nujoma.

4. Bertolt Brecht, *Questions from a Worker Who Reads*, trans. M. Hamburger, from *Bertolt Brecht: Poems, 1913–1956* (New York: Methuen, 1976).

5. In Charles Castella, *Abderrahmane Sissako: Une fenêtre sur le monde* (France, 2010).

6. See "Christiane Taubira fait le bilan de sa loi," *Afriscope* 21 (June-July 2011).

7. "And why not slavery too?" filmmaker Rachid Bouchareb said ironically, commenting on the so-called positive role of colonization at a 2010 roundtable at the Quai Branly museum in Paris.

8. Patrick Chamoiseau, in *Le Monde des livres*, October 30, 2009, 7.

9. Edouard Glissant, *Mémoires des esclavages* (Paris: Gallimard/La Documentation française, 2007), 42.

10. Ibrahima Thioub, *Le Monde*, June 1, 2010, 19.

11. Caroline Eades, *Le Cinéma post-colonial français* (Paris: Editions du Cerf-Corlet, 2006).

12. Benjamin Stora, "La guerre d'Algérie: La mémoire par le cinéma," in *Les Guerres de mémoire: La France et son Histoire*, ed. Pascal Blanchard and Isabelle Veyrat-Masson (Paris: Editions La Découverte, 2008), 262–72. Also see "Quand une mémoire (de guerre) peut en cacher une autre (coloniale)," in *La Fracture coloniale*, ed. Pascal Blanchard, Nicolas Bancel, Sandrine Lemaire (Paris: Editions La Découverte, 2005), 57–65.

13. That the facts were summarized for the needs of a film does not in anyway undermine the reality of these massacres, which, according to historian Benjamin Stora, resulted in approximately 10,000 Algerian and 103 French deaths. Documentaries by Medhi Laloui (*Les massacres de Sétif, un certain 8 mai 1945*, 55', broadcast on ARTE in 1995) and by Yamina Adi (*L'Autre 8 mai 1945: Aux origines de la guerre d'Algérie*, 52', on France 2 in 2008) attested to the massacres without causing an outcry.

14. Nicolas Bancel, Pascal Blanchard, "La colonisation: Du débat sur la guerre d'Algérie au discours de Dakar," in *Les Guerres de mémoire: La France et son Histoire*, ed. Pascal Blanchard and Isabelle Veyrat-Masson (Paris: Editions La Découverte, 2008), 154.

15. Albert Memmi, *Portrait du colonisé*, précédé de *Portrait du colonisateur* (1957; Paris: Gallimard, 1997), 133.

16. Achille Mbembe, *De la postcolonie* (Paris: Karthala, 2000), 38.

17. "Igowi nyi fala nyi compini" (In the Franco-German War), anonymous, sung in Omyènè (Gabon).

18. Myron Echenberg, *Colonial Conscripts: The Tirailleurs Sénégalais in French West Africa, 1857–1960* (Portsmouth, NH: Heineman, 1991), 98.

19. See Ken Harrow, "*Camp de Thiaroye*: Who's That Hiding in Those Tanks, and How Come We Can't See Their Faces?," *New Discourses of African Cinema, Iris* 18 (Spring 1995): 147–53.

20. Out of the 21,290 victims who contacted the TRC, 19,050 were declared victim to "serious human rights violations," and 2,975 other victims emerged during the procedures. Out of the 7,116 requests for amnesty, 1,312 were granted and 5,505 rejected, while 248 claimants were heard during public audiences; see "Dire la vérité, faire la réconciliation, manquer la réparation," in *Vérité, réconciliation, réparation*, ed. Barbara Cassin, Olivier Cayla, Philippe-Joseph Salazar, *Le Genre humain* (November 2004): 23. The large number of rejections was due to the fact that most of the prisoners had "submitted" for an amnesty; the TRC had to distinguish between political and common law crime.

21. Ibid., 19.

22. See "Introduction by the the Minister of Justice, Mr Dullah Omar, to the Truth and Reconciliation Commission," The Department of Justice and Constitutional Development, South Africa, http://www.justice.gov.za/trc/legal/justice.htm.

23. Oliver Schmitz discreetly joined forces with Thomas Mogatlane to make *Mapantsula* in 1988—one of the only critical films to have managed, by virtue of it being a thriller, to slip past the censors.

24. Jacques Derrida, "Versöhnung, ubuntu, pardon: Quel genre?," in *Vérité, réconciliation, réparation*, ed. Cassin, Cayla, and Salazar, 149.

25. Cited by Jean-Phillipe Rémy in his report "Johannesburg, la ville-happening," *Le Monde*, July 4–5, 2010, 26.

26. See Rita Kempley, "'Movies' 'Magic Negro' Saves the Day, but at the Cost of His Soul," dvrepublic.com.

27. See Claudine Drame, *Des films pour le dire: Reflets de la Shoah au cinéma, 1945–1985* (Geneva: Editions Métropolis, 2007), 304.

28. *Le Cinéma et la Shoah: Un art à l'épreuve du 20e siècle*, ed. Jean-Michel Frodon (Paris: Editions Cahiers du Cinéma, 2007), 26.

29. The November 2002 Amnesty International report, "Rwanda: Gacaca: A Question of Justice," is available online at http://www.refworld.org/docid/3f1524bc4.html.

30. Marie-José Mondzain, *L'image peut-elle tuer?* (Paris: Bayard, 2002), 32.

31. See François-Xavier Destors, *Images d'après: Cinéma et génocide au Rwanda* (Lormont: Editions Le bord de l'eau, 2010), 159. This book offers a wealth of information and an excellent overview of the question.

32. Susan Sontag, *On Photography* (London: Penguin Books, 1977), 20.

33. Mondzain, *L'Image peut-elle tuer?*, 54 then 51.

34. See *Rwanda 2000: Mémoires d'avenir*, *Africultures* 30 (September 2000).

35. In *Abécédaire de Gilles Deleuze* (*Gilles Deleuze's ABC Primer*), directed by Pierre-André Boutang (France, 1996), interviews filmed in 1988–1989, here *R comme résistance* (*R for Resistance*).

36. See Guido Convents, *Images et paix: Les Rwandais et les Burundais face au cinéma et à l'audiovisuel*, a politico-cultural history of German and Belgian Ruanda-Urundi and of the Republics of Rwanda and Burundi (1896–2008) (Louvain: Editions Afrika Film Festival, 2008), 420–65.

37. Cited by Destors, *Images d'après*, 186.

Chapter 5. Styles and Strategies

1. The numbers in parentheses correspond to the *Africultures* website. See full explanation in the bibliography.

2. Roland Barthes, *S/Z*, trans. Richard Miller (Malden, MA: Blackwell, 1990), 5. See also Barthes, *The Pleasure of Text*, trans. R. Miller (New York: Hill & Wang, 1973).

3. Gilles Mouëllic, *Improviser le cinéma* (Crisnée: Yellow Now, 2011), 136–40.

4. Ibid., 61.

5. Michel de Certeau, *L'invention du quotidien*, vol. 1, *Arts de faire* (Paris: Gallimard, 1990), 216.

6. See Gisèle Braunberger's film *La Direction d'acteur par Jean Renoir* (France, 1968, 22') and Jacques Rivette's *Jean Renoir le patron, 2e partie: La direction d'acteur* (France, 1967, in the "Cinéastes de notre temps" series).

7. Marie-José Mondzain, *Homo spectator* (Paris: Bayard, 2007), 269 and 15.

8. Hitchcock distinguished between suspense and surprise. Unlike with surprise, with suspense, the spectator knows in advance what will, or is likely to, happen, and that is what creates the tension.

9. In Charles Castella, *Abderrahmane Sissako: Une fenêtre sur le monde* (France, 2010).

10. Classical cinema highlights the legibility of the intrigue and characters, readily focuses on conflicts that the hero ends up resolving, opts for transparent mise-en-scène so that the film's fluidity encourages identification, often resorts to genre, and constructs the film as an organic ensemble.

11. *Notre librairie* 162 (June–August 2006): 47–53.

12. Florence Aubenas and Miguel Benasayag, *Résister, c'est créer* (Paris: La Découverte, 2002), 48.

13. See Olivier Barlet, *African Cinemas: Decolonizing the Gaze* (New York: Zed Books, 2000), 178–81, and the entire chapter on orality, 143–82.

14. Edouard Glissant, *Introduction à une poétique du divers* (Paris: Gallimard, 1996), 39.

15. André Gardies, *Cinéma d'Afrique noire francophone: L'espace miroir* (Paris: L'Harmattan, 1989), 163.

16. Jean Godefroy Bidima, *La Philosophie négro-africaine* (Paris: Presses universitaires de France, 1995), 59–65.

17. Edouard Glissant, *Philosophie de la relation: Poésie en étendue* (Paris: Gallimard, 2009), 69.

18. "In the shot in which Emmanuelle Riva commits suicide in *Kapo*, throwing herself at the electrified barbed wire, the man who decides, at that moment, to have the camera track in to reframe her corpse in a high-angle shot, taking care to precisely inscribe her raised hand in the angle of his final frame, that man deserves nothing more that the deepest contempt." Jacques Rivette, "De l'abjection," *Cahiers du cinéma* 120 (June 1961).

19. Jean-Michel Frodon, "L'Horizon éthique," *Cahiers du Cinéma* 596 (December 2004).

20. See the *Black Camera* edition devoted to him: 22, no. 2/23, no. 1 (Spring 2008) (Black Film Center/Archive, Indiana University, Bloomington).

21. Jacques Rancière, *La Fable cinématographique* (Paris: Seuil, 2001), 202; *Film Fables*, trans. E. Battista (London: Bloomsbury Academic, 2006).

22. Gilles Deleuze, *The Time-Image*, trans. Hugh Tomlinson and Robert Galeta (Minneapolis: University of Minnesota Press, 1989).

23. See *L'Etat du documentaire, 2000–2010* (Réseau des organisations du documentaire, ROD, available at www.addoc.net); and Sophie Barreau-Brouste, *Arte et le documentaire* (Paris: INA Editions, 2011).

24. Gilles Deleuze, *Cinema 2: The Time Image*, trans. Hugh Tomlinson and Robert Galeta (London: Continuum, 2005), 36.

25. François Niney, *Le Documentaire et ses faux-semblants* (Paris: Klincksieck, 2009), 70.

26. Julian Gaertner, "Troublantes relations sur grand écran," in *Générations: Un siècle d'histoire culturelle des Maghrébins en France*, ed. Driss El Yazami, Yvan Gastaut, and Naïma Yahi (Paris: Gallimard/Génériques/CNHI, 2009), 69–75.

27. Maryse Condé, interview with Valérie Marin la Meslée, in *La Pensée noire*, special issue of *Point* (April–May 2009): 80.

28. François-Xavier Destors, *Images d'après: Cinéma et génocide au Rwanda* (Lormont: Editions Le bord de l'eau, 2010), 136.

29. See Christine Eyene, "La Virginité passée: Femme, sexualité et art," in *L'Art au féminin: Approches contemporaines, Africultures* 85 (March 2011): 52.

30. The film brings to mind *Hymen national, malaise dans l'Islam/National Hymen: Malaise in Islam*, by Jamel Mokni (Tunisia, 2011).

31. It is worth mentioning two 2006 documentaries made on the fight against FGM in Europe, notably with GAMS (Group for the Abolition of Genital Mutilation): *Noires douleurs/Black Pain*, by Lorène Debaisieux, and *Mon enfant, ma sœur, songe à la douleur/My Child, My Sister, Think of the Pain*, by Violaine de Villiers. Both are based on the testimonies of women having undergone FGM, and document awareness campaigns. The former also informs us about the operation that reconstructs the clitoris and repairs the nerves, allowing the women to live normal sex lives again.

32. Christine Eyene, "Rejoindre les rangs de la lutte invisible," in *L'Art au féminin: Approches contemporaines, Africultures* 85 (March 2011), 18.

33. Ibtissam Bouachrine, "*Rjal* et leurs reines: Le printemps arabe et le discours sur la masculinité et la féminité," in *Naqd* 29 (Autumn/Winter 2011): 80 and 86.

34. Vincent Malausa, interview with Leïla Kilani, *Jeunesse des cinémas arabes, Cahiers du cinéma* supplement (October 2011): 9.

35. Wassyla Tamzali in *Le Monde*, December 12, 2009, 25. Also see *Une femme en colère: Lettre d'Alger aux Européens désabusés* (Paris: Gallimard, 2009).

36. Obioma Nnaemeka, "Autres féminismes: Quand la femme africaine repousse les limites de la pensée et de l'action féministes," *Africultures* 74–75 (June–September 2008): 18.

37. Gisèle Halimi, *La Cause des femmes* (1973; Paris: Gallimard, 1992), 221.

38. See Jacqueline Rosemain, *Jazz et biguine: Les musiques noires du nouveau monde* (Paris: L'Harmattan, 1993).

39. See Gérald Arnaud and Henri Lecomte, *Musiques de toutes les Afriques* (Paris: Fayard, 2006), 547–48.

40. Brenda F. Berrian, "Manu Dibango and *Ceddo*'s Transatlantic Soundscape," in *Focus on African Films*, ed. Françoise Pfaff (Bloomington: Indiana University Press, 2004), 143 and 154.

41. Gilles Mouëllic, *Jazz et cinéma* (Paris: Editions Cahiers du cinéma, 2000); Gilles Mouëllic and Koffi Kwahulé, *Frères de son* (Montreuil: Editions Théâtrales, 2007), 6.

42. Jean-Pierre Bekolo speaking in *Filmmakers in Conversation*, the DVD accompanying *African Film: New Forms of Aesthetics and Politics*, by Manthia Diawara (Berlin: Prestel, 2010).

43. See the chapter "If your song is no improvement on silence, keep quiet!," in Olivier Barlet, *African Cinemas: Decolonizing the Gaze* (New York: Zed Books, 2000), 183–94.

44. See *La geste musicale dans les cinémas noirs*, *Africultures* 37 (April 2001), or www.africultures.com.

45. Denise Brahimi, *50 ans de cinéma maghrébin* (Paris: Editions Minerve, 2009), 146.

Chapter 6. Economic Perspectives

1. The numbers in parentheses correspond to the *Africultures* website. See full explanation in the bibliography.

2. Marie-José Mondzain, *Le Commerce des regards* (Paris: Seuil, 2003), 167.

3. See Emmanuel Ethis, *Sociologie du cinéma et de ses publics* (Paris: Armand Colin, 2005), 26.

4. Interview published in Juan Branco, *Réponses à Hadopi* (Nantes: Capricci, 2010), 79.

5. The Canal+ group still invests approximately $660 million a year in the French audiovisual sector, and is a partner in two-thirds of films produced each year.

6. See Tristan Mattelart, ed., *Piratages audiovisuels: Les voies souterraines de la mondialisation culturelle* (Paris: De Boeck/INA Editions, 2011).

7. Jean-Louis Comolli, *Voir et pouvoir: L'innocence perdue: cinéma, télévision, fiction, documentaire* (Paris: Verdier, 2004), 172.

8. *Le Monde télévision*, March 13–14, 2011, 3.

9. While the term "series" is becoming generic, it is still worth recalling the actual definitions:

- A television series is a fiction with recurrent characters, divided into episodes, each of which is an autonomous unit that can be understood unto itself.
- A sitcom or situation comedy is a predominantly amusing television series.
- A television drama is divided into episodes, each of which follows on from the previous one. The episodes are regrouped into seasons.
- Soap operas (or soaps) are daily television series, originally screened in the afternoons in the English-speaking countries. They may last for decades, with thousands of episodes. Their name comes from the fact that most were originally sponsored by U.S. washing-powder companies.
- Telenovelas (or novelas) are the daily series broadcast in the evenings in the Spanish and Portuguese-speaking countries.

10. Pierrette Ominetti, in "Le documentaire en quête d'espace sur les écrans," *Le Monde*, February 10, 2010, 19.

11. Michel Reilhac, *Plaidoyer pour l'avenir du cinéma d'auteur*, interviews with Frédéric Sojcher (Paris: Editions Archimbaud Klincksieck, 2009), 175.

12. See Jonathan Haynes and Onookome Okome, "Evolving Popular Media: Nigerian Video Films," in *Nigerian Video Films*, ed. Jonathan Haynes (Lagos: Kraft Books Ltd, 1997), 23–24.

13. Video Compact Disc, a low-quality digital PAL system, with a resolution of 352 x 288 pixels, in other words, a quarter to half the resolution of television.

14. Pierre Barrot, "La Production vidéo nigériane: Miroir d'une société en ébullition," *Afrique contemporaine* 238 (2011–2012): 109.

15. In *Nollywood, le phénomène vidéo au Nigeria* (Paris: L'Harmattan, 2005), 14, Pierre Barrot recounts that, of the projects submitted to the French Foreign Ministry's Fonds Sud Télévision fund in 2003, the most expensive project came from Burkina Faso ($11,685 a minute) and the cheapest from Nigeria ($240 a minute) for a film by Tunde Kelani, considered the greatest director working in Nigeria!

16. See Frances Harding, "Mythes populaires dans les home videos: De l'amour tendre au sexe terrifiant," in *Nollywood, le phénomène vidéo au Nigeria*, ed. Pierre Barrot (Paris: L'Harmattan, 2005), 143–60.

17. Edouard Glissant, *Le Discours antillais* (Paris: Gallimard, 1981), 759.

18. See Claude Forest, "L'industrie du cinéma en Afrique: Introduction thématique," *Afrique contemporaine* n°238 (2011): 61–73.

19. Marie-José Mondzain, *Homo spectator* (Paris: Bayard, 2007), 208.

20. See Florent Coulon, "Une histoire du cinéma camerounais: Cheminement vers l'indépendance de la production," *Afrique contemporaine* n°238 (2011): 102–3.

21. See articles 2624 and 2629 on www.africultures.com.

22. Marie-José Mondzain, *L'image peut-elle tuer?* (Paris: Bayard, 2002), 47 and 57.

23. The film also received funding from the French Fonds Sud, the Fonds Francophone, the Hubert Bals Fund in Rotterdam, and the World Cinema Fund in Berlin, for a final budget of $2.15 million—that is, ten times less than Rachid Bouchareb's *Hors-la-loi/Outside the Law* (Algeria, 2010).

24. In the decade from 1991 to 2001, French film funding to its Priority Solidarity Zone countries represented an average of approximately $3 million a year, 88 percent of which was spent on film production, and essentially spent in France (in totality for the Fonds Sud grants; over 60 percent for the Fonds de Solidarité Prioritaire). See Frédéric Lefebvre-Naré, Olivier Barlet, Lucie Pothin, and Paulin Yameogo, *Soutenir le cinéma des pays du Sud: Evaluation rétrospective de la coopération française dans la Zone de Solidarité Prioritaire (1991–2001)* (Paris: Ministère des Affaires étrangères, April 2003), 13.

25. In order to maintain funding to vulnerable filmmaking, two commissions were created (one for first or second works, the other for established filmmakers), with particular attention paid to films from sub-Saharan Africa, which, moreover, were the only ones allowed to be submitted by companies from the South.

26. In Africa, FESPACO has organized the MICA (International African Film Market) since 1983, but it is more a programming fair and thus more focused on distributing existing films. Durban created the Filmart in 2010, which clearly aims to bring producers and distributors together on film projects, as does the Luma in St. Louis, Senegal, for documentaries, under the auspices of the Africadoc program.

Conclusion

1. Jean-Luc Nancy, *L'Intrus* (Paris: Galilée 2000), 33, 45.

Bibliography

Adorno, Theodor W. *Théorie esthétique*. Klincksieck, 1974.

Adotevi, Stanislas. *Négritude et négrologues*. UGE, 1972.

Africultures nº37: *La Geste musicale dans les cinémas noirs*. L'Harmattan, 2001.

Amiel, Vincent, and Pascal Couté. *Formes et obsessions du cinéma américain contemporain*. Klincksieck, 2003.

Arnaud, Gérald, and Henri Lecomte, *Musiques de toutes les Afriques*. Fayard 2006.

Aubenas, Florence, and Miguel Benasayag. *Résister, c'est créer*. Ed. La Découverte, 2008.

Aumont, Jacques. *Moderne?* Ed. Cahiers du cinéma, 2007.

Badiou, Alain. "Du cinéma comme emblème démocratique." *Cinéphilosophie, Critique* nº692–693 (January–February 2005).

Bancel, Nicolas, and Pascal Blanchard. "De l'indigène à l'immigré: Images, messages et réalités." In *Hommes et Migrations* nº1207, dossier "Imaginaire colonial et figures de l'immigré" (May–June 1997).

———. "La colonisation: Du débat sur la guerre d'Algérie au discours de Dakar." In *Les Guerres de mémoire: La France et son Histoire*, ed. Pascal Blanchard and Isabelle Veyrat-Masson. Ed. La Découverte, 2008.

———. "Sauvage ou assimilé?" *Africultures* nº25, dossier "Tirailleurs en images." L'Harmattan, 2000.

Barlet, Olivier, ed. *Cinéma: L'exception africaine*. *Africultures* n°45. L'Harmattan, 2002.

———. "Les cinémas d'Afrique noire: Le nouveau malentendu." *Cinémathèque* n°14 (Autumn 1998). Cinémathèque française.

———. *Les Cinémas d'Afrique noire: Le regard en question*. L'Harmattan, 1996.

———. "Postcolonialism and Cinema: From Difference to Relationships." In *Film Studies: The Essential Resource*, ed. Pete Wall, Andrew Hickman, and Peter Bennett. Routledge, 2006.

———. "Le regard occidental sur les images d'Afrique." *Passerelles* n°16, *Afriques*. Thionville, 1998.

Barlet, Olivier, and Pascal Blanchard. "Cinéma colonial: L'impossible tentation." *Culture coloniale, 1871–1931*. Autrement, 2003.

Barreau-Brouste, Sophie. *Arte et le documentaire*. INA Editions, 2011.

Barrot, Pierre. "La Production vidéo nigériane, miroir d'une société en ebullition." *Afrique contemporaine* n°238.

———. *Nollywood, le phénomène vidéo au Nigeria*. L'Harmattan, 2005.

Barthes, Roland. *Le Plaisir du texte*. Le Seuil, 1973.

———. *S/Z*. Points Essais, 1976.

Baudelaire, Charles. "Le Dandy." In *Le Peintre de la vie moderne*. 1863; Ed. Mille et une nuits, 2010.

Béji, Hélé. *Désenchantement national (Essai sur la décolonisation)*. Ed. François Maspero, 1982.

Ben Ali, Saindoune. *Testaments de transhumance*. Komedit, Moroni, 2004.

Benasayag, Miguel. *Le Mythe de l'individu*. Ed. La Découverte, 2004.

Bergala, Alain. "Le Choix de Godard." *Cahiers du cinéma* n°537, special supplement, *Histoire(s) du cinéma* (July–August 1999).

———. *Le Cinéma comment ça va?* Petite bibliothèque des Cahiers du cinéma, 2005.

———. *L'Hypothèse cinema*. Ed. Cahiers du cinéma.

Berrian, Brenda F. "Manu Dibango and *Ceddo*'s Transatlantic Soundscape." In *Focus on African Films*, ed. Françoise Pfaff. Indiana University Press, 2004.

Bidima, Jean Godefroy. *La Philosophie négro-africaine*. Presses universitaires de France, 1995.

Black Camera 22 n°2/23 n°1, *St. Clair Bourne* (Spring 2008), Black Film Center/Archive, Indiana University, Bloomington.

Blanchard, Pascal. "L'image des Maghrébins dans les films postcoloniaux français traitant du temps colonial ou de la Guerre d'Algérie." *Migrance* n°37: *Images et représentations des Maghrébins dans le cinéma en France*. Ed. Mémoire-Génériques, 2011.

Boni, Tanella. *L'Avenir a rendez-vous avec l'aube*. Vents d'ailleurs, 2011.

Bouachrine, Ibtissam. "*Rjal* et leurs reines: Le printemps arabe et le discours sur la masculinité et la féminité." *Naqd* n°29, Alger (Autumn/Winter 2011).

Boughedir, Férid. *Le Cinéma africain de A à Z*. OCIC, 1987.

Bourdieu, Pierre. *Les Règles de l'art: Genèse et structure du champ littéraire*. Le Seuil, Points essais, 1998.

Bourriaud, Nicola. *Radicant: Pour une esthétique de la mondialisation*. Denoël, 2009.

Brahimi, Denise. *50 ans de cinéma maghrébin*. Minerve, 2009.

Branco, Juan. *Réponses à Hadopi*. Capricci, 2010.

Braudel, Fernand. "L'histoire de l'Algérie et l'iconographie." *Gazette des beaux-arts* (June 1930).

Brecht, Bertolt. *Questions que pose un ouvrier qui lit*. L'Arche, 1997.

Bresson, Robert. *Notes sur le cinématographe*. Gallimard 1988.

Bugul, Ken. *Rue Félix Faure*. Hoëbecke, 2005.

Bulletin de la Guilde africaine n°1 (March 2000).

Bulletin de la Guilde africaine n°3 (March 2001).

Cahiers d'Afrique n°1 (March 2009). Hémisphèresudprod, Dakar.

Cassin, Barbara, Oliver Cayla, and Philippe-Joseph Salazar. "Dire la vérité, faire la réconciliation, manquer la reparation." In *Vérité, réconciliation, réparation*, special issue of *Le Genre humain* (November 2004). Le Seuil.

Césaire, Aimé. *Cahier d'un retour au pays natal*. Présence Africaine, 2000.

———. "Calendrier lagunaire." *Anthologie poétique*. Imprimerie nationale, 1996.

Chalaye, Sylvie. *Afrique noire: Ecritures contemporaines. Théâtre/Public* n°158.

———, ed. *Fratries Kwahulé: Scène contemporaine choeur à corps. Africultures* n°77–78. L'Harmattan 2009.

———, ed. *L'Africanité en questions. Africultures* n°41. L'Harmattan, 2001.

Chevrier, Jacques. "Entretien avec William Sassine." *Jeune Afrique* n°1241 (October 17, 1984).

Comolli, Jean-Louis. *Voir et pouvoir: L'innocence perdue: cinéma, télévision, fiction, documentaire*. Verdier, 2004.

Convents, Guido. *Images et paix: Les Rwandais et les Burundais face au cinéma et à l'audiovisuel, une histoire politico-culturelle du Ruanda-Urundi allemand et belge et des Républiques du Rwanda et du Burundi (1896–2008)*. Ed. Afrika Film Festival, 2008.

Coulon, Florent. "Une histoire du cinéma camerounais—cheminement vers l'indépendance de la production." *Afrique contemporaine* n°238. De Boeck, 2011.

Crémieux, Anne. *Les Cinéastes noirs américains et le rêve hollywoodien*. Collection Images plurielles. L'Harmattan, 2004.

Dardenne, Luc. *Au dos de nos images*. Seuil 2008.

De Certeau, Michel. *L'invention du quotidien*, vol. 1, *Arts de faire*. Gallimard, 1990.

Deleuze, Gilles. "L'épuisé." In *Samuel Beckett: Quad et autres pièces pour la television*. Ed. de Minuit, 1992.

———. *L'Image-temps*. Ed. de Minuit, 1985.

Derrida, Jacques. "Versöhnung, ubuntu, pardon: Quel genre?" In *Vérité, réconciliation, réparation*, special issue of *Le Genre humain* (November 2004). Ed. du Seuil.

Destors, François-Xavier. *Images d'après: Cinéma et génocide au Rwanda*. Ed. Le bord de l'eau, 2010.

Dia, Thierno Ibrahima, and Olivier Barlet, eds. *Sembene Ousmane (1923–2007)*. *Africultures* n°76. L'Harmattan, 2009.

Diawara, Manthia. "L'autoreprésentation dans le cinéma africain." Catalogue de l'exposition *Africa Remix*, 2004.

———. *African Cinema, Politics, and Culture*. Indiana University Press, 1992.

———. *African Film: New Forms of Aesthetics and Politics*. Prestel, 2010.

Drame, Claudine. *Des films pour le dire: Reflets de la Shoah au cinéma, 1945–1985*. Ed. Métropolis, 2007.

Eades, Caroline. *Le Cinéma post-colonial français*. Cerf-Corlet, 7ème art, 2006.

Echenberg, Myron. *Colonial Conscripts: The Tirailleurs Sénégalais in French West Africa, 1857–1960*. Heinemann, 1991.

Eco, Umberto. *Lector in fabula*. French translation, 2nd ed. LGF, Le livre de poche biblio, 1999.

Efoui, Kossi. *Concessions*. Lansman/Théâtre de la Digue, 2005.

Ethis, Emmanuel. *Sociologie du cinéma et de ses publics*. Armand Colin, 2005.

Eyene, Christine. "La Virginité passée: Femme, sexualité et art." *L'Art au féminin: Approches contemporaines*. *Africultures* n°85 (March 2011). L'Harmattan.

———. "Rejoindre les rangs de la lutte invisible." *L'Art au féminin: Approches contemporaines*. *Africultures* n°85 (March 2011). L'Harmattan.

Fanon, Frantz. *Peau noire, masques blancs*. Essais Points, Seuil, 1952.

Fatmi, Mounir. *Hard Head/Tête dure*. Ed. Rijksakademie van beeldende kunsten, 2008.

Forest, Claude. "L'Industrie du cinéma en Afrique: Introduction thématique." *Afrique contemporaine* n°238.

Frodon, Jean-Michel, ed. *Le Cinéma et la Shoah: Un art à l'épreuve du 20e siècle*. Ed. Cahiers du Cinéma, 2007.

———. *Le Cinéma français de la Nouvelle Vague à nos jours*. Ed. Cahiers du cinéma, 2010.

———. *Horizon cinéma: L'art du cinéma dans le monde contemporain à l'âge du numérique et de la mondialisation*. Ed. Cahiers du cinéma, 2006.

———. "L'Horizon éthique." *Cahiers du Cinéma* n°596 (December 2004).

———. *La Projection nationale: Cinéma et nation*. Ed. Odile Jacob, 1998.

Gadjigo, Samba. *Ousmane Sembene, une conscience africaine: Genèse d'un destin hors du commun*. Homnisphères, 2007.

Gaertner, Julien. "Troublantes relations sur grand écran." In *Générations: Un siècle d'histoire culturelle des Maghrébins en France.* Gallimard/Génériques/CNHI, 2009.

———. "Vitalité artistique et poids économique des Français d'origine maghrébine dans le paysage cinématographique français." *Migrance* n°37, *Images et représentations des Maghrébins dans le cinéma en France.* Ed. Mémoire-Génériques, 2011.

Gardies, André. *Cinéma d'Afrique noire francophone: L'espace-miroir. L'Harmattan, 1999.*

———. "Le montage comme fondement de la cohérence textuelle." In *Regards sur le cinéma négro-africain,* ed. André Gardies and Pierre Haffner. Editions OCIC, 1987.

Garson, François. *Enquête sur le cauchemar de Darwin.* Flammarion, 2006.

Glissant, Edouard. *Introduction à une poétique du divers.* 1996; Gallimard 2006.

———. *Le Discours antillais.* Paris: Gallimard "Folio," 1981.

———. *Mémoires des esclavages.* Gallimard/La Documentation française, 2007.

———. *Philosophie de la relation: Poésie en étendue.* Gallimard 2009.

———. *Poétique de la relation: Poétique III.* Gallimard 1990.

———. *Traité du Tout-monde: Poétique IV.* Gallimard, 1997.

Gontier, Samuel. "Pourquoi 'télé' ne rime toujours pas avec 'diversité.'" *Télérama* n°3096 (May 12, 2009).

Graham, Huggan. *The Postcolonial Exotic: Marketing the Margins.* Routledge, 2001.

Haffner, Pierre. "D'une fleur double et de quatre mille autres: Sur le développement du cinéma africain." *Afrique Contemporaine* n°196 (October–December 2000).

Halimi, Gisèle. *La Cause des femmes.* 1973; Gallimard, 1992.

Hall, Stuart. "Minimal Selves." In *Identity: The Real Me,* ed. Lisa Appignanesi. Institute of Contemporary Art Documents, 1987.

Harding, Frances. "Mythes populaires dans les *home videos*: De l'amour tendre au sexe terrifiant." In *Nollywood: Le phénomène vidéo au Nigeria,* ed. Pierre Barrot. L'Harmattan, 2005.

Hargreaves, Alec G. "Vers une reconnaissance de la postcolonialité en France." *Mouvements* n°51 (September–October 2007).

Haroun, Mahamat-Saleh. "Du cinéma militant au cinéma schizophrène." *Géopolitique africaine* n°13 (Winter 2004).

Harrow, Kenneth. "*Camp de Thiaroye*: Who's That Hiding in Those Tanks, and How Come We Can't See Their Faces?" *Iris* n°18 (Spring 1995).

———. *Postcolonial African Cinema.* Bloomington: Indiana University Press, 2007.

Haynes, Jonathan, and Onookome Okome. "Evolving Popular Media: Nigerian Video Films." In *Nigerian Video Films,* ed. Jonathan Haynes. Kraft Books Limited, 1997.

Hennebelle, Guy. *Cinémas africains en 1972.* Société africaine d'édition.

Hennebelle, Guy, and Catherine Ruelle. "Cinéastes d'Afrique noire." *L'Afrique Littéraire et Artistique*, n°49 (1978).

Hugo, Victor. *Actes et paroles*. Vol. 4, *Oeuvres complètes*. Club Français du Livre, 1967–1970.

Imbert, Henri-François. *Samba Félix Ndiaye, cinéaste documentariste africain*. L'Harmattan, Images plurielles, 2007.

Imorou, Abdoulaye. "La Tâche affective: De l'Afrique comme objet d'étude." In *Penser l'Afrique—des objets de pensée aux sujets pensants*, comp. Tanella Boni. *Africultures* n°82. L'Harmattan, 2010.

———. "Un cas d'indépendance réussie: La littérature africaine." *Africultures* n°83. L'Harmattan, 2010.

Jauss, Hans-Robert. *Pour une esthétique de la reception*. Gallimard, 1978.

Kane, Momar Désiré. *Marginalité et errance dans la littérature et le cinéma africains francophones—Les carrefours mobiles*. L'Harmattan, Images plurielles, 2003.

Kwahulé, Koffi. *Jaz*. Ed. Théâtrales, 1998.

———. *Misterioso 119*. Ed. Théâtrales, 2005.

Labou Tansi, Sony. *Antoine m'a vendu son destin*. Ed. Acoria, 1997.

———. *La Vie et demie*. Le Seuil, 1979.

———. *Les Sept solitudes de Lorsa Lopez*. Seuil, 1985.

Lavaudant, Georges. "Respectons la volonté de Koltès." *Le Monde*, June 3–4, 2007.

Le Clezio, Jean-Marie Gustave. "Discours de réception du prix Nobel de Littérature," Stockholm, December 7, 2008.

Le Point. Special issue, *La Pensée noire* (April–May, 2009).

Lefebvre-Naré, Frédéric, Olivier Barlet, Lucie Pothin, and Paulin Yameogo. *Soutenir le cinéma des pays du Sud: Evaluation rétrospective de la coopération française dans la Zone de Solidarité Prioritaire (1991–2001)*. Ministère des Affaires étrangères, April 2003.

Lequeret, Elisabeth. "Indépendants, de Sundance à iTunes." *Cahiers du cinéma* n°670 (September 2011).

———. *Le Cinéma africain: Un continent à la recherche de son propre regard*. Cahiers du Cinéma, Les Petits cahiers, SCEREN-CNDP, 2003.

Lessing, Doris. Nobel Prize Acceptance Speech, December 7, 2007.

Loeb, Edouard. *Cinéma et politique: L'effet Indigènes*. Ed. INA, 2011.

Lopes, Henri. *Sur l'autre rive* (Paris: Le Seuil, 1992).

Louvel, Roland. *L'Afrique noire et la différence culturelle*. L'Harmattan, 1996.

Macé, Eric. "Postcolonialité et francité dans les imaginaires télévisuels de la nation." In *Ruptures postcoloniales: Les nouveaux visages de la société française*. La Découverte, 2010.

Magnier, Bernard, ed. *Sony Labou Tansi: Paroles inédites*. Ed. Théâtrales, 2005.

Malausa, Vincent. "Cinéma de combat: Entretien avec Leïla Kilani." In *Jeunesse des cinémas arabes*, supplement to *Cahiers du cinéma* (October 2011).

Malkmus, Lizbeth, and Roy Armes. *Arab and African Filmmaking*. Zed Books, 1991.

Mattelart, Tristan, ed. *Piratages audiovisuels: Les voies souterraines de la mondialisation culturelle*. De Boeck/INA Editions, 2011.

Mbembe, Achille. "A propos des écritures africaines de soi." *Bulletin du Codesria* 1 (2000). Dakar.

———. "A propos des écritures africaines de soi." *Politique africaine* n°77. Karthala, 2000.

———. *De la postcolonie*. Karthala, 2000.

———. "La République et l'impensé de la 'race.'" In *Ruptures postcoloniales: Les nouveaux visages de la société française*. La Découverte, 2010.

———. *Sortir de la grande nuit: Essai sur l'Afrique décolonisée*. Ed. La Découverte, 2010.

Memmi, Albert. *Portrait du colonisé*, précédé de *Portrait du colonisateur*. 1957; Gallimard, 1997.

Metz, Christian. *L'Enonciation impersonnelle ou le site du film*. Méridiens Klincksieck, 1991.

Millet, Raphaël. *Cinémas de la Méditerranée, cinémas de la mélancolie*. L'Harmattan, Images plurielles, 2002.

Mondzain, Marie-José. *Le Commerce des regards*. Seuil, 2003.

———. *Homo Spectator*. Bayard, 2007.

———. *L'image peut-elle tuer?* Bayard, 2002.

———. "Qu'est-ce que la critique?" In *L'œil critique—le journaliste critique de télévision*, ed. Jérôme Bourdon and Jean-Michel Frodon. De Boeck, 2002.

Mongo-Mboussa, Boniface. *Désir d'Afrique*. Gallimard, 2002.

———. *L'Indocilité, supplément à Désir d'Afrique*. Gallimard, 2005.

———, ed. *Postcolonialisme: Inventaire et débats*, *Africultures* n°28. L'Harmattan, 2000.

———, ed. *Rwanda 2000: Mémoires d'avenir*, *Africultures* n°30. L'Harmattan, 2000.

Mouëllic, Gilles. *Improviser le cinema*. Yellow Now, 2011.

———. *Jazz et cinema*. Ed. Cahiers du cinéma, 2000.

Mouëllic, Gilles, and Koffi Kwahulé. *Frères de son*. Ed. Théâtrales, 2007.

Mouralis, Bernard. *L'Europe, l'Afrique et la folie*. Présence Africaine, 1993.

Mudimbe, Vumbi Yoka. *The Idea of Africa*. Bloomington: Indiana University Press, 1994.

———. *The Invention of Africa*. Bloomington: Indiana University Press, 1988.

Nancy, Jean-Luc. *L'Intrus*. Galilée, 2000.

Nathan, Tobie. *L'Influence qui guérit*. Ed. Odile Jacob, 1994.

Ndiaye, Pap. "Favoriser les expressions dissidents." *Le Monde,* June 19, 2010.

Ndjehoya, Blaise. *Le Nègre Potemkine*. Ed. Lieu commun, 1988.

Niney, François. *Le Documentaire et ses faux-semblants*. Klincksieck, 2009.

Nnaemeka, Obioma. "Autres féminismes: Quand la femme africaine repousse les limites de la pensée et de l'action feministes." In *Féminisme(s) en Afrique et dans la diaspora, Africultures* n°74–75. L'Harmattan, 2008.

Otten, Rik. *Le Cinéma au Zaïre, au Rwanda et au Burundi.* OCIC/L'Harmattan, 1984.

Pigoullié, Jean-François. *Serge Daney ou la morale d'un ciné-fils.* Aléas, 2006.

Raharimanana. *Les Cauchemars du gecko.* Vents d'ailleurs, 2011.

Rancière, Jacques. *La Fable cinématographique.* Seuil, 2001.

———. *La Mésentente: Politique et philosophie.* Galilée, 1995.

———. *Malaise dans l'esthétique.* Galilée, 2004.

Reilhac, Michel. *Plaidoyer pour l'avenir du cinéma d'auteur: Entretiens avec Frédéric Sojcher.* Ed. Archimbaud Klincksieck 2009.

Rivette, Jacques. "De l'abjection." *Cahiers du cinéma* n°120 (June 1961).

———. "L'art de la fugue." *Cahiers du cinéma,* n°26 (August–September 1953).

Rosemain, Jacqueline. *Jazz et biguine: Les musiques noires du nouveau monde.* L'Harmattan, 1993.

Ruelle, Catherine, ed. *Afrique 50: Singularités d'un cinéma pluriel.* L'Harmattan, Images plurielles, 2005.

Sartre, Jean-Paul. "Coexistences." In *Situation IX.* Paris: Gallimard-NRF, 1970.

———. "Qu'est-ce que la littérature?" *Les Temps modernes.* 1947; Folio Gallimard, 1973.

Sene, Nar. *Djibril Diop Mambety: La caméra . . . au bout du nez.* L'Harmattan, la Bibliothèque d'Africultures, 2001.

Sontag, Susan. *Sur la photographie.* Christian Bourgeois Ed., 2000.

Souny, William. *Sahan.* L'Harmattan, 2001.

Steiner, George. *Réelles présences: Les arts du sens.* 1989; Folio 255, 1994.

Stora, Benjamin. "La guerre d'Algérie: La mémoire par le cinema." In *Les Guerres de mémoire: La France et son Histoire,* ed. Pascal Blanchard and Isabelle Veyrat-Masson. Ed. La Découverte, 2008.

———. "Quand une mémoire (de guerre) peut en cacher une autre (coloniale)." In *La Fracture coloniale,* ed. Pascal Blanchard, Nicolas Bancel, and Sandrine Lemaire. Ed. La Découverte, 2005.

Tamzali, Wassyla. *Une femme en colère: Lettre d'Alger aux Européens désabusés.* Gallimard, 2009.

Teshome, Gabriel. *Third Cinema and the Third World: The Aesthetics of Liberation.* UMI Research Press, 1982.

Tzu, Sun. *L'Art de la guerre.* Champs Flammarion, 1972.

Ukadike, Nwachukwu Frank. *Questioning African Cinema: Conversations with Filmmakers.* University of Minnesota Press, 2002.

U Tam'si, Tchicaya. *Le Mauvais Sang*. 1955; L'Harmattan, 1998.

Vieyra, Paulin Soumanou. *Le Cinéma africain des origines à 1973*. Présence Africaine, 1975.

———. *Le Cinéma au Sénégal*. OCIC/L'Harmattan, 1983.

———. *Le Cinéma et l'Afrique*. Présence Africaine, 1969.

Viveiros de Castro, Eduardo. *Métaphysiques cannibales*. Presses universitaires de France, 2009.

Walcott, Derek. *The Sea Is History*. Circé, 1992.

Wright, Richard. *Black Boy (American Hunger): A Record of Childhood and Youth*. Harper Perennial, 2006.

Zacks, Stephen. "The Theoretical Construction of African Cinema." In *African Cinema: Postcolonial and Feminist Readings*, ed. Kenneth W. Harrow. Africa World Press, 1999.

Africultures Reference Articles

The numbers in parentheses in the text correspond to the numbers of articles cited or referenced that are available on the *Africultures* website. To access these articles, go to the website at www.africultures.com and enter the number in the "quick search" box, then go to "Articles."

nº/title of article/authors

0036, "*Les Siestes grenadines*, de Mahmoud Ben Mahmoud," Olivier Barlet

0039, "*Quand les hommes pleurent*, de Yasmine Kassari," Olivier Barlet

0040, "*Loin*, d'André Téchiné," Olivier Barlet

0041, "*L'Autre monde*, de Merzak Allouache," Olivier Barlet

0056, "De la phobie du métissage à l'ambivalence au cinéma," Olivier Barlet

0070, "*Silence on tourne*, de Youssef Chahine," Olivier Barlet

0108, "Oser un cinéma africain populaire," interview, Christine Sitchet with Manthia Diawara

0138, "Le regard occidental sur les images d'Afrique," Olivier Barlet

0158, "*Fools*, de Ramadan Suleman," Olivier Barlet

0161, "*Buud Yam*, de Gaston Kaboré," Olivier Barlet

0191, "*Imuhar, une légende*, de Jacques Dubuisson," Olivier Barlet

0192, "*Keïta: L'héritage du griot*, de Dani Kouyaté," Olivier Barlet

0203, "Ce que filmer veut dire," interview, Olivier Barlet with Youssef El Ftouh

0216, "*Sous les pieds des femmes*, de Rachida Krim," Olivier Barlet

0250, "Filmer pour exorciser," Olivier Barlet

0271, "*Vivre me tue*, de Paul Smaïl," Fayçal Chehat

0299, "La traite négrière: Mythes et idées reçues," Olivier Barlet

0300, Interview, Boniface Mongo-Mboussa with Daniel Maximin

0305, "Cinéma: Un retour vers le futur," Olivier Barlet

0320, "*Amistad*, de Steven Spielberg," Olivier Barlet

0332, "Pour la fraternité," Olivier Barlet

0383, "*Jackie Brown*, de Quentin Tarantino," Olivier Barlet

0401, "*Filles de poussière*, de Julie Dash," Olivier Barlet

0501, Interview, Olivier Barlet with René Vautier, filmmaker

0550, "*Corps plongés*, de Raoul Peck," Olivier Barlet

0591, "*Africa Dreamings*," Olivier Barlet

0620, "A propos du texte et de la mise en scène de *Fama*," interview, Sylvie Chalaye with Koffi Kwahulé

0793, "*Adieu Forain*, de Daoud Aoulad Syad," Olivier Barlet

0841, "*Dakan*, de Mohamed Camara," Olivier Barlet

0843, "*Letting Go*, de Bernard Joffa," Olivier Barlet

0845, "*Femmes . . . et femmes*, de Saâd Chraibi," Olivier Barlet

0901, "*Bye Bye Africa*, de Mahamat Saleh Haroun," Olivier Barlet

0939, "Une mémoire tronquée," interview, Sylvie Chalaye with Kossi Efoui

0944, "Visions d'ailleurs, visions intérieures," interview, Elisabeth Monteiro Rodrigues with Mia Couto

0957, "Une réflexion sur le pouvoir," interview, Olivier Barlet with Roger Gnoan M'Bala

0969, "*La Sueur des palmiers*, de Radwan El-Kashef," Olivier Barlet

0970, Interview, Olivier Barlet with Radwan El-Kashef

0971, "*Ghost Dog: La voie du samouraï*, de Jim Jarmusch," Olivier Barlet

0972, "*Pleure, ô pays bien aimé*, de Darrell James Roodt," Olivier Barlet

1022, "Lussas 1999: Comment filmer l'Afrique?," Olivier Barlet

1094, "*Chroniques marocaines*, de Moumen Smihi," Olivier Barlet

1138, "*Un rêve d'indépendance*, de Monique Mbeka Phoba," Olivier Barlet

1194, "A propos de *Barbecue Pejo*," interview, Olivier Barlet with Jean Odoutan

1215, "Sauvage ou assimilé? Quelques réflexions sur les représentations du corps des tirailleurs sénégalais (1880–1918)," Nicolas Bancel and Pascal Blanchard

1220, "La contradiction du tirailleur dans le cinéma africain," Olivier Barlet

1319, "Fictions TV: Des Noirs dans l'ombre," Marie-France Malonga

1321, "Autour du 'Collectif Egalité,'" interview, Sylvie Chalaye with Jacques Martial

1348, "*Royal de Luxe, retour d'Afrique*, de Dominique Deluze (France)," Sylvie Chalaye

1359, "Littérature et postcolonie," Lydie Moudileno

1360, "La critique postcoloniale, étude des spécificités," interview, Boniface Mongo-Mboussa with Jean-Marc Moura

1364, "Les interrogations du monde noir," interview, Boniface Mongo-Mboussa with Philippe Dewitte

1369, "Postcolonialisme et cinéma: De la différence à la relation," Olivier Barlet

1386, "*Vacances au pays*, de Jean-Marie Teno," Olivier Barlet

1388, "*Mabrouk Moussa!*, de Jean-Philippe Gaud," Olivier Barlet

1465, "Le Rwanda m'a appris à appeler les monstres par leur nom," interview, Boniface Mongo-Mboussa with Boubacar Boris Diop

1500, "*Je rêvais de l'Afrique*, de Hugh Hudson," Olivier Barlet

1504, "*Dans la maison de mon père*, documentaire de Fatima Jebli Ouazzani," Olivier Barlet

1551, "*Lumumba*, de Raoul Peck," Olivier Barlet

1552, "*Le Conte du ventre plein*, de Melvin van Peebles," Olivier Barlet

1602, "*Les Portes fermées*, d'Atef Hetata," Olivier Barlet

1604, "*Djib*, de Jean Odoutan," Olivier Barlet

1659, "*Bronx-Barbès*, d'Eliane de Latour," Olivier Barlet

1660, "*La Saison des hommes*, de Moufida Tlatli," Olivier Barlet

1704, "*La Squale*, de Fabrice Génestal," Olivier Barlet

1735, "C'est parce qu'on va à l'encontre de la tradition qu'on est traité de fou," interview, Olivier Barlet with Mohamed Camara

1738, "Femmes et hommes dans les cinémas d'Afrique noire," Olivier Barlet

1754, "*La Faute à Voltaire*, d'Abdel Kechiche," Olivier Barlet

1755, "*Le Passage du milieu*, de Guy Deslauriers," Olivier Barlet

1838, "Les masques de l'africanité," Sylvie Chalaye

1861, "*Karmen*: Une censure à l'arme blanche," Iba Ndiaye Diadji

1862, "*Makibefo*, d'Alexander Abela," Olivier Barlet

2005, "*Fatou la Malienne*, téléfilm de Daniel Vigne," Olivier Barlet

2060, "Un esprit de jeu et de camaraderie," interview, Olivier Barlet with Jean-Marie Teno

2061, "Il faut oublier les sunlights," interview, Olivier Barlet with François Woukoache

2063, "Notre génération a une chance historique," interview, Olivier Barlet with Mama Keïta

2064, "*Le 11ème commandement*, de Mama Keïta," Olivier Barlet

2065, "Une relation d'amour avec le spectateur," interview, Olivier Barlet with Mahamat Saleh Haroun

2066, "Improviser l'intime," interview, Olivier Barlet with Zeka Laplaine

2067, "*(Paris: xy)*, de Zeka Laplaine," Olivier Barlet

2068, "Tourner en guérilla," interview, Olivier Barlet with Balufu Bakupa-Kanyinda

2069, "Je vis à Conakry mais j'habite à Paris," interview, Olivier Barlet with Gahité Fofana

2070, "*Immatriculation temporaire*, de Gahité Fofana," Olivier Barlet

2071, "*Daresalam*, d'Issa Serge Coelo," Olivier Barlet

2123, "Ecrire le Congo à partir de l'ailleurs: Tchicaya U Tam'Si," Boniface Mongo-Mboussa

2131, "*Frontières*, de Mostéfa Djadjam," Olivier Barlet

2145, "Le lâchage d'Atria," interview, Olivier Barlet with Andrée Davanture

2171, "*Karmen* censuré," interview, Catherine Ruelle with Jo Gaye Ramaka

2186, "Quelle chemise prendre?," Flora Gomes, about *Po di Sangui*, interview by Olivier Barlet

2188, "*Po di Sangui*, de Flora Gomes," M'Bissine Diop

2189, "Le salut ne peut venir que de nous mêmes," interview, Guy Hennebelle with Ababacar Samb-Makharam

2197, "Les images meurent aussi . . . ," Pascal Blanchard and Eric Deroo

2242, "*Le Cheval de vent*, de Daoud Aoulad Syad," Olivier Barlet

2291, "Tu ne peux pas t'asseoir et croiser les bras," interview, Olivier Barlet with Mimi Diallo

2292, "*Sia, le rêve du python*, de Dani Kouyaté," Olivier Barlet

2293, "Universel comme le conte," interview, Olivier Barlet with Dani Kouyaté

2294, "*Sucre amer*, de Christian Lara," Olivier Barlet

2296, "*Satin Rouge*, de Raja Amari," Olivier Barlet

2297, "*Wesh wesh, ça me regarde!*, de Rabah Ameur-Zaïmèche," Olivier Barlet

2298, "*Si-Gueriki, la reine-mère*, d'Idrissou Mora-Kpaï," Olivier Barlet

2299, "*Konorofili*, de Cheick Fantamady Camara," Olivier Barlet

2314, "*Le Chant de la Noria*, d'Abdellatif Benammar," Olivier Barlet

2315, "A propos de *Le Chant de la Noria*," interview, Olivier Barlet with Abellatif Ben Ammar and Houyem Rassaa

2323, "*Deux cent dirhams*, de Laïla Marrakchi," Olivier Barlet

2325, "*La Voie lente*, de Samia Meskaldji," Olivier Barlet

2332, Interview, Olivier Barlet with Flora Gomes and Serge Zeitoun

2333, "Toucher tous les publics," interview, Olivier Barlet with Magda Wassef, delegate general of la Biennale

2350, "*Heremakono—En attendant le bonheur*, d'Abderrahmane Sissako," Olivier Barlet

2351, "A propos de *Heremakono*," interview, Olivier Barlet with Abderrahmane Sissako

2352, "*Kabala*, d'Assane Kouyaté," Olivier Barlet

2353, "A propos de *Kabala*," interview, Olivier Barlet with Assane Kouyaté

2355, "*Rachida*, de Yamina Bachir-Chouikh," Olivier Barlet

2356, "A propos de *Rachida*," interview, Olivier Barlet with Yamina Bachir-Chouikh

2357, "*Abouna*, de Mahamat Saleh Haroun," Olivier Barlet

2358, "*Abouna*, éloge du respect," interview, Olivier Barlet with Mahamat Saleh Haroun

2361, "Cannes 2002 au jour le jour," *Journal de Cannes*, Olivier Barlet

2424, "*Le Chant du millénaire*, de Mohamed Zran," Olivier Barlet

2431, "*Afriques, comment ça va avec la douleur?*, de Raymond Depardon," Olivier Barlet

2432, "*L'Algérie des chimères*: Série en trois épisodes de François Luciani," Olivier Barlet

2436, "*Bedwin Hacker*, de Nadia El Fani," Olivier Barlet

2438, "Fespaco 97: Les courts valent le détour," Olivier Barlet

2439, "A propos de *Le Clandestin* et *Macadam tribu*," interview, Olivier Barlet with José Laplaine

2441, "*Kankouran*, de Malick Sy," Olivier Barlet

2442, "*Karmen Geï*, de Joseph Gaye Ramaka," Olivier Barlet

2449, "*Les Pillules du mal*, de Malick Sy," Olivier Barlet

2450, "*Libre*, de Jean-Pierre Sauné," Olivier Barlet

2454, "A propos de *Ngor, l'esprit des lieux*," interview, Olivier Barlet with Samba Félix N'Diaye

2461, "*Shaft*, de John Singleton," Olivier Barlet

2464, "*Tchicaya*, de Léandre-Alain Baker," Olivier Barlet

2466, "*Le Damier—Papa National Oyé!*, de Balufu Baku," Olivier Barlet

2473, Interview, Olivier Barlet with the actresses Zalika Souley (Niger) and Isseu Niang (Senegal)

2474, Interview, Olivier Barlet with Adama Drabo, about *Ta Dona* and *Taafe Fanga*

2477, Interview, Olivier Barlet with Jean-Pierre Bekolo (Cameroon), about *Complot d'Aristote*

2496, Interview, Olivier Barlet with Melvin van Peebles (United States)

2506, Interview, Olivier Barlet with Sembene Ousmane

2508, Interview, Olivier Barlet with Tony Coco-Viloin (Guadeloupe)

2511, "Casser les clichés: A propos de *Bedwin Hacker*," interview, Olivier Barlet with Nadia El Fani

2573, "2000: 5ème Biennale des cinémas arabes à Paris: 5ème Biennale au jour le jour," Olivier Barlet

2617, "*The Jazz Singer* et l'héritage des *minstrel shows*: Entre musique et images," Gilles Mouëllic

2629, "*Faat Kine*: Sembene s'explique," ed. Olivier Barlet

2631, "*Soif*, de Saad Chraïbi," Olivier Barlet

2657, "*Poussières de ville*, de Moussa Touré," Olivier Barlet

2658, "A propos de *Poupées d'argile*," interview, Olivier Barlet with Nouri Bouzid

2659, "*Poupées d'argile*, de Nouri Bouzid," Olivier Barlet

2660, "A propos de *Les Pygmées de Carlo*," interview, Olivier Barlet with Radu Mihaileanu

2661, "*Les Pygmées de Carlo*, de Radu Mihaileanu," Olivier Barlet

2666, "*Toza é bélé (Nous sommes nombreuses)*, de Moussa Touré," Olivier Barlet

2670, "La critique face aux cinémas africains et arabes," Colloque au festival international du film de Carthage 2002, Olivier Barlet

2676, "A propos de *Le Fleuve*," interview, Olivier Barlet with Mama Keïta

2677, "*Jours de Sadate*, de Mohamed Khan," Olivier Barlet

2680, "*La Boîte magique*, de Ridha Behi," Olivier Barlet

2683, "*Le Fleuve*, de Mama Keïta," Olivier Barlet

2691, "*Ames sœurs (Riches)*, d'Ingrid Sinclair," Olivier Barlet

2716, "Les Kinois et la télé," Serge Mumbu Tshimanga

2727, "Des Mozart qu'on assassine," interview, Taina Tervonen with Emmanuel Dongala

2732, "*Je chanterai pour toi*, de Jacques Sarasin," Olivier Barlet

2736, "*Un homme sans l'Occident*, de Raymond Depardon," Olivier Barlet

2738, "*Contes cruels de la guerre*, d'Ibéa Atondi et Karim Miské," Olivier Barlet

2741, "*Bamako Sigi-kan (Le Pacte de Bamako)*, de Manthia Diawara," Olivier Barlet

2749, "*Tasuma, le feu*, de Daniel Sanou Kollo," Olivier Barlet

2758, "Travailler dorénavant dans la proximité!," interview, Olivier Barlet with Idrissa Ouedraogo

2764, "Le modèle nigérian de la vidéo domestique est-il exportable?," Lagos, Olivier Barlet, July 2002

2775, "*Sia, le rêve du python*: L'adaptation littéraire au cinéma," Moussa Diagana and Dani Kouyaté, ed. Olivier Barlet

2778, "Etonnants scénarios à Bamako: Littérature et cinéma en confrontation étonnée," at Bamako, Olivier Barlet

2782, "A propos de *La Colère des dieux*," interview, Olivier Barlet with Idrissa Ouedraogo

2783, Interview, Olivier Barlet with Rasmané Ouedraogo

2786, "*100 Days (Cent jours)*, de Nick Hughes," Olivier Barlet

2791, "*Le Déchaussé*, de Laurence Attali," Olivier Barlet

2796, "La leçon de cinéma d'Abderrahmane Sissako," ed. Olivier Barlet

2798, "*Madame Brouette*, de Moussa Sene-Absa," Olivier Barlet

2799, "*Petite lumière*, d'Alain Gomis," Olivier Barlet

2800, "*Promised Land*, de Jason Xenopoulos," Olivier Barlet

2807, "Fespaco 2003: Priorité au cinéma," Olivier Barlet

2808, "*Moi et mon Blanc*, de Pierre Yaméogo," Olivier Barlet

2809, "*La Colère des dieux*, d'Idrissa Ouedraogo," Olivier Barlet

2813, "Les comédiens au Fespaco 2003: Le discours de Rasmané Ouedraogo et la synthèse du colloque"

2822, "*Black*, de Pierre Maraval," Olivier Barlet

2824, "*Rwanda pour mémoire*, de Samba Félix Ndiaye," Olivier Barlet

2825, "*Chouchou*, de Merzak Allouache," Olivier Barlet

2839, "*Fatou l'espoir*, téléfilm de Daniel Vigne," Olivier Barlet

2842, "Migrations et Mondialité," interview, Landry-Wilfrid Miampika with Édouard Glissant

2884, "*L'Adieu*, téléfilm de François Luciani," Olivier Barlet

2888, "*Breath Control: The History of the Human Beat Box*, de Joey Garfield," Anne Crémieux

2890, "*Royal Bonbon*, de Charles Najman," Olivier Barlet

2897, "A propos d'*Ali Zaoua*," interview, Olivier Barlet with Nabil Ayouch

2899, "A propos du *Silence de la forêt*," interview, Olivier Barlet with Nadège Beausson-Diagne

2900, Interview, Olivier Barlet with Hubert Koundé

2905, "La coproduction en francophonie: Table-ronde à Cannes 2003," ed. Olivier Barlet

2909, Interview, Olivier Barlet with Didier Ouenangaré, codirector of *Le Silence de la forêt*

2910, Interview, Olivier Barlet with Eriq Ebouaney, actor in *Le Silence de la forêt*

2911, Interview, Olivier Barlet with Faouzi Bensaïdi, director of *Mille mois*

2912, "*Mille mois*, de Faouzi Bensaïdi," Olivier Barlet

2917, "Quel avenir pour le financement des films du Sud?: Une table ronde à Cannes 2003," ed. Olivier Barlet

2925, "*Moro no Brasil*, de Mika Kaurismäki," Olivier Barlet

2999, "Cannes 2003: Mobilisation générale!," Olivier Barlet

3020, "*Les Maux de la faim*, de Jihan El Tahri," Olivier Barlet

3038, "Lussas 2003: Le droit à l'invisibilité," Olivier Barlet

3040, "*Amours zoulous*, d'Emmanuelle Bidou," Olivier Barlet

3041, "*Et les arbres poussent en Kabylie*, de Djamila Sahraoui," Olivier Barlet

3043, "A propos de *Tanger, le rêve des brûleurs*," interview, Olivier Barlet with Leïla Kilani

3044, "Un cri de colère," interview, Olivier Barlet with Michael Raeburn, about *Zimbabwe, de la libération au chaos*

3046, "*L'Enfant noir*, de Laurent Chevallier," Olivier Barlet

3049, "*Mozambique, journal d'une indépendance*, de Margerida Cardoso," Olivier Barlet

3051, "*Racines lointaines*, de Pierre-Yves Vandeweerd," Olivier Barlet

3053, "*Tanger, le rêve des brûleurs*, de Leïla Kilani," Olivier Barlet

3054, "*Voyage au pays des peaux blanches*, de Laurent Chevallier," Olivier Barlet

3065, "Au Sénégal, nous inventons nos pratiques documentaires," interview, Benjamin Bibas and Boris Mélinand with Moussa Touré

3069, "*Le Soleil assassiné*, d'Abdelkrim Bahloul," Olivier Barlet

3070, "*Le Jardin de Papa*, de Zeka Laplaine," Olivier Barlet

3071, "Je voulais que la peau parle!," interview, Olivier Barlet with Zeka Laplaine, about *Jardin de Papa*

3073, "La critique n'est pas jugement," Olivier Barlet

3074, "*Traces, empreintes de femmes*, de Katy Lena Ndiaye," Olivier Barlet

3075, "Anetina donne de l'espoir," interview, Heike Hurst, Tahar Chikhaoui, and Olivier Barlet with Katy Lena Ndiaye, about *Traces, empreintes de femmes*

3077, "Diffusion, promotion et distribution des films francophones: Réalités et perspectives, Colloque au château de Namur, 1er octobre 2003"

3081, "Cinéastes africains et censeurs: L'autocratie toujours!," Une mise au point de Jean-Marie Teno

3236, "*Hollywood sur Nil—regards sur le cinéma musical arabe*, de Saida Boukhemal," Olivier Barlet

3237, "*Algériennes, trente ans après (Elles 2)*, de Ahmed Lallem," Olivier Barlet

3242, "Au-delà des discours," interview, Olivier Barlet with Abdelkader Lagtaâ, about *Face à face*

3246, "Une vision circulaire," interview, Elisabeth Monteiro-Rodrigues with Mia Couto

3250, "Au revoir les z'enfants!: Jean-Marie Teno s'explique sur son départ de la Guilde," Jean-Marie Teno

3252, "Lussas 2001: Carnet de route aux Etats généraux du film documentaire," Lussas (07), August 19–25, 2001, Olivier Barlet

3258, "*L'Esquive*, d'Abdellatif Kechiche," Olivier Barlet

3330, "*Du Mali au Mississipi*, de Martin Scorsese," Olivier Barlet

3344, "*Wa'n wina (Amicalement vôtre)*, de Dumisani Phakathi," Olivier Barlet

3346, "*Mariage et ménage (Heart and Home)*, de Fabintou Diop," Olivier Barlet

3349, "*Mémoire entre deux rives*, de Frédéric Savoye et Wolimité Sié Palenfo," Olivier Barlet

3350, Interview, Olivier Barlet with Olivier Delahaye, producer of *La Caméra de bois*

3351, "A propos de *Les Bandits*," interview, Olivier Barlet with Saïd Naciri

3361, "Colloque 'Ecrans pâles,' Institut du monde arabe, 26 avril 2004," ed. Olivier Barlet

3362, "Ne plus être seulement séduisante," interview, Olivier Barlet with Sonia Rolland

3363, "Classe de cinéma de Gaston Kaboré, Festival Vues d'Afrique, Montréal, 23 avril 2004," ed. Olivier Barlet

3364, "A propos de *La Danse du vent*," interview, Olivier Barlet with Taïeb Louhichi

3368, "Les 20 ans de Vues d'Afrique à Montréal," Olivier Barlet

3369, "Le problème est plus mental qu'économique," interview, Samba Gadjigo with Ousmane Sembene, about *Moolade*

3423, "*Moolaade*, d'Ousmane Sembene," Olivier Barlet

3424, "Cannes 2004: Du social au regard," Olivier Barlet

3431, "*La Blessure*, de Nicolas Klotz," Olivier Barlet

3433, "*Un fils*, d'Amal Bedjaoui," Olivier Barlet

3435, "*Après (Un voyage dans le Rwanda)*, de Denis Gheerbrant," Olivier Barlet

3436, "*Bè Kunko (Nos problèmes)*, de Cheick Fantamady Camara," Olivier Barlet

3439, "Ecrans noirs: Le Nigeria à la porte," at Yaoundé, Olivier Barlet

3440, "Le renouvellement de l'Afrique se fera par la culture," press conference with Ousmane Sembene at the festival Ecrans noirs, Yaoundé, June 6, 2004, ed. Olivier Barlet

3442, "*La Valse des gros derrières*, de Jean Odoutan," Olivier Barlet

3451, "*Un héros*, de Zézé Gamboa," Olivier Barlet

3452, "Le documentaire dans le paysage audiovisuel arabe: Table-ronde à la Biennale des cinémas arabes, 1er juillet 2004," ed. Olivier Barlet

3454, "*Aliénations*, de Malek Bensmaïl," Olivier Barlet

3459, "*Raïs Labhar (Ô Capitaine des mers)*, de Hichem Ben Ammar," Olivier Barlet

3460, "Biennale des cinémas arabes 2004: L'émergence du documentaire," Olivier Barlet

3474, "*La Danse du vent*, de Taïeb Louhichi," Olivier Barlet

3475, "*1802, l'épopée guadeloupéenne*, de Christian Lara," Olivier Barlet

3477, "Lussas 2004: Rwanda, Afrique, les seuils de la représentation," Olivier Barlet

3479, "*Le Refuge*, de Nedia Touijer," Olivier Barlet

3482, "Produire une connaissance qui nous fasse rencontrer l'autre," interview, Sylvain Baldus and Benjamin Bibas with Denis Gheerbrant, about *Après (Un voyage dans le Rwanda)*

3524, "L'émergence des jeunes réalisateurs au Cameroun," Yvette Mbogo and Olivier Barlet

3560, "Le corps est-il soluble dans la narration?," Abdelkader Lagtaâ

3561, "Salé 2004: Quels écrans de femmes?," Olivier Barlet

3567, "Ne pas jouer une Noire mais un personnage," interview, Olivier Barlet with Mata Gabin

3569, "Filmer sans responsabilité revient à torturer une deuxième fois," interview, Olivier Barlet and Mohammed Bakrim with Ramadan Suleman, about *Lettre d'amour zoulou*

3570, "*Lettre d'amour zoulou (Zulu Love Letter)*, de Ramadan Suleman," Olivier Barlet

3571, "*La Chute du faucon noir*, de Ridley Scott," Olivier Barlet

3574, "*Le Prince*, de Mohamed Zran," Olivier Barlet

3577, "*Parole d'Hommes*, de Moez Kamoun," Olivier Barlet

3580, "*Tenja*, d'Hassan Legzouli," Olivier Barlet

3591, "Jamais on n'entend dire que les femmes partent avec la caisse," interview, Olivier Barlet with Naky Sy Savané, Ivorian actress

3598, "Le phénomène des productions vidéo à Madagascar," interview, Olivier Barlet with Henry Randrianierenana

3599, "*Les Suspects*, de Kamal Dehane," Olivier Barlet

3600, "*Visa*, d'Ibrahim Letaïef," Olivier Barlet

3611, "Hassan Legzouli parle de *Tenja*," ed. Aurore Engelen Loosen

3668, "*Massai, les guerriers de la pluie*, de Pascal Plisson," Anne Crémieux

3674, "*Nèg Maron*, de Jean-Claude Flamand Barny," Olivier Barlet

3675, "*Biguine*, de Guy Deslauriers," Olivier Barlet

3679, "Avoir la foi!," interview, Olivier Barlet with the actress Aïssa Maïga

3682, "*Mahaleo*, de Cesar Paes et Raymond Rajaonarivelo," Olivier Barlet

3685, "Pour un cinéma pensé," interview, Olivier Barlet with Mahamat Saleh Haroun

3688, "*La Noiraude*, de Fabienne et Véronique Kanor," Olivier Barlet

3689, "De la schizophrénie antillaise," interview, Olivier Barlet with Fabienne Kanor

3691, "*L'Enfant endormi*, de Yasmine Kassari," Olivier Barlet

3693, "Manosque 2005: La bonne distance," Olivier Barlet

3697, "Le cinéma africain, ce cinéma nomade," interview, Hassouna Mansouri with Mahamat Saleh Haroun

3700, "*Arlit, deuxième Paris*, d'Idrissou Mora Kpai," Olivier Barlet

3702, Interview, Olivier Barlet with Yasmine Kassari, about *L'Enfant endormi*

3727, "Du cinéma métis au cinéma nomade: Défense du cinéma," Olivier Barlet

3731, "Le métissage? Un concept qui asservit," interview, Olivier Barlet with Claire Denis

3747, "Lagunimages 2004: Les télévisions africaines en question," Samuel Lelièvre

3773, "Si vous suivez la route américaine, il vous faut lâcher un peu de vous-même," interview, Olivier Barlet with Zola Maseko, about *Drum*

3776, "*Hôtel Rwanda*, de Terry George," Olivier Barlet

3799, "The Brown University Africana Film Festival 2005: Questions d'identité," Olivier Barlet

3800, "Ecrire pour le théâtre et le cinéma en République démocratique du Congo: Table-ronde réunissant Pierre Mujomba, Ngangura Mweze, Ngwarsungu Chiwengo, Mbala Nkanga à la Brown University, Providence, USA, 14 avril 2005," notes by Olivier Barlet

3801, "*Paul Robeson: Here I Stand*, de St. Clair Bourne," Olivier Barlet

3802, "*Les Habits neufs du gouverneur*, de Dieudonné Ngangura Mweze," Olivier Barlet

3818, "De l'indicible au romantique: Les masques de l'amour au cinéma," Olivier Barlet

3850, "*Delwende (Lève-toi et marche)*, de S. Pierre Yameogo," Olivier Barlet

3851, "*Marock*, de Laïla Marrakchi," Olivier Barlet

3855, "*Afriques 50*: Regards singuliers, auteurs singuliers—une recherche esthétique permanente: Rencontre au festival de Cannes 2005," ed. Olivier Barlet

3866, "*Djourou, une corde à ton cou*, d'Olivier Zuchuat," Olivier Barlet

3875, "*Comment conquérir l'Amérique en une nuit*, de Dany Laferrière," Olivier Barlet

3882, "La production audiovisuelle dans la région des Grands Lacs: Ateliers internationaux au 10ème Afrika Filmfestival Leuven 2005," Afrika Filmfestival Leuven, June 15, 2005

3930, "Ecrans noirs 2005: La solution locale," Olivier Barlet

3931, "Mon travail ne peut se situer que dans la revendication et la critique," interview, Virginie Andriamirado with Barthélémy Toguo

3942, "*Le Malentendu colonial*, de Jean-Marie Teno," Olivier Barlet

3943, "*Les Saignantes*, de Jean-Pierre Bekolo," Olivier Barlet

3944, "Etre à la fois africain et contemporain," interview, Olivier Barlet with Jean-Pierre Bekolo, about *Les Saignantes*

3948, "*Nanga Def (Comment ça va?)*, de Moussa Touré," Olivier Barlet

3950, "*Sorcière, la vie!*, de Monique Mbeka Phoba," Olivier Barlet

3951, "*Brasileirinho*, de Mika Kaurismäki," Olivier Barlet

3952, "*Mon beau sourire*, d'Angèle Diabang Brener," Olivier Barlet

3953, "*D'une fleur double et de quatre mille autres*, de Claude Haffner," Olivier Barlet

3954, "*Un amour pendant la guerre*, d'Osvalde Lewat," Olivier Barlet

3955, "*Hadja Moï*, de Laurent Chevallier," Olivier Barlet

3956, "*Justice à Agadez*, de Christian Lelong," Olivier Barlet

3957, "*Lâche-moi, j'ai 51 frères et sœurs!* (Don't Fuck with Me, I Have 51 Brothers and Sisters), de Dumisani Phakathi," Olivier Barlet

3958, "*Pourquoi?*, de Sokhna Amar," Olivier Barlet

3959, "*Cinq sur cinq*, de Moussa Touré," Olivier Barlet

3961, "Lussas 2005: Des films qui dérangent," Olivier Barlet

3963, "*Ils étaient la France libre*, d'Eric Blanchot," Olivier Barlet

3970, "Les enjeux de la télévision en Afrique: Ecrans d'Etat, écrans d'ailleurs, écrans miroirs . . . : Colloque au Sénat organisé par CFI, 15 septembre 2005"

4040, "*Rize*, de David LaChapelle," Anne Crémieux

4047, "Le cinéma peut montrer la voie," interview, Olivier Barlet with Souleymane Cissé

4069, "*Douar de femmes*, de Mohamed Chouikh," Olivier Barlet

4072, "*Congo River*, au-delà des ténèbres, de Thierry Michel," Olivier Barlet

4084, "Les fermetures de salles sont inéluctables," interview, Olivier Barlet with Frédéric Massin, cinema owner in Africa

4099, "La République et sa Bête: A propos des émeutes dans les banlieues de France," Achille Mbembe

4113, "*Manderlay*, de Lars von Trier," Samir Ardjoum

4142, "Nous faisons pire qu'Hollywood," interview, Steve Ayorinde (*The Punch*, Lagos) and Olivier Barlet with Kwaw Ansah, Accra, October 7, 2005

4240, "Apt 2005: Quelle morale de l'image?," Olivier Barlet

4248, "Afropolitanisme," Achille Mbembe

4255, "*The Constant Gardener*, de Fernando Meirelles," Olivier Barlet

4261, "*Sisters in Law (Sœurs de loi)*, de Florence Ayissi et Kim Longinotto," Olivier Barlet

4265, "*La Reconnaissance*, de Didier Bergounhoux et Claude Hivernon," Olivier Barlet

4266, "*Parcours de dissidents*, d'Euzhan Palcy," Olivier Barlet

4271, "*La Trahison*, de Philippe Faucon," Samir Ardjoum

4272, "Un témoignage français sur la guerre d'Algérie," interview, Samir Ardjoum with Philippe Faucon, about *La Trahison*

4278, "*Vers le sud*, de Laurent Cantet," Samir Ardjoum

4287, "*La Piste*, d'Eric Valli," Olivier Barlet

4290, "Afropolitanisme," Achille Mbembe

4319, "Les ambiguïtés du Cauchemar de Darwin," Olivier Barlet

4342, "*Maria Bethania, mûsica é perfume*, de Georges Gachot," Olivier Barlet

4345, "*Dunia*, de Jocelyne Saab," Olivier Barlet

4359, "Vidéofilms: Vers une renaissance du cinéma malgache?," Karine Blanchon

4361, Interview, Olivier Barlet with Jean-Servais Bakyon

4363, "Corps noirs dans l'espace et le temps: Black is beautiful? Le code des couleurs dans les films africains-américains," Anne Crémieux

4378, "*Inside Man (L'Homme de l'intérieur)*, de Spike Lee," Anne Crémieux and Olivier Barlet

4380, "*Lili et le baobab*, de Chantal Richard," Olivier Barlet

4381, "*Bab'Aziz—Le Prince qui contemplait son âme*, de Nacer Khemir," Olivier Barlet

4383, "Nous n'avons pas droit à la fiction," interview, Olivier Barlet with Nacer Khemir, about *Bab'Azi*

4384, "On n'oubliera jamais," interview, Olivier Barlet with Jillali Ferhati, about *Mémoire en détention*

4386, "*Mémoire en détention*, de Jillali Ferhati," Olivier Barlet

4387, "Rome 2006: Qu'est-ce qu'un film 'bien fait'?," Olivier Barlet

4397, "Lifting de la fédération panafricaine des cinéastes (Fepaci) à Tshwane," Claude Haffner

4403, "*Mon nom est Tsotsi*, de Gavin Hood," Olivier Barlet

4406, "Comment penser l'Afrique? De la famille africaine, des artistes, des intellectuels, de la critique et des évolutions de la création," interview, Achille Mbembe with Célestin Monga

4410, "*Beur, Blanc, Rouge*, de Mahmoud Zemmouri (Algérie)," Samir Ardjoum

4413, "Télévision et cinéma au Cameroun," interview, Olivier Barlet with Rémi Atangana

4414, "Réveiller le cinéma à Madagascar," interview, Karine Blanchon with Laza, about the Premières Rencontres du Film Court, April 27 and 28, 2006, at Antananarivo

4428, "Ce tribunal, ils y croyaient!," interview, Heike Hurst and Olivier Barlet with Abderrahmane Sissako, about *Bamako*

4429, "*Bamako*, d'Abderrahmane Sissako," Olivier Barlet

4433, "*Indigènes*, de Rachid Bouchareb," Olivier Barlet

4434, "Le passé nous fait réfléchir sur aujourd'hui et sur notre futur," interview, Olivier Barlet with Rachid Bouchareb, about *Indigènes*

4438, "Cannes 2006: Qu'est-ce que le cinéma populaire?," Olivier Barlet

4439, "*Halim*, de Sherif Arafa," Olivier Barlet

4442, "*VHS—Kahloucha*, de Nejib Belkadhi," Olivier Barlet

4443, "*Barakat!*, de Djamila Sahraoui," Olivier Barlet

4451, "*La Symphonie marocaine*, de Kamal Kamal," Olivier Barlet

4452, "*Le Regard*, de Nour-Eddine Lakhmari," Olivier Barlet

4454, "*Caramel*, d'Henri Duparc," Olivier Barlet

4460, "*Un matin bonne heure* (*Yaguine et Fodé*), de Gahité Fofana," Olivier Barlet

4510, "Un film utile," interview, Olivier Barlet with Sol de Carvalho, about *Le Jardin d'un autre homme*

4511, "*Le Jardin d'un autre homme* (*O Jardim do outro homem*), de Sol de Carvalho," Olivier Barlet

4513, "*Nosaltres*, de Moussa Touré," Olivier Barlet

4514, "*The Amazing Grace*, de Jeta Amata," Olivier Barlet

4516, "*Sometimes in April*, de Raoul Peck," Olivier Barlet

4517, "*Juju Factory*, de Balufu Bakupa-Kanyinda," Olivier Barlet

4529, "Le prix à payer," interview, Olivier Barlet with Charles Mensah, president of FEPACI

4533, "From Nollywood to Nollyweight? or, Reflections on the Possibilities of Literature and the Burgeoning Film Industry in Nigeria, by Prof. Femi Osofisan," Femi Osofisan

4539, "Nourrir les esprits," interview, Achille Mbembe and Célestin Monga with Fabien Eboussi Boulaga

4556, "Pour un jeu intérieur," interview, Olivier Barlet with Rokhaya Niang, Senegalese actress

4558, "Le développement est une diplomatie qui n'a rien à voir avec la qualité," interview, Olivier Barlet with Balufu Bakupa-Kanyinda, about *Juju Factory*

4565, "L'oubli ne veut pas dire effacer mais inventer," interview, Olivier Barlet with the philosopher Marie-José Mondzain

4568, "Lussas 2006: Les enjeux d'Africadoc," Olivier Barlet

4577, "*Africa paradis*, de Sylvestre Amoussou," Olivier Barlet

4599, "Pourquoi un Marocain ne pourrait-il pas faire du polar?," interview, Olivier Barlet with Faouzi Bensaïdi, about *WWW: What a Wonderful World*

4600, "Namur 2006: Au-delà de la chronique," Olivier Barlet

4601, "*Bénarès*, de Barlen Pyamootoo," Olivier Barlet

4602, "*WWW—What a Wonderful World*, de Faouzi Bensaïdi," Olivier Barlet

4649, "Je ne pouvais quitter le Rwanda sans rien faire," interview, Olivier Barlet with Raoul Peck, about *Sometimes in April*

4653, "*Kigali, des images contre un massacre*, de Jean-Christophe Klotz," Olivier Barlet

4663, "*L'Ombre de Liberty*, d'Imunga Ivanga," Olivier Barlet

4666, "*Mon colonel*, de Laurent Herbiet (France)" Samir Ardjoum

4679, "Apt 2006: Pédagogie du cinéma," Olivier Barlet

4681, "Cette guerre, on l'a déjà gagnée car ce que nous faisons s'inscrit dans l'éternité," interview, Olivier Barlet with Mahamat-Saleh Haroun, about *Daratt*

4688, "*Making of*, de Nouri Bouzid," Olivier Barlet

4689, "*Tarfaya (Bab Labhar)*, de Daoud Aoulad Syad," Olivier Barlet

4698, "Festival du film amazigh 2007: Une nouvelle génération algérienne," Olivier Barlet

4700, "*J'en ai vu des étoiles (Choft Ennoujoum fil Quaïla)*, de Hichem Ben Ammar (Tunisie)," Olivier Barlet

4701, "Le documentaire comme combat," interview, Leïla Elgaaïed with Hichem Ben Ammar, about *J'en ai vu des étoiles*

4703, "*Angano . . . Angano, nouvelles de Madagascar*, de Marie-Clémence et César Paes," Olivier Barlet

4705, "*Blood Diamond*, de Edward Zwick: Les affrontements sont éternels," Anne Crémieux

4706, "*Questions à la terre natale*, de Samba Félix N'Diaye," Olivier Barlet

4707, "*Le Dernier roi d'Ecosse (The Last King of Scotland)*, de Kevin Macdonald: L'Afrique à travers un kilt," Anne Crémieux

5460, "Interview with Samba Felix Ndiaye," by Olivier Barlet

5541, "Interview with Wole Soyinka," by Boniface Mongo-Mboussa and Tanella Boni

5739, "*Max and Mona*: Confronting Death," interview with Teddy Matera, by Olivier Barlet

5751, "I'm proud of Nigeria," interview with Jeta Amata (Nigeria), by Olivier Barlet, on *The Amazing Grace*

5770, "Manosque 2007: Les pièges de la bonne intention," Olivier Barlet

5771, "*Si le vent soulève les sables (Sounds of Sand)*, de Marion Hänsel," Olivier Barlet

5775, "Le cinéma malgache en mal de reconnaissance internationale," Karine Blanchon

5801, "Cinéma: Un public sans marché," Olivier Barlet

5829, "Conditionner l'aide à une implication des États," interview, Olivier Barlet with Toussaint Tiendrebeogo

5857, "*Ezra*, de Newton Aduaka," Olivier Barlet

5858, "Entre substance et public," interview, Baba Diop, Bassirou Niang, and Olivier Barlet with Newton Aduaka, about *Ezra*

5862, "*Il va pleuvoir sur Conakry*, de Cheick Fantamady Camara," Olivier Barlet

5871, "*Sénégalaises et islam*, d'Angèle Diabang-Brener," Olivier Barlet

5872, "Carthage 2006: La critique tunisienne face aux films tunisiens," Olivier Barlet

5889, "*Goodbye Bafana*, de Bille August," Anne Crémieux

5897, "*Un dimanche à Kigali*, de Robert Favreau," Olivier Barlet

5910, "*La Maison de Mariata*, de Gaëlle Vu et Mariata Abdallah," Olivier Barlet

5931, "*Delice Paloma*, de Nadir Moknèche," Olivier Barlet

5955, "C'est en Afrique que je trouve encore la soif de rêver le monde," interview, Olivier Barlet with Émile Abossolo M'Bo

5957, "*Cartouches gauloises*, de Mehdi Charef," Olivier Barlet

5958, "Le travail critique n'est pas fait," interview, Olivier Barlet with Abderrahmane Sissako, jury of the 60th Festival de Cannes

5964, "*Munyurangabo*: A Prayer for the World," interview with Lee Isaac Chung, by Olivier Barlet

5965, "*Munyurangabo*, de Lee Isaac Chung," Olivier Barlet

5969, "*Tartina City*, d'Issa Serge Coelo," Olivier Barlet

6633, "Porter l'espoir de l'Afrique suppose être africain," interview, Olivier Barlet with the actor and storyteller Makena Diop

6656, "Masterclass with Gaston Kaboré, Cannes Film Festival 2007"

6680, "*Mémoires des esclavages*," interview, François Noudelman with Edouard Glissant

6699, "*Max and Mona*, by Teddy Matera," Olivier Barlet

6735, "*Vers le sud*, de Dany Laferrière," Nimrod

6776, "*Bled Number One*, by Rabah Ameur-Zaïmeche," Olivier Barlet

6785, "Allocution de M. Nicolas Sarkozy, président de la République française, prononcée à l'Université de Dakar, le 26 juillet 2007"

6788, "*Kinshasa Palace*, de Zeka Laplaine," Olivier Barlet

6816, "Nicholas Sarkozy's Africa," Achille Mbembe

6820, "Perspectives du cinéma haïtien," Olivier Barlet

6821, "Le cinéma en Haïti," Arnold Antonin and Joël Lorquet

6845, "*Le Sergent noir*, de John Ford," Samir Ardjoum

6846, "*Maïmouna la vie devant moi*, de Fabiola Maldonado," Olivier Barlet

6847, "*Maïsama m'a dit*, d'Isabelle Thomas," Olivier Barlet

6848, "*Retour à Gorée*, de Pierre-Yves Borgeaud," Olivier Barlet

6864, "*France-Afrique: The Idiocies That Divide Us*," Achille Mbembe

6865, "You must have the courage to look back at your past," interview with Jean-Marie Teno by Olivier Barlet, on *The Colonial Misunderstanding* and the *banlieue* riots

6946, "*L'Ennemi intime*, de Florent Emilio Siri," Samir Ardjoum

7003, "Nairobi 2007: Le souci du public," Olivier Barlet

7082, "*American Gangster*, de Ridley Scott," Anne Crémieux

7111, "Nigeria: Le critique et la 'renaissance nationale,'" interview, Olivier Barlet with Jahman Anikulapo

7125, "*La Graine et le mulet*, d'Abdellatif Kechiche," Olivier Barlet

7180, "*Whatever Lola Wants*, de Nabil Ayouch," Olivier Barlet

7190, "*La Maison jaune*, d'Amor Hakkar," Olivier Barlet

7195, "*Le Temps d'un film*, de Laurence Attali," Olivier Barlet

7202, "*En attendant les hommes*, de Katy Lena Ndiaye," Olivier Barlet

7209, "L'Afrique va nécessairement trouver son tempo et son souffle bientôt," interview, Olivier Barlet with Gaston Kaboré

7212, "*Le Chaos* face à la censure," interview, Olivier Barlet with Khaled Youssef

7254, "*Andalucia*, d'Alain Gomis," Olivier Barlet

7303, "Je voulais faire un film d'amour," interview, Olivier Barlet with Amor Hakkar, about *La Maison jaune*

7304, "Les cinq décennies des cinémas d'Afrique," Olivier Barlet

7305, "Grandeur et ambivalences de la révolution numérique," Olivier Barlet

7308, "Il faut travailler pour la postérité," interview, Olivier Barlet with Cheick Fantamady Camara, about *Il va pleuvoir sur Conakry*

7347, "L'exil côtoie le plaisir comme la douleur," interview, Virginie Andriamirado with Barthélémy Toguo

7353, "Nous représentons une nouvelle humanité," interview, Olivier Barlet with Gérard Théobald, about *Etre ou ne pas être . . .*

7416, "*Algérie, histoires à ne pas dire*, de Jean-Pierre Lledo," Olivier Barlet

7458, "*Rome plutôt que vous (Roma wa la N'touma)*, de Tariq Teguia," Olivier Barlet

7496, "*Arezki l'indigène*, de Djamel Bendeddouche," Olivier Barlet

7530, "Aimé Césaire: Le volcan s'est éteint," Achille Mbembe

7559, "*Mafrouza* (1 et 2), série documentaire en cinq parties d'Emmanuelle Demoris," Olivier Barlet

7613, "La figure de l'immigré en 1968, si distante, si actuelle," Olivier Barlet

7619, "*Entre les murs*, de Laurent Cantet (France)," Olivier Barlet

7627, "*Dernier maquis*, de Rabah Ameur-Zaimeche," Olivier Barlet

7636, "*Johnny Mad Dog*, de Jean-Stephane Sauvaire," Olivier Barlet

7637, "Ce n'est pas la peau qui importe mais le cœur," interview, Olivier Barlet with Fatoumata Diawara

7639, "Yandé Codou Sène, 'plus qu'une cantatrice': *Yandé Codou, la griotte de Senghor*, d'Angèle Diabang-Brener et *Yandé Codou Sène, diva séeréer*, de Laurence Gavron," Olivier Barlet

7657, "Ce film est né de la douleur de voir la détresse de la jeunesse africaine," interview, Olivier Barlet with Joséphine Ndagnou, about *Paris à tout prix*

7658, "Il n'y a que des réalisateurs africains qui nous donnent de vrais rôles," interview, Olivier Barlet with the actress Tella Kpomahou

7669, "Il est important pour moi de me réapproprier mon histoire," interview, Olivier Barlet with Mati Diop, about *1000 soleils*

7674, "*Freedom*: Arte documente la lutte d'émancipation des Africains-américains," Olivier Barlet

7683, "*Sexe, gombo et beurre salé*, de Mahamat-Saleh Haroun," Olivier Barlet

7684, "I really do believe in that kind of films," interview with Darrel James Roodt on *Zimbabwe*, by Olivier Barlet

7693, "In Eritrea, cinema theaters are very crowded for local films," interview with Rahel Tewelde, by Olivier Barlet

7695, "Demain, le pire est encore possible," interview, Olivier Barlet with Osvalde Lewat, about *Une affaire de nègres*

7734, "Which Country Are We Talking About? One World!," interview with Michelange Quay, by Olivier Barlet

7946, "Cannes 2008: L'Afrique fantôme," Olivier Barlet

7956, "We were too much in Sembene's wake," interview with Samba Félix Ndiaye, by Olivier Barlet

7961, "To be a true democracy, we have to insure that everyone has access to be able to make films," interview with the South-African producer Bridget Pickering, by Olivier Barlet

7968, "*Hancock*, de Peter Berg: Gueule de Black," Anne Crémieux

7975, "*Touki bouki*: De quelle hyène parle-t-on?," Olivier Barlet

7976, "Hergla 2008: L'écriture de liberté de Djibril Diop Mambety," Olivier Barlet

7984, "Youssef Chahine, une vie contre l'intolérance," Olivier Barlet

8057, "*Les Dormants*, de Pierre-Yves Vandeweerd," Olivier Barlet

8067, "Mondialisation, Mondialité, Pierre-monde," Patrick Chamoiseau

8073, "La leçon de cinéma de Mahmoud Ben Mahmoud, Hergla, Tunisie, le 22 juillet 2008"

8106, "*Mascarades*, de Lyes Salem," Olivier Barlet

8107, "Bollywood et l'Afrique: Le divorce?," Olivier Barlet

8134, "Lussas 2008: Retrouver l'esprit d'enfance," Olivier Barlet

8197, "Cinémas d'Afrique: Adieu l'isolement!: Table-ronde au Festival international du film du Caire, 20 novembre 2008"

8198, "*En attendant Pasolini*, de Daoud Alouad-Syad," Olivier Barlet

8199, "*Nos lieux interdits*, de Leïla Kilani," Olivier Barlet

8219, "La leçon de cinéma de Lyes Salem," interview with Olivier Barlet

8225, "*Agathe Cléry*, d'Etienne Chatiliez," Olivier Barlet

8231, "*Amour, sexe et mobylette*, de Maria Silvia Bazzoli et Christian Lelong," Olivier Barlet

8306, "*14 kilomètres*, de Gerardo Olivares," Olivier Barlet

8307, "*35 rhums*, de Claire Denis," Olivier Barlet

8348, "*Jesus and the Giant*: L'usage de la violence comme positionnement féministe," Jyoti Mistry

8412, "*Lieux saints*, de Jean-Marie Teno," Olivier Barlet

8445, "*Les 16 de Basse-Pointe*, de Camille Mauduech," Olivier Barlet

8465, "Le peuple des fractures et des fissures," interview, Olivier Barlet with Léandre-Alain Baker, about *Ramata*

8467, "Fespaco 2009: L'inquiétude," Olivier Barlet

8481, "*Inland (Gabbla, Dans les terres)*, de Tariq Teguia," Olivier Barlet

8530, "*Behind the Rainbow (Le pouvoir détruit-il le rêve?)*, de Jihan El Tahri," Olivier Barlet

8595, "*Aliker*, de Guy Deslauriers," Olivier Barlet

8600, "*Le Pays à l'envers*, de Sylvaine Dampierre," Olivier Barlet

8622, "Cinémas du Maghreb: Tendances contemporaines," Olivier Barlet

8627, "*Le Jour où Dieu est parti en voyage*, de Philippe Van Leeuw," Olivier Barlet

8630, "L'homosexualité en Afrique, un tabou persistant: L'exemple de la RDC," Sylvestre Luwa and Christophe Cassiau-Haurie

8680, "*Mon voisin, mon tueur*, d'Anne Aghion," Olivier Barlet

8681, "Il est plus facile de tuer son voisin qu'un inconnu," interview, Olivier Barlet with Anne Aghion, about *Mon voisin, mon tueur*

8682, "*L'Armée silencieuse (The Silent Army)*, de Jean Van de Velde," Olivier Barlet

8734, "Les enjeux de la coopération culturelle," Olivier Barlet

8742, "Finalement, la FEPACI, c'est ce qui nous tient ensemble," Monique Mbeka Phoba

8743, "De nouvelles pistes pour la Fepaci," interview, Monique Mbeka Phoba with Seipati Bulane-Hopa

8744, "Les cinéastes devraient s'acquitter de leurs obligations basiques," interview, Monique Mbeka Phoba with Gaston Kaboré

8749, "*Black*, de Pierre Laffargue," Olivier Barlet

8770, "*Tu n'as rien vu à Kinshasa*, de Mweze Dieudonné Ngangura," Olivier Barlet

8827, "*En terre étrangère*, de Christian Zerbib," Olivier Barlet

8861, "Interroger les origines et la culture pour mieux trouver sa place dans le monde," interview, Olivier Barlet with Mamadou Sellou Diallo

8862, "Lussas 2009: Lumières d'Afrique: L'émergence d'une nouvelle génération de documentaristes africains," Olivier Barlet

8940, "Crise coloniale—crise mondiale: Rencontre avec Edouard Glissant"

8943, "La pauvreté de l'Afrique, c'est dans la tête des gens!," interview, Virginie Andriamirado with the filmmaker Mustapha Alassane

8950, "*Victimes de nos richesses*, de Kal Touré," Olivier Barlet

8967, "*Au loin des villages*, d'Olivier Zuchuat," Olivier Barlet

8971, "*D'Arusha à Arusha*, de Christophe Gargot," Olivier Barlet

8974, "*Waramutseho! (Bonjour!)*, de Bernard Auguste Kouemo Yanghu," Olivier Barlet

8975, "*Les Secrets*, de Raja Amari," Olivier Barlet

9013, "Ce qui m'intéresse, c'est de travailler sur des énergies," interview, Olivier Barlet with Dyana Gaye, about *Un Transport en commun*

9014, "La leçon de cinéma de Tariq Teguia, au festival des films d'Afrique du pays d'Apt 2009"

9015, "Emmener le spectateur là où il ne veut pas aller," interview, Olivier Barlet with Raja Amari, about *Les Secrets*

9028, "Art contemporain d'Afrique: Négocier les conditions de la reconnaissance," interview, Vivian Paulissen with Achille Mbembe

9073, "Je me sens redevable de mes poètes," interview, François-Xavier Dubuisson with Balufu Bakupa-Kanyinda, about *Nous aussi avons marché sur la lune*

9108, "ACPfilms et ACPcultures: Les heureux élus, les résultats des programmes d'aide de l'Union européenne aux industries culturelles ACP," Olivier Barlet

9109, "Identité nationale et passé colonial: Pour un véritable débat," by Le Collectif "Pour un véritable débat"

9135, "*Invictus*, de Clint Eastwood," Olivier Barlet

9139, "Cinquante ans de décolonisation africaine," Achille Mbembe

9152, "*Disgrâce*, de Steve Jacobs," Anne Crémieux

9161, "Lucien Lemoine s'est éteint," Amadou Lamine Sall

9206, "*Harragas*, de Merzak Allouache," Patricia Caillé

9274, "*Le Temps de la kermesse est terminé*, de Frédéric Chignac," Olivier Barlet

9280, "*White Material*, de Claire Denis," Olivier Barlet

9286, "*Femmes du Caire*, de Yousry Nasrallah," Olivier Barlet

9287, "Les gens sont obsédés par la religion et la sexualité, et bizarrement, ils les mettent en opposition," interview, Olivier Barlet with Yousry Nasrallah, about *Femmes du Caire*

9288, "*Vivre ici*, de Mohamed Zran," Olivier Barlet

9289, "Le si fragile équilibre du monde," interview, Olivier Barlet with Mohamed Zran, about *Vivre ici*

9317, "*Ousmane Sembene, tout à la fois*, de Christine Delorme," Olivier Barlet

9329, "La critique occidentale des cinémas africains entre cinéphilie et universalisme," Michel Serceau

9381, "*Au nom du père, de tous, du ciel*, de Marie-Violaine Brincard," Olivier Barlet

9400, "Panorama des Cinémas du Maghreb 2010: Des courts à la recherche du temps," Olivier Barlet

9402, "*Atlantiques*, de Mati Diop," Olivier Barlet

9412, "*Lignes de front*, de Jean-Christophe Klotz," Olivier Barlet

9448, "Antananarivo 2010: La nécessité de la formation," Olivier Barlet

9462, "*Nothing but the Truth (Rien que la vérité)*, de John Kani," Olivier Barlet

9463, "*Before and After: A Self-Critique in the Wars of African Cinema Criticism*," Kenneth W. Harrow

9467, "*Le Fil*, de Mehdi Ben Attia," Patricia Caillé

9479, "*Un homme qui crie*, de Mahamat-Saleh Haroun," Olivier Barlet

9498, Press conference for the film *Hors-la-loi* at the Festival de Cannes 2010

9500, "*Hors-la-loi*, de Rachid Bouchareb," Olivier Barlet

9501, "Plus l'Afrique est oubliée, plus il faut la ramener au souvenir du monde," interview, Olivier Barlet with Mahamat-Saleh Haroun, about *Un homme qui crie*

9503, "*Benda Bilili!*, de Florent de la Tullaye et Renaud Barret," Olivier Barlet

9515, "*Le Secret de Chanda (Life, above All)*, d'Oliver Schmitz," Olivier Barlet

9520, "*Un transport en commun*, de Dyana Gaye," Olivier Barlet

9526, "Comment faire un bon film sans fric?," interview, Olivier Barlet with Djinn Carrénard, about *Donoma*

9541, "Cannes 2010: Face à la cupidité," Olivier Barlet

9557, "Africadoc: Quatre réalisateurs tirent un bilan," interview, Olivier Barlet with Mamadou Sellou Diallo, Gentille Menguizani Assih, Elhadj Sani Magori, and Rama Thiaw

9562, "*Le Dernier vol du flamant rose*, de João Ribeiro," Olivier Barlet

9595, "Edouard Glissant: Un monde en relation, première mondiale du film de Manthia Diawara," Olivier Barlet

9602, "Une école de cinéma en Ethiopie," interview, Olivier Barlet with Abraham Hailé Biru

9622, "*Po di Sangui*, de Flora Gomes (Guinée-Bissau)," Olivier Barlet

9644, "La tache affective: De l'Afrique comme objet d'étude," Abdoulaye Imorou

9671, "Lussas 2010: Tristes tropiques?," Olivier Barlet

9708, "Poèmes 'Sans Titre,'" Umar Timol

9728, "*Moloch Tropical*, de Raoul Peck," Olivier Barlet

9763, "Que sont devenues les salles de cinéma au Tchad?," Patrick Ndiltah

9829, "*Vénus noire* de Kechiche: Un film qui vous soulève le cœur, mais ne vous tire aucune larme," Sylvie Chalaye

9846, "Zineb Sedira: Mémoire Vive: A travers 'Les rêves n'ont pas de titre' et 'Gardiennes de mémoires,'" Julie Crenn

9863, "De la francophonie à la littérature-monde," Boniface Mongo-Mboussa

9865, "France, je t'aime, France, je te hais: Les cinémas d'Afrique dans le trouble de la coopération," Olivier Barlet

9867, "Les Cinémas du Maghreb et leurs publics dans un contexte arabo-africain: Conception, perception, réception," Colloque international aux Journées cinématographiques de Carthage 2010

9877, "Eriger chez nous des instances de validation qui feraient que l'Europe ne soit plus le centre," interview, Virginie Andriamirado with Hervé Youmbi

9886, "*Indochine, sur les traces d'une mère*, d'Idrissou Mora-Kpaï," Olivier Barlet

9894, "*La Mosquée*, de Daoud Aoulad Syad," Olivier Barlet

9895, "Il faut un langage pour raconter une histoire," interview, Olivier Barlet with Daoud Aoulad Syad, about *La Mosquée*

9909, "Le cinéma tunisien à la lumière du printemps arabe," Olivier Barlet

9918, "L'inauguration du Normandie à Ndjaména: Quand l'international pousse le local," Patrick Ndilta

9924, "Colloque 'Images et représentations des Maghrébins dans le cinéma en France,'" Patricia Caillé

9941, "Le cinéma égyptien à la lumière du printemps arabe," Hassouna Mansouri, Samir Ardjoum, and Olivier Barlet

9970, "La formation des jeunes réalisateurs africains: Table-ronde au festival d'Apt 2010"

10002, "C'est le dernier Fespaco auquel j'assiste," interview, Olivier Barlet with Mahamat-Saleh Haroun

10009, "Fespaco 2011: Un festival menacé," Olivier Barlet

10049, "The Way to Help Us Is to Give Us Our Funding on Time," interview with Michel Ouedraogo, delegate general of FESPACO, by Olivier Barlet

10058, "*Territoire perdu*, de Pierre-Yves Vandeweerd," Olivier Barlet

10079, "De Sekou Touré à aujourd'hui," interview, Olivier Barlet with the filmmaker Moussa Kemoko Diakité

10080, "Lille 2011: Hommage à Moussa Kemoko Diakité, doyen du cinéma guinéen," Olivier Barlet

10081, "Immigration et cités: Se dire en images," Olivier Barlet

10141, "Christiane Taubira fait le bilan de sa loi," interview, Ousmane Ndiaye and Ayoko Mensah with Christiane Taubira

10158, "Antillais en France, on doit en permanence refaire ses preuves," interview, Olivier Barlet with Euzhan Palcy at the Festival de Cannes

10173, "*Rue des cités*, de Carine May et Hakim Zouhani," Olivier Barlet

10174, "Filmer dans les rues des Cités," interview, Olivier Barlet with Carine May and Hakim Zouhani

10203, "Cannes 2011: Cinéma et révolution," Olivier Barlet

10233, "*Skoonheid (Beauty)*, d'Oliver Hermanus," Olivier Barlet

10237, "Oliver Hermanus: It's not a judgement of character, it's a portrait," interview by Olivier Barlet

10254, "*Mafrouza* (3, 4 et 5), série documentaire en cinq parties d'Emmanuelle Demoris," Olivier Barlet

10298, "La leçon de cinéma de Faouzi Bensaïdi, Apt, novembre 2010," Olivier Barlet

10299, "Nigeria: Focusing More on Quality," interview with Victor Okhai, by Olivier Barlet

10300, "To Experience the Violence," interview with Khalo Matabane, by Olivier Barlet

10319, "*Case départ*, de Lionel Steketee, Thomas Ngijol et Fabrice Eboué," Olivier Barlet

10330, "Provoquer le débat," interview, Olivier Barlet with Didier Awadi, about *Le Point de vue du lion*

10372, "Lussas 2011: Enjeux documentaires," Olivier Barlet

10379, "Femmes, artistes, en Algérie," Nadira Laggoune-Aklouche

10389, "Zineb Sedira—Archéologie du Contemporain," Julie Crenn

10427, "*Les Hommes libres*, d'Ismaël Ferroukhi," Olivier Barlet

10465, "*La Mort de Danton*, d'Alice Diop," Olivier Barlet

10466, "C'est à nous de travailler sur nos propres complexes," interview, Olivier Barlet with Alice Diop

10467, "*Viva Riva!*, de Djo Tunda wa Munga," Olivier Barlet

10491, "Apt 2011: Les débats du printemps arabe," Olivier Barlet

10507, "Les clefs du succès d'*Intouchables*," Olivier Barlet

10526, "*Les Chants de Mandrin*, de Rabah Ameur-Zaïmeche," Olivier Barlet

10548, "1200 Local Mini-Movie Theaters: The ReaGilè Project in South Africa," Samuel Lelièvre

10571, "En politique, ce n'est pas grave de perdre," interview, Olivier Barlet with Nadia El Fani

10575, "Je ne vois aucun changement en Égypte," interview, Olivier Barlet with Ibrahim El Batout

10593, "*My Land*, de Nabil Ayouch," Olivier Barlet

10597, "Les nouvelles écritures du cinéma égyptien: Un débat avec Ibrahim El Batout et Ahmad Abdalla," Olivier Barlet

11483, "Fespaco 2013: Renewal or Demise," Olivier Barlet

11520, "Cannes 2013: De l'Afrique interlope à la lumière," Olivier Barlet

11857, "*Des Etoiles*, de Dyana Gaye," Djia Mambu and Olivier Barlet

12057, "Un film Youtubien," interview, Olivier Barlet with Hicham Lasri, about *C'est eux les chiens*

12233, "*Timbuktu, le chagrin des oiseaux*, d'Abderrahmane Sissako: Les visages de la dignité," Olivier Barlet

Index of Filmmakers and Films